ART HISTORY
PORTABLE EDITION THIRD EDITION

Fourteenth to Seventeenth Century Art

MARILYN STOKSTAD

Judith Harris Murphy Distinguished Professor of Art History Emerita
The University of Kansas

PEARSON
Prentice Hall

Upper Saddle River, NJ 07458

Editor-in-Chief: Sarah Touborg
Sponsoring Editor: Helen Ronan
Editorial Assistant: Christina DeCesare
Editor in Chief, Development: Rochelle Diogenes
Development Editors: Jeannine Ciliotta, Margaret Manos,
 Teresa Nemeth, and Carol Peters
Media Editor: Alison Lorber
Director of Marketing: Brandy Dawson
Executive Marketing Manager: Marissa Feliberty
AVP, Director of Production and Manufacturing: Barbara Kittle
Senior Managing Editor: Lisa Iarkowski
Production Editor: Barbara Taylor-Laino
Production Assistant: Marlene Gassler
Senior Operations Specialist: Brian K. Mackey
Operations Specialist: Cathleen Peterson
Creative Design Director: Leslie Osher
Art Director: Amy Rosen
Interior and Cover Design: Anne DeMarinis
Layout Artist: Gail Cocker-Bogusz
Line Art and Map Program Management: Gail Cocker-Bogusz,
 Maria Piper

Line Art Studio: Peter Bull Art Studio
Cartographer: DK Education, a division of Dorling Kindersley, Ltd.
Pearson Imaging Center: Corin Skidds, Greg Harrison, Robert
 Uibelhoer, Ron Walko, Shayle Keating, and Dennis Sheehan
Site Supervisor, Pearson Imaging Center: Joe Conti
Photo Research: Laurie Platt Winfrey, Fay Torres-Yap, Mary Teresa
 Giancoli, and Christian Peña, Carousel Research, Inc.
Director, Image Resource Center: Melinda Patelli
Manager, Rights and Permissions: Zina Arabia
Manager, Visual Research: Beth Brenzel
Manager, Cover Visual Research and Permissions: Karen Sanatar
Image Permission Coordinator: Debbie Latronica
Manager, Cover Research and Permissions: Gladys Soto
Copy Editor: Stephen Hopkins
Proofreaders: Faye Gemmellaro, Margaret Pinette, Nancy Stevenson,
 and Victoria Waters
Composition: Prepare, Inc.
Portable Edition Composition: Black Dot
Cover Printer: Phoenix Color Corporation
Printer/Binder: R. R. Donnelley

Maps designed and produced by DK Education, a division of Dorling Kindersley, Limited, 80 Strand London WC2R 0RL. DK and the DK logo are registered trademarks of Dorling Kindersley Limited.

Credits and acknowledgements borrowed from other sources and reproduced, with permission, in this textbook appear on the appropriate page within text or on the credit pages in the back of this book.

Cover Photo:
 Albrecht Dürer, *Four Horsemen of the Apocalypse,* from *The Apocalypse.* 1497–98. Woodcut, 15½ × 11⅛″ (39.4 × 28.3 cm). Photo: © Burstein Collection/Corbis.

Pearson Education LTD.
Pearson Education Australia PTY, Limited
Pearson Education Singapore, Pte. Ltd
Pearson Education North Asia Ltd

Pearson Education, Canada, Ltd
Pearson Educación de Mexico, S.A. de C.V
Pearson Education—Japan
Pearson Education Malaysia, Pte. Ltd

10 9 8 7 6 5 4 3 2 1

ISBN 0-13-605407-2
ISBN 978-0-13-605407-8

PEARSON
Prentice
Hall

CONTENTS

FOURTEENTH-CENTURY ART IN EUROPE 552

18 FIFTEENTH-CENTURY ART IN NORTHERN EUROPE AND THE IBERIAN PENINSULA 584

19 RENAISSANCE ART IN FIFTEENTH-CENTURY ITALY 618

20 SIXTEENTH-CENTURY ART IN ITALY 658

USE NOTES

The various features of this book reinforce each other, helping the reader to become comfortable with terminology and concepts that are specific to art history.

Starter Kit and Introduction The Starter Kit is a highly concise primer of basic concepts and tools. The Introduction is an invitation to the many pleasures of art history.

Captions There are two kinds of captions in this book: short and long. Short captions identify information specific to the work of art or architecture illustrated:

> artist (when known)
> title or descriptive name of work
> date
> original location (if moved to a museum or other site)
> material or materials a work is made of
> size (height before width) in feet and inches, with meters and centimeters in parentheses
> present location

The order of these elements varies, depending on the type of work illustrated. Dimensions are not given for architecture, for most wall paintings, or for most architectural sculpture. Some captions have one or more lines of small print below the identification section of the caption that gives museum or collection information. This is rarely required reading.

Long captions contain information that complements the narrative of the main text.

Definitions of Terms You will encounter the basic terms of art history in three places:

> IN THE TEXT, where words appearing in boldface type are defined, or glossed, at their first use. Some terms are boldfaced and explained more than once, especially those that experience shows are hard to remember.

> IN BOXED FEATURES, on technique and other subjects, where labeled drawings and diagrams visually reinforce the use of terms.

> IN THE GLOSSARY, at the end of the volume, which contains all the words in boldface type in the text and boxes. The Glossary begins on page G1, and the outer margins are tinted to make it easy to find.

Maps and Timelines At the beginning of each chapter you will find a map with all the places mentioned in the chapter. At the end of each chapter, a timeline runs from the earliest through the latest years covered in that chapter.

Boxes Special material that complements, enhances, explains, or extends the text is set off in three types of tinted boxes. Elements of Architecture boxes clarify specifically architectural features, such as "Space-Spanning Construction Devices" in the Starter Kit (page vi). Technique boxes (see "Lost-Wax Casting," page x) amplify the methodology by which a type of artwork is created. Other boxes treat special-interest material related to the text.

Bibliography The bibliography at the end of this book beginning on page B1 contains books in English, organized by general works and by chapter, that are basic to the study of art history today, as well as works cited in the text.

Dates, Abbreviations, and Other Conventions This book uses the designations BCE and CE, abbreviations for "Before the Common Era" and "Common Era," instead of BC ("Before Christ") and AD ("Anno Domini," "the year of our Lord"). The first century BCE is the period from 99 BCE to 1 BCE; the first century CE is from the year 1 CE to 99 CE. Similarly, the second century CE is the period from 199 BCE to 100 BCE; the second century CE extends from 100 CE to 199 CE.

100's	99–1	1–99	100's
second century BCE	first century BCE	first century CE	second century CE

Circa ("about" or "approximately") is used with dates, spelled out in the text and abbreviated to "c." in the captions, when an exact date is not yet verified.

An illustration is called a "figure," or "fig." Thus, figure 6–7 is the seventh numbered illustration in Chapter 6. Figures 1 through 24 are in the Introduction. There are two types of figures: photographs of artworks or of models, and line drawings. Drawings are used when a work cannot be photographed or when a diagram or simple drawing is the clearest way to illustrate an object or a place.

When introducing artists, we use the words *active* and *documented* with dates, in addition to "b." (for "born") and "d." (for "died"). "Active" means that an artist worked during the years given. "Documented" means that documents link the person to that date.

Accents are used for words in French, German, Italian, and Spanish only.

With few exceptions, names of museums and other cultural bodies in Western European countries are given in the form used in that country.

Titles of Works of Art Most paintings and works of sculpture created in Europe and North America in the past 500 years have been given formal titles, either by the artist or by critics and art historians. Such formal titles are printed in italics. In other traditions and cultures, a single title is not important or even recognized. In this book we use formal descriptive titles of artworks where titles are not established. If a work is best known by its non-English title, such as Manet's *Le Déjeuner sur l'Herbe (The Luncheon on the Grass)*, the original language precedes the translation.

STARTER KIT

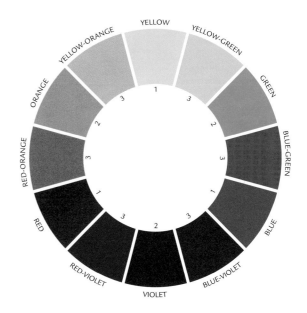

Art history focuses on the visual arts—painting, drawing, sculpture, graphic arts, photography, decorative arts, and architecture. This Starter Kit contains basic information and addresses concepts that underlie and support the study of art history. It provides a quick reference guide to the vocabulary used to classify and describe art objects. Understanding these terms is indispensable since you will encounter them again and again in reading, talking, and writing about art, and when experiencing works of art directly.

Let us begin with the basic properties of art. A work of art is a material object having both form and content. It is also described and categorized according to its style and medium.

FORM

Referring to purely visual aspects of art and architecture, the term form encompasses qualities of *line, shape, color, texture, space, mass* and *volume,* and *composition.* These qualities all are known as *formal elements.* When art historians use the term formal, they mean "relating to form."

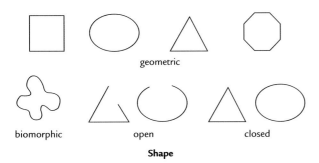

geometric

biomorphic open closed

Shape

Line and **shape** are attributes of form. Line is a form—usually drawn or painted—the length of which is so much greater than the width that we perceive it as having only length. Line can be actual, as when the line is visible, or it can be implied, as when the movement of the viewer's eyes over the surface of a work follows a path determined by the artist. Shape, on the other hand, is the two-dimensional, or flat, area defined by the borders of an enclosing *outline,* or *contour.* Shape can be *geometric, biomorphic* (suggesting living things; sometimes called organic), *closed,* or *open.* The *outline,* or *contour,* of a three-dimensional object can also be perceived as line.

Color has several attributes. These include *hue, value,* and *saturation.*

Hue is what we think of when we hear the word color, and the terms are interchangeable. We perceive hues as the result of differing wavelengths of electromagnetic energy. The visible spectrum, which can be seen in a rainbow, runs from red through violet. When the ends of the spectrum are connected through the hue red-violet, the result may be diagrammed as a color wheel. The *primary hues* (numbered 1) are red, yellow, and blue. They are known as primaries because all other colors are

made of a combination of these hues. Orange, green, and violet result from the mixture of two primaries and are known as secondary hues (numbered 2). *Intermediate hues,* or *tertiaries* (numbered 3), result from the mixture of a primary and a secondary. *Complementary colors* are the two colors directly opposite one another on the color wheel, such as red and green. Red, orange, and yellow are regarded as warm colors and appear to advance toward us. Blue, green, and violet, which seem to recede, are called cool colors. Black and white are not considered colors but neutrals; in terms of light, black is understood as the absence of color and white as the mixture of all colors.

Value is the relative degree of lightness or darkness of a given color and is created by the amount of light reflected from an object's surface. A dark green has a deeper value than a light green, for example. In black-and-white reproductions of colored objects, you see only value, and some artworks—for example, a drawing made with black ink—possesses only value, not hue or saturation.

Value scale from white to black.

+ WHITE PURE HUE + BLACK

Value variation in red.

Saturation, also sometimes referred to as intensity, is a color's quality of brightness or dullness. A color described as highly saturated looks vivid and pure; a hue of low saturation may look a little muddy or dark.

| PURE HUE | DULLED | PURE HUE |

Intensity scale from bright to dull.

Texture, another attribute of form, is the tactile (or touch-perceived) quality of a surface. It is described by words such as *smooth, polished, rough, grainy,* or *oily.* Texture takes two forms: the texture of the actual surface of the work of art and the implied (illusionistically depicted) surface of the object that the work represents.

Space is what contains objects. It may be actual and three-dimensional, as it is with sculpture and architecture, or it may be represented illusionistically in two dimensions, as when artists represent recession into the distance on a wall or canvas.

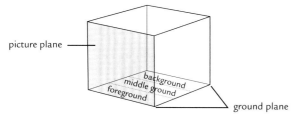

Mass and **volume** are properties of three-dimensional things. Mass is matter—whether sculpture or architecture—that takes up space. Volume is enclosed or defined space, and may be either solid or hollow. Like space, mass and volume may be illusionistically represented in two dimensions.

Composition is the organization, or arrangement, of form in a work of art. Shapes and colors may be repeated or varied, balanced symmetrically or asymmetrically; they may be static or dynamic. The possibilities are nearly endless and depend on the time and place where the work was created as well as the personal sensibility of the artist. *Pictorial depth* (spatial recession) is a specialized aspect of composition in which the three-dimensional world is represented in two dimensions on a flat surface, or *picture plane.* The area "behind" the picture plane is called the *picture space* and conventionally contains three "zones": *foreground, middle ground,* and *background.*

Various techniques for conveying a sense of pictorial depth have been devised by artists in different cultures and at different times. A number of them are diagrammed below. In Western art, the use of various systems of *perspective* has created highly convincing illusions of recession into space. In other cultures, perspective is not the most favored way to treat objects in space.

CONTENT

Content includes *subject matter,* which is what a work of art represents. Not all works of art have subject matter; many buildings, paintings, sculptures, and other art objects include no recognizable imagery but feature only lines, colors, masses, volumes, and other formal elements. However, all works of art—even those

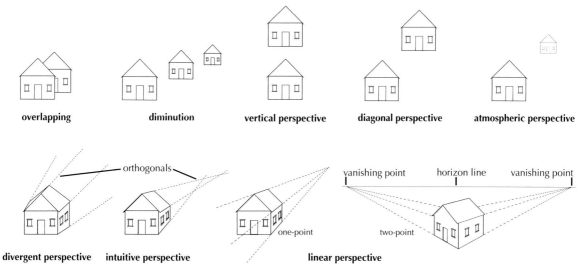

PICTORIAL DEVICES FOR DEPICTING RECESSION IN SPACE

The top row shows several comparatively simple devices, including *overlapping,* in which partially covered elements are meant to be seen as located behind those covering them, and *diminution,* in which smaller elements are to be perceived as being farther away than larger ones. In *vertical* and *diagonal perspective,* elements are stacked vertically or diagonally, with the higher elements intended to be perceived as deeper in space. Another way of suggesting depth is through *atmospheric perspective,* which depicts objects in the far distance, often in bluish gray hues, with less clarity than nearer

objects and treats sky as paler near the horizon than higher up. In the lower row, *divergent perspective,* in which forms widen slightly and lines diverge as they recede in space, was used by East Asian artists. *Intuitive perspective,* used in some late medieval European art, takes the opposite approach: forms become narrower and converge the farther they are from the viewer, approximating the optical experience of spatial recession. *Linear perspective,* also called *scientific, mathematical, one-point,* and *renaissance perspective,* is an elaboration and standardization of intuitive perspective and was developed

in fifteenth-century Italy. It uses mathematical formulas to construct illusionistic images in which all elements are shaped by imaginary lines called *orthogonals* that converge in one or more vanishing points on a *horizon line.* Linear perspective is the system that most people living in Western cultures think of as perspective. Because it is the visual code they are accustomed to reading, they accept as "truth" the distortions it imposes. One of these distortions is *foreshortening,* in which, for instance, the soles of the feet in the foreground are the largest elements of a figure lying on the ground.

without recognizable subject matter—have content, or meaning, insofar as they seek to convey feelings, communicate ideas, or affirm the beliefs and values of their makers and, often, the people who view or use them.

Content may comprise the social, political, religious, and economic *contexts* in which a work was created, the *intention* of the artist, the *reception* of the work by the beholder (the audience), and ultimately the meanings of the work to both artist and audience. Art historians applying different methods of interpretation often arrive at different conclusions regarding the content of a work of art.

The study of subject matter is *iconography* (literally, "the writing of images"). The iconographer asks, What is the meaning of this image? Iconography includes the study of *symbols* and *symbolism*—the process of representing one thing by another through association, resemblance, or convention.

STYLE

Expressed very broadly, *style* is the combination of form and composition that makes a work distinctive. *Stylistic analysis* is one of art history's most developed practices, because it is how art historians recognize the work of an individual artist or the characteristic manner of several artists working in a particular time or place. Some of the most commonly used terms to discuss *artistic styles* include *period style, regional style, representational style, abstract style, linear style*, and *painterly style*.

Period style refers to the common traits detectable in works of art and architecture from a particular historical era. For instance, Roman portrait sculpture created at the height of the Empire is different from sculpture made during the late imperial period, but it is recognizably Roman. It is good practice not to use the words style and period interchangeably. Style is the sum of many influences and characteristics, including the period of its creation. An example of proper usage is "an American house from the Colonial period built in the Georgian style."

Regional style refers to stylistic traits that persist in a geographic region. An art historian whose specialty is medieval art can recognize French style through many successive medieval periods and can distinguish individual objects created in medieval France from other medieval objects that were created in, for example, the Low Countries.

Representational styles are those that create recognizable subject matter. *Realism, naturalism*, and *illusionism* are representational styles.

> REALISM AND NATURALISM are terms often used interchangeably, and both describe the artist's attempt to describe the observable world. *Realism* is the attempt to depict objects accurately and objectively. *Naturalism* is closely linked to realism but often implies a grim or sordid subject matter.
>
> IDEAL STYLES strive to create images of physical perfection according to the prevailing values of a culture. The artist may work in a representational style or may try to capture an

underlying or expressive reality. Both the *Medici Venus* and Utamaro's *Woman at the Height of Her Beauty* (see Introduction, figs. 7 and 9) can be considered *idealized*.

> ILLUSIONISM refers to a highly detailed style that seeks to create a convincing illusion of reality. *Flower Piece with Curtain* is a good example of this trick-the-eye form of realism (see Introduction, fig. 2).
>
> IDEALIZATION strives to realize an image of physical perfection according to the prevailing values of a culture. The *Medici Venus* is idealized, as is Utamaro's *Woman at the Height of Her Beauty* (see Introduction, figs. 7 and 9).

Abstract styles depart from literal realism to capture the essence of a form. An abstract artist may work from nature or from a memory image of nature's forms and colors, which are simplified, stylized, distorted, or otherwise transformed to achieve a desired expressive effect. Georgia O'Keeffe's *Red Canna* is an abstract representation of nature (see Introduction, fig. 5). *Nonrepresentational art* and *expressionism* are particular kinds of abstract styles.

> NONREPRESENTATIONAL (OR NONOBJECTIVE) ART is a form that does not produce recognizable imagery. *Cubi XIX* is nonrepresentational (see Introduction, fig. 6).
>
> EXPRESSIONISM refers to styles in which the artist uses exaggeration of form to appeal to the beholder's subjective response or to project the artist's own subjective feelings. Munch's *The Scream* is expressionistic (see fig 30–71).

Linear describes both style and techniques. In the linear style the artist uses line as the primary means of definition, and modeling—the creation of an illusion of three-dimensional substance, through shading. It is so subtle that brushstrokes nearly disappear. Such a technique is also called "sculptural." Raphael's *The Small Cowper Madonna* is linear and sculptural (fig. 20–5)

Painterly describes a style of painting in which vigorous, evident brushstrokes dominate and shadows and highlights are brushed in freely. Sculpture in which complex surfaces emphasize moving light and shade is called "painterly." Claudel's *The Waltz* is painterly sculpture (see fig. 30–75).

MEDIUM

What is meant by medium or mediums (the plural we use in this book to distinguish the word from print and electronic news media) refers to the material or materials from which a work of art is made.

Technique is the process used to make the work. Today, literally anything can be used to make a work of art, including not only traditional materials like paint, ink, and stone, but also rubbish, food, and the earth itself. Various techniques are explained throughout this book in Technique boxes. When several mediums are used in a single work of art, we employ the term *mixed mediums*. Two-dimensional mediums include painting, drawing, prints, and photography. Three-

dimensional mediums are sculpture, architecture, and many so-called decorative arts.

Painting includes wall painting and fresco, illumination (the decoration of books with paintings), panel painting (painting on wood panels) and painting on canvas, miniature painting (small-scale painting), and handscroll and hanging scroll painting. Paint is pigment mixed with a liquid vehicle, or binder.

Graphic arts are those that involve the application of lines and strokes to a two-dimensional surface or support, most often paper. Drawing is a graphic art, as are the various forms of printmaking. Drawings may be sketches (quick visual notes made in preparation for larger drawings or paintings); studies (more carefully drawn analyses of details or entire compositions); cartoons (full-scale drawings made in preparation for work in another medium, such as fresco); or complete artworks in themselves. Drawings are made with such materials as ink, charcoal, crayon, and pencil. Prints, unlike drawings, are reproducible. The various forms of printmaking include woodcut, the intaglio processes (engraving, etching, drypoint), and lithography.

Photography (literally "light writing") is a medium that involves the rendering of optical images on light-sensitive surfaces. Photographic images are typically recorded by a camera.

Sculpture is three-dimensional art that is *carved, modeled, cast,* or *assembled.* Carved sculpture is subtractive in the sense that the image is created by taking away material. Wood, stone, and ivory are common materials used to create carved sculptures. Modeled sculpture is considered additive, meaning that the object is built up from a material, such as clay, that is soft enough to be molded and shaped. Metal sculpture is usually cast (see "Lost-Wax Casting," page x) or is assembled by welding or a similar means of permanent joining.

Sculpture is either freestanding (that is, not attached) or in relief. Relief sculpture projects from the background surface of which it is a part. High relief sculpture projects far from its background; low relief sculpture is only slightly raised; and sunken relief, found mainly in Egyptian art, is carved into the surface, with the highest part of the relief being the flat surface.

Ephemeral arts include processions and festival decorations and costumes, performance art, earthworks, cinema, video art, and some forms of digital and computer art. All have a central temporal aspect in that the artwork is viewable for a finite period of time and then disappears forever, is in a constant state of change, or must be replayed to be experienced again.

Architecture is three-dimensional, highly spatial, functional, and closely bound with developments in technology and materials. An example of the relationship among technology, materials, and function can be seen in "Space-Spanning Construction Devices" (page xi). Several types of two-dimensional schematic drawings are commonly used to enable the visualization of a building. These architectural graphic devices include plans, elevations, sections, and cutaways.

PLANS depict a structure's masses and voids, presenting a view from above—as if the building had been sliced horizontally at about waist height.

plan

ELEVATIONS show exterior sides of a building as if seen from a moderate distance without any perspective distortion.

elevation

SECTIONS reveal a building as if it had been cut vertically by an imaginary slicer from top to bottom.

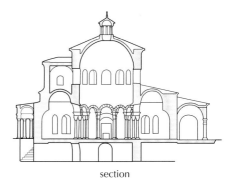

section

CUTAWAYS show both inside and outside elements from an oblique angle.

cutaway

Technique
LOST-WAX CASTING

The lost-wax process consists of a core on which the sculptor models the image in wax. A heat-resistant mold is formed over the wax. The wax is melted and replaced with metal, usually bronze or brass. The mold is broken away and the piece finished and polished by hand.

The usual metal for this casting process was bronze, an alloy of copper and tin, although sometimes brass, an alloy of copper and zinc, was used. The progression of drawings here shows the steps used by the Benin sculptors of Africa. A heat-resistant "core" of clay approximating the shape of the sculpture-to-be (and eventually becoming the hollow inside the sculpture) was covered by a layer of wax having the thickness of the final sculpture. The sculptor carved or modeled the details in the wax. Rods and a pouring cup made of wax were attached to the model. A thin layer of fine, damp sand was pressed very firmly into the surface of the wax model, and then model, rods, and cup were encased in thick layers of clay. When the clay was completely dry, the mold was heated to melt out the wax. The mold was then turned upside down to receive the molten metal, which is heated to the point of liquification. The cast was placed in the ground. When the metal was completely cool, the outside clay cast and the inside core were broken up and removed, leaving the cast brass sculpture. Details were polished to finish the piece of sculpture, which could not be duplicated because the mold had been destroyed in the process.

In lost-wax casting the mold had to be broken and only one sculpture could be made. In the eighteenth century a second process came into use—the piece mold. As its name implies, the piece mold could be removed without breaking allowing sculptors to make several copies (editions) of their work.

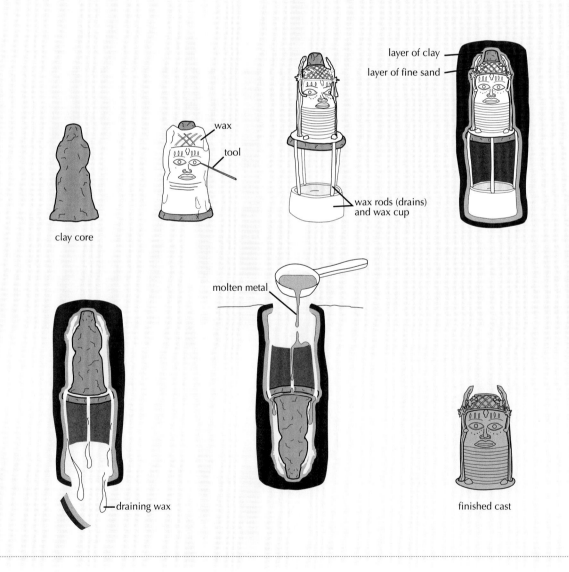

clay core

wax

tool

layer of clay

layer of fine sand

wax rods (drains) and wax cup

molten metal

draining wax

finished cast

Elements of Architecture
SPACE-SPANNING CONSTRUCTION DEVICES

Gravity pulls on everything, presenting great challenges to architects and sculptors. Spanning elements must transfer weight to the ground. The simplest space-spanning device is **post-and-lintel** construction, in which uprights are spanned by a horizontal element. However, if not flexible, a horizontal element over a wide span may break under the pressure of its own weight and the weight it carries.

Corbeling, the building up of overlapping stones, is another simple method for transferring weight to the ground. Arches, round or pointed, span space. **Vaults**, which are essentially extended arches, move weight out from the center of the covered space and down through the corners. The cantilever is a variant of post-and-lintel construction. **Suspension** works to counter the effect of gravity by lifting the spanning element upward. **Trusses** of wood or metal are relatively lightweight spanners but cannot bear heavy loads. Large-scale modern construction is chiefly steel frame and relies on steel's properties of strength and flexibility to bear great loads. When **concrete** is **reinforced** with steel or iron rods, the inherent brittleness of cement and stone is overcome because of metal's flexible qualities. The concrete can then span much more space and bear heavier loads. The **balloon frame**, an American innovation, is based on **post-and-lintel** principles and exploits the lightweight, flexible properties of wood.

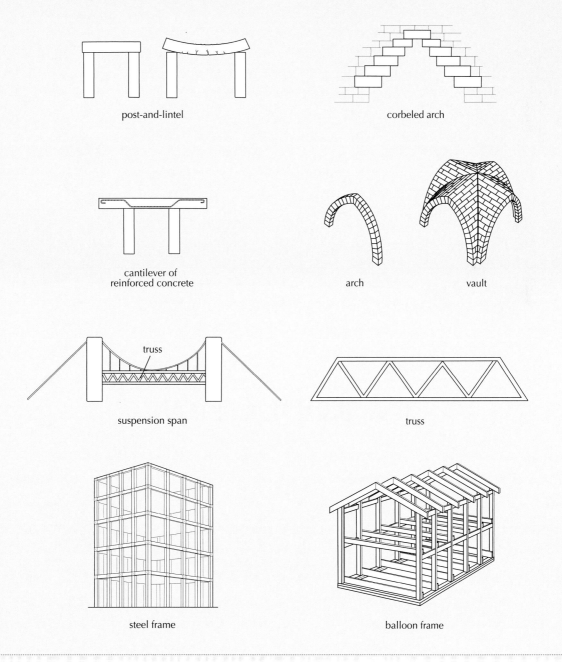

post-and-lintel

corbeled arch

cantilever of
reinforced concrete

arch

vault

truss

suspension span

truss

steel frame

balloon frame

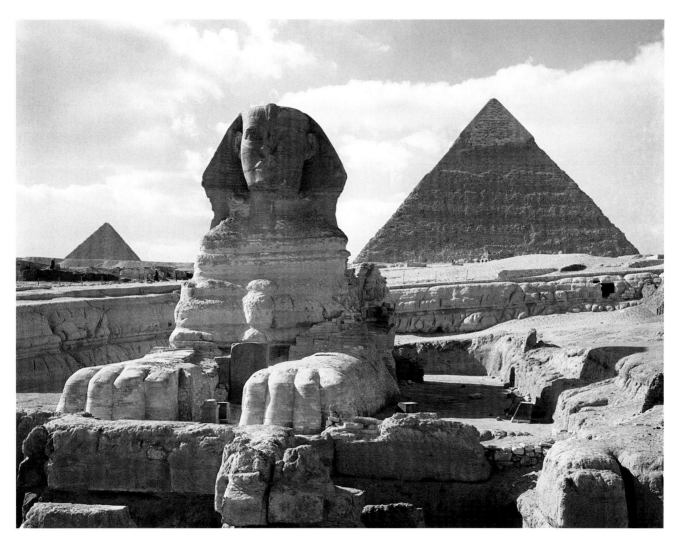

1 THE GREAT SPHINX, Giza, Egypt
Dynasty 4, c. 2613–2494 BCE. Sandstone, height approx. 65′ (19.8 m).

INTRODUCTION

Crouching in front of the pyramids of Egypt and carved from the living rock of the Giza plateau, the **GREAT SPHINX** is one of the world's best-known monuments (FIG. 1). By placing the head of the ancient Egyptian king Khafre on the body of a huge lion, the sculptors merged human intelligence and animal strength in a single image to evoke the superhuman power of the ruler. For some 4,600 years, the Sphinx has defied the desert sands; today it also must withstand the sprawl of greater Cairo and the impact of air pollution. In its majesty, the Sphinx symbolizes mysterious wisdom and dreams of permanence, of immortality. But is such a monument a work of art? Does it matter that the people who carved the Sphinx—unlike today's independent, individualistic artists—obeyed formulaic conventions and followed the orders of priests? No matter what the ancient Egyptians may have called it, today most people would say, "Certainly, it is art." Human imagination conceived this creature, and human skill gave it material form. Combining imagination and skill, the creators have conceived an idea of awesome grandeur and created a work of art. But we seldom stop to ask: What is art?

WHAT IS ART?

At one time the answer to the question "what is art?" would have been simpler than it is today. The creators of the *Great Sphinx* demonstrate a combination of imagination, skill, training, and observation that appeal to our desire for order and harmony—perhaps to an innate aesthetic sense. Yet, today some people question the existence of an aesthetic faculty, and we realize that our tastes are products of our education and our experience, dependent on time and place. Whether acquired at home, in schools, in museums, or in other public places, our responses are learned—not innate. Ideas of truth and falsehood, of good and evil, of beauty and ugliness are influenced as well by class, gender, race, and economic status. Some historians and critics even go so far as to argue that works of art are mere reflections of power and privilege.

Even the idea of "beauty" is questioned and debated today. Some commentators find discussions of aesthetics (the branch of philosophy concerned with The Beautiful) too subjective and too personal, and they dismiss the search for objective criteria that preoccupied scholars in the eighteenth and nineteenth centuries. As traditional aesthetics come under challenge, we can resort to discussing the authenticity of expression in a work of art, even as we continue to analyze its formal qualities. We can realize that people at different times and in different places have held different values. The words "art history" can be our touchstone. Like the twofold term itself, this scholarly discipline considers both art and history—the work of art as a tangible object and as part of its historical context. Ultimately, because so-called objective evaluations of beauty seem to be an impossibility, beauty again seems to lie in the eye of the beholder.

Today's definition of art encompasses the intention of the creator as well as the intentions of those who commissioned the work. It relies, too, on the reception of the artwork by society—both today and at the time when the work was made. The role of art history is to answer complex questions: Who are these artists and patrons? What is this thing they have created? When and how was the work done? Only after we have found answers to practical questions like these can we acquire an understanding and appreciation of the artwork and, answering our earlier question, we can say, Yes, this is a work of art.

ART AND NATURE

The ancient Greeks enjoyed the work of skillful artists. They especially admired the illusionistic treatment of reality in which the object represented appears to actually be present. The Greek penchant for realism is illustrated in a story from the late fifth century BCE about a rivalry between two painters named Zeuxis and Parrhasios as to whom was the better painter. First, Zeuxis painted a picture of grapes so accurately that birds flew down to peck at them. But, when Parrhasios

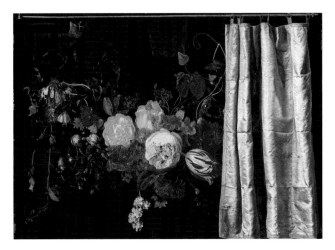

2 Adriaen van der Spelt and Frans van Mieris
FLOWER PIECE WITH CURTAIN
1658. Oil on panel, 18¼ × 25¼″ (46.5 × 64 cm). The Art Institute of Chicago.

took his turn, and Zeuxis asked his rival to remove the curtain hanging over his rival's picture, Parrhasios pointed out with glee that the "curtain" was his painting. Zeuxis had to admit that Parrhasios had won the competition since he himself had fooled only birds, while Parrhasios had deceived a fellow artist.

In the seventeenth century, the painters Adriaen van der Spelt (1630–73) and Frans van Mieris (1635–81) paid homage to the story of Parrhasios's curtain in a painting of blue satin drapery drawn aside to show a garland of flowers. We call the painting simply **FLOWER PIECE WITH CURTAIN** (FIG. 2). The artists not only re-created Parrhasios's curtain illusion but also included a reference to another popular story from ancient Greece, Pliny's anecdote of Pausias and Glykera. In his youth, Pausias had been enamoured of the lovely flower-seller Glykera, and he learned his art by persistently painting the exquisite floral garlands that she made, thereby becoming the most famously skilled painter of his age. The seventeenth-century people who bought such popular still-life paintings appreciated their classical allusions as much as the artists' skill in drawing and painting and their ability to manipulate colors on canvas. But, the reference to Pausias and Glykera also raised the conundrum inherent in all art that seeks to make an unblemished reproduction of reality: Which has the greater beauty, the flower or the painting of the flower? And which is the greater work of art, the garland or the painting of the garland? So then, who is the greater artist, the garland maker or the garland painter?

MODES OF REPRESENTATION

Many people think that the manner of Zeuxis and Parrhasios, and of van der Spelt and van Mieris—the manner of representation that we call **naturalism**, or **realism**—the mode of

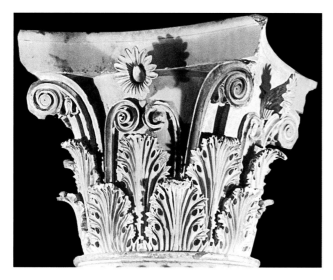

3 CORINTHIAN CAPITAL FROM THE THOLOS AT EPIDAURUS
c. 350 BCE. Archaeological Museum, Epidaurus, Greece.

aspects of the natural world. This approach to defining "What is art?" is a realistic or naturalistic one. But, of course, while artists may work in a naturalistic style, they also can render lifelike such fictions as a unicorn, a dragon, or a sphinx by incorporating features from actual creatures.

In contrast to Aristotle, Plato looked beyond nature for a definition of art. In his view even the most naturalistic painting or sculpture was only an approximation of an eternal ideal world in which no variations or flaws were present. Rather than focus on a copy of the particular details that one saw in any particular object, Plato focused on an unchangeable ideal—for artists, this would be the representation of a subject that exhibited perfect symmetry and proportion. This mode of interpretation is known as **idealis** . In a triumph of human reason over nature, idealism wishes to eliminate all irregularities, ensuring a balanced and harmonious work of art.

Let us consider a simple example of Greek idealism from architecture: the carved top, or capital, of a Corinthian column, a type that first appeared in ancient Greece during the fourth century BCE. The Corinthian capital has an inverted bell shape surrounded by acanthus leaves (FIG. 3). Although the acanthus foliage was inspired by the appearance of natural vegetation, the sculptors who carved the leaves eliminated blemishes and irregularities in order to create the Platonic ideal of the acanthus plant's foliage. To achieve Plato's ideal images and represent things "as they ought to be" rather than as they are, classical sculpture and painting established ideals that have inspired Western art ever since.

interpretation that seeks to record the visible world—represents the highest accomplishment in art, but not everyone agrees. Even the ancient Greek philosophers Aristotle (384–322 BCE) and Plato (428–348/7 BCE), who both considered the nature of art and beauty in purely intellectual terms, arrived at divergent conclusions. Aristotle believed that works of art should be evaluated on the basis of mimesis ("imitation"), that is, on how well they copy definable or particular

4 Edward Weston
SUCCULENT
1930. Gelatin silver print,
7½ × 9½" (19.1 × 24 cm).
Center for Creative Photography, The University of Arizona, Tucson.

Like ancient Greek sculptors, Edward Weston (1886–1958) and Georgia O'Keeffe (1887–1986) studied living plants. In his photograph SUCCULENT, Weston used straightforward camera work without manipulating the film in the darkroom in order to portray his subject (FIG. 4). He argued that although the camera sees more than the human eye, the quality of the image depends not on the camera, but on the choices made by the photographer-artist.

When Georgia O'Keeffe painted RED CANNA, she, too, sought to capture the plant's essence, not its appearance—although we can still recognize the flower's form and color (FIG. 5). By painting the canna lily's organic energy rather than the way it actually looked, she created a new abstract beauty, conveying in paint the pure vigor of the flower's life force. This **abstraction**—in which the artist appears to transform a visible or recognizable subject from nature in a way that suggests the original but purposefully does not record the subject in an entirely realistic or naturalistic way—is another manner of representation.

Furthest of all from naturalism are pure geometric creations such as the polished stainless steel sculpture of David Smith (1906–65). His Cubi works are usually called **nonrepresentational** art—art that does not depict a recognizable subject. With works such as CUBI XIX (FIG. 6), it is important to distinguish between subject matter and content. Abstract art like O'Keeffe's has both subject matter and content, or meaning. Nonrepresentational art does not have subject matter but it does have content, which is a product of the interaction between the artist's

6 David Smith **CUBI XIX**
1964. Stainless steel, 9′5⅛″ × 1′9¾″ × 1′8″ (2.88 x .55 × .51 m).
Tate Gallery, London.
© Estate of David Smith/Licensed by VAGA, New York, NY

intention and the viewer's interpretation. Some viewers may see the Cubi works as robotic plants sprung from the core of an unyielding earth, a reflection of today's mechanistic society that challenges the natural forms of trees and hills.

At the turn of the fifteenth century, the Italian master Leonardo da Vinci (1452–1519) argued that observation alone produced "mere likeness" and that the painter who copied the external forms of nature was acting only as a mirror. He believed that the true artist should engage in intellectual activity of a higher order and attempt to render the inner life—the energy and power—of a subject. In this book we will see that artists have always tried to create more than a superficial likeness in order to engage their audience and express the cultural contexts of their particular time and place.

5 Georgia O'Keeffe **RED CANNA**
1924. Oil on canvas mounted on Masonite, 36 × 29⅞″
(91.44 × 75.88 cm). Collection of the University of Arizona
Museum of Art, Tucson.
© 2007 The Georgia O'Keeffe Foundation/Artists Rights Society (ARS), New York

Beauty and the Idealization of the Human Figure

Ever since people first made what we call art, they have been fascinated with their own image and have used the human body to express ideas and ideals. Popular culture in the twenty-first century continues to be obsessed with beautiful people—with Miss Universe pageants and lists of the Ten

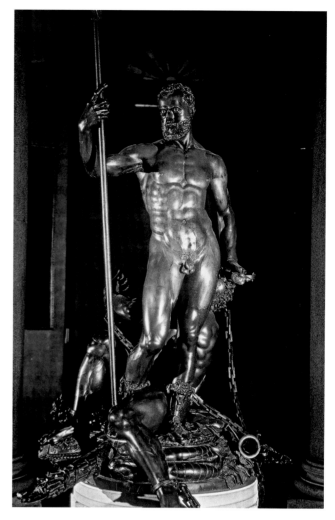

8 Leone Leoni **CHARLES V TRIUMPHING OVER FURY, WITHOUT ARMOR**
c. 1549–55. Bronze, height to top of head 5'8" (1.74 m).
Museo Nacional del Prado, Madrid.

7 THE MEDICI VENUS
Roman copy of a 1st-century BCE Greek statue.
Marble, height 5 (1.53 m) without base. Villa Medici, Florence, Italy.

Best-Dressed Women and the Fifty Sexiest Men, just to name a few examples. Today the **MEDICI VENUS**, with her plump arms and legs and sturdy body, would surely be expected to slim down, yet for generations such a figure represented the peak of female beauty (**FIG. 7**).

This image of the goddess of love inspired artists and those who commissioned their work from the fifteenth through the nineteenth century. Clearly, the artist had the skill to represent a woman as she actually appeared, but instead he chose to generalize her form and adhere to the classical canon (rule) of proportions. In so doing, the sculptor created a universal image, an ideal rather than a specific woman.

The *Medici Venus* represents a goddess, but artists also represented living people as idealized figures, creating symbolic portraits rather than accurate likenesses. The sculptor Leone Leoni (1509–90), commissioned to create a monumental bronze statue of the emperor Charles V (ruled 1519–56), expressed the power of this ruler of the Holy Roman Empire just as vividly as did the sculptors of the

Egyptian king Khafre, the subject of the *Great Sphinx* (SEE FIG. 1). Whereas in the sphinx, Khafre took on the body of a vigilant lion, in **CHARLES V TRIUMPHING OVER FURY**, the emperor has been endowed with the muscular torso and proportions of the classical ideal male athlete or god (FIG. 8). Charles does not inhabit a fragile human body; rather, in his muscular nakedness, he embodies the idea of triumphant authoritarian rule. (Not everyone approved. In fact, a full suit of armor was made for the statue, and today museum officials usually exhibit the sculpture clad in armor rather than nude.)

Another example of ideal beauty is the abstract vision of a woman depicted in a woodblock print by Japanese artist Kitagawa Utamaro (1753–1806). In its stylization, **WOMAN AT THE HEIGHT OF HER BEAUTY** (FIG. 9), reflects a social context regulated by convention and ritual. Simplified shapes depict the woman's garments and suggest the underlying human forms. The treatment of the rich textiles turn the body into an abstract pattern, and pins turn the hair into another elaborate shape. Utamaro rendered the decorative silks and carved pins meticulously, but he depicted the woman's face and hands with a few sweeping lines. The attention to surface detail combined with an effort to capture the essence of form is characteristic of abstract art in Utamaro's time and place, and images of men were equally elegant.

Today, when images—including those of great physical and spiritual beauty—can be captured with a camera, why should an artist draw, paint, or chip away at a knob of stone? Does beauty even play a significant role in our world? Attempting to answer these and other questions that consider the role of art is a branch of philosophy called *aesthetics*, which considers the nature of beauty, art, and taste as well as the creation of art.

Laocoön: A Meditation on Aesthetics

Historically, the story of Laocoön has focused attention on the different ways in which the arts communicate. In the *Iliad*, Homer's epic poem about the Trojan War, Laocoön was the priest who forewarned the Trojans of an invasion by the Greeks. Although Laocoön spoke the truth, the goddess Athena, who took the Greeks' side in the war, dispatched serpents to strangle him and his sons. His prophecy scorned, Laocoön represents the virtuous man tragically destroyed by unjust fate. In a renowned ancient sculpture, his features twist in agony, and the muscles of his and his sons' torsos and arms extend and knot as they struggle (FIG. 10). When this sculpture was discovered in Rome in 1506, Michelangelo rushed to watch it being excavated, an astonishing validation of his own ideal, heroic style coming straight out of the earth. The pope acquired it for the papal collection, and it can be seen today in the Vatican Museum.

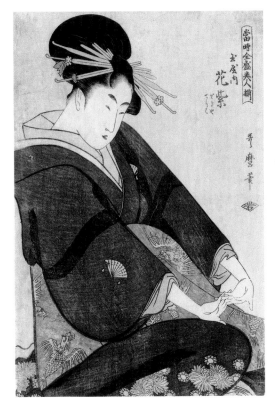

9 Kitagawa Utamaro **WOMAN AT THE HEIGHT OF HER BEAUTY**
Mid-1790s. Color woodblock print, 15⅛ × 10″ (38.5 × 25.5 cm). Spencer Museum of Art, The University of Kansas, Lawrence.
William Bridges Thayer Memorial, (1928.7879)

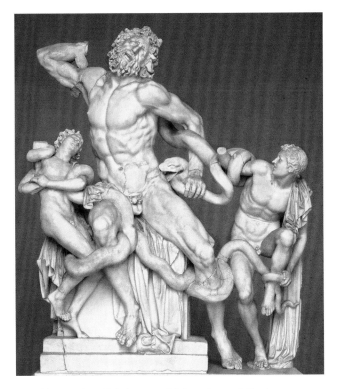

10 Hagesandros, Polydoros, and Athanadoros of Rhodes **LAOCOÖN AND HIS SONS**
As restored today. Probably the original of 1st century CE or a Roman copy of the 1st century CE. Marble, height 8′ (2.44 m). Musei Vaticani, Museo Pio Clementino, Cortile Ottagono, Rome, Italy.

Like other learned people in the eighteenth century, the German philosopher Lessing knew the story of Laocoön and admired the sculpture as well. In fact, he titled his study of the relationship between words and images "Laocoon: An Essay upon the Limits of Painting and Poetry" (1766). Lessing saw literary pursuits such as poetry and history as arts of time, whereas painting and sculpture played out in a single moment in space. Using words, writers can present a sequence of events, while sculptors and painters must present a single critical moment. Seen in this light, the interpretation of visual art depends upon the viewer who must bring additional knowledge in order to reconstitute the narrative, including events both before and after the depicted moment. For this reason, Lessing argued for the primacy of literature over the visual arts. The debate over the comparative virtues of the arts has been a source of excited argument and even outrage among critics, artists, philosophers, and academics ever since.

Underlying all our assumptions about works of art—whether in the past or the present—is the idea that art has meaning, and that its message can educate and move us, that it can influence and improve our lives. But what gives art its meaning and expressive power? Why do images fascinate and inspire us? Why do we treasure some things but not others? These are difficult questions, and even specialists disagree about the answers. Sometimes even the most informed people must conclude, "I just don't know."

Studying art history, therefore, cannot provide us with definitive answers, but it can help us recognize the value of asking questions as well as the value of exploring possible answers. Art history is grounded in the study of material objects that are the tangible expression of the ideas—and ideals—of a culture. For example, when we become captivated by a striking creation, art history can help us interpret its particular imagery and meaning. Art history can also illuminate the cultural context of the work—that is, the social, economic, and political situation of the historical period in which it was produced, as well as its evolving significance through the passage of time.

Exceptional works of art speak to us. However, only if we know something about the **iconography** (the meaning and interpretation) of an image can its larger meaning become clear. For example, let's look again at *Flower Piece with Curtain* (SEE FIG. 2). The brilliant red and white tulip just to the left of the blue curtain was the most desirable and expensive flower in the seventeenth century; thus, it symbolizes wealth and power. Yet insects creep out of it, and a butterfly—fragile and transitory—hovers above it. Consequently, here flowers also symbolize the passage of time and the fleeting quality of human riches. Informed about its iconography and cultural context, we begin to fathom that this painting is more than a simple still life.

WHY DO WE NEED ART?

Before we turn to Chapter 1—before we begin to look at, read about, and think about works of art and architecture historically, let us consider a few general questions that studying art history can help us answer and that we should keep in mind as we proceed: Why do we need art? Who are artists? What role do patrons play? What is art history? and What is a viewer's role and responsibility? By grappling with such questions, our experience of art can be greatly enhanced.

Biologists account for the human desire for art by explaining that human beings have very large brains that demand stimulation. Curious, active, and inventive, we humans constantly explore, and in so doing we invent things that appeal to our senses—fine art, fine food, fine scents, fine fabrics, and fine music. Ever since our prehistoric ancestors developed their ability to draw and speak, we have visually and verbally been communicating with each other. We speculate on the nature of things and the meaning of life. In fulfilling our need to understand and our need to communicate, the arts serve a vital function. Through art we become fully alive.

Self-Expression: Art and the Search for Meaning

Throughout history art has played an important part in our search for the meaning of the human experience. In an effort to understand the world and our place in it, we turn both to introspective personal art and to communal public art. Following a personal vision, James Hampton (1909–64) created profoundly stirring religious art. Hampton worked as a janitor to support himself while, in a rented garage, he built THRONE OF THE THIRD HEAVEN OF THE NATIONS' MILLENNIUM GENERAL ASSEMBLY (FIG. 11), his monument to his faith. In rising tiers, thrones and altars have been prepared for Jesus and Moses. Placing New Testament imagery on the right and Old Testament imagery on the left, Hampton labeled and described everything. He even invented his own language to express his visions. On one of many placards he wrote his credo: "Where there is no vision, the people perish" (Proverbs 29:18). Hampton made this fabulous assemblage out of discarded furniture, flashbulbs, and all sorts of refuse tacked together and wrapped in gold and silver aluminum foil and purple tissue paper. How can such worthless materials turn into an exalted work of art? Art's genius transcends material.

In contrast to James Hampton, whose life work was compiled in private and only came to public attention after his death, most artists and viewers participate in more public expressions of art and belief. Nevertheless, when people employ special objects in their rituals, such as statues, masks, and vessels, these pieces may be seen as works of art by others who do not know about their intended use and original significance.

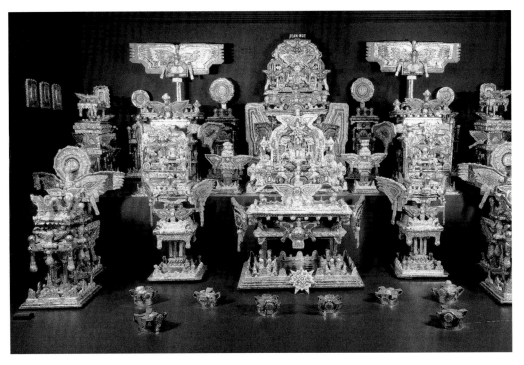

11 James Hampton **THRONE OF THE THIRD HEAVEN OF THE NATIONS'
MILLENNIUM GENERAL ASSEMBLY**
c. 1950–1964. Gold and silver aluminum foil, colored Kraft paper, and plastic sheets over wood,
paperboard, and glass, 10'6" × 27' × 14'6" (3.2 × 8.23 × 4.42 m). Smithsonian American Art
Museum, Smithsonian Institution, Washington, D.C.
Gift of Anonymous Donors, 1970.353.1

Social Expression: Art and Social Context

The visual arts are among the most sophisticated forms of
human communication, at once shaping and being shaped by
their social context. Artists may unconsciously interpret their
times, but they also may be enlisted to consciously serve
social ends in ways that range from heavy-handed propa-
ganda (as seen earlier in the portrait of Charles V, for example)
to subtle suggestion. From ancient Egyptian priests to elected
officials today, religious and political leaders have understood
the educational and motivational value of the visual arts.

Governments and civic leaders use the power of art to
strengthen the unity that nourishes society. In sixteenth-cen-
tury Venice, for example, city officials ordered Veronese (Paolo
Caliari, 1528–88) to fill the ceiling in the Great Council Hall
with a huge and colorful painting, **THE TRIUMPH OF VENICE**
(**FIG. 12**). Their contract with the artist survives as evidence of
their intentions. They wanted a painting that showed their
beloved Venice surrounded by peace, abundance, fame, happi-
ness, honor, security, and freedom—all in vivid colors and ide-
alized forms. Veronese and his assistants complied by painting
the city personified as a mature, beautiful, and splendidly robed

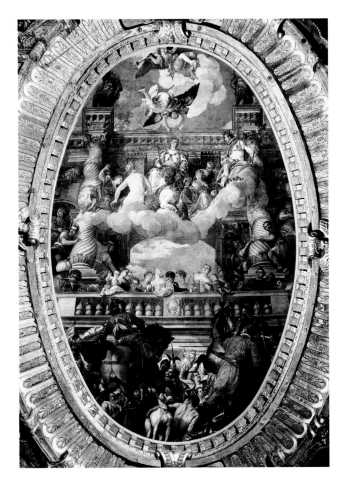

12 Veronese **THE TRIUMPH OF VENICE**
Ceiling painting in the Council Chamber, Palazzo Ducale, Venice,
Italy. c. 1585. Oil on canvas, 29'8" × 19' (9.04 × 5.79 m).

woman enthroned between the towers of the Arsenal, a building where ships were built for worldwide trade, the source of the city's wealth and power. Veronese painted enthusiastic crowds of cheering citizens, together with personifications of Fame blowing trumpets and of Victory crowning Venice with a wreath. Supporting this happy throng, bound prisoners and trophies of armor attest to Venetian military prowess. The Lion of Venice—the symbol of the city and its patron, Saint Mark—oversees the triumph. Although Veronese created this splendid propaganda piece to serve the purposes of his patrons, his artistic vision was as individualistic as that of James Hampton, whose art was purely self-expression.

Social Criticism: Uncovering Sociopolitical Intentions

Although powerful patrons have used artworks throughout history to promote their political interests, modern artists are often independent-minded and astute critics of the powers that be. For example, among Honoré Daumier's most trenchant comments on the French government is his print RUE TRANSONAIN, LE 15 AVRIL 1834 (FIG. 13). During a period of urban unrest, the French National Guard fired on unarmed citizens, killing fourteen people. For his depiction of the massacre, Daumier used lithography—a cheap new means of illustration. He was not thinking in terms of an enduring historical record, but rather of a medium that would enable him to spread his message as widely as possible. Daumier's political commentary created such horror and revulsion among the public that the government reacted by buying and destroying all the newspapers in which the lithograph appeared. As this example shows, art historians sometimes need to consider not just the historical context of a work of art but also its political content and medium to have a fuller understanding of it.

Another, more recent, work with a critical message recalls how American citizens of Japanese ancestry were removed from their homes and confined in internment camps during World War II. In 1978, Roger Shimomura (b. 1939) painted DIARY, which illustrates his grandmother's account of the family's experience in one such camp in Idaho (FIG. 14). Shimomura has painted his grandmother writing in her diary, while he (the toddler) and his mother stand by an open door—a door that does not signify freedom but opens on to a field bounded by barbed wire. In this commentary on discrimination and injustice, Shimomura combines two stylistic traditions—the Japanese art of the color woodblock print and American Pop art of the 1960s—to create a personal style that expresses his own dual culture.

WHO ARE THE ARTISTS?

We have focused so far mostly on works of art. But what of the artists who make them? How artists have viewed themselves and have been viewed by their contemporaries has

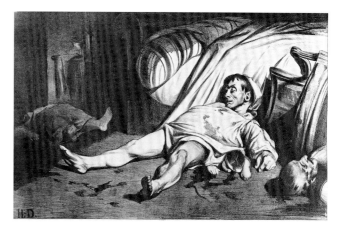

13 Honoré Daumier **RUE TRANSONAIN, LE 15 AVRIL 1834**
Lithograph, 11″ × 17⅜″ (28 × 44 cm). Bibliothèque Nationale, Paris.

changed over time. In Western art, painters and sculptors were at first considered artisans or craftspeople. The ancient Greeks and Romans ranked painters and sculptors among the skilled workers; they admired the creations, but not the creators. The Greek word for art, *tekne*, is the source for the English word "technique," and the English words *art* and *artist* come from the Latin word *ars*, which means "skill." In the Middle Ages, people sometimes went to the opposite extreme and attributed especially fine works of art not to human artisans, but to supernatural forces, to angels, or to Saint Luke. Artists continued to be seen as craftspeople—admired, often prosperous, but not particularly special—until the Renaissance, when artists such as Leonardo da Vinci proclaimed themselves to be geniuses with "divine" abilities.

14 Roger Shimomura
DIARY (MINIDOKA SERIES #3)
1978. Acrylic on canvas, 4′11⅞″ x 6′ (1.52 × 1.83 m). Spencer Museum of Art, The University of Kansas, Lawrence.
Museum purchase, (1979.51)

Soon after the Renaissance, the Italian painter Guercino (Giovanni Francesco Barbieri, 1591–1666) combined the idea that saints and angels have miraculously made works of art with the concept that human painters have special, divinely inspired gifts. In his painting SAINT LUKE DISPLAYING A PAINTING OF THE VIRGIN (FIG. 15), Guercino portrays the Evangelist who was regarded as the patron saint of artists. Christians widely believed that Luke had painted a portrait of the Virgin Mary holding the Christ Child. In Guercino's painting, Luke, seated before just such a painting and assisted by an angel, holds his palette and brushes. A book, a quill pen, and an inkpot decorated with a statue of an ox (Saint Luke's symbol) rest on a table, reminders of his status as the author of a gospel. Guercino seems to say that if Saint Luke is a divinely endowed artist, then surely all other artists share in this special power and status. This image of the artist as an inspired genius has persisted.

Even after the idea of "specially endowed" creators emerged, numerous artists continued to conduct their work as craftspeople leading workshops, and oftentimes artwork continued to be a team effort. Nevertheless, as the one who conceives the work and controls its execution—the artist is the "creator," whose name is associated with the final product.

This approach is evident today in the glassworks of American artist Dale Chihuly (b. 1941). His team of artist-craftspeople is skilled in the ancient art of glass-making, but Chihuly remains the controlling mind and imagination behind the works. Once created, his multipart pieces may be transformed when they are assembled for display; they can take on a new life in accordance with the will of a new owner, who may arrange the pieces to suit his or her own preferences. The viewer/owner thus becomes part of the creative team. Originally fabricated in 1990, VIOLET PERSIAN SET WITH RED LIP WRAPS (FIG. 16) has twenty separate pieces, but the person who assembles them determines the composition.

How Does One Become an Artist?

Whether working individually or communally, even the most brilliant artists spend years in study and apprenticeship and continue to educate themselves throughout their lives. In his painting THE DRAWING LESSON, Dutch artist Jan Steen (1626–79) takes us into a well-lit artist's studio. Surrounded by the props of his art—a tapestry backdrop, an easel, a stretched canvas, a portfolio, musical instruments, and decorative *objets d'art*—a painter instructs two youngsters—a boy apprentice at a drawing board, and a young woman in an elegant armchair (FIG. 17). The artist's pupil has been drawing from sculpture and plaster casts because women were not permitted to work from nude models. *The Drawing Lesson* records contemporary educational practice and is a valuable record of an artist's workplace in the seventeenth century.

Even the most mature artists learn from each other. In the seventeenth century, Rembrandt van Rijn carefully studied

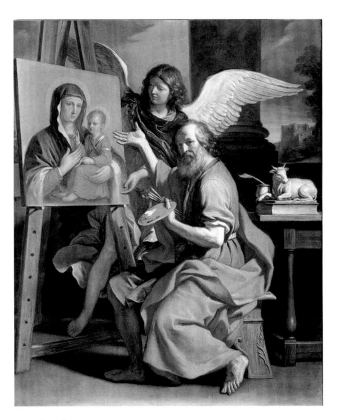

15 Guercino **SAINT LUKE DISPLAYING A PAINTING OF THE VIRGIN**
1652–53. Oil on canvas, 7'3″ × 5'11″ (2.21 × 1.81 m).
The Nelson-Atkins Museum of Art, Kansas City, Missouri.
Purchase (F83-55)

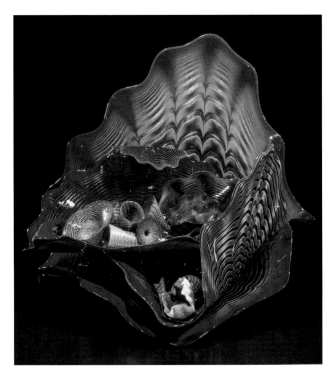

16 Dale Chihuly **VIOLET PERSIAN SET WITH RED LIP WRAPS**
1990. Glass, 26 x 30 × 25″ (66 x 76.2 × 63.5 cm). Spencer Museum of Art, The University of Kansas, Lawrence.
Museum Purchase: Peter T. Bohan Art Acquisition Fund, 1992.2

Leonardo's painting of THE LAST SUPPER (FIG. 18). Leonardo had turned this traditional theme into a powerful drama by portraying the moment when Christ announces that one of the assembled apostles will betray him. Even though the men react with surprise and horror to this news, Leonardo depicted the scene in a balanced symmetrical composition typical of the Italian Renaissance of the fifteenth and early sixteenth centuries, with the apostles in groups of three on each side of Christ. The regularly spaced tapestries and ceiling panels lead the viewers' eyes to Christ, who is silhouetted in front of an open window (the door seen in the photograph was cut through the painting at a later date).

Rembrandt, working 130 years later in the Netherlands—a very different time and place—knew the Italian master's painting from a print, since he never went to Italy. Rembrandt copied THE LAST SUPPER in hard red chalk (FIG. 19). Then he reworked the drawing in a softer chalk, assimilating Leonardo's lessons but revising the composition and changing the mood of the original. With heavy overdrawing he recreated the scene, shifting Jesus's position to the left, giving Judas more emphasis. Gone are the wall hangings and ceiling, replaced by a huge canopy. The space is undetermined and expansive rather than focused. Rembrandt's drawing is more than an academic exercise; it is also a sincere tribute from one

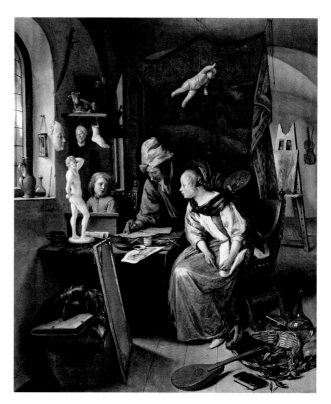

17 Jan Steen **THE DRAWING LESSON**
1665. Oil on wood, 19⅜ × 16¼" (49.3 × 41 cm).
The J. Paul Getty Museum, Los Angeles, California.

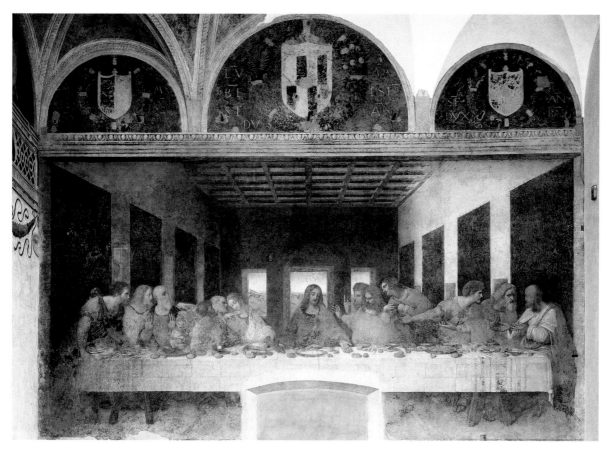

18 Leonardo da Vinci **THE LAST SUPPER**
Wall painting in the refectory, Monastery of Santa Maria delle Grazie, Milan, Italy. 1495–98. Tempera and oil on plaster, 15'2" × 28'10" (4.6 × 8.8m).

great master to another. The artist must have been pleased with his version of Leonardo's masterpiece because he signed his drawing boldly in the lower right-hand corner.

WHAT ROLE DO PATRONS AND COLLECTORS PLAY?

As we have seen, the person or group who commissions or supports a work of art—the patron—can have significant impact on it. The *Great Sphinx* (SEE FIG. 1) was "designed" following the conventions of priests in ancient Egypt; the monumental statue of Charles V was cast to glorify absolutist rule (SEE FIG. 8); the content of Veronese's *Triumph of Venice* (SEE FIG. 12) was determined by that city's government officials; and Chihuly's glassworks (SEE FIG. 16) may be reassembled according to the collector's wishes or whims.

The civic sponsorship of art is epitomized by fifth-century BCE Athens, a Greek city-state whose citizens practiced an early form of democracy. Led by the statesman and general Perikles, the Athenians defeated the Persians, and then rebuilt Athens's civic and religious center, the Acropolis, as a tribute to the goddess Athena and a testament to the glory of Athens. In FIGURE 20, a nineteenth-century British artist, Sir Lawrence Alma-Tadema, conveys the accomplishment of the

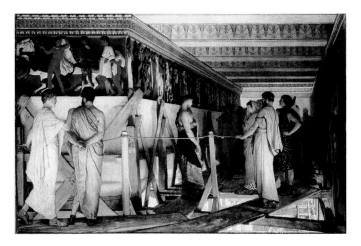

20 Lawrence Alma-Tadema **PHEIDIAS AND THE FRIEZE OF THE PARTHENON**, Athens 1868. Oil on canvas, 29⅗ × 42⅓″ (75.3 × 108 cm). Birmingham City Museum and Art Gallery, England.

Athenian architects, sculptors, and painters, who were led by the artist Pheidias. Alma-Tadema imagines the moment when Pheidias showed the carved and painted frieze at the top of the wall of the Temple of Athena (the Parthenon) to Perikles and a group of Athenian citizens—his civic sponsors.

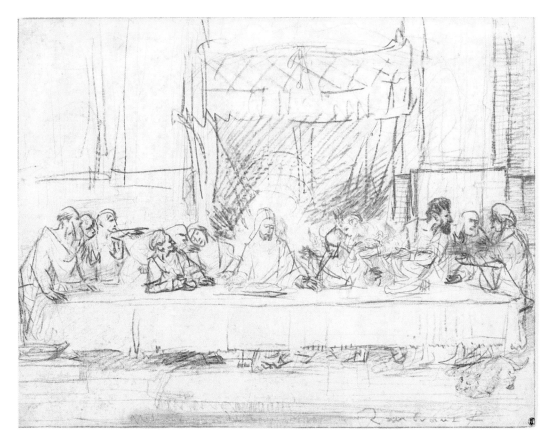

19 Rembrandt van Rijn **THE LAST SUPPER**
After Leonardo da Vinci's fresco. Mid-1630s. Drawing in red chalk, 14⅜ × 18¾″ (36.5 × 47.5 cm).
The Metropolitan Museum of Art, New York.
Robert Lehman Collection, 1975 (1975.1.794)

THE ◉BJECT SPEAKS

THE VIETNAM VETERANS MEMORIAL

"Cattle die. Kinfolk die. We all die. Only fame lasts," said the Vikings. Names remain. Flat, polished stone walls inscribed with thousands of names reflect back the images of the living as they contemplate the memorial to the Vietnam War's (1964–75) dead and missing veterans. The idea is brilliant in its simplicity. The artist Maya Ying Lin (b. 1959) combined two basic ideas: the minimal grandeur of long, black granite walls and row upon row of engraved names—the abstract and the intimate conjoined. The power of Lin's monument lies in its understatement. The wall is a statement of loss, sorrow, and the futility of war, and the names are so numerous that they lose individuality and become a surface texture. It is a timeless monument to suffering humanity, faceless in sacrifice. Maya Lin said, "The point is to see yourself reflected in the names."

The VIETNAM VETERANS MEMORIAL, now widely admired as a fitting testament to the Americans who died in that conflict, was the subject of public controversy when it was first proposed due to its severely Minimalist style. In its request for proposals for the design of the monument, the Vietnam Veterans Memor-ial Fund—composed primarily of veterans themselves—stipulated that the memorial be without political or military content, that it be reflective in character, that it harmonize with its surroundings, and that it include the names of the more than 58,000 dead and missing. They awarded the commission to Maya Lin, then an undergraduate studying in the architecture department at Yale University. Her design called for two 200-foot long walls (later expanded to 246 feet) of polished black granite to be set into a gradual rise in Constitution Gardens on the Mall in Washington, D.C., meeting at a 136 degree angle at the point where the walls and slope would be at their full 10-foot height. The names of the dead were to be incised in the stone in the order in which they died, with only the dates of the first and last deaths to be recorded.

The walls also reflect more than visitors. One wall faces and reflects the George Washington Monument (constructed 1848–84). Robert Mills, the architect of many public buildings at the beginning of the nineteenth century, chose the obelisk, a time-honored Egyptian sun symbol, for his memorial to the nation's founder. The other wall leads the eye to the Neoclassical-style Lincoln Memorial. By subtly incorporating the Washington and Lincoln monuments into the design, Lin's *Vietnam Veterans Memorial* reminds the viewer of sacrifices made in defense of liberty throughout the history of the United States.

Until the modern era, most public art celebrated political and social leaders and glorified aspects of war in large, free-standing monuments. The motives of those who commissioned public art have ranged from civic pride and the wish to honor heroes to political propaganda and social intimidation. Art in public places may engage our intellect, educating or reminding us of significant events in history. Yet the most effective memorials also appeal to our emotions. Public memorials can provide both a universal and intimate experience, addressing subjects that have entered our collective conscious as a nation, yet remain highly personal. Lin's memorial in Washington, D.C., to the American men and women who died in or never returned from the Vietnam War is among the most visited works of public art of the twenty-first century and certainly among the most affecting war monuments ever conceived.

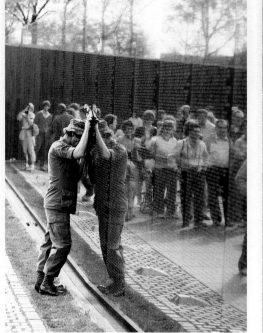
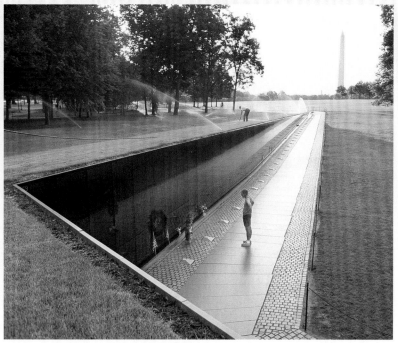

Maya Ying Lin **VIETNAM VETERANS MEMORIAL**
1982. Black Granite, length 500' (152 m). The Mall, Washington, D.C.

Although artists sometimes work speculatively, hoping afterwards to sell their work on the open market, throughout history interested individuals and institutions have acted as patrons of the arts. During periods of great artistic vigor, enlightened patronage has been an essential factor. Today, museums and other institutions, such as governmental agencies (for example, in the United States, the National Endowment for the Arts), also provide financial grants and support for the arts.

Individual Patrons

People who are not artists often want to be involved with art, and patrons of art constitute a very special audience for artists. Many collectors truly love works of art, but some collect art only to enhance their own prestige, to give themselves an aura of power and importance. Patrons can vicariously participate in the creation of a work by providing economic support to an artist. Such individual patronage can spring from a cordial relationship between a patron and an artist, as is evident in an early fifteenth-century manuscript illustration in which the author, Christine de Pizan, presents her work to her patron Isabeau, the Queen of France (FIG. 21). Christine—a widow who supported her family by writing—hired painters and scribes to copy, illustrate, and decorate her books. She especially admired the painting of a woman named Anastaise, whose work she considered unsurpassed in the city of Paris. While Queen Isabeau was Christine's patron, Christine in turn was Anastaise's patron; and all the women seen in the painting were patrons of the brilliant textile workers who supplied the brocades for their gowns, the tapestries for the wall, and the embroideries for the bed. Such networks of patronage shape a culture.

Relations between artists and patrons are not always necessarily congenial. Patrons may change their minds or fail to pay their bills. Artists may ignore their patron's wishes, or exceed the scope of their commission. In the late nineteenth century, for example, the Liverpool shipping magnate Frederick Leyland asked James McNeill Whistler (1834–1903), an American painter living in London, what color to paint the shutters in the dining room where he planned to hang Whistler's painting *The Princess from The Land of Porcelain* (FIG. 22).

The room had been designed by Thomas Jeckyll with embossed and gilded leather on the walls and finely crafted shelves to show off Leyland's collection of blue and white Chinese porcelain. While Leyland was away, Whistler, inspired by the Japanese theme of his own painting as well as by the porcelain, painted the window shutters with splendid turquoise and gold peacocks, the walls and ceiling with peacock feathers, and then he gilded the walnut shelves. When Leyland, shocked and angry at what seemed to him to be wanton destuction of the room, paid him less than half the agreed on price, Whistler added a painting of himself and Leyland as fighting peacocks. Whistler called the room **HARMONY IN BLUE AND GOLD: THE PEACOCK ROOM**.

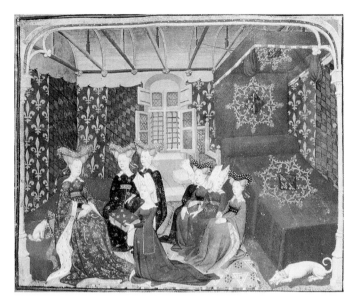

21 CHRISTINE DE PIZAN PRESENTING HER BOOK TO THE QUEEN OF FRANCE 1410–15. Tempera and gold on vellum, image approx. 5½ × 6¾" (14 × 17 cm). The British Library, London.
MS. Harley 4431, folio 3

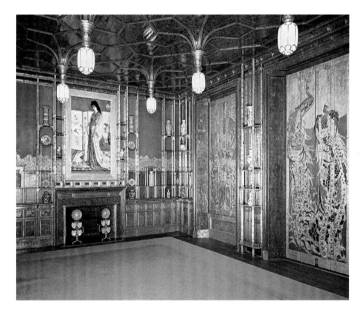

22 James McNeill Whistler **HARMONY IN BLUE AND GOLD: THE PEACOCK ROOM** northeast corner, from a house owned by Frederick Leyland, London. 1876–77. Oil paint and metal leaf on canvas, leather, and wood, 13'11⅞" × 33'2" × 19'11½" (4.26 × 10.11 × 6.83 m). Over the fireplace, Whistler's *The Princess from The Land of Porcelain*. Freer Gallery of Art, Smithsonian Institution, Washington, D.C.
Gift of Charles Lang Freer, (F1904.61)

Luckily, Leyland did not destroy the Peacock Room. After Leyland's death, Charles Lang Freer (1854–1919) purchased the room and the painting of *The Princess*. Freer reinstalled the room in his home in Detroit, Michican, and filled the delicate gold shelves with his own collection of porcelain. When Freer died in 1919, the Peacock Room was moved to the Freer

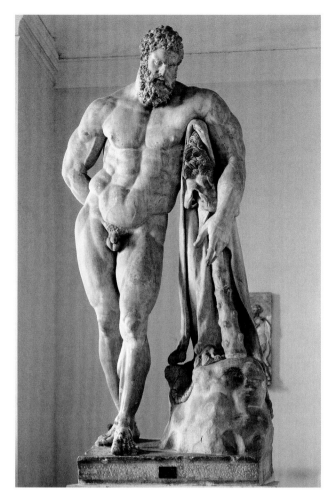

23 THE FARNESE HERCULES
3rd century BCE. Copy of *The Weary Hercules* by Lysippos. Found in the Baths of Caracalla in 1546; exhibited in the Farnese Palace until 1787. Marble, 10½' (3.17 m). Signed "Glykon" on the rock under the club. Left arm restored.

Gallery of Art, which he had founded in Washington D.C., where it remains as an extraordinary example of interior design and late nineteenth-century patronage.

Collectors and Museums

From the earliest times, people have collected and kept precious objects that convey the idea of power and prestige. Today both private and public museums are major patrons, collectors, and preservers of art. Curators of such collections acquire works of art for their museums and often assist patrons in obtaining especially desirable pieces, although the idea of what is best and what is worth collecting and preserving often changes from one generation to another.

Charles Lang Freer, mentioned on the previous page, is another kind of patron—one who was a sponsor of artists, a collector, and the founder of the museum that bears his name. Freer was an industrialist in Detroit—the manufacturer of railway cars—who was inspired by the nineteenth-century ideal of art as a means of achieving universal harmony and of the philosophy "Art for Art's Sake." The leading American exponent of

this philosophy was James McNeill Whistler. On a trip to Europe in 1890, Freer met Whistler, who inspired him to collect Asian art as well as the art of his own time. Freer became an avid collector and supporter of Whistler, whom he saw as a person who combined the aesthetic ideals of both East and West. Freer assembled a large and distinguished collection of American and Asian art, including the *Peacock Room*. (SEE FIG. 22). In his letter written at the founding the Freer Gallery, donating his collection to the Smithsonian Institution and thus to the American people, he wrote of his desire to "elevate the human mind."

WHAT IS ART HISTORY?

Art history became an academic field of study relatively recently. Many art historians consider the first art history book to be the 1550 publication *Lives of the Most Excellent Italian Architects, Painters, and Sculptors*, by the Italian artist and writer Giorgio Vasari. As the name suggests, art history combines two studies—the study of individual works of art outside time and place (**formal analysis** and **theory**) and the study of art in its historical and cultural context (**contextualism**), the primary approach taken in this book. The scope of art history is immense. As a result, art history today draws on many other disciplines and diverse methodologies.

Studying Art Formally and Contextually

The intense study of individual art objects is known as **connoisseurship**. Through years of close contact with artworks and through the study of the formal qualities that compose style in art (such as the design, the composition, and the way materials are manipulated)—an approach known as **formalism**—the connoisseur learns to categorize an unknown work through comparison with related pieces, in the hope of attributing it to a period, a place, and sometimes even a specific artist. Today such experts also make use of the many scientific tests—such as x-ray radiography, electron microscopy, infrared spectroscopy, and x-ray diffraction—but ultimately connoisseurs depend on their visual memory and their skills in formal analysis.

As a humanistic discipline, art history adds theoretical and contextual studies to the formal and technical analyses of connoisseurship. Art historians draw on biography to learn about artists' lives; on social history to understand the economic and political forces shaping artists, their patrons, and their public; and on the history of ideas to gain an understanding of the intellectual currents influencing artists' works. Some art historians are steeped in the work of Sigmund Freud (1856–1939), whose psychoanalytic theory addresses creativity, the unconscious mind, and art as an expression of repressed feelings. Others have turned to the political philosopher Karl Marx (1818–83) who saw human beings as the products of their economic environment and art as a reflection of humanity's excessive concern with material val-

ues. Some social historians see the work of art as a status symbol for the elite in a highly stratified society.

Art historians also study the history of other arts—including music, drama, and literature—to gain a fuller sense of the context of visual art. Their work results in an understanding of the iconography (the narrative and allegorical significance) and the context (social history) of the artwork. Anthropology and linguistics have added yet another theoretical dimension to the study of art. The Swiss linguist Ferdinand de Saussure (1857–1913) developed structuralist theory, which defines language as a system of arbitrary signs. Works of art can be treated as a language in which the marks of the artist replace words as signs. In the 1960s and 1970s structuralism evolved into other critical positions, the most important of which are semiotics (the theory of signs and symbols) and deconstruction. To the semiologist a work of art is an arrangement of marks or "signs" to be decoded, and the artist's meaning or intention holds little interest. Similarly the deconstructionism of the French philosopher Jacques Derrida (1930–2004) questions all assumptions including the idea that there can be any single correct interpretation of a work of art. So many interpretations emerge from the creative interaction between the viewer and the work of art that in the end the artwork is "deconstructed."

The existence of so many approaches to a work of art may lead us to the conclusion that any idea or opinion is equally valid. But art historians, regardless of their theoretical stance, would argue that the informed mind and eye are absolutely necessary.

As art historians study a wider range of artworks than ever before, many have come to reject the idea of a fixed canon of superior pieces. The distinction between elite fine arts and popular utilitarian arts has become blurred, and the notion that some mediums, techniques, or subjects are better than others has almost disappeared. This is one of the most telling characteristics of art history today, along with the breadth of studies it now encompasses and its changing attitude to challenges such as preservation and restoration.

WHAT IS A VIEWER'S ROLE AND RESPONSIBILITY?

As viewers we enter into an agreement with artists, who in turn make special demands on us. We re-create the works of art for ourselves as we bring to them our own experiences, our intelligence, our knowledge, and even our prejudices. Without our participation, artworks are merely chunks of stone or flecks of paint. But remember, all is change. From extreme realism at one end of the spectrum to entirely non-representational art at the other, artists have worked with varying degrees of naturalism, idealism, and abstraction. For students of art history, the challenge is to discover not only how those styles evolved, but also why they changed, and

ultimately what significance these changes hold for us, for our humanity, and for our future.

Our involvement with art can be casual or intense, naive or sophisticated. At first we may simply react instinctively to a painting or a building or a sculpture (FIG. 23), but this level of "feeling" about art—"I know what I like"—can never be fully satisfying. Like the sixteenth-century Dutch visitors to Rome (FIG. 24), we too can admire and ponder the ancient marble FARNESE HERCULES, and we can also ponder Hendrick Goltzius's engraving that depicts his Dutch friends as they ponder, and we can perhaps imagine an artist depicting us as our glance leaps backwards and forwards pondering art history. Because as viewers we participate in the re-creation of a work of art, its meaning changes from individual to individual, from era to era.

Once we welcome the arts into our lives, we have a ready source of sustenance and challenge that grows, changes, mellows, and enriches our daily experience. This book introduces us to works of art in their historical context, but no matter how much we study or read about art and artists, eventually we return to the contemplation of an original work itself, for art is the tangible evidence of the ever-questing human spirit.

24 Hendrick Goltzius **DUTCH VISITORS TO ROME LOOKING AT THE FARNESE HERCULES** c. 1592. Engraving, 16 × 11½″ (40.5 x 29.4 cm). After Goltzius returned from a trip to Rome in 1591–92, he made engravings based on his drawings. The awestruck viewers have been identified as two of his Dutch friends.

17–1 | Andrea Orcagna **TABERNACLE** Orsanmichele, Florence, Probably begun 1355, completed 1359.
Marble, mosaic, gold, lapis lazuli.
Bernardo Daddi **MADONNA AND CHILD** 1346-7. Tempera and gold on wood panel.

FOURTEENTH-CENTURY ART IN EUROPE

17

One of the many surprises greeting the modern visitor to Florence is a curious blocky building with statue-filled niches. Originally a **loggia** (a covered, open-air gallery), today its dark interior is dominated by a huge and ornate tabernacle built to house the important **MADONNA AND CHILD** (**FIG. 17–1**) by Bernardo Daddi. Daddi was commissioned to create this painting in 1346/47, just before the Black Death swept through the city in the summer of 1348.

Daddi's painting was the second replacement of a late thirteenth-century miracle-working image of the Madonna and Child. The original image had occupied a simple shrine in the central grain market, known as *Orsanmichele* (Saint Michael in the Garden). The original painting may have been irreparably damaged in the fire of 1304 that also destroyed the first market loggia, built at the end of the thirteenth century. A second painting, also lost, was made sometime later, but it was believed that the healing power of the image passed from painting to painting with continued potency.

Florence grew rapidly in the late Middle Ages. By the fourteenth century two-thirds of the city's grain supply had to be imported. The central grain market and warehouse established at Orsanmichele, as insurance against famine, made that site the economic center of the city. The Confraternity (charitable society) of Orsanmichele was created to honor the image of the Madonna and Child and to collect and distribute alms to needy citizens. In 1337 a new loggia

was built to protect the miracle-working image, and two upper stories were added to the loggia to store the city's grain reserves.

Orsanmichele remained Florence's central grain market for about ten years after Daddi painted the newest miracle-working *Madonna and Child* in 1346/47. As a reflection of its wealth and piety, the Confraternity of Orsanmichele commissioned Andrea di Cione, better known as Orcagna (active c. 1343–68), to create a new and rich tabernacle for Daddi's painting. A member of the stone- and woodworkers guild, Orcagna was in charge of building and decorating projects at Orsanmichele. To protect and glorify the *Madonna and Child*, he created a tour-de-force of architectural sculpture in marble, encrusted with gold and glass mosaics. In Orcagna's shrine, Daddi's *Madonna and Child* seems to be revealed by a flock of angels drawing back carved curtains. Sculpted saints stand on the pedestals against the piers, and reliefs depicting the life of the Madonna occupy the structure's base. The tabernacle was completed in 1359, and a protective railing was added in 1366.

Orsanmichele answered practical economic and social needs (granary and distribution point for alms), as well as religious and spiritual concerns (a shrine to the Virgin Mary), all of which characterized the complex society of the fourteenth century. In addition, Orsanmichele was a civic rallying point for the city's guilds. The significance of the guilds in the life of cities in the later Middle Ages cannot be overestimated. In

Florence, guild members were not simple artisans; the major guilds, composed of rich and powerful merchants and entrepreneurs, dominated the government and were key patrons of the arts. For example, the silk guild oversaw the construction of Orsanmichele. In 1380, the arches of the loggia were walled up. At that time, fourteen of the most important Florentine guilds were each assigned an exterior niche on the ground level in which to erect an image of their patron saint.

The cathedral, the Palazzo della Signoria, and Orsanmichele, three great buildings in the city center, have come to symbolize power and patronage in the Florentine Republic. But of the three, the miraculous Madonna in her shrine at Orsanmichele witnessed the greatest surge of interest in the years following the Black Death. Pilgrims flocked to Orsanmichele, and those who had died during the plague left their estates in their wills to the shrine's confraternity. On August 13, 1365, the Florentine government gathered the people together to proclaim the Virgin of Orsanmichele the special protectress of the city.

EUROPE IN THE FOURTEENTH CENTURY

By the middle of the fourteenth century, much of Europe was in crisis. Earlier prosperity had fostered population growth, which by about 1300 had begun to exceed food production. A series of bad harvests then meant that famines became increasingly common. To make matters worse, a prolonged conflict known as the Hundred Years' War (1337–1453) erupted between France and England. Then, in the middle of the fourteenth century, a lethal plague known as the Black Death swept across Europe, wiping out as much as 40 percent of the population (see "The Triumph of Death," page 556). By depleting the labor force, however, the plague gave surviving peasants increased leverage over their landlords and increased the wages of artisans.

The papacy had emerged from its conflict with the Holy Roman Empire as a significant international force. But its temporal success weakened its spiritual authority and brought it into conflict with growing secular powers. In 1309, after the election of a French pope, the papal court moved from Rome to Avignon, in southern France. Italians disagreed, and during the Great Schism from 1378 to 1417, there were two popes, one in Rome and one in Avignon, each claiming legitimacy. The Church provided some solace but little leadership, as rival popes in Rome and Avignon excommunicated each other's followers. Secular rulers took sides: France, Scotland, Aragon, Castile, Navarre, and Sicily supported the pope in Avignon; England, Flanders, Scandinavia, Hungary, and Poland supported the pope in Rome. Meanwhile, the Church experienced great strain from challenges from reformers like John Hus (c. 1370–1415) in Bohemia. The cities and states that composed present-day Germany and the Italian Peninsula were divided among different factions.

The literary figures Dante, Petrarch, and Boccaccio (see "A New Spirit in Fourteenth-Century Literature," page 561) and the artists Cimabue, Duccio, and Giotto fueled a cultural explosion in fourteenth-century Italy. In literature, Petrarch (Francesco Petrarca, 1304–74) was a towering figure of change, a poet whose love lyrics were written not in Latin but in Italian, marking its first use as a literary language. A similar role was played in painting by the Florentine Giotto di Bondone (c. 1277–1337). In deeply moving mural paintings, Giotto not only observed the people around him, he ennobled the human form by using a weighty, monumental style, and he displayed a new sense of dignity in his figures' gestures and emotions

This new orientation toward humanity, combined with a revived interest in classical learning and literature, we now designate as *humanism*. Humanism embodied a worldview that focused on human beings; an education that perfected individuals through the study of past models of civic and personal virtue; a value system that emphasized personal effort and responsibility; and a physically active life that was directed toward the common good as well as individual

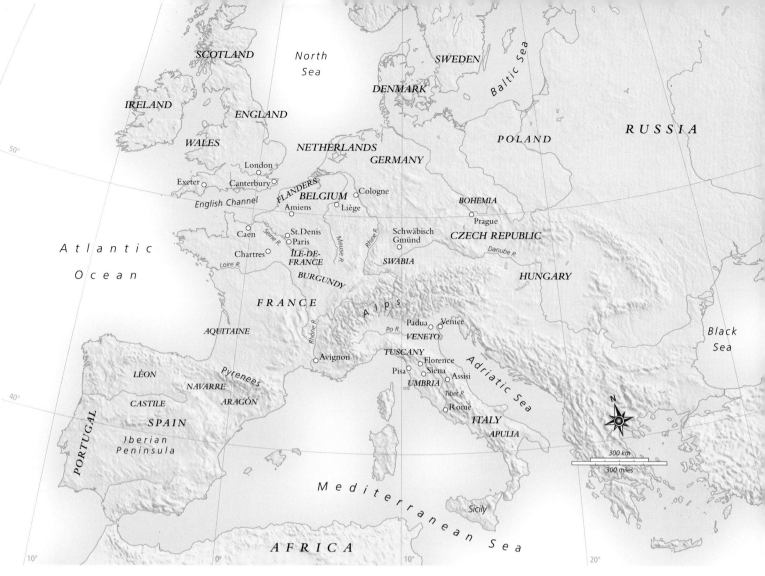

MAP 17–1 | Europe in the Fourteenth Century

Avignon in Southern France, Prague in Bohemia, and Exeter in Southern England joined Paris, Florence, and Siena as centers of art patronage in the late Gothic period.

nobility. For Petrarch and his contemporaries an appreciation of Greek and Roman writers became the defining element of the age. Humanists mastered the Greek and Latin languages so that they could study the classical literature—including newly rediscovered works of history, biography, poetry, letters, and orations.

In architecture, sculpture, and painting, the Gothic style—with its soaring vaults, light, colorful glass, and linear qualities—persisted in the fourteenth century, with regional variations. Toward the end of the century, devastation from the Hundred Years' War and the Black Death meant that large-scale construction gradually ceased, ending the great age of cathedral building. The Gothic style continued to develop, however, in smaller churches, municipal and commercial buildings, and private residences. Many churches were modernized or completed in this late Gothic period.

From the growing middle class of artisans and merchants, talented and aggressive leaders assumed economic and in some places political control. The artisan guilds—organized by occupation—exerted quality control among members and supervised education through an apprenticeship sys-

tem. Admission to the guild came after examination and the creation of a "masterpiece"—literally, a piece fine enough to achieve master's status. The major guilds included cloth finishers, wool merchants, and silk manufacturers, as well as pharmacists and doctors. Painters belonged to the pharmacy guild, perhaps because they used mortars and pestles to grind their colors. Their patron saint, Luke, who was believed to have painted the first image of the Virgin Mary (see Chapter 7, page 266), was also a physician—or so they thought. Sculptors who worked in wood and stone had their own guild, while those who worked in metals belonged to another guild. Guilds provided social services for their members, including care of the sick and funerals for the deceased. Each guild had its patron saint and maintained a chapel and participated in religious and civic festivals.

Complementing the economic power of the guilds was the continuing influence of the Dominican and Franciscan religious orders (see Chapter 16), whose monks espoused an ideal of poverty, charity, and love and dedicated themselves to teaching and preaching. The new awareness of societal needs manifested itself in the

THE ● BJECT SPEAKS

THE TRIUMPH OF DEATH

The Four Horsemen of the Apocalypse—Plague, War, Famine, and Death—stalked the people of Europe during the fourteenth century. France, England, and Germany pursued their seemingly endless wars, and roving bands of soldiers and brigands looted and murdered unprotected peasants and villagers. Natural disasters—fires, droughts, floods, and wild storms—took their toll. Disease spread rapidly through a population already weakened by famine and physical abuse.

Then a deadly plague, known as the Black Death, spread by land and sea from Asia. The plague soon swept from Italy and France across the British Isles, Germany, Poland, and Scandinavia. Half the urban population of Florence and Siena—some say 80 percent—died in the summer of 1348. To people of the time the Black Death seemed to be an act of divine wrath against sinful humans.

In their panic, some people turned to escapist pleasures; others to religious fanaticism. Andrea Pisano and Ambrogio Lorenzetti were probably among the many victims of the Black Death. But the artists who survived had work to do—chapels and hospitals, altarpieces and votive statues. The sufferings of Christ, the sorrows as well as the joys of the Virgin, the miracles of the saints, and new themes—"The Art of Dying Well," and "The Triumph of Death"—all carried the message "Remember, you too will die." An unknown artist, whom we call the Master of the Triumph of Death, painted such a theme in the cemetery of Pisa (Camposanto).

The horror and terror of impending death are vividly depicted in the huge mural, THE TRIUMPH OF DEATH. In the center of the wall dead people lie in a heap while devils and angels carry their souls to hell or heaven. Only the hermits living in the wilderness escape the holocaust. At the right, wealthy young people listen to music under the orange trees, unaware of Death flying toward them with a scythe. At the left of the painting, a group on horseback who have ridden out into the wilderness discover three open coffins. A woman recoils at the sight of her dead counterpart. A courtier covers his nose, gagging at the smell, while his wild-eyed horse is terrified by the bloated, worm-riddled body in the coffin. The rotting corpses remind them of their fate, a medieval theme known as "The Three Living and the Three Dead."

Perhaps the most memorable and touching images in the huge painting are the crippled beggars who beg Death to free them from their earthly miseries. Their words appear on the scroll: "Since prosperity has completely deserted us, O Death, you who are the medicine for all pain, come to give us our last supper!"* The painting speaks to the viewer, delivering its message in words and images. Neither youth nor beauty, wealth nor power, but only piety like that of the hermits provides protection from the wrath of God.

Strong forces for change were at work in Europe. For all the devastation caused by the Four Horsemen, those who survived found increased personal freedom and economic opportunity.

* Translated by John Paoletti and Gary Radke, *Art in Renaissance Italy*, 3rd ed. Upper Saddle River, New Jersey. Pearson Prentice Hall, 2005. p. 154.

Master of the Triumph of Death (Buffalmacco?) **THE TRIUMPH OF DEATH**
Camposanto, Pisa. 1330s. Fresco, 18′6″ × 49′2″ (5.6 × 15 m).

Reproduced here in black and white, photo taken before the fresco was damaged by American shells during World War II.

I7–2 | **PIAZZA DELLA SIGNORIA WITH PALAZZO DELLA SIGNORIA (TOWN HALL)**
1299–1310 and **LOGGIA DEI LANZI (LOGGIA OF THE LANCERS)**
Florence. 1376-82. Speakers' platform and since the sixteenth century a guard station and sculpture gallery.

architecture of churches designed for preaching as well as liturgy, and in new religious themes that addressed personal or sentimental devotion.

ITALY

Great wealth and a growing individualism promoted art patronage in northern Italy. Artisans began to emerge as artists in the modern sense, both in their own eyes and in the eyes of patrons. Although their methods and working conditions remained largely unchanged, artisans in Italy contracted freely with wealthy townspeople and nobles and with civic and religious bodies. Their ambition and self-confidence reflect their economic and social freedom.

Florentine Architecture and Sculpture

The typical medieval Italian city was a walled citadel on a hilltop. Houses clustered around the church and an open city square. Powerful families added towers to their houses both for defense and out of family pride. In Florence, by contrast, the ancient Roman city—with its rectangular plan, major north–south and east–west streets, and city squares—remained the foundation for civic layout. The cathedral stood northeast of the ancient forum. The north–south street joining the cathedral and the Piazza della Signoria followed the Roman line.

THE PALAZZO DELLA SIGNORIA. The governing body of the city (the Signoria) met in the **PALAZZO DELLA SIGNORIA,** a massive fortified building with a tall bell tower 300 feet (91 m) high (**FIG. 17–2**). The building faces a large square, or piazza, which became the true civic center. Town houses often had seats along their walls to provide convenient public seating. In 1376 (finished in 1381/82), a huge loggia was built at one side to provide a covered space for ceremonies and speeches. After it became a sculpture gallery and guard station in the sixteenth century, the loggia became known as the **LOGGIA OF THE LANCERS.** The master builders were Berici di Cione and Simone Talenti. Michelangelo's *David* (SEE FIG. 20–10) once stood in front of the Palazzo della Signoria facing the loggia (it is replaced today by a modern copy).

THE CATHEDRAL. In Florence, the cathedral *(duomo)* (FIGS. 17–3, 17–4) has a long and complex history. The original plan, by Arnolfo di Cambio (c. 1245–1302), was approved in 1294, but political unrest in the 1330s brought construction to a halt until 1357. Several modifications of the design were made, and the cathedral we see today was built between 1357 and 1378. (The façade was given its veneer of white and green marble in the nineteenth century to coordinate it with the rest of the building and the nearby Baptistry of San Giovanni.)

Sculptors and painters rather than masons were often responsible for designing Italian architecture, and as the Florence Cathedral reflects, they tended to be more concerned with pure design than with engineering. The long, square-bayed nave ends in an octagonal domed crossing, as wide as the nave and side aisles. Three polygonal apses, each with five radiating chapels, surround the central space. This symbolic Dome of Heaven, where the main altar is located, stands apart from the worldly realm of the congregation in the nave. But the great ribbed dome, so fundamental to the planners' conception, was not begun until 1420, when the architect Filippo Brunelleschi (1377–1446) solved the engineering problems involved in its construction (see Chapter 19).

THE BAPTISTRY DOORS. In 1330, Andrea Pisano (c.1290–1348) was awarded the prestigious commission for a pair of gilded bronze doors for the Florentine Baptistry of San Giovanni. (Although his name means "from Pisa," Andrea was not related to Nicola and Giovanni Pisano.) The Baptistry doors were completed within six years and display

17–3 | FLORENCE CATHEDRAL (DUOMO)
Plan 1294, costruction begun 1296, redisegned 1357 and 1366, drum and dome 1420–36.
Illustration by Philipe Biard in Guide Gallimard Florence © Gallimard Loisirs.

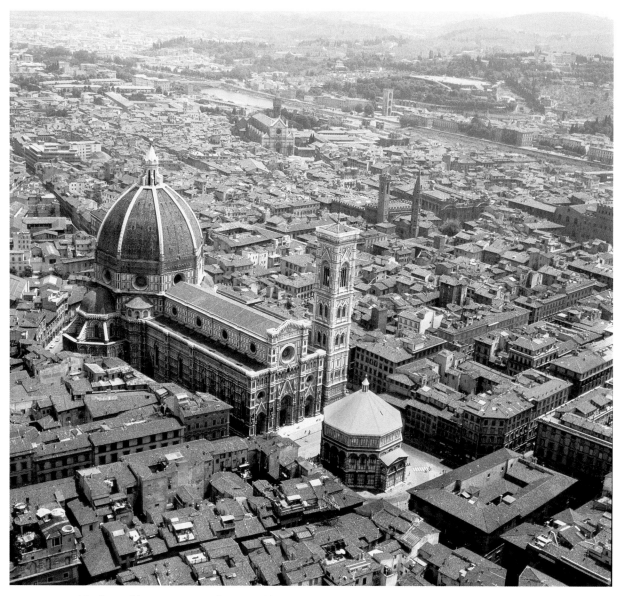

17–4 Arnolfo di Cambio, Francesco Talenti, Andrea Orcagna, and others **FLORENCE CATHEDRAL (DUOMO)**
1296-1378; drum and dome by **Brunelleschi**, 1420-36; bell tower (Campanile) by **Giotto, Andrea Pisano,** and
Francesco Talenti, c. 1334-50.

The Romanesque Baptistry of San Giovanni stands in front of the *Duomo.*

twenty scenes from the life of John the Baptist (San Gio-vanni) set above eight personifications of the Virtues (FIG. **17–5**). The reliefs are framed by quatrefoils, the four-lobed decorative frames introduced at the Cathedral of Amiens in France (SEE FIG. 16–21). The figures within the quatrefoils are in the monumental, classicizing style inspired by Giotto then current in Florentine painting, but they also reveal the soft curves of northern Gothic forms in their gestures and draperies, and a quiet dignity of pose particular to Andrea. The individual scenes are elegantly natural. The figures' placement, on shelflike stages, and their modeling create a remarkable illusion of three-dimensionality, but the overall effect created by the repeated barbed quatrefoils is two-dimensional and decorative, and emphasizes the solidity of the doors. The bronze vine scrolls filled with flowers, fruits, and birds on the lintel and jambs framing the door were added in the mid-fifteenth century.

Florentine Painting

Florence and Siena, rivals in so many ways, each supported a flourishing school of painting in the fourteenth century. Both grew out of the Italo-Byzantine style of the thirteenth century, modified by local traditions and by the presence of individual artists of genius. The Byzantine influence, also referred to as the *maniera greca* ("Greek manner"), was characterized by dramatic pathos and complex iconography and showed

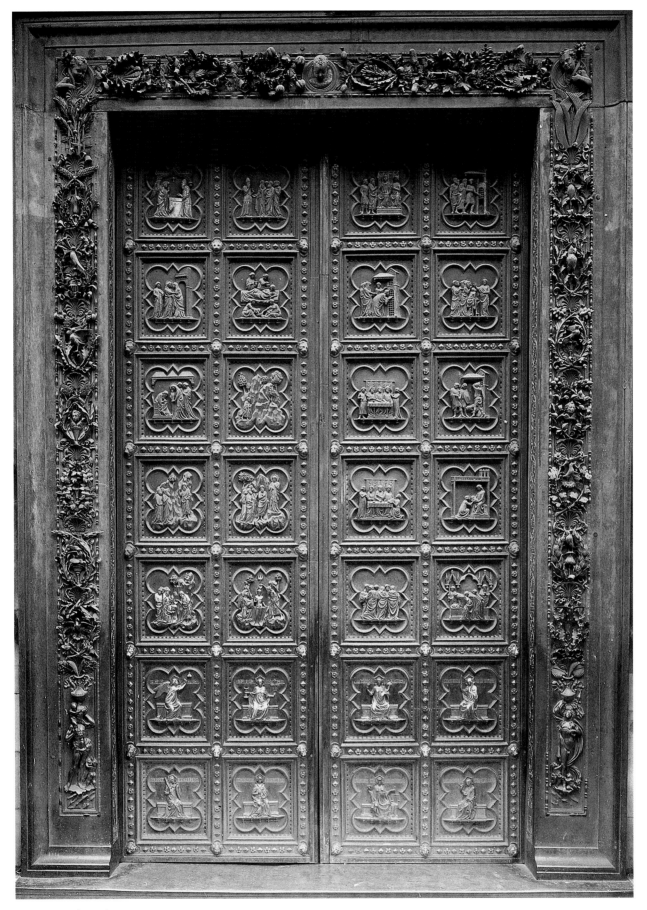

17-5 Andrea Pisano **LIFE OF JOHN THE BAPTIST**
South doors, Baptistry of San Giovanni, Florence. 1330–36. Gilded bronze, each panel 19¼ × 17″ (48 × 43 cm).
Frame, Ghiberti workshop, mid-15th century.

itself in such elements as elongated figures, often exaggerated, iconic gestures, stylized features including the use of gold for drapery folds, and striking contrasts of highlights and shadows in the modeling of individual forms. By the end of the fourteenth century, the painter and commentator Cennino Cennini (see "Cennino Cennini [c. 1370–1440] on Painting," page 564) would be struck by the accessibility and modernity of Giotto's art, which, though it retained traces of the "Greek manner," was moving toward the depiction of a humanized world anchored in three-dimensional form.

CIMABUE. In Florence, the transformation of the Italo-Byzantine style began a little earlier than in Siena. About 1280, a painter named Cenni di Pepi (active c. 1272–1302), better known by his nickname "Cimabue," painted the **VIR-GIN AND CHILD ENTHRONED** (FIG. 17–6), perhaps for the main altar of the Church of Santa Trinita in Florence. At almost 12 feet tall, this enormous panel painting set a new precedent for monumental altarpieces. Cimabue uses the traditional Byzantine iconography of the "Virgin Pointing the Way," in which Mary holds the infant Jesus in her lap and points to him as the path to salvation. Mother and child are surrounded by saints, angels, and Old Testament prophets.

A comparison with a Byzantine icon (SEE FIG. 7–51) shows that Cimabue employed Byzantine formulas in determining the proportions of his figures, the placement of their schematic features, and even the tilt of their haloed heads. Mary's huge throne, painted to resemble gilded bronze with inset enamels and gems, provides an architectural framework for the figures. To render her drapery and that of the infant Jesus, Cimabue used the Italo-Byzantine technique of highlighting drapery with thin lines of gold to indicate divinity. The viewer seems suspended in space in front of the image, simultaneously looking down on the projecting elements of the throne and Mary's lap, while looking straight ahead at the prophets at the base of the throne and the angels at each side. These spatial ambiguities, the subtle asymmetries within the centralized composition, the Virgin's thoughtful gaze, and the individually conceived faces of the old men enliven the picture with their departure from Byzantine tradition. Cimabue's concern for spatial volumes, solid forms delicately modeled in light and shade, and warmly naturalistic human figures contributed to the course of later Italian painting.

GIOTTO DI BONDONE. Compared to Cimabue's *Virgin and Child Enthroned,* Giotto's painting of the same subject (FIG. 17–7), done about 1310 for the Church of the Ognissanti (All Saints) in Florence, exhibits a groundbreaking spatial consistency and sculptural solidity while retaining some of Cimabue's conventions. The central and overtly symmetrical composition and the position of the figures reflect Cimabue's influence. Gone, however, are Mary's modestly inclined head and the delicate gold folds in her drapery. Instead, her face is

A NEW SPIRIT IN FOURTEENTH-CENTURY LITERATURE

For Petrarch and his contemporaries—Boccaccio, Chaucer, Christine de Pizan—the essential qualifications for a writer were an appreciation of Greek and Roman authors and an ability to observe and appreciate people from every station in life. Although fluent in Latin, they chose to write in the language of their own daily life—Italian, English, French. Leading the way was Dante Alighieri (1265–1321), who wrote *The Divine Comedy,* his great summation of human virtue and vice, and ultimately human destiny, in Italian. Dante established the Italian language as worthy of great themes in literature.

Francesco Petrarca, called simply Petrarch (1304–74), raised the status of secular literature with his sonnets (love lyrics) to his unobtainable, beloved Laura; his histories and biographies; and his discovery of the ancient Roman writings on the joys of country life. Petrarch's imaginative updating of classical themes in a work called *The Triumphs*—which examines the themes of Chastity triumphant over Love, Death over Chastity, Fame over Death, Time over Fame, and Eternity over Time—provided later Renaissance poets and painters with a wealth of allegorical subject matter.

More earthy, Giovanni Boccaccio (1313–75) perfected the art of the short story in *The Decameron,* a collection of amusing and moralizing tales told by a group of young Florentines who moved to the countryside to escape the Black Death. With wit and sympathy, Boccaccio presents the full spectrum of daily life in Italy. Such secular literature, including the discovery and translation of ancient authors (for some of the tales had a long lineage), written in Italian as it was then spoken in Tuscany, provided a foundation for the Renaissance of the fifteenth century.

In England, Geoffrey Chaucer (c. 1342–1400) was inspired by Boccaccio to write his own series of short stories, *The Canterbury Tales,* told by pilgrims traveling to the shrine of Saint Thomas à Becket (1118?–1170) in Canterbury. Observant and witty, Chaucer depicted the pretensions and foibles, as well as the virtues, of humanity.

Christine de Pizan (1364–c. 1431), born in Venice but living and writing at the French court, became an author out of necessity when she was left a widow with three young children and an aged mother to support. Among her many works are a poem in praise of Joan of Arc and a history of famous women—including artists—from antiquity to her own time. In *The Book of the City of Ladies* she defended women's abilities and argued for women's rights and status. These writers, as surely as Giotto, Duccio, Peter Parler, and Master Theodoric, led the way into a new era.

individualized, and her action—holding her child's leg instead of merely pointing to him—seems entirely natural. This colossal Mary seems too large for the slender Gothic tabernacle, where figures peer through the openings and haloes overlap the faces. In spite of the formal, enthroned image and flat, gold background, Giotto renders the play of light and shadow across these substantial figures to create a sense that they are fully three-dimensional beings inhabiting real space. Details of the Virgin's solid torso can be glimpsed under her thin tunic, and Giotto's angels, unlike those of Cimabue, have ample wings that fold over in a resting position.

According to the sixteenth-century chronicler Vasari, "Giotto obscured the fame of Cimabue, as a great light out-shines a lesser." Vasari also credited Giotto with "setting art upon the path that may be called the true one [for he] learned to draw accurately from life and thus put an end to the crude Greek [i.e., Italo-Byzantine] manner" (translated by J. C. and P. Bondanella).

Giotto may have collaborated on murals at the prestigious Church of Saint Francis in Assisi (see "The Church of Saint Francis at Assisi," page 546). Certainly he worked for the Franciscans in Florence and reacted to their teaching. Saint Francis's message of simple, humble devotion, direct experience of God, and love for all creatures was gaining followers throughout Western Europe, and it had a powerful impact on thirteenth- and fourteenth-century Italian literature and art.

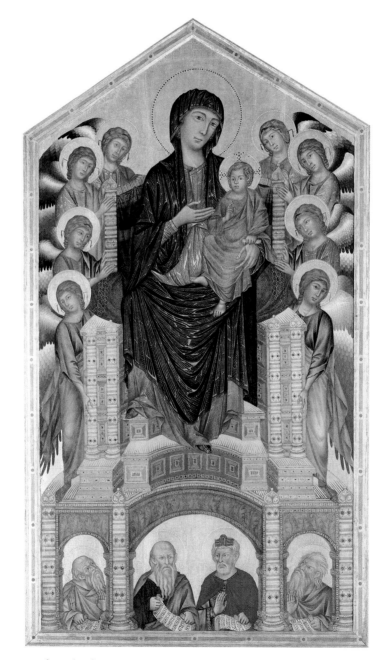

17–6 | Cimabue **VIRGIN AND CHILD ENTHRONED**
Most likely painted for the high altar of the Church of Santa Trinita, Florence. c. 1280. Tempera and gold on wood panel, 12′17″ × 7′ 4″ (3.53 × 2.2 m). Galleria degli Uffizi, Florence.

Early in the fourteenth century Giotto traveled to northern Italy. While working at the Church of Saint Anthony in Padua, he was approached by a local banker, Enrico Scrovegni, to decorate a new family chapel. He agreed, and the **SCROVEGNI CHAPEL** was dedicated in 1305 to the Virgin of Charity and the Virgin of the Annunciation. (The chapel is also called the "Arena Chapel" because it and the family palace were built on and in the ruins of an ancient Roman arena.) The building is a simple, barrel-vaulted room (**FIG. 17–8**). As viewers look toward the altar, they see the story of Mary and Jesus unfolding before them in a series of rectangular panels. On the entrance wall Giotto painted the Last Judgment.

Sequencing Events
MARCH OF THE BLACK DEATH

1346	Plague enters the Crimian Peninsula
1347	Plague arrives in Sicily
1348	Plague reaches port cities of Genoa, Italy, and Marseilles, France
1349	First recorded cases of plague in Cologne and Vienna
1350	Plague reaches Bergen, Norway, via England

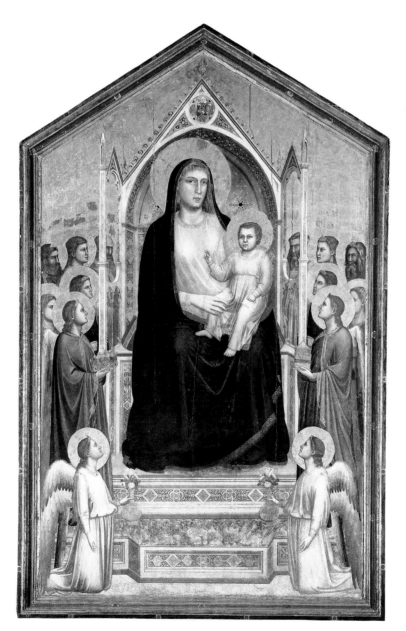

17–7 | Giotto di Bondone **VIRGIN AND CHILD ENTHRONED**
Most likely painted for the high altar of the Church of the Ognissanti (All Saints), Florence. 1305-10. Tempera and gold on wood panel, 10'8" × 6' 8¼" (3.53 × 2.05 m). Galleria degli Uffizi, Florence.

Technique

CENNINO CENNINI (c. 1370–1440) ON PAINTING

Cennino Cennini's *Il Libro dell' Arte (The Book of Art)* is a handbook of Florentine and north Italian painting techniques from about 1400. Cennini includes a description of the artist's life as well as step-by-step painting instructions.

"You, therefore, who with lofty spirit are fired with this ambition, and are about to enter the profession, begin by decking yourselves with this attire: Enthusiasm, Reverence, Obedience, and Constancy. And begin to submit yourself to the direction of a master for instruction as early as you can, and do not leave the master until you have to" (Chapter III).*

The first step in preparing a panel for painting is to cover its surface with clean white linen strips soaked in a **gesso** made from gypsum. Gesso provides a ground, or surface, on which to paint. Cennini specified that at least nine layers of gesso should be applied. The gessoed surface should then be burnished until it resembles ivory. The artist can now sketch the composition of the work with charcoal. At this point, advised Cennini, "When you have finished drawing your figure, especially if it is in a very valuable [altarpiece], so that you are counting on profit and reputation from it, leave it alone for a few days, going back to it now and then to look it over and improve it wherever it still needs something . . . (and bear in mind that you may copy and examine things done by other good masters; that it is no shame to you). The final version of the design should be inked in with a fine squirrel-hair brush, and the charcoal brushed off with a feather. Gold leaf should be affixed on a humid day, the tissue-thin sheets carefully glued down with a mixture of fine powdered clay and egg white, on the reddish clay ground (called bole). Then the gold is burnished with a gemstone or the tooth of a carnivorous animal. Punched and incised patterning should be added to the gold leaf later."*

Italian painters at this time worked in **tempera** paint, powdered pigments mixed most often with egg yolk, a little water, and an occasional touch of glue.

Cennini specified a detailed and highly formulaic painting process. Faces, for example, were always to be done last, with flesh tones applied over two coats of a light greenish pigment and highlighted with touches of red and white. The finished painting was to be given a layer of varnish to protect it and enhance its colors. An elaborate frame, which included the panel or panels on which the painting would be executed, would have been produced by a specialist according to the painter's specifications and brought fully assembled to the studio.

Cennini claimed that panel painting was a gentleman's job, but given its laborious complexity, that was wishful thinking. The claim does, however, reflect the rising social status of painters.

* Cennino Cennini, *The Craftsman's Handbook (Il Libro dell' Arte)*. Trans. by Daniel V. Thompson. New York: Dover, 1960. pp. 3, 16, 75.

A base of faux marble and allegorical *grisaille* (gray monochrome) paintings of the Virtues and Vices support vertical bands painted to resemble marble inlay and carved relief and containing quatrefoil portrait medallions. The central band of medallions spans the vault, crossing a brilliant, lapis blue, star-spangled sky in which large portrait disks float like glowing moons. Set into this framework are the rectangular narrative scenes juxtaposing the life of the Virgin with that of Jesus (FIG. 17–9).

Both the individual scenes and the overall program display Giotto's genius for distilling a complex narrative into a coherent visual experience. The life of the Virgin Mary begins the series and fills the upper band of images. Following in historical sequence, events in the life and ministry of Jesus circle the chapel in the middle band, while scenes of the Passion (the arrest, trial, and Crucifixion of Jesus) fill the lowest band. Read vertically, however, each set of three scenes foreshadows or comments on the others.

The first miracle, when Jesus changes water to wine during the wedding feast at Cana, recalls that his blood will become the wine of the Eucharist, or Communion. The raising of Lazarus becomes a reference to Jesus's Resurrection. Below, the Lamentation over the body of Jesus by those closest to him leads to the Resurrection, indicated by angels at the empty tomb and his appearance to Mary Magdalen in the *Noli Me Tangere* ("Do not touch me"). The juxtaposition of dead and live trees in the two scenes also becomes a telling detail of death and resurrection. Giotto used only a few large figures and essential props in settings that never distract the viewer by their intricate detail. The scenes are reminiscent of *tableaux vivants* ("living pictures"), in which people dressed in costume re-created poses from familiar works of art—scenes that were played out in the city square in front of the chapel in Padua.

Among Giotto's achievements was his ability to model form with color. He rendered his bulky figures as pure color masses, painting the deepest shadows with the most intense hues and highlighting shapes with lighter shades mixed with white. These sculpturally modeled figures enabled Giotto to convey a sense of depth in landscape settings without relying on the traditional convention of an architectural framework.

In one of the most moving works, **LAMENTATION** (FIG. 17–10), in the lowest **register** (horizontal band) of the Arena Chapel, Giotto focused the composition off center for maximum emotional effect, concentrating on the faces of Mary and the dead Jesus. A great downward-swooping ridge— its barrenness emphasized by a single dry tree, a medieval

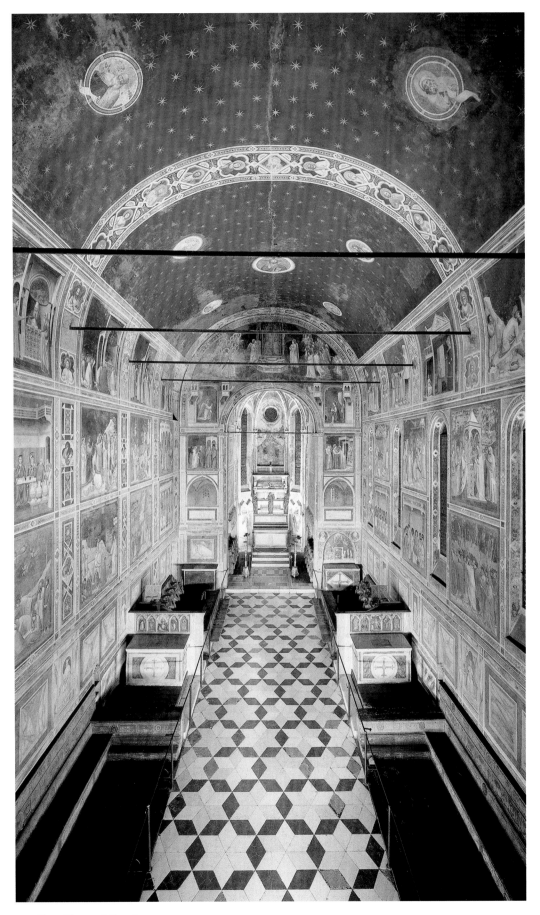

17–8 | Giotto di Bondone **SCROVEGNI (ARENA) CHAPEL,**
Frescoes, Padua. 1305–6. View toward east wall.

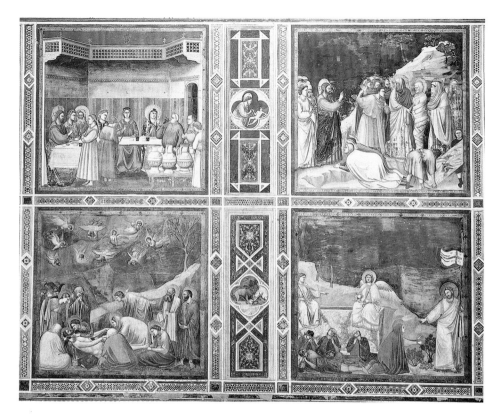

17–9 Giotto di Bondone
MARRIAGE AT CANA,
RAISING OF LAZARUS,
RESURRECTION, and **NOLI ME**
TANGERE and **LAMENTATION**
Frescoes on north wall of
Scrovegni (Arena) Chapel,
Padua. 1305–6. Each scene
approx. 6′5″ × 6′ (2 × 1.85 m).

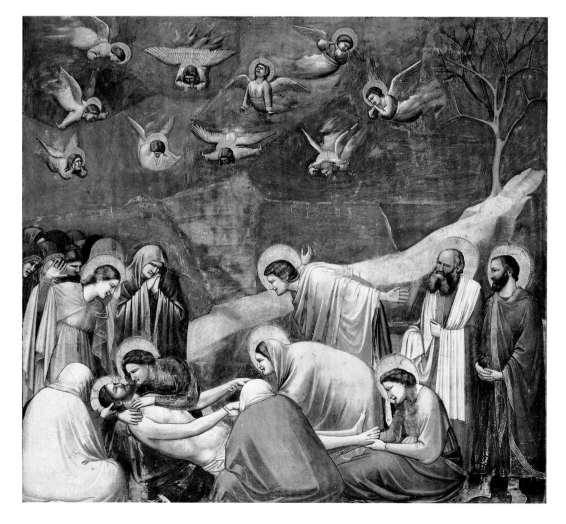

17–10 Giotto di
Bondone **LAMENTATION**
Fresco in the Scrovegni
(Arena) Chapel, Padua.
1305–6. Approx.
6′5″ × 6′ (2 x 1.85 m).

symbol of death—carries the psychological weight of the scene to its expressive core. Mourning angels hovering overhead mirror the anguish of Jesus's followers. The stricken Virgin communes with her dead son with mute intensity, while John the Evangelist flings his arms back in convulsive despair and other figures hunch over the corpse. Instead of symbolic sorrow, more typical of art from the early Middle Ages, Giotto conveys real human suffering, drawing the viewer into the circle of personal grief. The direct, emotional appeal of his art, as well as its deliberate plainness, seems to embody Franciscan values.

BERNARDO DADDI. Giotto dominated Florentine painting in the first half of the fourteenth century. His combination of humanism and realism was so memorable that other artists' work paled beside his. The artists who worked in his studio picked up the mannerisms but not the essence of his style. Bernardo Daddi (active c. 1312–48), who painted the *Madonna and Child* in Orsanmichele (SEE FIG. 17–1), typifies the group with his personal reworking of Giotto's powerful figures. Daddi's talent lay in the creation of sensitive, lyrical images rather than the majestic realistic figures. He may have

been inspired by courtly French art, which he would have known from luxury goods, such as imported ivory carvings. The artists of the school of Giotto were responsible for hundreds of panel paintings. They also frescoed the walls of chapels and halls (see "Buon Fresco," page 569).

Sienese Painting

Like their Florentine rivals, the Sienese painters at first worked in a strongly Byzantine style. Sienese painting continued to emphasize abstract decorative qualities and a love of applied gold and brilliant colors. Consequently, Sienese art often seems slightly conservative.

DUCCIO DI BUONINSEGNA. Siena's foremost painter in the later Gothic period was Duccio di Buoninsegna (active 1278–1318). Duccio knew thirteenth-century Byzantine art, with its elongated figures, stacks of angels, patterned textiles, and lavish use of gold. Between 1308 and 1311, Duccio painted a huge altarpiece for the high altar of Siena Cathedral. The **MAESTÀ (MAJESTY)** was dedicated, like the town itself, to the Virgin (FIGS. 17–11, 17–12).

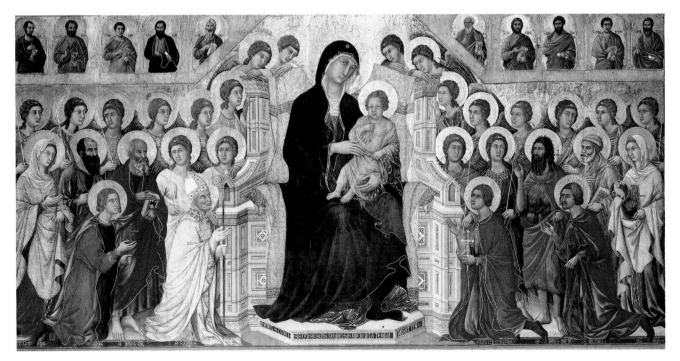

17–11 | Duccio di Buoninsegna **VIRGIN AND CHILD IN MAJESTY,** Central Panel from Maestà Altarpiece
Siena Cathedral. 1308–11. Tempera and gold on wood panel, 7′ × 13′6″ (2.13 × 3.96 m).
Museo dell'Opera del Duomo, Siena.

"On the day that it was carried to the [cathedral] the shops were shut, and the bishop conducted a great and devout company of priests and friars in solemn procession, accompanied by . . . all the officers of the commune, and all the people, and one after another the worthiest with lighted candles in their hands took places near the picture, and behind came the women and children with great devotion. And they accompanied the said picture up to the [cathedral], making the procession around the Campo [square], as is the custom, all the bells ringing joyously, out of reverence for so noble a picture as is this" (Holt, page 69).

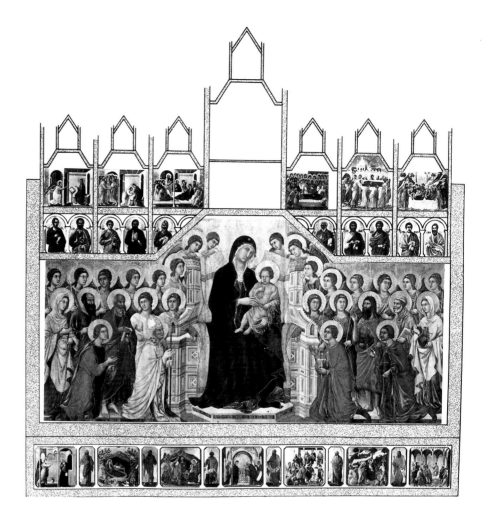

17–12 | **PLAN OF FRONT AND BACK OF THE MAESTÀ ALTARPIECE**

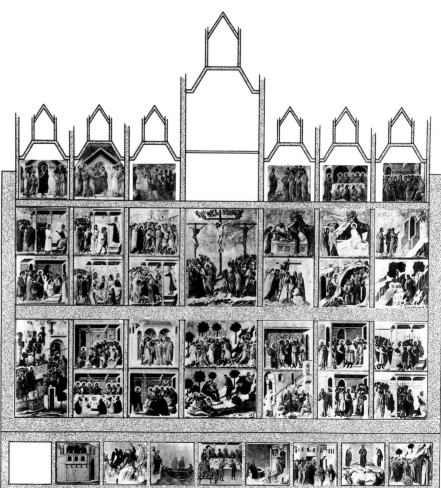

Creating this altarpiece was an arduous undertaking. The central panel alone was 7 by 13 ½ feet, and it had to be painted on both front and back, because it was meant to be seen from both sides. The main altar for which it was designed stood beneath the dome in the center of the sanctuary. Inscribed on Mary's throne are the words, "Holy Mother of God be thou the cause of peace for Siena and, because he painted thee thus, of life for Duccio" (cited in Hartt and Wilkins 4.2, page 104).

Mary and Christ, adored by angels and the four patron saints of Siena—Ansanus, Savinus, Crescentius, and Victor—kneeling in front, fill the large central panel. This *Virgin and Child in Majesty* represents both the Church and its specific embodiment, Siena Cathedral. Narrative scenes from the early life of the Virgin and the infancy of the Christ Child appear below the central image. The **predella** (the lower zone of the altarpiece) was entirely painted with the events in the childhood of Jesus. The back of this immense work was dedicated to scenes of his adult life and the miracles. The entire composition was topped by pinnacles—on the front, angels and the later life of the Virgin, and on the back, events after the Passion.

Duccio created a personal style that combines a softened Italo-Byzantine figure style with the linear grace and the easy relationship between figures and their settings characteristic of French Gothic. This subtle blending of northern and southern elements can be seen in the haloed ranks of angels around Mary's architectonic throne. The central, most holy figures retain a solemnity and immobility with some realistic touches, such as the weighty figure of the child; the adoring saints reflect a more naturalistic, courtly Gothic style that became the hallmark of the Sienese school for years to come. The brilliant palette, which mingles pastels with primary hues, the delicately patterned textiles that shimmer with gold, and the ornate **punchwork**—tooled designs in gold leaf on the haloes—are characteristically Sienese.

In 1771 the altarpiece was broken up, and individual panels were sold. One panel—the **NATIVITY WITH PROPHETS ISAIAH AND EZEKIEL**—is now in Washington, D.C. Duccio represented the Nativity in the tradition of Byzantine icons. Mary lies on a fat mattress within a cave hollowed out of a jagged, stylized mountain (**FIG. 17–13**). Jesus appears twice: first lying in the manger and then with the midwife below. However, Duccio followed Western tradition by placing the scene in a shed. Rejoicing angels fill the sky, and the shepherds and sheep add a realistic touch in the lower right corner. The light, intense colors, the calligraphic linear quality, even the meticulously rendered details recall Gothic manuscripts (see Chapter 16). The tentative move toward a defined space in the shed as well as the subtle modeling of the figures point the way toward future development in representing people and their world. Duccio's graceful, courtly art contrasts with Giotto's austere monumentality.

Technique
BUON FRESCO

The two techniques used in mural painting are **buon** ("true") **fresco** ("fresh"), in which paint is applied with water-based paints on wet plaster, and **fresco secco** ("dry"), in which paint is applied to a dry plastered wall. The two methods can be used on the same wall painting.

The advantage of *buon fresco* is its durability. A chemical reaction occurs as the painted plaster dries, which bonds the pigments into the wall surface. In *fresco secco*, by contrast, the color does not become part of the wall and tends to flake off over time. The chief disadvantage of *buon fresco* is that it must be done quickly without mistakes. The painter plasters and paints only as much as can be completed in a day. In Italy, each section is called a **giornata**, or day's work. The size of a *giornata* varies according to the complexity of the painting within it. A face, for instance, can occupy an entire day, whereas large areas of sky can be painted quite rapidly.

In medieval and Renaissance Italy, a wall to be frescoed was first prepared with a rough, thick undercoat of plaster. When this was dry, assistants copied the master painter's composition onto it with charcoal. The artist made any necessary adjustments. These drawings, known as **sinopia**, have an immediacy and freshness lost in the finished painting. Work proceeded in irregularly shaped sections conforming to the contours of major figures and objects. Assistants covered one section at a time with a fresh, thin coat of very fine plaster over the *sinopia*, and when this was "set" but not dry, the artist worked with pigments mixed with water. Painters worked from the top down so that drips fell on unfinished portions. Some areas requiring pigments such as ultramarine blue (which was unstable in *buon fresco*), as well as areas requiring gilding, would be added after the wall was dry using the *fresco secco* method.

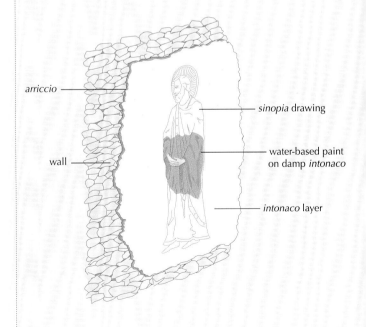

arriccio

sinopia drawing

wall

water-based paint on damp *intonaco*

intonaco layer

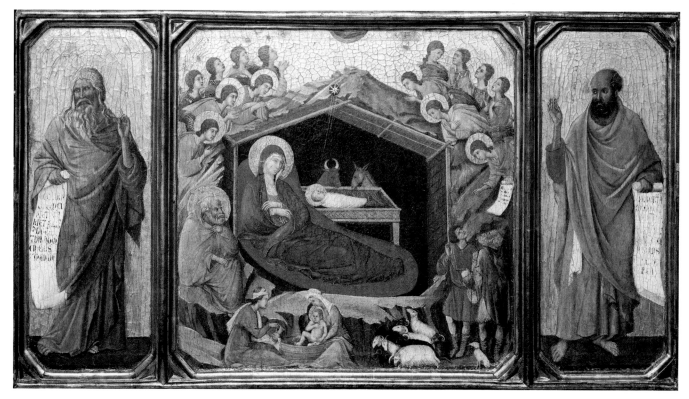

17–13 | Duccio di Buoninsegna **NATIVITY WITH PROPHETS ISAIAH AND EZEKIEL**
Predella of the Maestà Altarpiece, 17 × 17½″ (44 × 45 cm); Prophets, 17¼″ × 6½″ (44 × 16.5 cm).
National Gallery, Washington, D.C.

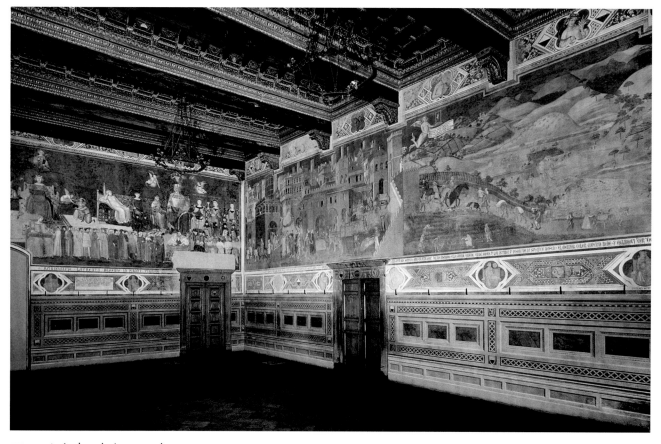

17–14 | Ambrogio Lorenzetti **FRESCO SERIES OF THE SALA DELLA PACE, PALAZZO PUBBLICO**
Siena city hall, Siena, Italy. 1338–40. Length of long wall about 46′ (14 m).

AMBROGIO LORENZETTI. In Siena, a strain of seemingly native realism also began to emerge. In 1338, the Siena city council commissioned Ambrogio Lorenzetti to paint in fresco the council room of the Palazzo Pubblico (city hall) known as the **SALA DELLA PACE (CHAMBER OF PEACE)** (FIG. 17–14). The murals were to depict the results of good and bad government. On the short wall Ambrogio painted a figure symbolizing the Commune of Siena, enthroned like an emperor holding an orb and scepter and surrounded by the Virtues. Justice, assisted by Wisdom and Concord, oversees the local magistrates. Peace lounges on a bench against a pile

of armor, having defeated War. The figure is based on a fragment of a Roman sarcophagus still in Siena.

Ambrogio painted the results of both good and bad government on the two long walls. For the **ALLEGORY OF GOOD GOVERNMENT,** and in tribute to his patrons, Ambrogio created an idealized but recognizable portrait of the city of Siena and its immediate environs (FIG. 17–15). The cathedral dome and the distinctive striped campanile (see Chapter 16) are visible in the upper left-hand corner; the streets are filled with productive citizens. The Porta Romana, Siena's gateway leading to Rome, divides the city from the country. Over the portal

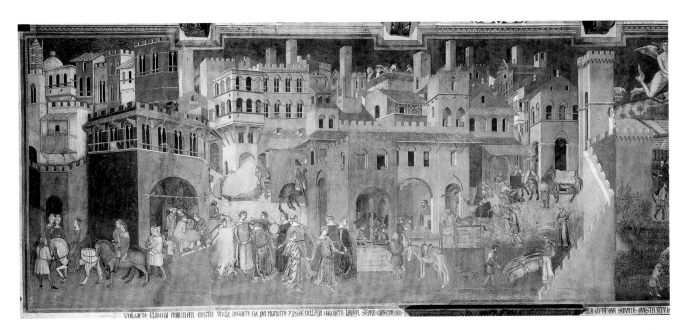

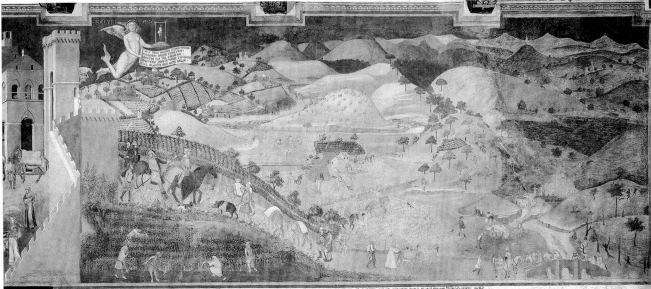

17–15 | Ambrogio Lorenzetti **ALLEGORY OF GOOD GOVERNMENT IN THE CITY AND IN THE COUNTRY**
Sala della Pace, Palazzo Pubblico, Siena, Italy. 1338–40. Fresco, total length about 46′ (14 m).

stands the statue of the wolf suckling Romulus and Remus, the legendary founders of Rome. Representations of these twin boys were popular in Siena because of the legend that Remus's son Senus founded Siena. Hovering above outside the gate is a woman clad in a wisp of transparent drapery, a scroll in one hand and a miniature gallows complete with a hanged man in the other. She represents Security, and her scroll bids those entering the city to come in peace. The gallows is a sharp reminder of the consequences of not doing so.

Ambrogio's achievement in this fresco was twofold. First, despite the shifts in vantage point and scale, he maintained an overall visual coherence and kept all parts of the flowing composition intelligible. Second, he maintained a natural relationship between the figures and the environment. Ambrogio conveys a powerful vision of an orderly society, of peace and plenty, from the circle of young people dancing to a tambourine outside a shoemaker's shop to the well-off peasants tending fertile fields and lush vineyards. Sadly, plague struck in the next decade. Famine, poverty, and disease overcame Siena just a few years after this work was completed.

The world of the Italian city-states—which had seemed so full of promise in Ambrogio Lorenzetti's *Good Government* fresco—was transformed into uncertainty and desolation by epidemics of the plague. Yet as dark as those days must have seemed to the men and women living through them, beneath the surface profound, unstoppable changes were taking place. In a relatively short span of time, the European Middle Ages gave way to what is known as the Renaissance.

FRANCE

At the beginning of the fourteenth century the royal court in Paris was still the arbiter of taste in Western Europe, as it had been in the days of Saint Louis. During the Hundred Years' War, however, the French countryside was ravaged by armed struggles and civil strife. The power of the old feudal nobility, weakened significantly by warfare, was challenged by townsmen, who took advantage of new economic opportunities that opened up in the wake of the conflict. Leadership in the arts and architecture moved to the duchy of Burgundy, to England, and—for a brief golden moment—to the court of Prague.

Gothic sculptors found a lucrative new outlet for their work in the growing demand among wealthy patrons for religious art intended for homes as well as churches. Busy urban workshops produced large quantities of statuettes and reliefs in wood, ivory, and precious metals, often decorated with enamel and gemstones. Much of this art was related to the cult of the Virgin Mary. Architectural commissions were smaller—chapels rather than cathedrals, and additions to already existing buildings, such as towers, spires, and window tracery.

In the second half of the thirteenth century, architects working at the royal court in Paris (see Chapter 16) introduced a new style, which continued into the first part of the fourteenth century. Known as the French Court style, or Rayonnant style or Rayonnant Gothic in France, the art is characterized by elegance and refinement achieved through extraordinary technical virtuosity. In sculpture and painting, elegant figures move gracefully through a narrow stage space established by miniature architecture and elements of landscape. Sometimes a focus on the details of nature suggests the realism that appears in the fourteenth century.

Manuscript Illumination

By the late thirteenth century, literacy had begun to spread among laypeople. Private prayer books became popular among those who could afford them. Because they contained special prayers to be recited at the eight canonical "hours" between morning and night, an individual copy of one of these books came to be called a Book of Hours. Such a book included everything the lay person needed—psalms, prayers to the Virgin and the other saints, a calendar of feast days, the office of the Virgin, and even the offices of the dead. During the fourteenth century, a richly decorated Book of Hours was worn or carried like jewelry and was among a noble person's most important portable possessions.

THE BOOK OF HOURS OF JEANNE D'EVREUX. Shortly after their marriage in 1325, King Charles IV gave his queen, Jeanne d'Evreux, a tiny, exquisite **BOOK OF HOURS,** the work of the illuminator Jean Pucelle (FIG. 17–16). This book was precious to the queen, who mentioned it in her will. She named its illuminator, Jean Pucelle, an unusual tribute.

In this manuscript, Pucelle worked in the *grisaille* technique—monochromatic painting in shades of gray with faint touches of color (here, blue and pink). The subtle shades emphasized his accomplished drawing. Queen Jeanne appears in the initial below the *Annunciation,* kneeling before a lectern and reading, perhaps, from her Book of Hours. This inclusion of the patron in prayer within a scene conveyed the idea that the scenes were visions inspired by meditation rather than records of historical events. In this case, the young queen would presumably have identified with Mary's joy at Gabriel's message.

Jeanne d'Evreux's Book of Hours combines two narrative cycles in its illuminations. One, the Hours of the Virgin, juxtaposes scenes from the Infancy and Passion of Christ, a form known as the Joys and Sorrows of the Virgin. The other is dedicated to the recently canonized king, Saint Louis. In the opening shown here, the joy of the *Annunciation* on the

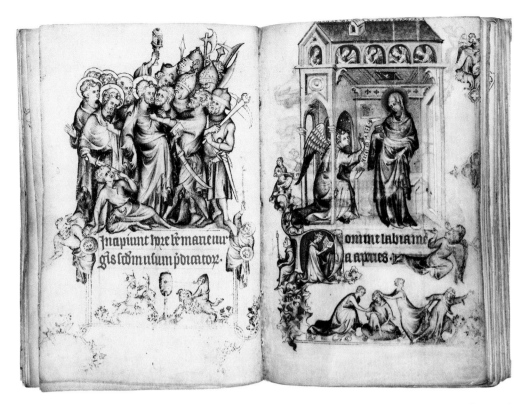

17–16 | Jean Pucelle **PAGES WITH BETRAYAL AND ARREST OF CHRIST,** folio 15v. (left), and
ANNUNCIATION, folio 16r. (right), **BOOK OF HOURS OF JEANNE D'EVREUX**
Paris c. 1325–28. *Grisaille* and color on vellum, each page 3½ × 2¼" (8.9 × 6.2 cm).
The Metropolitan Museum of Art, New York. The Cloisters Collection 1954 (54.1.2).

right is paired with the "sorrow" of the *Betrayal and Arrest of Christ* on the left. In the *Annunciation,* Mary is shown receiving the archangel Gabriel in a Gothic building, while rejoicing angels look on from windows under the eaves. The group of romping children at the bottom of the page (known as the ***bas-de-page*** in French) at first glance seems to echo the joy of the angels. They might be playing "love tag," which would surely relate to Mary as the chosen one of the Annunciation. Folklorists have suggested, however, that the children are playing "froggy in the middle," or "hot cockles," games in which one child was tagged by the others. To the medieval reader the game symbolized the mocking of Christ or the betrayal of Judas, who "tags" his friend, and it evokes a darker mood by foreshadowing Jesus's death even as his life is beginning. In the *Betrayal* on the opposite page, Judas Iscariot embraces Jesus, thus identifying him to the Roman soldiers. The traitor sets in motion the events that lead to the Crucifixion. Saint Peter, on the left, realizing the danger, draws his sword to defend Jesus and slices off the ear of the high priest's servant Malchus. The *bas-de-page* on this side shows knights riding goats and jousting at a barrel stuck on a pole, a spoof of the military that may comment on the lack of valor of the soldiers assaulting Jesus.

Pucelle's work represents a sophisticated synthesis of contemporary French, English, and Italian art. From English illuminators he borrowed the merging of Christian narrative with allegory, the use of foliate borders filled with real and grotesque creatures (instead of the standard French vine scrolls), and his lively *bas-de-page* illustrations. His presentation of space, with figures placed within coherent architectural settings, suggests a firsthand knowledge of Sienese art: The small angels framed by the rounded arches of the attic are reminiscent of the half-length saints who appear above the front panel of Duccio's *Maestà*. Pucelle also adapted to manuscript illumination the Parisian Court style in sculpture, with its softly modeled, voluminous draperies gathered around tall, elegantly curved figures with curly hair and delicate features.

Sculpture

Sculpture in the fourteenth century is exemplified by its intimate character. Religious subjects became more emotionally expressive. In the secular realm, the cult of chivalry was revived just as the era of the knight on horseback was being rendered obsolete. Tales of love and valor were carved on luxury items to delight the rich, middle class, and aristocracy alike. Precious metals—gold, silver, and ivory—were preferred.

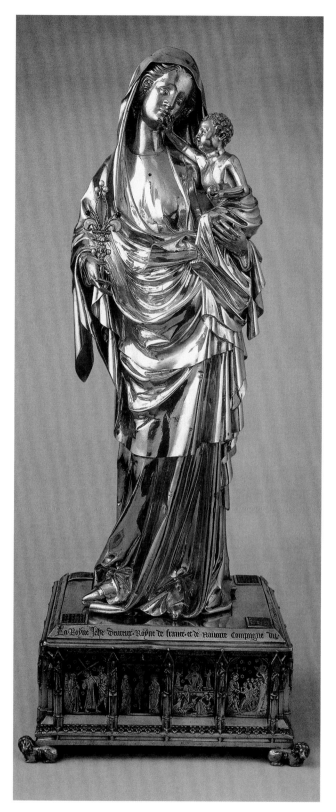

17–17 | **VIRGIN AND CHILD**
c. 1339. Silver gilt and enamel, height 27⅛″ (69 cm).
Musée du Louvre, Paris.

Given by Jeanne d'Evreux to the Abbey Church of Saint-Denis,
France.

THE VIRGIN AND CHILD FROM SAINT-DENIS. A silver-gilt
image of a standing **VIRGIN AND CHILD** (FIG. 17–17) was once
among the treasures of the Abbey Church of Saint-Denis
(see Chapter 16). An inscription on the base bears the date
1339 and the donor's name, Queen Jeanne d'Evreux. The
Virgin holds Jesus in her left arm, her weight on her left
leg, creating the graceful S-curve pose that became charac-
teristic of the period. Fluid drapery, suggesting the consis-
tency of heavy silk, covers her body. She originally wore a
crown, and she holds a scepter topped with a large enam-
eled and jeweled *fleur-de-lis,* the heraldic symbol of French
royalty. The scepter served as a reliquary for a few strands of
Mary's hair. The Virgin's sweet, youthful face and simple
clothing, although based on thirteenth-century sculpture,
anticipate the so-called Beautiful Mother imagery of four-
teenth-century Prague (SEE FIG. 17–25), Flanders, and Ger-
many. The Christ Child reaching out to touch his
mother's lips is babylike in his proportions and gestures, a
hint of realism. The image is not entirely joyous, however;
on the enameled base, scenes of Christ's Passion remind us
of the suffering to come.

COURTLY LOVE: AN IVORY BOX. A strong market also
existed for personal items like boxes, mirrors, and combs with
secular scenes inspired by popular literature and folklore. A
box—perhaps a gift from a lover—made in a Paris workshop
around 1330–50 provides a delightful example of such a
work (FIG. 17–18). In its ivory panels, the God of Love shoots
his arrows; knights and ladies throw flowers as missiles and
joust with flowers. The subject is the **ATTACK ON THE CASTLE
OF LOVE,** but what the owner kept in the box—jewelry? love
tokens?—remains a mystery.

A tournament takes place in front of the Castle of Love.
The tournament—once a mock battle, designed to keep
knights fit for war—has become a lovers' combat. In the cen-
ter panel, women watch jousting knights charge to the blare
of the heralds' trumpets. In the scene on the left, knights use
crossbows and a catapult to hurl roses at the castle, while the
God of Love helps the women by aiming his arrows at the
attackers. The action concludes in the scene on the right,
where the tournament's victor and his lady love meet in a
playful joust of their own.

Unlike the aristocratic marriages of the time, which
were essentially business contracts based on political or finan-
cial exigencies, romantic love involved passionate devotion.
Images of gallant knights serving ladies, who bestowed tokens
of affection on their chosen suitors or cruelly withheld their
love on a whim, captured the popular imagination. Tales of
romance were initially spread by the musician-poets known
as troubadours. Twelfth-century troubadour poetry marked a
shift away from the usually negative way in which women
had previously been portrayed as sinful daughters of Eve.

17–18 | ATTACK ON THE CASTLE OF LOVE
Lid of a box. Paris. c. 1330–50. Ivory box with iron mounts, panel 4½ × 9¹¹⁄₁₆″ (11.5 × 24.6 cm).
The Walters Art Museum, Baltimore.

ENGLAND

Fourteenth-century England prospered in spite of the ravages of the Black Death and the Hundred Years' War with France. Life in medieval England is described in the rich store of Middle English literature. The brilliant social commentary of Geoffrey Chaucer in the *Canterbury Tales* (see "A New Spirit in Fourteenth-Century Literature," page 561) includes all classes of society. The royal family, especially Edward I—the castle builder—and many of the nobles and bishops were generous patrons of the arts.

Embroidery: Opus Anglicanum

An English specialty, pictorial needlework in colored silk and gold thread, gained such fame that it came to be called *opus anglicanum (English work)*. Among the collectors of this luxurious textile art were the popes, who had more than 100 pieces in the Vatican treasury. The names of several prominent embroiderers are known, but few names can be connected to specific pieces.

Opus anglicanum was employed for court dress, banners, cushions, bed hangings, and other secular items, as well as for the vestments worn by the clergy to celebrate the Mass (see Introduction Fig. 3, *Christine de Pizan Presenting a Book to the Queen of France)*. Few secular pieces survive, since clothing and furnishings were worn out and discarded when fashions changed. But some vestments have survived, stored in church treasuries.

A liturgical vestment (that is, a special garment worn by the priest during mass), the red velvet **CHICHESTER-CONSTABLE**

CHASUBLE (FIG. 17–19) was embroidered with colored silk, gold threads forming the images as subtly as painting. Where gold threads were laid and couched (tacked down with colored silk), the effect resembles the burnished gold-leaf backgrounds of manuscript illuminations. The Annunciation, the Adoration of the Magi, and the Coronation of the Virgin are set in cusped, crocketed **ogee** (S-shaped) arches amid twisting branches sprouting oak leaves, seed-pearl acorns, and animal masks. Because the star and crescent moon in the Coronation of the Virgin scene are heraldic emblems of Edward III (ruled 1327–77), perhaps he or a family member ordered this luxurious vestment.

During the celebration of the Mass, garments of *opus anglicanum* would have glinted in the candlelight amid treasures on the altar. Court dress was just as rich and colorful, and at court such embroidered garments established the rank and

Sequencing Events	
c. 1307–21	Dante writes *The Divine Comedy*
1309–77	Papacy transferred from Rome to Avignon
1348	Arrival of Black Death on European mainland
1378–1417	Great Schism in Catholic Church
1396	Greek studies instituted in Florence; beginning of the revival of Greek literature

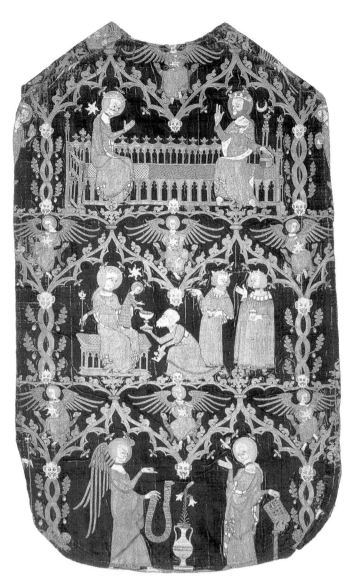

17–19 | LIFE OF THE VIRGIN, BACK OF THE CHICHESTER-CONSTABLE CHASUBLE
From a set of vestments embroidered in *opus anglicanum* from southern England. 1330–50. Red velvet with silk and metallic thread and seed pearls; length 4'3" (129.5 cm), width 30" (76 cm). The Metropolitan Museum of Art, New York.
Fletcher Fund, 1927 (27 162.1).

status of the wearer. So heavy did such gold and bejeweled garments become that their wearers often needed help to move.

Architecture

In the later years of the thirteenth century and early years of the fourteenth, a distinctive and influential style, popularly known as the "Decorated style," which corresponded to the Rayonnant style in France (see Chapter 16), developed in England. This change in taste has been credited to Henry III's ambition to surpass his brother-in-law, Saint Louis (Louis IX) of France, as a royal patron of the arts.

THE DECORATED STYLE AT EXETER. The most complete Decorated style building is the **EXETER CATHEDRAL.** Thomas of Witney began work at Exeter in 1313 and was the master

mason from 1316 until 1342. He supervised construction of the nave and redesigned upper parts of the choir. He left the towers of the original Norman cathedral but turned the interior into a dazzling stone forest of colonnettes, moldings, and vault ribs (FIG. 17–20). From diamond-shaped piers covered with colonnettes rise massed moldings that make the arcade seem to ripple. Bundled colonnettes spring from sculptured **corbels** (supporting brackets that project from a wall) between the arches to support conical clusters of thirteen ribs that meet at the summit of the vault, a modest 69 feet above the floor. The basic structure here is the four-part vault with intersecting cross-ribs, but the designer added additional ribs, called **tiercerons,** to create a richer linear pattern. Elaborately carved **bosses** (decorative knoblike elements) cover the intersections where ribs meet. Large clerestory windows with bartracery mullions (slender vertical elements dividing the windows into subsections) illuminate the 300-foot-long nave. Unpolished gray marble shafts, yellow sandstone arches, and a white French stone, shipped from Caen, used in the upper walls add subtle graduations of color to the many-rayed space.

Detailed records survive for the building of Exeter Cathedral. They extend over the period from 1279 to 1514, with only two short breaks. Included is such mundane information as where the masons and carpenters were housed (in a hostel near the cathedral) and how they were paid (some by the day with extra for drinks, some by the week, some for each finished piece); how materials were acquired and transported (payments for horseshoes and fodder for the horses); and of course payments for the building materials (not only stone and wood but rope for measuring and parchment on which to draw forms for the masons). The bishops contributed generously to the building funds. Building was not an anonymous labor of love as imagined by romantic nineteenth-century historians.

Thomas of Witney also designed the bishop's throne. Richard de Galmeton and Walter of Memburg led a team of a dozen carpenters to build the throne and the intricate canopy, 57 feet high. The canopy is like a piece of embroidery translated into wood, revealing characteristic forms of the Decorated style: S-curves, nodding arches (called "nodding ogee arches" because they curve outward—and nod—as well as upward) lead the eye into a maze of pinnacles, bursting with leafy **crockets** and tiny carved animals and heads. To finish the throne in splendor, Master Nicolas painted and gilded the wood. When the bishop was seated on his throne wearing embroidered vestments like the *Chichester-Constable Chasuble,* he must have resembled a golden image in a shrine rather than a living man. Enthroned, he represented the power and authority of the Church.

THE PERPENDICULAR STYLE AT EXETER. During years following the Black Death, work at Exeter Cathedral came to a

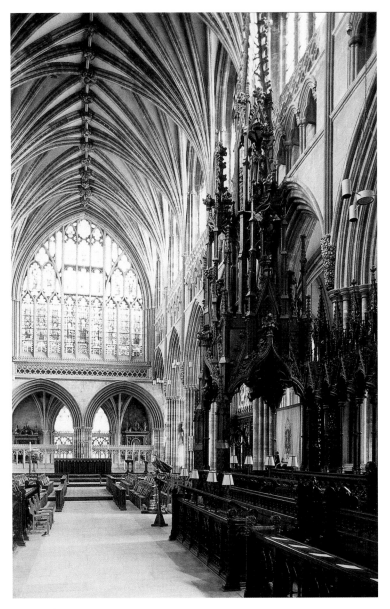

17–20 | EXETER CATHEDRAL
Exeter, Devon, England. Thomas of Witney, Choir, 14th century and
Bishop's Throne, 1313–17; Robert Lesyngham, East Window, 1389-90.

standstill. The nave had been roofed but not vaulted, and the windows had no glass. When work could be resumed, taste had changed. The exuberance of the Decorated style gave way to an austere style in which rectilinear patterns and sharp angular shapes replaced intricate curves, and luxuriant foliage gave way to simple stripped-down patterns. This phase is known as the Perpendicular style.

In 1389–90, well-paid master mason Robert Lesyngham rebuilt the great East Window (FIG. 17–20), and he designed the window tracery in the new Perpendicular style. The window fills the east wall of the choir like a glowing altarpiece. A single figure in each light stands under a tall painted canopy that flows into and blends with the stone tracery. The Virgin with the Christ Child stands in the center over the high altar,

with four female saints at the left and four male saints, including Saint Peter, to whom the church is dedicated, on the right. At a distance the colorful figures silhouetted against the silver *grisaille* glass become a band of color, reinforcing the rectangular pattern of the mullions and transoms. The combination of *grisaille*, silver stain (creating shades of gold), and colored glass produces a cool silvery light.

The Perpendicular style produces a decorative scheme that heralds the Renaissance style (see Chapter 19) in its regularity, its balanced horizontal and vertical lines, and its plain wall or window surfaces. When Tudor monarchs introduced Renaissance art into the British Isles, builders did not have to rethink the form and structure of their buildings; they simply changed the ornament from the pointed cusped and

crocketed arches of the Gothic style to the round arches and ancient Roman columns and capitals of the classical era. The Perpendicular style, used throughout the Late Gothic period in the British Isles, became England's national style. It remains popular today in the United States for churches and college buildings.

THE HOLY ROMAN EMPIRE

By the fourteenth century, the Holy Roman Empire existed more as an ideal fiction than a fact. The Italian territories had established their independence, and in contrast to England and France, Germany had become further divided into multiple states with powerful regional associations and princes. The Holy Roman Emperors, now elected by Germans, concentrated on securing the fortunes of their families. They continued to be patrons of the arts, promoting local styles.

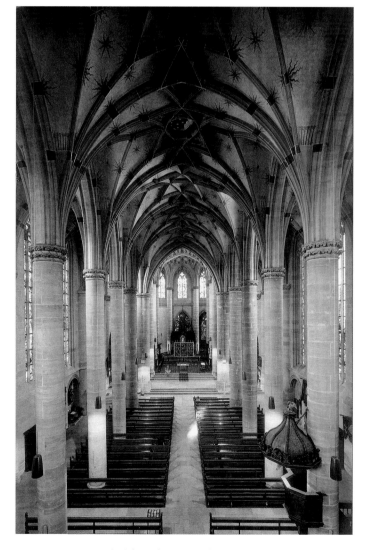

17–21 | Heinrich and Peter Parler **CHURCH OF THE HOLY CROSS**
Schwäbisch Gmünd, Germany. Interior. Begun in 1317 by Henrich Parler; choir by Peter Parler begun in 1351; vaulting completed 16th century.

The Supremacy of Prague

Charles IV of Bohemia (ruled 1346–75), whose admiration for the French king Charles IV was such that he changed his own name from Wenceslas to Charles, had been raised in France. He was officially crowned king of Bohemia in 1347 and Holy Roman Emperor in 1355.

Charles established his capital in Prague, which, in the view of its contemporaries, replaced Constantinople as the "New Rome." Prague had a great university, a castle, and a cathedral overlooking a town that spread on both sides of a river joined by a stone bridge, a remarkable structure itself.

When Pope Clement VI made Prague an archbishopric in 1344, construction began on a new cathedral in the Gothic style—to be named for Saint Vitus—which would also serve as the coronation church and royal pantheon. At Charles's first coronation, however, the choir remained unfinished. Charles, deeply involved in his projects, brought Peter Parler from Swabia to complete the building. Peter came from a distinguished family of architects.

THE PARLER FAMILY. In 1317 Heinrich Parler, a former master of works on the Cologne Cathedral, designed and began building the **CHURCH OF THE HOLY CROSS** in Schwäbisch Gmünd, in southwest Germany. In 1351, his son Peter (c. 1330–99), the most brilliant architect of this talented family, joined the shop. Peter designed the choir (FIG. 17–21) in the manner of a hall church in which a triple-aisled form was enlarged by a ring of deep chapels between the buttresses

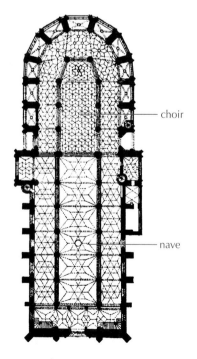

17–22 | **PLAN OF CHURCH OF THE HOLY CROSS**
Schwäbisch Gmünd.

of the choir. The unity of the entire space was enhanced by the complex net vault—a veritable web of ribs created by eliminating transverse ribs and ridge ribs. Seen clearly in the plan (FIG. 17–22), the contrast between Heinrich's nave and Peter's choir illustrates the increasing complexity of rib patterns, a complexity that in fact finally led to the unified interior space of the Renaissance.

Called by Charles IV to Prague in 1353, Peter turned the unfinished Saint Vitus Cathedral into a "glass house," adding a vast clerestory and glazed triforium supported by double flying buttresses, all covered by net vaults that created a continuous canopy over the space. Photos do not do justice to the architecture; but the small, gilded icon shrine suggests the richness and elaborateness of Peter's work. The shrine stands in the reliquary chapel of Saint Wenceslas (FIG. 17–23)—once a freestanding Romanesque chapel, now incorporated into the cathedral—on the south side of the church. The chapel itself, with walls encrusted with semiprecious stones, recalls a reliquary (c. 1370–71).

Peter, his family, and heirs became the most successful architects in the Holy Roman Empire. Their concept of space, luxurious decoration, and intricate vaulting dominated central European architecture for three generations.

MASTER THEODORIC AND THE "BEAUTIFUL STYLE." At Karlstejn Castle, a day's ride from Prague, the emperor built another chapel and again covered the walls with gold and precious stones as well as with paintings. One hundred thirty paintings of the saints also served as reliquaries, for they had relics inserted into their frames. Master Theodoric, the court painter, provided drawings on the wood panels, and he painted about thirty images himself (FIG. 17–24). These figures are crowded into—and even extend over—the frames,

17–23 Peter Parler and workshop **SAINT WENCESLAS CHAPEL, CATHEDRAL OF SAINT VITUS**
Prague. Begun 1356. In 1370–71, the walls were encrusted with slabs of jasper, amethyst, and gold, forming crosses. Tabernacle, c. 1375: gilded iron. Height 81⅞" (208 cm).

The spires, pinnacles, and flying buttresses of the tabernacle may have been inspired by Peter Parler's drawings for the cathedral.

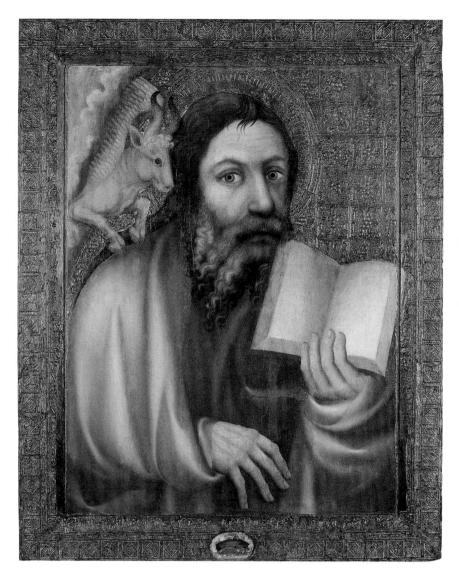

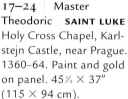

17–24 | Master Theodoric **SAINT LUKE** Holy Cross Chapel, Karlstejn Castle, near Prague. 1360-64. Paint and gold on panel. 45¼ × 37" (115 × 94 cm).

emphasizing their size and power. Master Theodoric was head of the Brotherhood of Saint Luke, the patron saint of painters, and his painting of **SAINT LUKE,** accompanied by his symbol, the ox, looks out at the viewer, suggesting that this may really be a self-portrait of Master Theodoric. Master Theodoric's personal style—heavy bodies, oversized heads and hands, dour and haunted faces, and soft, deeply modeled drapery—merged with the French Gothic style to become what is known as the Beautiful style of the end of the century. The chapel, consecrated in 1365, so pleased the emperor that in 1367 he gave the artist a farm in appreciation for his work.

Like the architecture of the Parler family, the style created by Master Theodoric spread through central and northern Europe. Typical of this Beautiful style is the sweet-faced Virgin and Child, as seen in the **"BEAUTIFUL" VIRGIN AND CHILD** (FIG. 17–25), engulfed in swaths of complex drapery.

Cascades of V-shaped folds and clusters of vertical folds ending in rippling edges surround a squirming infant to create the feeling of a fleeting movement. Emotions are restrained, and grief as well as joy become lost in a naive piety. Yet, this art emerges against a background of civil and religious unrest. The Beautiful style seems like an escape from the realities of fourteenth-century life.

Mysticism and Suffering

The ordeals of the fourteenth century—famines, wars, and plagues—helped inspire a mystical religiosity that emphasized both ecstatic joy and extreme suffering. Devotional images, known as *Andachtsbilder* in German, inspired the worshiper to contemplate Jesus's first and last hours, especially during evening prayers, or vespers (giving rise to the term *Vesperbild* for the image of Mary mourning her son).

17–25 | **"BEAUTIFUL" VIRGIN AND CHILD**
Probably from the Church of Augustinian Canons, Sternberk. c. 1390. Limestone with original paint and gilding; height 33⅛" (84 cm).

17–26 | VESPERBILD
From Middle Rhine region, Germany. c. 1330. Wood, height 34½″ (88. 4 cm). Landesmuseum, Bonn.

Through such religious exercises, worshipers hoped to achieve understanding of the divine and union with God. In the well-known example shown here (FIG. 17–26), blood gushes from the hideous rosettes that are the wounds of an emaciated Jesus. The Virgin's face conveys the intensity of her ordeal, mingling horror, shock, pity, and grief. Such images had a profound impact on later art, both within Germany and beyond.

Prague and the Holy Roman Empire under Charles IV had become a multicultural empire where people of different religions (Christians and Jews) and ethnic heritage (German and Slav) lived side by side. Charles died in 1378, and without his strong central government, political and religious dissent overtook the empire. Jan Hus, dean of the philosophy faculty at Prague University and a powerful reforming preacher, denounced the immorality he saw in the Church. He was burned at the stake, becoming a martyr and Czech national hero. The Hussite Revolution in the fifteenth century ended Prague's—and Bohemia's—leadership in the arts.

IN PERSPECTIVE

The emphasis on suffering and on supernatural power inspired many artists to continue the formal, expressive styles of earlier medieval and Byzantine art. At the same time, the humanism emerging in the paintings of Giotto and his school at the beginning of the fourteenth century could not be denied. Painters began to combine the flat, decorative, linear quality of Gothic art with the new representation of forms defined by light and space. In Italy they created a distinctive new Gothic style that continued through the fourteenth century. North of the Alps, Gothic elements survived in the arts well into the fifteenth century.

The courtly arts of manuscript illumination, embroidery, ivory carving, and of jewel, enamel, gold, and silver work flourished, becoming ever richer, more intricate and elaborate. Stained glass filled the ever-larger windows, while paintings or tapestries covered the walls. In Italy, artists inspired by ancient Roman masters and by Giotto looked with fresh eyes at the natural world. The full impact of their new vision was not fully assimilated until the beginning of the fifteenth century.

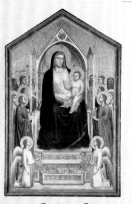

GIOTTO DI BONDONE
VIRGIN AND CHILD ENTHRONED
1305–10

AMBROGIO LORENZETTI.
**ALLEGORY OF GOOD GOVERNMENT IN THE CITY
AND IN THE COUNTRY**
SALA DELLA PACE, PALAZZO PUBBLICO, SIENA, ITALY
1338–40

LIFE OF THE VIRGIN
BACK OF THE
CHICHESTER-CONSTABLE CHASUBLE,
SOUTHERN ENGLAND
1330–50

PETER PARLER AND WORKSHOP.
ST. WENCESLAS CHAPEL
BEGUN 1356

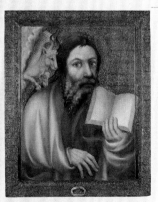

MASTER THEODORIC
ST. LUKE
1360–64

FOURTEENTH-
CENTURY ART
IN EUROPE

◀ **Papacy resides in Avignon** 1309–77

◀ **Hundred Years' Wars** 1337–1453

◀ **Black Death begins** 1348
◀ **Boccaccio begins writing**
The Decameron 1349–51

◀ **Great Schism** 1378–1417

◀ **Chaucer starts work on**
The Canterbury Tales 1387

1300
1320
1340
1360
1380
1400

583

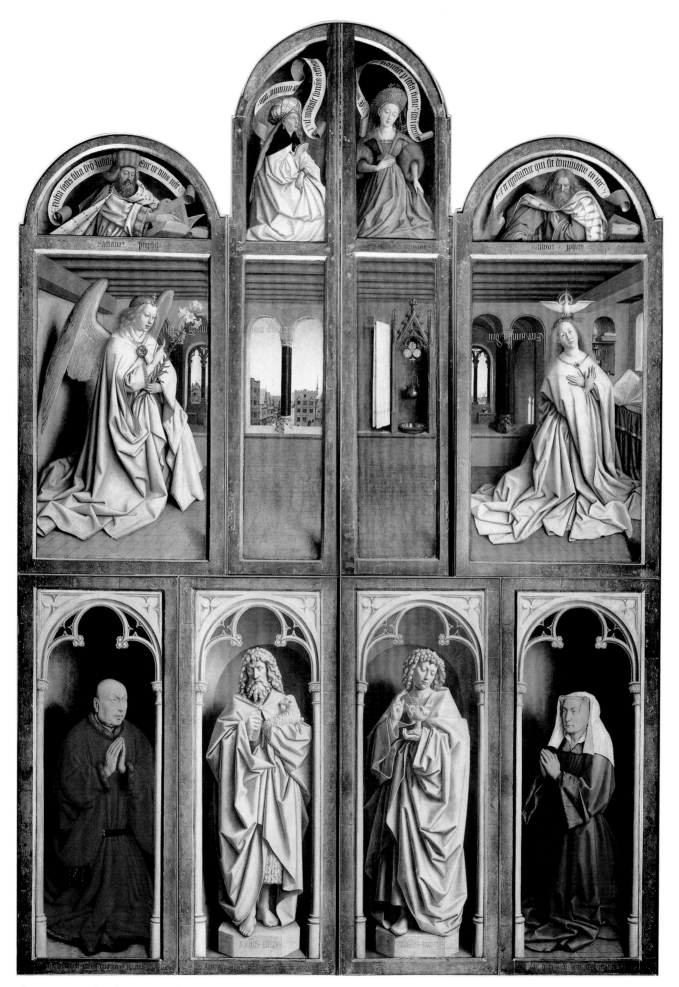

18–1 | Jan and Hubert van Eyck **GHENT ALTARPIECE (CLOSED). ANNUNCIATION WITH DONORS**
Completed 1432. Oil on panel, height 11′5″. Cathedral of Saint Bavo. Ghent.

FIFTEENTH-CENTURY ART IN NORTHERN EUROPE AND THE IBERIAN PENINSULA

When Philip the Good, duke of Burgundy, entered Ghent in 1458, the entire Flemish city turned out. Townspeople made elaborate decorations and presented theatrical events, and local artists designed banners and made sets for the performances. That day in Ghent became an especially dramatic and fascinating example of the union of visual arts and performance, as groups of citizens welcomed Philip with *tableaux vivants* ("living pictures"). They dressed in costume and stood "absolutely frozen, like statues" to re-create scenes from their town's most celebrated work of art, Jan and Hubert van Eyck's *Ghent Altarpiece* (SEE FIG. 18–11), completed twenty-six years earlier. The altarpiece had an enthroned figure of God, seated between the Virgin Mary and John the Baptist and flanked by angel musicians. Below, a depiction of the Communion of Saints, based on the biblical passage Revelation 14:1, described the Lamb of God receiving the veneration of a multitude of believers. The church fathers, prophets, martyrs, and other saints depicted in the altarpiece were among those scenes staged that day to greet Philip.

Closed, as we see it here (FIG. 18–1), the wings of the altarpiece present the **ANNUNCIATION,** with Gabriel and the Virgin on opposite sides of an upper room that overlooks a city. In panels above them, Old Testament prophets and seers from the ancient classical world foretell the coming of Christ.

Below, the donors are portrayed beside statues of the church's patron saints, Saint John the Baptist and Saint John the Evangelist, who, although painted to represent stone, seem to acknowledge the presence of their supplicants in glance and gesture. Before the altarpiece is even opened, as it was at Easter time, it signals the new interests of the fifteenth century: the intellectual change from religious symbolism to secular and ancient learning, a formal change to detailed realism and awareness of the world, and a social and economic change to middle-class power and patronage.

The vision of the Annunciation takes place in a domestic interior, and a prosperous Flemish city can be seen through the open windows. We are at once made aware of the remarkable rise of the middle class to wealth, power, and patronage. The donors are represented by true-to-life portraits, and the patron saints are sculptured figures on pedestals in niches, not visions. In fact, the two Saint Johns do not present the donors to God. Instead, the donors Jodocus Vijd and Elizabeth Borluut kneel in prayer, just as they must have knelt in front of the altarpiece in life.

Because of its monumental scale, complex iconography, and masterly painting techniques, the *Ghent Altarpiece* has continued to be one of the most studied and respected works of the early Renaissance in Europe since its creation in the early fifteenth century.

HUMANISM AND THE NORTHERN RENAISSANCE

Revitalized civic life and economic growth in the late fourteenth century gave rise to a prosperous middle class of artisans, merchants, and bankers who attained their place in the world through personal achievement, not inherited wealth. This newly rich middle class supported scholarship, literature, and the arts. Their patronage resulted in the explosion of learning and creativity known as the Renaissance. Though the actual term *Renaissance* (French for "rebirth") was applied by later historians, the characterization has its origins in the thinking of Petrarch and other fourteenth-century scholars, who believed in *humanism*—the power and potential of human beings.

Humanism is also fundamentally tied to the revival of classical learning and literature that appeared in fourteenth-century Italy with Petrarch, Boccaccio, and others (see "A New Spirit in Fourteenth-Century Literature," page 561). Beginning with Petrarch, humanists of the later fourteenth and fifteenth centuries looked back at the thousand years extending from the collapse of the Roman Empire to their own time, and they determined that human achievement of the ancient classical world was followed by a period of decline (a "middle age" or "dark age"). The third period—their own era—saw a revival, a rebirth, a renaissance, when humanity began to emerge from an intellectual and cultural stagnation and scholars again appreciated the achievements of the ancients.

Humanists extended education to the laity, investigated the natural world, and subjected philosophical and theological positions to logical scrutiny. They constantly invented new ways to extend humans' intellectual and physical reach. For all our differences, we still live in the modern era envisioned by these Renaissance thinkers—a time when human beings, their deeds, and their beliefs have primary importance.

The rise of humanism did not signify a decline in the importance of Christian belief, however. An intense Christian spirituality continued to inspire and pervade most European art. But despite the enormous importance of Christian faith, the established Western Church was plagued with problems. Its hierarchy was bitterly criticized for a number of practices, including a perceived indifference to the needs of common people. Strains within the Western Church exemplified the skepticism of the Renaissance mind. In the next century, these strains would give birth to the Protestant Reformation.

The new intense interest in the natural world manifested itself in the detailed observation and recording of nature. Artists depicted birds, plants, and animals with breathtaking accuracy. They looked at people and objects, and they modeled these forms with light and shadow, giving them three dimensions. In the north, artists such as Jan van Eyck (FIGS. 18–1, 18–11, 18–12, 18–13), Dirck Bouts (FIG. 18–19), and Hugo van der Goes (FIG. 18–20) used an **intuitive perspective** in order to approximate the appearance of things growing smaller and closer together in the distance. They coupled it with a masterful use of **atmospheric** or **aerial perspective**. This technique—applied to the landscape scenes that were a northern specialty—was based on observation that distant elements appear less distinct and less colorful than things close by: The sky becomes paler near the horizon and the distant landscape turns bluish-gray.

Along with the desire for accurate depiction of the world came a new interest in individual personalities. Fifteenth-century portraits have an astonishingly lifelike quality, combining careful—sometimes even unflattering—description with an uncanny sense of vitality. Indeed, the individual becomes important in every sphere. More names of artists survive from the fifteenth century, for example, than in the entire span from the beginning of the Common Era to the year 1400.

The new power of cities in the Flanders region and the greater Low Countries (present-day Belgium, Luxembourg, and the Netherlands; SEE MAP 18–1) provided a critical tension and balance with the traditional powers of royalty and the Church. Increasingly, the urban lay public sought to express personal and civic pride by sponsoring secular architecture, sculptured monuments, or paintings directed toward the community. The common sense values of the merchants formed a solid underpinning for humanist theories and enthusiasms.

But if the *Ghent Altarpiece* donors Jodocus Vijd and Elizabeth Borluut represent the new influence of the middle class, this influence nevertheless remained intertwined with the continuing power of the Church and the royal and noble

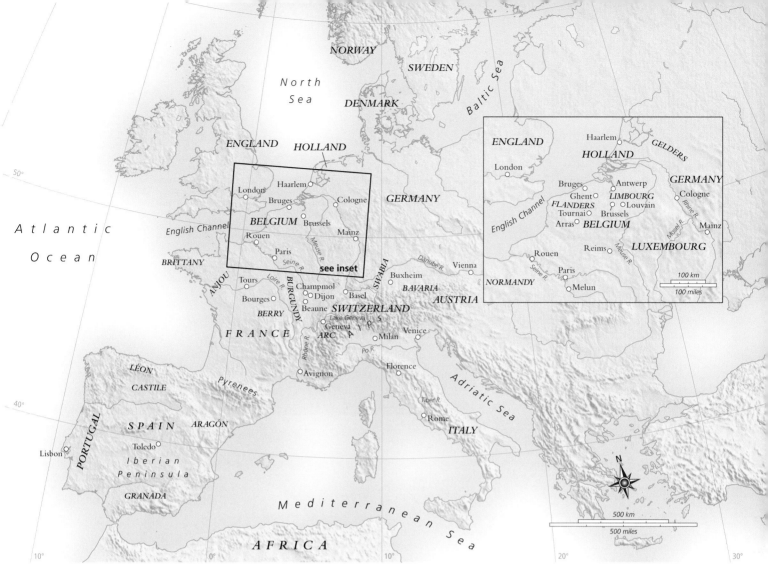

MAP 18–1 | **FIFTEENTH-CENTURY NORTHERN EUROPE AND THE IBERIAN PENINSULA**

The dukes of Burgundy, whose territory included much of present-day Belgium and Luxembourg, the Netherlands, and eastern France, became the cultural and political leaders of Western Europe. Their major cities of Bruges (Belgium) and Dijon (France) were centers of art and industry as well as politics.

courts. Like other wealthy individuals, Jodocus and Elizabeth sought eternal salvation with their donation to the Church; and though Jodocus eventually became the mayor of Ghent, he also served as a high official to the Burgundian duke Philip the Good (ruled 1419–67).

ART FOR THE FRENCH DUCAL COURTS

The dukes of Burgundy were the most powerful rulers in northern Europe for most of the fifteenth century, and a primary reason for this was their control not only of Burgundy but also of Flemish and Netherlandish centers of finance and trade, including the thriving cities of Ghent, Bruges, Tournai, and Brussels (FIG. 18–2). The major seaport, Bruges, was the commercial center of northern Europe and the rival of the Italian city-states of Florence, Milan, and Venice. In the late fourteenth century, Philip the Good's predecessor Philip the Bold (ruled 1363–1404) had acquired territory in the Nether-

lands—including the politically desirable region of Flanders—by marrying the daughter of the Flemish count. Though dukes Philip the Bold of Burgundy, John of Berry, and Louis of Anjou were brothers of King Charles V of France, their interests rarely coincided. Even the threat of a common enemy, England, during the Hundred Years' War was not a strong unifying factor. Burgundy and England were often allied because of common financial interests in Flanders.

While the French king held court in Paris, the dukes held even more splendid courts in their own cities. The dukes of Burgundy (including present-day east-central France, Belgium, Luxembourg, and the Netherlands) and Berry (central France), not the king in Paris, were arbiters of taste. The painting of the Duke of Berry in his great hall (FIG. 18–3), from an illuminated manuscript, which we will take up in more detail later, shows us how the dukes collected splendid robes and jewels, tapestry, goldsmithing, and monumental stone sculpture. Painting on panel also gained a place of importance, with early enthusiasm appearing in the ducal

18–2 | Robert Campin
A FLEMISH CITY
Detail of right wing of the *Mérode Altarpiece (Triptych of the Annunciation)*, fig. 18–10.
c. 1425–28. Oil on wood panel, wing approx. 25⅜ × 10¾" (64.5 × 27.3 cm).
The Metropolitan Museum of Art, New York.
The Cloisters Collection, 1956 (56.70)

The windows in Joseph's carpentry shop open onto a view of a prosperous Flemish city. Tall, well-kept houses crowd around churches, whose towers dominate the skyline. People gather in the open market square, walk up a major thoroughfare, and enter the shops, whose open doors and windows suggest security as well as commercial activity—an ideal to be sure.

courts under Philip the Bold. The duke commissioned many works from Flemish and Netherlandish painters. Those that survive show a debt to the International Gothic style.

A new, composite style emerged in the late fourteenth century from the papal court in Avignon in the south of France, where artists from Italy, France, and Flanders worked side by side. The International Gothic style, the prevailing manner of the late fourteenth century, is characterized by slender, gracefully posed figures whose delicate features are framed by masses of curling hair and extraordinarily complex headdresses. Noble men and women wear rich brocaded and embroidered fabrics and elaborate jewelry. Landscape and architectural settings are miniaturized; however, details of nature—leaves, flowers, insects, birds—are rendered with nearly microscopic detail. Spatial recession is represented by rising tiled floors in buildings open at the front like stage sets, by fanciful mountains and meadows having high horizon lines, and some diminution in size of objects and lightening of color near the horizon. Artists and patrons alike preferred light, bright colors and a liberal use of gold in manuscript and panel paintings, tapestries, and polychromed sculpture. The International Gothic was so appealing that patrons throughout Europe continued to commission such works well into the fifteenth century.

Painting and Sculpture for the Chartreuse de Champmol

One of Philip the Bold's most lavish projects was the Carthusian monastery, or chartreuse ("chartrehouse"), at Champmol, near Dijon, his Burgundian capital city. Land was acquired in 1377 and 1383 and construction began in 1385. The monastic

18–3 | Paul, Herman, and Jean Limbourg **JANUARY, THE DUKE OF BERRY AT TABLE. TRÈS RICHES HEURES**
1411–16. Colors and ink on parchment, 8⅞ × 5⅜" (22.5 × 13.7 cm). Musée Condé, Chantilly, France.

18–4 | Melchior Broederlam **CHAMPMOL ALTARPIECE**
Wings of the altarpiece for the Chartreuse de Champmol. 1393-99. Oil on wood panel, 5′5¼″ × 4′1¼″ (1.67 × 1.25 m).
Musée des Beaux-Arts, Dijon.

The paintings depict the Annunciation and Visitation at the left and the Presentation in the Temple and Flight into Egypt on the right.
The irregular shape of the paintings was determined by the sculpture they were meant to protect.

church was intended to house the family's tombs, and the monks were expected to pray continuously for the souls of Philip and his family. A Carthusian monastery was particularly expensive to maintain because the Carthusian monks did not provide for themselves by farming or other physical work but were dedicated to prayer and solitary meditation. In effect, Carthusians were a brotherhood of hermits.

Melchior Broederlam. The duke ordered a magnificent carved and painted altarpiece for the Chartreuse de Champmol (see "Altars and Altarpieces," page 591). The altarpiece, of gilded wood carved by Jacques de Baerze, depicts scenes of the Crucifixion flanked by the Adoration of the Magi and the Entombment. The primary interest today, however, is in the protective shutters, painted by Melchior Broederlam (active 1381–1410) with scenes from the life of the Virgin and the infancy of Christ (FIG. 18–4). In a personal style that carries the budding realism of the International Style further toward a faithul rendering of the natural world, Broederlam creates tangible figures in fanciful miniature architectural and landscape settings. Christian religious symbolism is present everywhere.

Under the benign eyes of God, the archangel Gabriel greets Mary with the news of her impending motherhood. A door leads into the dark interior of the tall pink rotunda meant

to represent the Temple of Jerusalem, a symbol of the Old Law. According to legend, Mary was an attendant in the Temple prior to her marriage to Joseph. The tiny enclosed garden and a pot of lilies are symbols of Mary's virginity. In International Gothic fashion, both the interior and exterior of the building are shown, and the floors are tilted up to give clear views of the action. Next, in the Visitation, just outside the temple walls, the now-pregnant Mary greets her older cousin Elizabeth, who is also pregnant and will soon give birth to John the Baptist.

On the right shutter, in the Presentation in the Temple, Mary and Joseph have brought the newborn Jesus to the temple for the Jewish purification rite. The priest Simeon takes him in his arms to bless him (Luke 2:25–32). At the far right, the Holy Family flees to Egypt to escape King Herod's order that all Jewish male infants be killed. The family travels along treacherous terrain similar to that in the Visitation scene. The landscape has been arranged to lead the eye up from the foreground and into the distance along a rising ground plane. Despite the imaginative architecture, fantastic mountains, miniature trees, and solid gold sky, the artist has created a sense of light and air around solid figures. Reflecting a new realism creeping into art, a hawk flies through the golden sky, and Joseph drinks from a flask and carries the family belongings in a satchel over his shoulder. The statue of

18–5 | Claus Sluter **WELL OF MOSES, DETAIL OF MOSES AND DAVID**
The Chartreuse de Champmol, Dijon, France. 1395–1406. Limestone with traces of paint, height of figures about 5′8″ (1.69 m).

The sculpture's original details included metal used for buckles and even eyeglasses. It was also painted: Moses wore a gold mantle with a blue lining over a red tunic; David's gold mantle had a painted lining of ermine, and his blue tunic was covered with gold stars and wide bands of ornament.

a pagan god, visible at the upper right, breaks and tumbles from its pedestal as the Christ Child approaches. A new era dawns and the New Law replaces the Old.

CLAUS SLUTER. Philip the Bold commissioned the Flemish sculptor Jean de Marville (active 1366–89) to direct the decoration of the monastery. When Jean died in 1389, he was succeeded by his assistant Claus Sluter (c. 1360–1406), from Haarlem, in Holland. Although the Chartreuse and its treasures were nearly destroyed during the French Revolution, the distinctive character of Sluter's work can still be seen in the surviving parts of a monumental well in the main cloister (FIG. 18–5). Begun in 1395, the **WELL OF MOSES** was unfinished at Sluter's death.

The concept of the *Well of Moses* is complex. A pier rose from the water and supported large freestanding figures of Christ on the cross mourned by the Virgin Mary, Mary Magdalen, and John the Evangelist. Forming a pedestal for this Crucifixion group are life-size stone figures of Old Testament men who foretold the coming of Christ: Moses (prophet and lawgiver), David (king of Israel and an ancestor of Jesus), and the prophets Jeremiah, Zachariah, Daniel, and Isaiah. These images and their texts may have been inspired by contemporary mystery plays such as *The Trial of Jesus* and *The Procession of Prophets*, in which prophets foretell and explain events of the Passion. *Meditations on the Life of Christ*, written between 1348 and 1368, by Ludolph of Saxony, provides another source.

Sluter depicted the Old Testament figures as physically and psychologically distinct individuals. Moses's sad old eyes blaze out from a memorable face entirely covered with a fine web of wrinkles. Even his horns—traditionally given to him because of a mistranslation in the Latin Bible—are wrinkled. A mane of curling hair and a beard cascade over his heavy shoulders and chest, and an enormous cloak envelops his body. Beside him stands David, in the voluminous robes of a medieval king, the personification of nobility.

Sluter looked at the human figure in a new way—as a ponderous mass defined by voluminous drapery. Drapery lies in deep folds falling in horizontal arcs and cascading lines; its heavy sculptural masses both conceal and reveal the body, creating strong highlights and shadows. With these vigorous, imposing, and highly individualized figures of the *Well of Moses,* Sluter introduced a radically new style in northern sculpture. He abandoned the idealized faces, elongated figures, and vertical drapery of the International Gothic style for surface realism and the broad horizontal movement of forms. Nevertheless, Sluter retained the detailed naturalism and rich colors (now almost lost but revealed in recent cleaning) and surfaces preferred by his patrons.

Manuscript Illumination

Of all the family, the duke of Burgundy's older brother Jean, duke of Berry, was the most enthusiastic art collector and bibliophile. In addition to commissioning religious art works for personal salvation and public devotion, he collected illuminated manuscripts, which signified both his worldly status and a commitment to learning.

Besides religious texts, wealthy patrons treasured richly illuminated secular writings such as herbals (encyclopedias of plants), health manuals, and both ancient and contemporary works of history and literature. Workshops in France and the Netherlands produced outstanding manuscripts to fill the demand. A typical manuscript page might have leafy tendrils framing the text, decorated opening initials, and perhaps a small inset picture, such as the illustration of Thamyris in Boccaccio's *Concerning Famous Women* (see "Women Artists

Art and Its Context
ALTARS AND ALTARPIECES

The altar in a Christian church symbolizes both the table of Jesus's Last Supper and the tombs of Christ and the saints. The front surface of a block altar is the *antependium*. Relics of the church's patron saint may be placed in a reliquary on the altar, beneath the floor on which the altar rests, or even within the altar itself.

Altarpieces are painted or carved constructions placed at the back or behind the altar in a way that makes altar and altar-piece appear to be visually joined. The altarpiece evolved into a large and elaborate architectural structure filled with images and protected by movable wings that function like shutters. An altarpiece may have a firm base, called a **predella**. A winged altarpiece can be a **diptych**, in which two panels are hinged together (SEE FIG. 18-22); a **triptych**, in which two wings fold over a center section (SEE FIG. 18-21); or a **polyptych**, consisting of many panels (SEE FIG. 18-16 AND 18-17).

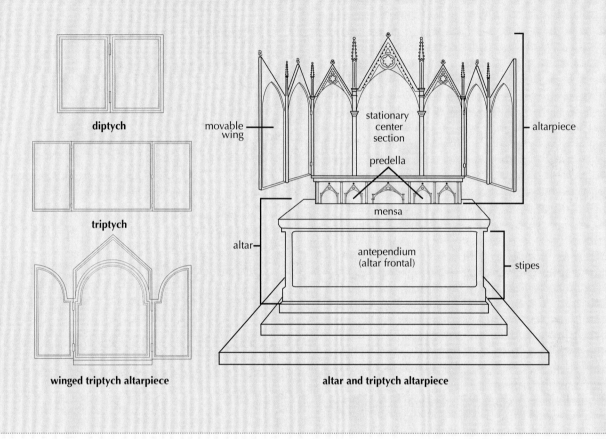

diptych

triptych

winged triptych altarpiece

movable wing

stationary center section

predella

mensa

altar

antependium (altar frontal)

altarpiece

stipes

altar and triptych altarpiece

in the Late Middle Ages and the Renaissance," page 592). The illustrations for the books made for the royal family might be large and lavish, as we see in the detail of the page where Christine de Pizan presents her work to the queen of France (Fig. 21, Introduction). Here the glimpse into the queen's private room displays tapestries on the walls and embroidered bed coverings.

The Flemish style that would influence all of fifteenth-century Europe originated in manuscript illumination of the late fourteenth century, when artists began to create full-page scenes set off with frames that functioned almost as windows looking into rooms or out onto landscapes with distant hori-zons. Painters in the Netherlands and Burgundy were espe-cially skilled at creating an illusion of reality.

THE LIMBOURG BROTHERS. Among the finest Netherlandish illuminators at the beginning of the century were three broth-ers—Paul, Herman, and Jean Limbourg—commonly known as the Limbourg brothers, probably referring to their home region.

About 1404 the brothers entered the service of Duke John of Berry (1340–1416), for whom they produced their major work, the so-called *Très Riches Heures (Very Sumptuous Book of Hours)*, between 1413 and 1416 (see figs. 18–3, 18–6). A Book of Hours was a selection of prayers and readings to be

Art and Its Context

WOMEN ARTISTS IN THE LATE MIDDLE AGES AND THE RENAISSANCE

Medieval and Renaissance women artists typically learned to paint from their husbands and fathers because formal apprenticeships were not open to them. Noblewomen, who were often educated in convents, learned to draw, paint, and embroider. One of the earliest examples of a signed work by a woman painter is a tenth-century manuscript of the Apocalypse illustrated in Spain by a woman named Ende (SEE FIG. 14–10), who describes herself as "painter and helper of God." In Germany, women began to sign their work in the twelfth century. A collection of sermons was decorated by a nun named Guda (SEE FIG. 15–37), who not only signed her work but also included a self-portrait, one of the earliest in Western art.

Examples abound of women artists in the fourteenth and fifteenth centuries. In the fourteenth century, Jeanne de Montbaston and her husband, Richart, worked together as book illuminators under the auspices of the University of Paris. After Richart's death, Jeanne continued the workshop and, following the custom of the time, was sworn in as a *libraire* (publisher) by the university in 1353. In the fifteenth century, women could be admitted to the guilds in some cities, including the Flemish towns of Ghent, Bruges, and Antwerp, and by the 1480s one-quarter of the members of the painters' guild of Bruges were female.

Particularly talented women received major commissions. Bourgot, the daughter of the miniaturist Jean le Noir, illuminated books for King Charles V of France and Jean, duke of Berry. Christine de Pizan (1365–c. 1430), a well-known writer patronized by Philip the Bold of Burgundy and Queen Isabeau of France, described the work of an illuminator named Anastaise, "who is so learned and skillful in painting manuscript borders and miniature backgrounds that one cannot find an artisan . . . who can surpass her . . . nor whose work is more highly esteemed" (*Le Livre de la Cité des Dames*, I.41.4, translated by Earl J. Richards).

In a French edition of a book by the Italian author Boccaccio entitled *Concerning Famous Women*, the anonymous illuminator shows Thamyris, an artist of antiquity, at work in her studio. She is depicted in fifteenth-century dress, painting an image of the Virgin and Child. At the right, an assistant grinds and mixes the colors Thamyris will need to complete her painting. In the foreground, her brushes and paints are laid out conveniently on a table.

PAGE WITH THAMYRIS
From Giovanni Boccaccio's *De Claris Mulieribus (Concerning Famous Women)*. 1402. Ink and tempera on vellum. Bibliothèque Nationale de France, Paris.

used in daily prayer and meditation, and it included a calendar of holy days. The Limbourgs created full-page illustrations for the calendar in the International Gothic style, with subjects including both peasant labors and aristocratic pleasures. Like most European artists of the time, the Limbourgs showed the laboring classes in a light acceptable to aristocrats—that is, happily working for the nobles' benefit. But they also showed peasants enjoying their own pleasures.

In the **FEBRUARY** page (FIG. 18–6), farm people relax cozily before a blazing fire. This farm looks comfortable and well maintained, with timber-framed buildings, a row of beehives, a sheepfold, and tidy woven wattle fences. In the distance are a village and church. Most remarkably, the artists convey the feeling of cold winter weather: the breath of the bundled-up worker turning to steam as he blows on his hands, the leaden sky and bare trees, the snow covering the

18–6 | Paul, Herman, and Jean Limbourg
FEBRUARY, LIFE IN THE COUNTRY. TRÈS RICHES HEURES
1411–16. Colors and ink on parchment, 8⅞ × 5⅜″
(22.5 × 13.7 cm). Musée Condé, Chantilly, France.

table or buffet holds his collection of gold vessels. His chamberlain invites courtiers to approach (the words written overhead say "approach"). John is singled out visually by the red "cloth of honor" with his heraldic arms—swans and the lilies of France—and by a large fire screen that circles his head like a secular halo. Tapestries with battle scenes cover the walls and are rolled up around the fireplace. Rich clothing and jewels, embroidered fabrics and brocades, turbans, golden collars and chains attest to the wealth and lavish lifestyle of this great patron of the arts and brother of King Charles V.

THE MARY OF BURGUNDY PAINTER. By the end of the century, each scene on a manuscript page was a tiny image of the world rendered in microscopic detail. Complex compositions and ornate decorations were commonplace, with framed images surrounded by a fantasy of vines, flowers, insects, animals, shellfish, or other objects painted as if seen under a magnifying glass. Christine de Pizan's preferred artist, Anastaise, probably worked in this mode (see Fig. 21, Introduction).

One of the finest later painters was the anonymous artist known as the Mary of Burgundy Painter—so called because he painted a Book of Hours for Mary of Burgundy, daughter of Charles the Bold. Mary married the Habsburg heir, Maximilian of Austria, in 1477, and her grandson became both King of Spain as Charles I and Holy Roman Emperor as Charles V (see Chapter 20).

Within an illumination in a book only 7½ by 5¼ inches, reality and vision have been rendered equally tangible (FIG. 18–7). The painter has attained a new complexity in treating pictorial space. We look not only through the "window" of the illustration's frame but through another window in the wall of the room depicted in the painting. The spatial recession leads the eye into the far reaches of the church interior, past the Virgin and the gilded altarpiece in the sanctuary to two people conversing in the far distance.

Mary of Burgundy appears twice: once seated in the foreground by a window, reading from her Book of Hours; and again in the background, perhaps in a vision inspired by her reading. She kneels with attendants and angels in front of the Virgin and Child. On the window ledge is an exquisite

landscape, and the comforting smoke curling from the farmhouse chimney. The painting employs several International Gothic conventions: the high placement of the horizon line, the small size of trees and buildings in relation to people, and the cutaway view of the house showing both interior and exterior. The muted palette is sparked with touches of yellowish-orange, blue, and a patch of bright red on the man's turban at the lower left. The landscape recedes continuously from foreground to middle ground to background. An elaborate calendar device, with the chariot of the sun and the zodiac symbols, fills the upper part of the page.

In contrast, the illustration for the other winter month—January—depicts an aristocratic household (SEE FIG. 18–3). The Duke of Berry sits behind a table laden with food and rich tableware, including a huge gold standing salt. A second

18—7 | Mary of Burgundy Painter **MARY AT HER DEVOTIONS, HOURS OF MARY OF BURGUNDY**
Before 1482. Colors and ink on parchment, size of image 7½ × 5¼" (19.1 × 13.3 cm). Österreichische Nationalbibliothek, Vienna.

Often they were woven for specific places or for festive occasions such as weddings, coronations, and other state events. Many were given as diplomatic gifts, and the wealth of individuals can often be judged by the number of tapestries listed in their household inventories.

The price of a tapestry depended on the work required and the materials used. Rarely was a fine, commissioned series woven only with wool; instead, tapestry producers enhanced the weaving with silk, silver, and gold threads. The richest kind of tapestry was made almost entirely of silk and gold. Because silver and gold threads were made of silk wrapped with real metal, people later burned many tapestries to retrieve the precious materials. As a result, few royal tapestries in France survived the French Revolution. Many existing works show obvious signs, however, that the metallic threads were painstakingly pulled out in order to get the gold but preserve the tapestries.

THE UNICORN TAPESTRY. Tapestries often formed series. One of the best-known surviving tapestry series is the *Hunt of the Unicorn*. Each piece exhibits many people and animals in a dense field of trees and flowers, with a distant view of a castle, as in the **UNICORN IS FOUND AT THE FOUNTAIN** (FIG. 18–8). The unusually fine condition of the tapestry allows us to appreciate its rich colors and the subtlety in modeling the faces, the tonal variations in the animals' fur, and even the depiction of reflections in the water. The unicorn, a mythical horselike animal with cloven hooves, a goat's beard, and a single long twisted horn, was said to be supernaturally swift and, in medieval belief, could only be captured by a virgin, to whom it came willingly. Thus, the unicorn became a symbol of the Incarnation (Christ is the unicorn captured by the Virgin Mary) and also a metaphor for romantic love.

Because of its religious connotations, the unicorn was an important animal in the medieval **bestiary**, an encyclopedia of real and imaginary animals that gave information of both moral and practical value. For example, the unicorn's horn (in fact, the narwhal's horn) was thought to be an antidote to poison. In the tapestry, the unicorn purifies the water by dipping its horn into the stream. This beneficent act, resulting in the capture and killing of the unicorn, was equated with Christ's death on the cross to save humanity. The prominence of the red roses (symbols both of the Passion and of Mary) growing behind the unicorn suggests that the tapestries may have celebrated Christian doctrine, but they could also have been a wedding gift.

All the woodland creatures included in the tapestry have symbolic meanings. For instance, lions, ancient symbols of power, represent valor, faith, courage, and mercy, and even—because they breathe life into their cubs—the Resurrection of Christ. The stag is another symbol of the Resurrection (it sheds and grows its antlers) and a protector against poisonous serpents and evil in general. Even today

still life—a rosary (symbol of Mary's devotion), carnations (flowers symbolizing the nails of the Crucifixion), and a glass vase holding purple irises, representing the Virgin Mary's sorrows over the sacrifice of Christ (SEE FIG. 18–21). The artist has skillfully executed the filmy veil covering Mary's steeple headdress, the transparent glass vase, and the glass of the window (circular panes whose center "lump" was formed by the glassblower's pipe).

The Fiber Arts

The lavish detail with which textiles are depicted in Flemish manuscripts and paintings reflects their great importance in fifteenth-century society. In the fifteenth and sixteenth centuries, Flemish tapestry making was the finest in Europe. Major weaving centers at Brussels, Tournai, and Arras produced these intricately woven wall hangings for royal and aristocratic patrons, important church officials, and even town councils. Among the most common subjects were foliage and flower patterns, scenes from the lives of the saints, and themes from classical mythology and history, such as the Battle of Troy seen hanging on the Duke of Berry's walls. Tapestries provided both insulation and luxurious decoration for the stone walls of castle halls, churches, and municipal buildings.

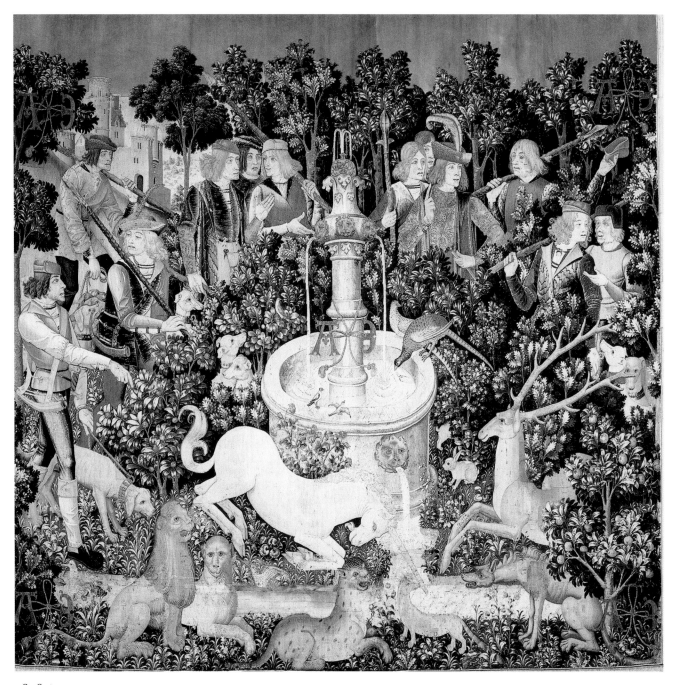

18–8 | **UNICORN IS FOUND AT THE FOUNTAIN**
From the *Hunt of the Unicorn* tapestry series.
c. 1495–1505. Wool, silk, and silver- and gilt-wrapped thread (13–21 warp threads per inch), 12'1" × 12'5"
(3.68 × 3.78 m). The Metropolitan Museum of Art, New York.
Gift of John D. Rockefeller Jr., the Cloisters Collection, 1937 (37.80.2)

we expect the rabbits to symbolize fertility, and the dogs, fidelity. The pair of pheasants is an emblem of human love and marriage, and the goldfinch is another symbol of fertility and also of the Passion of Christ. Only the ducks swimming away have no apparent message.

The flowers and trees in the tapestry, identifiable from their botanically correct depictions, reinforce the theme of protective and curative powers. Each has both religious and secular meanings—as explained in herbals (encyclopedias of plants, their uses and significance)—but the theme of mar-

riage, in particular, is referred to by the presence of such plants as the strawberry, a common symbol of sexual love; the pansy, a symbol for remembrance; and the periwinkle, a cure for spiteful feelings and jealousy. The trees include oak for fidelity, beech for nobility, holly for protection against evil, hawthorn for the power of love, and pomegranate and orange for fertility. The parklike setting with its prominent fountain was inspired by the biblical love poem the Song of Songs (4:12, 13, 15–16): "You are an enclosed garden, my sister, my bride, an enclosed garden, a fountain sealed."

18–9 | **COPE OF THE ORDER OF THE GOLDEN FLEECE**
Flemish, mid-15th century. Cloth with gold and colored silk embroidery, 5'4 ⁹⁄₁₆" × 10'9 ⁹⁄₁₆" (1.64 × 3.3 m).
Imperial Treasury, Vienna.

COPE OF THE ORDER OF THE GOLDEN FLEECE. Remarkable examples of the Flemish fiber arts are the vestments of the Order of the Golden Fleece. The Order of the Golden Fleece was an honorary fraternity founded by Duke Philip the Good of Burgundy in 1430 with twenty-three knights chosen for their moral character and bravery. Religious services were an integral part of the order's meetings, and opulent liturgical and clerical objects were created for the purpose.

The surface of the sumptuous cope (cloak) in FIGURE 18–9 is divided into compartments filled with the standing figures of saints. At the top of the neck edge, as if presiding over the company, is an enthroned figure of Christ, flanked by scholar-saints in their studies. The embroiderers worked with great precision to create illusionistic effects of contemporary Flemish painting. The particular stitch used here is known as couching, that is, gold threads are tacked down using unevenly spaced colored silk threads to create images and an iridescent effect. (For the effect of a cope when worn, see the angels in the center panel of the *Portinari Alta*rpiece, FIG. 18–20.)

PAINTING IN FLANDERS

A strong economy based on wool, the textile industry, and international trade provided stability and money for the arts to flourish. Civic groups, town councils, and wealthy merchants were also important patrons in the Netherlands, where the cities were self-governing and largely independent of the landed nobility. Guilds oversaw nearly every aspect of their members' lives, and high-ranking guild members served on town councils and helped run city governments. Even experienced artists who moved from one city to another usually had to work as assistants in a local workshop until they met the requirements for guild membership.

The diversity of clientele encouraged artists to experiment with new types of images—with outstanding results. Throughout most of the fifteenth century, Flemish art and artists were greatly admired; artists from abroad studied Flemish works, and their influence spread throughout Europe, including Italy. Only at the end of the fifteenth century did a general preference for the Netherlandish painting style give way to a taste for the new styles of art and architecture developing in Italy.

The Founders of the Flemish School

Flemish artists were known for their exquisite illuminated manuscripts, tapestries, and stained glass. For works ranging from enormous altarpieces to small portraits, Flemish painters perfected the technique of painting with an oil medium rather than the tempera paint preferred by the Italians. Oil paint provided more flexibility: Slow to dry, it permitted artists to make changes as they worked. Most important, it had a luminous quality. Oil paint applied in thin glazes produced luminous effects that enabled the artists to capture rich jewel-like colors and subtle changes in textures and surfaces. Like manuscript illuminations, the panel paintings provided a window onto a scene, which fifteenth-century Flemish painters typically rendered with keen attention to individual

features—whether of people, objects, or the natural world—in works laden with symbolic meaning.

ROBERT CAMPIN. One of the first outstanding exponents of the new Flemish style was Robert Campin (active 1406–44). His paintings reflect the Netherlandish taste for lively narrative and a bold three-dimensional treatment of figures reminiscent of the sculptural style of Claus Sluter. About 1425–28, Campin painted an altarpiece now known as the **MÉRODE ALTARPIECE** from the name of later owners (FIG. 18–10). Slightly over 2 feet tall and about 4 feet wide with the wings open, it was probably made for a small private chapel.

By depicting the Annunciation inside a Flemish home, Campin turned common household objects into religious symbols. The treatment is often referred to as "hidden symbolism" because objects are treated as an ordinary part of the scene, but their religious meanings would have been widely understood by contemporary people. The lilies in the **majolica** (glazed earthenware) pitcher on the table, for example, symbolize Mary's virginity, and were a traditional element of Annunciation imagery. The white towel and hanging waterpot in the niche symbolize Mary's purity and her role as the vessel for the Incarnation of God. Unfortunately, the precise meanings are not always clear today. The central panel may simply portray Gabriel telling Mary that she will be the Mother of Christ. Another interpretation suggests that the painting shows the moment immediately following Mary's acceptance of her destiny. A rush of wind riffles the book pages and snuffs the candle as a tiny figure of Christ carrying a cross descends on a ray of light. Having accepted the miracle of the Incarnation (God assuming human form), Mary reads her Bible while sitting humbly on the footrest of the long bench. Her position becomes a symbol of her submission to God's will. But another interpretation of the scene suggests that it represents the moment just prior to the Annunciation. In this view, Mary is not yet aware of Gabriel's presence, and the rushing wind is the result of the angel's rapid entry into the room, where he appears before her, half kneeling and raising his hand in salutation.

The complex treatment of light in the *Mérode Altarpiece* is another Flemish innovation. Campin combines natural and supernatural light, with the strongest illumination coming from an unseen source at the upper left in front of the picture plane. The sun seems to shine through a miraculously transparent wall that allows the viewer to observe the scene. In addition, a few rays enter the round window at the left as the vehicle for the Christ Child's descent. More light comes from the window at the rear of the room, and areas of reflected light can also be detected, such as the right side of the brass waterpot.

Campin maintained some of the conventions typical of the International Gothic style: the abrupt recession of the bench toward the back of the room, the sharply uplifted floor and tabletop, and the disproportionate relationship between the figures and the architectural space. In an otherwise

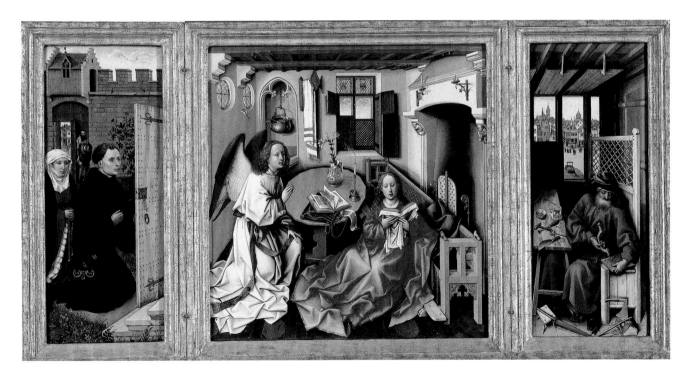

18–10 | Robert Campin **MÉRODE ALTARPIECE (TRIPTYCH OF THE ANNUNCIATION) (OPEN)**
c. 1425–28. Oil on wood panel, center 25¼ × 24⅞" (64.1 × 63.2 cm); each wing approx 25⅜ × 10¾"
(64.5 × 27.6 cm). The Metropolitan Museum of Art, New York.
The Cloisters Collection, 1956 (56.70)

intense effort to mirror the real world, this treatment of space may be a conscious remnant of medieval style, serving the symbolic purpose of visually detaching the religious realm from the world of the viewers. Unlike figures by such International Gothic painters as the Limbourg brothers (SEE FIGS. 18–3, 18–6), the Virgin and Gabriel are massive rather than slender, and their abundant draperies increase the impression of material weight.

Although in the biblical account Joseph and Mary were not married at the time of the Annunciation, this house clearly belongs to Joseph, who is shown in his carpentry shop. A prosperous Flemish city can be seen through the shop window, with people going about their business unaware of the drama taking place inside the carpenter's home (SEE FIG. 18–2). One clue indicates that this is not an everyday scene: the shop, displaying wooden wares—mousetraps, in this case—would have been on the ground floor, but Campin has the window apparently opening from the second floor. Furthermore, the significance of the mousetraps would have been recognized by knowledgeable people. They could refer to Saint Augustine's reference to Christ as the bait in a trap set by God to catch Satan. Joseph is drilling holes in a small board used as a drainboard for wine making, which would have been understood as symbolic of the Eucharistic wine and Christ's Passion.

Joseph's house has a garden planted with a rosebush; roses allude to both the Virgin and the Passion. Perhaps the man standing behind the open entrance gate, clutching his hat in one hand and a document in the other, is a self-portrait of the artist, but he has also been called the prophet Isaiah. Kneeling in front of the open door to the house are the donors of the altarpiece, Peter Inghelbrecht and his wife. Although they could observe the Annunciation through the door their eyes seem unfocused. Perhaps the scene of the Annunciation is a vision induced by their prayers.

JAN VAN EYCK. Campin's contemporary Jan van Eyck (active 1420s-41) was a trusted official as well as painter in the court of Philip the Good. His influence would extend through ducal Burgundy and into France, Spain, and Portugal, where he traveled on diplomatic missions for the duke. Duke Philip alluded to Jan's remarkable technical skills in a letter of 1434-35, saying that he could find no other painter equal to his taste or so excellent in art and science. Part of the secret of Jan's "science" was his technique of painting with oil glazes on wood panel. So brilliant were the results of his experiments that Jan has been mistakenly credited with being the inventor of oil painting. Actually, the medium had been known for several centuries, and medieval painters had used oil paint to decorate stone, metal, and occasionally plaster walls. Jan perfected the medium by building up his images in very thin transparent oil layers. This technique permitted a precise, objective description of what he saw, with tiny, carefully applied brushstrokes so well blended that they are only visible at very close range.

The **GHENT ALTARPIECE** (FIG. 18–11), which we have already seen in closed form, presents questions of authorship. An inscription on the frame identifies both Jan and Hubert van Eyck as artists, but Hubert died in 1426. Perhaps Hubert left several unfinished panels in his studio when he died and Jan assembled them, repainting and adding to them to bring them into harmony. In addition to the visual evidence, modern scientific analysis—X-ray, infrared reflectography, and chemical analysis—supports this theory.

Dominating the altarpiece by size, central location, and brilliant red and gold color is the enthroned figure of God, wearing the triple crown of Saint Peter (the papal crown) and having an earthly crown at his feet. He is joined in his golden shrine by the Virgin Mary and John the Baptist, each enthroned and holding an open book. This divine trio (in Byzantine art, known as the Deësis) is flanked first by angel musicians and then by Adam and Eve. Van Eyck emphasizes humanity's fall from grace by depicting the murder of Abel by Cain, in the upper **lunette** (semicircular wall area), and Eve, who holds the forbidden fruit. In the upper register, each of the three themes—God with Mary and John, musical angels, and Adam and Eve—is represented in a different space and at a different scale. Angels stand on a tiled floor but against a blue sky. Adam and Eve stand in shallow stone niches.

The five lower panels present a unified field—a vast landscape with meadows, woods, and distant cities against a continuous horizon. All saints—apostles, martyrs, confessors and virgins, hermits, pilgrims, warriors, and judges—gather to adore the Lamb of God as described in the Book of Revelation. The Lamb stands on an altar, blood flowing into a chalice, ultimately leading to the fountain of life.

The three-dimensional mass of the figures, the voluminous draperies as well as the remarkable surface realism, even the faux sculpture, recall the art of Claus Sluter for the Burgundian court in Dijon. The extraordinary painting of brocades and jewels, the facial expressions (especially of the angels), the detailed rendering of plants, including Mediterranean palms and orange trees, and the concern with atmospheric perspective—all suggest Jan's unique contribution. Jan's technique is firmly grounded in the terrestrial world despite his visionary subject.

The portrait of a **MAN IN A RED TURBAN** of 1433 (FIG. 18–12) projects a strong sense of personality, and the signed and dated frame also bears Jan's personal motto, in Flemish, "As I can" ("The best that I am capable of doing"). This motto, derived from classical sources and written here in Greek letters, is a telling illustration of the humanist spirit of the age and the confident expression of an artist who

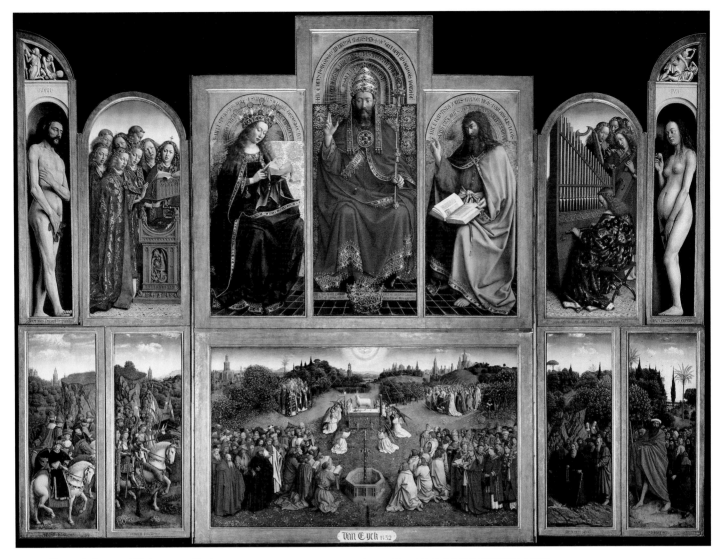

18—11 | Jan and Hubert van Eyck **GHENT ALTARPIECE (OPEN), ADORATION OF THE MYSTIC LAMB**
Completed 1432. Oil on panel, 11′5¾″ × 15′1½″ (3.5 × 4.6 m). Cathedral of Saint Bavo, Ghent.

On the frame of the altarpiece was written, "The painter Hubert van Eyck, greater than whom no one was found, began [this work]; and Jan, his brother, second in art, having carried through the task at the expense of Jodocus Vijd, invites you by this verse, on the sixth of May, to look at what has been done." (Translation by L. Silver)

knows his capabilities and is proud to display them. The *Man in a Red Turban* is a portrait in which the physical appearance seems recorded in a magnifying mirror. We see every wrinkle and scar, the stubble of a day's growth of beard on his chin and cheeks, and the tiny reflections of light from a studio window in the pupils of the eyes. The outward gaze of the subject is new in portraiture, and it suggests the subject's increased sense of self-confidence as he catches the viewer's eye.

Jan's best-known painting today is an elaborate portrait of a man and woman traditionally identified as **GIOVANNI ARNOLFINI AND HIS WIFE, GIOVANNA CENAMI** (FIG. 18–13). This fascinating work continues to be subject to a number of interpretations, most of which suggest that it represents a wedding or betrothal. One remarkable detail is the artist's inscription above the mirror on the back wall: *Johannes de eyck fuit hic 1434* ("Jan van Eyck was present, 1434"). Normally, a work of art in fifteenth-century Flanders would have been signed "Jan

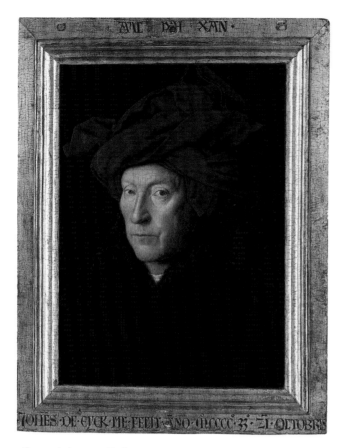

18–12 | Jan van Eyck **MAN IN A RED TURBAN**
1433. Oil on wood panel, 13⅛ × 10¼″ (33.3 × 25.8 cm). The National Gallery, London.

On the frame is written, "Als ich Kan. Joh. de Eyck me Fecit," Jan's personal motto, which translates "As I can."

wealth, piety, and married life. The convex mirror reflecting the entire room and its occupants is a luxury object, but it may also symbolize the all-seeing eye of God. The roundels decorating its frame depict the Passion of Christ, a reminder of Christian redemption.

Many other details suggest the piety of the couple: the crystal prayer beads on the wall; the image of Saint Margaret, protector of women in childbirth, carved on the top of a high-backed chair next to the bed; and the single burning candle in the chandelier, a symbol of Christ's presence. The fruits shown at the left, seemingly placed there to ripen in the sun, may allude to fertility in a marriage, and also to the Fall of Adam and Eve in the Garden of Eden. The small dog may simply be a pet, but it serves also as a symbol of fidelity, and its rare breed—affenpinscher—suggests wealth.

The woman wears an aristocratic fur-lined overdress with a long train. Fashion dictated that the robe be gathered up and held in front of the abdomen, giving an appearance of pregnancy. This ideal of feminine beauty emphasized women's potential fertility. The merchant class copied the fashions of the court, and a beautifully furnished room containing a large bed hung with rich draperies was often a home's primary public space, not a private retreat.

Jan delighted in complex symbolism in the guise of ordinary objects. The paintings of his contemporaries and followers seem relatively straightforward by comparison.

ROGIER VAN DER WEYDEN. Little as we know about Jan van Eyck, we know less about the life of Rogier van der Weyden. Not a single existing work of art bears his name. He may have studied under Robert Campin, but this relationship is not altogether certain. At the peak of his career, Rogier maintained a large workshop in Brussels, where he was the official city painter. Apprentices and shop assistants came from as far away as Italy to study with him, adding to modern scholars' difficulties.

To establish the thematic and stylistic characteristics for Rogier's art, scholars have turned to a painting of the **DEPOSITION** (FIG. 18–14), an altarpiece commissioned by the Louvain Crossbowmen's Guild sometime before 1443, the date of the earliest known copy of it by another artist. The copy has wings painted with the four evangelists—Matthew, Mark, Luke, and John—and Christ's Resurrection. Perhaps the *Deposition* was once a triptych too.

The Deposition was a popular theme in the fifteenth century, in part because of its dramatic, emotionally moving nature. Rogier set the act of removing Jesus's body from the cross on a shallow stage closed off by a wooden backdrop that has been covered with a thin overlay of gold like a carved and painted altarpiece. The ten solid, three-dimensional figures seem to press forward into the viewer's space, forcing the viewer to identify with the grief of Jesus's friends—made palpably real by their portraitlike faces and elements of contem-

van Eyck made this." The wording is that of a witness to a legal document, and indeed, two witnesses to the scene are reflected in the mirror, a man in a red turban—perhaps the artist—and one other. The man in the portrait, identified by early sources as Giovanni Arnolfini, a member of an Italian merchant family living in Flanders, holds the hand of the woman and raises his right hand before the two witnesses. In the fifteenth century, a marriage was rarely celebrated with a religious ceremony. The couple signed a legal contract before two witnesses, after which the bride's dowry might be paid and gifts exchanged. However, it has been suggested that the painting might be a pictorial "power of attorney," giving the woman the right to act in her husband's absence. The recent discovery of a document showing that Arnolfini married in 1447, six years after Jan's death, adds to the mystery.

Whatever event or situation the painting depicts, the artist has juxtaposed secular and religious themes in a work that seems to have several levels of meaning. On the man's side of the painting, the room opens to the outdoors, the external "masculine" world, while the woman is silhouetted against a domestic interior, with its allusions to the roles of wife and mother. The couple is surrounded by emblems of

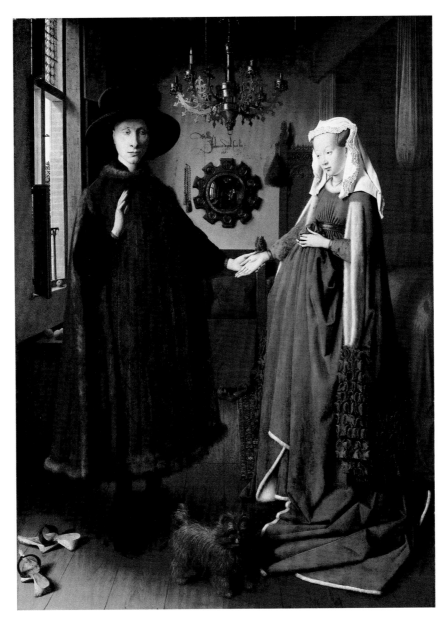

18–13 | Jan van Eyck **DOUBLE PORTRAIT; TRADITIONALLY KNOWN AS GIOVANNI ARNOLFINI AND HIS WIFE, GIOVANNA CENAMI**
1434. Oil on wood panel, 33 × 22½″ (83.8 × 57.2 cm).
The National Gallery, London.

"Johannes de eyck fuit hic [was present]." According to a later inventory, the original frame was inscribed with a quotation from Ovid, a Roman poet known for his celebration of romantic love.

porary dress—as they tenderly and sorrowfully remove his body from the cross for burial. Rogier has arranged Jesus, the life-size corpse at the center of the composition, in a graceful curve that is echoed in angular fashion by the fainting Virgin, thereby increasing the emotional identification between the Son and the Mother. The artist's compassionate sensibility is especially evident in the gestures of John the Evangelist, who supports the Virgin at the left, and Jesus's friend Mary Magdalen, who wrings her hands in anguish at the right. Rogier's

emotionalism links the Gothic past with the fifteenth-century humanistic concern for individual expressions of emotion. Although united by their sorrow, the mourning figures react in personal ways.

Rogier's choice of color and pattern balances and enhances his composition. For example, the complexity of the gold brocade worn by Joseph of Arimathea, who offered his new tomb for the burial, and the contorted pose and vivid dress of Mary Magdalen increase the visual impact of the

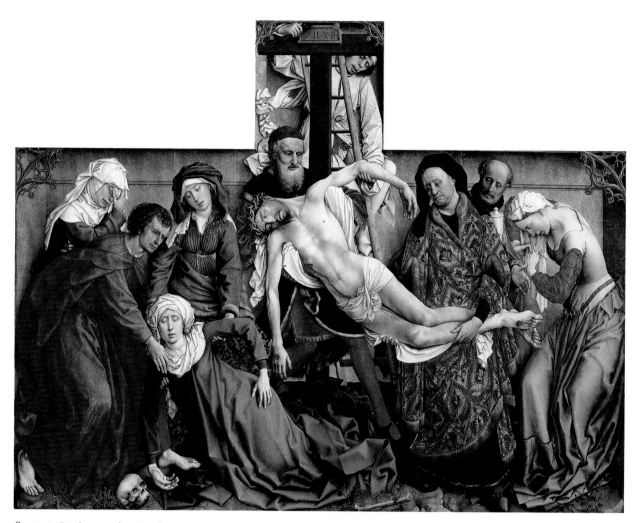

18–14 Rogier van der Weyden DEPOSITION
From an altarpiece commissioned by the Crossbowmen's Guild, Louvain, Belgium. Before 1443, possibly c. 1435–38. Oil on wood panel, 7′2⅝″ × 8′7⅛″ (2.2 × 2.62 m). Museo del Prado, Madrid.

right side of the panel and counter the pictorial weight of the larger number of figures at the left. The palette of subtle, slightly muted colors is sparked with red and white accents that focus the viewer's attention on the main subject. The whites of the winding cloth and the tunic of the youth on the ladder set off Jesus's pale body, as the white turban and shawl emphasize the ashen face of Mary.

Rogier painted his largest and most elaborate work, the altarpiece of the **LAST JUDGMENT**, for the hospital in Beaune, founded by the chancellor of the Duke of Burgundy, Nico-las Rolin (FIGS. 18–15, 18–16). Whether Rogier painted this altarpiece before or after he made a trip to Rome for the Jubilee of 1450 is debated by scholars. He would have known the iconography of the Last Judgment from medieval church tympana, but he could also have been inspired by the paintings and mosaics of the theme in Rome. The tall, straight figure of the archangel Michael, dressed in a white robe and cope, dominates the center of

the wide polyptych as he weighs souls under the direct order of God, who sits on the arc of a giant rainbow above him. The Virgin Mary and John the Baptist kneel at either end of the rainbow. Behind them on each side, six apostles and a host of saints (men at the right side of Christ and women at the left) witness the scene. The cloudy gold back-ground serves, as it did in medieval art, to signify events in the heavenly realm or in a time remote from that of the viewer.

The bodily resurrection takes place on a narrow, barren strip of earth that runs across the bottom of all but the outer panels. Men and women climb out of their tombs, turning in different directions as they react to the call to Judgment. The scales of justice held by Michael tip in an unexpected direc-tion; instead of Good outweighing Bad, the saved soul has become pure spirit and rises, while the damned soul sinks, weighed down by unrepented sins. The damned throw them-selves into the flaming pit of hell—no demons drag them

down; the saved greet the archangel Gabriel at the shining gate of heaven, depicted as a Gothic portal.

When the altarpiece's shutters are closed, they show Rogier's debt to Jan and the *Ghent Altarpiece*. The donors, Nicolas Rolin and Guigone de Salins, kneel in prayer before sculptures of the patron saints of the hospital chapel, Saint Sebastian and Saint Anthony. On the upper level the angel Gabriel greets the Virgin Mary, in yet another version of the Annunciation. The high status of the donors is indicated by their coats of arms and the gold brocade on the walls of their room. In contrast, the central images of Mary, Gabriel, and the two saints are represented in *grisaille* as unpainted stone sculpture set in shallow niches. As on the wings of the *Ghent Altarpiece*, the contrast of living and carved figures is dramatic and interactive. The popularity of *grisaille* in fifteenth-century northern panel painting goes back to Giotto's use of frescoed *grisaille* figures on the fictive marble base of the Arena Chapel (SEE FIG. 17–8), and is at odds with the actual fifteenth-century practice of adding polychromy to stone sculpture before it left the workshop. For Rogier (as for Jan van Eyck), perhaps leaving the stone "unfinished" was more effective and illusionary than depicting painted sculpture.

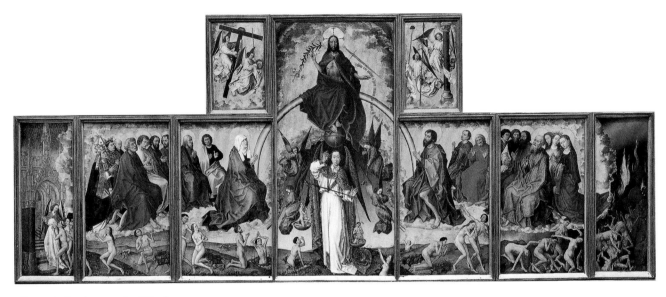

18–15 | Rogier van der Weyden
LAST JUDGMENT ALTARPIECE (OPEN)
After 1443, c. 1445-48. Oil on wood panel, open: 7′4⅝″ × 17′11″ (2.25 × 5.46 m).
Musée de l'Hôtel-Dieu, Beaune, France.

18–16 | Rogier van der Weyden
LAST JUDGMENT ALTARPIECE (CLOSED)
Oil on panel, height 7′4⅝″ (2.28 m). Donors: Nicolas Rolin and
Guigone de Salins.

18–17 | Rogier van der Weyden **PORTRAIT OF A LADY**
c. 1455. Oil and tempera on wood panel, 14¹⁄₁₆ × 10⅝"
(37 × 27 cm). National Gallery of Art, Washington, D.C.
Andrew W. Mellon Collection (1937.1.44)

In his portraits, Rogier balanced a Flemish love of indi-
vidual detail with a flattering idealization of the features of
men and women. In **PORTRAIT OF A LADY** (FIG. 18–17), painted
after his return from Italy, Rogier transformed the young
woman into a vision of exquisite but remote beauty. Her long,
almond-shape eyes, regular features, and smooth translucent
skin appear in many portraits of women attributed to Rogier.
He popularized the half-length pose that includes the
woman's high waistline and clasped hands. Images of the Vir-
gin and Child often formed diptychs with small portraits of
this type. The woman is pious and humble, wealthy but proper
and modest; nevertheless, her tense fingers convey a sense of
inner controlled emotion. The portrait expresses the complex
and often contradictory attitudes of both aristocratic and
middle-class patrons of the arts, who balanced pride in their
achievements with appropriate modesty.

Painting at Midcentury: The Second Generation

The extraordinary accomplishments of Robert Campin, Jan
van Eyck, and Rogier van der Weyden attracted many fol-
lowers in Flanders. The work of this second generation of
Flemish painters was simpler, more direct, and easier to
understand than that of their predecessors. These artists pro-
duced high-quality work of great emotional power, and they
were in large part responsible for the rapid spread of the
Flemish style throughout Europe.

PETRUS CHRISTUS. Among the most interesting of the
second-generation painters was Petrus Christus (active
1444–c. 1475/76). He came from Holland, but nothing is
known of his life before 1444, when he became a citizen of
Bruges. He signed and dated six paintings.

In 1449 Christus painted a goldsmith, perhaps Saint
Eligius, in his shop (FIG. 18–18). According to Christian tra-
dition, Eligius, a seventh-century ecclesiastic, goldsmith, and
mintmaster for the French court, used his wealth to ransom
Christian captives. He became the patron saint of metalwork-
ers. Here he weighs a jeweled ring, as a handsome couple
looks on. The man wears a badge identifying him as a mem-
ber of the court of the duke of Gelders; the young woman,
dressed in Italian gold brocade, wears a jeweled double-
horned headdress fashionable at midcentury (worn by
Christine de Pisan and the ladies of the queen of France;
see Fig. 21, Introduction).

The counter and shelves hold a wide range of metalwork
and jewelry. The coins are Burgundian gold ducats and gold
"angels" of Henry VI of England (ruled 1422–61, 1470–71),
and on the bottom shelf are a box of rings, two bags with
precious stones, and pearls. Behind them stands a crystal reli-
quary with a gold dome and a ruby and amethyst pelican.
Many of the objects on the shelves had a protective func-
tion—for example, the red coral and the serpents' tongues
(actually fossilized sharks' teeth) hanging above the coral
could ward off the evil eye, and the coconut cup at the left
neutralized poison. Slabs of porphyry and rock crystal were
"touchstones," used to test gold and precious stones, such as
the pendant and two brooches of gold with pearls and pre-
cious stones pinned to a dark fabric. Rosary beads and a belt
end hang from the top shelf, where two silver flagons and a
covered cup stand. A bridal belt, similar to the one worn in
Rogier's *Portrait of a Lady*, curls across the counter. Such a
combination of pieces suggests that the painting expresses the
hope for health and well-being for the couple whose
betrothal or wedding portrait this may be. Or perhaps the
painting simply advertises the guild's wares.

As in Jan's *Giovanni Arnolfini and his wife Giovanna
Cenami*, a convex mirror extends the viewer's field of vision,
in this instance to the street outside, where two men appear.
One is stylishly dressed in red and black, and the other holds
a falcon, another indication of high status since only the
nobility hunted with falcons. Whether or not the reflected
image has symbolic meaning, the mirror has a practical value
in allowing the goldsmith to observe the approach of a
potential customer.

DIRCK BOUTS. Dirck Bouts (active c. 1444–75) is the best storyteller among the Flemish painters, skillful in direct narration rather than complex symbolism. The two remaining panels (FIG. 18–19) from a set of four on the subject of justice illustrate this skill. The town council of Louvain, for whom Bouts was the official painter, ordered these huge paintings for the city hall to be examples and warnings to city officials. The paintings depict an early moral tale, the **WRONGFUL EXECUTION OF THE COUNT**. The empress, seen standing with Emperor Otto III in her palace garden, falsely accuses a count of a sexual impropriety. Otto III has the count beheaded and the countess receives her husband's head, in the presence of the councilors. In the second panel, the countess successfully endures a trial by ordeal to prove her husband's innocence. Unscathed and still holding her husband's head, she lifts up a glowing iron bar before the shocked and repentant emperor. In the far distance, justice is done and the evil empress is executed by burning at the stake.

Dirck Bouts's paintings are notable for his use of spacious outdoor settings and his inclusion of contemporary portraits.

He is the first to create an illusion of space that recedes continuously and gradually from the picture plane to the far horizon. To achieve this effect, he employed devices such as walkways, walls, and winding roads along which characters in the scene are placed. His use of atmospheric perspective can be seen in the gradual lightening of the sky and the smoky blue hills at the horizon. Bouts is also credited with inventing

18–18 | Petrus Christus
A GOLDSMITH (SAINT ELIGIUS?) IN HIS SHOP 1449. Oil on oak panel, 38⅜ × 33½" (98 × 85 cm). The Metropolitan Museum of Art, New York.
Robert Lehman Collection, 1975. (1975.1.110)

The artist signed and dated his work on the house reflected in the mirror.

18–19 │ Dirck Bouts **WRONGFUL EXECUTION OF THE COUNT (LEFT), JUSTICE OF OTTO III (RIGHT)**
1470–75. Oil on wood panel, each 12'11" × 6'7½" (3.9 × 2 m). Musées Royaux des Beaux-Arts de Belgique,
Brussels, Belgium-Koninklijke Musea voor Schone Kunsten van Belgie, Brussels.

the official group portrait in which living individuals are
integrated into a narrative scene along with fictional or reli-
gious characters. In the Louvain justice panels, the men
observing the execution may have been members of the
town council. Their impassive faces are realistic but their fig-
ures are impossibly tall and slender.

HUGO VAN DER GOES. Hugo van der Goes (c. 1440–82), dean
of the painters guild in Ghent (1468–75), united the intellec-
tual prowess of Jan van Eyck and the emotional sensitivity of
Rogier van der Weyden. Hugo's major work was a large altar-
piece of the Nativity (FIG. 18–20). The altarpiece was com-
missioned by Tommaso Portinari, head of the Medici bank in
Bruges. Painted probably between 1474 and 1476, the triptych
was sent to Florence and installed in 1483 in the Portinari fam-

ily chapel in the Church of Sant'Egidio. It had a noticeable
impact on Florentine painters such as Ghirlandaio, whose own
altarpiece in the Sassetti Chapel in the Church of Santa Trinita
(SEE FIG. 19–35) reflects his study of Hugo's painting. Tommaso,
his wife Maria Baroncelli, and their three oldest children are
portrayed kneeling in prayer on the wings. On the left wing,
looming larger than life behind Tommaso and his son Antonio,
are the saints for whom they are named, Saint Thomas and
Saint Anthony. The younger son, Pigello, born in 1474, was
apparently added after the original composition was set. On
the right wing, Maria and her daughter Margherita are pre-
sented by the saints Mary Magdalen and Margaret.

The theme of the altarpiece is the Nativity as told
by Luke (2:10–19). The central panel represents the Adoration
of the newborn Christ Child by Mary and Joseph, a host of

angels, and the shepherds who have rushed in from the fields. In the middle ground of the wings are scenes invented by Hugo, a part of his personal vision. Winding their way through the winter landscape are two groups headed for Bethlehem. On the left wing, Mary and Joseph travel to their native city to take part in a census ordered by the region's Roman ruler, King Herod. Near term in her pregnancy, Mary has dismounted from her donkey and staggers, supported by Joseph. On the right wing, a servant of the three Magi, who are coming to honor the awaited Savior, asks directions from a peasant. The continuous landscape across the wings and central panel is the finest evocation of cold, barren winter since the Limbourg brothers' *February* (SEE FIG. 18–6).

Hugo's technique is firmly grounded in the terrestrial world despite the visionary subjects. Meadows and woods are painted meticulously. Like Bouts (SEE FIG. 18–19) and many other northern artists at this time, he used atmospheric perspective to approximate distance in the landscape. Although Hugo's brilliant palette and meticulous accuracy recall Jan van Eyck, and although the intense but controlled emotions he depicts suggest the emotional content of Rogier van der Weyden's works, the composition and interpretation of the altarpiece are entirely his own. He shifts figure size for emphasis: The huge figures of Joseph, Mary, and the shepherds are the same size as the patron saints on the wings, in contrast to the much smaller *Portinari* family and still smaller angels. Hugo also uses color, as well as the gestures and gazes of the figures, to focus our eyes on the center panel where the mystery of

the Incarnation takes place. Instead of lying swaddled in a manger or in his mother's arms, Jesus rests naked and vulnerable on the barren ground. Rays of light emanate from his body. The source of this image was the visionary writing of the Swedish mystic Saint Bridget (who composed her work c. 1360–70), which describes Mary kneeling to adore the Christ Child immediately after giving birth.

Hugo was also a master of disguised symbolism (FIG. 18–21). In the foreground the ceramic pharmacy jar (*albarello*), glass, flowers, and wheat have multiple meanings. The wheat sheaf refers both to the location of the event at Bethlehem, which in Hebrew means "house of bread," and to the Host, or bread, at Communion, which represents the Body of Christ. The majolica *albarello* is decorated with vines and grapes, alluding to the wine of Communion at the Eucharist, which represents the Blood of Christ. It holds a red lily for the Blood of Christ and three irises—white for purity and purple for Christ's royal ancestry. Every little flower has a meaning. The three irises may refer to the Trinity of Father (God), Son (Jesus), and Holy Ghost. The iris, or "little sword," also refers to Simeon's prophetic words to Mary at the Presentation in the Temple: "And you yourself a sword will pierce so that the thoughts of many hearts may be revealed" (Luke 2:35). The glass vessel symbolizes Mary and the entry of the Christ Child into the Virgin's womb, the way light passes through glass without breaking it. The seven blue columbines in the glass remind the viewer of the Virgin's future sorrows, and scattered on the ground are violets, symbolizing humility.

18–20 | Hugo van der Goes **PORTINARI ALTARPIECE (OPEN)**
c. 1474–76. Tempera and oil on wood panel; center 8′3½″ × 10′ (2.53 × 3.01 m),
wings each 8′3½″ × 4′7½″ (2.53 × 1.41 m). Galleria degli Uffizi, Florence.

THE **O**BJECT SPEAKS

HANS MEMLING'S SAINT URSULA RELIQUARY

Among the works securely assigned to Memling is the reliquary of Saint Ursula, a container in the form of a Gothic chapel, made in 1489 for the Hospital of Saint John in Bruges. According to legend, Ursula, the daughter of the Christian king of Brittany, was betrothed to a pagan English prince. She requested a three-year delay in the marriage to travel to Rome, during which time her husband-to-be was to convert to Christianity. On the trip home, she stopped in Cologne, which had been taken over by Attila the Hun and his nomadic warriors from Central Asia. When Ursula rejected an offer of marriage, they killed her with an arrow through the heart and also murdered her companions. The story of Ursula is told on the six side panels of the reliquary. Visible in the illustration are the pope bidding Ursula goodbye in Rome; the murder of her female companions in Cologne har-

bor; and Ursula's own death. On the reliquary's "roof" are roundels with musical angels flanking the Coronation of the Virgin. At the corners are carved saints, and on the end is Saint Ursula in the doorway of the "chapel," sheltering her followers under her mantle. In early stories, Ursula was accompanied on her trip by ten maidens. By the tenth century, however, she had become the leader of 11,000 young virgin martyrs.

Although the events supposedly took place in the fourth century, Memling has set them in contemporary Cologne: the city's Gothic cathedral, under construction (with the huge lifting wheel still visible), looms in the background of the Martyrdom panel. Memling created this deep space as a foil for his idealized female martyr, a calm aristocratic figure amid menacing men-at-arms. The surface pattern and intricately arranged folds of the drapery draw our attention to her.

Saints continued to play a role in the pre-Reformation Church although the need for personal intercessors began to be questioned by reformers. The possession of relics (remains) of the saints was an important source of prestige for a church, and relics attracted offerings from petitioners. The reliquary was commissioned presumably by the two women dressed in the white habits and black hoods worn by hospital sisters and depicted on the end of the reliquary not visible in the illustration. One hypothesis is that they are Jossine van Dudzeele and Anna van den Moortele, two nuns who were administrators of the hospital of Saint John in the fifteenth century. The reliquary of Saint Ursula, for all the beauty and interest of its paintings, is not a gold and jewel bedecked casket but a simple wooden shrine, an appropriate gift from the women who led the community and the hospital they served.

Hans Memling **SAINT URSULA RELIQUARY**
1489. Painted and gilded oak, 34 × 36 × 13″
(86.4 × 91.4 × 33 cm). Memling Museum,
Hospital of Saint John, Bruges, Belgium.

Hans Memling **MARTYRDOM OF SAINT URSULA**
Detail of the *Saint Ursula Reliquary*.
Panel 13¾ × 10″ (35 × 25.3 cm).

18–21 | Hugo van der Goes **DETAIL OF STILL LIFE FROM THE CENTER PANEL OF THE PORTINARI ALTARPIECE**

Hugo's artistic vision goes far beyond this formal religious symbolism. For example, the shepherds, who stand in unaffected awe before the miraculous event, are among the most sympathetically rendered images of common people to be found in the art of any period. The portraits of the children are among the most sensitive studies of children's features.

HANS MEMLING. The artist who summarizes and epitomizes the end of the era in Flanders is Hans Memling (1430/35–94). Memling combines the intellectual depth and virtuoso rendering of his predecessors with a delicacy of feeling and exquisite grace. A German from the nearby Rhineland, Memling may have worked in Rogier van der Weyden's Brussels workshop in the 1460s, since Rogier's style remained the dominant influence on his art. Soon after Rogier's death in 1464, Memling moved to Bruges, where he developed an international clientele. In 1489 he produced the reliquary of Saint Ursula for the Hospital of Saint John (see "Hans Memling's Saint Ursula Reliquary," page 608). It has the form of a basilican church, and instead of gold, silver, and enamels, it is made of painted wood, modest materials in keeping with a commission from the nuns of the hospital.

EUROPE BEYOND FLANDERS

Flemish art—its complex symbolism, its realism and atmospheric space, its brilliant colors and sensuous textures— delighted wealthy patrons and well-educated courtiers both inside and outside of Flanders. At first, Flemish artists worked in foreign courts; later, many artists went to study in Flanders. Flemish manuscripts, tapestries, altarpieces, and portraits appeared in palaces and chapels throughout Europe. Soon local artists learned Flemish oil painting techniques and emulated the Flemish style. By the end of the fifteenth century, distinctive regional variations of Flemish art could be found throughout Europe, from the Atlantic Ocean to the Danube.

France

The centuries-long struggle for power and territory between France and England continued well into the fifteenth century. When King Charles VI of France died in 1422, England claimed the throne for the king's nine-month-old grandson, Henry VI of England. The plight of Charles VII, the late French king's son, inspired Joan of Arc to lead a crusade to return him to the throne. Thanks to Joan's efforts Charles was crowned at Reims in 1429. Although Joan was burned at the stake in 1431, the revitalized French forces drove the English from French lands. In 1461, Louis XI succeeded his father, Charles VII, as king of France. Under his rule the French royal court again became a major source of patronage for the arts.

JEAN FOUQUET. The leading court artist of the period in France, Jean Fouquet (c. 1420–81), was born in Tours and may have trained in Paris as an illuminator. He may have visited Italy in about 1445–47, but by about 1450 he was back in Tours, a renowned painter. Fouquet adapted contemporary Italian classical motifs in architectural decoration, and he was also strongly influenced by Flemish realism. He painted Charles VII, the royal family, and courtiers, and he illustrated manuscripts and designed tombs.

Among the court officials Fouquet painted is Étienne Chevalier, the treasurer of France under Charles VII. Fouquet painted a diptych showing Chevalier praying to the Virgin and Child (FIG. 18–22). According to an inscription, the painting was made to fulfill a vow made by Chevalier to the king's much-loved and respected mistress, Agnès Sorel, who died in 1450. Agnès Sorel, whom contemporaries described as a highly moral, extremely pious woman, was probably the model for the Virgin; her features were taken from her death mask, which is still preserved. Fouquet paints the figures of Virgin and angels as stylized, simplified forms, reducing the color to near-*grisaille,* then surrounds them with amazing jewels in the crown and the throne. The brilliant red and blue cherubs form a tapestrylike background.

In the other wing of the diptych, Fouquet uses a realistic style. Étienne Chevalier, who kneels in prayer with clasped hands and a meditative gaze, is presented to the Virgin by his name saint, Stephen (*Étienne* in French). Fouquet has followed the Flemish manner in depicting the courtier's ruddy features with a mirrorlike accuracy that is confirmed by other known portraits. Saint Stephen's features are also distinctive enough to

18–22 | Jean Fouquet **ÉTIENNE CHEVALIER AND SAINT STEPHEN** Left wing of the Melun Diptych c. 1450.
Oil on wood panel, 36½ × 33½″ (92.7 × 85.5 cm). Staatliche Museen zu Berlin, Preussischer Kulturbesitz, Gemäldegalerie.
VIRGIN AND CHILD Right wing of the Melun Diptych c. 1451. Oil on wood panel,
37¼ × 33½″ (94.5 × 85.5 cm). Koninklijk Museum voor Schone Kunsten, Antwerp, Belgium.

The diptych was separated long ago and the two paintings went to collections in different countries. They are reunited on this page.
The original frame was of blue velvet embroidered with pearls and gold and silver thread.

have been a portrait. According to legend and biblical accounts, Stephen, a deacon in the early Christian Church in Jerusalem, was the first Christian martyr, stoned to death for defending his beliefs. Here the saint wears liturgical, or ritual, vestments and carries a large stone on a closed Gospel book as evidence of his martyrdom. A trickle of blood can be seen on his tonsured head (male members of religious orders shaved their heads as a sign of humility). The two figures are shown in a hall decorated with the kind of marble paneling and classical architectural decoration Fouquet could have seen in Italy. Fouquet arranged the figures in an unusual spatial setting; the diagonal lines of the wall and uptilted tile floor recede toward an unseen vanishing point at the right. Despite his debt to Flemish realism and his nod to Italian architectural forms and to linear perspective (discussed in Chapter 19), Fouquet's austere geometric style is uniquely his own.

THE FLAMBOYANT STYLE. The great age of cathedral building that had begun about 1150 was over by the end of the fourteenth century, but the growing urban population needed houses, city halls, guild halls, and more parish churches. The richest patrons commissioned master masons

to build light-filled spacious halls and sculptors to cover their buildings with elaborate Gothic architectural decoration. Like painters, sculptors also turned to the realistic depiction of nature, and they covered capitals and moldings with ivy, hawthorn leaves, and other vegetation. Called the Flamboyant style (meaning "flaming" in French) because of its repeated, twisted, flamelike tracery, this intricate, elegant decoration was used to cover new buildings and was added to older buildings being modernized with spires, porches, or window tracery. The forms often recall the earlier English Decorated style (see Chapter 17).

The **CHURCH OF SAINT-MACLOU** in Rouen, which was begun after a fund-raising campaign in 1432 and dedicated in 1521, is an outstanding example of the Flamboyant style (FIG. 18–23). It may have been designed by the Paris architect Pierre Robin. A projecting porch bends to enfold the façade of the church in a screen of tracery. Sunlight on the flame-shaped openings casts ever-changing shadows across the intentionally complex surface. Crockets—small, knobby leaflike ornaments that line the steep gables and slender buttresses—break every defining line. In the Flamboyant style, decoration sometimes seems divorced from structure. The strength of load-bearing

18–23 Pierre Robin (?)
CHURCH OF SAINT-MACLOU, ROUEN
Normandy, France. West façade, 1432–1521; façade
c. 1500–14.

walls and buttresses is often disguised by an overlay of tracery;
and traceried pinnacles, gables, and S-curve moldings combine
with a profusion of ornament in geometric and natural shapes,
all to dizzying effect. The interior of such a church, filled with
light from huge windows, can be seen in the *Book of Hours of
Mary of Burgundy* (SEE FIG. 18–7).

The **HOUSE OF JACQUES COEUR,** the fabulously wealthy
merchant in Bourges, reflects the popularity of the Flamboy-
ant style for secular architecture (**FIG. 18–24**). Built at great
expense between 1443 and 1451, it survives almost intact,
although it has been stripped of its rich furnishings. The ram-
bling, palatial house is built around an irregular open court-
yard, with spiral stairs in octagonal towers giving access to the
rooms. Tympana over doors indicate the function of the
rooms within; for example, over the door to the kitchen a
cook stirs the contents of a large bowl. Flamboyant decora-
tion enriches the cornices, balustrades, windows, and gables.

Sequencing Events

1416	Death of Jean, Duke of Berry
1431	Joan of Arc burned at the stake in Rouen
1455	Gutenberg prints the Bible
1453	Hundred Years' War ends
1492	Columbus reaches the West Indies and North America

Among the carved decorations are puns on the patron's sur-
name, *Coeur* (meaning "heart" in French). The house was also
Jacques Coeur's place of business, so it had large storerooms
for goods and a strong room for treasure. (A well-stocked but
lesser merchant's shop can be seen in the painting of Petrus
Christus, *A Goldsmith in His Shop*; SEE FIG. 18–18.)

Spain and Portugal

Many Flemish and French artists traveled to Spain and Por-
tugal, where they were held in high esteem. Queen Isabella
of Castile, for example, assembled a large collection of
Flemish paintings and illuminated manuscripts as well as a
collection of tapestries, jewels, and gold- and silversmith's
work. She was also a patron of architecture. In Toledo,

18–24 **HOUSE OF JACQUES COEUR**
Bourges. France. Interior courtyard, 1443–51.

18–25 | Juan Güas **SAN JUAN DE LOS REYES**
Interior, wall with carved coats-of-arms and saints. Toledo, Spain. Begun 1477.

18–26 | Juan Güas **PLAN OF SAN JUAN DE LOS REYES**
Begun 1477.

Isabella built a church for the Franciscans, which she intended to be the royal burial chapel.

SAN JUAN DE LOS REYES. Founded in 1477, **SAN JUAN DE LOS REYES** (Saint John of the Kings) was never used as intended, since the conquest of Granada in 1492 permitted Ferdinand and Isabella to build their pantheon in the former Moorish capital rather than in Toledo. Nevertheless, the church in Toledo established a new church type known as "Isabellan" (FIGS. 18–25, 18–26). The church had a single nave flanked by lateral chapels built between the wall buttresses, a raised choir over the western entrance (Spanish churches usually had the choir in the nave), and raised pulpits at the crossing. The transept did not extend beyond the line of the buttresses and chapels. A low lantern tower over the crossing focused the light on the space reserved for the tombs, which were never built. This simple compact design allowed ample space for the congregation, and the expanses of wall could be used for educational paintings, sculptures, or tapestries.

Lavish sculptural decoration at San Juan de los Reyes honored Ferdinand and Isabella. Heraldry—an art form in itself—became a major decorative feature in the fifteenth century. Huge shields with the royal coat of arms (chains and bars for King Ferdinand's Aragon and Catalunya and lions and castles for Queen Isabella's Leon and Castile) are held by the gigantic eagles of Saint John. They are flanked by saints standing on pedestals under flamboyant canopies. On moldings and piers the artists, led by Juan Güas, carved plants, insects, and animals as avidly and accurately as painters of manuscripts. Friezes with inscriptions mimic Moorish architectural inscriptions, and the luxurious surface decoration may also reflect the Moorish taste with which the Christians were well informed.

Isabellan art has a special relevance for the Americas. In 1492, when Isabella and Ferdinand entered the Moorish capital city of Granada in triumph, Spanish ships reached the Americas. Soon missionaries were sent to the New World, where they built churches in the Isabellan style, using local materials and workmen. The Mission style of California and the American Southwest (SEE FIG. 29–46) is a simplified version of the Isabellan style of San Juan de los Reyes.

NUÑO GONÇALVES. Local painters and sculptors quickly absorbed the Flemish style. They could have had firsthand experience, since Jan van Eyck, among others, visited Spain and Portugal. Jan was sent by the Duke of Burgundy to paint the portrait of a Portuguese princess who was a candidate for marriage to the duke. A little later Nuño Gonçalves (active 1450–71) painted the members of the Portuguese royal family. Gonçalves reflects Jan's influence in his monumental figures and intense interest in surfaces and rich colors, although the severity of the portraits recalls Dirck Bouts. Perhaps as early as 1465–67, Gonçalves painted a large multipanel altar-

piece for the Convent of Saint Vincent de Fora in Lisbon (FIG. 18–27). The paintings are filled with remarkable portraits of people from all walks of life—the royal family, Cistercians, businessmen, fishermen—most of whom are identifiable. The central panel with the royal family holds a special interest for Americans. Here the painter has included a portrait of Prince Henry the Navigator, the man who inspired and financed Portuguese exploration. Prince Henry sent ships down the west coast of Africa and out into the Atlantic, but he died before Columbus's ships reached the Americas. Dressed in black, he kneels behind his nephew, King Alfonso V.

Saint Vincent, magnificent in red and gold vestments, stands in a tightly packed group of people, with members of the royal family at the front and courtiers forming a solid block across the rear. With the exception of the idealized features of the saint, all are portraits: At the right, King Alfonso V kneels before Saint Vincent, while his young son and his deceased uncle, Henry the Navigator, look on. Alfonso and his son rest their hands on their swords; Henry's hands are tented in prayer. At the left, Alfonso's deceased wife and mother hold rosaries. The appearance of Saint Vincent is clearly a vision, brought on by the intense prayers of the individuals around him.

Germany and Switzerland

Present-day Germany and Switzerland were situated within the Holy Roman Empire, a loose confederation of primarily German-speaking states. Industries, especially metalworking, developed in the Rhine Valley and elsewhere, and the artisan guilds grew powerful. Trade flourished under the auspices of the Hanseatic League, an association of cities and trading outposts, and both trade and manufacture were stimulated by the financial acumen of the rising merchant class. The Fugger family began their spectacular rise from simple textile workers and linen merchants to bankers for the Habsburgs and the popes. The Holy Roman Emperor and the pope continued their disputes, although a church council, held in Constance (1414–18), temporarily settled some of the problems of church-state relations. These problems would resurface, however, and lead to the Protestant Reformation in the next century.

Germanic artists worked in two very different styles. Some, working around Cologne, continued the International Gothic style with increased prettiness, softness, and sweetness of expression. The "Beautiful Style" of the fourteenth century continued, especially in the Rhineland, where artists perfected a soft, lyrical style. Other artists began an intense investigation and detailed description of the physical world. The major exponent of the latter style was Konrad Witz (active 1434–46). Witz, a native of Swabia in southern Germany, moved to Basel (in present-day Switzerland), where he found a rich source of patronage in the Church.

18–27 | Nuño Gonçalves **SAINT VINCENT WITH THE PORTUGUESE ROYAL FAMILY**
Panel from the *Altarpiece of Saint Vincent*. c. 1465–67.
Oil on wood panel, 6′9¾″ × 4′ 2⅜″ (2.07 × 1.28 m).
Museu Nacional de Arte Antiga, Lisbon.

Witz's last large commission before his early death in 1446 was an altarpiece dedicated to Saint Peter for the Cathedral of Saint Peter in Geneva. Witz signed and dated his work in 1444. In the **MIRACULOUS DRAFT OF FISHES** (FIG. 18–28), a scene from the altarpiece which depicts Jesus's calling of the fishermen Peter and Andrew, Witz painted Lake Geneva, not Galilee. He has gone beyond the generic realism of the Flemings to paint a realistic portrait of a specific landscape: the dark mountain (the Mole) rising on the far shore of Lake Geneva and the snow-covered Alps shining in the distance. Witz records every nuance of light and water—the rippling surface, the reflections of boats, figures, and buildings, even the lake bottom. Peter's body and legs, visible through the water, are distorted by the refraction. The floating clouds above create shifting light and dark passages over the water. Perhaps for the first time in European art, the artist captures both the appearance and spirit of nature.

18–28 | Konrad Witz **MIRACULOUS DRAFT OF FISHES**
From an altarpiece from the Cathedral of Saint Peter, Geneva,
Switzerland. 1444. Oil on wood panel, 4′3″ × 5′1″
(1.29 × 1.55 m). Musée d'Art et d'Histoire, Geneva.

18–29 | **THE BUXHEIM SAINT CHRISTOPHER**
1423. Hand-colored woodcut, 11⅜ × 8⅛″ (28.85 × 20.7 cm).
Courtesy of the Director and Librarian, the John Rylands University Library, the
University of Manchester, England.

The Latin verse reads, "Whenever you look at the face of Christo-
pher, in truth, you will not die a terrible death that day." "1423"

THE GRAPHIC ARTS

Printmaking emerged in Europe at the end of the four-
teenth century with the development of printing presses
and the increased local manufacture and wider availability
of paper. The techniques used by printmakers during the
fifteenth century were woodcut and engraving (see "Wood-
cuts and Engravings on Metal," page 614). Woodblocks cut
in relief had long been used to print designs on cloth, but
only in the fifteenth century did the printing of images and
texts on paper and the production of books in multiple
copies of a single edition, or version, begin to replace the
copying of each book by hand. Both handwritten and
printed books were often illustrated, and printed images
were sometimes hand colored.

Single Sheets

Single-sheet prints in the woodcut and engraving techniques
were made in large quantities in the early decades of the fif-
teenth century. Initially, woodcuts were made primarily by
woodworkers with no training in drawing, but soon artists
began to draw the images for them to cut from the block.

THE BUXHEIM SAINT CHRISTOPHER. Devotional images
were sold as souvenirs to pilgrims at holy sites. The **BUXHEIM
SAINT CHRISTOPHER** was found in the Carthusian Monastery
of Buxheim, in southern Germany, glued to the inside of the
back cover of a manuscript (FIG. 18–29). Saint Christopher,
patron saint of travelers, carries the Christ Child across the
river. His efforts are witnessed by a monk holding out a light
to guide him to the monastery door, but ignored by the
hardworking millers on the opposite bank. Both the cutting
of the block and the quality of the printing are very high.
The artist and cutter vary the width of the lines to
strengthen major forms. Delicate lines are used for inner
modeling (facial features) and short parallel lines to indicate
shadows (the inner side of draperies). Since the date 1423 is
cut into the block, the print was thought to be among the
earliest to survive. Recent studies have determined that the
date refers to some event and the print was made at
midcentury.

MARTIN SCHONGAUER. Engraving may have originated with
goldsmiths and armorers, who recorded their work by rubbing
lampblack into the engraved lines and pressing paper over the
plate. German artist Martin Schongauer (c. 1435–91), who
learned engraving from his goldsmith father, was an immensely
skillful printmaker who excelled both in drawing and in the
difficult technique of shading from deep blacks to faintest grays
using only line. He was also a skilled painter. In **DEMONS TOR-
MENTING SAINT ANTHONY,** engraved about 1470–75
(FIG. 18–30), Schongauer illustrated the original biblical
meaning of temptation as a physical assault rather than a
subtle inducement. Wildly acrobatic, slithery, spiky demons lift

Technique
WOODCUTS AND ENGRAVINGS ON METAL

Woodcuts are made by drawing on the smooth surface of a block of fine-grained wood, then cutting away all the areas around the lines with a sharp tool called a *gouge*, leaving the lines in high relief. When the block's surface is inked and a piece of paper pressed down hard on it, the ink on the relief areas transfers to the paper to create a reverse image. The effects can be varied by making thicker and thinner lines, and shading can be achieved by placing the lines closer or farther apart. Sometimes the resulting black-and-white images were then painted by hand.

Engraving on metal requires a technique called *intaglio*, in which the lines are cut into the plate with tools called *gravers* or *burins*. The engraver then carefully burnishes the plate to ensure a clean, sharp image. Ink is applied over the whole plate and forced down into the lines, then the plate's surface is carefully wiped clean of the excess ink. When paper and plate are held tightly together by a press, the ink in the lines transfers to the paper.

Woodblocks and metal plates could be used repeatedly to make nearly identical images. If the lines of the block or plate wore down, the artists could repair them. Printing large numbers of identical prints of a single version, called an *edition*, was usually a team effort in a busy workshop. One artist would make the drawing. Sometimes it was drawn directly on the block or plate with ink, in reverse of its printed direction, sometimes on paper to be transferred in reverse onto the plate or block by another person, who then cut the lines. Others would ink and print the images.

In the illustration of books, the plates or blocks would be reused to print later editions and even adapted for use in other books. A set of blocks or plates for illustrations was a valuable commodity and might be sold by one workshop to another. Early in publishing, there were no copyright laws, and many entrepreneurs simply had their workers copy book illustrations onto woodblocks and cut them for their own publications.

Anthony up off the ground to torment and terrify him in midair. The engraver intensified the horror of the moment by condensing the action into a swirling vortex of figures beating, scratching, poking, tugging, and no doubt shrieking at the stoical saint, who remains impervious to all by reason of his faith.

Printed Books

The explosion of learning in Europe in the fifteenth century encouraged experiments in faster and cheaper ways of producing books than by hand-copying them. The earliest printed books were block books, for which each page of text, with or without illustrations, was cut in relief on a single block of wood. Movable-type printing, in which individual letters could be arranged and locked together, inked, and then printed onto paper, was first achieved in the workshop of Johann Gutenberg in Mainz, Germany. More than forty copies of Gutenberg's Bible, printed around 1455, still exist. As early as 1465, two German printers were working in Italy, and by the 1470s there were presses in France, Flanders, Holland, and Spain. With the invention of this fast way to make a number of identical books, the intellectual and spiritual life of Europe—and with it the arts—changed forever.

WILLIAM CAXTON. England got its first printing press as the result of a second career launched by a former English cloth merchant, William Caxton (active c. 1441–91). Caxton had lived for thirty years in Bruges, where he came in contact with the humanist community as well as with local printing ventures. In 1476 Caxton moved back to London, where he

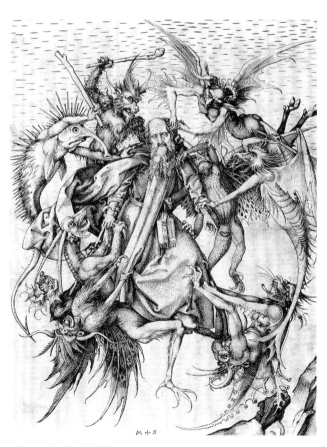

18–30 | Martin Schongauer
DEMONS TORMENTING SAINT ANTHONY
c. 1480–90. Engraving, 12¼ × 9″ (31.1 × 22.9 cm).
The Metropolitan Museum of Art, New York.
Rogers Fund, 1920 (20.5.2)

18–31 | PAGE WITH PILGRIMS AT TABLE, PROLOGUE TO CANTERBURY TALES

By Geoffrey Chaucer, published by William Caxton, London, 1484 (second edition, the first with illustrations). Woodcut, 4¹/₁₆ × 4⅞″ (10.2 × 12 cm). The Pierpont Morgan Library, New York.

PML 693.

established the first English publishing house. He printed eighty books in the next fourteen years, including works by the fourteenth-century author Geoffrey Chaucer (see "A New Spirit in Fourteenth–Century Literature," page 561).

In the second edition of Chaucer's *Canterbury Tales*, published in 1484, Caxton added woodblock illustrations by an unknown artist (FIG. 18–31). The assembled pilgrims journeying to the shrine of Saint Thomas à Becket are seated around a table. Included in the group of storytellers is an engaging woman, Alice, the Wife of Bath. Some critics see the Wife of Bath as an example of a woman who good women should avoid, but Chaucer put words in the lively

Alice's mouth that are well understood by many women today. Simple woodcut illustrations such as this are typical of the popular art of the time.

New techniques for printing illustrated books in Europe at the end of the fifteenth century held great promise for the spread of knowledge and ideas in the following century.

IN PERSPECTIVE

The fifteenth century marks the end of the Middle Ages and the beginning of the modern world, our own era. The period has been called the Renaissance, for some people saw it as a period of "rebirth," but in fact Western Europeans built on the accomplishments of the twelfth century—a renaissance in its own right—and on the achievements of the thirteenth and fourteenth centuries. By the fifteenth century thoughtful people focused their attention on human beings and their accomplishments, on life in this world as well as the next. They held a sense of human history, including a new respect for ancient learning.

The fifteenth century saw the growth of a secular spirit, related to the growth of towns into cities where the stimulating hurly-burly of urban life encouraged verbal and intellectual exchange. Whereas towns had once revolved around a court or cathedral, the new cities were industrial and commercial centers. Business joined religion and politics as a powerful motivating force. While the church continued to be a major patron of the arts and architecture, new sources of patronage emerged in the cities.

Architects followed the basic Gothic principles and methods of construction, but they added increasingly elaborate carved decoration that turned solid stone into lacy confections. Sculpture was freed from architecture, and freestanding figures gave the impression of life, vitality, and even possibility of movement. This realism extended into all the arts. Painters and tapestry makers, like writers and sculptors, included images from daily life.

By the middle of the century, a new medium—the graphic arts—came into being. The rapid dissemination of information both in words and pictures now available through the printing press allowed people to read—and see—for themselves. The new empirical frame of mind that characterized the fifteenth century gave rise in the sixteenth century to an explosion of inquiry and new ways of looking at the world.

SLUTER.
WELL OF MOSES,
THE CHARTREUSE DE CHAMPMOL, DIJON
1395–1406

CAMPIN.
MÉRODE ALTARPIECE
C. 1425–28

HOUSE OF JACQUES COEUR
BOURGES
1443–51

ROGIER VAN DER WEYDEN.
PORTRAIT OF A LADY
C. 1455

MARTIN SCHONGAUER
DEMONS TORMENTING SAINT ANTONY
C. 1480–90

HUNT OF THE UNICORN
TAPESTRY SERIES
C. 1495–1505

1400

1420

1440

1460

1480

1500

FIFTEENTH-CENTURY ART IN NORTHERN EUROPE AND THE IBERIAN PENINSULA

◄ **Great (Western) Schism Ends** 1417

◄ **Duke Philip The Good of Burgundy Founds The Order of the Golden Fleece** 1430

◄ **Habsburgs Begin Rule of Holy Roman Empire** 1452
◄ **Hundred Year's War Ends** 1453
◄ **Gutenberg Prints** *Bible* 1455

◄ **William Caxton Establishes First English Publishing House** 1476

◄ **Columbus Reaches the West Indies** 1492

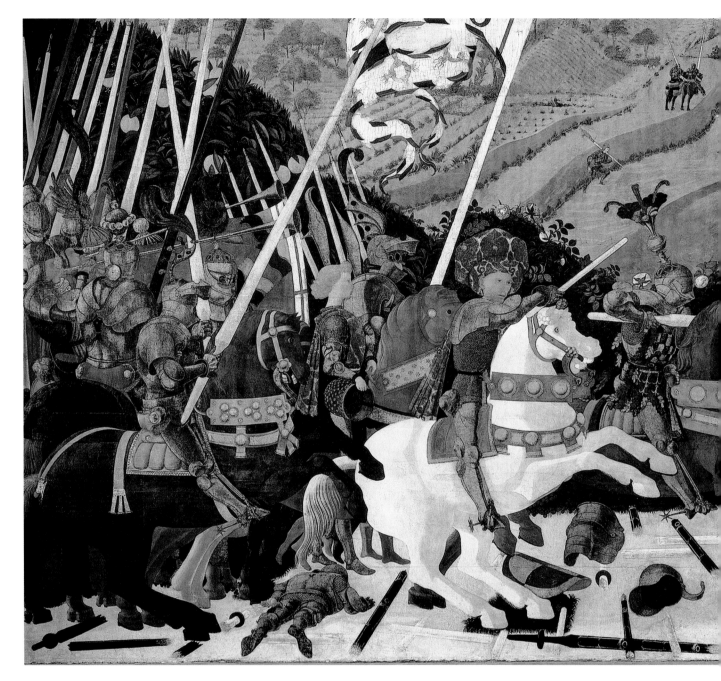

19–1 | Paolo Uccello **THE BATTLE OF SAN ROMANO** 1438–40. Tempera on wood panel, approx. 6′ × 10′ 7″ (1.83 × 3.23 m). National Gallery, London.

RENAISSANCE ART IN FIFTEENTH-CENTURY ITALY

The ferocious but bloodless battle we see in FIGURE 19–1 could take place only in our dreams. Under an elegantly fluttering banner, the Florentine general Niccolò da Tolentino leads his men against the Sienese at the Battle of San Romano, which took place on June 1, 1432. In the center foreground, Niccolò holds aloft a baton of command, the sign of his authority. His bold gesture, together with his white horse and fashionable crimson and gold damask hat, ensure that he dominates the scene. The general's knights charge into the fray, and when they fall, like the soldier at the lower left, they join the many broken lances on the ground—all arranged in conformity with the new mathematical depiction of space, **one-point (linear) perspective.**

The battle rages across a shallow stage defined by the debris of warfare arranged in a neat pattern on a pink ground and backed by a hedge of blooming orange trees and rosebushes. In the cultivated hills beyond, crossbowmen prepare their lethal bolts. A Florentine painter nicknamed Paolo Uccello ("Paul Bird"), whose given name was Paolo di Dono (c. 1397–1475), created this panel painting, housed today in London's National Gallery. It is one of three panels now separated; the other two are hanging in major museums in Florence and Paris.

The complete history of these paintings has only recently come to light. Lionardo Bartolini Salimbeni (1404–79), who led the Florentine city government during the war against Lucca and Siena, probably commissioned the paintings. Uccello's remarkable accuracy when depicting armor from the 1430s, heraldic banners, and even fashionable fabrics and crests surely would have appealed to civic pride.

The hedges of oranges, roses, and pomegranates—all ancient fertility symbols—make a tapestry-like background for the action. Lionardo and his wife Maddalena had six sons, two of whom inherited the paintings. According to a complaint brought by one of the heirs, Damiano, Lorenzo de' Medici, the powerful de facto ruler of Florence, "forcibly removed" the paintings from Damiano's house. The paintings were never returned, and Uccello's masterpieces are recorded in a 1492 inventory as hanging in Lorenzo's private chamber in the Medici palace. Perhaps Lorenzo, who was called "the Magnificent," saw Uccello's heroic pageant as a trophy worthy of a Medici merchant prince.

In the sixteenth century, the artist, courtier, and historian Giorgio Vasari devoted a chapter to Paolo Uccello in his book *The Lives of the Most Excellent Italian Architects, Painters, and Sculptors*. He described Uccello as a man so obsessed with the study of perspective that he neglected his painting, his family, and even his beloved birds, until he finally became "solitary, eccentric, melancholy, and impoverished" (Vasari, page 79). His wife "used to declare that Paolo stayed at his desk all night, searching for the vanishing points of perspective, and when she called him to bed, he dawdled, saying: 'Oh, what a sweet thing this perspective is!'" (Vasari, page 83; translation by J. C. and P. Bondanella, Oxford, 1991). Such passion for science is typical of fifteenth-century artists, who were determined to capture the appearance of the material world and to subject it to overriding human logic. Thus a battle scene becomes a demonstration of the science of perspective.

CHAPTER-AT-A-GLANCE

HUMANISM AND THE ITALIAN RENAISSANCE

By the end of the Middle Ages, the most important Italian cultural centers lay north of Rome in the cities of Florence, Milan, and Venice, and in the smaller duchies of Mantua, Ferrara, and Urbino. In the south, Naples, Apulia, and Sicily were under French and then Aragonese control. Much of the power and influential art patronage was in the hands of wealthy families: the Medici in Florence, the Montefeltro in Urbino, the Gonzaga in Mantua, the Visconti and Sforza in Milan, and the Este in Ferrara. Cities grew in wealth and independence as people moved to them from the countryside in unprecedented numbers. Commerce became increasingly important. In some of the Italian states a noble lineage was not necessary for—nor did it guarantee—political and economic success. Money conferred status, and a shrewd business or political leader could become very powerful. The period saw the rise of mercenary armies led by entrepreneurial (and sometimes brilliant) military commanders called *condottieri*. Unlike the knights of the Middle Ages, they owed allegiance only to those who paid them well; their employer might be a city-state, a lord, or even the pope. Some *condottieri*, like Niccolò da Tolentino, became rich and famous. Others, like Federico da Montefeltro (SEE FIG. 19–29), were lords or dukes themselves, with their own territories in need of protection. Patronage of the arts was an important public activity with political overtones. As one Florentine merchant, Giovanni Rucellai, succinctly noted, he supported the arts "because they serve the glory of God, the honour of the city, and the commemoration of myself" (cited in Baxandall, page 2).

Like their northern counterparts (see Chapter 18), Italian humanists had a new sense of the importance of human thought and action, and they looked to the acccomplishments of ages past for inspiration and instruction. For Italians, though, this had added significance. Although politically divided into many small entities, and therefore not resembling the country we know today, Italy existed as a geographic unit with a common heritage descended from ancient Rome. Ancient Rome therefore provided not only a unifying ideal of power and wealth but also a unifying culture based on ethical principles. Humanists sought the physical and literary records of the ancient world—assembling libraries, collecting sculpture and fragments of architecture, and beginning archaeological investigations of ancient Rome. They imagined a golden age of

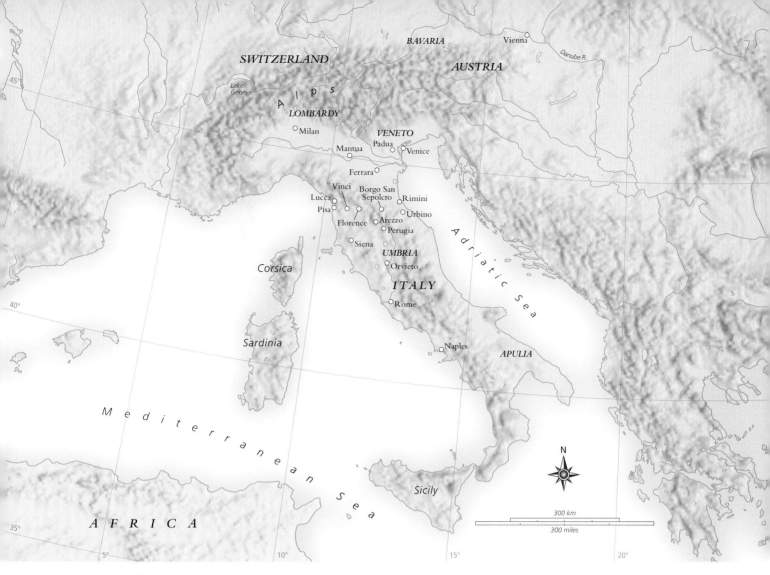

MAP 19–1 | Fifteenth-century Italy

Powerful families divided the Italian peninsula into city-states—the Medici in Florence, the Visconti and Sforza in Milan, the Montefeltro in Urbino, the Gonzaga in Mantua, and the Este in Ferrara. After 1420 the popes ruled Rome, while in the south Naples and Sicily were French and then Spanish (Aragonese) territories. Venice maintained her independence as a republic.

philosophy, literature, and the arts, which they hoped to recapture. Their aim was to live a rich, noble, and productive life—usually within the framework of Christianity but always adhering to a school of philosophy as a moral basis.

Artists, like the humanist scholars, turned to classical antiquity for inspiration even as they continued to fulfill commissions for predominantly Christian subjects. Secular works other than portraits do not survive in great numbers until the second half of the century. Much has been lost, especially painted home furnishings such as birth trays and marriage chests. Allegorical and mythological themes appeared, as patrons began to collect art for their personal enjoyment. Because few examples of ancient Roman painting were known in the fifteenth century, Renaissance painters looked to Roman sculpture and to literature. The male nude became an acceptable subject in Renaissance art, often justified as a religious image—Adam, Jesus on the cross, and martyrdoms of saints such as Sebastian. Other than representations of Eve or an occasional allegorical or mythological figure such as Venus, female nudes were rare until the end of the century.

Like the Flemish artists, Italian painters and sculptors moved gradually toward a greater precision in rendering the illusion of physical reality. They did so in a more analytical way than the northerners had, with the goal of achieving correct but perfected figures set within a rationally, rather than visually, defined space. Painters and sculptors developed a mathematical system called *linear perspective,* which achieved the illusion of a measured and continuously receding space (see "Brunelleschi, Alberti, and Renaissance Perspective," page 622). Italian architects also came to apply abstract, mathematically derived design principles to the plans and elevations of the buildings.

FLORENCE

In seizing Uccello's battle painting (SEE FIG. 19–1), Lorenzo de' Medici was asserting the role his family had come to play in the history of Florence. The fifteenth century witnessed the rise of the Medici from among the most successful of a newly rich middle class (comprising primarily merchants and

Technique
BRUNELLESCHI, ALBERTI, AND RENAISSANCE PERSPECTIVE

Artists such as Jan van Eyck refined intuitive perspective in order to approximate the appearance of things growing smaller and closer together in the distance, coupling it with atmospheric, or aerial, perspective. In Italy, the humanists' study of the natural world and their belief that "man is the measure of all things" led to the invention of a system of perspective that enabled artists to represent the visible world in a convincingly illusionistic way. This system—known variously as mathematical, linear, or one-point perspective—was first demonstrated by the architect Filippo Brunelleschi about 1420.

Brunelleschi's biographer, writing in the 1480s, describes two perspective panels that the architect created. One of them depicted the front of the Florentine Baptistry as if it were seen by someone standing three *braccia* inside the front door of the cathedral—a total of 60 *braccia* from the Baptistry. (In Florence, a *braccia*—meaning "arm," in Italian—measured about 2 feet.) To obtain this illusion, Brunelleschi pierced a hole in the back of the panel at the center point of the composition and placed a mirror one *braccia* length in front of it. Viewers could peep through the hole and see a reflection of the Baptistry that could be understood in actual space. The illusion was made even more striking by Brunelleschi's use of a burnished silver background, which reproduced real weather conditions.

Leon Battista Alberti developed and codified Brunelleschi's rules of perspective into a mathematical system for representing three dimensions on a two-dimensional surface in his treatise, in Latin, *De pictura (On Painting)* in 1435. A year later he published an Italian version, *Della pittura,* making a standardized, somewhat simplified method available to a larger number of draftspeople, painters, and relief sculptors. The goal he articulated is to make an image resemble a "view through a window," the view being the image represented, and the window, the picture plane.

In this highly artificial Italian system, the picture's surface was a flat plane that intersected the viewer's field of vision at a right angle. The system is based on a one-eyed viewer standing a prescribed distance from a work, dead center. From this fixed vantage point everything would appear to recede into the distance at the same rate, following imaginary lines called **orthogonals** that met at a single **vanishing point** on the horizon. Using orthogonals as a guide, artists could **foreshorten** objects, replicating the effect of perspective on individual objects. Despite its limitations, mathematical perspective seems to extend pictorial space into real space, providing the viewer with a direct, almost physical connection to the picture. It creates a compelling, even exaggerated sense of depth.

Early Renaissance artists relied on a number of mechanical methods. Many constructed devices with peepholes through which they sighted the figure or object to be represented. They used mathematical formulas to translate three-dimensional forms onto the picture plane, which they overlaid with a grid to provide reference points, or they emphasized the orthogonals created by tiled floors or buildings in the composition. As Italian artists became more comfortable with mathematical perspective over the course of the fifteenth century, they came to rely less on peepholes and formulas. Many artists adopted multiple vanishing points, which gave their work a more relaxed, less tunnel-like feeling.

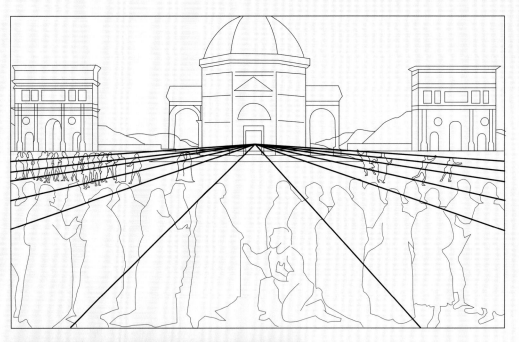

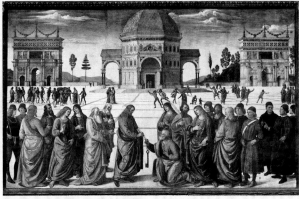

(ABOVE) Perugino **THE DELIVERY OF THE KEYS TO SAINT PETER: SCHEMATIC DRAWING SHOWING THE ORTHOGONALS AND VANISHING POINT**

(LEFT) Perugino **THE DELIVERY OF THE KEYS TO SAINT PETER** Fresco on the right wall of the Sistine Chapel, Vatican, Rome. 1481. 11′5½″ × 18′ 8½″ (3.48 × 5.70 m).

bankers) to become the city's virtual rulers. Unlike hereditary aristocracy, the Medici rose up from obscure roots to make their fortune in banking. The competitive Florentine atmosphere that had fostered mercantile success and civic pride also cultivated competition in the arts and encouraged an interest in the ancient literary texts. These factors have led observers to consider Florence the cradle of the Italian Renaissance. Under Cosimo the Elder (1389–1464), the Medici became leaders in intellectual and artistic patronage. They sponsored philosophers and other scholars who wanted to study the classics, especially the works of Plato and his followers, the Neoplatonists. Neoplatonism distinguished between the spiritual (the ideal or Idea) and the physical (Matter) and encouraged artists to represent ideal figures. Writers, philosophers, and musicians dominated the Medici Neoplatonic circle. Few architects, sculptors, or painters were included, because most of them had learned their craft in apprenticeships and were considered little more than manual laborers. Nevertheless, interest in the ancient world rapidly spread beyond the Medici circle to artists and craftspeople, who sought to reflect the new interests of their patrons in their work. Gradually, artists began to see themselves as more than artisans, and society eventually recognized their best works as achievements of a very high order.

Although the Medici were the de facto rulers, Florence was considered to be a republic. The Council of Ten (headed for a time by Salimbeni, who commissioned Uccello's *Battle of San Romano*) was a kind of constitutional oligarchy where wealthy men formed the government. At the same time, the various guilds wielded tremendous power, and evidence of this is the fact that guild membership was a prerequisite for holding government office. Consequently, artists could look to the church and the state and civic groups—the city and the guilds—as well as private individuals for patronage, and the patrons expected the artists to reaffirm and glorify their achievements.

Architecture

The defining civic project of the early years of the fifteenth century was the completion of the Florence Cathedral with a magnificent dome over the high altar. The construction of the cathedral had begun in the late thirteenth century and had continued intermittently during the fourteenth century (see Chapter 17). As early as 1367, the builders had envisioned a very tall dome to span the huge interior space of the crossing, but they lacked the engineering know-how to construct it. When interest in completing the cathedral revived, around 1407, the technical solution was proposed by a young sculptor-turned-architect, Filippo Brunelleschi.

FILIPPO BRUNELLESCHI. Filippo Brunelleschi (1377–1446), whose father had been involved in the original plans for the cathedral dome in 1367, achieved what many considered impossible: He solved the problem of the dome. Brunelleschi originally had trained as a goldsmith. To further his education

19–2 | Filippo Brunelleschi **DOME OF FLORENCE CATHEDRAL**
1417–36; lantern completed 1471; the gallery, 1515.

The cathedral dome was a source of immense local pride. Renaissance architect and theorist Leon Battista Alberti described it as rising "above the skies, large enough to cover all the peoples of Tuscany with its shadow."

he traveled to Rome, probably with his friend, the sculptor Donatello. In Rome he studied ancient Roman sculpture and architecture. On his return to Florence, he tackled the problem of the cathedral. First he advised constructing a tall octagonal **drum,** as a base. The drum was finished in 1412, and in 1417, Brunelleschi was ready to design the dome itself (FIG. 19–2). From 1420 until 1436, workers built the dome. A revolutionary feat of engineering, the dome is a double shell of masonry 138 feet across. The octagonal outer shell is supported on eight large and sixteen lighter ribs. Instead of using a costly and even dangerous scaffold and centering, Brunelleschi devised a system in which temporary wooden supports were cantilevered out from the drum. He moved these supports up as building progressed. As the dome was built up course by course, each portion of the structure reinforced the next one. Vertical marble ribs interlocked with horizontal sandstone rings, connected and reinforced with iron rods and oak beams. The inner and outer shells were linked internally by a system of arches. When completed, this self-buttressed unit required no external support to keep it standing. Unsure of Brunelleschi's still theoretical approach to building, the men responsible for

19-3 | Filippo Brunelleschi **OLD SACRISTY, CHURCH OF SAN LORENZO, FLORENCE**
1421-28, approx. 38 × 38′ (11.6 × 11.6 m).
Sculpture by Donatello.

Brunelleschi wanted simple architecture and protested the addition of sculpture.

the cathedral also appointed a respected master mason to assist with practical details of construction.

An **oculus** (round opening) in the center of the dome was surmounted by a **lantern** designed in 1436. After Brunelleschi's death, this crowning structure, made up of Roman architectural forms, was completed by another Florentine architect, Michelozzo di Bartolomeo (1396–1472). The final touch—a gilt bronzed ball—was added in 1468–71.

Other commissions came quickly after the cathedral dome project, as Brunelleschi's innovative designs were well received by Florentine patrons. From about 1418 until his death in 1446, Brunelleschi was involved in a series of influential projects. In 1419 he designed a foundling hospital for the city (see "The Foundling Hospital," page 626). For the Medici's parish church of San Lorenzo, he designed a sacristy (a room where ritual attire and vessels are kept), which also served as a burial chapel for Giovanni di Bicci de' Medici, who established the Medici fortune, and his wife (FIG. 19–3). Completed in 1428, it is called the **OLD SACRISTY** to distinguish it from the one built in the sixteenth century that lies opposite it on the other side of the church's choir. The Old Sacristy has a centralized plan, like a martyr's shrine in the Early Christian period. Later, Leon Battista Alberti, in his treatise on architecture (see page 622), wrote of the central plan as an ideal, derived from the

humanist belief that the circle was a symbol of divine perfection and that both the circle inscribed in a square and the cross inscribed in a circle were symbols of the cosmos.

The present church of San Lorenzo replaced an eleventh-century basilica. Brunelleschi conceived plans for the new church during the time that he designed and built the sacristy, that is, between 1421 and 1428, but Michelozzo, whose name appears in the construction documents, finished the building after Brunelleschi's death. The façade was never built.

The **CHURCH OF SAN LORENZO** has a basilican plan with a long nave flanked by side aisles that open into shallow lateral chapels (FIG. 19–4). A short transept and square crossing lead to a square sanctuary flanked by additional chapels opening off the transept. Projecting from the left transept, as one faces the altar, are Brunelleschi's sacristy and the older Medici tomb. The Church of San Lorenzo is notable for its mathematical regularity. Brunelleschi based his plan on a square **module**—a basic unit of measure that could be multiplied or divided and applied to every element of the design. Medieval builders had used modular plans, but Brunelleschi applied the module with greater consistency, and the result was a series of clear, harmonious spaces (FIG. 19–5). Ornamental details, all in a classical style, were carved in *pietra serena,* a grayish stone that became synonymous with Brunelleschi's interiors. Below the plain clerestory (upper-story wall of windows) with its unobtrusive openings, the arches of the nave arcade are carried on tall, slender Corinthian columns made even taller by the insertion of an **impost block** between the column capital and the springing of the round arches—one of Brunelleschi's favorite details. Flattened architectural forms in *pietra serena* repeat the arcade in the outer walls of the side aisles, and each bay is covered by its own shallow domical

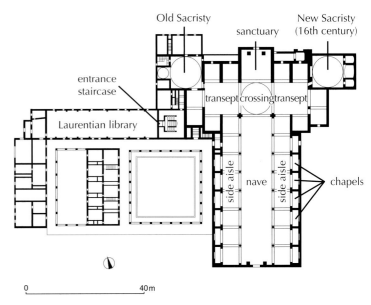

19-4 | Filippo Brunelleschi **PLAN OF THE CHURCH OF SAN LORENZO, FLORENCE**
Includes later additions and modifications.

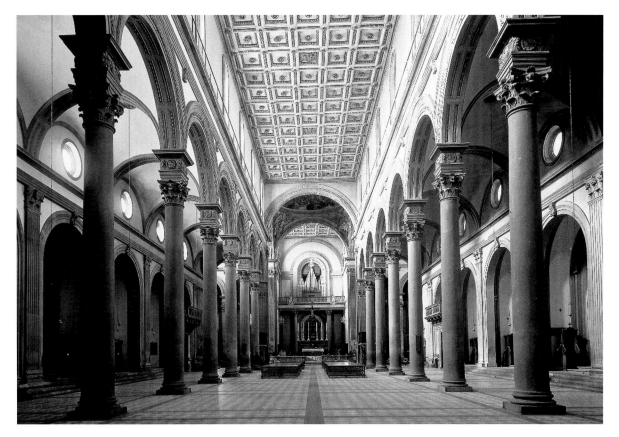

19–5 | Filippo Brunelleschi; continued by Michelozzo di Bartolomeo **NAVE, CHURCH OF SAN LORENZO, FLORENCE**
c. 1421–28, nave (designed 1434?) 1442–70.

vault. The square crossing is covered by a hemispherical dome; the nave and transept by flat ceilings. Brunelleschi's rational approach, unique sense of order, and innovative incorporation of classical motifs inspired later Renaissance architects, many of whom learned from his work firsthand by completing his unfinished projects.

THE MEDICI PALACE. Brunelleschi may have been involved in designing the nearby Medici Palace (now known as the **PALAZZO MEDICI-RICCARDI**) in 1446. According to sixteenth-century gossip recorded by Giorgio Vasari, Cosimo de' Medici the Elder rejected Brunelleschi's model for the *palazzo* as too grand (any large house was called a "palace"—*palazzo*). The courtyards of both buildings were the work of Michelozzo, whom many scholars have accepted as the designer of the building (**FIG. 19–6**). The austere exterior was in keeping with the republican political climate and Florentine religious attitudes, imbued with the Franciscan ideals of

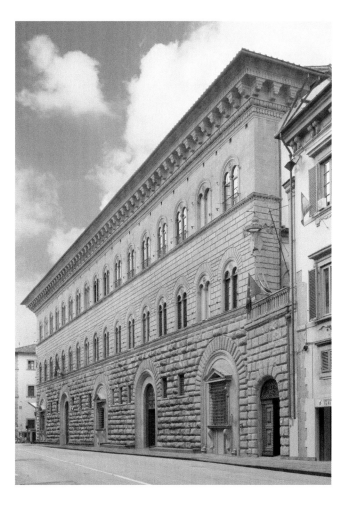

19–6 | Attributed to Michelozzo di Bartolomeo
FAÇADE, PALAZZO MEDICI-RICCARDI, FLORENCE
Begun 1446.

For the palace site, Cosimo de' Medici the Elder chose the Via de' Gori at the corner of the Via Larga, the widest city street at that time. Despite his practical reasons for constructing a large residence and the fact that he chose simplicity and austerity over grandeur in the exterior design, his detractors commented and gossiped. As one exaggerated: "[Cosimo] has begun a palace which throws even the Colosseum at Rome into the shade."

THE OBJECT SPEAKS

THE FOUNDLING HOSPITAL

In 1419 the Guild of Silk Manufacturers and Goldsmiths in Florence undertook a significant public service: It established a large public orphanage and commissioned the brilliant young architect Filippo Brunelleschi to build it next to the Church of the Santissima Annunziata ("Most Holy Annunciation"), which housed a miracle-working painting of the Annunciation. Completed in 1444, the Foundling Hospital, the *Ospedale degli Innocenti,* was unprecedented in terms of scale and design innovation.

In the Foundling Hospital, Brunelleschi created a building that paid homage to traditional forms while introducing what came to be known as the Italian Renaissance style. Traditionally, a charitable foundation's building had a portico open to the street to provide shelter. Brunelleschi built an arcade of hitherto unimagined lightness and ele-

gance, using smooth round columns and richly carved capitals—his own interpretation of the classical Corinthian order. The underlying mathematical basis for his design creates a sense of classical harmony. Each bay of the arcade encloses a cube of space defined by the 10-*braccia* (20-foot) height of the columns and the diameter of the arches. Hemispherical pendentive domes, half again as high as the columns, cover the cubes. The bays at the end of the arcade are slightly larger than the rest, creating a subtle frame for the composition. Brunelleschi defined the perfect squares and circles of his building with dark gray stone (*pietra serena*) against plain white walls. His training as a goldsmith and sculptor served him well as he led his artisans to carve crisp, elegantly detailed capitals and moldings for the open, covered gallery.

A later addition to the building seems eminently suitable: About 1487, Andrea della Robbia, who had inherited the family firm and its secret glazing formulas from his uncle Luca (see "Ceramics," page 634), created blue-and-white glazed terra-cotta medallions that signified the building's function. The babies in swaddling clothes, one in each medallion, are among the most beloved images of Florence.

The medallions seem to embody the human side of Renaissance humanism, reminding viewers that the city's wealthiest guild cared for the most helpless members of society. Perhaps the Foundling Hospital spoke to fifteenth-century Florentines of an increased sense of social responsibility. Or perhaps, by so publicly demonstrating social concerns, the wealthy guild that sponsored it solicited the approval and support of the lower classes in the cutthroat power politics of the day.

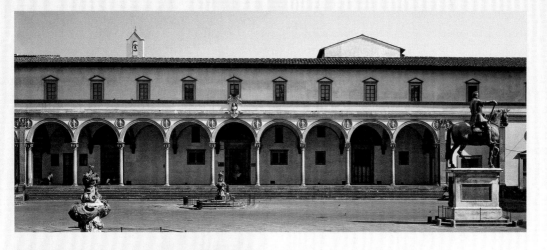

(ABOVE) Filippo Brunelleschi
FOUNDLING HOSPITAL, FLORENCE
Italy. Designed 1419; built 1421–44.

(LEFT) Andrea della Robbia
DETAIL OF TERRA-COTTA MEDALLION

poverty and charity. Like many other European cities, Florence had sumptuary laws, which forbade ostentatious displays of wealth—but they were often ignored. For example, private homes were supposed to be limited to a dozen rooms; Cosimo, however, acquired and demolished twenty small houses to provide the site for his new residence. The house was more than a dwelling place; it was his place of business, company headquarters. The *palazzo* symbolized the family and underscored the family's place in society. The building is linked to the seat of government, the Palazzo della Signoria (SEE FIG. 17–2), logistically by means of a straight line of connecting streets and symbolically through its imposing massiveness.

Huge in scale (each story is more than twenty feet high—today's builders calculate ten feet per story), the building has harmonious proportions and elegant, classically inspired details. On one side, the ground floor originally opened through large, round arches onto the street, creating in effect a loggia that provided space for the family business. These arches were walled up in the sixteenth century and given windows designed by Michelangelo. The façade of large, **rusticated** stone blocks—that is, blocks with their outer faces left rough, typical of Florentine town house exteriors—was derived from fortifications. On the façade, the stories are clearly set off from each other by the change in the stone surfaces from very rough at the ground level to almost smooth on the third.

The builders followed the time-honored tradition of placing rooms around a central courtyard. Unlike the still-medieval plan of the House of Jacques Coeur (SEE FIG. 18–24), however, the **MEDICI PALACE COURTYARD** is square in plan with rooms arranged symmetrically (**FIG. 19–7**). Round arches on slender columns form a continuous arcade and support an enclosed second story. Tall windows in the second story match the exterior windows. Disks bearing the Medici arms surmount each arch in a frieze decorated with swags in **sgraffito** work (tinted and engraved plaster). Such classical elements, inspired by the study of Roman ruins, gave the great house an aura of dignity and stability and undoubtedly enhanced the status of its owners. The Medici Palace inaugurated a new monumentality and regularity of plan in residential urban architecture. Wealthy Florentine families soon copied it in their own houses.

LEON BATTISTA ALBERTI. The relationship of the façade to the body of the building behind it was a continuing challenge for Italian Renaissance architects. Early in his architectural career, Leon Battista Alberti (1404–72), a lawyer turned humanist, architect, and author, devised a façade to be the unifying front for a planned merger of eight adjacent houses in Florence acquired by Giovanni Rucellai (**FIG. 19–8**). Work began about 1455, but the house was never finished, as is obvious on the right side of the view seen here. It has been suggested that Alberti designed a five-bay façade with a central door and that Bernardo Rossellino (1409–64), the builder on record, added two more bays and began the eighth but was unable to finish

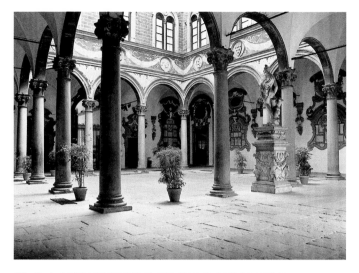

19–7 | **COURTYARD WITH SGRAFFITO DECORATION, PALAZZO MEDICI-RICCARDI, FLORENCE**
Begun 1446.

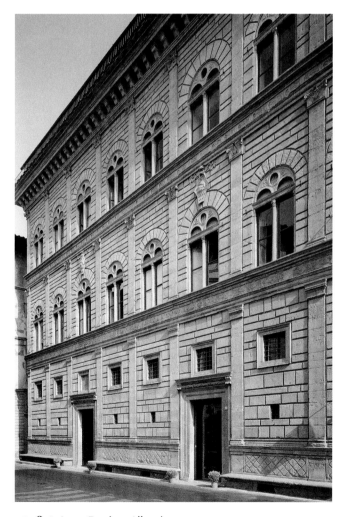

19–8 | Leon Battista Alberti **PALAZZO RUCELLAI, FLORENCE**
Left five bays 1455-58; later extended but never finished.

the Corinthian on the second floor, and a standard Corinthian on the third. The **PALAZZO RUCELLAI** provided a visual lesson for local architects in the use of classical elements and mathematical proportions, and Alberti's enthusiasm for classicism and his architectural projects in other cities were catalysts for the spread of the Renaissance movement.

Sculpture

The new architectural language inspired by ancient classical form was accompanied by a similar impetus in sculpture. By 1400, Florence had enjoyed internal stability and economic prosperity for over two decades. However, until 1428, the city and its independence were challenged by two great antirepublican powers: the Duchy of Milan and the Kingdom of Naples. In an atmosphere of wealth and civic patriotism, Florentines turned to commissions that would express their self-esteem and magnify the importance of their city. A new attitude toward realism, space, and the classical past set the stage for more than a century of creativity.

In the early fifteenth century the two principal sculptural commissions in Florence included the new set of bronze doors for the Baptistry of Florence Cathedral and the exterior niche decorations of Orsanmichele. Individual commissions for the Orsanmichele sculptures were awarded to a number of different artists. The competitive and distinctive nature of the works produced reveals a great deal about the artistic climate of early Renaissance Florence.

ORSANMICHELE. In the fourteenth century, the city's fourteen most powerful guilds had been assigned the ground floor niches that decorated the exterior of Orsanmichele and were asked to fill them with images of their patron saints (SEE FIG. 17–1). By 1400, only three had fulfilled this responsibility. In the new climate of republicanism and civic pride, the government pressured the guilds to furnish their niches with statuary. The assignment, with some replacements, took almost a century to reach its conclusion. In the meantime, Florence witnessed a dazzling sculptural exposition. Among the most important examples were two early commissions given to the sculptors Nanni di Banco and Donatello.

Nanni di Banco (c. 1385–1421), son of a sculptor in the Florence Cathedral workshop, produced statues for three of Orsanmichele's niches in his short but brilliant career. **THE FOUR CROWNED MARTYRS** was commissioned about 1409 by the stone carvers' and woodworkers' guild, to which Nanni himself belonged (FIG. 19–9). These martyrs, according to tradition, were third-century Christian sculptors who were executed for refusing to make an image of a pagan Roman god. Although the architectural setting resembles a small-scale Gothic chapel, Nanni's figures—with their solid bodies; heavy, form-revealing togas; stylized hair and beards; and naturalistic features—reveal Nanni's interest in ancient Roman sculpture, particularly portraiture, and are testimony to his role in the

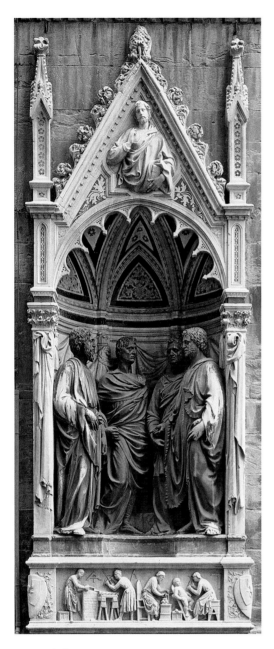

19–9 | Nanni di Banco **THE FOUR CROWNED MARTYRS** c. 1409-17. Marble, height of figures 6′ (1.83 m). Orsanmichele, Florence (photographed before removal of figures to museum). The sculpture has been cleaned and restored.

the façade because Rucellai could not acquire the additional land. Alberti's design, influenced in its basic approach by the Palazzo Medici, was a simple rectangular front suggesting a coherent, cubical three-story building capped with an over-hanging cornice, the heavy, projecting horizontal molding at the top of the wall. The double windows under round arches were a feature of Michelozzo's Palazzo Medici, but other aspects of the façade were entirely new. Inspired by the ancient Colosseum in Rome, Alberti created systematic divisions on the surface of the lightly rusticated wall with a horizontal-vertical pattern of pilasters and architraves. He superimposed the classically inspired orders on three levels: a novel type of the Doric on the ground floor (the first time this order is employed in Renaissance architecture), a modified version of

19–10 | Donatello **SAINT GEORGE**
1415-17. Marble, height 6′5″ (1.95 m). Bargello, Florence.
Formerly Orsanmichele, Florence.

Renaissance sculpture and one of the most influential figures of the century in Italy. A member of the guild of stone carvers and woodworkers, he worked in both mediums. During his long and productive career, he rethought and executed each commission as if it were a new experiment. Donatello took a remarkably pictorial approach to relief sculpture. He developed a technique for creating the impression of very deep space by improving on the ancient Roman technique of varying heights of relief—high relief for foreground figures and very low relief, sometimes approaching engraving, for the background.

Commissioned by one of Florence's lesser guilds—the armorers and sword makers—to carve their patron saint for their niche, Donatello created a marble figure of **SAINT GEORGE** (FIG. 19–10). As originally conceived, Saint George would have been a standing advertisement for the guild. The figure carried a sword in his right hand and probably wore a metal helmet, a sword belt, and a sheath. The figure is remarkably successful even without these accoutrements. Saint George holds his shield squarely in front of his braced legs; he seems alert and ready as he turns to meet any challenge, yet the expression on his face is tense and worried. His rather sensitive features and wrinkled brow contrast with the serene confidence of medieval knights or aggressive *condottieri* (SEE FIG. 19–1).

The base of the niche, where Saint George is seen slaying a dragon to save the princess, is a remarkable feat of low-relief carving. The contours of the foreground figures are slightly undercut to emphasize their mass, while the landscape and architecture are in progressively lower relief until they are barely incised rather than carved. The result is a spatial setting in relief sculpture as believable as any illusionistic painting.

GATES OF PARADISE. In 1401, a competition was announced in order to determine who would design bronze relief panels for a new set of doors for the east—and most important—side of the Baptistry of San Giovanni. These doors faced the main entrance to the cathedral, and the commission carried enormous prestige—and expense. The commission was awarded to Lorenzo Ghiberti (1381?–1455), a young artist trained as a goldsmith, at the very beginning of

revival of classicism. The saints convey a new spatial relationship to the building and to the viewer. They stand in a semicircle with forward feet and drapery protruding beyond the floor of the niche. The saints appear to be four individuals talking together, in an open arrangement that involves the passerby. Nanni's sense of a unified geometric composition is based on a circle completed in the space beyond the niche. In the relief panel below the niche, showing the four sculptors at work, Nanni has given the forms a similar solid vigor. He achieved this by deeply undercutting both figures and objects to cast shadows and enhance the illusion of three-dimensionality.

Another sculptor to receive guild commissions for the niches at Orsanmichele was Donatello (Donato di Niccolò di Betto Bardi, c. 1386/87–1466), the great genius of early Italian

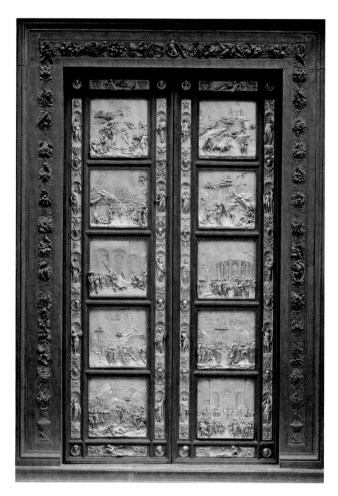

19–11 | Lorenzo Ghiberti **GATES OF PARADISE (EAST DOORS), BAPTISTRY OF SAN GIOVANNI, FLORENCE**
1425–52. Gilt bronze, height 15' (4.57 m). Museo dell'Opera del Duomo, Florence.

Ghiberti, whose bust portrait appears at the lower right corner of Jacob and Esau, wrote in his *Commentaries* (c. 1450–55): "I strove to imitate nature as clearly as I could, and with all the perspective I could produce, to have excellent compositions with many figures."

his career. His rival was none other than Brunelleschi, who claimed the competition ended in a tie.

Ghiberti's doors were such a success that in 1425 he was awarded the commission for the third set of doors for the east side of the baptistry, and his first set was moved to the north side. The door panels, commissioned by the Wool Manufacturers' Guild, were a significant conceptual leap from the older schemes of twenty-eight small scenes employed for Ghiberti's earlier doors and those of Andrea Pisano in the fourteenth century (SEE FIG. 17–5). The chancellor of Florence expressed the desire for a magnificent and memorable work. Ghiberti responded to the challenge by departing entirely from the old arrangement: He produced a set of ten Old Testament scenes, from the Creation to the reign of Solomon. Michelangelo reportedly said that those doors, installed in 1452, were worthy of being the **GATES OF PARADISE** (FIG. 19–11). Overall gilding unites the ten large, square reliefs. Ghiberti organized the space either by a system

of linear perspective, with obvious orthogonal lines approximating the system described by Alberti in his 1435 treatise on painting (see "Brunelleschi, Alberti, and Renaissance Perspective," page 622) or sometimes more intuitively by a series of arches or rocks or trees leading the eye into the distance. Foreground figures are grouped in the lower third of the panel, while the other figures decrease gradually in size, suggesting deep space. The use of a system of perspective, with background and foreground clearly marked, also helped the artist to combine a series of related events within only one frame. In some panels, the tall buildings suggest ancient Roman architecture and illustrate the emerging antiquarian tone in Renaissance art.

The story of Jacob and Esau (Genesis 25 and 27) forms the relief in the center panel of the left door. Ghiberti creates a coherent and measurable space peopled by graceful, idealized figures (FIG. 19–12). He unifies the composition by paying careful attention to one-point perspective in the architectural setting. Squares marked out in the pavement establish the lines of the orthogonals that recede to a central vanishing point under the loggia, and towering arches supported on piers with Corinthian pilasters define the space above the figures. The story from Genesis unfolds in a series of individual episodes and begins in the background. On the rooftop (upper right) Rebecca stands, listening to God, who warns of her unborn sons' future conflict; under the left-hand arch she gives birth to the twins. The adult Esau sells his rights as oldest son to Jacob, and when he goes hunting (center right), Rebecca and Jacob plot against him. Finally, in the

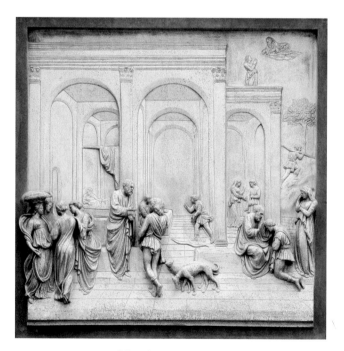

19–12 | Lorenzo Ghiberti **JACOB AND ESAU, PANEL OF THE GATES OF PARADISE (EAST DOORS)**
Formerly on the Baptistry of San Giovanni, Florence. c. 1435. Gilded bronze, 31¼" (79 cm) square. Museo dell'Opera del Duomo, Florence.

19–14 Donatello **EQUESTRIAN MONUMENT OF ERASMO DA NARNI (GATTAMELATA)**
Piazza del Santo, Padua. 1443–53. Bronze, height approx. 12'2" (3.71 m).

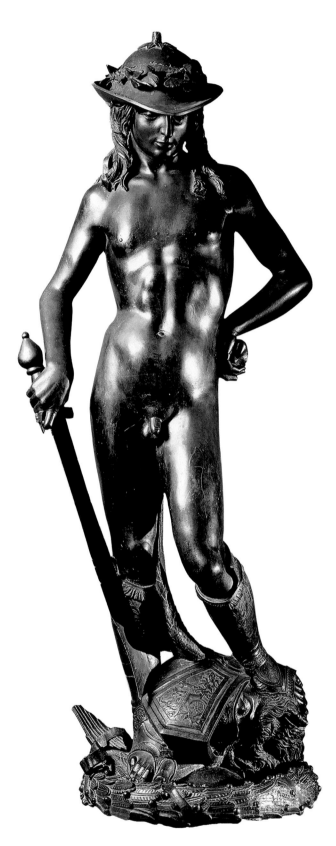

19–13 Donatello **DAVID**
c. 1446–60(?). Bronze, height 5' 2¼" (1.58 m). Museo Nazionale del Bargello, Florence.

While still in the Medici courtyard, the base was inscribed:

> "The victor is whoever defends the fatherland.
> All-powerful God crushes the angry enemy.
> Behold, a boy overcomes the great tyrant.
> Conquer, O citizens!"

right foreground, Jacob receives Isaac's blessing, while in the center, Esau faces his father.

In the Renaissance interpretation, Esau symbolized the Jews and Jacob the Christians. The story explains conflict between the two religions and compositionally balances the panel on the opposite door valve. The vanishing point lies between the two panels. Therefore Jacob, who occupies the right foreground, is near the center of interest for the doors as a whole. Esau and his faithful hound complete the beautiful curve of figures that begins with the trio of women at the far left and shows Ghiberti's debt to the International Gothic. In the spirit of Renaissance individuality, Ghiberti not only signed his work, but also included his self-portrait in the medallion beside the lower right-hand corner of the panel.

DONATELLO: NEW EXPRESSIVENESS. Donatello excelled for three reasons: his constant exploration of human emotions and expressions; his vision and insight in representing the formal problems inherent in his subjects; and his ability to solve the technical problems posed by various mediums, from bronze and marble to polychromed wood. In bronze sculpture, he produced the first life-size male nude, **DAVID** (FIG. 19–13); one of the first life-size bronze equestrian portraits, **GATTAME-LATA** (FIG. 19–14); and the first statuettes since antiquity.

19–15 Donatello **MARY MAGDALEN**
1450s(?). Polychromy and gold on wood, height 6′1″
(1.85 m). Museo dell'Opera del Duomo, Florence.

Since nothing is known about the circumstances of its creation, the sculpture of the *David* has been the subject of continuous inquiry and speculation. Although the statue clearly draws on the classical tradition of heroic nudity, this sensuous, adolescent boy in a jaunty laurel-trimmed shepherd's hat and boots has long piqued interest in its meaning. In one interpretation, the boy's angular pose, his underdeveloped torso, and the sensation of his wavering between childish interests and adult responsibility heighten his heroism in taking on the giant and destroying him. With Goliath's severed head now under his feet, David seems to have lost interest in warfare and now seems to be retreating into his dreams. The sculpture is first recorded in 1469 in the courtyard of the Medici palace, where it stood on a base engraved with an inscription extolling Florentine heroism and virtue. This inscription supports the suggestion that the sculpture celebrated the triumph of the Florentines over the Milanese in 1425. A peace treaty was signed in 1428. It ended the struggle with the despots of Milan, which had endured for over a quarter of a century, and helped give Florence a vision of itself as a strong, virtuous republic.

In 1443, Donatello was probably called to Padua to execute the equestrian statue commemorating the Paduan general of the Venetian army, Erasmo da Narni, nicknamed "Gattamelata" (meaning "Honeyed Cat"—a reference to his mother, Melania Gattelli). If one image were to characterize the self-made men of the Italian Renaissance, surely the most appropriate examples would be the *condottieri*—the brilliant generals (such as Tolentino, from Uccello's *Battle of San Romano*) who organized the armies and fought for any city-state willing to pay. The very word *chivalry* with all its connotations of honor, courage, and courtesy comes from the French word for "horse"—*cheval*. Italian Renaissance *condottieri* may have seen themselves as chivalric, as guardians of the state, although they were in fact tough, opportunistic mercenaries. But they, too, subscribed to an ideal of military and civic virtue.

Donatello's sources for this statue were two surviving Roman bronze equestrian portraits, one (now lost) in the north Italian city of Pavia, the other of the emperor Marcus Aurelius, which the sculptor certainly saw and probably sketched during his stay in Rome. Equestrian monuments of ancient Roman emperors demonstrated their virtues of bravery, nobility, and authority. Horsemanship was more than a necessary skill before the age of automobiles: It had symbolic meanings. The horse, a beast of enormous brute strength, symbolized the passions and man's physical animal nature. Consequently, skilled horsemanship demonstrated physical and intellectual control—self-control, as well as control of the animal—the triumph of the intellect, of "mind over matter."

Viewed from a distance, Donatello's man-animal juggernaut, installed on a high marble base in front of the Church of Sant'Antonio in Padua, seems capable of thrusting forward at the first threat. Seen up close, however, the man's sunken cheeks, sagging jaw, ropy neck, and stern but sad expression

suggest a warrior grown old and tired from the constant need for military vigilance and rapid response.

During the decade that he remained in Padua, Donatello executed other commissions for the Church of Sant'Antonio, including a bronze crucifix and reliefs for the high altar and pulpits. His presence in the city introduced Renaissance ideas to northeastern Italy and gave rise to a new Paduan school of painting and sculpture. The expressionism of Donatello's late work inspired some artists to add psychological intensity even in public monuments. His **MARY MAGDALEN,** traditionally dated about 1455 (although it may have been executed before his stay in Padua), shows the saint, known for her physical beauty, as an emaciated, vacant-eyed hermit clothed by her own hair (FIG. 19–15). Few can look at this figure without a wrenching reaction to the physical deterioration caused by age and years of self-denial. Nothing is left for her but an ecstatic vision of the hereafter, and yet that is everything. Despite Donatello's total rejection of the classical ideal form in this figure, the powerful force of the Magdalen's personality makes this a masterpiece of Renaissance imagery.

VERROCCHIO'S *CONDOTTIERE*. In the early 1480s, the Florentine painter and sculptor Andrea del Verrocchio (1435–88) was commissioned by the government to produce an equestrian monument honoring the Venetian army general Bartolommeo Colleoni (d. 1475), who left money for a memorial to himself (FIG. 19–16). In contrast to the thoughtful and even tragic over-

19–17 | Antonio del Pollaiuolo **HERCULES AND ANTAEUS** c. 1475. Bronze, height with base 18″ (45.7 cm). Museo Nazionale del Bargello, Florence.

tones communicated by Donatello's *Gattamelata,* the impression conveyed by the tense forms of Verrocchio's equestrian monument is one of vitality and brutal energy. The general's ferocious determination is expressed in his clenched jaw and staring eyes. The taut muscles of the horse, the fiercely erect posture of the rider, and the complex interaction of the two make this image of will and domination a singularly compelling monument. It still presides over the square of Santi Giovanni e Paolo in Venice.

POLLAIUOLO. Sculptors in the fifteenth century worked not only on a monumental scale for the public sphere; they also created small works, each designed to inspire the mind and delight the eye of its private owner (see "Ceramics," page 634). The enthusiasm of European collectors in the latter part of the fifteenth century for small, easily transported bronzes contributed to the spread of classical taste. Antonio del Pollaiuolo, ambitious and multitalented—a goldsmith, embroiderer, printmaker, sculptor, and painter—came to work for the Medici family in Florence about 1460. His sculptures were mostly small bronzes; his **HERCULES AND ANTAEUS** of about 1475 is one of the largest (FIG. 19–17). This study of complex interlocking figures has an explosive energy that can best be appreciated by viewing it from every angle.

19–16 | Andrea del Verrocchio **EQUESTRIAN MONUMENT OF BARTOLOMMEO COLLEONI, CAMPO SANTI GIOVANNI E PAOLO, VENICE** Clay model 1486-88; cast after 1490; placed 1496. Bronze, height approx. 13′ (4 m). Bronze cast by Alessandro Leopardi.

Technique
CERAMICS

Italian sculptors did not limit themselves to the traditional materials of wood, stone and marble, and bronze. They also returned to **terra cotta**, a clay medium whose popularity in Italy went back to Etruscan and ancient Roman times. Techniques of working with and firing clay had been kept alive by the ceramics industry and by a few sculptors, especially in northern Italy.

Typical of Renaissance ceramics in shape and decoration is the *albarello,* a jar designed especially for pharmacies: The tall concave shape made it easy to remove from a line of jars on pharmacy shelves, and the lip at the rim helped secure the cord that tied a parchment cover over the mouth. Sometimes the name of the owner or the contents of the jar were inscribed on a band around the center (the jar shown held syrup of lemon). The jars were glazed white and decorated in deep, rich colored enamel—orange, blue, green, and purple. The technique for making this lustrous, tin-glazed earthenware had been developed by Islamic potters and then by Christian potters in Spain. It spread to Italy from the Spanish island of Mallorca—known in Italian as Maiorca, which gave rise to the term *maiolica* to describe such wares. The painted decoration of broad scrolling leaves seen here is characteristic of the fifteenth century.

Ceramics were also used to supply the ever-increasing demand for architectural sculpture. Luca della Robbia (1399/1400–1482), although an accomplished sculptor in marble, began to experiment in 1441–42 with tin glazing to make his ceramic sculpture both weatherproof and decorative. As his inexpensive and rapidly produced sculpture gained an immediate popularity, he added color to the traditional white glaze. His

workshop even made molds so that a particularly popular work could be replicated many times. The elegant and lyrical della Robbia style was continued by Luca's nephew Andrea and his children long after Luca's death (see "The Foundling Hospital," page 626).

ALBARELLO
Cylindrical pharmacy jar, from Faenza. c. 1480. Glazed ceramic, height 12⅜"
(31.5 cm). Getty Museum, Los Angeles.
Getty .84.DE.104

Statuettes of religious subjects were still popular, but humanist art patrons began to collect bronzes of Greek and Roman subjects. Many sculptors, especially those trained as goldsmiths, began to cast small copies after well-known classical works. Some artists also executed original designs *all'antica* ("in the antique style"). Although there were outright forgeries of antiquities at this time, works in the antique manner were intended simply to appeal to a cultivated humanist taste. Hercules was always a popular figure, as a patron of Florence. He was even used on the city seal. Among the many courageous acts by which Hercules gained immortality was the slaying of the evil Antaeus in a wrestling match by lifting him off the earth, the source of the giant's great physical power. Hercules had been attacked by Antaeus, the son of the earth goddess Ge (or Gaia), on his search for a garden that produced pure gold apples.

An engraving by Pollaiuolo, **THE BATTLE OF THE NUDES** (FIG. 19–18), reflects the interests of Renaissance scholars—the study of classical sculpture and the anatomical research

that leads to greater realism—as well as the artist's technical skill in fine work on a metal plate. Pollaiuolo may have intended this, his only known—but highly influential—print, as a study in composition involving the human figure in action. The naked men, fighting each other ferociously against a tapestry-like background of foliage, seem to have been drawn from a single model in a variety of poses, many of which were taken from classical sources. Like the artist's *Hercules and Antaeus,* much of the engraving's fascination lies in how it depicts muscles of the male body reacting under tension.

Painting

Italian patrons generally commissioned murals and large altarpieces for their local churches and smaller panel paintings for their private chapels. Artists experienced in fresco, mural painting on wet plaster, were in great demand and traveled widely to execute wall and ceiling decorations. At first the Italians showed little interest in oil painting, for the most part

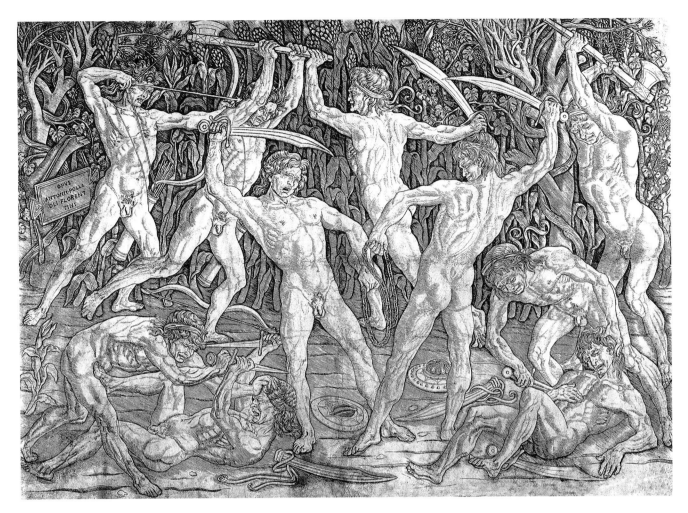

19–18 | Antonio del Pollaiuolo **BATTLE OF THE NUDES**
c. 1465–70. Engraving, 15⅛ × 23¼" (38.3 × 59 cm). Cincinnati Art Museum, Ohio.
Bequest of Herbert Greer French. 1943.118

using tempera even for their largest works. But, in the last decades of the century, Venetians began to use the oil medium for major panel paintings.

MASACCIO. The most innovative of the early Italian Renaissance painters was Tommaso di Ser Giovanni di Mone Cassai (1401–28/29?), nicknamed "Masaccio." In his short career of less than a decade, he established a new direction in Florentine painting, much as Giotto had a century earlier. Masaccio rejected the International Gothic style in favor of monumental forms that occupy rationally defined and unified space. Masaccio's interest in one-point perspective, the new architectural style, and classical sculpture allies him, especially, with his older contemporary Brunelleschi. Masaccio's fresco of the Trinity in the Church of Santa Maria Novella in Florence must have been painted around 1426, the date on the Lenzi family tombstone that was once in front of the fresco (FIG. 19–19). The **TRINITY** was meant to give the illusion of a stone funerary monument and altar table set below

a deep *aedicula* (framed niche) in the wall. The praying donors in front of the pilasters may be members of the Lenzi family. The red robes of the male donor at the left signify that he was a member of the governing council of Florence.

Masaccio created the unusual *trompe l'oeil* ("fool-the-eye") effect of looking up into a barrel-vaulted niche, made plausible through precisely rendered linear perspective. The eye and level of an adult viewer determined the horizon line on which the vanishing point was centered, just above the base of the cross. The painting demonstrates Masaccio's intimate knowledge of both Brunelleschi's perspective experiments and his architectural style (SEE FIG. 19–5). The painted architecture is an unusual combination of classical orders; on the wall surface, Corinthian pilasters support a plain architrave below a cornice, while inside the niche Renaissance variations on Ionic columns support arches on all four sides. The Trinity is represented by Jesus on the cross, the dove of the Holy Spirit poised in downward flight above his tilted halo, and God the Father, who stands behind the cross on a

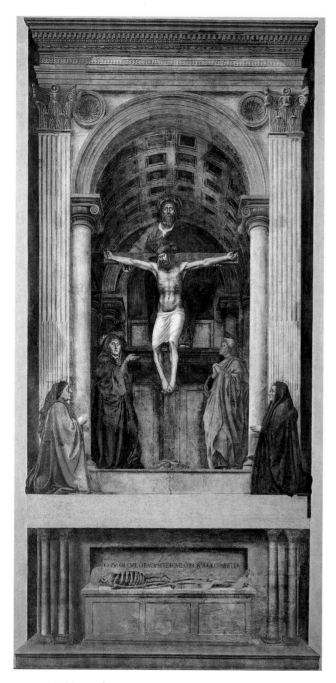

19-19 | Masaccio **TRINITY WITH THE VIRGIN, SAINT JOHN THE EVANGELIST, AND DONORS**
Church of Santa Maria Novella, Florence. c. 1425-27/28.
Fresco 21′ × 10′5″ (6.4 × 3.2 m).

the Trinity. Below, in an open sarcophagus, is a skeleton, a grim reminder that death awaits us all and that our only hope is redemption and life in the hereafter through Christian belief. The skeleton represents Adam, on whose tomb the cross was thought to have been set. The inscription above the skeleton reads: "I was once that which you are, and what I am you also will be."

THE BRANCACCI CHAPEL. Masaccio's brief career reached its height in his collaboration with another painter, Masolino (1383–c. 1440), on the fresco decoration of the **BRANCACCI CHAPEL** in the Church of Santa Maria del Carmine in Florence (**FIG. 19–20**). The project was ill-fated, however: The painters never finished their work—Masolino traveled to Hungary in 1425–27, and the two painters went to Rome in 1428. Masaccio died in Rome in 1428 or 1429. Felice Brancacci, the patron, was exiled in 1435. Eventually, another Florentine painter, Filippino Lippi, finished painting the chapel in the 1480s. The chapel was dedicated to Saint Peter, and the frescoes illustrate events in his life.

Masaccio combined a study of the human figure with an intimate knowledge of ancient Roman sculpture. In **THE EXPULSION FROM PARADISE,** he presented Adam and Eve as monumental nude figures (**FIG. 19–21**). In contrast to Flemish painters, who sought to record every visible hair or scratch (compare Adam and Eve from the *Ghent Altarpiece,* **FIG. 18–11**), Masaccio focused on the mass of bodies formed by the underlying bone and muscle structure to create a new realism. He used a generalized light shining on the figures from a single source and further emphasized their tangibility with cast shadows. Ignoring earlier interpretations of the event that emphasized wrongdoing and the fall from grace, Masaccio was concerned with the psychology of individual humans who have been cast mourning and protesting out of Paradise, and he captured the essence of humanity thrown naked into the world.

Adam and Eve lead to **THE TRIBUTE MONEY** (**FIG. 19–22**). The painting was done in thirty-one working days. Completed about 1427, it was rendered in a continuous narrative of three scenes within one setting (a medieval compositional technique). The painting illustrates an incident in which a collector of the Jewish temple taxes (the "tribute money") demands payment from Peter, shown in the central group with Jesus and the other disciples (Matt. 17:24–27). Saying "Render unto Caesar that which is Caesar's," Jesus instructs Peter to "go to the sea, drop in a hook, and take the first fish that comes up," which Peter does at the far left. In the fish's mouth is a coin worth twice the tax demanded, which Peter gives to the tax collector at the far right. The tribute story was especially significant for Florentines because in 1427, to raise money for defense against military aggression, the city enacted a graduated tax, based on the value of one's personal property.

high platform apparently supported on the rear columns. The "source" of the consistent illumination modeling the figures with light and shadow lies in front of the picture, casting reflections on the **coffers,** or sunken panels, of the ceiling. As in many scenes of the Crucifixion, Jesus is flanked by the Virgin Mary and John the Evangelist, who contemplate the scene. Mary gazes calmly out at us, her raised hand presenting

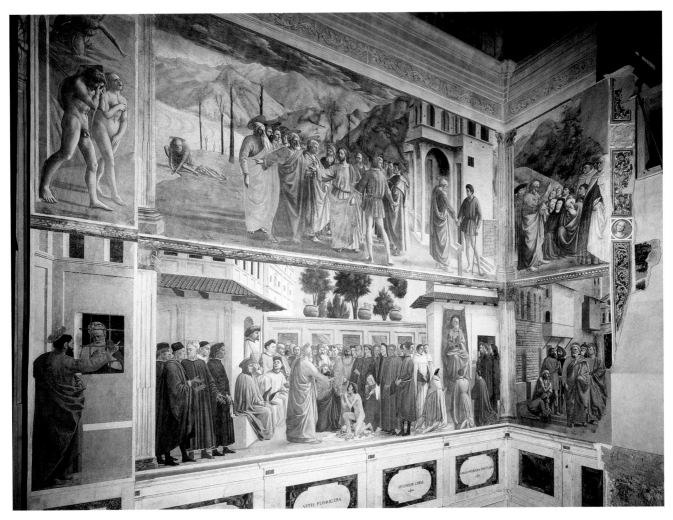

19–20 | INTERIOR OF THE BRANCACCI CHAPEL, CHURCH OF SANTA MARIA DEL CARMINE, FLORENCE
Frescoes by Masaccio and Masolino (1426–27) and Filippino Lippi (lower register) (c. 1482–84).

The Tribute Money is remarkable for its integration of figures, architecture, and landscape into a consistent scene. The group of Jesus and his disciples forms a clear central focus, from which the landscape seems to recede naturally into the far distance. To create this illusion, Masaccio used linear perspective in the depiction of the house and then reinforced it by diminishing the sizes of the trees and reducing Peter's size at the left. At the vanishing point established by the lines of the house is the head of Jesus. A second vanishing point determines the steps and stone rail at the right. Masaccio used atmospheric perspective as well as linear perspective in the distant landscape, where mountains fade from grayish green to grayish white and the houses and trees on their slopes are loosely sketched. Green leaves were painted on the branches *al secco* (meaning "on the dry plastered wall"; see Chapter 17, "Buon Fresco," page 569).

Masaccio modeled the foreground figures with strong highlights and cast their long shadows on the ground toward the left, implying a light source at the far right, as if the scene were lit by the actual window in the rear wall of the Brancacci Chapel. Not only does the lighting give the forms sculptural definition, but the colors vary in tone according to the strength of the illumination. Masaccio used a wide range of hues—pale pink, mauve, gold, blue green, apple green, peach—and a sophisticated color technique in which Andrew's green robe is shaded with red instead of darker green. All of the figures in *The Tribute Money*, except those of the temple tax collector, originally had gold-leaf halos, several of which had flaked off before the painting underwent restoration (1982–90). Rather than silhouette the heads against flat gold circles in the medieval manner, Masaccio conceived of the halo as a gold disk hovering in space above each head, and he subjected it to perspective foreshortening—shortening the lines of forms seen head-on to align them with the overall perspectival system—depending on the position of the figure.

19–21 | Masaccio **THE EXPULSION FROM PARADISE**
Brancacci Chapel. c. 1427. Fresco, 7′ × 2′ 11″ (214 × 90 cm).

Cleaning and restoration of the Brancacci Chapel paintings revealed the remarkable speed and skill with which Masaccio worked. He painted Adam and Eve in four *giornate* (each *giornata* of fresh plaster representing a day's work). Working from the top down and left to right, he painted the angel on the first day; on the second day, only the portal; the magnificent figure of Adam on the third day; and Eve on the fourth day.

Stylistic innovations take time to be fully accepted, and Masaccio's genius for depicting weight and volume, consistent lighting, and spatial integration was best appreciated by a later generation. Many important sixteenth-century Italian artists, including Michelangelo, studied and sketched from Masaccio's Brancacci Chapel frescoes. In the meantime, painting in Florence after Masaccio's death developed along lines somewhat different from that of *The Tribute Money* or *Trinity,* as other artists such as Paolo Uccello experimented in their own ways of conveying the illusion of a believably receding space (SEE FIG. 19–1).

Mural Painting in Florence After Masaccio

The tradition of covering walls with paintings in fresco continued through the fifteenth century. Walls of churches and chapels provided space for painters to combine Christian themes with local incidents and realistic portraits. Between 1438 and 1445, the decoration of the Dominican Monastery of San Marco in Florence, where Fra Angelico lived, was one of the most extensive projects.

FRA ANGELICO. Guido di Piero da Mugello (c. 1395/1400–55), known as Fra Giovanni da Fiesole, earned the designation "Fra Angelico" ("Angelic Brother") through his piety as well as his painting. He was beatified, the first step toward sainthood, in 1984. He is first documented as a painter in Florence in 1417–18, and he continued to be a very active painter after taking his vows as a Dominican monk (see "The Mendicant Orders," page 524).

Between 1438 and 1445, in the Monastery of San Marco, Fra Angelico and his assistants created a painting to inspire meditation in each monk's cell (forty-four in all), and they also added paintings to the chapter house (meeting room) and the corridors. The paintings were probably commissioned by Cosimo de' Medici. At the top of the stairs in the north corridor Fra Angelico painted the scene of the **ANNUNCIATION** **(FIG. 19–23).** Here the monks were to pause for prayer before going to their individual cells. The illusion of space created by the careful linear perspective seems to extend the stair and corridor out into a second cloister, the Virgin's home and verdant enclosed garden, where the angel Gabriel greets the modest, youthful Mary. The slender, graceful figures wearing flowing draperies assume modest poses. The natural light falling from the left models their forms and casts an almost supernatural radiance over their faces and hands. The scene is a vision that welcomes the monks to the most private areas of the monastery and prepares them for their meditations.

CASTAGNO. Another notable Florentine fresco, **THE LAST SUPPER,** is the work of Andrea del Castagno (c. 1417/19–57), painted for a convent of Benedictine nuns in 1447 **(FIG. 19–24).** The Last Supper was often painted in monastic refectories (dining halls) to remind the monks or nuns of

19–22 | Masaccio **THE TRIBUTE MONEY**
Brancacci Chapel. c. 1427. Fresco, 8'1" × 19'7" (1.87 × 1.57 m).

19–23 | Fra Angelico **ANNUNCIATION NORTH CORRIDOR, MONASTERY OF SAN MARCO, FLORENCE**
c. 1438–45. Fresco, 7'½" × 19'6" (230 × 297 m).

The shadowed vault of the portico is supported by a wall on one side and by slender Ionic and Corinthian columns on the other, a new building technique being used by Brunelleschi in the very years when the painting was being created.

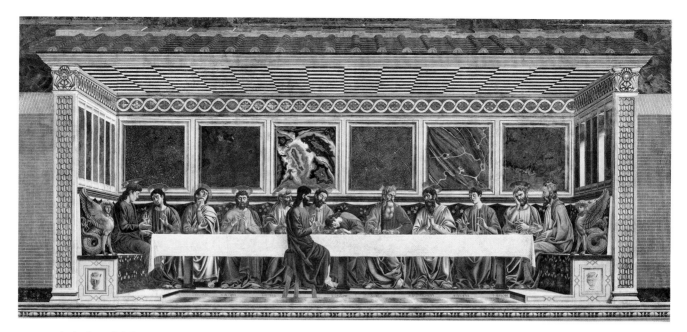

19–24 | Andrea del Castagno **THE LAST SUPPER**
Refectory, Convent of Sant'Apollonia, Florence. 1447. Fresco, width approx. 16 × 32′
(4.6 × 9.8 m).

Christ's sacrifice and of the bread and wine as his Body and Blood. Here the scene takes place in the "upper room"—the biblical setting—but the humble house described in the Bible has become a great palace with sumptuous marble panels. A brilliantly colored and wildly patterned marble panel frames the heads of Christ and Judas. Judas is separated from the apostles and sits on the viewer's side of the table. Saint John sleeps, head on the table. The strong perspective lines of floor tiles, ceiling rafters, and paneled walls draw the viewer into the scene. The religious would have seen the painting as an extension of their hall. At first, the lines of the orthogonals seem to follow Alberti's perfect logic, but close examination reveals that only the lines of the ceiling converge, below the hands of Saint John; consequently, an uneasy situation is established, and we do not know why. Two windows light the room from the direction of the actual windows, further unifying the painted and actual spaces, and Castagno paints his figures in solid sculptured fashion with clear outlines and strong highlights. He worked quickly, completing the huge mural in at most thirty-two days.

ITALIAN ART IN THE SECOND HALF OF THE FIFTEENTH CENTURY

In the second half of the fifteenth century, the ideas and ideals of artists like Brunelleschi, Donatello, and Masaccio began to spread from Florence to the rest of Italy, combining with local styles. Artists who trained or worked in Florence then traveled to other cities to work, either temporarily or perma-

nently, carrying the style with them. Northern Italy embraced the new classical ideas swiftly, with the ducal courts at Mantua and Urbino taking the lead. The Republic of Venice and the city of Padua, which Venice had controlled since 1405, also emerged as innovative art centers in the last quarter of the century.

Urbino

East of Florence lay another outstanding cultural center, Urbino, where Count (later, in 1474, Duke) Federico da Montefeltro attracted writers, philosophers, and the finest artists of the day to his court. The palace at Urbino would have made a glorious backdrop for the courtly pageantry. The Renaissance book of manners, *The Book of the Courtier,* by Baldassare Castiglione, was written there.

THE PALACE AT URBINO. Construction of Federico's palace had begun about 1450, and in 1468 Federico hired Luciano Laurana (c. 1420/25–1479), who had been an assistant on the project, to direct the work. Among Laurana's major contributions to the palace were closing the courtyard with a fourth wing and redesigning the courtyard façades (FIG. 19–25). The result is a superbly rational solution to the problems of courtyard elevation design, particularly the awkward juncture of the arcades at the four corners. The ground-level portico on each side has arches supported by columns; the corner angles are bridged with piers having engaged columns on the arcade sides and pilasters facing the courtyard. This arrangement avoided the awkward visual effect of two arches springing

from a single column and gave the corner a greater sense of stability. A variation of the composite capital (a Corinthian capital with added Ionic volutes) was used, perhaps for the first time, on the ground level. Corinthian pilasters flank the windows in the story above, forming divisions that repeat the bays of the portico. (The two short upper stories were added later.) The plain architrave was engraved with inscriptions lauding Federico's many virtues. Not visible in the photograph is an exceptionally magnificent monumental staircase leading from the courtyard to the main floor.

The interior of the Urbino palace likewise reflected its patron's embrace of new Renaissance ideas and interest in classical antiquity, seen in carved marble fireplaces and window and door surrounds. In creating luxurious home furnishings and interior decorations for educated clients such as Federico, Italian craft artists found freedom to experiment with new subjects, treatments, and techniques. Among these was the creation of *trompe l'oeil* effects, which had become more convincing with the development of linear perspective. *Trompe l'oeil,* commonly used in painting, was carried to its ultimate expression in **intarsia** (wood inlay) decoration, exemplified by the walls of Federico da Montefeltro's "**STUDIOLO**," or study, a room for private conversation and the collection of fine books and art objects (FIG. 19–26). The work was probably done by the architect and woodworker Giuliano da Maiano (1432–90) and carries a date of 1476.

The elaborate scenes in the small room are created entirely of wood inlaid on flat surfaces with scrupulously applied linear perspective and foreshortening. Each detail is rendered in *trompe l'oeil:* the illusionistic pilasters, carved cupboards with latticed doors, niches with statues, paintings, and built-in tables. Prominent in the decorative scheme is the prudent and industrious squirrel, a Renaissance symbol of the ideal ruler: in other words, of Federico da Montefeltro. A large window looks out onto an elegant marble loggia with a distant view of the countryside through its arches; and the shelves, cupboards, and tables are filled with all manner of fascinating things—scientific instruments, books, even the Duke's armor hanging like a suit in a closet. On the walls above were paintings of great scholars (whose books Federico

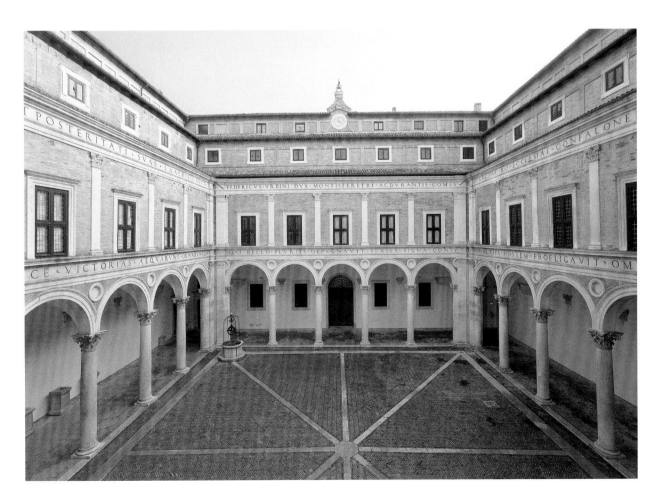

19–25 | Luciano Laurana **COURTYARD, DUCAL PALACE, URBINO**
Italy. Courtyard c. 1467-72; palace begun c. 1450.

The inscription extolling Federico's virtues—Justice, Clemency, Liberality, and Religion—was added in 1476 when he was made Duke of Urbino.

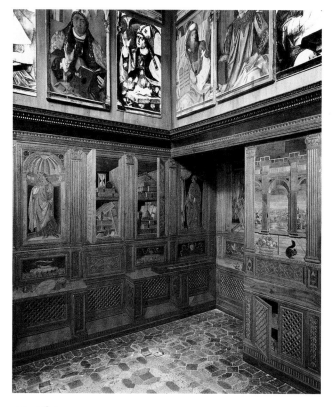

19–26 | **STUDIOLO OF FEDERICO DA MONTEFELTRO, DUCAL PALACE, URBINO**
1476. Intarsia, height 7′3″ (2.21 m). Woodwork probably by Giuliano da Maiano (1432–90).

owned) by Pedro Berruguete from Spain and Justus of Ghent from Flanders.

In 1472 Federico's wife Battista died, shortly after the birth of her ninth child, a son who would inherit the duchy. She was only 26, and Federico was disconsolate. Leaving the palace unfinished, he turned to building a funeral chapel, the church of San Bernardino, on a neighboring hilltop. The church can be seen in the background of Raphael's *Madonna and Child* (FIG. 20–5).

PIERO DELLA FRANCESCA. One artist Federico brought to Urbino was Piero della Francesca (c. 1415–92). Piero had worked in Florence in the 1430s before settling down in his native Borgo Sansepulcro, a Tuscan hill town under papal control. He knew current thinking in art and art theory—including Brunelleschi's system of spatial illusion and linear perspective, Masaccio's powerful modeling of forms and atmospheric perspective, and Alberti's theoretical treatises. Piero was one of the few practicing artists who also wrote about his own theories. Not surprisingly, in his treatise on perspective he emphasized the geometry and the volumetric construction of forms and spaces that were so apparent in his own work. He traveled widely—to Rome, to the Este court in Ferrara, and especially to Urbino.

From about 1454 to 1458, Piero was in Arezzo, where he decorated the Bacci Chapel of the Church of San Francesco

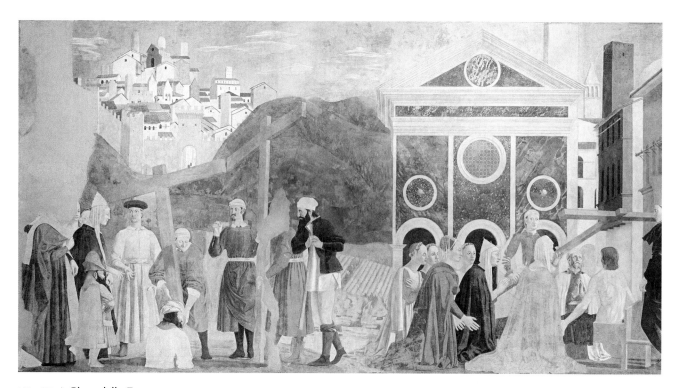

19–27 | Piero della Francesca **RECOGNITION AND PROVING OF THE TRUE CROSS**
San Francesco, Arezzo. 1450s. Fresco, 11′8″ × 24′6″ (3.56 × 7.47 m).

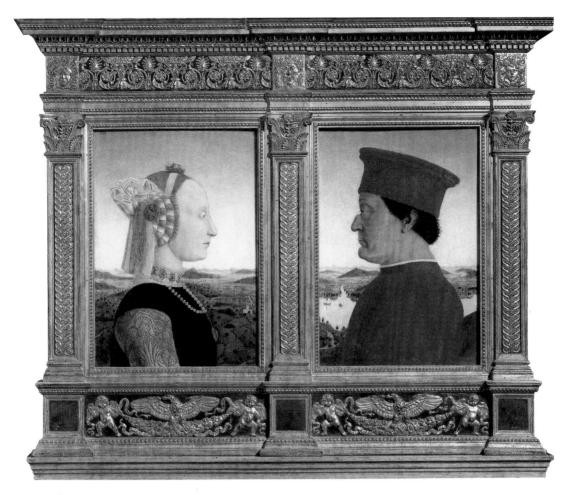

19–28 | Piero della Francesca **BATTISTA SFORZA AND FEDERICO DA MONTEFELTRO**
c. 1474. Oil on wood panel, each 18½ × 13″ (47 × 33 cm). Galleria degli Uffizi, Florence.

with a cycle of frescoes illustrating the legend of the True Cross, the cross on which Jesus was crucified. The Cross was buried after the Crucifixion, but Helena (the mother of Constantine, who was believed to be the first Christian Roman emperor) discovered and proved the authenticity of the cross when its touch brings to life a man being carried to his tomb.

In the **RECOGNITION AND PROVING OF THE TRUE CROSS,** (**FIG. 19–27**), Piero's analytical modeling and perspective projection result in a highly believable illusion of space around his monumental figures. He reduced his figures to cylindrical and ovoid shapes and established a geometric patterned setting in marble veneered buildings. The building that forms a background is a brilliant example of the ideal Renaissance façade as designed by Alberti. Few such façades were ever finished. Particularly remarkable are the foreshortening of figures and objects such as the cross at the right and the anatomical accuracy of the revived youth's nude figure. Unlike many of his contemporaries, however, Piero gave his figures no expression of human emotion. They observe the miracle with an indifference born of complete confidence.

In about 1474 Piero painted the portraits of Federico and his recently deceased wife, Battista Sforza (**FIG. 19–28**). The small panels, painted in tempera in light colors, resemble Flemish painting in their detail and luminosity, their record of surfaces and textures, and their vast landscapes. In the traditional Italian fashion, the figures are portrayed in strict profile, as remote psychologically from the viewer as icons. The profile format also allowed for an accurate recording of Federico's likeness without emphasizing two disfiguring scars—the loss of his right eye from a sword blow and his broken nose. His good left eye is shown, and the angular profile of his nose seems like a distinctive family trait. Typically, Piero emphasized the underlying geometry of the forms. Dressed in the most elegant fashion (Federico wears his red ducal robe), Battista and Federico are silhouetted against a distant view recalling the hilly landscape around Urbino. The influence of Flemish art (which Piero would have known from Flemish and Spanish painters working with him in Urbino) is also strong in the careful record of Battista's jewels and in the well-observed atmospheric perspective, making the landscape as subtle and luminous as any Flemish panel or manuscript. Piero used another northern European device in the harbor view near the center of Federico's panel: The water narrows into a river that leads the eye into the distant landscape.

19–29 Piero della Francesca **TRIUMPH OF FEDERICO AND BATTISTA**
Reverse of FIGURE 19–28.

Federico's inscription can be translated, "He that the perennial fame of virtues rightly celebrates holding the scepter, equal to the highest dukes, the illustrious, is borne in outstanding triumph." Battista had been dead two years when hers was written: "She that kept her modesty in favorable circumstances, flies on the mouths of all men, adorned with the praise of the acts of her great husband." (Translated by John Paolitti and Gary Radke, *Art in Renaissance Italy*. Prentice Hall, 2002, p. 288.)

The painting on the reverse of the portraits reflects the humanist interests of the court (FIG. 19–29). Engraved on the fictive parapets in letters inspired by ancient Roman inscriptions are stanzas praising the couple's respective virtues—Federico's moderation and the fame of his virtue; and Battista's restraint, shining in the reflected glory of her husband. Behind these laudatory inscriptions a wide landscape of hills and valleys appears to be nearly continuous across the two panels. Across the flat top of a jagged cliff in the foreground, triumphal carts roll, and we catch a glimpse of the kind of pageantry and spectacle that must have been enacted at court. The *Triumphs of Petrarch*—poetic allegories of love, chastity, fame, time, eternity (Christianized as Divinity), and death (see "A New Spirit in Fourteenth-Century Literature," page 561)—inspired many of these extravaganzas. White horses pull Federico's wagon. The Duke is crowned by a winged figure—either Victory or Fortune—and accompanied by personifications of Justice, Prudence, Fortitude, and Temperance. Battista's cart is controlled by a winged *putto* (nude little boy) driving a team of unicorns. The virtues standing behind her may be per-

sonifications of Chastity and Modesty. Seated in front of her are Faith and Charity, who holds a pelican. This bird, believed to feed its young from its own blood, may symbolize the recently deceased Battista's maternal sacrifices.

Mantua

Lodovico Gonzaga, the Marquis of Mantua, ruled a territory that lies on the north Italian plain between Venice and Milan. Like Federico, he made his fortune as a *condottiere*. Lodovico was schooled by humanist teachers and created a court where humanist ideas flourished in art as well as in literature. His relationship with Cosimo de' Medici led to a connection with Florentine artists and architects, including Alberti.

ALBERTI. The spread of Renaissance architectural style beyond Florence was due in significant part to Leon Battista Alberti, who traveled widely, wrote on architecture, and expounded his views to potential patrons. In 1470 Ludovico Gonzaga commissioned Alberti to enlarge the small **CHURCH**

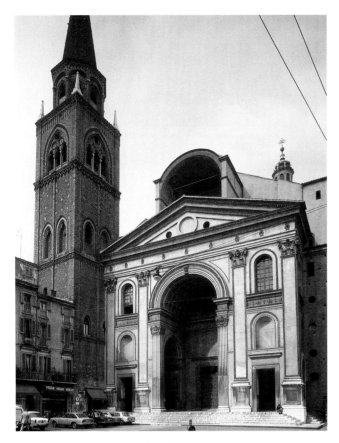

19–30 | Leon Battista Alberti
FAÇADE, CHURCH OF SANT'ANDREA, MANTUA
Designed 1470, begun 1472.

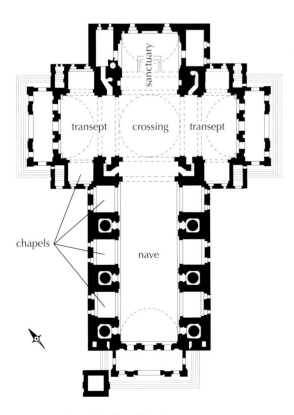

19–31 | Leon Battista Alberti **PLAN OF THE CHURCH OF SANT'ANDREA, MANTUA**
Designed 1470.

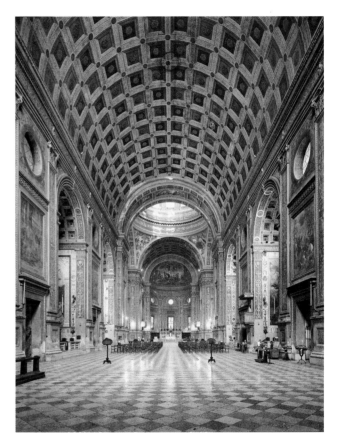

19–32 | **NAVE, CHURCH OF SANT'ANDREA, MANTUA**
Designed 1470. Vault width 60′ (18.3 m).

OF SANT'ANDREA, which housed a sacred relic believed to be the actual blood of Christ (**FIG. 19–30**). To satisfy his patron's desire for a sizable building to handle crowds coming to see the relic, Alberti proposed to build an "Etruscan temple." Work began on the new church in 1472, but Alberti died that summer. Construction went forward slowly, at first according to his original plan, but it was finally completed only at the end of the eighteenth century. Thus, it is not always clear which elements belong to Alberti's original design.

The Church of Sant'Andrea follows the Latin-cross plan, in which the transept intersects the nave high above the

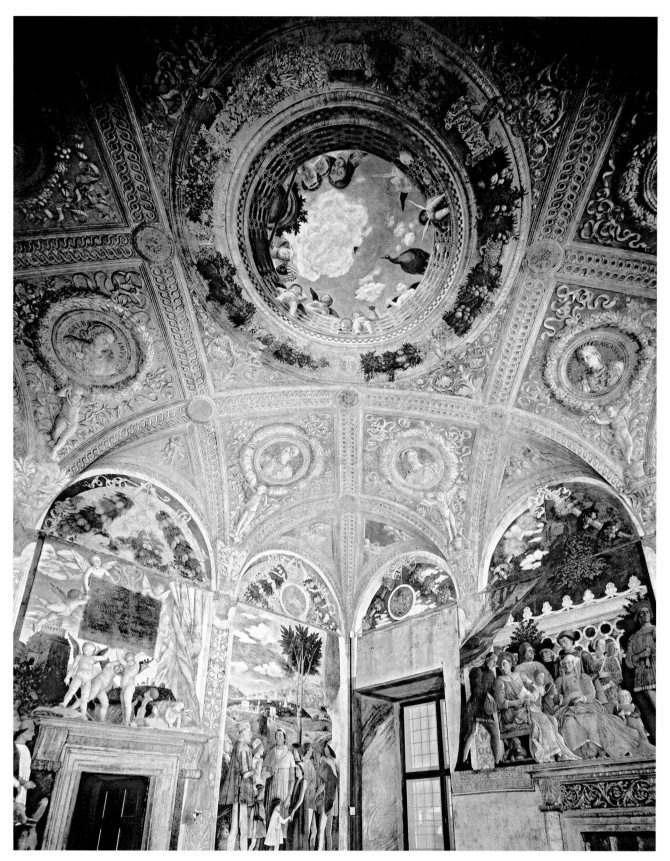

19–33 | Andrea Mantegna **CAMERA PICTA, DUCAL PALACE, MANTUA**
1465–74. Frescoes. Diameter of false oculus 8′9″ (2.7 m); room 62′ 6″ square (8 × 5 m square).

midpoint of the church. Here, the nave, nearly 60 feet wide, meets a transept of equal width at a square, domed crossing (FIGS. 19–31, 19–32). A rectangular sanctuary on axis with the nave is certainly in keeping with Alberti's ideas. Alberti was responsible, too, for the barrel-vaulted chapels at right angles to the nave that give the appearance of an arcade. Low chapel niches are carved out of the huge piers supporting the barrel vault of the nave. Light enters from chapel windows.

Alberti's design for the façade of Sant'Andrea (SEE FIG. 19–30) integrates two classical forms—a temple front and a triumphal arch with two sets of colossal Corinthian pilasters. The façade now has a clear volume of its own, which sets it off visually from the building behind. Pilasters flanking the barrel-vaulted triumphal-arch entrance are two stories high, whereas the others, raised on pedestals, run through three stories to support the entablature and pediment of the temple form. The arch itself has lateral barrel-vaulted spaces opening through two-story arches on the left and right.

Neither the simplicity of the plan nor the complexity of the façade hints at the grandeur of Sant'Andrea's interior. Its immense barrel-vaulted nave, extended on each side by tall chapels, was inspired by the monumental interiors of such ancient ruins as the Basilica of Maxentius and Constantine in the Roman Forum (SEE FIG. 6–75). This clear reference to Roman imperial art is put to Christian use. Alberti created a building of such colossal scale, spatial unity, and successful expression of Christian humanist ideals that it affected architectural design for centuries.

MANTEGNA. Andrea Mantegna (1431–1506) also worked at the court of Mantua. Mantegna, a painter, was trained in Padua and profoundly influenced by the sculptor Donatello, who arrived in Padua in 1443 and worked there for a decade. Mantegna absorbed such techniques as the Florentine linear perspective system, which Mantegna pushed to its limits with experiments in radical perspective views and foreshortenings. In 1460 Mantegna went to work for Ludovico Gonzaga, and he continued to work for the Gonzaga family for the rest of his life.

Mantegna's mature style is characterized by a virtuoso use of perspective, the skillful integration of figures into their settings, and a love of naturalistic details. His finest works are the frescoes of the CAMERA PICTA ("Painted Room"), a tower chamber in Ludovico Gonzaga's palace, which Mantegna decorated between 1465 and 1474 (FIG. 19–33). Around the walls the family receives its returning cardinal in scenes set in landscapes and loggias. (Ludovico's son, Cardinal Francesco, was head of the Church of Sant'Andrea; SEE FIG. 19–30). The paintings create a continuous scene with figures and countryside behind a fictive arcade. The people are all recognizable portraits of the family and court. On the domed ceiling, the artist painted a tour de force of radical perspective, a tech-

nique called *di sotto in sù* ("from below upwards"). The room appears to be open to a cloud-filled sky through a large oculus in a simulated marble- and mosaic-covered vault. On each side of a precariously balanced planter, three young women and an exotically turbaned African man peer over a marble balustrade into the room below. A fourth young woman in a veil looks dreamily upward. Joined by a large peacock, several *putti* play around the balustrade. The ceiling began a long tradition of illusionistic ceiling painting that culminated in the seventeenth century.

Although Mantegna made trips to Florence and Pisa in the 1460s and to Rome in 1488–90, he spent most of his time in Mantua. There he became a member of the humanist circle, whose interests in classical literature and archaeology he shared. He often signed his name using Greek letters.

Rome

Rome's establishment as a Renaissance center of the arts was enhanced by Pope Sixtus IV's decision to call to the city the best artists he could find to decorate the walls of his newly built chapel, named the Sistine Chapel after him. The resolution in 1417 of the Great Schism in the Western Church had secured the papacy in Rome, precipitating the restoration of not only the Vatican but the city as a whole.

PERUGINO. Among the artists who went to Rome was Pietro Vannucci, called "Perugino" (c. 1445–1523). Originally from near the town of Perugia in Umbria, Perugino worked for a while in Florence and by 1479 was in Rome. Two years later, he was working on the Sistine murals. One of his contributions, DELIVERY OF THE KEYS TO SAINT PETER (FIG. 19–34), portrayed the event that provided biblical support for the supremacy of papal authority, Christ's giving the keys of the kingdom of heaven to the apostle Peter (Matt. 16:19), who became the first bishop (pope) of Rome.

Delivery of the Keys is a remarkable work. Its carefully studied linear perspective reveals much about Renaissance ideals. In a light-filled piazza in which banded paving stones provide a geometric grid for perspectival recession, the figures stand like chess pieces on the squares, scaled to size according to their distance from the picture plane and modeled by a consistent light source from the upper left. The composition is divided horizontally between the lower frieze of massive figures and the band of widely spaced buildings above. Vertically, it is divided by the open space at the center between Christ and Peter and by the symmetrical architectural forms on each side of this central axis. Triumphal arches inspired by ancient Rome frame the church and focus the attention on the center of the composition, where the vital key is being transferred. The carefully calibrated scene is softened by the subdued colors, the distant idealized landscape and cloudy skies, and the variety of the

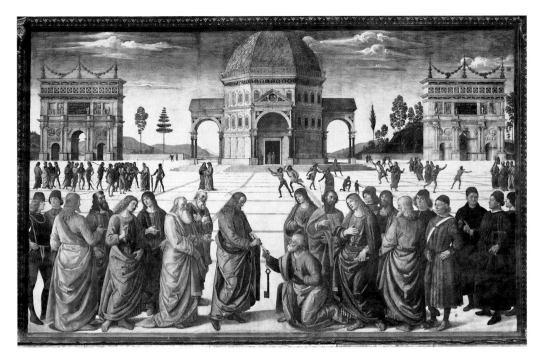

19–34 | Perugino **DELIVERY OF THE KEYS TO SAINT PETER**
Fresco on the right wall of the Sistine Chapel, Vatican City, Rome. 1481. 11′5½″ × 18′8½″ (3.48 × 5.70 m).

figures' positions. Perugino's painting is, among other things, a representation of Alberti's ideal city, described in his treatise on architecture as having a "temple" (that is, a church) at the very center of a great open space raised on a dais and separate from any other buildings that might obstruct its view. His ideal church had a central plan, illustrated here as a domed octagon.

The Later Fifteenth Century in Florence

In the final decades of the fifteenth century, Florentine painting was characterized on one hand by a love of material opulence and an interest in describing the natural world, and on the other by a poetic, mystical spirit. The first trend was encouraged by the influence of Netherlandish art and the patronage of citizens who sought to advertise their wealth and position, the second by philosophic circles surrounding the Medici and the religious fervor that arose at the very end of the century.

GHIRLANDAIO. In Florence, the most prolific painting workshop of the later fifteenth century was that of the painter Domenico di Tommaso Bigordi (1449–94), known as Domenico "Ghirlandaio" ("Garland Maker"), a nickname adopted by his father, who was a goldsmith noted for his floral wreaths. A skilled painter of narrative cycles, Ghirlandaio reinterpreted the art of earlier fifteenth-century painters into a popular visual language of great descriptive immediacy.

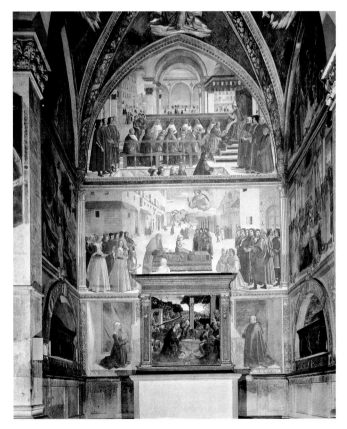

19–35 | Domenico Ghirlandaio **VIEW OF THE SASSETTI CHAPEL, CHURCH OF SANTA TRINITA, FLORENCE**
Frescoes of scenes from the Legend of Saint Francis; altarpiece with *Nativity and Adoration of the Shepherds*. 1483-86.
Chapel: 12′2″ deep × 17′2″ wide (3.7 × 5.25 m).

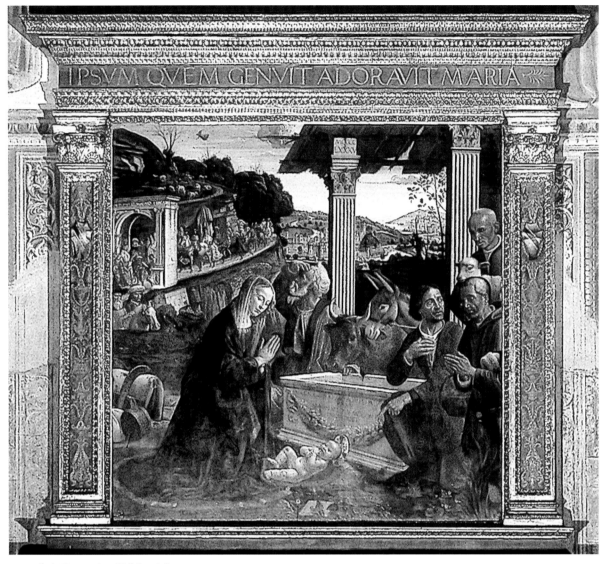

19–36 | Domenico Ghirlandaio **NATIVITY AND ADORATION OF THE SHEPHERDS, SASSETTI CHAPEL PANEL, ALTARPIECE, SANTA TRINITÀ, FLORENCE**
1485. 65¾" square (1.67 m square).

The taste for Flemish painting in Florence grew noticeably after about 1450, and works such as Hugo van der Goes's *Portinari Altarpiece* (SEE FIG. 18–20), which Tommaso Portinari had sent home to Florence from Bruges in 1483, had considerable impact on Ghirlandaio's style.

Among Ghirlandaio's most effective narrative programs were frescoes of the life of Saint Francis created between 1483 and 1486 for the Sassetti family burial chapel in the Church of Santa Trinita, Florence (FIG. 19–35). In the uppermost tier of the paintings, Pope Honorius confirms the Franciscan order. The Loggia of the Lancers (see Chapter 17, FIG. 17–2) and the Palazzo della Signoria can be seen in the background. All the figures, including those coming up the stairs, are portraits of well-known Florentines. In the middle register, a small boy who has fallen from an upper window is resurrected by Saint Francis. The miracle is witnessed by contemporary Florentines, including members of the Sassetti family, and the scene takes place in the piazza outside the actual church. Thus, Ghirlandaio transferred the events of the traditional story from thirteenth-century

Rome to the Florence of his own day, painting views of the city and portraits of Florentines, taking delight in local color and anecdotes. Perhaps Renaissance painters represented events from the distant past in contemporary terms to emphasize their current relevance, or perhaps they and their patrons simply enjoyed seeing themselves in their fine clothes acting out the dramas in the cities of which they were justifiably proud.

The Sassetti Chapel altarpiece, **NATIVITY AND ADORA-TION OF THE SHEPHERDS** (FIG. 19–36), is still in its original frame and in the place for which it was painted. Ghirlandaio clearly was inspired by Hugo's *Portinari Altarpiece* (SEE FIG. 18–20), which had been placed on the high altar of the church of Sant'Egidio two years earlier in 1483. As in Hugo's painting, Domenico's Christ Child lies on the

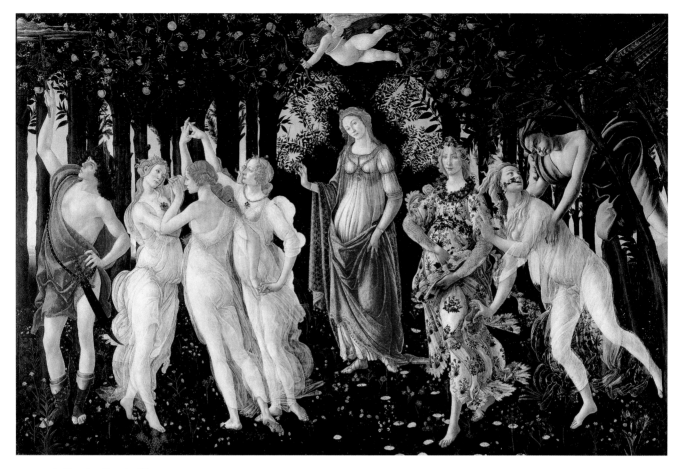

19–37 | Sandro Botticelli **PRIMAVERA**
c. 1482. Tempera on wood panel, 6′8″ × 10′4″ (2.03 × 3.15 m). Galleria degli Uffizi, Florence.

ground, adored by the Virgin while shepherds—rugged countrymen—kneel at the right. He even copies some of Hugo's flowers—although here the iris, a symbol of the Passion, springs not from a vase, but from the earth in the lower right corner. Instead of elaborate late-medieval symbolism, Ghirlandaio includes references to classical Rome. First to catch the eye are the two classical pilasters with Corinthian capitals, one of which has the date 1485. The manger is an ancient sarcophagus with an inscription that promises resurrection (as in the fresco directly above the altarpiece where Saint Francis is reviving a child); and in the distance a classical arch inscribed with a reference to the Roman general Pompey the Great frames the road along which the Magi travel. Domenico replaces the psychological intensity of Hugo's figures with weighty, restrained actors. His mastery of linear perspective is revealed in the manner in which the diagonally placed wooden planks that support the thatched roof of the shed organize the space. A clear foreground, middle ground, and background are joined together in part by the road and in part by aerial perspective, which creates a seamless transition of color, from the sharp details and primary hues of the Adoration to the soft gray mountains in the distance.

BOTTICELLI. Like most artists in the second half of the fifteenth century, Sandro Botticelli (1445–1510) learned to draw and paint sculptural figures that were modeled by light from a consistent source and placed in a setting rendered with strict linear perspective. An outstanding portraitist, he, like Ghirlandaio, often included recognizable contemporary figures among the saints and angels in religious paintings. He worked in Florence, often for the Medici, then was called to Rome in 1481 by Pope Sixtus IV to help decorate the new Sistine Chapel along with Ghirlandaio, Perugino, and other artists.

Botticelli returned to Florence that same year and entered a new phase of his career. Like other artists working for patrons steeped in classical scholarship and humanistic speculation, he was exposed to a philosophy of beauty—as well as to the examples of ancient art in his employers' collections. For the Medici, Botticelli produced secular paintings of mythological subjects inspired by ancient works and by contemporary Neoplatonic thought, including **PRIMAVERA,** or **SPRING** (FIG. 19–37), and *Birth of Venus* (SEE FIG. 19–38).

The overall appearance of *Primavera* recalls Flemish tapestries, which were popular in Italy at the time. The decorative quality of the painting is deceptive, however, for it is a highly complex **allegory** (a symbolic illustration of a concept

or principle), interweaving Neoplatonic ideas with esoteric references to classical sources. In simple terms, Neoplatonic philosophers and poets conceived of Venus, the goddess of love, as having two natures. The first ruled over earthly, human love and the second over universal divine love. In this way the philosophers could argue that Venus was a classical equivalent of the Virgin Mary. *Primavera* was painted at the time of the wedding of Lorenzo di Pierfrancesco de' Medici and Semiramide d'Appiano in 1482. The theme suggests love and fertility in marriage and provides in the image of Venus a model of the ideal woman. Venus is silhouetted and framed by an arching view through the trees. She is flanked by Flora, the Roman goddess of flowers and fertility, and by the Three Graces. Her son, Cupid, hovers above, playfully aiming an arrow at the Graces. At the far right is the wind god, Zephyr, in pursuit of the nymph Chloris, his breath causing her to sprout flowers from her mouth. At the far left, the messenger god, Mercury, uses his characteristic snake-wrapped wand, the caduceus, to dispel a patch of gray clouds drifting in Venus's direction. He is the sign of the month of May, and he looks out of the painting and onto summer. Venus, clothed in contemporary costume and wearing a marriage wreath on her head, here represents her terrestrial nature, governing wedded love. She stands in a grove of orange trees (a Medici

symbol) weighted down with lush fruit, suggesting human fertility; Cupid also embodies romantic desire. As practiced in central Italy in ancient times, the goddess Flora's festival had definite sexual overtones.

Several years later, some of the same mythological figures reappeared in Botticelli's **BIRTH OF VENUS** (FIG. 19–38), in which the central image represents the Neoplatonic idea of divine love and is based on an antique statue type known as the "modest Venus." The classical goddess of love and beauty, born of sea foam, floats ashore on a scallop shell, gracefully arranging her hands and hair to hide—or enhance—her sexuality. Her hair is highlighted with gold. Blown by the

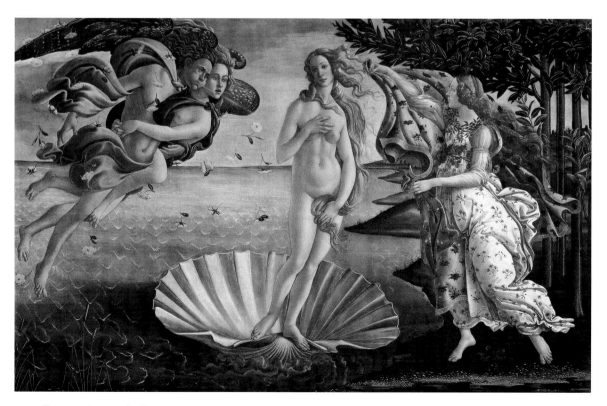

19–38 | Sandro Botticelli **BIRTH OF VENUS**
c. 1484-86. Tempera and gold on canvas, 5'8⅞" × 9' 1⅞" (1.8 × 2.8 m). Galleria degli Uffizi, Florence.

Art and Its Context
THE PRINTED BOOK

A book entitled *Hypnerotomachia Poliphili (The Love-Dream Struggle of Poliphilo)* tells of the search of Poliphilo through exotic places for his lost love, Polia. The book, written in the 1460s or 1470s by Fra Francesco Colonna, was published in 1499 by the noted Venetian printer Aldo Manuzio (Aldus Manutius in Latin), who had established a press in Venice in 1490 (known today as the Aldine Press). Many historians of the printed book consider Aldo's *Hypnerotomachia* to be the most beautiful book ever produced, from the standpoint of type and page design. The woodcut illustrations in the *Hypnerotomachia* incorporate pseudoclassical structures that would influence future architects and garden designers. *The Garden of Love*, illustrated here, provides a setting for music, story telling, and romance, while Venus as a fountain discreetly turns her back.

Although woodcuts, constantly refined and increasingly complex, would remain a popular medium of book illustration for centuries to come, books also came to be illustrated with engravings. The innovations in printing at the end of the 1400s held great promise for the spread of knowledge and ideas in the following century.

Fra Francesco Colonna **PAGE WITH GARDEN OF LOVE, HYPNEROTOMACHIA POLIPHILI**
Published by Aldo Manuzio (Aldus Manutius), Venice, 1499. Woodcut, image 5⅛ × 5⅛″ (13.5 × 13.5 cm). The Pierpont Morgan Library, New York.
PML 373.

wind, Zephyr (and his love, the nymph Chloris), Venus arrives at her earthly home. She is welcomed by a devotee—sometimes identified as one of the Hours—who holds a garment embroidered with flowers. The circumstances of this commission are uncertain. It is painted on canvas, which suggests that it is a banner or a painted tapestry-like wall hanging. The birth of Venus has been interpreted as the birth of the idea of beauty.

Botticelli's later career was affected by a profound spiritual crisis. While the artist was creating his mythologies, a Dominican monk, Fra Girolamo Savonarola (active in Florence 1490–98), had begun to preach impassioned sermons denouncing the worldliness of Florence. Many Florentines reacted with orgies of self-recrimination, and processions of weeping penitents wound through the streets. Botticelli, too, fell into a state of religious fervor. In a dramatic gesture of repentance, he burned many of his earlier paintings and began to produce highly emotional pictures pervaded by an intense religiosity.

In 1500, when many people feared that the end of the world was imminent, Botticelli painted **MYSTIC** nativity (**FIG. 19–39**) his only signed and dated painting. The Nativity takes place in a rocky, forested landscape in which the cave-stable follows the tradition of the Eastern Orthodox (Byzantine) Church, while the timber shed in front recalls the Western iconographic tradition (**SEE FIG. 17–13**). In the center of the painting, the Virgin Mary kneels in adoration of the Christ Child, who lies on the earth, as recorded in the vision of the fourteenth-century mystic Saint Bridget. Joseph crouches and hides his face, while the ox and the ass bow their heads to the Holy Child. The shepherds at the right and the Magi at the left also kneel before the Holy Family. A circle of singing angels holding golden crowns and laurel branches flies jubilantly above the central scene. Tiny devils, vanquished by the coming of Christ, try to escape from the bottom of the picture.

The most unusual element of the painting is the frieze of wrestling figures below the Holy Family. The men are

ancient classical philosophers, who ceremonially struggle with angels. Each of the three pairs holds an olive branch, a symbol of peace, and a scroll—as do the angels circling above, whose scrolls are inscribed (in Greek) with the words: "Glory to God in the Highest; peace on earth to men of good will." (Palm Sunday in fifteenth-century Florence was called Olive Sunday, and olive branches, symbols of peace, rather than palms were carried in processions.) The inscription at the top of the painting (in Greek) begins: "I Alessandro made this picture. . . ." and goes on to reference the Book of Revelation, Chapter 11, which describes woes to come, and Chapter 12, which includes the vision of a woman crowned with stars and clothed by the sun (the woman of Revelations was interpreted by Christians as a portrayal of the Virgin Mary) and the description of the defeat of Satan. Thus, in spite of the troubles Botticelli saw all around him, he believed that Christ would come to save humankind.

Venice

In the last quarter of the fifteenth century, Venice emerged as a major Renaissance art center. Venice was an oligarchy (government by a select few) with an elected duke (*doge* in the Venetian dialect). The city government was founded at the end of the Roman empire and survived until the Napoleonic era. In building their city the Venetians had turned marshes into a commercial seaport, and they saw the sea as a resource, not a threat. They depended on naval power and on their lagoons rather than city walls. The city turned toward the east, especially after the Crusaders' conquest of Constantinople in 1204. Even earlier the Venetians were investing the Church of Saint Mark, a great Byzantine-inspired building, with the rich color of mosaics and gold liturgical decorations from the Eastern Christian empire. They excelled in the arts of textiles, gold and enamel, glass and mosaic, and fine printing (see "The Printed Book," page 652), as well as book binding.

THE VENETIAN PALACE. Venice was a city of waterways with few large public spaces. Even palaces had only small interior courtyards and tiny gardens, and were separated by narrow alleys. They faced out on canals, whose waters gave protection and permitted the owners to build houses with large portals, windows, and loggias. This presented a sharp contrast to the fortresslike character of most Italian townhouses. But, as with the Florentine great houses, their owners combined in these structures a place of business with a dwelling.

The **CA D'ORO (HOUSE OF GOLD),** the home of the wealthy nobleman Marino Contarini, has a splendid front with three superimposed loggias facing the Grand Canal (FIG. 19–40). The house was constructed between 1421 and 1437, and its asymmetrical elevation is based on a traditional Byzantine plan. A wide central hall ran from front to back all the way through the building to a small inner courtyard with

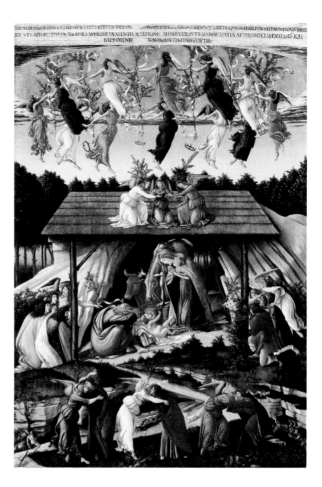

19–39 | Sandro Botticelli **MYSTIC NATIVITY**
1500. Oil on canvas, 42 × 29½" (106.7 × 74.9 cm).
The National Gallery, London.

This is the only work signed and dated by Botticelli; translated from the Greek, his inscription reads: "I Alessandro made this picture at the conclusion of the 1500th year" (National Gallery, London, files).

a well and garden. An outside stair led to the main floor on the second level. The entrance on the canal permitted goods to be delivered directly into the warehouse that constituted the ground floor. The principal floor, on the second level, had a salon and reception room opening on the richly decorated loggia. It was filled with light from large windows, and more light reflected off the polished terrazzo floor. Private family rooms filled the upper stories. In contrast to the massive stone façades of Florentine palaces (SEE FIGS. 19–6, 19–8), Contarini's instructions to his contractors and workers specified that the façade was to be painted with white enamel and ultramarine blue and that the red stones in the patterned wall should be oiled to make them even brighter. Details of carving, such as coats of arms and balls on the crest at the roof line, were to be gilded. Beautiful as the palace is today (it is now an art museum), in the fifteenth and sixteenth centuries it must have been truly spectacular.

19–40 CA D'ORO, VENICE
1421–37. Contarini Palace, known as the Ca d'Oro.

THE BELLINI BROTHERS. The domes of the Church of Saint Mark dominated the city center, and the rich colors of its glowing mosaics captured painters' imaginations. The love of color encouraged the use of the oil medium. Venetian painters eagerly embraced the oil paint technique for both panel and canvas painting.

The most important Venetian artists of this period were two brothers, Gentile (c. 1429–1507) and Giovanni (c. 1430–1516) Bellini, whose father, Jacopo (c. 1400–70), had also been a central figure in Venetian art. Andrea Mantegna was also part of this circle, for he had married Jacopo's daughter in 1453.

Gentile Bellini celebrated the daily life of the city in large, lively narratives, such as the **PROCESSION OF THE RELIC OF THE TRUE CROSS BEFORE THE CHURCH OF SAINT MARK** (**FIG. 19–41**). Every year on the Feast of Saint Mark (April 25) the Confraternity of Saint John the Evangelist carried the miracle-working Relic of the True Cross in a procession through the square in front of the church. Bellini's painting of 1496 depicts an event that had occurred in 1444: the miraculous recovery of a sick child whose father, the man in red kneeling to the right of the relic, prayed for help as the relic passed by. Gentile has rendered the cityscape with great accuracy and detail. The mosaic-encrusted Byzantine Church of Saint Mark (SEE ALSO FIG. 7–44) forms a backdrop for the procession, and the *doge's* palace and base of the bell tower can be seen at the right. The relic, in a gold reliquary under a canopy, is surrounded by marchers with giant candles, led by a choir and followed at the far right by the *doge* and other officials. The procession and spectators bring the huge piazza to life.

Gentile's brother, Giovanni, amazed and attracted patrons with his artistic virtuosity for almost sixty years. The **VIRGIN**

19–41 Gentile Bellini **PROCESSION OF THE RELIC OF THE TRUE CROSS BEFORE THE CHURCH OF SAINT MARK**
1496. Oil on canvas, 12′ × 24′5″ (3.67 × 7.45 m). Galleria dell'Accademia, Venice.

**AND CHILD ENTHRONED WITH SAINTS FRANCIS, JOHN THE BAP-
TIST, JOB, DOMINIC, SEBASTIAN, AND LOUIS OF TOULOUSE**
(FIG. 19–42), painted about 1478 for the Chapel of the Hospi-
tal of San Giobbe (Saint Job), exhibits a dramatic perspectival
view up into a vaulted apse. Certainly, Giovanni knew his
father's perspective drawings well, and he may also have been
influenced by his brother-in-law Mantegna's early experiments
in radical foreshortening and the use of a low vanishing point.
In Giovanni's painting, the vanishing point for the rapidly con-
verging lines of the architecture lies at the center, on the feet of
the lute-playing angel. Giovanni has placed his figures in a clas-
sical architectural interior with a coffered barrel vault, reminis-
cent of Masaccio's *Trinity* (SEE FIG. 19–19). The gold mosaic,
with its identifying inscription and stylized **seraphim** (angels of
the highest rank), recalls the art of the Byzantine Empire in the
eastern Mediterranean and the long tradition of Byzantine-
inspired painting and mosaics produced in Venice.

Giovanni Bellini also demonstrates the intense investiga-
tion and recording of nature associated with the early
Renaissance. His early painting of **SAINT FRANCIS IN ECSTASY**
(FIG. 19–43), painted in the 1470s, illustrates his command of
an almost Flemish realism. The saint stands in communion
with nature, bathed in early morning sunlight, his outspread
hands showing the stigmata. Francis had moved to a cave in
the barren wilderness in his search for communion with
God, but in this landscape, the fields blossom and flocks of
animals graze. The grape arbor over his desk and the leafy tree
toward which he directs his gaze add to an atmosphere of syl-
van delight. True to fifteenth-century religious art, however,
Bellini unites Old and New Testament themes to associate
Francis with Moses and Christ: The tree symbolizes the
burning bush; the stream, the miraculous spring brought
forth by Moses; the grapevine and the stigmata, Christ's sacri-
fice. The crane and donkey represent the monastic virtue of
patience. The detailed realism, luminous colors, and symbolic
elements suggest Flemish art, but the golden light suffusing
the painting is associated with Venice, a city of mist, reflec-
tions, and above all, color.

Giovanni's career spanned the second half of the fif-
teenth century, but he produced many of his greatest paint-
ings in the early years of the sixteenth, when his work
matured into a grand, simplified, idealized style. It seems fit-
ting to end our consideration of the first phase of Renais-
sance painting in Italy with Giovanni Bellini as an important
and influential bridge to the future.

IN PERSPECTIVE

In many people's minds the Renaissance and Italy are syn-
onymous—the Renaissance is the Italian Renaissance. Flo-
rence is its home, and the Medici family, its patrons. As we
have seen, however, the fifteenth century witnessed changes
throughout Western Europe—in Bruges as well as Florence.

19–42 | Giovanni Bellini **VIRGIN AND CHILD ENTHRONED
WITH SAINTS FRANCIS, JOHN THE BAPTIST, JOB, DOMINIC,
SEBASTIAN, AND LOUIS OF TOULOUSE**
(computer reconstruction) Commissioned for the Chapel of
the Hospital of San Giobbe, Venice. c. 1478. Oil on wood
panel, 15′4″ × 8′4″ (4.67 × 2.54 m). Galleria dell'Accademia,
Venice. The original frame is in the Chapel of the Hospital of
San Giobbe, Venice. c. 1478.

Art historians have given the special name *sacra conversazione*
("holy conversation") to this type of composition that shows
saints, angels, and sometimes even the painting's donors in the
same pictorial space with the enthroned Virgin and Child. Despite
the name, no "conversation" or other interaction among the fig-
ures takes place in a literal sense. Instead, the individuals por-
trayed are joined in a mystical and eternal communion occurring
outside of time.

The art of the fifteenth century reflects the values and
worldview of the new social order. A spirit of inquiry was
fueled by the study of classical texts begun in the four-
teenth century. The kind of logical discourse formerly
reserved for theological debate now was applied to the
material world. Theories based on the close observation of

19–43 | Giovanni Bellini
SAINT FRANCIS IN ECSTASY
c. 1470's. Oil and tempera on wood
panel, 49 × 55⅞″ (125 × 142 cm).
The Frick Collection, New York.
Copyright the Frick Collection, New York.

phenomena were put forth to be challenged and defended. During this time individuals gained importance, not only as inquiring minds but as the subject of inquiry. Artists, too, emerged from anonymity and were recognized as distinct personalities.

Patrons wanted to see themselves and their possessions depicted as they were. Fifteenth-century portraits have an uncanny sense of vitality, in part because of their careful, even unflattering, representations of individuals. The patrons' desire for realism extended to their surroundings; they wanted identifiable views of the buildings and countryside where they worked and played, fought and died. Artists tacitly agreed to follow new ways of representing space and visually organizing a scene using linear and atmospheric perspective. By the end of the fifteenth century, the visual mastery of the material

world seemed complete; rational and scientific thought had triumphed in both secular and religious art.

Power was no longer the prerogative of divinely sanctioned elites; it now also lay in the hands of commoners—the merchants and bankers, the leaders of the major guilds and professions. The arts flourished as patronage extended beyond the church and the court to civic, mercantile, and religious associations, as well as to families grown powerful through business and banking.

The last decade of the century saw a sudden reversal of artistic fortunes as the fiery preacher Savonarola spread the fear of damnation and inspired a need for repentance. In great "bonfires of the vanities" people destroyed their finery and great works of art as well. The furor was brief but devastating, a dramatic prelude to the tumultuous sixteenth century.

NANNI DI BANCO
FOUR CROWNED MARTYRS
C. 1409–17

MASACCIO
EXPULSION FROM PARADISE,
BRANCACCI CHAPEL
C. 1427

CA D'ORO, VENICE
1421–37

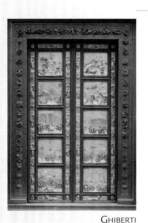

GHIBERTI
EAST DOORS, FLORENCE
BAPTISTRY COMPLETED
1452

ALBERTI
CHURCH OF SANT'ANDREA DESIGNED
1470

BOTTICELLI
MYSTIC NATIVITY
1500

RENAISSANCE ART IN FIFTEENTH-CENTURY ITALY

1400

1420

1440

1460

1480

1500

◀ **Great Schism Ends** 1417

◀ **Alberti Writes *De Pictura* *(On Painting)*** 1435

◀ **Ghiberti Writes *Commentaries*** c. 1450–55

◀ **Lorenzo de' Medici Rules Florence** 1469–92

◀ **Savonarola Executed** 1498

20–1 | Raphael **STANZA DELLA SEGNATURA** Vatican, Rome.
Fresco in the left lunette, *Parnassus*; in the right lunette, *School of Athens*. 1510–11. *School of Athens*,
19 × 27′ (5.79 × 8.24 m).

CHAPTER TWENTY

SIXTEENTH-CENTURY ART IN ITALY

20

Two young artists—Raphael (Raffaello Santi) and Michelangelo Buonarroti— although rivals in every sense, were both in the service of Pope Julius II in the early years of the sixteenth century. Raphael was painting the pope's private library (1509–11) while nearby Michelangelo painted the ceiling of his chapel (1508–12). The pope demanded an art that reflected his imperial vision of a new, worldwide Church based on humanistic ideas. In fulfilling this demand, Raphael and Michelangelo brought early Renaissance principles of harmony and balance together with a new monumentality based on classical ideals, and they knit these separate elements into a dynamic and synthetic whole. Together with the architect Donato Bramante and the multifaceted genius Leonardo da Vinci, they created a style we now think of as the High Renaissance.

Pope Julius II (ruled 1503–13) intended the **STANZA DELLA SEGNATURA,** or *Room of the Signature*, to be his library and study (FIG. 20–1). In painting the all-encompassing iconographic program we see here, Raphael created an ideal setting for the activities of a pope who believed that all human knowledge existed under the power of divine wisdom. Raphael based his mural program on the traditional organization of a library into divisions of theology, philosophy, the arts, and justice; and he created allegories to illustrate these themes. On one wall, churchmen discussing the sacraments represent theology, while across the room ancient philosophers debate in the *School of Athens,* led by Plato and Aristotle. Plato holds his book *Timaeus,* in which creation is seen in terms of geometry, and in which humanity encompasses and explains the universe. Aristotle holds his *Nicomachean Ethics,* a decidedly human-centered book concerned with

relations between people. Ancient representatives of the academic curriculum—Grammar, Rhetoric, Dialectic, Arithmetic, Music, Geometry, and Astronomy—surround them. On a window wall, Justice, holding a sword and scales, assigns each his due. Across the room, Poetry and the Arts are represented by Apollo and the Muses, and the poet Sappho reclines against the fictive frame of an actual window. Raphael included his own portrait among the onlookers on the extreme lower right in the *School of Athens* and signed the painting with his initials—a signal that artists were increasingly aware of their individual significance.

Raphael achieved a lofty style in keeping with the papal ideals of classical grandeur, faith in human rationality and perfectibility, and the power of the pope as God's earthly administrator. But when Raphael died at the age of 37 on April 6, 1520, the grand moment was already passing: Luther and the Protestant Reformation were challenging papal authority.

EUROPE IN THE SIXTEENTH CENTURY

The sixteenth century was an age of social, intellectual, and religious ferment that transformed European culture. It was also marked by continual warfare triggered by the expansionist ambitions of the continent's various rulers. The humanism of the fourteenth and fifteenth centuries, with its medieval roots and its often uncritical acceptance of the authority of classical texts, slowly developed a critical spirit that led Europeans to further their exploration of new ideas, nature, and lands. New methods in cartography that took account of the earth's curvature and the degrees of distance undermined traditional views of the world and led to a more accurate understanding of Europe's distinct place in it. The use of the printing press caused an explosion in the number of books available, spreading new ideas through the translation and publication of ancient and contemporary texts, broadening the horizons of educated Europeans and encouraging more people to learn to read. Travel became more common than in earlier centuries; artists and their work became mobile; consequently, artistic styles became less regional and more international.

At the start of the sixteenth century, England, France, and Portugal were nation-states under strong monarchs. Central Europe (Germany) was divided into dozens of principalities, counties, free cities, and other small territories. But even states as powerful as Saxony and Bavaria acknowledged the overlordship of the Habsburg (Holy Roman) Empire—in theory the greatest power in Europe. Charles V, elected Holy Roman Emperor in 1519, also inherited Spain, the Netherlands, and vast territories in the Americas. Italy, which was divided into many small states, was a diplomatic and military battlefield where, for much of the century, the Italian city-states, Habsburg Spain, France, and the papacy fought each other in shifting alliances. The popes themselves behaved like secular princes, using diplomacy and military force to regain control over central Italy and in some cases to establish family members as hereditary rulers. The popes' incessant demands for money, to finance the rebuilding of Saint Peter's as well as their self-aggrandizing art projects and luxurious lifestyles, aggravated the religious dissent that had long been developing, especially north of the Alps. Early in the century, religious reformers within the established Church challenged beliefs and practices—especially Julius II's sale of indulgences, which entailed a financial contribution to the Church in return for forgiveness of sins and insurance of salvation. Because they protested, these northern European reformers came to be called Protestants. Their demand for reform gave rise to a movement called the Reformation.

Although Italy remained staunchly Catholic, the Reformation had profound repercussions there. It drove the Catholic church not only to launch a fight against Protestantism but also to seek internal reform and renewal—a movement that became known as the Counter-Reformation. The Counter-Reformation would have a profound effect on artists and the works they created.

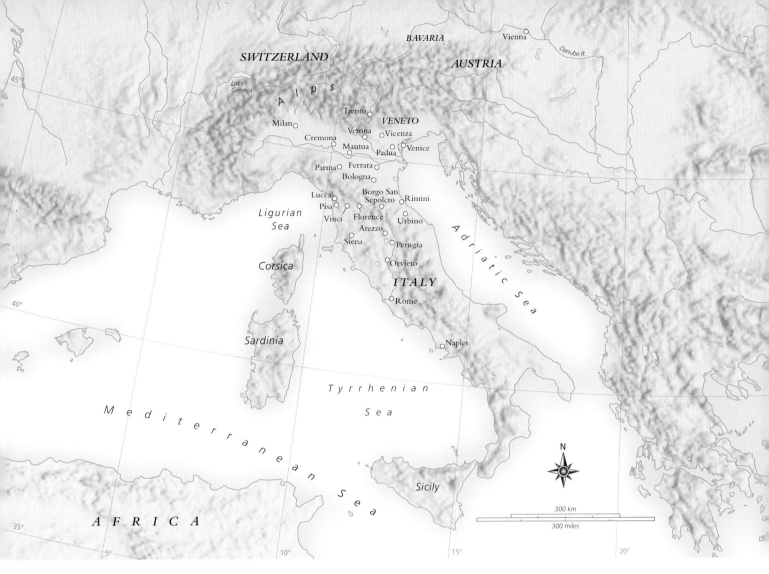

MAP 20—I | SIXTEENTH-CENTURY ITALY

In the 16th century Italy remained a peninsula divided into city-states in the north and the Papal States in the center. In the south Naples and Sicily were part of the vast and powerful Hasburg domains.

The political maneuvering of Pope Clement VII (papacy 1523–34) led to a direct clash with Holy Roman Emperor Charles V. In May 1527, Charles's German mercenary troops attacked Rome, beginning a six-month orgy of killing, looting, and burning. The Sack of Rome, as it is called, shook the sense of stability and humanistic confidence that until then had characterized the Renaissance, and it sent many artists fleeing from the ruined city. Nevertheless, Charles saw himself as the leader of the Catholic forces—and he was the sole Catholic ally Clement had at the time. In 1530 Clement VII crowned Charles emperor in Bologna.

Sixteenth-century patrons valued artists highly and rewarded them well, not only with generous commissions but sometimes even with high social status. Charles V, for example, knighted the painter Titian. Some painters and sculptors became entrepreneurs, selling prints of their works on the side. The sale of prints was a means by which reputations and styles became widely known, and a few artists of stature became international celebrities. With their new fame and independence, the most successful artists could decide which commissions to accept or reject.

Many artists recorded their activities in private diaries, notebooks, and letters that have come down to us. In addition, contemporary writers reported on everything about artists, from their physical appearance to their personal reputation. In 1550, Giorgio Vasari wrote the first survey of Italian art history, *Lives of the Best Architects, Painters, and Sculptors*. Vasari included more than simple biographical details; he made value judgments on work, commented on the role of patrons, and argued that art had become more realistic and more beautiful over time. He described the art of his own age as the culmination of historical processes, with its fulfillment in the life and work of Michelangelo. From his characterization, in part, stems our notion of this time period as the High Renaissance—that is, as a high point in art since Cimabue and Giotto that marks a balanced synthesis of classical ideals and an ordered naturalism.

During this period, the fifteenth-century humanists' argument that the conception of a painting, sculpture, or work of architecture was not a manual art but a liberal (intellectual) art, which therefore required education in the classics and mathematics, became a topic of intense interest. The

artist could express as much through painted, sculptural, and architectural forms as the poet could with words or the musician with melody. The myth of the divinely inspired creative genius—which arose during the Renaissance—is still with us today.

As with the business side of artistic production, however, the newly elevated status to which artists aspired favored men. Although few artists of either sex had access to the humanist education required for the sophisticated, often esoteric, subject matter used in paintings (most artists depended on outside sources for this aspect of their work), women were denied even the studio practice necessary to draw nude figures in foreshortened poses. Furthermore, it was almost impossible for an artist to achieve international status without traveling extensively and frequently relocating to follow commissions—something most women could not do. Still, women artists were active in European cultural life despite the obstacles to their entering any profession.

ITALY IN THE EARLY SIXTEENTH CENTURY: THE HIGH RENAISSANCE

Italian art from the 1490s to about the time of the Sack of Rome in 1527 has been called the "High Renaissance," the "Imperial style," and the "classical phase" of the Renaissance. It is characterized by a sense of gravity, a complex but balanced relationship of individual parts to the whole, and a deeper understanding of humanism and of ancient classical art than in the previous century. As before, outstanding Italian artists practicing in Rome, Florence, and other Italian cities spread this Italian Renaissance style throughout Europe.

Two important practical developments at the turn of the sixteenth century affected the arts in Italy: Technically, the use of tempera gave way to the more flexible oil medium in painting; and economically, commissions from private sources increased. Artists no longer depended so exclusively on the patronage of the Church, the aristocracy, or civic associations. Some members of the middle class in Italy and other European countries amassed wealth and became avid collectors of classical antiquities, paintings, and small bronzes, as well as coins, minerals, and fossils from the natural world.

Three Great Artists of the Early Sixteenth Century

Florence's renowned artworks and tradition of arts patronage attracted a stream of young artists to that city. The frescoes in the Brancacci Chapel there (SEE FIG. 19–20) inspired young artists, who went to study Masaccio's solid, monumental figures and eloquent facial features, poses, and gestures. For example, the young Michelangelo's sketches of the chapel frescoes clearly show the importance of Masaccio to his developing style. Michelangelo, Leonardo, and Raphael—the three leading artists of the classical phase of the Italian

Renaissance—all began their careers in Florence, although they soon moved to other centers of patronage and their influence spread far beyond that city.

LEONARDO DA VINCI. Leonardo da Vinci (1452–1519) was twelve or thirteen when his family moved to Florence from the Tuscan village of Vinci. He was an apprentice in the shop of the painter and sculptor Verrocchio until about 1476. After a few years on his own, Leonardo traveled to Milan in 1481 or 1482 to work for the ruling Sforza family.

Leonardo spent much of his time in Milan on military and civil engineering projects, including both urban-renewal and fortification plans for the city, but he also created one of the key monuments of Renaissance art there: At Duke Ludovico Sforza's request, Leonardo painted **THE LAST SUPPER** (FIG. 20–2, AND Fig. 18, Introduction) in the refectory, or dining hall, of the Monastery of Santa Maria delle Grazie in Milan between 1495 and 1498. In fictive space defined by a coffered ceiling and four pairs of tapestries that seem to extend the refectory into another room, Jesus and his disciples are seated at a long table placed parallel to the picture plane and to the living diners seated in the hall. The stagelike space recedes from the table to three windows on the back wall, where the vanishing point of the one-point perspective lies behind Jesus's head. Jesus forms an equilateral pyramid at the center, his arms uniting the twelve disciples, who are grouped in four interlocking sets of three. As a narrative, the scene captures the moment when Jesus tells his companions that one of them will betray him. They react with shock, disbelief, and horror. Judas recoils, clutching his money bag in the shadows to the left of Jesus. Leonardo was an acute observer of human beings and his art vividly expressed human emotions.

On another level, *The Last Supper* is a symbolic evocation of both Jesus's coming sacrifice for the salvation of humankind and the institution of the ritual of the Mass. Breaking with traditional representations of the subject, such as the one by Andrea del Castagno (SEE FIG. 19–25), Leonardo placed the traitor Judas in the first triad to the left of Jesus, with the young John the Evangelist and the elderly Peter, rather than isolating him on the opposite side of the table. Judas, Peter, and John were each to play an essential role in Jesus's mission: Judas to set in motion the events leading to Jesus's sacrifice; Peter to lead the Church after Jesus's death; and John, the visionary, to foretell the Second Coming and the Last Judgment in the Apocalypse. By arranging the disciples and architectural elements into four groups of three, Leonardo incorporated a medieval tradition of numerical symbolism. He eliminated another symbolic element—the halo—and substituted the natural light from a triple window framing Jesus's head (compare Rembrandt's reworking of the composition, Fig. 19, Introduction).

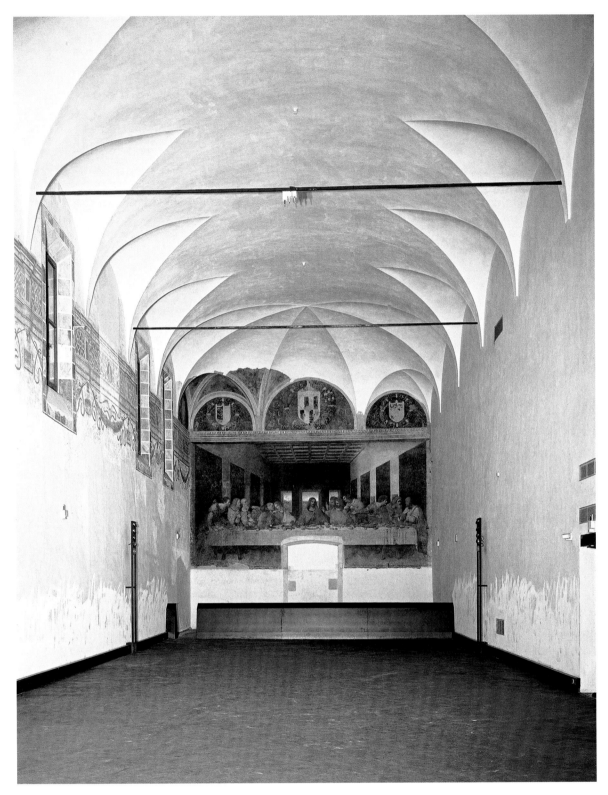

20–2 | Leonardo **THE LAST SUPPER**
Wall painting in the refectory of the Monastery of Santa Maria delle Grazie, Milan, Italy. 1495–98. Tempera and oil on plaster, 15′2″ × 28′10″ (4.6 × 8.8 m). See Introduction, Fig. 18.

Instead of painting in fresco, Leonardo devised an experimental technique for this mural. Hoping to achieve the freedom and flexibility of painting on wood panel, he worked directly on dry *intonaco*—a thin layer of smooth plaster—with an oil-and-tempera paint for which the formula is unknown. The result was disastrous. Within a short time, the painting began to deteriorate, and by the middle of the sixteenth century its figures could be seen only with difficulty. In the seventeenth century, the monks saw no harm in cutting a doorway through the lower center of the composition. Since then the work has barely survived, despite many attempts to halt its deterioration and restore its original appearance. The painting narrowly escaped complete destruction in World War II, when the refectory was bombed to rubble around its heavily sandbagged wall. The coats of arms at the top are those of patron Ludovico Sforza, the Duke of Milan (ruled 1494–99), and his wife, Beatrice.

20–3 | Leonardo **VIRGIN AND SAINT ANNE WITH THE CHRIST CHILD AND THE YOUNG JOHN THE BAPTIST**
c. 1500. Charcoal heightened with white on brown paper, 55½ × 41″ (141.5 × 104.6 cm). The National Gallery, London.

20–4 | Leonardo **MONA LISA**
c. 1503. Oil on wood panel, 30¼ × 21″ (77 × 53 cm). Musée du Louvre, Paris.

The painting's careful geometry, the convergence of its perspective lines, the stability of its pyramidal forms, and Jesus's calm demeanor at the mathematical center of all the commotion together reinforce the sense of gravity, balance, and order. The work's qualities of stability, calm, and timelessness, coupled with the established Renaissance forms modeled after those of classical sculpture, characterize the art of the Renaissance at the beginning of the sixteenth century.

Leonardo returned to Florence in 1500, after the French, who had invaded Italy in 1494, claimed Milan. (They defeated Leonardo's Milanese patron, Ludovico Sforza, who remained imprisoned until his death in 1508.) Upon his return, Leonardo produced a large drawing of the **VIRGIN AND SAINT ANNE WITH THE CHRIST CHILD AND THE YOUNG JOHN THE BAPTIST** (FIG. 20–3). This work may be a full-scale model, called a **cartoon**, for a major painting, but no known painting can be associated with it. Scholars today believe it to be a finished work—perhaps one of the drawings artists often made as gifts. Mary sits on the knee of her mother, Anne, and turns to the right to hold the Christ Child, who strains away from her to reach toward his cousin, the young John the Bap-

tist. Leonardo created the illusion of high relief by modeling the figures with strongly contrasted light and shadow, a technique called **chiaroscuro** (Italian for "light-dark"). Rather than a central focus, carefully placed highlights create interlocking circular movements that activate the composition; they underscore the individual importance of each figure while making each of them an integral part of the whole. This effect emphasizes the figures' complex interactions, which are suggested by their exquisitely tender expressions, particularly those of Saint Anne and the Virgin.

Between about 1503 and 1506, Leonardo painted the renowned portrait known as **MONA LISA** (FIG. 20–4). The subject may have been 24-year-old Lisa Gherardini del Giocondo, the wife of a prominent merchant in Florence. Leonardo never delivered the painting and kept it with him for the rest of his life. Remarkably for the time, the young woman is portrayed without any jewelry, not even a ring. The solid pyramidal form of her half-length figure—a significant departure from the traditional portraits, which stopped at the upper torso—is silhouetted against distant mountains, whose desolate grandeur reinforces the painting's mysterious atmosphere.

Defining Art
THE VITRUVIAN MAN

Artists throughout history have turned to geometric shapes and mathematical proportions to seek the ideal representation of the human form. Leonardo da Vinci, and before him Vitruvius, equated the ideal man with both circle and square. Ancient Egyptian artists laid out square grids as aids to design. Medieval artists adapted a variety of figures, from triangles to pentagrams. The Byzantines used circles centered on the bridge of the nose to create face, head, and halo.

The first-century BCE Roman architect and engineer Vitruvius, in his ten-volume *De architectura* (*On Architecture*), wrote: "For if a man be placed flat on his back, with his hands and feet extended, and a pair of compasses centered at his navel, the fingers and toes of his two hands and feet will touch the circumference of a circle described therefrom. And just as the human body yields a circular outline, so too a square figure may be found from it. For if we measure the distance from the soles of the feet to the top of the head, and then apply that measure to the outstretched arms, the breadth will be found to be the same as the height" (Book III, Chapter 1, Section 3). Vitruvius determined that the body should be eight heads high. Leonardo added his own observations in the reversed writing he always used for his notebooks when he created his well-known diagram for the ideal male figure, called the **VITRUVIAN MAN.**

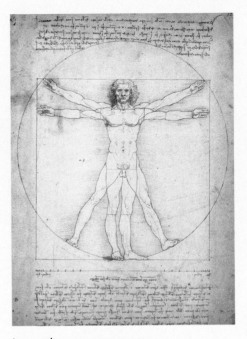

Leonardo **VITRUVIAN MAN**
c. 1490. Ink, 13½ × 9⅝″ (34.3 × 24.5 cm).
Galleria dell'Accademia, Venice.

Mona Lisa's expression has been called enigmatic because her gentle smile is not accompanied by the warmth one would expect to see in her eyes. The contemporary fashion for plucked eyebrows and a shaved hairline to increase the height of the forehead adds to her arresting appearance. Perhaps most unsettling is the bold and slightly flirtatious way her gaze has shifted toward the right to look straight out at the viewer. The implied challenge of her direct stare, combined with her apparent serenity and inner strength, has made the *Mona Lisa* one of the most haunting and consequently one of the most popular and best-known works in the history of art.

A fiercely debated topic in Renaissance Italy was the question of the superiority of painting or sculpture. Leonardo insisted on the supremacy of painting as the best and most complete means of creating an illusion of the natural world, while Michelangelo argued for sculpture. Yet in creating a painted illusion, Leonardo considered color to be secondary to the depiction of sculptural volume, which he achieved through his virtuosity in highlighting and shading. He also unified his compositions by covering them with a thin, lightly tinted varnish, which resulted in a smoky overall haze called *sfumato*. Because early evening light tends to produce a similar effect naturally, Leonardo considered dusk the finest time of day and recommended that painters set up their studios in a courtyard with black walls and a linen sheet stretched overhead to reproduce twilight.

Leonardo's fame as an artist is based on only a few works, for his many interests took him away from painting. Unlike his humanist contemporaries, he was not particularly interested in classical literature or archaeology. Instead, his passions were mathematics, engineering, and the natural world. He compiled volumes of detailed drawings and notes on anatomy, botany, geology, meteorology, architectural design, and mechanics. In his drawings of human figures, he sought not only the precise details of anatomy but also the geometric basis of perfect proportions (see "The Vitruvian Man," above). Leonardo's searching mind is evident in his drawings, not only of natural objects and human beings, but also of machines. His drawings are so clear and complete that modern engineers have been able to construct working models from them. He designed flying machines, a sort of automobile, a parachute, and all sorts of military equipment, including a mobile fortress. His imagination outran his means to bring his creations into being. For one thing, he lacked a source of power other than men and horses. For another, he may have lacked focus and follow-through: His contemporaries complained that he never finished anything and that his inventions distracted him from his painting.

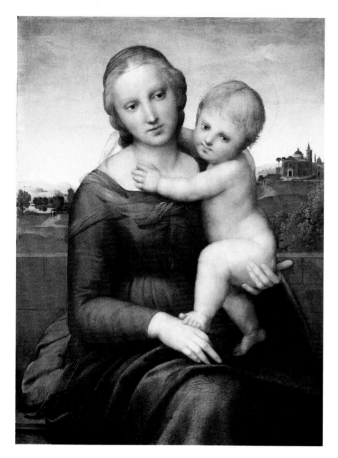

20–5 | Raphael **THE SMALL COWPER MADONNA**
c. 1505. Oil on wood panel, 23⅜ × 17⅜″ (59.5 × 44.1 cm).
National Gallery of Art, Washington, D.C.
Widener Collection (1942.9.57)

RAPHAEL. About 1505, Raphael (Raffaello Santi or Sanzio, 1483–1520) arrived in Florence from his native Urbino. He had studied in Perugia with the leading artist of that city, Perugino (SEE FIG. 19–34). Raphael quickly became successful in Florence, especially with paintings of the Virgin and Child, such as **THE SMALL COWPER MADONNA** (named for a modern owner) of about 1505 (FIG. 20–5). Already a superb painter technically, the youthful Raphael shows his indebtedness to his teacher in the delicate tilt of the figures' heads and the tranquil, even mood that pervades the painting. But Raphael must have studied Leonardo's work to achieve the simple grandeur created by these monumental shapes, the pyramid activated by the spiraling movement of the child, and the figure-enhancing draperies of the Virgin. The solidly modeled forms are softened by the clear, even light of the outdoor setting.

In the distance on a hilltop, Raphael has painted a scene he knew well from his childhood, the domed Church of San Bernardino, two miles outside Urbino. The church contains the tombs of the dukes of Urbino, Federico and Guidobaldo da Montefeltro, and their wives (SEE FIG. 19–28). Donato Bramante, whose architecture was key in establishing the High Renaissance style (see page 677), may have designed the church.

Raphael left Florence about 1508 for Rome, where Pope Julius II put him to work almost immediately decorating rooms (*stanze*, singular *stanza*) in the papal apartments. In the *Stanza della Segnatura*—the papal library, which we saw at the beginning of the chapter (SEE FIG. 20–1)—Raphael painted the four branches of knowledge as conceived in the sixteenth century: Religion (the *Disputà*, depicting the disputation over the true presence of Christ in the Host, the Communion bread), Philosophy (the *School of Athens*), Poetry (*Parnassus*, home of the Muses), and Law (the *Cardinal Virtues under Justice*). The shape of the walls and vault of the room itself inspired the composition of the paintings—for example, the receding arches and vaults in the *School of Athens*, or the inclusion of the window as part of the rocky mountain in *Parnassus*.

Raphael's most outstanding achievement in the papal rooms was the **SCHOOL OF ATHENS,** painted about 1510–11 (FIG. 20–6). Here, the painter seems to summarize the ideals of the Renaissance papacy in his grand conception of harmoniously arranged forms in a rational space, as well as in the calm dignity of its figures. The learned Julius II may have actually devised the subjects painted; he certainly must have approved them.

Viewed through a *trompe l'oeil* arch, the Greek philosophers Plato and Aristotle—placed to the right and left of the compositional vanishing point—are silhouetted against the sky (the natural world) and command our attention. At the left, Plato gestures upward, indicating the "ideal" as impossible to attain on earth. Aristotle, with his outstretched hand palm down, seems to emphasize the importance of gathering empirical knowledge from observing the material world. Looking down from niches in the walls are sculptures of Apollo, the god of sunlight, rationality, poetry, music, and the fine arts; and Minerva, the goddess of wisdom and the mechanical arts. Around Plato and Aristotle are mathematicians, naturalists, astronomers, geographers, and other philosophers debating and demonstrating their theories to onlookers and to each other. The scene, flooded with a clear, even light from a single source, takes place in an immense barrel-vaulted interior, possibly inspired by the new design for Saint Peter's, under construction at the time. The grandeur of the building is matched by the monumental dignity of the philosophers themselves, each of whom has a distinct physical and intellectual presence. The sweeping arcs of the composition are activated by the variety and energy of the poses and gestures of these striking individuals. Such dynamic unity is an expression of the High Renaissance style.

Raphael continued to work for Julius II's successor, Leo X (papacy 1513–21), as director of all archaeological and architectural projects in Rome. Leo was born Giovanni de' Medici, the son of Lorenzo the Magnificent, and his driving ambition was the advancement of the Medici family—who had been exiled from Florence in 1494 and only returned to power there in 1512. Raphael's portrait of Leo X is, in effect,

20–6 | Raphael **SCHOOL OF ATHENS**
Fresco in the Stanza della Segnatura, Vatican, Rome. c. 1510–11. 19 × 27′ (5.79 × 8.24 m).

Raphael gave many of the figures in his imaginary gathering of philosophers the features of his friends and colleagues. It is speculated that Plato, standing immediately to the left of the central axis and pointing to the sky, was modeled after Leonardo da Vinci; Euclid, shown inscribing a slate with a compass at the lower right, was, according to Vasari, a portrait of Raphael's friend the architect Donato Bramante. Michelangelo, who was at work on the Sistine Chapel ceiling, only steps away from the *stanza* where Raphael was painting his fresco, may be the solitary figure at the lower left center, leaning on a block of marble and sketching, in a pose reminiscent of the figures of the sibyls and prophets on his great ceiling. Raphael's own features are represented on the second figure from the front group at the far right, as the face of a young man listening to a discourse by the astronomer Ptolemy.

a dynastic group portrait (FIG. 20–7). Facing the pope at the left is his cousin Giulio, Cardinal de' Medici, who governed Florence from 1519 to 1523 and then became Pope Clement VII (papacy 1523–34). Behind Pope Leo stands Luigi de' Rossi, a nephew whom he made a cardinal. Dressed in splendid brocades and enthroned in a velvet chair, the pope looks up from a richly illuminated fourteenth-century manuscript that he has been examining with a magnifying glass. He seems to stare into space, and, curiously, none of the three men look at each other. The mood seems uneasy, disconnected. Raphael carefully depicted the contrasting textures and surfaces in the picture, including the visual distortion caused by the magnifying glass on the book page. The polished brass knob on the

pope's chair reflects the window and the painter himself. In these telling details, Raphael acknowledges his debt—despite great stylistic differences—to fifteenth-century Flemish artists such as Jan van Eyck.

How could a man—even a brilliant artist—accomplish so much? Raphael was only 37 when he died. The answer lies partly in Raphael's genius for organizing his studio, which enabled him to accept numerous commissions. Retaining a flexible method, Raphael was able to assign assistants wherever he felt it was appropriate, even if that meant finishing major figures in a painting or making preparatory drawings—work generally assumed by the master. Raphael thus freed himself to concentrate on what he considered most necessary at any given

20-7 Raphael **POPE LEO X WITH CARDINALS GIULIO DE' MEDICI AND LUIGI DE' ROSSI** c. 1517. Oil on wood panel, 5'⅝" × 3'10⅞" (1.54 × 1.19 m). Galleria degli Uffizi, Florence.

time. This method sometimes resulted in uneven products, especially toward the end of the artist's short life, when he was overwhelmed with work. Yet, even then, Raphael's major pieces show his contribution to be the dominant one.

In 1515–16, Raphael and his shop provided cartoons on themes from the Acts of the Apostles to be made into tapestries to cover the wall below the fifteenth-century wall paintings of the Sistine Chapel (FIG. 20–8). This commission must have suited Raphael's method, accustomed as he was to teamwork. For the production of tapestries, which were woven in workshops in Flanders, artists made full-scale charcoal drawings, then painted over them with glue-based colors for the weavers to match. Pictorial weaving was the most prestigious and expensive kind of wall decoration. With murals by the leading painters of the fifteenth century above and Michelangelo circling over all, Raphael must have felt the challenge. The pope had given him the place of honor among the artists in the papal chapel.

The first tapestry in Raphael's series was the **MIRACULOUS DRAFT OF FISHES** on the Sea of Galilee (Matt. 4:18–22). The fisherman Simon, whom Christ called to be his first apostle, Peter, became the cornerstone on which the papal claims to authority rested. Andrew, James, and John would also become apostles. The two boats establish a friezelike composition, and

20-8 Shop of Pieter van Aelst, Brussels, after cartoons by Raphael and assistants **MIRACULOUS DRAFT OF FISHES** 1515-16. From the nine-piece set, the *Acts of the Apostles* series; lower border, two incidents from the life of Giovanni de' Medici, later Pope Leo X. Woven 1517, installed 1519 in the Sistine Chapel. Wool and silk with silver-gilt wrapped threads, 16'1" × 21' (4.9 × 6.4 m). Musei Vaticani, Pinacoteca, Rome.

Raphael's *Acts of the Apostles* cartoons were used as the models for several sets of tapestries woven in van Aelst's Brussels shop, including one for Francis I of France and another for Henry VIII of England. In 1630, the Flemish painter Peter Paul Rubens (Chapter 22) discovered seven of the ten original cartoons in the home of a van Aelst heir and convinced his patron Charles I of England to buy them. Still part of the British royal collection today, they are exhibited at the Victoria & Albert Museum in London. The original tapestries were stolen during the Sack of Rome in 1527, returned in the 1530s, taken to Paris by Napoleon in 1798, purchased by a private collector in 1808, and returned to the Vatican as a gift that year. They are now displayed in the Raphael Room of the Vatican Painting Gallery.

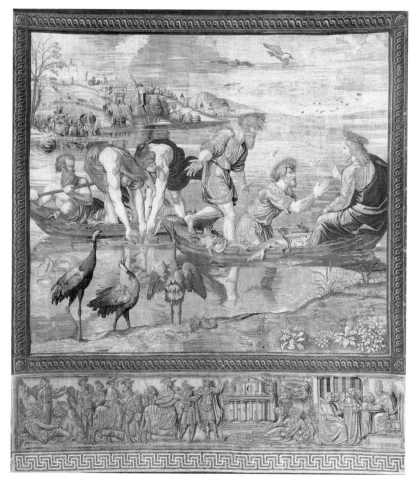

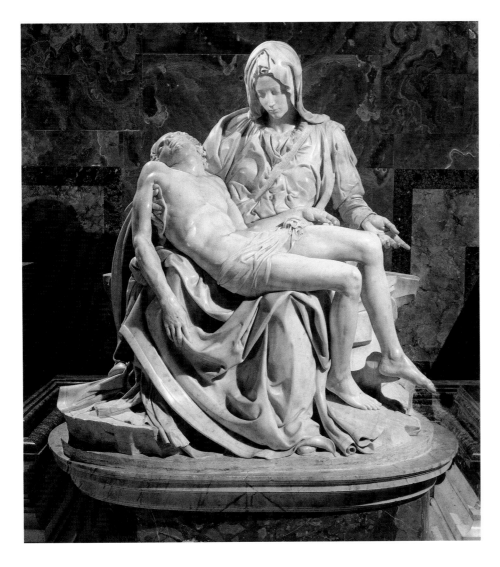

20–9 | Michelangelo **PIETÀ**
c. 1500. Marble, height 5′8½″
(1.74 m). Saint Peter's, Vatican,
Rome.

the huge straining figures remind us that Raphael felt himself in clear competition with Michelangelo, whose Sistine ceiling had been completed only three years earlier. Raphael studied not only his contemporaries' paintings, but also antique sources in his efforts to achieve both monumentality and realism. For example, he copied the face of Christ from a fifteenth-century bronze copy of an ancient emerald cameo, which at the time was thought to be the true portrait of Jesus. The panoramic landscape behind the fishermen includes a crowd on the shore, and the city of Rome with its walls and churches. The three cranes in the foreground were not a simple pictorial device; in the sixteenth century they symbolized the ever-alert and watchful pope. The cranes proved to be a timely addition. When the tapestries were first displayed in the Sistine Chapel on December 26, 1519, papal authority was already being challenged by reformers like Martin Luther in Germany (see Chapter 21).

MICHELANGELO'S EARLY WORK. Michelangelo Buonarroti (1475–1564) was born in the Tuscan town of Caprese into an impoverished Florentine family that laid claim to nobility: a claim the artist carefully advanced throughout his life. He grew up in Florence, and spent his long career working there and in Rome. At thirteen, he was apprenticed to Ghirlandaio (SEE FIG. 19–36), in whose workshop he learned the rudiments of fresco painting and studied drawings of classical monuments. Soon the talented youth joined the household of Lorenzo the Magnificent, head of the ruling Medici family, where he came into contact with the Neoplatonic philosophers and studied sculpture with Bertoldo di Giovanni, a pupil of Donatello. Bertoldo worked primarily in bronze, and Michelangelo later claimed that he had taught himself to carve marble by studying the Medici collection of classical statues. After Lorenzo died in 1492, Michelangelo traveled to Venice and Bologna, then returned to Florence, where he fell under the spell of the charismatic preacher Fra Girolamo Savonarola (see Chapter 19). The preacher's execution for heresy in 1498 had a traumatic effect on Michelangelo, who said in his old age that he could still hear the sound of Savonarola's voice.

Michelangelo's major early work at the turn of the century was a **pietà** marble sculpture group, commissioned by a French cardinal and installed as a tomb monument in the Vatican basilica of Saint Peter (FIG. 20–9). The pietà—in

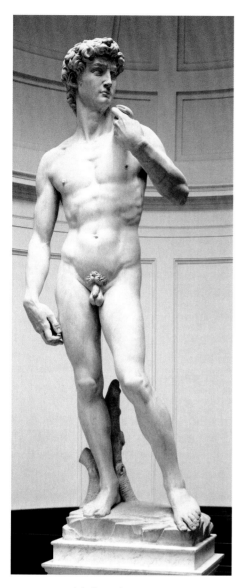 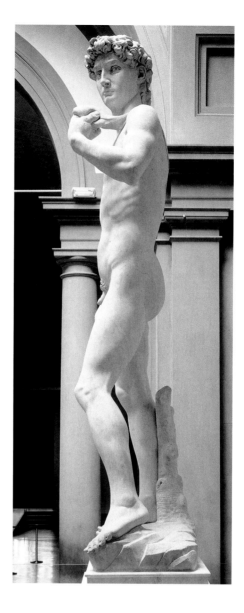

20–10 | Michelangelo **DAVID**
1501–04. Marble, height 17' (5.18 m) without pedestal. Galleria dell'Accademia, Florence.

Michelangelo's most famous sculpture was cut from an 18-foot-tall marble block. The sculptor began with a small model in wax, then sketched the contours of the figure as they would appear from the front on one face of the marble. Then, according to his friend and biographer Vasari, he chiseled in from the drawn-on surface, as if making a figure in very high relief. The completed statue took four days to move on tree-trunk rollers down the narrow streets of Florence from the premises of the cathedral shop where he worked to its location outside the Palazzo della Signoria (SEE FIG. 17-2). In 1504, the Florentines gilded the tree stump and added a gilded wreath to the head and a belt of twenty-eight gilt-bronze leaves, since removed. In 1873 the statue was replaced by a copy, and the original was moved into the museum of the Florence Academy.

which the Virgin supports and mourns the dead Jesus—had long been popular in northern Europe but was an unusual theme in Italian art at the time. Michelangelo traveled to the marble quarries at Carrara in central Italy himself to select the block from which to make this large work, a practice he was to follow for nearly all of his sculpture. His choice of stone was important, for Michelangelo envisioned the statue as already existing within the marble and needing only to be "set free" from it. Michelangelo was a poet as well as an artist, and later wrote in his Sonnet 15:

"The greatest artist has no conception which a single block of marble does not potentially contain within its mass, but only a hand obedient to the mind can penetrate to this image" (1536–47).

Michelangelo's *Pietà* is a very young Virgin of heroic stature holding the lifeless, smaller body of her grown son. The seeming inconsistencies of age and size are forgotten in contemplating the sweetness of expression, the finely finished surfaces, and the softly modeled forms. Michelangelo's compelling vision of beauty is meant to be seen up close, from

directly in front of the statue and on the statue's own level, so that the viewer can look into Jesus's face. The 25-year-old artist is said to have slipped into the church at night to sign the finished sculpture, to answer the many questions about its creator. It is the only signature of Michelangelo's that has not been disputed.

In 1501, Michelangelo accepted a commission for a statue of one of the symbols of Florence, the biblical **DAVID** (FIG. 20–10), to be placed high atop a buttress of the Cathedral. When it was finished in 1504, the David was so admired that the city council instead placed it at eye-level in the square next to the Palazzo Vecchio, the seat of Florence's government. There it stood as a reminder of Florence's republican status, which was briefly reinstated after the expulsion of the powerful Medici oligarchy in 1494. Although, in its muscular nudity, Michelangelo's *David* embodies the athletic ideal of antiquity—particularly of Hellenistic sculptures of Hercules (another symbol of Florence)—the emotional power of its expression and its concentrated gaze is entirely new. Unlike Donatello's bronze *David* (SEE FIG. 19–13), this is not a triumphant hero with the head of the giant Goliath under his feet. Instead, slingshot over his shoulder and a rock in his right hand, Michelangelo's *David* frowns and stares into space, seemingly preparing himself psychologically for the danger ahead, a mere youth confronting a gigantic experienced warrior. Here the male nude implies heroic or even divine qualities, as it did in classical antiquity. Traditionally no match for his opponent in experience, weaponry, or physical strength, Michelangelo's powerful *David* represents the supremacy of right over might—a perfect emblematic figure for the Florentines, who recently had fought the forces of Milan, Siena, and Pisa and still faced political and military pressure.

THE SISTINE CHAPEL. Despite Michelangelo's contractual commitment to the Florence Cathedral for statues of the apostles, in 1505 Pope Julius II, who saw Michelangelo as an ideal collaborator in the artistic aggrandizement of the papacy, arranged for him to come to Rome to work on the spectacular tomb-monument Julius planned for himself. Michelangelo began the new project, but two years later in 1506 the pope put this commission aside and ordered him to paint the **SISTINE CHAPEL CEILING** instead (FIG. 20–11).

Michelangelo considered himself a sculptor, but the strong-minded pope wanted his chapel painted and paid Michelangelo well for the work, which began in 1508. Michelangelo complained bitterly in a sonnet to a friend: "This miserable job has given me a goiter . . . The force of it has jammed my belly up beneath my chin. Beard to the sky . . . Brush splatterings make a pavement of my face . . . I'm not a painter." Despite his physical misery as he stood on a scaffold, painting the ceiling just above him, he achieved the

Sequencing Events
REIGNS OF THE GREAT PAPAL PATRONS OF THE SIXTEENTH CENTURY

1492–1503	Alexander VI (Borgia)
1503–13	Julius II (della Rovere)
1513–21	Leo X (Medici)
1523–34	Clement VII (Medici)
1534–49	Paul III (Farnese)
1585–90	Sixtus V (Peretti)

desired visual effects for viewers standing on the floor far below. His Sistine Chapel ceiling frescoes established a new and extraordinarily powerful style in Renaissance painting.

Julius's initial order for the ceiling was simple: *trompe l'oeil* coffers to replace the original star-spangled blue ceiling. Later he wanted the twelve apostles seated on thrones to be painted in the triangular walls between the lunettes framing the windows. According to Michelangelo, when he objected to the limitations of Julius's plan, the pope told him to paint whatever he liked. This Michelangelo presumably did, although a commission of this importance probably involved an adviser in theology. Certainly it required the pope's approval. Then, as master painter, Michelangelo assembled a team of expert assistants, who probably continued to work with him under close supervision.

In Michelangelo's final composition, illusionistic marble architecture establishes a framework for the figures on the vault of the chapel (FIG. 20–12). Running completely around the ceiling is a painted cornice with projections supported by short pilasters decorated with *putti*. Set within this frame are figures of Old Testament prophets and classical sibyls (female prophets) who were believed to have foretold Jesus's birth. Seated on the fictive cornice are heroic figures of nude young men, called *ignudi* (singular, *ignudo*), holding sashes attached to large gold medallions. Rising behind the *ignudi*, shallow bands of fictive stone span the center of the ceiling and divide it into compartments in which are painted scenes of the Creation, the Fall, and the Flood. The narrative sequence begins over the altar and ends near the chapel entrance (FIG. 20–13). God's earliest acts of creation are therefore closest to the altar, the Creation of Eve at the center of the ceiling, followed by the imperfect actions of humanity: the Temptation, the Fall, the Expulsion from Paradise, and God's eventual destruction of all people except Noah and his family by the Flood. The triangular spandrels contain paintings of the ancestors of Jesus; each is flanked by mirror-image nudes in reclining and seated poses.

According to discoveries during the most recent restoration, Michelangelo worked on the ceiling in two

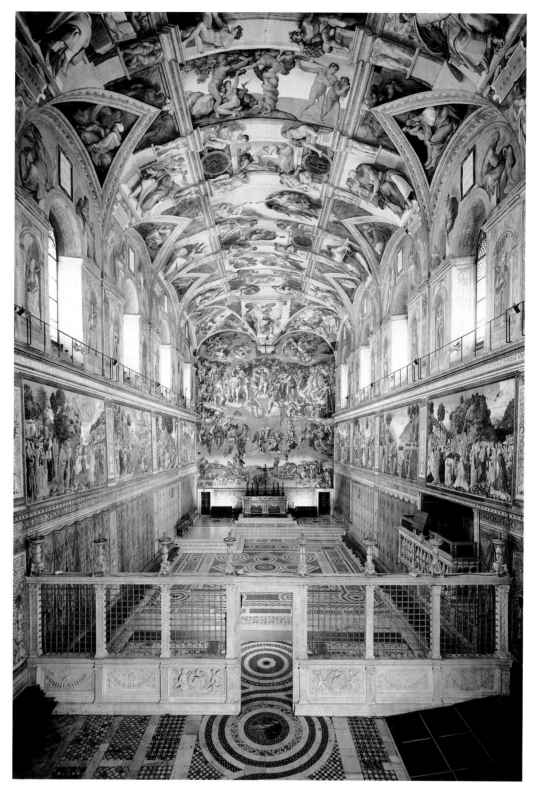

20–11 | **INTERIOR, SISTINE CHAPEL**
Vatican, Rome. Built 1475–81; ceiling painted 1508–12; end wall, 1536–41. The ceiling measures
45 × 128′ (13.75 × 39 m).

Named after its builder, Pope Sixtus (Sisto) IV, the chapel is slightly more than 130 feet long and about 143½ feet wide, approximately the same measurements recorded in the Old Testament for the Temple of Solomon. The floor mosaic was recut from the colored stones used in the floor of an earlier papal chapel. The walls were painted in fresco between 1481 and 1483 with scenes from the lives of Moses and Jesus by Perugino (SEE FIG. 19-34), Botticelli, Ghirlandaio, and others. Below these are *trompe l'oeil* painted draperies, where Raphael's tapestries illustrating the Acts of the Apostles once hung (SEE FIG. 20-8). Michelangelo's famous ceiling frescoes begin with the lunette scenes above the windows. On the end above the altar is his *Last Judgment* (SEE FIG. 20-28).

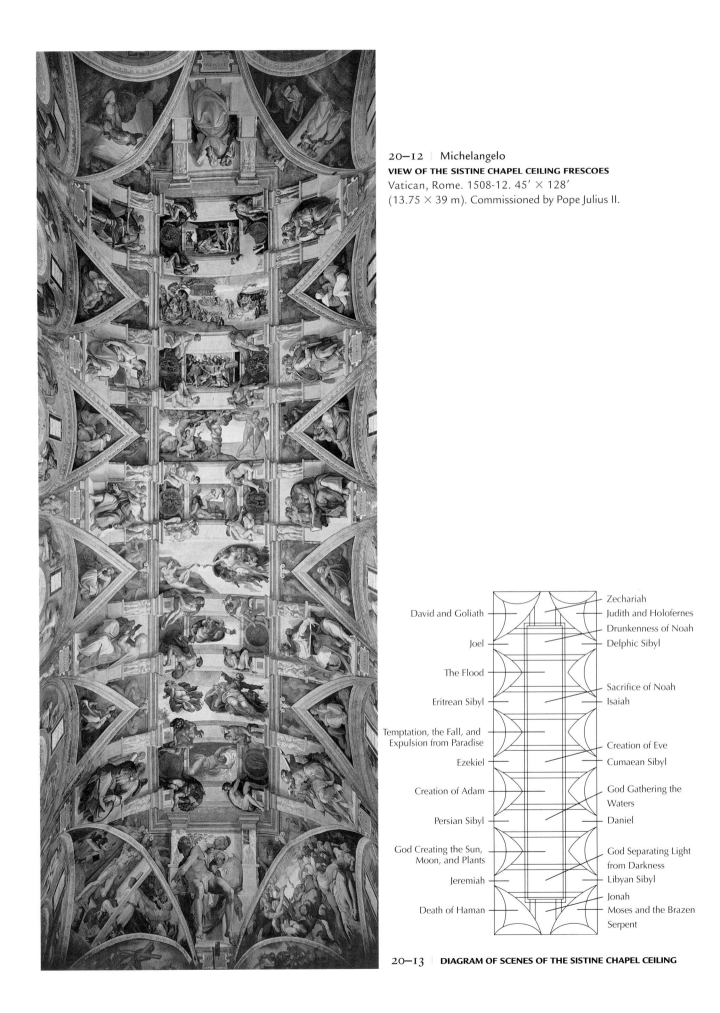

20–12 | Michelangelo
VIEW OF THE SISTINE CHAPEL CEILING FRESCOES
Vatican, Rome. 1508-12. 45′ × 128′
(13.75 × 39 m). Commissioned by Pope Julius II.

Zechariah
David and Goliath
Judith and Holofernes
Drunkenness of Noah
Joel
Delphic Sibyl
The Flood
Sacrifice of Noah
Eritrean Sibyl
Isaiah
Temptation, the Fall, and
Expulsion from Paradise
Creation of Eve
Ezekiel
Cumaean Sibyl
Creation of Adam
God Gathering the
Waters
Persian Sibyl
Daniel
God Creating the Sun,
Moon, and Plants
God Separating Light
from Darkness
Jeremiah
Libyan Sibyl
Jonah
Death of Haman
Moses and the Brazen
Serpent

20–13 | **DIAGRAM OF SCENES OF THE SISTINE CHAPEL CEILING**

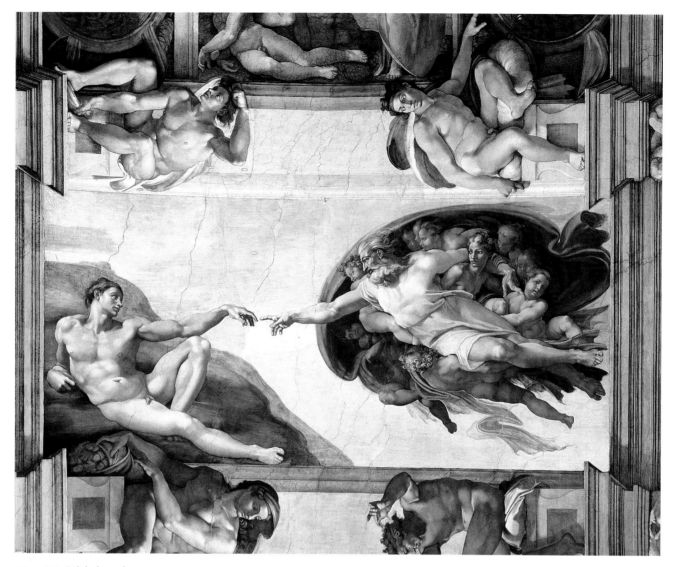

20–14 | Michelangelo **CREATION OF ADAM, SISTINE CHAPEL CEILING** 1511–12.

The *Creation of Adam,* which opens the second stage of Michelangelo's fresco cycle, has the simplified background and the powerful male figures, and nude youths twisting into contrapposto poses characteristic of this phase of his work. Stylus marks above Adam's head show where the artist transferred his design onto the wet plaster.

stages, beginning in the late summer or fall of 1508 and moving from the chapel's entrance toward the altar, in reverse of the narrative sequence. The first half of the ceiling up to the Creation of Eve was unveiled in August 1511 and the second half in October 1512. His style became broader and the composition simpler as he progressed.

Perhaps the most familiar scene on the ceiling is the **CREATION OF ADAM** (FIG. 20–14). Here Michelangelo depicts the moment when God charges the languorous Adam with the spark of life. As if to echo the biblical text, Adam's

heroic body and pose mirror those of God, in whose image he has been created. Directly below Adam is an *ignudo* grasping a bundle of oak leaves and giant acorns, which refer to Pope Julius's family name (della Rovere, or "of the oak") and possibly also to a passage in the Old Testament prophecy of Isaiah (61:3): "They will be called oaks of justice, planted by the Lord to show his glory."

MICHELANGELO'S LATER SCULPTURE. Michelangelo's first papal sculpture commission, the tomb of Julius II, still incomplete at

Julius's death in 1513, was to plague him and his patrons for forty years. In 1505, he had presented his first designs to the pope for a huge freestanding structure crowned by the pope's sarcophagus and covered with more than forty statues and reliefs in marble and bronze. But Julius had halted the tomb project to divert money toward other ends. After Julius died, his heirs soon began to cut back on the expense and size of the tomb. At this time, between 1513 and 1516, and again from 1542 to 1545, Michelangelo worked on the figure of **MOSES** (FIG. 20–15), the only sculpture from the original design to be incorporated into the final, much-reduced monument to Julius II. No longer an actual tomb—Julius was buried elsewhere—the monument was installed in 1545, after decades of wrangling, in the Church of San Pietro in Vincoli, Rome, where Julius had been the cardinal. In the original design, Moses was to have been one of four seated figures; in the final configuration, however, Moses becomes the focus of the monument and a stand-in for the long-dead pope.

Moses is an inspired figure, a prophet holding the tablets of the Law, which he has just received from God on Mount Sinai. Like the prophets on the Sistine Chapel ceiling, his gigantic muscular figure, swathed in great sheets of drapery, is seated in a restless contrapposto that seems to strain the confines of the niche. Moses's beard is an extraordinary curling, flowing mass that covers his chest. Michelangelo's carving of this beard as it is drawn aside by a finger is a tour de force of marble sculpture.

After the Medici regained power in Florence in 1512, and Leo X succeeded Julius in 1513, Michelangelo became chief architect for Medici family projects at the Church of San Lorenzo in Florence—including a new chapel for the tombs of Lorenzo the Magnificent, his brother Giuliano, and two younger dukes, also named Lorenzo and Giuliano, ordered in 1519. The older men's tombs were never built to Michelangelo's designs, but the unfinished tombs for the younger relatives were placed on opposite side walls of the so-called New Sacristy (FIG. 20–16). The Old Sacristy, by Filippo Brunelleschi, is at the other end of the transept (SEE FIG. 19–3).

In the New Sacristy, each of the two monuments consists of an idealized portrait of the deceased, who turns to face the family's unfinished ancestral tomb. The men are dressed in a sixteenth-century interpretation of classical armor and seated in niches above pseudoclassical sarcophagi. Balanced precariously atop the sarcophagi are male and female figures representing the times of day. Their positions would not seem so unsettling had reclining figures of river gods been installed below them, as originally planned. Giuliano represents the Active Life, and his sarcophagus figures are allegories of Night and Day. Night is accompanied by her symbols: a star and crescent moon on her tiara; poppies, which induce sleep; and an owl under the arch of her leg. The huge mask at her back may allude to Death, since Sleep and Death were said to be the children of Night. Lorenzo, representing the

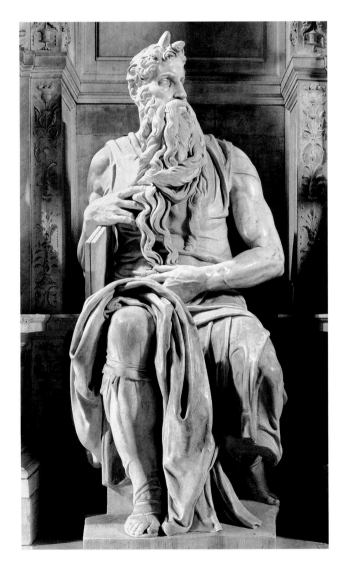

20–15 Michelangelo **MOSES**
Tomb of Julius II. 1513–16, 1542–45. Marble, height 7′8½″ (2.35 m). Church of San Pietro in Vincoli, Rome.

20–16 | Michelangelo **NEW SACRISTY (MEDICI CHAPEL)**
1519–34. Church of San Lorenzo, Florence.

Looking from the altar, we see on the left the tomb of Giuliano de' Medici, with Giuliano seated in the niche and
personifications of Day and Night reclining on the pseudo-classical sarcophagus; on the right, the tomb of Lorenzo with the
personifications of Dusk and Dawn. Facing the altar is the unfinished tomb of Lorenzo the Magnificent with the "Medici
Madonna" in the center and the Medici patron saints, Sts. Cosmas and Damian, at each side.

Contemplative Life, is supported by Dawn and Evening. The
allegorical figures for the empty niches that flank the tombs
were never carved. The walls of the sacristy are articulated
with Brunelleschian *pietra serena* pilasters and architraves in
the Corinthian order.

Ongoing political struggles in Florence interrupted
Michelangelo's work. In 1534, detested by the new Duke
of Florence and fearing for his life, Michelangelo returned
to Rome, where he settled permanently. He had left the
Medici chapel unfinished. Many years later, in 1545, his
students assembled the tomb sculptures, including unfin-
ished figures of the times of day, into the composition we
see today. The figures of the dukes are finely finished, but
the times of day are notable for their contrasting areas of
rough unfinished and polished marble. These are the only
unfinished sculptures Michelangelo may have permitted to
be put in place, and we do not know what his reasons were.
Michelangelo specialists call this his *nonfinito* ("unfin-
ished") quality, suggesting that he had begun to view his
artistic creations as symbols of human imperfection.
Indeed, Michelangelo's poetry often expressed his belief
that humans could achieve perfection only in death.
The lack of finish may also reflect his belief that the block
of marble held the image prisoner within it. Some of

Michelangelo's unfinished sculptures were placed in the Great Grotto of the Boboli Gardens in Florence (see "The Grotto," right).

Michelangelo's style continued to evolve throughout his career in sculpture, painting, and architecture, and he produced significant works until his death in 1564. We will return to him later in this chapter to examine his further development and his direct influence on artists of the later sixteenth century.

Architecture in Rome and the Vatican

The election of Julius II as pope in 1503 crystallized a resurgence of the papal power. France, Spain, and the Holy Roman Empire all had designs on Italy. The political turmoil that beset Florence, Milan, and other northern cities left Rome as Italy's most active artistic and intellectual center. During the ten years of his reign, Julius fought wars and formed alliances to consolidate his power. And in addition to commissioning large painting programs and sculpture projects, he also enlisted the artists Bramante, Raphael, and Michelangelo as architects to carry out his vision of revitalizing Rome and the Vatican, the pope's residence, as the center of a new Christian art based on classical forms and principles.

Inspired by the achievements of their fifteenth-century predecessors as well as the monuments of antiquity, architects working in Rome created a new ideal classical style typified by the architecture of Bramante. The first-century Roman architect and engineer Vitruvius wrote a treatise on classical architecture (see "The Vitruvian Man," page 665) that became an important source for sixteenth-century Italian architects. Although most commissions were for churches, opportunities also arose to build urban palaces and country villas.

BRAMANTE. Donato Bramante (1444–1514) was born near Urbino and trained as a painter, but turned to architectural design early in his career. Earlier in this chapter, we saw a church attributed to him, the Church of San Bernardino near Urbino, in the landscape background of Raphael's *Small Cowper Madonna* (SEE FIG. 20–5). About 1481, he became attached to the Sforza court in Milan, where he would have known Leonardo da Vinci. In 1499, Bramante settled in Rome, but work came slowly. The architect was nearing sixty when, according to a dedicatory inscription, the Spanish rulers Queen Isabella and King Ferdinand commissioned a small shrine over the spot in Rome where the apostle Peter was believed to have been crucified (FIG. 20–17). In this tiny building, known as the TEMPIETTO ("Little Temple"), Bramante combined his interpretation of the principles of Vitruvius and the fifteenth-century architect Leon Battista Alberti, from the stepped base to the Doric columns and frieze (Vitruvius had advised that the Doric order be used for temples to gods of particularly forceful character) to the elegant balustrade. The centralized plan and the tall drum, or

Elements of Architecture
THE GROTTO

Of all the enchanting features of Renaissance gardens, none is more intriguing than a *grotto*, a recess typically constructed of irregular stones and shells and covered with fictive foliage and slime to suggest a natural cave. The fancifully decorated grotto usually included a spring, pool, fountain, or other waterworks. Sculpture of earth giants might support its walls, and depictions of nymphs might suggest the source of the water that nourished the garden. Great Renaissance gardens had at least one grotto where one could commune with nymphs and Muses and escape the summer heat. Alberti recommended that the contrived grotto be covered "with green wax, in imitation of mossy Slime which we always see in moist grottoes" (Alberti, *On Architecture*, 9.4).

The Great Grotto of the Boboli Gardens of the Pitti Palace in Florence, designed by Bernardo Buontalenti in 1583 and constructed in 1587-93, contained four marble captives (originally conceived for the tomb of Pope Julius II) carved by Michelangelo and, in its inner cave, a 1592 copy of *Astronomy* (or *Venus Urania* by Giovanni da Bologna (SEE FIG. 20–41). Flowing water operated fountains, hydraulic organs, and other devices, such as mechanical birds that fluttered their wings and chirped or sang, filling the grotto with noise, if not music. Water jets concealed in the floor, stairs, or crevasses in the rockwork could be turned on by the owner to drench his guests, to the great amusement of all.

Bernardo Buontalenti **THE GREAT GROTTO, BOBOLI GARDENS, PITTI PALACE, FLORENCE**
1583-93. Sculpture by Michelangelo.

20–17 | Donato Bramante **TEMPIETTO, CHURCH OF SAN PIETRO IN MONTORIO**
Rome. 1502–10; dome and lantern were restored in the 17th century.

20–18 | Antonio da Sangallo the Younger and Michelangelo
PALAZZO FARNESE, ROME
1517–50. When Sangallo died in 1546, Michelangelo added the third floor and cornice.

circular wall, supporting a hemispheric dome recall early Christian shrines built over martyrs' relics, as well as ancient Roman circular temples. Especially notable is the sculptural effect of the building's exterior, with its deep wall niches creating contrasts of light and shadow, and the Doric frieze of carved papal emblems. Bramante's design called for a circular cloister around the church, but the cloister was never built.

Shortly after Julius II's election as pope, he commissioned Bramante to renovate the Vatican Palace. Julius also appointed him chief architect of a project to replace Saint Peter's Basilica (see "Saint Peter's Basilica," right).

THE ROMAN PALACE. Sixteenth-century Rome was more than a city of churches and public monuments. Wealthy families, many of whom had connections with the pope or the cardinals—the "princes of the church"—commissioned architects to design residences to enhance their prestige. For example, Cardinal Alessandro Farnese (who became Pope Paul III in 1534) set Antonio da Sangallo the Younger (1484–1546) the task of rebuilding the **PALAZZO FARNESE** into the largest, finest palace in Rome (FIG. 20–18). The main façade of the great rectangular building faces a public square—which was created by tearing down blocks of

houses. The massive central door is emphasized by elaborate rusticated stonework (as are the building's corners, where the shaped stones are known as **quoins**) and is surmounted by a balcony suitable for ceremonial appearances, over which is set the **cartouche** (a decorative plaque) with the Farnese coat of arms—lilies. The palace's three stories are clearly defined by two horizontal bands of stonework, or stringcourses. Windows are treated differently on each story: on the ground floor, the twelve windows sit on supporting brackets. The story directly above is known in Italy as the *piano nobile*, or first floor (Americans would call it the second floor), which contains large and richly decorated reception rooms. Its twelve windows are decorated with alternating triangular and arched pediments supported by pairs of engaged half-columns in the Corinthian order. The second floor (or American third floor) has windows all with triangular pediments whose supporting Ionic half columns are set on brackets echoing those under the windows on the ground floor. At the back, a loggia overlooks a garden and the Tiber River. Annibale Carracci painted the loggia in 1597–1601 (SEE FIG. 22–13). When Sangallo died, the pope turned work on the palace over to Michelangelo, who added focus to the building by emphasizing the portal and gave it added dignity by increasing the height of the top story, capping the building with a magnificent cornice.

Great patrons of the arts were also great collectors of antiquities, none greater than Farnese, and none more generous to artists wanting to study. The Farnese *Hercules* stood in the courtyard, to impress visitors with the extensive collection of antiquities—and the erudition—of the owner (Figs. 23, 24, Introduction). Imagine walking into the Farnese Palace; then identify with the two "tourists" who come upon the colossal figure. The Farnese *Hercules*, along with the *Laocoön* and other discoveries by sixteenth-century art excavators, created new

Elements of Architecture
SAINT PETER'S BASILICA

The history of Saint Peter's in Rome is an interesting case of the effects of individual and institutional demands on the practical congregational needs of a major religious building. The original church, now referred to as Old Saint Peter's, was built in the fourth century CE by Constantine, the first Christian Roman emperor, to mark the grave of the apostle Peter, the first bishop of Rome and therefore the first pope. Because the site was considered the holiest in Europe, Constantine's architect had to build a structure large enough to house Saint Peter's tomb and to accommodate the crowds of pilgrims who came to visit it. To provide a platform for the church, a huge terrace was cut into the side of the Vatican Hill, across the Tiber River from the city. Here Constantine's architect erected a basilica, with a new feature, a transept, to allow large numbers of visitors to approach the shrine at the front of the apse. The rest of the church was, in effect, a covered cemetery, carpeted with the tombs of believers who wanted to be buried near the apostle's grave. When it was built, Constantine's basilica, as befitted an imperial commission, was one of the largest buildings in the world (interior length 368 feet; width 190 feet), and for more than a thousand years it was the most important pilgrim shrine in Europe.

In 1506, Pope Julius II made the astonishing decision to demolish the Constantinian basilica, which had fallen into disrepair, and to replace it with a new building. That anyone, even a pope, had the nerve to pull down such a venerated building is an indication of the extraordinary sense of assurance of the age—and of Julius himself. To design and build the new church, the pope appointed Donato Bramante. Bramante envisioned the new Saint Peter's as a central-plan building, in this case a Greek cross (with four arms of equal length) crowned by an enormous dome. This design was intended to continue the tradition of domed and round *martyria* (martyrs' shrines). In Renaissance thinking, the central plan and dome symbolized the perfection of God.

The deaths of pope and architect in 1513 and 1514 put a temporary halt to the project. Successive plans by Raphael, Antonio da Sangallo, and others changed the Greek cross to a Latin cross (with three shorter arms and one long one) to provide the church with a full-length nave. However, when Michelangelo was appointed architect in 1546, he returned to the Greek-cross plan. Michelangelo simplified Bramante's design to create a single, unified space covered with a hemispherical dome. The dome was finally completed some years after Michelangelo's death by Giacomo della Porta, who retained Michelangelo's basic design but gave the dome a taller profile (SEE FIG. 20–29).

During the Counter-Reformation, the Church emphasized congregational worship, so more space was needed to house the congregation and allow for processions. To expand the church—and to make it more closely resemble Old Saint Peter's—Pope Paul V in 1606 commissioned the architect Carlo Maderno to change Michelangelo's Greek-cross plan to a Latin-cross plan. Maderno extended the nave to its final length of slightly more than 636 feet and added a new façade, thus completing Saint Peter's as it is today. Later in the seventeenth century, the sculptor and architect Gianlorenzo Bernini changed the approach to the basilica by creating an enormous piazza. In the twentieth century a wide avenue was built joining the piazza and the Tiber River.

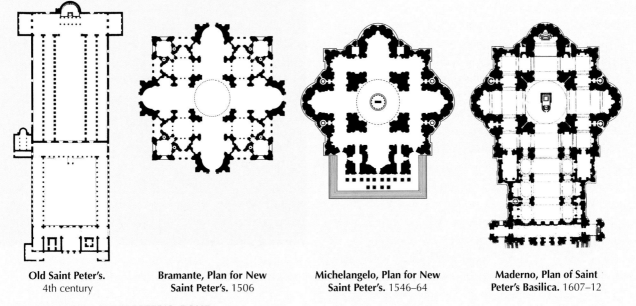

Old Saint Peter's.
4th century

Bramante, Plan for New Saint Peter's. 1506

Michelangelo, Plan for New Saint Peter's. 1546–64

Maderno, Plan of Saint Peter's Basilica. 1607–12

FOUR PLANS OF SAINT PETER'S, ROME

ideals for the contemporary artists. Like our two gentlemen, once having seen these extraordinary muscle men their view of art would be forever changed. Who could return to the bony figure of Jan van Eyck's Adam?

Architecture and Painting in Northern Italy

While Rome ranked as Italy's preeminent arts center at the beginning of the sixteenth century, wealthy and powerful families elsewhere in Italy also patronized the arts and letters, just as the Montefeltro had in Urbino and the Gonzaga had in Mantua during the fifteenth century. Their architects created fanciful structures and their painters developed a new colorful, illusionistic style—witty, elegant, and finely executed art designed to appeal to the jaded taste of the intellectual elite of Mantua, Parma, and Venice.

GIULIO ROMANO. In Mantua, Federigo II Gonzaga (ruled 1519–40) continued the family tradition of patronage when in 1524 he lured a Roman architect and follower of Raphael, Giulio Romano (c. 1499–1546), to Mantua to build a pleasure palace. The **PALAZZO DEL TÈ** (FIG. 20–19) is not "serious" architecture and was never meant to be. Giulio Romano devoted more space in his design to gardens, pools, and stables than he did to rooms for living—and partying. Federigo and his erudite friends would have known classical orders and proportions so well that they could appreciate this travesty of classical ideals—visual jokes such as lintels masquerading as arches and dropped triglyphs. The building itself is skillfully constructed. Later architects and scholars have studied the palace, with its sophisticated humor and exquisite craft, as a precursor to Mannerism or as Mannerist itself (see page 692).

Giulio Romano continued his witty play on the classics in the decoration of the two principal rooms. One, dedicated to the loves of the gods, depicted the marriage of Cupid and Psyche. The other room is a remarkable feat of *trompe l'oeil* painting in which the entire building seems to be collapsing about the viewer as the gods defeat the giants (FIG. 20–20). Here, Giulio Romano accepted the challenge Andrea Mantegna had laid down in the Camera Picta of the Gonzaga palace (SEE FIG. 19–33), painted for Federigo's grandfather. Like the building itself, the mural paintings display brilliant craft in the service of lighthearted, even superficial, goals: to distract, amuse, and enchant the viewer.

CORREGGIO. At about the same time that Giulio Romano was building and decorating the Palazzo del Tè in Mantua, in nearby Parma an equally skillful master, Correggio, was creating just as theatrical effects through dramatic foreshortening in the Parma Cathedral dome. In his brief but prolific career, Correggio (Antonio Allegri, c. 1489–1534) produced most of his work for patrons in Parma and Mantua. Correggio's great work, the **ASSUMPTION OF THE VIRGIN** (FIG. 20–21),

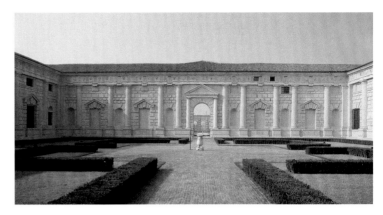

20–19 | Giulio Romano **COURTYARD FAÇADE, PALAZZO DEL TÈ, MANTUA**
1527–34.

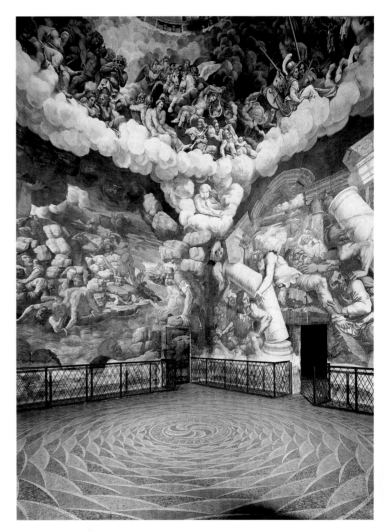

20–20 | Giulio Romano **FALL OF THE GIANTS**
Fresco in the Sala dei Giganti, Palazzo del Tè. 1530–32.

a fresco painted between 1526 and 1530 in the dome of Parma Cathedral, distantly recalls the illusionism of Mantegna's ceiling in the Gonzaga palace. But Leonardo da Vinci also clearly inspired Correggio's use of softly modeled forms,

20–21 | Correggio **ASSUMPTION OF THE VIRGIN**
Fresco in main dome, interior, Parma Cathedral, Italy. c. 1526–30. Diameter of base of dome approx. 36′ (11 m).

spotlighting effects of illumination, and a slightly hazy over-all appearance (*sfumato*). Correggio also assimilated Raphael's idealism into his personal style. In the *Assumption*, Correggio created a dazzling illusion: The architecture of the dome seems to dissolve and the forms seem to explode through the building, drawing the viewer up into the swirling vortex of saints and angels who rush upward, amid billowing clouds, to accompany the Virgin as she soars into heaven. Correggio's painting of the sensuous flesh and clinging draperies of the figures contrasts with the spirituality of the theme (the Virgin's miraculous transport to heaven at the moment of her death). The viewer's strongest impression is of a powerful, spiraling upward motion of alternating cool clouds and warm, sensuous figures. Illusionistic painting directly derived from this work became a hallmark of ceiling decoration in Italy in the following century.

20–22 | Properzia de' Rossi
JOSEPH AND POTIPHAR'S WIFE
San Petronio, Bologna. 1525–26. Marble, 1′9″ × 1′11″
(54 × 58 cm). Museo de S. Petronio, Bologna.

PROPERZIA DE' ROSSI. Very few women had the opportunity or inclination to become sculptors. Properzia de' Rossi (c. 1490–1529/30), who lived in Bologna, was an exception. She mastered many arts, including engraving, and was famous for her miniature carvings, including an entire Last Supper carved on a peach pit! She carved several pieces in marble—two sibyls, two angels, and this relief of **JOSEPH AND POTIPHAR'S WIFE**—for the cathedral of San Petronio in Bologna (**FIG. 20–22**). The contemporary historian Vasari wrote that a rival male sculptor prevented her from being paid fairly and from getting more commissions. This particular relief, according to Vasari, was inspired by her own love for a young man, which she got over by carving this panel. Joseph escapes, running, as the partially clad seductress snatches at his cloak. Properzia is the only woman Vasari includes in the 1550 edition of the *Lives*.

Venice and the Veneto

In the sixteenth century the Venetians did not see themselves as rivals of Florence and Rome, but rather as superiors. Their city was the greatest commercial sea power of the Mediterranean; they had challenged Byzantium and now they confronted the Muslim Turks. Favored by their unique geographical situation—protected by water and controlling sea routes in the Adriatic Sea and the eastern Mediterranean—the Venetians became wealthy and secure patrons of the arts. Their Byzantine heritage, preserved by their natural conservatism, encouraged an art of rich patterned surfaces emphasizing light and color.

The idealized style and oil painting technique initiated by the Bellini family in the late fifteenth century (see Chapter 19) were developed further by sixteenth-century painters in Venice and the Veneto region, the part of northeastern Italy ruled by Venice. Venetians were the first Italians to use oils for painting on both wood panel and canvas. Possibly because they were a seafaring people accustomed to working with large sheets of canvas, and possibly because of humidity problems in their walls, the Venetians were also the first to use large canvas paintings instead of frescoes. Because oils dried slowly, errors could be corrected and changes made easily during the work. The flexibility of the canvas support, coupled with the radiance and depth of oil-suspended color pigments, eventually made oil painting an almost universally preferred medium. Oil paint was particularly suited to the rich color and lighting effects employed by Giorgione and Titian, two of the city's major painters of the sixteenth century. (Two others, Veronese and Tintoretto, will be discussed later in this chapter.)

GIORGIONE. The career of Giorgione (Giorgio da Castelfranco, c. 1475–1510) was brief—he died from the plague—and most scholars accept only four or five paintings as entirely by his hand. Nevertheless, his importance to Venetian painting is critical, as he introduced new, enigmatic pastoral themes, known as *poesie* (or painted poems), that were inspired by the contemporary literary revival of ancient pastoral poetry. He is significant for his sensuous nude figures, and, above all, an appreciation of nature in his landscape painting. His early life and training are undocumented, but his work suggests that he studied with Giovanni Bellini. Perhaps Leonardo da Vinci's subtle lighting system and mysterious, intensely observed landscapes also inspired him.

Giorgione's most famous work, called today **THE TEMPEST** (**FIG. 20–23**), was painted shortly before his death. It is an example of the imaginative and sensual (rather than historical and intellectual) aspects of the *poesie*. Simply trying to understand what is happening in the picture piques our interest. At the right, a woman is seated on the ground, nude except for the end of a long white cloth thrown over her shoulders. Her nudity seems maternal rather than erotic as she nurses the baby at her side. Across the dark, rock-edged spring stands a man wearing the uniform of a German mercenary soldier. His head is turned toward the woman, but he appears to have paused for a moment before continuing to turn toward the viewer. X-rays of the painting show that Giorgione altered his composition while he was still at work on it—the soldier replaces a second woman. Inexplicably, a spring gushes forth between the figures to feed a lake surrounded by

20–23 | Giorgione **THE TEMPEST**
c. 1506. Oil on canvas, 32 × 28¾" (82 × 73 cm). Galleria dell'Accademia, Venice.

The subject of this enigmatic picture preoccupied twentieth-century art historians, many of whom came up with well-reasoned possible solutions to the mystery. However, the painting's subject seems not to have particularly intrigued sixteenth-century observers, one of whom described it in 1530 simply as a small landscape in a storm with a gypsy woman and a soldier.

substantial houses, and in the far distance a bolt of lightning splits the darkening sky. Indeed, the artist's attention seems focused on the landscape and the unruly elements of nature rather than on the figures. By making the landscape central to the composition, Giorgione gave nature an importance that is new in Western painting.

Although he may have painted *The Tempest* for purely personal reasons, most of Giorgione's known works were of traditional subjects, produced on commission for clients: portraits, altarpieces, and paintings on the exteriors of Venetian buildings. When commissioned in 1507 to paint the exterior of the Fondaco dei Tedeschi, the warehouse and offices of German merchants in Venice, Giorgione hired Titian (Tiziano Vecellio, c. 1489–1576) as an assistant. For the next three years, before Giorgione's untimely death, the two artists' careers were closely bound together.

20–24 | Titian
**THE PASTORAL CONCERT OR
ALLEGORY ON THE INVENTION
OF PASTORAL POETRY**
c. 1510. Oil on canvas, 41¼ × 54¾"
(105 × 136.5 cm). Musée du Louvre,
Paris.

The painting known as **THE PASTORAL CONCERT**
(FIG. 20–24) has been attributed to both Giorgione and Titian,
although today scholarly opinion favors Titian. As in Gior-
gione's *The Tempest*, the idyllic, fertile landscape, here bathed in
golden, hazy late-afternoon sunlight, seems to be the true
subject of the painting. In this mythic world, two men—an aris-
tocratic musician in rich red silks and a barefoot, singing peasant
in homespun cloth—turn toward each other, ignoring the two
women in front of them. One woman plays a pipe and the
other pours water into a well, oblivious of the swaths of white
drapery sliding to the ground that enhance rather than hide
their nudity. Are they the musicians' muses? Behind the figures
the sunlight illuminates another shepherd and his animals near
lush woodland. The painting evokes a mood, a golden age of
love and innocence recalled in ancient Roman pastoral poetry.
In fact, the painting is now interpreted as an allegory on the
invention of poetry. *The Pastoral Concert* had a profound influ-
ence on later painters—even into the nineteenth century, when
Édouard Manet (SEE FIG. 30–49) reinterpreted it.

TITIAN. Everything about Titian's early life is obscure,
including his birth, probably about 1489. He supposedly
began an apprenticeship as a mosaicist, then studied painting
under Gentile and Giovanni Bellini (see page 654). He was
about 20 when he began work with Giorgione, and whatever
Titian's early work had been, he had completely absorbed
Giorgione's style by the time Giorgione died two years later.
Titian completed paintings that they had worked on
together, and when Giovanni Bellini died in 1516, Titian
became the official painter to the Republic of Venice.

In 1519, Jacopo Pesaro, commander of the papal fleet
that had defeated the Turks in 1502, commissioned Titian
to commemorate the victory in a votive altarpiece for a
side-aisle chapel in the Franciscan Church of Santa Maria
Gloriosa dei Frari in Venice. Titian worked on the painting
for seven years and changed the concept three times
before he finally came up with a revolutionary composi-
tion—one that complemented the viewer's approach from
the left: He created an asymmetrical setting of huge
columns on high bases soaring right out of the frame (FIG.
20–25). Into this architectural setting, he placed the Virgin
and Child on a high throne at one side and arranged saints
and the Pesaro family at the sides and below on a diagonal
axis, crossing at the central figure of Saint Peter (a
reminder of Jacopo's role as head of the papal forces in
1502). The red of Francesco Pesaro's brocade garment and
of the banner diagonally across sets up a contrast of pri-
mary colors against Saint Peter's blue tunic and yellow
mantle and the red and blue draperies of the Virgin. Saint
Maurice (behind Jacopo at the left) holds the banner with
the coat of arms of the pope, and a cowering Turkish cap-
tive reminds the viewer of the Christian victory. Light
floods in from above, illuminating not only the faces, but
also the great columns, where *putti* in the clouds carry a
cross. Titian was famous for his mastery of light and color
even in his own day, but this altarpiece demonstrates that
he also could draw and model as solidly as any Florentine.
The composition, perfectly balanced but built on diago-
nals instead of a vertical and horizontal grid, looks forward
to the art of the seventeenth century.

20–25 | Titian **PESARO MADONNA**
1519–26. Oil on canvas, 16′ × 8′10″ (4.9 × 2.7 m). Side-aisle altarpiece, Santa Maria Gloriosa dei Frari, Venice.

In 1529, Titian, who was well-known outside Venice, began a long professional relationship with Emperor Charles V, who vowed to let no one else paint his portrait. Charles ennobled Titian in 1533. The next year Titian was commissioned to paint a portrait of Isabella d'Este (see "Women Patrons of the Arts," page 688). Isabella was past 60 when Titian portrayed her in 1534–36, but she asked to appear as she had in her twenties. A true magician of portraiture, Titian was able to satisfy her wish by referring to an early portrait by another artist while also conveying the mature Isabella's strength, self-confidence, and energy.

No photograph can convey the vibrancy of Titian's paint surfaces, which he built up in layers of pure colors, chiefly red, white, yellow, and black. A recent scientific study of Titian's paintings revealed that he ground his pigments much finer than had earlier wood-panel painters. The complicated process by which he produced many of his works began with a charcoal drawing on the prime coat of lead white that was used to seal the pores and smooth the surface of the rather coarse Venetian canvas. The artist then built up the forms with fine glazes of different colors, sometimes in as many as ten to fifteen layers. Titian and others had the

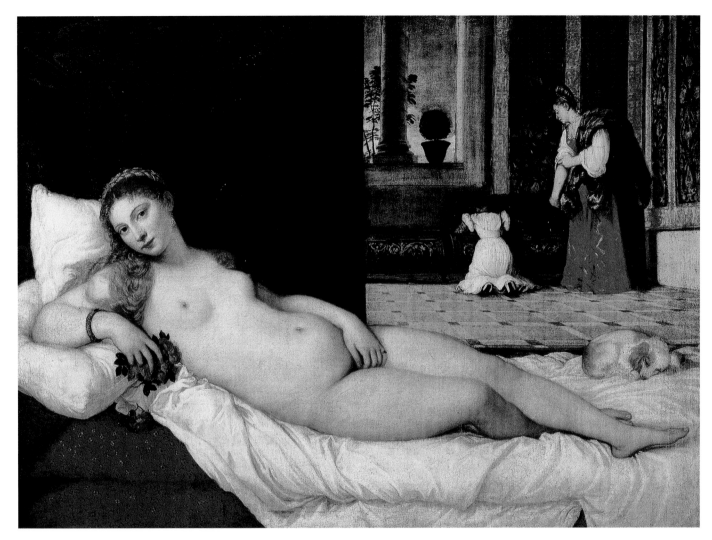

20–26 | Titian **VENUS OF URBINO**
c. 1538. Oil on canvas, 3'11" × 5'5" (1.19 × 1.65 m). Galleria degli Uffizi, Florence.

advantage of working in Venice, the first place to have professional retail "color sellers." These merchants produced a wide range of specially prepared pigments, even mixing their oil paints with ground glass to increase its glowing transparency. Not until the second half of the sixteenth century did color sellers open their shops in other cities.

According to a contemporary, Titian could make "an excellent figure appear in four brushstrokes." His technique was admirably suited to the creation of female nudes, whose flesh seems to glow with an incandescent light. Paintings of nude reclining women became especially popular in sophisticated court circles, where male patrons could enjoy and appreciate the "Venuses" under the cloak of respectable classical mythology. Typical of such paintings is the Venus Titian painted about 1538 for the Duke of Urbino (FIG. 20–26). The sensuous quality of this work suggests that Titian was as inspired by flesh-and-blood beauty as by any source from mythology or the history of art. Here, a beautiful Venetian courtesan—whose gestures seem deliberately provocative—

stretches languidly on her couch in a spacious palace, white sheets and pillows setting off her glowing flesh and golden hair. A spaniel, symbolic of fidelity, sleeping at her feet and maids assembling her clothing in the background lend a comfortable domestic air. The **VENUS OF URBINO** inspired artists as distant in time as Manet (SEE FIG. 30–50).

Over the course of his lengthy career, Titian continued to explore art's expressive potential. In his late work he sought the essence of the form and idea, not the surface perfection of his youthful works. Beset by failing eyesight and a trembling hand, Titian left the **PIETÀ** he was painting for his tomb unfinished at his death in 1576 (FIG. 20–27). Against a monumental arched niche, the Virgin mourns her son. Titian painted himself as Saint Jerome kneeling before Christ. The figures emerge out of darkness, their forms defined by the broken brushstrokes that activate the dynamic diagonal of the composition. Titian, like Michelangelo, outlived the classical phase of the Renaissance and his new style profoundly influenced Italian art of the later years of the sixteenth century.

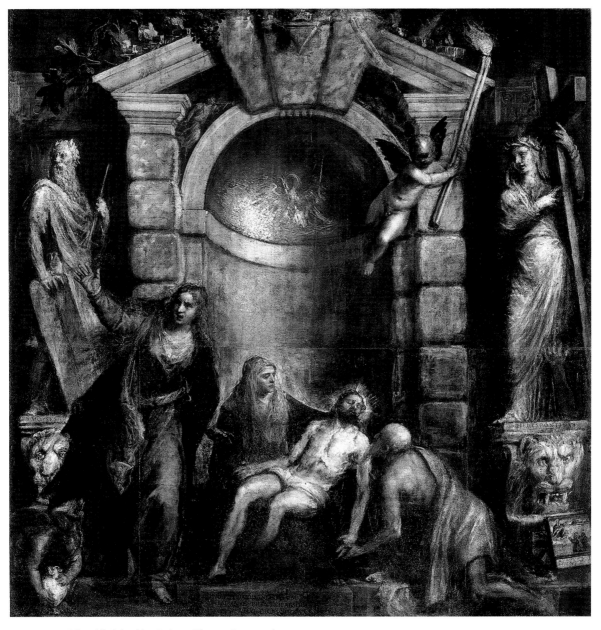

20–27 | Titian (finished by Palma Giovane) **PIETÀ**
c. 1570–76. Oil on canvas, 11'6" × 12'9" (3.5 × 3.9 m). Galleria dell'Accademia, Venice.

ART AND THE COUNTER-REFORMATION

Pope Clement VII, whose miscalculations had spurred Emperor Charles V to attack and destroy Rome in 1527, also misjudged the threat to the Church and to papal authority posed by the Protestant Reformation. His failure to address the issues raised by the reformers enabled the movement to spread. His successor, the rich and worldly Roman noble Alessandro Farnese, who was elected Pope Paul III (papacy 1534–49), was the first pope to grapple directly with the rise of Protestantism and vigorously pursue Church reform. In 1536, he appointed a commission to investigate charges of corruption within the Church. He convened the Council of Trent (1545–63) to define Catholic dogma, initiate disciplinary reforms, and regulate the training of clerics.

Pope Paul III also addressed Protestantism through repression and censorship. In 1542, he instituted the Inquisition, a papal office that sought out heretics for interrogation, trial, and sentencing. The enforcement of religious unity extended to the arts. Traditional images of Christ and the saints continued to be used to inspire and educate, but art was scrutinized for traces of heresy and profanity. Guidelines issued by the Council of Trent limited what could be represented in Christian art and led to the destruction of some works. At the same time, art became a powerful weapon of propaganda, especially in the hands of members of the Society of Jesus, a new religious order

Art and Its Context
WOMEN PATRONS OF THE ARTS

In the sixteenth century, many wealthy women, from both the aristocracy and the merchant class, were enthusiastic patrons of the arts. The Habsburg princesses Margaret of Austria and Mary of Hungary presided over brilliant humanist courts. The Marchesa of Mantua, Isabella d'Este (1474-1539), became a patron of painters, musicians, composers, writers, and literary scholars. Married to Francesco II Gonzaga at age 15, she had great beauty, great wealth, and a brilliant mind that made her a successful diplomat and administrator. A true Renaissance woman, her motto was the epitome of rational thinking—"Neither through Hope nor Fear." An avid collector of manuscripts and books, she sponsored the publication of an edition of Virgil while still in her twenties. She also collected ancient art and objects, as well as works by contemporary Italian artists such as Mantegna, Leonardo, Perugino, Correggio, and Titian. Her study in the Mantuan palace was a veritable museum for her collections. The walls above the storage and display cabinets were painted in fresco by Mantegna, and the carved wood ceiling was covered with mottoes and visual references to Isabella's impressive literary interests.

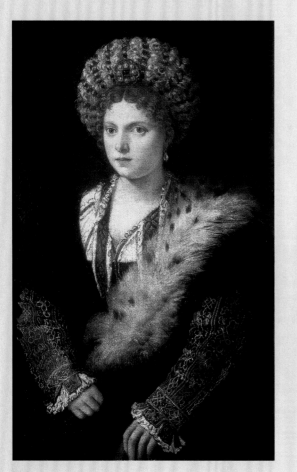

Titian **ISABELLA D'ESTE**
1534-36. Oil on canvas, 40⅛ × 25³/₁₆" (102 × 64.1 cm). Kunsthistorisches Museum, Vienna.

founded by the Spanish nobleman Ignatius of Loyola (1491–1556) and confirmed by Paul III in 1540. The Jesuits, dedicated to piety, education, and missionary work, spread worldwide from Il Gesù, their headquarters church in Rome (SEE FIG. 20–31). They came to lead the Counter-Reformation movement and the revival of the Catholic Church.

The Reformation and Counter-Reformation inspired the papacy to promote the Church's preeminence by undertaking an extensive program of building and art commissions. Under such patronage, religious art of the Italian late Renaissance flourished in the second half of the sixteenth century.

Art and Architecture in Rome and the Vatican

To restore the heart of the city of Rome, Paul III began rebuilding the Capitoline Hill as well as continuing work on Saint Peter's. His commissions include some of the finest art and architecture of the late Italian Renaissance. His first major commission brought Michelangelo, after a quarter of a century, to the Sistine Chapel.

MICHELANGELO'S LATE WORK. In his early sixties, Michelangelo complained bitterly of feeling old, but he nonetheless began the important and demanding task of painting the **LAST JUDGMENT** on the 48-foot-high end wall above the chapel altar (**FIG. 20–28**).

Abandoning the clearly organized medieval conception of the Last Judgment, in which the saved are neatly separated from the damned, Michelangelo painted a writhing swarm of rising and falling humanity. At the left (the right side of Christ), the dead are dragged from their graves and pushed up into a vortex of figures around Christ, who wields his arm like a sword of justice. The shrinking Virgin represents a change from Gothic tradition, where she sat enthroned beside, and equal in size to, her son. To the right of Christ's feet is Saint Bartholomew, who in legend was martyred by being skinned alive. He holds his flayed skin, the face of which may be painted with Michelangelo's own distorted features. Despite the efforts of several saints to save them at the last minute, the rejected souls are plunged toward hell on the right, leaving the elect and still-unjudged in a dazed, almost uncomprehending state. On the lowest level of the mural is the gaping, fiery entrance to hell, toward which Charon, the ferryman of the dead to the underworld, propels his craft. Conservative clergy criticized the painting for its nudity, and after Michelangelo's death they ordered bits of drapery to be added. The painting was long interpreted as a grim and constant reminder to the celebrants of the Mass—the pope and his cardinals—that ultimately they would be judged for their deeds. However, the brilliant colors revealed by recent cleaning contrast with the grim message.

Another of Paul III's ambitions was to complete the new Saint Peter's, a project that had been under way for forty years (see "Saint Peter's Basilica," page 679). Michelangelo was well

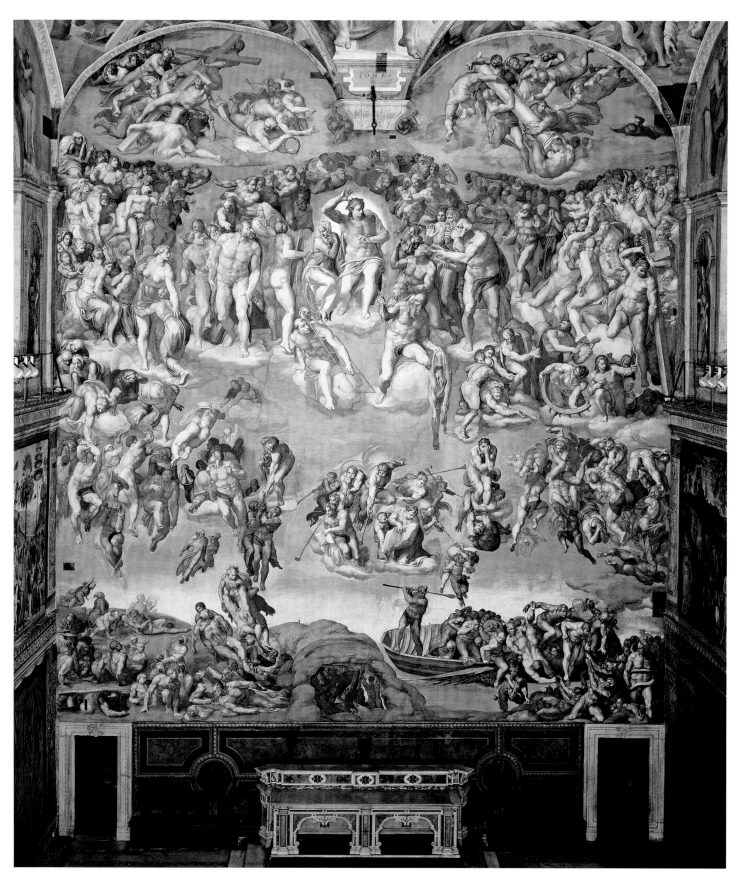

20–28 | Michelangelo **LAST JUDGMENT, SISTINE CHAPEL**
1536–41 (cleaning finished 1994). Fresco, 48 × 44′(14.6 × 13.4 m).

Dark, rectangular patches left by the restorers (visible, for example, in the upper left and right corners) contrast with the vibrant colors of the chapel's frescoes. These dark areas show just how dirty the walls had become over the centuries before their recent cleaning.

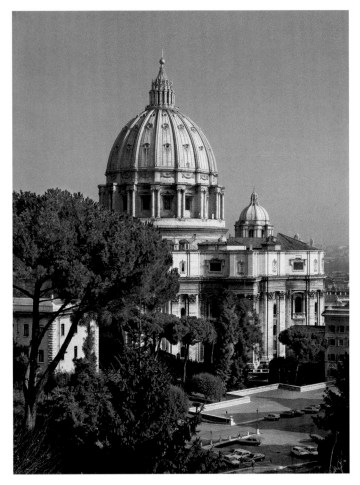

20–29 | Michelangelo **SAINT PETER'S BASILICA, VATICAN**
c. 1546-64; dome completed 1590 by Giacomo della Porta;
lantern 1590-93. View from the west.

height, narrowing its segmental bands, and changing the shape of its openings.

Michelangelo—often described by his contemporaries as difficult and even arrogant—alternated between periods of depression and frenzied activity. Yet he was devoted to his friends and helpful to young artists. He believed that his art was divinely inspired; later in life, he became deeply absorbed in religion and dedicated himself to religious works.

Michelangelo's last days were occupied by an unfinished sculpture now known, from the name of a modern owner, as the **RONDANINI PIETÀ** (FIG. 20–30). The *Rondanini Pietà* is the final artistic expression of a lonely, disillusioned, and physically debilitated man who struggled to end his life as he had lived it—working. In his youth, the stone had released the *Pietà* in Saint Peter's as a perfect, exquisitely finished work (SEE FIG. 20–9), but this block resisted his best efforts to shape it. He was still working on the sculpture six days before his death. The ongoing struggle between artist and medium is nowhere more apparent than in this moving example of Michelangelo's *nonfinito* creations. In his late work, Michelangelo subverted Renaissance ideals of human perfectability and denied his own youthful idealism, uncovering new forms that mirrored the tensions in Europe during the second half of the sixteenth century.

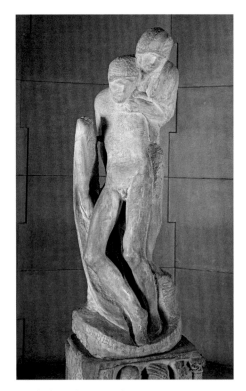

20–30 | Michelangelo **PIETÀ (KNOWN AS THE RONDANINI PIETÀ)**
1559-64. Marble, height 5′3⅛″ (1.61 m). Castello Sforzesco, Milan. Intended for his own tomb.

Shortly before his death in 1564, Michelangelo resumed work on this sculpture group, which he had begun some years earlier. He cut down the massive figure of Jesus, merging the figure's now elongated form with that of the Virgin, who seems to carry her dead son upward toward heaven.

aware of the work done by his predecessors—from Bramante to Raphael to Antonio da Sangallo the Younger. The 71-year-old sculptor, confident of his architectural expertise, demanded the right to deal directly with the pope, rather than through a committee of construction deputies. Michelangelo further shocked the deputies—but not the pope—by tearing down or canceling parts of Sangallo's design and returning to Bramante's central plan, long associated with Christian martyr shrines. Although seventeenth-century additions and renovations dramatically changed the original plan of the church and the appearance of its interior, Michelangelo's **SAINT PETER'S BASILICA** (FIG. 20–29) still can be seen in the contrasting forms of the flat and angled walls and the three **hemicycles** (semicircular structures), in which colossal pilasters, blind windows (having no openings), and niches form the sanctuary of the church. The level above the heavy entablature was later given windows of a different shape. The dome that was erected by Giacomo della Porta in 1588–90 retains Michelangelo's basic design: a segmented dome with regularly spaced openings, resting on a high drum with pedimented windows between paired columns, and surmounted by a tall lantern reminiscent of Bramante's Tempietto (SEE FIG. 20–17). Della Porta's major changes were raising the dome

The elderly artist Michelangelo, like Titian, secure in the techniques gained over decades of masterful craft, could abandon the knowledge of a lifetime as he attempted to express ultimate truths through art. In his late work, he discovered new stylistic directions that would inspire succeeding generations of artists.

VIGNOLA. Michelangelo alone could not satisfy the demand for architects. One young artist who helped meet the need for new churches was Giacomo Barozzi (1507–73), known as Vignola after his native town. He worked in Rome in the late 1530s surveying ancient Roman monuments and providing illustrations for an edition of Vitruvius. From 1541 to 1543 he was in France with Francesco Primaticcio at the Château of Fontainebleau (see Chapter 21). After returning to Rome, he secured the patronage of the Farnese family.

Vignola profited from the Counter-Reformation program of church building. The Church's new emphasis on individual, emotional participation brought a focus on sermons and music. It also required churches to have wide naves and unobstructed views of the altar instead of the complex interiors of medieval and earlier Renaissance churches. Ignatius of Loyola was determined to build the Jesuit headquarters church in Rome under these precepts, although he did not live to see his church finished (FIG. 20–31). The cornerstone was laid in 1540, but construction of the **CHURCH OF IL GESÙ** did not begin until 1568, as the Jesuits had to raise considerable funds. Cardinal Alessandro Farnese (Paul III's namesake and grandson) donated funds to the project in 1561 and selected Vignola as architect. After Vignola died in 1573, Giacomo della Porta finished the dome and façade.

Il Gesù was admirably suited for its congregational purpose. Vignola designed a wide, barrel-vaulted nave, shallow connected side chapels but not aisles, and short transepts that

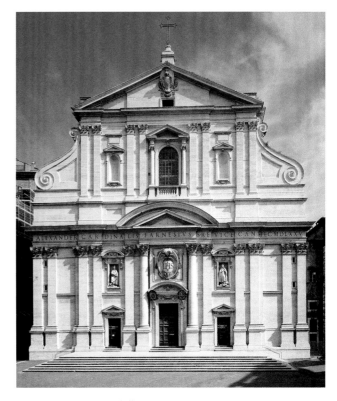

20–31 | Giacomo della Porta **FAÇADE OF THE CHURCH OF IL GESÙ, ROME**
c. 1573-84.

did not extend beyond the line of the outer walls—enabling all worshipers to gather in the central space. A single huge apse and dome over the crossing (FIG. 20–32) directed their attention to the altar. The building fit compactly into the city block—a requirement that now often overrode the desire to orient a church along an east-west axis. The façade design emphasized the central portal with classical pilasters, engaged

20–32 | Giacomo da Vignola **PLAN AND SECTION OF THE CHURCH OF IL GESÙ, ROME**
Cornestone laid in 1540; Project begun in 1550; Giacomo da Vignola's design begun in 1563; building begun in 1568; completed by Giacomo della Porta in 1584.

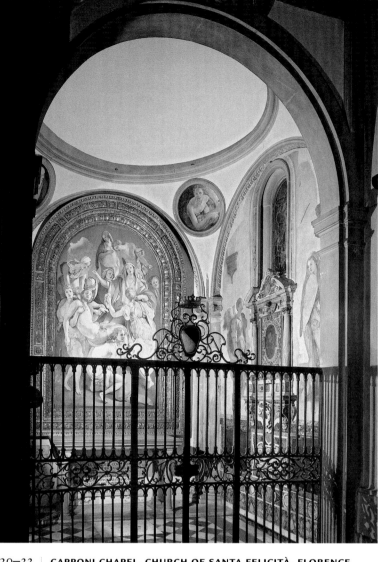

20–33 | **CAPPONI CHAPEL, CHURCH OF SANTA FELICITÀ, FLORENCE**
Chapel by Filippo Brunelleschi for the Barbadori family, 1419–23; acquired by the Capponi family, who ordered paintings by Pontormo, 1525–28.

One of the few surviving early Mannerist interiors—fresco, stained-glass window, and altarpiece in an early Renaissance structure.

columns and pediments, and volutes scrolling out to hide the buttresses of the central vault and to link the tall central section with the lower sides.

As finally built by Giacomo della Porta, the design, in its verticality and centrality, would have significant influence on church design well into the next century. The façade abandoned the early Renaissance grid of classical pilasters and entablatures for a two-story design of paired colossal order columns that reflected and tied together the two stories of the nave elevation. Each of these stories was further subdivided by moldings, niches, and windows. The entrance of the church, with its central portal and tall window, became the focus of the composition. Pediments at every level break into the level above, leading the eye upward to the cartouches with coats of arms. Both Cardinal Farnese, the patron, and the Jesuits (whose arms entail the initials IHS, the monogram of Christ) are commemorated here on the façade.

MANNERISM

A word that has inspired controversy—sometimes even rancorous debate—among historians of Italian art is *Mannerism*. The term comes from the Italian word *maniera*, used in the sixteenth century to suggest self-aware elegance and grace to the point of artifice. When modern critics began to use the term, some defined it as a style opposed to the principles of High Renaissance art; others treated it as an historical period in art between the early sixteenth-century High Renais-

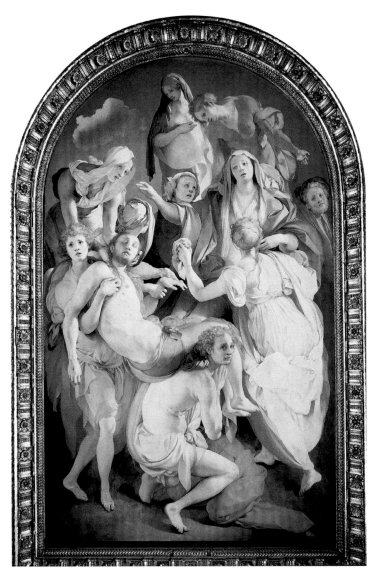

20-34 | Pontormo **ENTOMBMENT**
1525-28. Oil and tempera on wood panel, 10'3" × 6'4"
(3.1 × 1.9 m). Altarpiece in Capponi Chapel, Church of Santa
Felicità, Florence.

unfathomable secondary scenes. Mannerist artists admired the great artists of the earlier generation, and the late styles of Michelangelo and Titian also became a source of inspiration.

Elements of Mannerism, stimulated and supported by aristocratic, sophisticated, and courtly patrons, began to appear in Florence and Rome at the height of the High Renaissance around 1510. The term has been interpreted as an artistic expression of the unsettled political and religious conditions in Europe. Furthermore, a formal relationship between new art styles and aesthetic theories began to appear at this time—especially the elevation of "grace" as an ideal.

Painting

Examples of early Mannerism are the frescoes and altarpieces painted between 1525 and 1528 by Jacopo da Pontormo (1494–1557) for the hundred-year-old **CAPPONI CHAPEL** in the Church of Santa Felicità in Florence (FIG. 20–33). Open on two sides, the chapel forms an interior loggia. The altarpiece depicts the **ENTOMBMENT** (FIG. 20–34), and frescoes depict the Annunciation. The Virgin accepts the angel's message, but the juxtaposition with the altarpiece also seems to present her with a vision of her future sorrow, as she sees her son's body lowered from the cross. Pontormo's ambiguous composition in the altarpiece enhances the visionary quality of the painting. The bare ground and cloudy sky give little sense of physical location. Some figures press into the viewer's space, while others seem to levitate or stand on the smooth boulders. Pontormo chose a moment just after Jesus's removal from the cross, when the youths who have lowered him have paused to regain their hold. The emotional atmosphere of the scene is expressed in the odd poses, and drastic shifts in scale, but perhaps most poignantly in the use of secondary colors and colors shot through with contrasting colors, like iridescent silks. The palette is predominantly blue and pink with accents of olive green, gray, scarlet, and creamy white. The overall tone of the picture is set by the color treatment of the crouching youth, whose skintight bright pink shirt is shaded in iridescent, pale gray-green.

sance and the seventeenth-century Baroque. Today many critics would like to drop the term altogether, but it has entered the standard art historical vocabulary. Certainly one can agree that different styles existed at the same time in sixteenth-century Italy.

Today, in the visual arts, Mannerism has come to mean intellectually intricate subjects, highly skilled techniques, and art concerned with beauty for its own sake. Mannerism is an attitude, a point of view, as much as a "style." Certain characteristics do occur regularly: extraordinary virtuosity; intricate compositions; sophisticated, elegant figures; and fearless manipulations or distortions of accepted formal conventions. Some artists and patrons favored obscure, unsettling, and often erotic imagery; unusual colors and juxtapositions; and

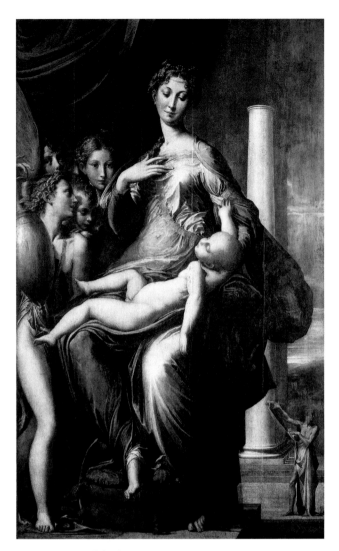

20–35 Parmigianino **MADONNA WITH THE LONG NECK**
1534–40. Oil on wood panel, 7'1" × 4'4"
(2.16 × 1.32 m). Galleria degli Uffizi, Florence.

PARMIGIANINO. Parmigianino (Francesco Mazzola, 1503–40) created equally intriguing variations on the classical style. Until he left his native Parma in 1524 for Rome, the strongest influence on his work had been Correggio. In Rome, Parmigianino met Giulio Romano, and he also studied the work of Raphael and Michelangelo. He assimilated what he saw into a distinctive style of Mannerism, calm but strangely unsettling. After the Sack of Rome in 1527, he moved to Bologna and then back to Parma.

Left unfinished at the time of his early death is a painting known as the **MADONNA WITH THE LONG NECK** (FIG. 20–35). The elongated figure of the Madonna, whose massive legs and lower torso contrast with her narrow shoulders and long neck and fingers, resembles the large metal vase inexplicably being carried by the youth at the left. The sleeping Christ Child recalls the pose of the pietà, and in the background Saint Jerome unrolls a scroll beside tall white columns that

have no more substance than theater sets in the middle distance. Like Pontormo, Parmigianino presents a well-known image in a manner calculated to unsettle viewers. The painting challenges the viewer's intellect while it exerts its strange appeal to aesthetic sensibility.

BRONZINO. Agnolo di Cosimo (1503–72), whose nickname of "Bronzino" means "Copper-colored" (just as we might call someone "Red"), was born near Florence. About 1522, he became Pontormo's assistant. (He probably helped with the tondos in the corners of the Capponi Chapel.) In 1530, he established his own workshop, though he continued to work occasionally with Pontormo on large projects. In 1540, Bronzino became the court painter to the Medici. Although he was a versatile artist who produced altarpieces, fresco decorations, and tapestry designs over his long career, he is best known today for his courtly portraits. Bronzino's virtuosity in rendering costumes and settings creates a rather cold and formal effect, but the self-contained demeanor of his subjects admirably conveys their haughty personalities. The **PORTRAIT**

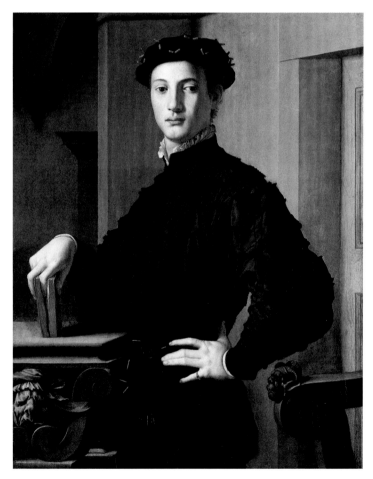

20–36 Bronzino **PORTRAIT OF A YOUNG MAN**
c. 1540–45. Oil on wood panel, 37½ × 29½"
(95.5 × 74.9 cm). The Metropolitan Museum of Art,
New York.
The H. O. Havemayer Collection (29.100.16).

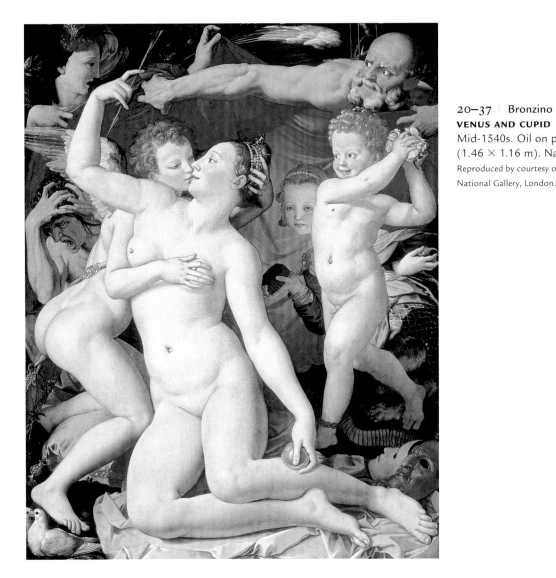

OF A YOUNG MAN (FIG. 20–36) demonstrates Bronzino's characteristic portrayal of his subjects as intelligent, aloof, elegant, and self-assured. The youth toys with a book, suggesting his scholarly interests, but his walleyed stare creates a slightly unsettling effect and seems to associate his portrait with the carved masks surrounding him.

Bronzino's **ALLEGORY WITH VENUS AND CUPID**, one of the strangest paintings in the sixteenth century, contains all the formal, iconographical, and psychological characteristics of Mannerist art (FIG. 20–37). The painting could stand alone as a summary of the period. Seven figures, two masks, and a dove interweave in an intricate formal composition pressed breathlessly into the foreground plane. Taken as individual images, they display the apparent ease of execution and grace of form, ideal perfection of surface and delicacy of color that characterize Mannerist art. Together they become a disturbingly erotic and inexplicable composition.

The painting defies easy explanation for it is one of the complex allegories that delighted the sophisticated courtiers who enjoyed equally esoteric wordplay and classical references. Nothing is quite what it seems. Venus and her son Cupid engage in lascivious dalliance, encouraged by a *putto* representing Folly, Jest, or Playfulness, who is about to throw pink roses at them. Cupid kisses his mother and squeezes her breast and nipple while Venus lifts up an arrow from Cupid's quiver, leading some scholars to suggest that the painting's title should be "*Venus Disarming Cupid.*" Venus holds the golden apple of discord given to her by Paris; her dove seems to support Cupid's feet, while a pair of ugly red masks lying at her feet reiterates the theme of duplicity. An old man, Time or Chronos, assisted by an outraged Truth, pulls back a curtain to expose the couple. Lurking just behind Venus a monstrous serpent with a lion's legs and claws and the head of a beautiful young girl crosses her hands to hold a honeycomb and scorpion's stinger. She has been called Inconstancy and Fraud but also Pleasure. In the shadows a screaming head tears its hair—if female, she is Jealousy or Envy, but if male, he would be Pain. The complexity of the painting and the

20–38 | Giulio Clovio (Jura Klovic, born in Croatia) **THE FARNESE HOURS: ADORATION OF THE MAGI AND THE MEETING OF SOLOMON AND THE QUEEN OF SHEBA**
1546. Vellum, each folio 6 × 4″ (17.3 × 11 cm). The Pierpont Morgan Library, New York.
M69 fl 380-3912

possibilities for multiple meanings are typical of the games enjoyed by sixteenth-century intellectuals. Perhaps the allegory tells of the impossibility of constant love and the folly of lovers, which will become apparent in time. But perhaps it is an allegory on sin and a condemnation of vice. In any event, Duke Cosimo ordered the painting himself, and he presented it to King Francis I of France.

Manuscripts and Miniatures

THE FARNESE HOURS. In spite of the increasing use of the printing press (see Chapter 19), luxury manuscripts continued to be made by hand. **THE FARNESE HOURS,** a book of hours commissioned by Cardinal Alessandro Farnese from Guilio Clovio (1498–1578), is a masterpiece among Italian Renaissance manuscripts (FIG. 20–38). The colophon (at the end of the manuscript) dates it at 1546, and the contemporary historian Giorgio Vasari wrote that Giulio worked for nine years painting the miniatures. Vasari perceptively calls him a "new, if small, Michelangelo." Small indeed, each page measures only 7 by 4 inches, but the paintings encompass every aspect of Mannerist art—the "serpentine figures" in graceful poses and the elongated proportions so noticeable in the nudes support the frames and the extraordinarily elongated figures in the narra-

tives. Brilliant colors combine with pale atmospheric space. The Old Testament supports the New, in a way typical of medieval manuscripts. Thus the Queen of Sheba's visit and homage to Solomon prefigures the Magi's journey with gifts for the Christ Child. King Solomon has the features of the patron, Cardinal Farnese, and beside him is a dwarf in painter's clothes making a typical sixteenth-century visual pun—he is a small man, a "miniature" painter.

ANGUISSOLA. Northern Italy, more than any other part of the peninsula, produced a number of gifted women artists. Sofonisba Anguissola (c. 1532–1625), born into a noble family in Cremona, was unusual as a woman artist in that she was not the daughter of an artist. Her father gave all his children a humanistic education and encouraged them to pursue careers in literature, music, and especially painting. He consulted Michelangelo about Sofonisba's artistic talents in 1557, asking for a drawing that she might copy and return to be critiqued. Michelangelo evidently obliged because Sofonisba Anguissola's father wrote an enthusiastic letter of thanks.

Anguissola was also skilled at miniatures and portraits, an important kind of painting in the sixteenth century, when people had few means of recording a lover, friend, or family

member's features. Anguissola painted herself holding a medallion, the border of which spells out her name and home town, Cremona (FIG. 20–39). Such visual and verbal games delighted sixteenth-century viewers. The interlaced letters at the center of the medallion are a riddle; they seem to form a monogram with the first letters of her sisters' names: Minerva, Europa, Elena. Such names are further evidence of the Anguissola family's enthusiasm for the classics.

Contemporaries especially admired Sofonisba Anguissola's self-portraits. One wrote that he liked to show off her painting as "two marvels, one the work, the other the artist" (quoted in Hartt/Wilkins, page 629). In 1560, Anguissola accepted the invitation of the queen of Spain to become a lady-in-waiting and court painter, a post she held for twenty years. In a 1582 Spanish inventory, Anguissola is described as "an excellent painter of portraits above all the painters of this time"—extraordinary praise in a court that patronized Titian.

CELLINI. The Florentine goldsmith and sculptor Benvenuto Cellini (1500–71), who wrote a dramatic—and scandalous—autobiography and a practical handbook for artists, worked in the French court at Fontainebleau, where he made the famous **SALTCELLAR OF KING FRANCIS I** (FIG. 20–40)—a table accessory transformed into an elegant sculptural ornament by fanciful imagery and superb execution. In gold and enamel, the Roman sea god Neptune, representing the source of salt, sits next to a tiny boat-shaped container that carries the seasoning, while a personification of Earth guards the plant-derived

20–39 | Sofonisba Anguissola **SELF-PORTRAIT**
c. 1552. Oil on parchment on cardboard, 2½ × 3¼″ (6.4 ×8.3 cm). Museum of Fine Arts, Boston.
Emma F. Munroe Fund (60.155)

20–40 | Benvenuto Cellini **SALTCELLAR OF KING FRANCIS I OF FRANCE**
1540-43. Gold and enamel, 10½ × 13⅛″ (26.67 × 33.34 cm). Kunsthistorisches Museum, Vienna.

20–41 | Giovanni da Bologna (Giambologna)
ASTRONOMY, or **VENUS URANIA**
c. 1573. Bronze gilt, height 15¼″ (38.8 cm). Kunsthistorisches Museum, Vienna.

pepper, contained in the triumphal arch to her right. Representations of the seasons and the times of day on the base refer to both daily meal schedules and festive seasonal celebrations. The two main figures, their poses mirroring each other with one bent and one straight leg, lean away from each other at impossible angles yet are connected and visually balanced by glances and gestures. Their supple, elongated bodies and small heads reflect the Mannerist conventions of artists like Parmigianino. Cellini wrote, "I represented the Sea and the Land, both seated, with their legs intertwined just as some branches of the sea run into the land and the land juts into the sea. . ." (quoted in Hartt/Wilkins, page 669).

Late Mannerism

In the second half of the sixteenth century, probably the most influential sculptor in Italy was Jean de Boulogne, better known by his Italian name, Giovanni da Bologna or Giambologna (1529–1608). Born in Flanders, he settled by 1557 in Florence, where both the Medici family and the sizable Netherlandish community there were his patrons. He not only influenced a later generation of Italian sculptors, he also spread the Mannerist style to the north through artists who came to study his work. Although inspired by Michelangelo, Giovanni was more concerned with graceful forms and poses, as in his gilded-bronze **ASTRONOMY,** or **VENUS URANIA** (FIG. 20–41) of about 1573. The figure's identity is suggested by the astronomical device on the base of the plinth. Designed with a classical prototype of Venus in mind, the sculptor twisted Venus's upper torso and arms to the far right and extended her neck in the opposite direction so that her chin was over her right shoulder, straining the limits of the human body. Consequently, Giambologna's statuette may be seen from any viewpoint. The elaborate coiffure of tight ringlets and the detailed engraving of drapery texture contrast strikingly with the smooth, gleaming flesh of Venus's body. Following the common practice for cast-metal sculpture, Giambologna replicated this statuette several times for different patrons.

The northern Italian city of Bologna was especially hospitable to accomplished women. In the latter half of the sixteenth century it boasted of some two dozen women painters and sculptors, as well as a number of women scholars who lectured at the university. There, Lavinia Fontana (1552–1614) learned to paint from her father. By the 1570s, her success was so well rewarded that her husband, the painter Gian Paolo Zappi, gave up his own painting career to care for their large family and help his wife with the technical aspects of her work, such as framing. In 1603 Fontana moved to Rome as an official painter to the papal court. She also soon came to the attention of the Habsburgs, who became major patrons of her work.

While still in her twenties, Fontana painted the **NOLI ME TANGERE** (FIG. 20–42), illustrating the biblical story of Christ

20–42 | Lavinia Fontana **NOLI ME TANGERE**
1581. Oil on canvas, 47⅜ × 36 ⅝" (120.3 × 93 cm).
Galleria degli Uffizi, Florence.

revealing himself before his Ascension to Mary Magdalen and warning her not to touch him (John 20:17). Christ's costume refers to the passage in the Gospel of John that tells us that Mary Magdalen at first thought Christ was the gardener.

Christ steps forward like a classical god—but dressed in a short tunic and wearing a gardener's hat. His graceful gesture echoes that of the Magdalen. In the middle distance a second confrontation is taking place: the earlier meeting of the women with the angel at the empty tomb. Like a medieval artist, Fontana ignores the sequence of earthly time and contrasts the large foreground figures with the tiny figures at the tomb, creating a striking plunge into depth. This unsettling spatial and temporal disconnect is a typical Mannerist conceit.

LATER SIXTEENTH-CENTURY ART IN VENICE AND THE VENETO

By the second half of the sixteenth century, Venice ruled supreme as "Queen of the Adriatic." Her power was not, however, unchallenged, and the Turks remained a threat to commerce. In 1571, allied with Spain and the pope, the Christian fleet with Venetian ships defeated the Turkish fleet at the Battle of Lepanto and so established Christian power for future generations. Victorious and wealthy Venetians entered on a lavish lifestyle, building palaces and villas, which they hung with lush oil paintings. The *Triumph of Venice* (see Fig. 12, Introduction), commissioned by the city government from the artist Veronese for the Hall of the Great Council in the Doge's palace, captures the splendor of Venice.

Oil Painting

Rather than the cool, formal, technical perfection sought by the Mannerists, painters in Venice expanded upon the techniques initiated there by Giorgione and Titian, concerning themselves above all with color, light, and expressively loose brushwork.

VERONESE. Paolo Caliari (1528–88) took his nickname— "Veronese"—from his hometown, Verona, but he worked mainly in Venice. His paintings are nearly synonymous today with the popular image of Venice as a splendid city of

THE ⬤BJECT SPEAKS

VERONESE IS CALLED BEFORE THE INQUISITION

Jesus among his disciples at the Last Supper was an image that spoke powerfully to believers during the sixteenth century. So it was not unusual when, in 1573, the highly esteemed painter Veronese revealed an enormous canvas that seemed at first glance to depict this scene. The Church officials of Venice were shocked and offended by the impiety of placing near Jesus a host of extremely unsavory characters. Veronese was called before the Inquisition to explain his painting.

Venice, July 18, 1573. The minutes of the session of the Inquisition Tribunal of Saturday, the 18th of July, 1573. . . . *

Q: What picture is this of which you have spoken?

A: This is a picture of the Last Supper that Jesus Christ took with His apostles in the house of Simon . . .

Q: At this supper of Our Lord have you painted other figures?

A: Yes, milords.

Q: Tell us how many people and describe the gestures of each.

(Veronese describes the painting.)

Q: What is the significance of those armed men dressed as Germans, each with a halberd in his hand?

A: We painters take the same license the poets and the jesters take and I have represented these two halberdiers, one drinking and the other eating nearby on the stairs. They are placed there so that they might be of service because it seemed to me fitting, according to what I have been told, that the master of the house, who was great and rich, should have such servants.

Q: And that man dressed as a buffoon with a parrot on his wrist, for what purpose did you paint him on that canvas?

A: For ornament, as is customary . . .

Q: Who do you really believe was present at that Supper?

A: I believe one would find Christ with His Apostles. But if in a picture there is some space to spare I enrich it with figures according to the stories.

Q: Did anyone commission you to paint Germans, buffoons, and similar things in that picture?

A: No, milords, but I received the commission to decorate the picture as I saw fit. It is large and, it seemed to me, it could hold many figures.

Q: Are not the decorations which you painters are accustomed to add to paintings or pictures supposed to be suitable and proper to the subject and the principal figures or are they for pleasure—simply what comes to your imagination without any discretion or judiciousness?

A: I paint pictures as I see fit and as well as my talent permits.

Q: Does it seem fitting at the Last Supper of the Lord to paint buffoons, drunkards, Germans, dwarfs, and similar vulgarities?

A: No, milords . . .

(The questions continue in this vein.)

The judges decreed that Veronese must change the painting within three months or be liable to penalties. Veronese changed the picture's title so that it referred to another banquet, given by the tax collector Levi. The "buffoons, drunkards . . . and similar vulgarities" remained, and Veronese noted his new source—Luke 5—on the balustrade. That Gospel reads that "Levi gave a great banquet for him [Jesus] in his house, and a large crowd of tax collectors and others were at table with them" (Luke 5:29). In changing the declared subject of the painting, Veronese also had modest revenge on the Inquisitors: When Jesus was criticized for associating with such people, he replied, "I have not come to call the righteous to repentance but sinners" (Luke 5:32).

* E. G. Holt, *Literary Sources of Art History*. Princeton, NJ: Princeton University Press, 1947. pp. 245–48.

Veronese **FEAST IN THE HOUSE OF LEVI**
From the refectory of the Dominican Monastery of Santi Giovanni e Paolo, Venice. 1573. Oil on canvas, 18′3″ × 42′ (5.56 × 12.8 m). Galleria dell'Accademia, Venice.

20–43 | Tintoretto **THE LAST SUPPER**
1592-94. Oil on canvas, 12′ × 18′8″ (3.7 × 5.7 m). Church of San Giorgio Maggiore, Venice.

Tintoretto, who had a large workshop, often developed a composition by creating a small-scale model like a miniature stage set, which he populated with wax figures. He then adjusted the positions of the figures and the lighting until he was satisfied with the entire scene. Using a grid of horizontal and vertical threads placed in front of this model, he could easily sketch the composition onto squared paper for his assistants to copy onto a large canvas. His assistants also primed the canvas, blocking in the areas of dark and light, before the artist himself, free to concentrate on the most difficult passages, finished the painting. This efficient working method allowed Tintoretto to produce a large number of paintings in all sizes.

pleasure and pageantry sustained by a nominally republican government and great mercantile wealth. Veronese's elaborate architectural settings and costumes, still lifes, anecdotal vignettes, and other everyday details, often unconnected with the main subject, proved immensely appealing to Venetian patrons. His vision of the glorious Venice reached an apogee in the ceiling of the council chamber in the ducal palace (Fig. 12, Introduction).

Veronese's most famous work is a Last Supper that he renamed **FEAST IN THE HOUSE OF LEVI** (see opposite), painted in 1573 for the Dominican Monastery of Santi Giovanni e Paolo. At first glance, the subject of the painting seems to be architecture and only secondarily Christ seated at the table. An enormous loggia framed by colossal triumphal arches and reached by balustraded stairs symbolizes Levi's house. Beyond the loggia an imaginary city of white marble gleams. Within this grand setting, realistic figures in splendid costumes assume exaggerated, theatrical poses. The huge size of the painting

allowed Veronese to include the sort of anecdotal vignettes beloved by the Venetians—the parrots, monkeys, and Germans—but detested by the Church's Inquisitors, who saw in them profane undertones.

TINTORETTO. Another Venetian master, Jacopo Robusti (1518–94), called "Tintoretto" ("Little Dyer," because his father was a dyer), worked in a style that developed from, and exaggerated, the techniques of Titian, in whose shop he reportedly apprenticed. Tintoretto's goal, declared on a sign in his studio, was to combine Titian's color with the drawing of Michelangelo. Like Veronese, Tintoretto often received commissions to decorate huge interior spaces. He painted **THE LAST SUPPER** (FIG. 20–43) for the choir of the Church of San Giorgio Maggiore, a building designed by Palladio (SEE FIG. 20–44). Comparison with Leonardo da Vinci's painting of almost a century earlier is instructive (see Figs. 20–2 and fig. 18, Introduction). Instead of Leonardo's closed

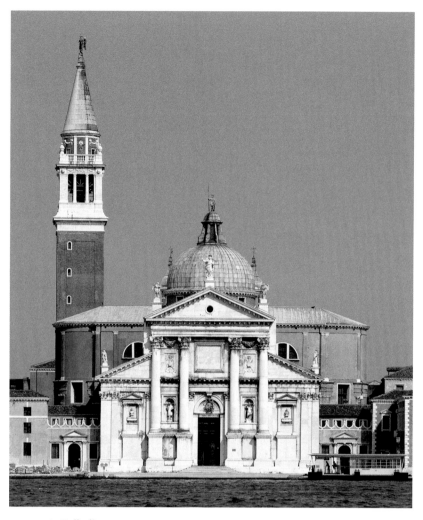

20–44 | Palladio **CHURCH OF SAN GIORGIO MAGGIORE, VENICE**
Plan 1565; construction 1565–80; façade, 1597–1610; campanile 1791.
Finished by Vincenzo Scamozzi following Palladio's design.

and logical space with massive figures reacting in individual ways to Jesus's statement, Tintoretto's view is from a corner, with the vanishing point on a high horizon line at the far right side. The table, coffered ceiling, and inlaid floor all seem to plunge dramatically into the distance. The figures, although still large bodies modeled by flowing draperies, turn and move in a continuous serpentine line that unites apostles, servants, and angels. Tintoretto used two light sources: one real, the other supernatural. Light streams from the oil lamp flaring dangerously over the near end of the table; angels seem to swirl out from the flame and smoke. A second light emanates from Jesus himself and is repeated in the glow of the apostles' halos. The mood of intense spirituality is enhanced by deep colors flashed with bright highlights, as well as by the elongated figures—treatments that reflect both the Byzantine art of Venice and the Mannerist aesthetic. The still lifes on the tables and the homey detail of a cat and basket emphasize the reality of the viewers' experience. At the same time, the deep chiaroscuro and brilliant dazzling lights catching forms in near-total darkness enhance the convincingly otherworldly atmosphere. The

interpretation of *The Last Supper* also has changed—unlike Leonardo's more secular emphasis on personal betrayal, Tintoretto has returned to the religious institution of the Eucharist: Jesus offers bread and wine, a model for the priest administering the sacraments at the altar next to the painting.

The speed with which Tintoretto drew and painted was the subject of comment in his own time, and the brilliance and immediacy so admired today (his slashing brushwork was fully appreciated by the gestural painters of the twentieth century) were derided as evidence of carelessness. His rapid production may be attributed to the efficiency of his working methods: Tintoretto had a large workshop of assistants and he usually provided only the original conception, the beginning drawings, and the final brilliant touches on the finished painting. Tintoretto's workshop included members of his family—of his eight children, four became artists. His oldest daughter, Marietta Robusti, worked with him as a portrait painter, and two or perhaps three of his sons also joined the shop. So skillfully did Marietta capture her father's style and technique that today art historians cannot identify her work in the shop.

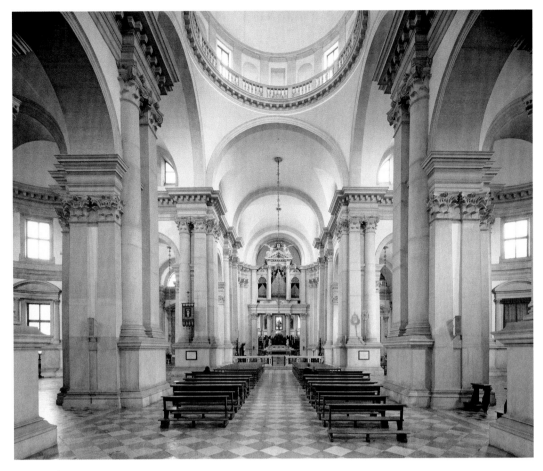

20–45 | **NAVE, CHURCH OF SAN GIORGIO MAGGIORE, VENICE**
Begun 1566. Tintoretto's *Last Supper* (not visible) hangs to the left of the altar.

Architecture: Palladio

Just as Veronese and Tintoretto expanded upon the rich Venetian tradition of oil painting established by Giorgione and Titian, Andrea Palladio dominated architecture during the second half of the century by expanding upon principles of Alberti and of ancient Roman architecture. His work—whether a villa, palace, or church—was characterized by harmonious symmetry and a rejection of ornamentation. Over the years, Palladio became involved in several publishing ventures, including a guide to Roman antiquities, an illustrated edition of Vitruvius, and books on architecture that for centuries would be valuable resources for architectural design.

Born Andrea di Pietro della Gondola (1508–80), probably in Padua, Palladio began his career as a stonecutter. After moving to Vicenza, he was hired by the nobleman, humanist scholar, and amateur architect Giangiorgio Trissino. Trissino gave him the nickname "Palladio" for the Greek goddess of wisdom, Pallas Athena, and the fourth-century Roman writer Palladius. Palladio learned Latin at Trissino's small academy and accompanied his benefactor on three trips to Rome, where he made drawings of Roman monuments.

SAN GIORGIO MAGGIORE. By 1559, when he settled in Venice, Palladio was one of the foremost architects of Italy. In 1565, he undertook a major architectural commission: the monastery **CHURCH OF SAN GIORGIO MAGGIORE** (FIG. 20–44). His design for the Renaissance façade to the traditional basilica-plan elevation—a wide lower level fronting the nave and side aisles surmounted by a narrower front for the nave clerestory—is ingenious. Inspired by Alberti's solution for Sant'Andrea in Mantua (SEE FIG. 19–31), Palladio created the illusion of two temple fronts of different heights and widths, one set inside the other. At the center, colossal columns on high pedestals, or bases, support an entablature and pediment that front the narrower clerestory level of the church. The lower temple front, which covers the triple-aisle width and slanted side-aisle roofs, consists of pilasters supporting an entablature and pediment running behind the columns of the taller clerestory front. Palladio retained Alberti's motif of the triumphal-arch entrance. Although the façade was not built until after the architect's death, his original design was followed.

The interior of San Giorgio (FIG. 20–45) is a fine example of Palladio's harmoniously balanced geometry, expressed here in strong verticals and powerful arcs. The tall engaged columns and shorter pairs of pilasters of the nave arcade echo the two levels of orders on the façade, thus unifying the building's exterior and interior.

THE VILLA ROTONDA. Palladio's versatility can best be seen in numerous villas built early in his career. In the 1560s, he started his most famous and influential villa just outside Vicenza (FIGS. 20–46, 20–47). Although traditionally villas were working farms, Palladio designed this one as a retreat for relaxation (a party house). To afford views of the countryside on each face of the building, he placed a porch, with four columns, arched openings in the walls, and a wide staircase. The main living quarters are on this second level, as is usual

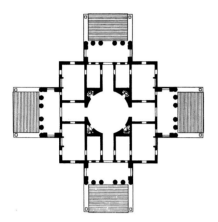

20–46 **PLAN OF THE VILLA ROTONDA**
c. 1550.

Palladio was a scholar and an architectural theorist as well as a designer of buildings. His books on architecture provided ideal plans for country estates, using proportions derived from ancient Roman structures. Despite their theoretical bent, his writings were often more practical than earlier treatises. Perhaps his early experience as a stonemason provided him with the knowledge and self-confidence to approach technical problems and discuss them as clearly as he did theories of ideal proportion and uses of the classical orders. By the eighteenth century, Palladio's *Four Books of Architecture* had been included in the library of most educated people. Thomas Jefferson had one of the first copies in America.

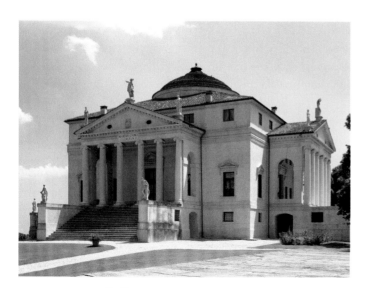

20–47 Palladio
VILLA ROTONDA (VILLA CAPRA), VICENZA
Italy. Begun, 1560s.

in European palace architecture, and the lower level is reserved for the kitchen, storage, and other utility rooms. Upon its completion in 1569, the villa was dubbed the **VILLA ROTONDA** because it had been inspired by another round hall, the Roman Pantheon. After its purchase in 1591 by the Capra family, it became known as the Villa Capra. The villa's plan shows the geometric clarity of Palladio's conception: a circle inscribed in a small square inside a larger square, with symmetrical rectangular compartments and identical rectangular projections from each of its faces. The use of a central dome on a domestic building was a daring innovation that effectively secularized the dome. The Villa Rotonda was the first of what was to become a long tradition of domed country houses, particularly in England and the United States.

IN PERSPECTIVE

In spite of ongoing struggles between the Holy Roman emperor and the pope, and in spite of the scandals beginning to envelop the Church, the early sixteenth century emerged as a golden age for the arts. As sixteenth-century artists built on the past, they carried the investigation of nature, classics, and humanistic learning further than their fifteenth-century predecessors. Art went beyond realism to idealism. Artists not only reproduced the surface appearances, they sought underlying forms. In painting a figure, for example, their study of anatomy had to be more than skin deep; their knowledge of the skeletal and muscular structure of the human body was on display, and the observation of a face led to the study of a personality. The ideal of the dignity of all human beings as creatures made by God, expounded by the philosophers and forcefully elucidated in Michelangelo's paintings in the Sistine Chapel, informed the art of this period.

As classicists, their fascination with the tangible remains of ancient Rome—inscriptions, fragments of architecture and sculpture—turned into full-scale archaeological excavation and the discovery of major pagan artworks such as the *Laocoön*. Like the ancient Greeks (whose sculpture they knew only in Roman copies), the Italian painters of the High Renaissance sought perfection. They, too, developed an ideal canon of proportions and a kind of spiritual geometry that underlies their painting and sculpture. This classical equilibrium in the arts, balancing physical and spiritual forces, proved to be fleeting.

By 1530 change was in the air, and an anticlassical style emerged in works of art that later critics defined as "Mannerist." A high level of technical skill could be assumed and was used to achieve dazzling displays of grace, elegance, and "manner." As complex in their compositions as they were in their subjects, the Mannerist artworks stimulate an uneasy imagination, and today they often defy analysis or explication. Social institutions might be crumbling but artists, secure in their technical achievements and admired by their patrons, continued to paint, carve, and build.

MICHELANGELO
DAVID
1501–4

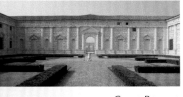

GIULIO ROMANO
COURTYARD FAÇADE , PALAZZO DEL TÈ, MANTUA
1527–34

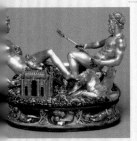

BENVENUTO CELLINI
**TCELLAR OF KING FRANCIS I
OF FRANCE**
1540–43

SOFONISBA ANGUISSOLA
SELF PORTRAIT
c. 1552

TINTORETTO
THE LAST SUPPER
1592–94

1500

1520

1540

1560

1580

1600

SIXTEENTH-CENTURY ART IN ITALY

◄ **Luther Officially Protests Church's Sale of Indulgences** 1517

◄ **Charles V Holy Roman Emperor** 1519–56

◄ **Charles V Orders Sack of Rome** 1527

◄ **Jesuit Order Confirmed** 1540

◄ **Pope Paul III Institutes Inquisition** 1542

◄ **Council of Trent** 1545–63

◄ **Vasari's *Lives* Published** 1550

◄ **Veronese Appears Before the Inquisition** 1573

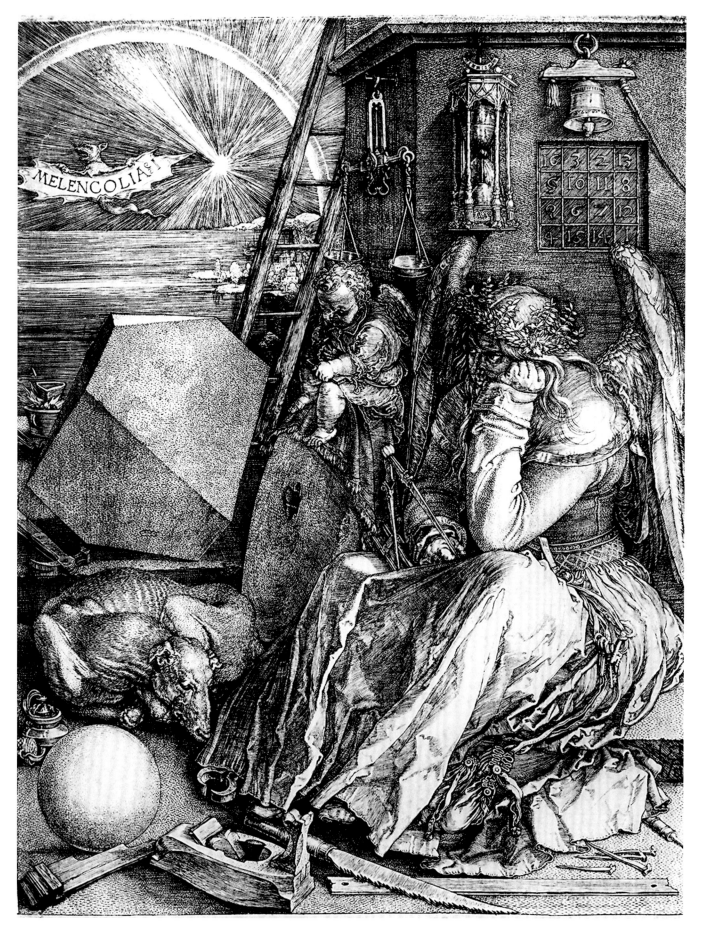

21–1 | Albrecht Dürer **MELENCOLIA I** 1514. Engraving, 9⅜ × 7½″ (23.8 × 18.9 cm). Victoria & Albert Museum, London.

SIXTEENTH-CENTURY ART IN NORTHERN EUROPE AND THE IBERIAN PENINSULA

21

A bat inscribed "Melencolia I" flits through the sky. The flashing light of a comet illuminates a huge winged creature seated below, who seems lost in thought and whose body expresses weariness and even despair, a mood reflected in the curled figure of a starving dog. Piled on the ground and hanging on the wall is a striking collection of objects, some associated with the mechanical arts and crafts—builders' tools such as a ladder, hammer, spikes, saw, and a plane—and others with intellectual activity—compasses, scales, an hourglass, and a measuring stick, all instruments used to describe the world in terms of geometry. A winged child scribbles mindlessly, but the adult figure seems to have created a perfect sphere, a truncated polyhedron, and a magic number square. Now, though, she sits in an attitude of defeat and frustration. What does this all mean? In his groundbreaking study, the scholar Erwin Panofsky identified the image as the "spiritual self-portrait" of its creator, the artist Albrecht Dürer.

A skilled graphic artist with a brilliant mind, Dürer was a leading figure in the German Renaissance. He was also a social and professional success in Italy, where he traveled in 1494 and 1505. There, he must have noted a certain distinction: Artists like Michelangelo could claim to be divinely inspired creators, but in Dürer's Germany artists were still considered artisans—craftsmen and manual laborers. They were not "humanists," not "intellectuals"; they were skilled and valued members of society, to be sure, but nevertheless people who worked with their hands. Dürer, caught up in the humanist spirit of Renaissance Italy, may have identified with his creation in **MELENCOLIA I** (**FIG. 21–1**): a superhuman, listlessly brooding figure surrounded by tools and symbols of the arts and humanities but still unable to act.

The ideas behind Dürer's image seem strange to us today. Renaissance scholars believed that the planets influenced human destiny. Artists, it was thought, were born under the distant and dark planet Saturn (the dog and bat are creatures of Saturn). From Saturn came a divine frenzy that inspired artistic creativity. If that frenzy was not kept in balance with what the discipline of art could reasonably accomplish, however, artists were led to frustration and ultimately inaction. In short, the creative genius was prone to melancholy and despair. Also, according to the Renaissance theory of the four humors (bodily fluids that determined human personality and temperament), the melancholy person had an excess of black bile. Black bile was associated with things dry and cold, with the earth, with endings—evening, autumn, age—and with the vices of greed and despair. As if to reinforce the identification with the melancholy humor, Dürer's winged figure wears a wreath of watercress and ranunculus, plants thought to cure the dryness caused by melancholy. The figure's rumpled purse lies on the ground, perhaps signifying the craving for—but absence of—wealth.

But what is the meaning of the roman numeral "I" after the word "Melencolia"? According to the belief of the time,

melancholy took three forms, conceived of as "limitations" that varied by profession. Scientists and physicians, for example, were "limited" by the second form of melancholy, reason; theologians were limited by intuition, the third form. Artists suffered from limitation by imagination, the first form—hence, Melencolia I. We are watching an artist struggling with the burden of the creative imagination.

The other two engravings Dürer made between 1513 and 1514 illustrate the active life—a knight defying death and the devil—and the contemplative life—the scholar Saint Jerome at work in his study. *Melencolia I*, however, shows us a secular genius and reflects the philosophical and social conflict that beset Dürer and many other thoughtful artists, especially in Protestant lands, in the early years of the sixteenth century. In its melancholy, the engraving also foreshadows the effects of the religious turmoil, social upheaval, and civil war soon to sweep northern Europe.

THE REFORMATION AND THE ARTS

In spite of dissident movements that challenged the Christian Church through the centuries, the authority of the Church and the pope ultimately prevailed—until the sixteenth century. Then, against a backdrop of broad dissatisfaction with financial abuses and lavish lifestyles among the clergy (see Chapter 20), religious reformers within the established Church challenged practices and went on to challenge beliefs.

Two of the most important reformers in the early sixteenth century were themselves Catholic priests and trained theologians: Desiderius Erasmus of Rotterdam (1466?–1536) in Holland who tried to reform the Roman Catholic Church from within, and Martin Luther (1483–1546) in Germany who eventually broke with the Church. Indeed, the Reformation may be said to begin in 1517, when Luther issued his Ninety-Five Theses calling for Church reform. Among Luther's concerns were the practice of selling indulgences (the forgiveness of sins and the assurance of salvation) and the excessive veneration of saints and their relics, which he considered superstitious. Luther and others emphasized individual faith and regarded the Bible as the ultimate religious authority. As they challenged the pope's supremacy, it became clear that the Protestants had to break away from Rome. The Church condemned Luther in 1521.

Increased literacy and the widespread use of the printing press aided the reformers and allowed scholars throughout Europe to debate religious matters and to influence many people. In Germany the wide circulation of Luther's writings—especially his German translation of the Bible and his works maintaining that salvation comes through faith alone—eventually led to the establishment of the Protestant (Lutheran) Church there. In Switzerland, John Calvin (1509–64) led an even more austere Protestant revolt, and in England, King Henry VIII (ruled 1509–47) also broke with Rome in 1534. By the end of the sixteenth century, some form of Protestantism prevailed throughout northern Europe.

Leading the Catholic cause was Holy Roman Emperor Charles V (see Chapter 20). Europe was wracked by religious war from 1546 to 1555 as Charles battled the Protestant forces in Germany. During this turbulent time, the Italian Leone Leoni (1509–90), working for the emperor in Spain, created a life-size bronze sculpture of *Charles V Triumphing over Fury* (see Fig. 8, Introduction). Yet Leone's portrayal of a victorious Charles proved premature. At a meeting of the provincial legislature of Augsburg in 1555, the emperor was forced to accommodate the Protestant Reformation in his lands. By the terms of the peace, local rulers selected the religion of their subjects—Catholic or Protestant. Tired of the strain of government and prematurely aged, Charles abdicated in 1556 and retired to a monastery in Spain, where he died in 1558. His son Philip II inherited Spain and the Spanish colonies; his brother Ferdinand led the Austrian branch of the Habsburg dynasty.

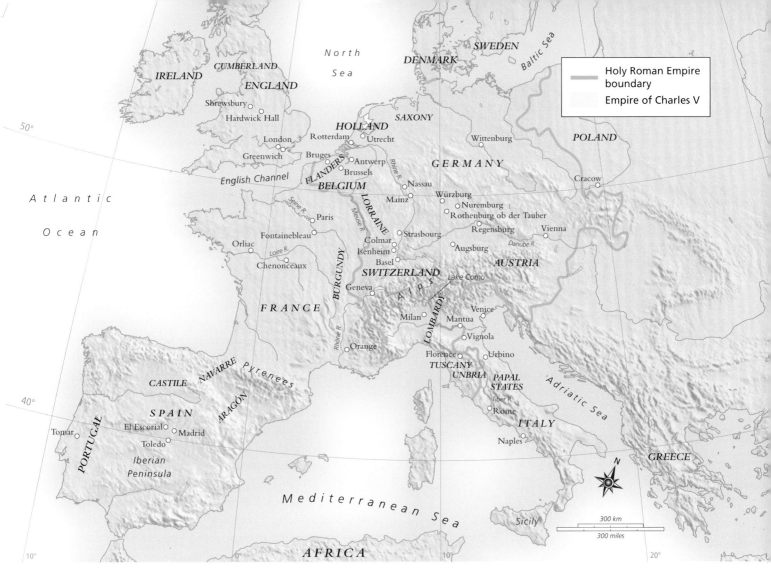

MAP 21–1 | NORTHERN EUROPE AND THE IBERIAN PENINSULA IN THE SIXTEENTH CENTURY

The 16th century saw Europe divided between Protestant and Catholic countries. While France, Spain, Flanders, Belgium, and Italy remained Catholic, Switzerland, the northern Netherlands (the United Provinces), and England became Protestant. By 1555 Emperor Charles V had to permit rulers in his German lands to follow their own religious beliefs.

The years of political and religious strife had a grave impact on artists. Some artists found their careers at an end because of their sympathies for rebels and reformers. Then as Protestantism gained ascendancy, artists who supported the Roman Catholic Church had to leave their homes to seek patronage abroad.

A tragic consequence of the Reformation was the destruction of religious art. In some places, Protestant zealots smashed sculpture and stained-glass windows and destroyed or whitewashed religious paintings to rid the churches of what they considered to be idolatrous images—though Luther, who understood the educational value of art, never directly supported **iconoclasm** (the smashing of religious images). With the sudden loss of patronage for religious art in the newly Protestant lands, many artists had to find new patrons and new themes. They turned to portraiture and other secular subjects, including moralizing depictions of human folly and weaknesses. Still-life (that is, the painting of objects alone) and landscape painting began to appear. The popularity of these themes stimulated a free art market, centered in Antwerp.

EARLY SIXTEENTH-CENTURY ART IN GERMANY

In German regions the arts flourished until religious upheavals and iconoclastic purges of religious images took a toll at mid-century. The German cities had strong business and trade interests and their merchants and bankers accumulated self-made, rather than inherited, wealth. They ordered portraits of themselves and fine furnishings for their large, comfortable houses. Entrepreneurial artists, like Albrecht Dürer, became major commercial successes.

Sculpture

At the end of the fifteenth century, sculpture gradually changed from the late Gothic to Renaissance style with an increased interest in naturalism. Although, like the Italians, German sculptors worked in stone and bronze, they produced their most original work in wood, especially fine-grained limewood. They gilded and painted these wooden images, until Tilman Riemenschneider began to use natural wood finishes.

TILMAN RIEMENSCHNEIDER. Tilman Riemenschneider (c. 1460–1531) became a master in 1485 and soon had the largest workshop in Würzburg. His shop included specialists in both wood and stone sculpture. Riemenschneider attracted patrons from other cities, and in 1501 he signed a contract with the Church of Saint James in Rothenburg, where a relic said to be a drop of Jesus's blood was preserved. The **ALTARPIECE OF THE HOLY BLOOD** (FIG. 21–2) is a spectacular limewood construction standing nearly 30 feet high. A specialist in architectural shrines had begun work on the elaborate Gothic frame in 1499. The frame cost fifty florins. Riemenschneider was commissioned to provide the figures and scenes to be placed within this frame, and Riemenschneider was paid sixty florins for the sculpture (a suggestive commentary on the value assigned the work by the patrons).

In the main scene of the altarpiece, the *Last Supper,* Riemenschneider depicted the moment when Christ revealed that one of his followers would betray him. Unlike Leonardo da Vinci, who chose the same moment (see Introduction, Fig. 18), Riemenschneider made Judas the central figure in the composition and placed Jesus off-center at the left. The disciples sit around the table. As the event is described in the Gospel of John (13:21–30), Jesus extends a morsel of food to Judas, signifying that Judas will be the traitor who sets in motion the events leading to the Crucifixion. An apostle points down, a strange gesture until one realizes that he points to the Crucifix in the predella, to the relic of Christ's blood, and to the altar table, the symbolic representation of the table of the Last Supper and the tomb of Christ.

Rather than creating individual images in his sculptures, Riemenschneider repeated a limited number of facial types. In this way he could make effective use of his workshop. His figures have large heads, prominent features, sharp cheekbones, sagging jowls, baggy eyes, and elaborate hair with thick wavy locks and deeply drilled curls. The muscles, tendons, and raised veins of hands and feet are also especially lifelike. His assistants and apprentices copied these faces and figures, either from drawings or from three-dimensional models made by the master. In the altarpiece, deeply hollowed folds and active patterned draperies create strong highlights and dark shadows that unite the figures with the intricate carving of the framework. In the *Last Supper* the scene is set in a real room with actual benches for the figures, with windows in the back wall glazed with bull's-eye glass. Natural light shining through both the church and altarpiece windows illuminates the scene, creating changing effects depending on the time of day and the weather.

In addition to producing an enormous number of religious images for churches, Riemenschneider was politically active in the city's government, and he even served as mayor in 1520. His career ended during the Peasants' War (1524–26), an early manifestation of the Protestant movement. His support for the peasants led to a fine and imprisonment in 1525, and he died in 1531.

21–2 | Tilman Riemenschneider **ALTARPIECE OF THE HOLY BLOOD (WINGS OPEN)**
Center, *Last Supper.* c. 1499-1505. Limewood, glass, height of tallest figure 39″ (99.1 cm); height of altar 29′6″ (9 m). Sankt Jakobskirche, Rothenburg ob der Tauber, Germany.

VEIT STOSS. Riemenschneider's contemporary Veit Stoss (1450–1533) spent his early years (1477–96) in Cracow, Poland, where he became wealthy from his sculpture and architectural commissions, as well as from financial investments. After returning to his native Nuremberg, he too began to specialize in limewood sculpture, probably because established artists already dominated commissions in other mediums. He had a small shop whose output was characterized by an easily recognizable realistic style. Following the lead of Riemenschneider and others, Stoss shows in his unpainted limewood sculptures a special appreciation for the wood itself, which he exploited for its inherent colorations, grain patterns, and range of surface finishes.

Stoss carved the **ANNUNCIATION AND VIRGIN OF THE ROSARY** (FIG. 21–3) for the choir of the Church of Saint Lawrence in Nuremberg in 1517–18. Gabriel's greeting to Mary takes place within a wreath of roses symbolizing the prayers of the rosary, which was being popularized by the Dominicans. Disks are carved with scenes of the Joys of the Virgin, to which are added her death (Dormition) and Coronation. Mary and Gabriel are adored and supported by angels. Their dignified figures are encased in elaborate crinkled and fluttering drapery that seems to blend with the delicate angels and to cause the entire work to float like an apparition in the upper reaches of the choir. The sculpture continues the expressive, mystical tradition prevalent since the Middle Ages in the art of Germany, where the recitation of prayers to the Virgin (the rosary) had become an important part of personal devotion.

NIKOLAUS HAGENAUER. Prayer was also the principal source of solace and relief to the ill before the advent of modern medicine. About 1505, the Strasbourg sculptor Nikolaus Hagenauer (active 1493–1530s) carved an altarpiece for the Abbey of Saint Anthony in Isenheim near Colmar (FIG. 21–4). The Abbey's hospital specialized in the care of patients with skin diseases, including the plague, leprosy, and Saint Anthony's Fire (a terrible disease caused by eating rye and other grains infected with the ergot fungus). The shrine includes images of Saint Anthony, Saint Jerome, and Saint Augustine. Three men kneel at the feet of the saints: the donor, Jean d'Orliac, and two men offering a rooster and a piglet. The three are tiny figures, as befits their subordinate status.

In the predella below, Jesus and the apostles bless the altar, Host, and assembled patients in the hospital. The limewood sculpture was painted in lifelike colors, and the shrine itself was gilded to enhance its resemblance to a precious reliquary. Later, Matthias Grünewald painted wooden shutters to cover the shrine (SEE FIGS. 21–5, 21–6).

Painting

German art during the first decades of the sixteenth century was dominated by two very different artists, Matthias Grünewald and Albrecht Dürer. Grünewald's unique style expressed the

21–3 | Veit Stoss **ANNUNCIATION AND VIRGIN OF THE ROSARY**
1517–18. Painted and gilt limewood, 12′2″ × 10′6″ (3.71 × 3.20 m). Church of Saint Lawrence, Nuremberg.

continuing currents of medieval German mysticism and emotional spirituality, while Dürer's intense observation of the natural world represented the scientific Renaissance interest in empirical observation, including mathematical perspective to create the illusion of space, and the use of a reasoned canon of proportions for depicting the human figure.

MATTHIAS GRÜNEWALD. As an artist in the court of the archbishop of Mainz, Matthias Grünewald (Matthias Gothart Neithart, c. 1470/75–1528) was a man of many talents, who worked as an architect and hydraulic engineer as well as a painter. He is best known today for painting the wings of the **ISENHEIM ALTARPIECE** (SEE FIGS. 21–5, 21–6), built to protect the shrine carved by Nikolaus Hagenauer. In his realism and intensity of feeling, Grünewald may have been inspired by the visions of Saint Bridget of Sweden, a fourteenth-century mystic whose works were published in Germany beginning in 1492. She described the Crucifixion in morbid detail.

21–4 | Nikolaus Hagenauer **SAINT ANTHONY ENTHRONED BETWEEN SAINTS AUGUSTINE AND JEROME,
SHRINE OF THE** *ISENHEIM ALTARPIECE* **(OPEN, SHOWING GRÜNEWALD WINGS.)**
From the Community of Saint Anthony, Isenheim, Alsace, France. c. 1500. Painted and gilt limewood,
center panel 9′9½″ × 10′9″ (2.98 × 3.28 m); predella 2′5½″ × 11′2″ (0.75 × 3.4 m). Wings 8′2½″ × 3′½″
(2.49 × 0.93 m). Predella: *Christ and the Apostles.* Wings *Saint Anthony and Saint Paul* (left)*; The Temptation of
Saint Anthony* (right). 1510-15. Musée d'Unterlinden, Colmar, France.

The altarpiece is impressive in size and complexity. Grünewald painted one set of fixed wings and two sets of movable ones, plus one set of sliding panels to cover the predella. The altarpiece could be exhibited in different configurations depending upon the Church calendar. The wings and carved wooden shrine complemented one another, the inner sculpture seeming to bring the surrounding paintings to life, and the painted wings protecting the precious carvings.

On weekdays, when the altarpiece was closed, viewers saw a shocking image of the Crucifixion in a darkened landscape, a Lamentation below it on the predella, and life-size figures of Saints Sebastian and Anthony Abbot—saints associated with the plague—standing on *trompe l'oeil* pedestals on the fixed wings (FIG. 21–5). Grünewald represented in the most horrific details the tortured body of Jesus, covered with gashes from being beaten and pierced by the thorns used to form a crown for his head. His ashen body, open mouth, and blue lips indicate that he is dead. In fact, he appears already to be decaying, an effect enhanced by the palette of putrescent green, yellow, and purplish red—all described by Saint Bridget; she wrote, "The color of death spread through his flesh. . ." A ghostlike Virgin Mary has collapsed in the arms of an emaciated John the Evangelist, and Mary Magdalen has fallen in anguish to her knees; her clasped hands with outstretched fingers seem to echo Jesus's fingers, cramped in rigor mortis. At the right John the Baptist points at Jesus and repeats his prophecy, "He shall increase." The Baptist and the lamb, holding a cross and bleeding from its breast into a golden chalice, allude to baptism, the Eucharist, and to Christ as the sacrificial Lamb of God (recalling the *Ghent Altarpiece;* SEE FIG. 18–12). In the predella below, Jesus's bereaved mother and friends prepare his body for burial—an activity that must have been a common sight in the abbey's hospital.

In contrast to these grim scenes, the first opening displays events of great joy—the Annunciation, the Nativity, and the Resurrection—appropriate for Sundays and Church festivals (FIG. 21–6). Praying in front of these images, the patients hoped for miraculous recovery. Unlike the awful darkness of the Crucifixion, the inner scenes are illuminated with clear natural daylight, phosphorescent auras and halos, and the glitter of stars in a night sky. Fully aware of contemporary formal achievements in Italy, Grünewald created the illusion of three-dimensional space and volumetric figures, and he simplified and idealized the forms. Underlying this attempt to arouse a sympathetic emotional response in the viewer is a complex religious symbolism, undoubtedly the result of close collaboration with his monastic patrons.

21–5 │ Matthias Grünewald **ISENHEIM ALTARPIECE (CLOSED)**
From the Community of Saint Anthony, Isenheim, Alsace, France. Center panels: *Crucifixion*; predella:
Lamentation; side panels: *Saints Sebastian* (left) and *Anthony Abbot* (right). c. 1510–15. Date 1515 on
ointment jar. Oil on wood panel, center panels 9′9½″ × 10′9″ (2.97 × 3.28 m) overall; each wing
8′2½″ × 3′½″ (2.49 × 0.93 m); predella 2′5½″ × 11′2″ (0.75 × 3.4 m). Musée d'Unterlinden,
Colmar, France.

21–6 │ Matthias Grünewald **ISENHEIM ALTARPIECE (FIRST OPENING)**
Left to right: *Annunciation, Virgin and Child with Angels, Resurrection*. c. 1510–15. Oil on wood panel, center panel
9′9½″ × 10′9″ (2.97 × 3.28 m), each wing 8′2½″ × 3′½″ (2.49 × 0.92 m). Musée d'Unterlinden, Colmar, France.

Materials and Techniques
GERMAN METALWORK: A COLLABORATIVE VENTURE

In Nuremberg, a city known for its master metalsmiths, Hans Krug (d. 1519) and his sons Hans the Younger and Ludwig were among its finest gold- and silversmiths. They created marvelous display pieces for the wealthy, such as this silver-gilt apple cup. Made about 1510, a gleaming apple, in which the stem forms the handle of the lid, balances on a leafy branch that forms its base.

The Krug family was responsible for the highly refined casting and finishing of the final product, but several artists worked together to produce such pieces—one drawing designs, another making the models, and others creating the final piece in metal. A drawing by Dürer may have been the basis for the apple cup. Though we know of no piece of goldwork by the artist himself, Dürer was a major catalyst in the growth of Nuremberg as a key center of German goldsmithing. He accomplished this by producing designs for metalwork throughout his career, evidence of the essential role of designers in the metalwork process. With design in hand, the model maker created a wooden form for the goldsmith to follow. The result of this artistic collaboration was a technical tour de force, an intellectual conceit, and a very beautiful object.

Workshop of Hans Krug (?) APPLE CUP
c. 1510–15. Gilt silver, height 8½" (21.5 cm).
Germanisches Nationalmuseum, Nuremberg.

The *Annunciation* on the left wing may have been inspired by a special liturgy called the Golden Mass, which celebrated the divine motherhood of the Virgin. The Mass included a staged reenactment of the angel's visit to Mary, as well as readings from the story of the Annunciation (Luke 1:26–38) and the Old Testament prophecy of the Savior's birth (Isaiah 7:14–15), which is inscribed in Latin on the pages of the Virgin's open book.

The central panels show the heavenly and earthly realms joined in one space. In a variation on the northern European visionary tradition, the new mother adores her miraculous Christ Child while envisioning her own future as Queen of Heaven amid angels and cherubs. Grünewald portrayed three distinct types of angels in the foreground—young, mature, and a feathered hybrid with a birdlike crest on its human head—and a range of ethnic types in the heavenly realm. Perhaps this latter was intended to emphasize the global dominion of the Church, whose missionary efforts were expanding as a result of European exploration. Saint Bridget describes the jubilation of the angels as "the glowing flame of love."

The panels are also filled with traditional imagery of the Annunciation: Marian symbols such as the enclosed garden, the white towel on the tub, and the clear glass cruet behind it, which signify Mary's virginity; the water pot next to the tub, which alludes both to purity and to childbirth; and the fig tree in the background, suggesting the Virgin Birth, since figs were thought to bear fruit without pollination. The bush of red roses at the right alludes not only to Mary but also to the Passion of Jesus, thus recalling the Crucifixion on the outer wings and providing a transition to the Resurrection on the right wing. There, the shock of Christ's explosive emergence from his stone sarcophagus tumbles the guards about, and his new state of being—no longer material but not yet entirely spiritual—is vibrantly evident in his dissolving, translucent figure.

The second opening of the altarpiece (SEE FIG. 21–4) reveals Hagenauer's sculpture and was reserved for the special festivals of Saint Anthony. The wings in this second opening show Saint Anthony attacked by horrible demons—perhaps inspired by the horrors of the diseased patients—and the meeting of Saint Anthony with the hermit Saint Paul. The meeting of the two hermits in the desert glorifies the monastic life, and in the wilderness Grünewald depicts medicinal plants used in the hospital's therapy. Grünewald painted his self-portrait as the face of Saint Paul, and Saint Anthony is a portrait of the donor and administrator of the hospital, the Italian Guido Guersi, whose coat of arms Grünewald painted on the rock.

Like Riemenschneider, Grünewald's career may have been damaged by his active support of the peasants in the Peasants' War. He left Mainz and spent his last years in Frankfurt and then Halle.

ALBRECHT DÜRER. Studious, analytical, observant, and meticulous—and as self-confident as Michelangelo—

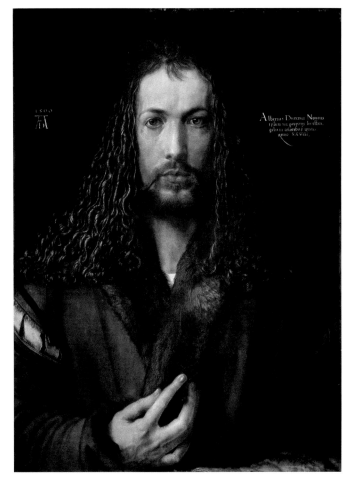

21–7 | Albrecht Dürer **SELF-PORTRAIT**
1500. Signed "Albrecht Dürer of Nuremberg...age 28." Oil on wood panel, 26¼ × 19¼″ (66.3 × 49 cm). Alte Pinakothek, Munich.

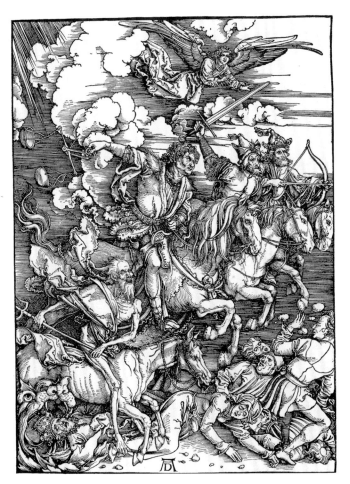

21–8 | Albrecht Dürer **FOUR HORSEMEN OF THE APOCALYPSE**
From *The Apocalypse*. 1497-98. Woodcut, 15½ × 11⅛″ (39.4 × 28.3 cm). The Metropolitan Museum of Art, New York.
Gift of Junius S. Morgan, 1919 (19.73.209)

Albrecht Dürer (1471–1528) was the foremost artist in the northern part of the Holy Roman Empire. He made his home in Nuremberg, where he became a prominent citizen. Its university made Nuremberg a center of learning as well as business, with an active group of humanists and internationally renowned artists. With the new scholarship the city became a leading publishing center.

Dürer's father was a goldsmith and must have expected his son to follow in his trade. Dürer did complete an apprenticeship in goldworking, as well as in stained-glass design, painting, and the making of woodcuts, but it was ultimately as a painter and graphic artist that he found his artistic fame (see "German Metalwork: A Collaborative Venture," p. 714).

In 1490, Dürer began traveling to extend his education. He went to Basel, Switzerland, hoping to meet Martin Schongauer, but arrived after the master's death. Dürer remained in Basel until 1494, providing drawings for woodcut illustrations for books. His first trip to Italy (1494–95) introduced him to Italian Renaissance ideas and attitudes and, as we considered at the beginning of this chapter, to the concept of the artist as an inde-

pendent creative genius. In the **SELF-PORTRAIT** of 1500 (FIG. 21–7), Dürer represents himself as an idealized, almost Christ-like, figure in a severely frontal pose, like an icon. He stares directly at the viewer. His rich fur-lined robes and flowing locks create an equilateral triangle, the timeless symbol of unity.

On his return to Nuremberg, Dürer began to publish his own prints to bolster his income, and ultimately the prints, not his paintings, made his fortune. His first major publication, *The Apocalypse*, appeared simultaneously in German and Latin editions in 1497–98. It consisted of a woodcut title page and fourteen full-page illustrations with the text printed on the back of each. The best-known of the woodcuts is the **FOUR HORSE-MEN OF THE APOCALYPSE** (FIG. 21–8), based on figures described in Revelation 6:1–8: a crowned rider, armed with a bow, on a white horse (Conquest); a rider with a sword, on a red horse (War); a rider with a set of scales, on a black horse (Plague and Famine); and a rider on a sickly pale horse (Death). Earlier artists had simply lined up the horsemen in the landscape. Dürer created a compact overlapping group of wild riders charging across the land and trampling the cowering men.

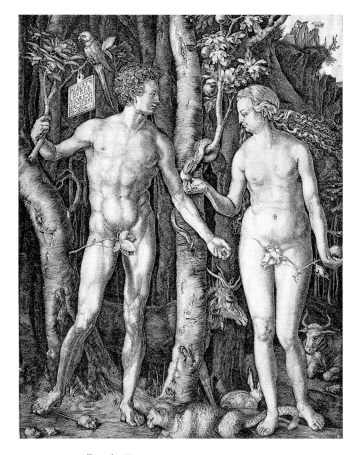

21–9 | Albrecht Dürer **ADAM AND EVE**
1504. Engraving, 9⅞ × 7⅝" (25.1 × 19.4 cm). Philadelphia Museum of Art.

Purchased: Lisa Nora Elkins Fund

Dürer embedded the landscape with symbolic content reflecting the medieval theory that after Adam and Eve disobeyed God, they and their descendants became vulnerable to imbalances in the body fluids that controlled human temperament. As we saw in *Melencolia I* (FIG. 20–1), an excess of black bile from the liver produced melancholy, despair, and greed. Yellow bile caused anger, pride, and impatience; phlegm in the lungs resulted in lethargy and disinterest; and an excess of blood made a person unusually optimistic but also compulsively interested in pleasures of the flesh. These four human temperaments, or personalities, are symbolized here by the melancholy elk, the choleric cat, the phlegmatic ox, and the sensual rabbit. The mouse is a symbol of Satan (see the mousetrap in FIG. 18–2), whose earthly power, already manifest in the Garden of Eden, was capable of bringing perfect human beings to a life of woe through their own bad choices. The parrot may symbolize false wisdom, since it can only repeat mindlessly what it hears. Dürer's pride in his engraving can be seen in the prominence of his signature—a placard bearing his full name and date hung on a branch of the tree of life.

Dürer's familiarity with Italian art was greatly enhanced by a second, leisurely trip over the Alps in 1505–06. Thereafter, he seems to have resolved to reform the art of his own country by publishing theoretical writings and manuals that discussed Renaissance problems of perspective, ideal human proportions, and the techniques of painting. Between 1513 and 1515, Dürer used images, not words, to define a philosophy of Christian life. He created what are known today as his master prints—three engravings having profound themes, but also demonstrating his skill as a graphic artist who could imply color, texture, and space by black lines alone.

Dürer admired Martin Luther, but they never met. In 1526, the artist openly professed his Lutheranism in a pair of inscribed panels, the **FOUR APOSTLES** (FIG. 21–10). On the left panel, the elderly Peter, who normally has a central position as the first pope, has been displaced by Luther's favorite evangelist, John, who holds an open Gospel that reads "In the beginning was the Word," reinforcing the Protestant emphasis on the Bible. On the right panel, Mark stands behind Paul, whose teachings and epistles were particularly admired by the Protestants. A long inscription on the frame warns the viewer not to be led astray by "false prophets" but to heed the words of the New Testament as recorded by these "four excellent men." Below each figure are excerpts from their letters and from the Gospel of Mark warning against those who do not understand the true word of God. In the inscriptions, Dürer used Luther's German translation of the New Testament. The paintings were surely meant to demonstrate that a Protestant art was possible.

Dürer presented the panels to the city of Nuremberg, which had already adopted Lutheranism as its official religion. Dürer wrote, "For a Christian would no more be led to superstition by a picture or effigy than an honest man to commit murder because he carries a weapon by his side. He must

Dürer probably did not cut his own woodblocks but employed a skilled carver who followed his drawings faithfully. Dürer's dynamic figures show affinities with Schongauer's *Temptation of Saint Anthony* (SEE FIG. 18–30). He adapted Schongauer's metal engraving technique to the woodcut medium, using a complex pattern of lines to model the forms. Dürer's early training as a goldsmith is evident in his meticulous attention to detail, and in his decorative cloud and drapery patterns. He fills the foreground with large, active figures just as late fifteenth-century artists had done.

Perhaps as early as the summer of 1494, Dürer began to experiment with engravings, cutting the metal plates himself with artistry equal to Schongauer's. His growing interest in Italian art and his theoretical investigations are reflected in his 1504 engraving **ADAM AND EVE** (FIG. 21–9), which represents his first documented use of ideal human proportions based on Roman copies of ancient Greek sculpture. He may have seen figures of Apollo and Venus in Italy, and he would have known ancient sculpture from contemporary prints and drawings. But behind his idealized human figures he represents plants and animals with typically northern European naturalistic detail.

indeed be an unthinking man who would worship picture, wood, or stone. A picture therefore brings more good than harm, when it is honourably, artistically, and well made" (cited in Snyder, 2nd ed., page 333).

LUCAS CRANACH THE ELDER. One of Dürer's friends, and Martin Luther's favorite painter, Lucas Cranach the Elder (1472–1553), had moved his workshop to Wittenberg in 1504, after a number of years in Vienna. In addition to the humanist milieu of its university and library, Wittenberg offered the patronage of the Saxon court. Appointed court painter to Elector Frederick the Wise, Cranach created woodcuts, altarpieces, and many portraits.

At the humanistic court Cranach met Italian artists who evidently inspired him to paint female nudes himself. Just how far the German artist's style and conception of the figure differ from Italian Renaissance idealism is easily seen in his **NYMPH OF THE SPRING**, a painting that characterizes the Renaissance in the north (FIG. 21–11; compare Titian's *Venus of Urbino*, FIG. 20–26). The sleeping nymph was a Renaissance theme, not an ancient one. Cranach was inspired by a fifteenth-century inscription on a fountain beside the Danube. Translated from the Latin, the text reads, "I am the nymph of the sacred font. Do not interrupt my sleep for I am at peace." Cranach records the Danube landscape with northern fidelity and turns his nymph into a highly provocative young woman, who glances

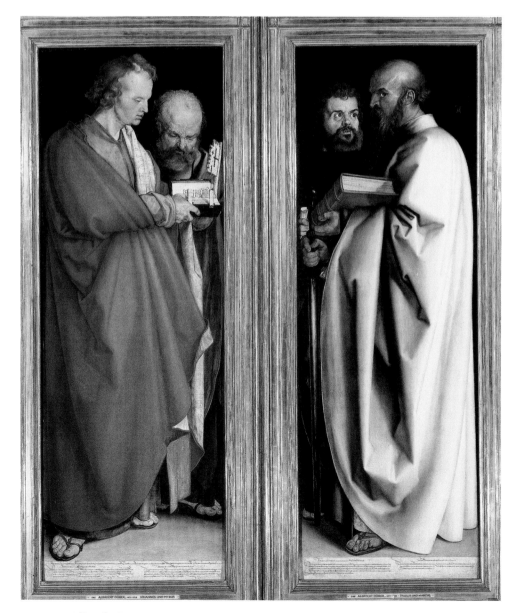

21–10 Albrecht Dürer **FOUR APOSTLES**
1526. Oil on wood panel, each panel 7′½″ × 2′6″ (2.15 × 0.76 m). Alte Pinakothek, Munich.

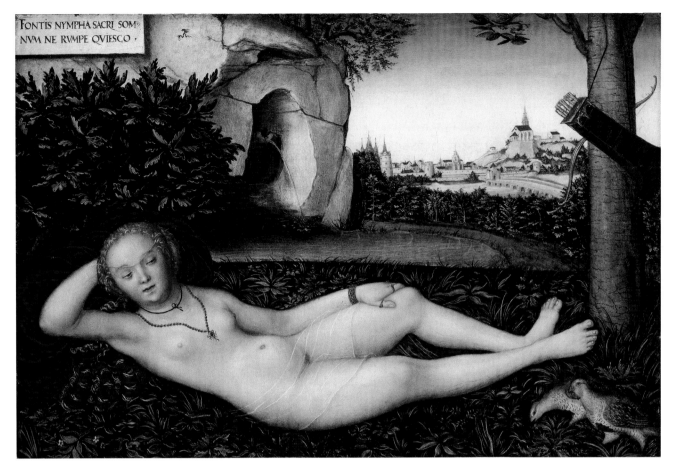

21–11 | Lucas Cranach the Elder **NYMPH OF THE SPRING**
c. 1537. Oil on panel, 19 × 28½" (48.5 × 72.9 cm). National Gallery of Art, Washington, D.C.

In 1537 Cranach adopted as his device a dragon with folded wings, seen on the rock above the fountain.

slyly out at the viewer through half-closed eyes. She has cast aside a fashionable red velvet gown, but still wears her jewelry, which together with her transparent veil enhances rather than conceals her nudity. Unlike other artists working for Protestant patrons, many of whom looked on earthly beauty as a sinful vanity, Cranach seems delighted by earthly things—the lush foliage that provides the nymph's couch, the pair of partridges (symbols of Venus and married love), and Cupid's bow and quiver of arrows hanging on the tree. The *Nymph of the Spring* seems to depict a beauty from the Wittenburg court rather than a follower of the classical Venus.

ALBRECHT ALTDORFER. Landscape, with or without figures, became a popular theme in the sixteenth century. In the fifteenth century, northern artists had examined and recorded nature with the care and enthusiasm of biologists, but they painted their landscapes as backgrounds for figural compositions, usually with religious themes. In the 1520s, however, religious art found little favor among Protestants. Landscape painting, on the other hand, had no overt religious imagery, although

it could be seen as a reflection or even glorification of God's works on earth. The most accomplished German landscape painter of the period was Albrecht Altdorfer (c. 1480–1538).

Altdorfer probably received his early training in Bavaria from his father; he then became a citizen in 1505 of the city of Regensburg in the Danube River valley. He remained there painting the Danube Valley for the rest of his life. The **DANUBE LANDSCAPE** of about 1525 (**FIG. 21–12**) is an early example of pure landscape painting—one without a narrative subject or human figures, and with no religious significance. A small work on vellum laid down on a wood panel, the landscape seems to be a minutely detailed view of the natural terrain, but the forest seems far more poetic and mysterious than Dürer's or Cranach's carefully observed views of nature. The low mountains, gigantic lacy pines, neatly contoured shrubberies, and fairyland castle with red-roofed towers at the end of a winding path announce a new sensibility. The eerily glowing yellow-white horizon below moving gray and blue clouds in a sky that takes up more than half the composition foretell the Romanticism that will characterize later German landscape painting.

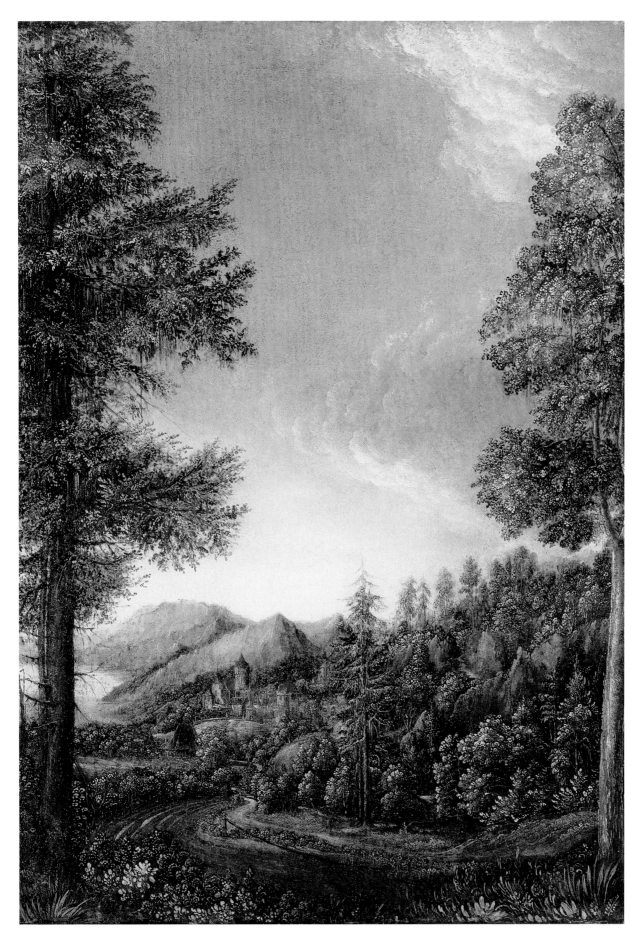

21-12 | Albrecht Altdorfer **DANUBE LANDSCAPE**
c. 1525. Oil on vellum on wood panel, 12 × 8½″ (30.5 × 22.2 cm). Alte Pinakothek, Munich.

RENAISSANCE ART IN FRANCE

France in the early sixteenth century took a different road than did Germany. Pope Leo X came to an agreement with the French king Francis I (ruled 1515–47) in 1519 that spared the country the turmoil suffered in Germany. Furthermore, whereas Martin Luther had devoted followers among the political leaders as well as the people, the French reformer John Calvin (1509–64) fled to Switzerland in 1534, where he led a theocratic state in Geneva. Nevertheless, wars of religion between political factions favoring either Catholics or Huguenots (Protestants), who each wished to exert power over the French crown, also devastated France in the second half of the century.

In 1560, the devoutly Catholic Catherine de' Medici, widow of Henry II (ruled 1547–59), became regent for her young son, Charles IX. She tried, but failed, to balance the warring factions, and her machinations ended in religious polarization and a bloody conflict that began in 1562. Her successor and third son Henry III (ruled 1574–89) was murdered by a fanatical Dominican friar, and his Protestant cousin, Henry, king of Navarre, the first Bourbon king, inherited the throne. Henry converted to Catholicism and ruled as Henry IV. Backed by a country sick of bloodshed, he quickly settled the religious question by granting toleration to Protestants in the Edict of Nantes in 1598.

The Introduction of Italian Art

The greatest French patron of Italian artists was King Francis I. Immediately after his ascent to the throne, Francis showed his desire to "modernize" the French court by acquiring the versatile talents of Leonardo da Vinci. Leonardo moved to France in 1516, officially to advise the king on royal architectural projects and, the king said, for the pleasure of his conversation. Francis continued to support the arts throughout his reign despite the distraction of continual wars against his brother-in-law, Emperor Charles V. Under his patronage, an Italian-inspired Renaissance blossomed in France.

JEAN CLOUET. The Flemish artist Jean Clouet (c. 1485–c. 1540) found great favor as the royal portrait painter. Clouet was in France as early as 1509, and in 1527 he moved to Paris as principal court painter. In his official portrait of the king (FIG. 21–13), Clouet created a flattering image by modeling Francis's distinctive features with subtle shading, a technique that may have been partially inspired by exposure to the work of Leonardo. At the same time he created an image of pure power. The depiction of the king's thick neck and huge body seems at odds with the nervous movement of his fingers. Elaborate, puffy sleeves broadened his shoulders to more than fill the panel, much as parade armor turned scrawny men into giants. The delicately worked costume of silk, satin, velvet, jewels, and gold embroidery could be painted separately from

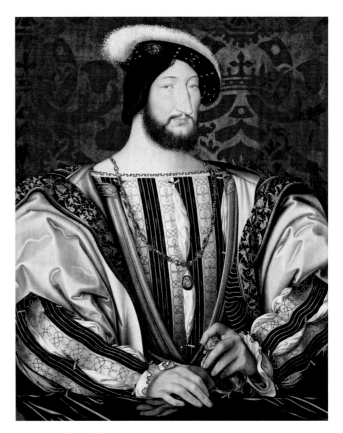

21–13 | Jean Clouet **FRANCIS I**
1525-30. Oil and tempera on wood panel, 37¾ × 29⅛"
(95.9 × 74 cm). Musée du Louvre, Paris.

the portrait itself. The clothing was often loaned to the artist or modeled by a servant to spare the "sitter" the boredom of posing. In creating such official portraits, the artist sketched the subject, then painted a prototype that, upon approval, was the model for numerous replicas made for diplomatic and family purposes.

THE CHÂTEAU OF CHENONCEAU. With the enthusiasm of Francis for things Italian and the widening distribution of Italian books on architecture, the Italian Renaissance style soon appeared in French architecture. Builders of elegant rural palaces, called châteaux, were quick to introduce Italianate decoration to otherwise Gothic buildings, but French architects soon adapted classical principles of building design as well.

One of the most beautiful of these Renaissance palaces was not built as a royal residence, although it soon became one. In 1512 Thomas Bohier, a royal tax collector, bought the castle of Chenonceau on the River Cher, a tributary of the Loire River (FIG. 21–14). He demolished the old castle, leaving only a tower. Using the piers of a water mill on the river bank as part of the foundations, he and his wife erected a new Renaissance home. The plan reflects the classical principles of geometric

regularity and symmetry—a rectangular building with rooms arranged on each side of a wide central hall. Only the library and chapel, which are corbelled out over the water, break the line of the walls. In the upper story, the builders used traditional features of medieval castles—battlements, corner turrets, steep roofs, and dormer windows. The château was finished in 1521. When the owners died soon after, their son gave the château to the king, who turned it into a hunting lodge (see "Chenonceau: The Castle of the Ladies," p. 722).

Later, the foremost French Renaissance architect, the Roman-trained Philibert de l'Orme (d. 1570), designed a gallery on a bridge across the river for Catherine de' Medici. The extension was completed about 1581 and incorporated contemporary Italianate window treatments, wall molding, and cornices that harmonized almost perfectly with the forms of the original turreted building. Chenonceau remains today one of the most important—and beautiful—examples of classical influence on French Renaissance architecture.

FONTAINEBLEAU. Francis I also began renovating royal properties. Having chosen as his primary residence the medieval hunting lodge at Fontainebleau, Francis began transforming it into a grand palace. Most of the exterior structure was altered or destroyed by later renovations, but parts of the interior decoration, the work of artists and artisans from Italy, have been preserved and restored. The first artistic director at

Sequencing Events
KEY EVENTS IN THE PROTESTANT REFORMATION

1517	Martin Luther propounds his Ninety-Five Theses at Wittenberg.
1534	Henry VIII of England breaks from Rome; founds Church of England.
1555	Lutheranism recognized in Germany by the Holy Roman Emperor at the Peace of Augsburg.

Fontainebleau, the Mannerist painter Rosso Fiorentino (d. 1540), arrived in 1530. Francesco Primaticcio (1504–70), who had worked with Giulio Romano in Mantua (SEE FIG. 20–19), joined Rosso in 1532 and succeeded him in 1540. Primaticcio worked on the decoration of Fontainebleau from 1532 until his death in 1570. During that time, he also commissioned and imported a large number of copies and casts of original Roman sculpture, from the newly discovered *Laocoön* (see Introduction, Fig. 10) to the relief decoration on the Column of Trajan. These works provided an invaluable visual source of figures and techniques for the northern European artists employed on the Fontainebleau project.

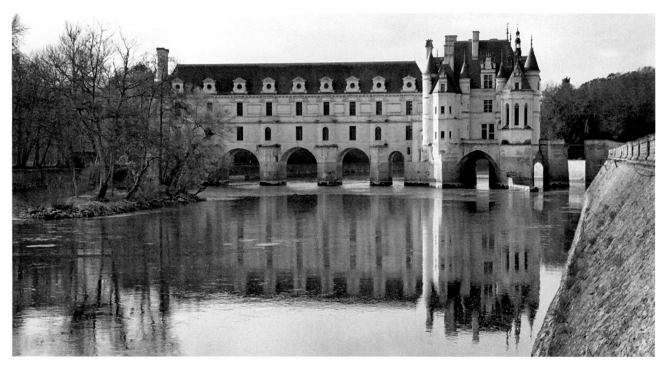

21–14 | **CHÂTEAU OF CHENONCEAU**
Touraine, France. 1513–21; gallery on bridge, finished c. 1581.

Art and Its Context
CHENONCEAU: THE CASTLE OF THE LADIES

Women played an important role in the patronage of the arts during the Renaissance. Nowhere is their influence stronger than in the castle-palaces (châteaux) built in the Loire River valley. At Chenonceau, built beside and literally over the River Cher, a tributary of the Loire, women built, saved, and restored the château. Catherine Briconnet and her husband Thomas Bohier originally acquired the property, including a fortified mill, on which they built their country residence. Catherine supervised the construction, which included such modern conveniences as a straight staircase (an Italian and Spanish feature) instead of traditional medieval spiral stairs, and a kitchen inside the château instead of in a distant outbuilding. When Thomas died in 1524 and Catherine in 1526, their son gave Chenonceau to King Francis I.

King Henry II, Francis's son, gave Chenonceau to his mistress Diane de Poitiers in 1547. She managed the estate astutely, increased revenue, developed the vineyards, added intricately planted gardens in the Italian style, and built a bridge across the Cher. When Henry died in a tournament, the queen Catherine de' Medici (1519-89) appropriated the château for herself.

Catherine, like so many of her family a great patron of the arts, added the two-story gallery to the bridge at Chenonceau, as well as outbuildings and additional formal gardens. Her parties were famous—mock naval battles on the river, fireworks, banquets, dances, and on one occasion two choruses of young women dressed as mermaids in the moat and nymphs in the shrubbery—who were then chased about by young men costumed as satyrs! When Catherine's third son became king as Henry III in 1574, she gave Chenonceau to his wife, Louise of Lorraine.

Louise of Lorraine lived in mourning at Chenonceau after Henry III was assassinated in 1589. She wore only white and covered the walls, windows, and furniture in her room with black velvet and damask. She gave Chenonceau to her niece when she died.

In the eighteenth and nineteenth centuries the ladies continued to determine the fate of Chenonceau. During the French Revolution (1789-93) the owner, Madame Dupin, was so beloved by the villagers that they protected her and saved her home. Then in 1864 Madame Pelouze bought Chenonceau and restored it by removing Catherine de' Medici's Italian "improvements."

Chenonceau continued to play a role in the twentieth century. During World War I it was used as a hospital. During the German occupation in World War II (1940–42), when the River Cher formed the border with Vichy "Free" France, the gallery bridge at Chenonceau became an escape route. In 2000 the Valley of the Loire and its châteaux became a UNESCO World Heritage site.

21–15 | Primaticcio **STUCCO AND WALL PAINTING, CHAMBER OF THE DUCHESS OF ÉTAMPES, CHÂTEAU OF FONTAINEBLEAU**
France. 1540s.

Following ancient tradition, the king maintained an official mistress—Anne, the duchess of Étampes, who lived at Fontainebleau. Among Primaticcio's first projects was the redecoration of Anne's rooms (FIG. 21–15). The artist combined woodwork, stucco relief, and fresco painting in his complex but lighthearted and graceful interior design. The lithe figures of stucco nymphs, with their long necks and small heads, recall Parmigianino's paintings (see fig. 20–35). Their spiraling postures are playfully sexual. The wall surface is almost overwhelmed with garlands, mythological figures, and Roman architectural ornament, yet the visual effect is extraordinarily confident and joyous. The first School of Fontainebleau, as this Italian phase of the palace decoration is called, established a tradition of Mannerism in painting and interior design that spread to other centers in France and into the Netherlands.

Art in the Capital

Before the defeat of King Francis I at Pavia by the Holy Roman Emperor Charles V, and the king's subsequent imprisonment in Spain in 1525, the French court was a mobile unit, and the locus of French art resided outside of Paris in the Loire valley. After 1525, Francis made Paris his bureaucratic seat; and the capital and region around it—the Île de France—took the artistic lead with an attendant shift in style.

RENOVATING THE LOUVRE. Paris saw the birth of a French classical style when the kings Francis I and Henry II decided to modernize the medieval castle of the Louvre. The work began in 1546, with the replacement of the west wing of the square court, the **COUR CARRÉ** (FIG. 21–16), by the architect Pierre Lescot (c. 1510–78). Working with the sculptor Jean Goujon (1510–68), Lescot designed a building incorporating Renaissance ideals of balance and regularity with classical architectural details and rich sculptural decoration. The irregular roof lines of a château, such as at Chenonceau, gave way to discreetly rounded arches and horizontal balustrades. Classical pilasters and entablatures replaced Gothic buttresses and stringcourses. Pediments topped a round-arched arcade on the ground floor, suggesting an Italian loggia. The sumptuous decoration recalls the French medieval Flamboyant style, but with classical pilasters and acanthus replacing Gothic colonnettes and cusps.

FRENCH GARDENS AND GROTTOS. Gardens played an important role in architectural designs, usually intended to be viewed from the owners' rooms on the principal (second) floor. Elaborate flower beds bordered with clipped evergreen yews were planted in generally symmetrical patterns. Long avenues enlivened by sculpture and sculptured fountains led to witty surprises such as trick waterworks and grottos. One of the most brilliant must have been the grotto created by Bernard Palissy for the Tuileries Palace facing the Louvre.

Bernard Palissy (1510–90) created a false earthenware grotto made of glazed ceramic rocks and shells, to which he added crumbling statues, a cat stalking birds, ferns, garlands of fruits and vegetation, fish and crayfish seeming to swim in the pool, and reptiles slithering or creeping over mossy rocks—all of which glistened with water and surely achieved Alberti's

21–17 | Attributed to Bernard Palissy
OVAL PLATE IN *"STYLE RUSTIQUE"*
1570–80/90 (?). Polychromed tin and glazed earthenware, length 20½" (52 cm). Musée du Louvre, Paris.

ideal Slime (see "The Grotto," page 677). Reportedly, he made all the figures from casts of actual animals and plants. In 1563, Palissy had been appointed the court's "inventor of rustic figurines." A Protestant, he was repeatedly arrested during periods of persecution, and he died in prison. Although his Tuileries grotto was destroyed, we can imagine its appearance from the distinctive ceramic designs attributed to him (FIG. 21–17). Platters decorated in high relief with plants, reptiles, and insects resemble descriptions of the grotto. Existing examples are best called "Palissy-style" works, because their authenticity is nearly impossible to prove.

THE OBJECT SPEAKS

SCULPTURE FOR THE KNIGHTS OF CHRIST AT TOMAR

One of the strangest—and in its own way most beautiful—sixteenth-century sculptures in Portugal seems to float over the cloisters of the Convent of Christ in Tomar. Unexpectedly, in the heart of the castle-monastery complex, one comes face to face with the Old Man of the Sea. He supports on his powerful shoulders an extraordinary growth—part roots and trunk of a gnarled tree, part tangled mass of seaweed, algae, ropes, and anchor chains. Barnacle- and coral-encrusted piers lead the eye upward, revealing a large lattice-covered window, the great west window of the Church of the Knights of Christ.

When in 1314 Pope Clement V disbanded the Templars (a monastic order of knights founded in Jerusalem in 1118 after the First Crusade), King Dinis of Portugal offered them a renewed existence as the Knights of Christ. In 1356, they made the former Templar castle and monastery in Tomar their headquarters. When Prince Henry the Navigator (1394–1460) became the Grand Master of the Order, he invested their funds in the exploration of the African coast and the Atlantic Ocean. The Templar insignia, the squared cross, became the emblem used on the sails of Portuguese ships.

King Manuel I of Portugal (ruled 1495–1521) commissioned the present church, with its amazing sculpture from Diogo de Arruda, in 1510. It reflects the wealth and power of sixteenth-century Portugal and the Knights of Christ. So distinctive is the style developed under King Manuel by artists like the Arruda brothers, Diogo (active 1508–31) and Francisco (active 1510–47), that Renaissance art in Portugal is called "Manueline." Architecture became more and more sculptural; piers and columns were carved to resemble twisted ropes; vaulting ribs multiplied into treelike branches. In the window of Tomar, Manueline sculpture reached the pinnacle of

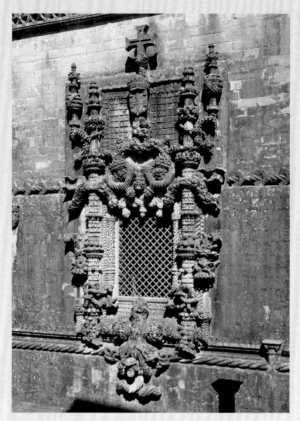

Diogo de Arruda
WEST WINDOW, CHURCH IN THE CONVENT OF CHRIST
Tomar, Portugal. c. 1510. Commissioned by King Manuel I of Portugal.

complexity. Every surface is carved with architectural and natural detail associated with the sea. Twisted ropes form the corners of the window; the coral pillars support great swathes of seaweed. Chains and cables drop through the watery depths to the place where the head of a man—some see him as the Old Man of the Sea; others see a self-portrait of Diogo de Arruda—emerges from the roots of a tree. Trees with generations of ancestors seated in their branches became an important theme in Portuguese art. Here, the idea of a male figure as the foundation block recalls the biblical Tree of Jesse.

Above the window more ropes, cables, and seaweed support the emblems of the patron—the armillary spheres and the coat of arms of Manuel I with its Portuguese castles framing the five wounds of Christ.

Topping the composition is the square cross of the Order of Christ—clearly delineated against the wall of the chapel.

The armillary sphere became a symbol of the era. This complex form of celestial globe, with the sun at the center surrounded by rings marking the paths of the planets, acknowledges the new scientific theory that the sun, not the earth, is the center of the solar system. (Copernicus, teaching in Germany at this time, only published his theories in 1531 and 1543.) Although the armillary sphere had no practical value in navigation, it was a teaching device, a way to demonstrate and learn astronomy. King Manuel's continued use of the armillary sphere as his emblem indicates his determination to make Portugal the leader in the exploration of the sea. Indeed, in Manuel's reign the Portuguese reached India and Brazil.

RENAISSANCE ART IN SPAIN AND PORTUGAL

The sixteenth century saw the high point of Spanish political power. The country had been united in the fifteenth century by the marriage of Isabella of Castile and Ferdinand of Aragon. Only Navarre (in the Pyrenees) and Portugal remained outside the union of the crowns (see "Sculpture for the Knights of Christ at Tomar," page 724).

When Isabella and Ferdinand's grandson Charles V abdicated in 1556, his son Philip II (1556–98) became the king of Spain, the Netherlands, and the Americas, as well as ruler of Milan, Burgundy, and Naples. Philip made Spain his permanent residence. From an early age, Philip was a serious art collector, and for more than half a century, he supported artists in Spain, Italy, and the Netherlands. His navy, the famous Spanish Armada, halted the advance of Islam in the Mediterranean and secured control of most American territories. Despite enormous effort and wealth, however, Philip could not suppress the revolt of the northern provinces of the Netherlands, nor could he prevail in his war against the English, who destroyed his navy in 1588. He was able to gain control of the entire Iberian Peninsula, however, by claiming Portugal when the king died in 1580. Portugal remained part of Spain until 1640.

Architecture

Philip built **EL ESCORIAL** (FIG. 21–18), the great monastery-palace complex outside Madrid, partly to comply with his father's direction to construct a "pantheon" in which all Spanish kings might be buried and partly to house his court and government. To build the palace, in 1559 Philip summoned from Italy Juan Bautista de Toledo (d. 1567), who had been Michelangelo's supervisor of work at Saint Peter's from 1546 to 1548. Juan Bautista's design reflected his indoctrination in Bramante's classical principles in Rome, but the king himself dictated the severity and size of the structure. El Escorial's grandeur comes from its overwhelming size, fine proportions, and excellent masonry. The complex includes not only the royal residence but also the Royal Monastery of San Lorenzo, a school, a library, and a church, its crypt serving as the royal burial chamber. The plan was said to resemble a gridiron, the instrument of martyrdom of its patron saint, Lawrence, who was roasted alive.

In 1572, Juan Bautista's assistant, Juan de Herrera, was appointed architect, and he immediately changed the design, adding second stories on all wings and breaking the horizontality of the main façade with a central frontispiece that resembled superimposed temple fronts. Before beginning the church in the center of the complex, Philip solicited the advice of Italian architects—including Vignola and Palladio (see p. 690 and p. 703). The final design combined ideas that Philip approved and Herrera carried out. Although not a replica of any Italian design, the building embodies Italian classicism in its geometric clarity and symmetry and the use of superimposed orders on the temple-front façade. In its sober and severe character, however, it embodies the austere and deeply religious spirit of the Spanish Philip II.

Painting

The arts continued to be sponsored by the Church and the nobles. Pageantry—including the sign language of heraldry, luxurious armor, and textiles—answered the aesthetic desires of the patrons. Philip II was a great patron of the Venetian painter Titian, and he collected Netherlandish artists such as Bosch (see page 728).

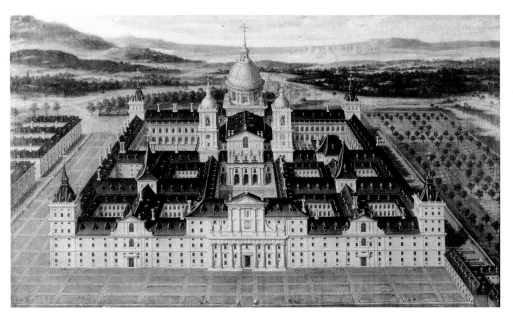

21–18 | Juan Bautista de Toledo and Juan de Herrera
EL ESCORIAL
Madrid. 1563–84. Detail from an anonymous 18th-century painting.

EL GRECO. Today the most famous Spanish painter from the last quarter of the sixteenth century is Domenikos Theotokopoulos (1541–1614), who arrived in Spain in 1577 after working for ten years in Italy. "El Greco" ("The Greek"), as he is called, was trained as an icon painter in the Byzantine manner in his native Crete, then under Venetian rule. In about 1566, he went to Venice and entered Titian's studio, where he also studied the paintings of Tintoretto and Veronese. From about 1570 to 1577, he worked in Rome, apparently without finding sufficient patronage, although he lived for a time in the Farnese Palace. Probably encouraged by Spanish Church officials whom he met in Rome, El Greco settled in Toledo, Spain, the seat of the archbishop. He had apparently hoped for a court appointment, but Philip II disliked the painting he had commissioned from El Greco for El Escorial and never gave him work again.

In Toledo, El Greco joined the circle of humanist scholars. His annotations in his own copies of Vitruvius and Vasari demonstrate his concern with the issues of the day. He wrote that the artist's goal should be to copy nature, that Raphael relied too heavily on the ancients, and that the Italians' use of mathematics to achieve ideal proportions hindered their painting of nature. At the same time an intense religious revival was under way in Spain, expressed in the impassioned preaching of Ignatius of Loyola, as well as in the poetry of the two great Spanish mystics: Saint Teresa of Ávila (1515–82), founder of the Discalced ("unshod") Carmelites, and her follower Saint John of the Cross (1542–91). El Greco's style—rooted in Byzantine icon painting and strongly reflecting Venetian artists' rich colors and loose brushwork—expressed in paint the intense spirituality of these mystics.

21–19 | El Greco **BURIAL OF COUNT ORGAZ**
1586. Oil on canvas, 16′ × 11′10″ (4.88 × 3.61 m).
Church of Santo Tomé, Toledo, Spain.

21–20 | El Greco
VIEW OF TOLEDO
c. 1610. Oil on
canvas, 47¾ × 42¾″
(121 × 109 cm).
The Metropolitan
Museum of Art,
New York.
The H. O. Havemeyer
Collection. Bequest of
Mrs. H. O. Havemeyer,
1929 (29.100.6)

In 1586, the Orgaz family commissioned El Greco to paint a large altarpiece honoring an illustrious fourteenth-century ancestor. Count Orgaz had been a great benefactor of the Church, and at his funeral in 1323 the saints Augustine and Stephen were said to have appeared to lower his body into his tomb as his soul was seen ascending to heaven. El Greco's painting the **BURIAL OF COUNT ORGAZ** (FIG. 21–19) reenacts the miraculous burial. An angel lifts Orgaz's tiny ghostly soul along the central axis of the painting through the heavenly hosts toward the enthroned Christ at the apex of the canvas. El Greco filled the space around the burial scene with portraits of the local aristocracy and religious notables. He placed his own eight-year-old son at the lower left next to Saint Stephen and signed the painting on the boy's white kerchief. El Greco may also have put his own features on the man just above the saint's head, the only one who looks straight out at the viewer.

In composing the painting, El Greco used Mannerist devices reminiscent of Pontormo (SEE FIG. 20–34), filling the pictorial field with figures and eliminating specific reference to the spatial setting. Yet he has distinguished between heaven and earth by the elongation of the heavenly figures and the light emanating from Christ, who sheds an otherworldly luminescence quite unlike the natural light below. The two realms are connected, however, by the descent of the light from heaven to strike the priestly figure in the white vestment at the lower right.

Late in his life, El Greco painted one of his rare landscapes, **VIEW OF TOLEDO** (FIG. 21–20), a topographical cityscape transformed into a mystical illusion by a stormy sky and a narrowly restricted palette of greens and grays. This conception is very different from Altdorfer's peaceful, idealized *Danube Landscape* (SEE FIG. 21–12). If any precedent comes to mind, it is the

lightning-rent sky and prestorm atmosphere in Giorgione's *The Tempest* (SEE FIG. 20–23). In El Greco's painting, the precisely accurate portrayal of Toledo's geography and architecture seems to have been overridden by the artist's desire to convey the power of nature. In this, El Greco looks forward to the art of the Baroque period.

RENAISSANCE PAINTING IN THE NETHERLANDS

In the Netherlands the sixteenth century was an age of bitter religious and political conflict. Despite the opposition of the Spanish Habsburg rulers, the Protestant Reformation took hold in the northern provinces. Seeds of unrest were sown still deeper over the course of the century by continued religious persecution, economic hardship, and control by inept governors. A long battle for independence began with a revolt in 1568 and lasted until Spain relinquished all claims to the region eighty years later. As early as 1579, when the seven northern Protestant provinces declared themselves the United Provinces, the discord split the Netherlands, eventually dividing it along religious lines into the northern provinces—United Provinces (present-day Netherlands)—and Catholic Flanders (present-day Belgium).

Even with the turmoil, the Netherlanders found the resources to pay for art, and Antwerp and other cities developed into art centers. The Reformation led artists to seek patrons outside the Church. While courtiers and burghers alike continued to commission portraits, the demand arose for small paintings with interesting secular subjects appropriate for homes. For example, some artists became specialists known for their landscapes or satires. In addition to painting, textiles, ceramics, and sculpture in wood and metal flourished in the Netherlands. Flemish tapestries were sought after, as they had been in the fifteenth century. In Italy fine Netherlandish tapestries were highly prized and leading Italian artists made paintings (cartoons) to be woven. For example, Raphael's cartoons for the tapestries of the Sistine Chapel were woven in Brussels by the workshop of Pieter van Aelst (SEE FIG. 20–8).

The graphic arts emerged as an important medium and provided many artists with another source of income. Pieter Bruegel began his career drawing amusing and moralizing images to be printed and published by At the Four Winds, an Antwerp publishing house. Artists such as Hendrick Goltzius, who traveled sketchbook in hand, turned their experiences to profit when they returned home. Goltzius, who had spent 1591–92 in Rome, recorded the awestruck wonder of his Dutch friends at the sight of the recently discovered 10-foot-tall Hercules displayed in the Farnese Palace (see Fig. 24, Introduction). Surely he meant to inform and amuse—and sell prints.

Netherlandish artists had their biographer. Like Vasari in Italy, Carel van Mander (1548–1606) recorded the lives of his contemporaries in lively stories that mix fact and gossip. He,

too, intended his book *Het Schilderbock (The Painter's Book)* to be a survey of the history of art, and he included material from the ancient Roman writers Pliny and Vitruvius as well as from Vasari, his contemporary. Vasari's revised and expanded *Lives* had been published in 1568 and served as a source and a model for Van Mander and others.

Art for Aristocratic and Noble Patrons

Artistic taste among the wealthy bourgeoisie and noble classes in early sixteenth-century Netherlands was characterized by a striking diversity: the imaginative and difficult visions of Hieronymous Bosch, as well as the more Italian-influenced compositions of Jan Gossaert. In the later years of his life (after 1500), Bosch's membership in a local but prestigious confraternity called the Brotherhood of Our Lady seems to have opened doors to noble patrons such as Count Hendrick III of Nassau and Duke Philip the Fair. His younger contemporary, Gossaert, left the city of Antwerp as a young man to spend the majority of his active years as the court painter for the natural son of Duke Philip the Good. His art also attracted members of the Habsburgs, including Charles V, who were seduced by Gossaert's combination of northern European and Italian styles.

HIERONYMUS BOSCH. One of the most fascinating of the Netherlandish painters to viewers today is Hieronymus Bosch (1450–1516), whose work depicts a world of fantastic imagination more often associated with medieval than Renaissance art. A superb colorist and technical virtuoso, Bosch spent his career in the town whose name he adopted, 's-Hertogenbosch. Bosch's religious devotion is certain, and his range of subjects shows that he was well educated.

Challenging and unsettling paintings such as the triptych **GARDEN OF EARTHLY DELIGHTS** (FIG. 21–21) have led modern critics to label Bosch both a mystic and a social critic. The subject of the painting seems to be the Christian belief in human beings' natural state of sinfulness. Because only the damned are shown in the Last Judgment on the right, the work seems to caution that damnation is the natural outcome of a life lived in ignorance and folly, that people ensure their damnation through their self-centered pursuit of pleasures of the flesh— the sins of gluttony, lust, greed, and sloth.

In the left wing, God introduces Adam and Eve, under the watchful eye of the owl of perverted wisdom. The owl symbolizes both wisdom and folly. Folly had become an important concept to the northern European humanists, who believed in the power of education. They believed that people would choose to follow the right way if they knew it. Here the owl peers out from a fantastic pink fountain in a lake from which vicious creatures creep out into the world. Their hybrid forms result from unnatural unions. In the central panel, the earth teems with revelers, monstrous birds, and huge fruits, symbolic of fertility and sexual abandon. In hell, at the right, the sensual pleasures— eating, drinking, music, and dancing—become torture in a dark

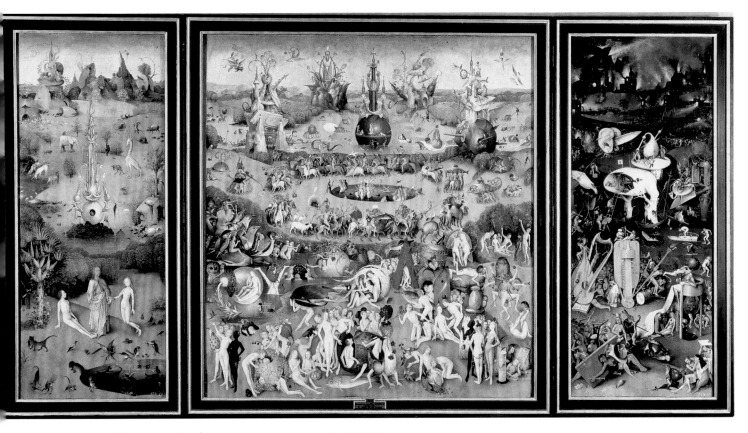

21–21 | Hieronymus Bosch **GARDEN OF EARTHLY DELIGHTS**
c. 1505–15. Oil on wood panel, center panel 7′2½″ × 6′4¾″ (2.20 × 1.95 m), each wing 7′2½″ × 3′2″
(2.20 × 0.97 m). Museo del Prado, Madrid.

world of fire and ice. A creature with stump legs balanced unsteadily on rowboats watches his own stomach, filled with lost souls in the proverbial "tavern on the road to hell."

One scholar has proposed that the central panel is a parable on human salvation in which the practice of alchemy—the process that sought to turn common metals into gold—parallels Christ's power to convert human dross into spiritual gold. In this theory, the bizarre fountain at the center of the lake in the middle distance can be seen as an alchemical "marrying chamber," complete with the glass vessels for collecting the vapors of distillation. Others see the theme known as "the power of women." In this interpretation the central pool is the setting for a display of seductive women and sex-obsessed men. Women frolic alluringly in the pool while men dance and ride in a mad circle trying to attract them. In this strange garden, men are slaves to their own lust. Yet another critic focused on the fruit, writing (c. 1600) that the triptych was known as *The Strawberry Plant* because it represented the "vanity and glory and the passing taste of strawberries or the strawberry plant and its pleasant odor that is hardly remembered once it has passed." Luscious fruits having sexual symbolism—strawberries, cherries, grapes, and pomegranates—appear everywhere in the

Garden, serving as food, as shelter, and even as a boat. Is human life as fleeting and insubstantial as the taste of a strawberry? Meaning clearly lies in the eye of the beholder of these very private paintings.

The *Garden of Earthly Delights* was commissioned by an aristocrat (probably Count Hendrick III of Nassau) for his Brussels town house, and the artist's choice of a triptych format, which suggests an altarpiece, may have been an understated irony. In a private home the painting may have inspired lively discussion and even ribald comment, much as it does today in its museum setting. Despite—or perhaps because of—its bizarre subject matter, the triptych was copied in 1566 into tapestry versions, one for a cardinal (now in the Escorial) and another for the French king Francis I. At least one painted copy was made as well. Bosch's original triptych was sold at the onset of the Netherlands revolt and sent in 1568 to Spain, where it entered the collection of Philip II.

JAN GOSSAERT. In contrast to the private visions of Bosch, Jan Gossaert (c. 1478–c. 1533) took a conservative line in subject matter and also embraced the new classical art of Italy. Gossaert (who later called himself "Mabuse" after his native

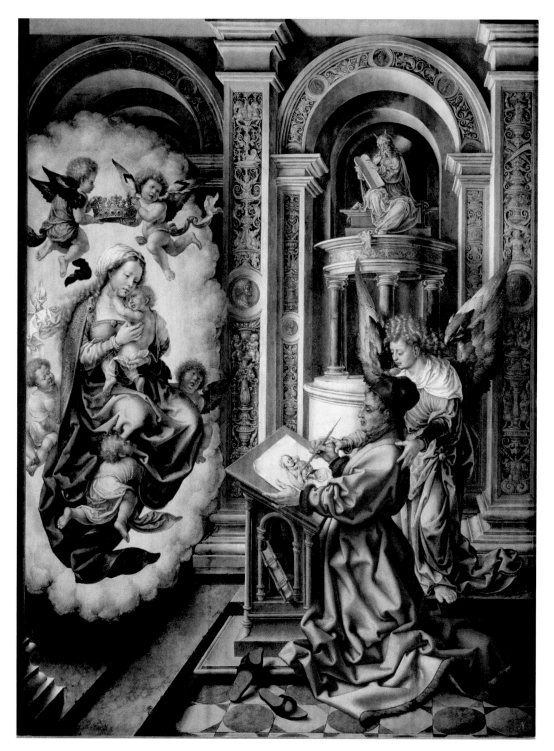

21–22 | Jan Gossaert **SAINT LUKE PAINTING THE VIRGIN MARY**
1520. Oil on panel, 43⅜ × 32¼″ (110.2 × 81.9 cm). Kunsthistorisches Museum, Vienna.

city Maubeuge) entered the service of Philip, the illegitimate son of the Duke of Burgundy. In 1508 he traveled to Italy with Philip, and on their return Gossaert continued to work for Philip—who became archbishop of Utrecht in 1517.

After a period when he had been influenced by Jan van Eyck, Gossaert settled into what has been called a "Romanizing" style, inspired by Italian Mannerist paintings with a strong interjection of decorative details based on ancient Roman art.

In **SAINT LUKE PAINTING THE VIRGIN MARY** (FIG. 21–22), the artist's studio is an extraordinary structure of barrel vaults and classical piers and arches, which are carved with a dense ornament of foliage and medallions. Mary and the Christ Child appear to Saint Luke in a vision of golden light and clouds. The saint kneels at a desk, drawing, his hand guided by an angel. Luke's crumpled red robe recalls fifteenth-century drapery conventions. Behind the saint, seated on a round, columnar

structure, Moses holds the tablets of the Law, having seen the burning bush (which, as with Mary's virginity, was not consumed) on Mount Sinai. Moses removed his shoes in the presence of God's manifestation and so has Saint Luke in the presence of his vision. In short, the artist is divinely inspired. Gossaert, like Dürer before him, emphasizes the divine inspiration of the artist.

Antwerp

In the sixteenth century the city of Antwerp was the commercial and artistic center of the southern Netherlands. Antwerp's deep port made it an international center of trade (it was one of the European centers for trade in spices), and it was the financial center of Europe. Painting, printmaking, and book production flourished in this environment, attracting artists and craftsmen from all over Europe. The demand for luxury goods (including art) fostered the birth of the art market, in which art was transformed into a commodity both for local and international consumption. In responding to this market, many artists became specialists in one area, such as portraiture or landscape. Eventually, art dealers emerged as middlemen, further shaping the nascent art market and the professions it includes.

MARINUS VAN REYMERSWAELE. In contrast to Gossaert's inspired *Saint Luke*, Marinus van Reymerswaele from Zeeland (c. 1493–after 1567) painted "Everyman" going about his daily affairs. In his popular Antwerp workshop he produced secular panel paintings featuring such characters as the universally despised money-lenders and tax collectors. **THE BANKER AND HIS WIFE** (FIG. 21–23), painted in 1540, is

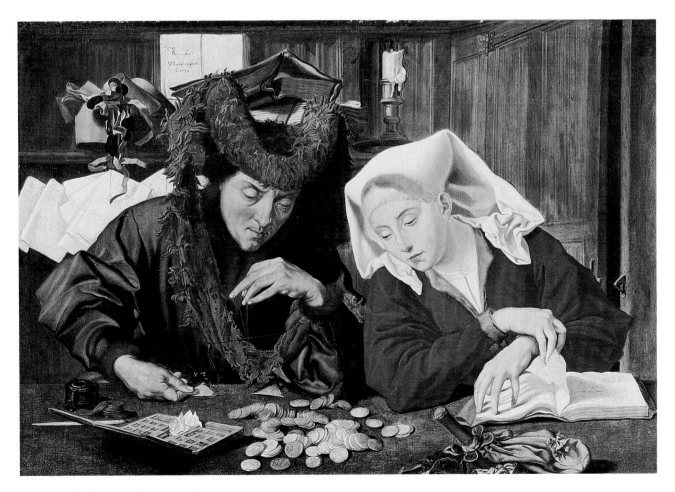

21–23 | Marinus van Reymerswaele **THE BANKER AND HIS WIFE**
1540. Oil on panel, 33¾ × 45⅞" (85.7 × 116.5 cm). Museo Nazionale del Bargello, Florence.

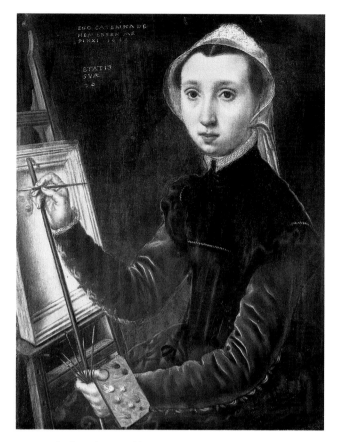

21–24 | Caterina van Hemessen **SELF-PORTRAIT**
1548. Oil on wood panel, 12¼ × 9¼″ (31.1 × 23.5 cm).
Öffentliche Kunstsammlung, Basel, Switzerland.

The panel on the easel already has its frame. Caterina holds a small palette and brushes and steadies her right hand with a mahlstick, an essential tool for an artist doing fine, detailed work.

almost a caricature of *A Goldsmith (Saint Eligius?) in His Shop* by Petrus Christus (SEE FIG. 18–18). In contrast to the pious saint, the banker greedily counts coins, avidly watched by his young wife, whose thin, clawlike fingers turn the pages of the account book. Two other popular themes emerge: "the power of women," a variation of "the world turned upside down," and the "mismatched couple"—the old man with a young wife. Virtuoso painting technique has been applied to a less-than-worthy subject, but the artist probably intended more than mere illustration. The painting recalls the sins of lust and greed—the folly of ill-matched lovers, and the sin caused by the love of money. The cluttered table and filled shelves suggest the emerging specialty of still-life painting—which, along with landscape painting, will become an important theme in the art of the next century.

CATERINA VAN HEMESSEN. As religious art declined in the face of Protestant disapproval, portraits became a major source of work for artists. Caterina van Hemessen (1528–87)

of Antwerp had an illustrious international reputation as a portraitist. She had learned to paint from her father, the Flemish Mannerist Jan Sanders van Hemessen, but her quiet realism and skilled rendering also had its roots in the Italian High Renaissance, whose ideas were brought back to the Netherlands by painters who had visited Italy. To maintain the focus on the foreground subject, van Hemessen painted her portraits against even, dark-colored backgrounds, on which she identified the sitter by name and age, signing and dating each work. The inscription in her **SELF-PORTRAIT** (FIG. 21–24) reads: "I Caterina van Hemessen painted myself in 1548. Her age 20." In delineating her own features, van Hemessen presented a serious young person without personal vanity yet seemingly already self-assured about her artistic abilities.

During her early career in Antwerp, van Hemessen became a favored court artist to Mary of Hungary, sister of Emperor Charles V and regent of the Netherlands, for whom she painted not only portraits but also religious works. In 1554, Caterina married the organist of Antwerp Cathedral, and when Mary ceased to be regent in 1556 (at the time of Charles's abdication), the couple accompanied Mary to Spain.

PIETER BRUEGEL THE ELDER. So popular did the works of Hieronymus Bosch remain that, nearly half a century after his death, Pieter Bruegel (c. 1525–69) began his career by imitating them. Fortunately, Bruegel's talents went far beyond those of an ordinary copyist. Like Bosch he often painted large narrative works crowded with figures, and he chose moralizing or satirical subject matter. He traveled throughout Italy, but, unlike many Renaissance artists, he did not record the ruins of ancient Rome or the wonders of the Italian cities. Instead, he seems to have been fascinated by the landscape, particularly the formidable jagged rocks and sweeping panoramic views of Alpine valleys, which he recorded in detailed drawings. Back home in his studio, he made an impressive leap of the imagination as he painted the flat and rolling lands of Flanders as broad panoramas, even adding imaginary mountains on the horizon (SEE FIG. 21–26).

In 1563, after his first career as a draftsman for the engravers in At the Four Winds publishing house, he moved to Brussels. Bruegel's style and subjects found great favor with local scholars, merchants, and bankers, who appreciated the beautifully painted, artfully composed works that also reflected contemporary social, political, and religious conditions. Bruegel visited country fairs to sketch the farmers and townspeople who became the focus of his paintings, whether religious or secular. He depicted characters not as unique individuals but as well-observed types, whose universality makes them familiar even today. Bruegel presented Flemish farmers vividly and sympathetically while also exposing their very human faults.

Clearly Bruegel knew the classics; he had been a member of the humanistic circles in Antwerp. He could only have

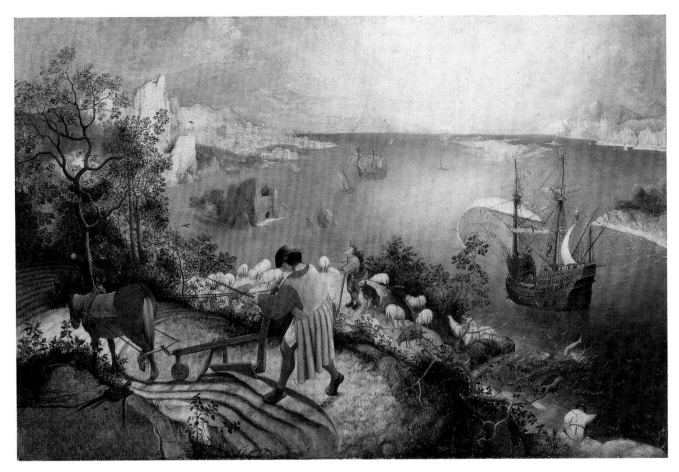

21–25 | Pieter Bruegel the Elder **THE FALL OF ICARUS**
c. 1555–56. Oil on panel transferred to canvas. 29 × 44⅛″ (73.6 × 112 cm). Konenklijke Musea voor Schone Kunsten van Belgie, Brussels.

painted **THE FALL OF ICARUS** (FIG. 21–25) after reading Ovid, so closely does he follow the ancient Roman's description of Icarus's fall. Icarus—thrilled by the experience and filled with exuberant self-confidence—ignored his father's warning and flew too near the sun, melting his wings of feathers and wax. As Ovid tells the story, in Book 8 of his *Metamorphoses*, no one noticed as the youth plunged into the sea—neither the fisherman, the shepherd, nor the plowman. Bruegel's painting of these workers indicates a very close observation of real people going about their normal activities. That he was as aware of local folklore as he was of the classics is demonstrated by his inclusion of a half-hidden corpse in the underbrush. A Flemish proverb says, "No plow stops at the death of any man."

But where is Icarus, the fallen hero? Amid rippling waves near the shore two tiny legs thrash madly as the boy plunges to his death. Man's great achievement—flight—and man's pride in accomplishment—and death because of this pride—all are irrelevant to the simple people whose goal is day-to-day survival in the continuous cycle of nature.

Bruegel was not only a great landscape painter, he could depict nature in all seasons and in all moods. His **RETURN OF THE HUNTERS** (FIG. 21–26) is one of a cycle of six panels, each representing two months of the year. In this December–January scene, Bruegel has captured the atmosphere of the damp, cold winter, with its early nightfall, in the same way that his compatriots the Limbourgs did 150 years earlier in the *February* calendar illustration (see fig. 18–6). At first, the *Hunters* appears neutral and realistic, but the sharp plunge into space, the juxtaposition of near and far without middle ground, is a typically sixteenth-century device. The viewer seems to hover with the birds slightly above the ground, looking down first on the busy foreground scene, then suddenly across the valley to the snow-covered village and frozen ponds. The main subjects of the painting, the hunters, have their backs turned and do not reveal their feelings as they slog through the snow, trailed by their dogs. They pass an inn, at the left, where a worker moves a table to receive a pig that others are singeing in a fire. But this is clearly not an accidental image; it is a slice of everyday life

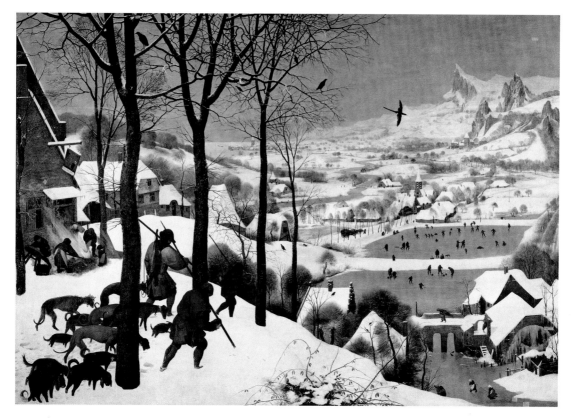

21–26 | Pieter Bruegel the Elder **RETURN OF THE HUNTERS**
1565. Oil on wood panel, 3′10½″ × 5′3¾″ (1.18 × 1.61 m). Kunsthistorisches Museum, Vienna.

faithfully reproduced within the carefully calculated composition. The sharp diagonals sweeping into space are countered by the pointed gables and roofs at the lower right as well as by the jagged mountain peaks along the right edge. Their rhythms are deliberately slowed and stabilized by a balance of vertical tree trunks and horizontal rectangles of water frozen over in the distance. As a depiction of Netherlandish life, this scene represents a relative calm before the storm. Three years after it was painted, the anguished struggle of the northern provinces for independence from Spain began.

Pieter the Elder died in 1569, leaving two children, Pieter the Younger and Jan, both of whom became successful painters in the next century. The dynasty continued with Jan's son, Jan the Younger. In the seventeenth century, the spelling of the family name was changed from Bruegel to Brueghel.

RENAISSANCE ART IN ENGLAND

England, although facing the disruption of the Reformation, was economically and politically stable enough to provide sustained support for architecture and the decorative arts during the Tudor dynasty. Music and literature also flourished, but painting was left to foreigners. Henry VIII was known for his love of music (he was himself a composer of considerable

accomplishment), and he also hoped to compete with the wealthy, sophisticated court of Francis I in the visual arts.

As a young man Henry VIII (ruled 1509–47) was loyal to the Church. When he wrote a book attacking Luther in 1520, the pope declared him "Defender of the Faith." But when the pope refused to annul his marriage to Catherine of Aragon, Henry broke with Rome. By action of Parliament in 1534 he became the "Supreme Head on earth of the Church and Clergy of England." He ordered an English translation of the Bible to be put in every church. In 1536 and 1539, he went further and dissolved the monasteries, confiscating their great wealth and rewarding his followers with monastic lands and buildings. Henry's need for money had disastrous effects on the arts as his men stripped shrines and altars of their jewels and precious metals. The final blow to religious art came during the reign of Henry's son Edward VI when in 1548 all images were officially prohibited and two years later altars were replaced by wooden tables.

During the brief reign of Mary (ruled 1553–58), England officially returned to Catholicism, but the accession of Elizabeth in 1558 confirmed England as a Protestant country. So effective was Elizabeth, who ruled until 1603, that the last decades of the sixteenth century in England are called the Elizabethan Age.

Artists in the Tudor Court

Religious painting had no place in England, but a remarkable record of the appearance of Tudor monarchs survives in portraiture. Because direct contacts with Italy became difficult after Henry's break with the Roman Catholic Church, the Tudors favored Netherlandish and German artists. Thus, it was a German-born painter, Hans Holbein the Younger (c. 1497–1543), who shaped the taste of the English court and upper classes, and a Flemish artist who held the title of "King's Painter."

HANS HOLBEIN. Holbein first visited London from 1526 to 1528 and was introduced by the Dutch scholar Erasmus to the humanist circle around the statesman Thomas More. He returned to England in 1532 and was appointed court painter to Henry VIII about four years later. One of Holbein's official portraits of Henry (FIG. 21–27), shown at age 49 according to the inscription on the dark blue-green background, was painted in 1540, although the king's appearance had already been established in an earlier prototype. Henry, who envied the

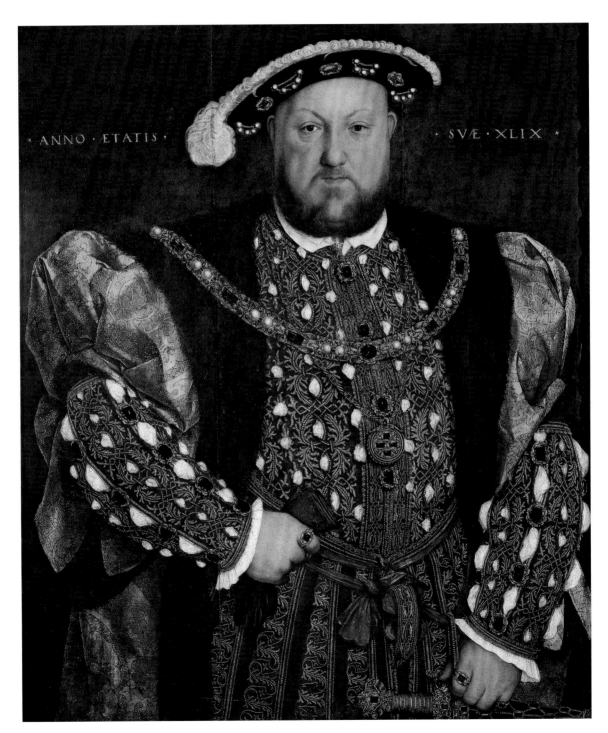

21–27 | Hans Holbein the Younger **HENRY VIII**
1540. Oil on wood panel, 32½ × 29½″ (82.6 × 75 cm). Galleria Nazionale d'Arte Antica, Rome.

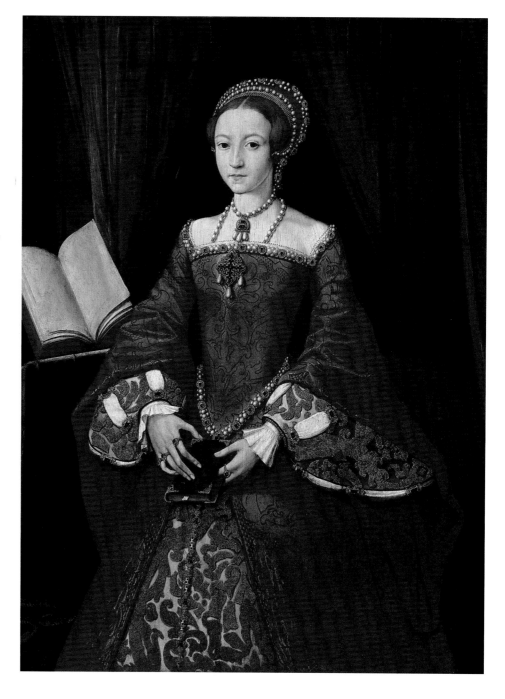

21–28 | Attributed to Levina Bening Teerlinc
PRINCESS ELIZABETH
c. 1559. Oil on oak panel, 42¾ × 32¼″ (109 × 81.8 cm). The Royal Collection, Windsor Castle, England.
(RCIN 404444, OM 46 WC 2010)

French king Francis I and attempted to outdo him in every way, imitated French fashions and even copied the style of the French king's beard. Henry's huge frame—he was well over 6 feet tall and had a 54-inch waist—is covered by the latest style of dress: a short puffed-sleeve coat of heavy brocade trimmed in dark fur; a narrow, stiff white collar fastened at the front; and a doublet, encrusted with gemstones and gold braid, which was slit to expose his silk shirt. Holbein used the English king's great size to advantage for this official portrait, enhancing Henry's majestic figure with embroidered cloth, fur, and jewelry to create one of the most imposing images of

power in the history of art. He is dressed for his wedding to his fourth wife, Anne of Cleves, on April 5, 1540.

LEVINA BENING TEERLINC. Holbein was not the highest-paid painter in Henry VIII's court. That status belonged to a Netherlandish woman, Levina Bening Teerlinc. Since Teerlinc worked in England for thirty years, her near-anonymity is an art-historical mystery. At Henry's invitation to become "King's Paintrix," she and her husband arrived in London in 1545 from Bruges, where her father was a leading manuscript illuminator. She maintained her court appointment

Art and Its Context
ARMOR FOR ROYAL GAMES

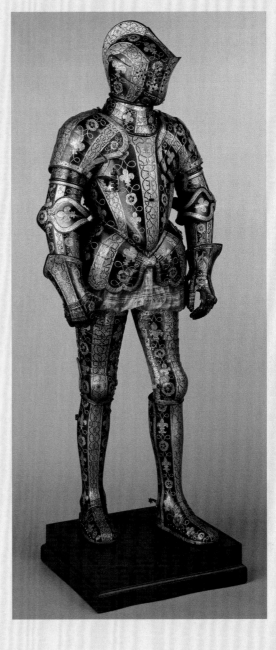

The medieval tradition of holding tilting, or jousting, competitions at English festivals and public celebrations continued during Renaissance times. Perhaps the most famous of these, the Accession Day Tilts, were held annually to celebrate the anniversary of Elizabeth I's coronation. The gentlemen of the court, dressed in armor made especially for the occasion, held mock battles in the queen's honor. They rode their horses from opposite directions, trying to strike each other with long lances. Each pair of competitors made six passes and the judges rated their performances.

The elegant armor worn by George Clifford, third Earl of Cumberland, at the Accession Day Tilts has been preserved in the collection of the Metropolitan Museum of Art in New York. Tudor roses and back-to-back capital E's in honor of the queen decorate the armor's surface. As the Queen's Champion beginning in 1590, Clifford also wore her jeweled glove attached to his helmet as he met all comers in the tiltyard of Whitehall Palace in London.

Made by Jacob Halder in the royal armories at Greenwich, the 60-pound suit of armor is recorded in the sixteenth-century Almain Armourers' Album along with its "exchange pieces." These allowed the owner to vary his appearance by changing mitts, side pieces, or leg protectors, and also provided backup pieces if one were damaged.

Jacob Halder **ARMOR OF GEORGE CLIFFORD, THIRD EARL OF CUMBERLAND**
Made in the royal workshop at Greenwich, England.
c. 1580–85. Steel and gold, height 5′9½″ (1.77 m).
The Metropolitan Museum of Art, New York.
Munsey Fund, 1932 (32.130.6)

until her death about 1576, in the reign of Elizabeth I. Because Teerlinc was the granddaughter and daughter of Netherlandish manuscript illuminators, she is assumed to have painted miniature portraits or scenes on vellum and ivory. Certainly, she designed Elizabeth's first official seal of 1559, which included the queen's likeness. One life-size portrait frequently attributed to her—but by no means securely—depicts Elizabeth Tudor as a young princess (FIG. 21–28). Elizabeth's pearled cap, an adaptation of the so-called French hood popularized by her mother, Anne Boleyn, is set back to expose her famous red hair. Her brocaded outer dress, worn over a rigid hoop, is split to expose an underskirt of cut velvet. Although her features are softened by youth and no doubt are idealized as well, her long, high-bridged nose and the fullness below her small lower lip give her a distinctive appearance. The prominently displayed books were no doubt included to signify Elizabeth's well-known love of learning.

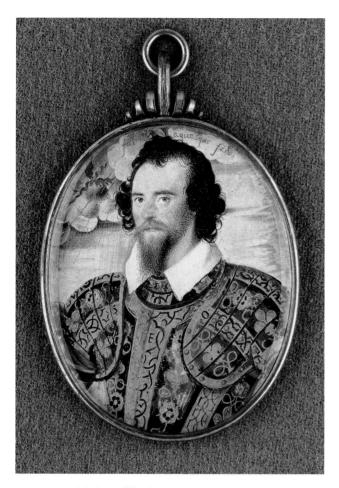

21–29 | Nicholas Hilliard **GEORGE CLIFFORD, THIRD EARL OF CUMBERLAND (1558–1605)**
c. 1595. Watercolor on vellum on card, oval 2¾ × 2³/₁₆″ (7.1 × 5.8 cm). The Nelson-Atkins Museum of Art, Kansas City, Missouri.

Gift of Mr. and Mrs. John W. Starr through the Starr Foundation. F58-60/188

NICHOLAS HILLIARD. In 1570, while Levina Teerlinc was still active at Elizabeth's court, Nicholas Hilliard (1547–1619) arrived in London from southwest England to pursue a career as a jeweler, goldsmith, and painter of miniatures. Hilliard never received a court appointment but worked instead on commission, creating miniature portraits of the queen and court notables, including **GEORGE CLIFFORD, THIRD EARL OF CUMBERLAND** (FIG. 21–29). Cumberland was a regular participant in the annual tilts and festivals celebrating the anniversary of Elizabeth I's ascent to the throne. In Hilliard's miniature, Cumberland wears a richly engraved and gold-inlaid suit of armor, forged for his first appearance, in 1583, at the tilts (see "Armor for Royal Games," page 737). Hilliard had a talent for giving his male subjects an appropriate air of courtly jauntiness. Cumberland, a man of about thirty with a stylish beard, mustache, and curled hair, is humanized by his direct gaze and unconcealed receding hair-

line. Cumberland's motto, "I bear lightning and water," is inscribed on a stormy sky, with a lightning bolt in the form of a caduceus (the classical staff with two entwined snakes), one of his emblems. After all, he was that remarkable Elizabethan type—a naval commander and a gentleman pirate.

Architecture

Henry VIII, as the newly declared head of the Church of England, sold or gave church land to favored courtiers. Many properties were bought by speculators who divided and resold them. To increase support for the Tudor dynasty, Henry and his successors also granted titles to rich landowners. To display their wealth and status, many of these newly created aristocrats embarked on extensive building projects. They built lavish country residences, which sometimes surpassed the French châteaux in size and grandeur. At this time, Elizabethan architecture still reflected the Perpendicular Gothic style (SEE FIG. 17–20), with its severe walls and broad expanses of glass, although designers modernized the forms by replacing medieval ornament with classical motifs copied from architectural handbooks and pattern books. The first architectural manual in English, published in 1563, was written by John Shute, one of the few builders who had spent time in Italy. But books by Flemish, French, and German architects were readily available. Most influential were the treatises on architectural design by the Italian architect Sebastiano Serlio.

HARDWICK HALL. One of the grandest of all the Elizabethan houses was **HARDWICK HALL**, the home of Elizabeth, Countess of Shrewsbury, known as "Bess of Hardwick" (FIG. 21–30). When she was in her seventies, the redoubtable countess—who inherited riches from all four of her deceased husbands—employed Robert Smythson (c. 1535–1614), England's first Renaissance professional architect, to build Hardwick Hall (1591–97).

Smythson's—and Bess's—plan for Hardwick was new. The medieval great hall became a two-story entrance hall, with rooms arranged symmetrically around it—a nod to classical balance. A sequence of rooms leads to a grand stair up to the Long Gallery and **HIGH GREAT CHAMBER** on the second floor (FIG. 21–31), where the countess received guests, entertained, and sometimes dined. The High Great Chamber was designed to display a set of six Brussels tapestries with the story of Ulysses. The room had enormous windows, ornate fireplaces, and a richly carved and painted plaster frieze around the room. The frieze, by the master Abraham Smith, depicts Diana and her maiden hunters in a forest where they pursue stags and boars. In the window bay, the frieze turns into an allegory on the seasons; Venus whipping Cupid represents spring, and the goddess Ceres, summer. Smith based his allegories on Flemish prints. Graphic arts transmitted images from artist to artist and country to country much as photography does today.

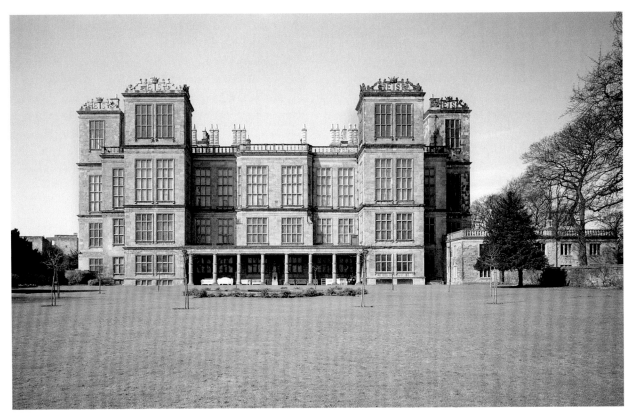

21–30 | Robert Smythson **HARDWICK HALL, SHREWSBURY**
England. 1591–97.

Elizabeth, Countess of Shrewsbury, who commissioned Smythson, participated actively in the design of her houses. She embellished the roofline with her initials, ES, in letters 4 feet tall.

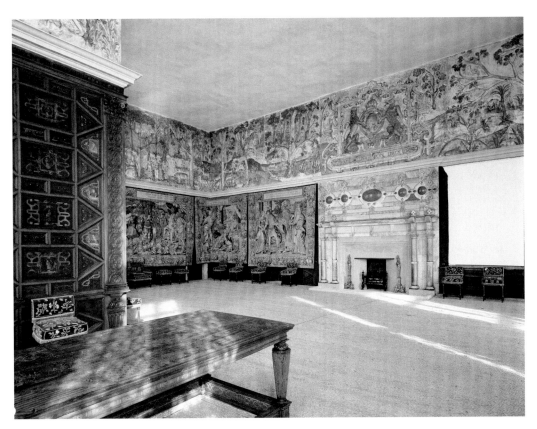

21–31 | Robert Smythson **HIGH GREAT CHAMBER, HARDWICK HALL**
Shrewsbury, England. 1591–97. Brussels tapestries, 1550s; painted plaster sculpture by Abraham Smith.

IN PERSPECTIVE

In the sixteenth century people faced many challenges—political, religious, and aesthetic. Humanistic learning, based on the written word, was dominant—Germany was, after all, the home of the first printed book—and an increasingly literate public gained access not only to practical information but also to new ideas. Germany was also the center of the Reformation within the Christian Church. In many places, the reformers' zeal led to the destruction first of religious art and then sometimes of all the arts. People worshiped in stark shells of church buildings. With no call to paint religious themes, the artists found new themes and focused on worldly subjects, especially on portraits.

Artists were well aware of the new forces at work across the Alps in Italy, and study tours were an essential part of education. Traveling artists could copy ancient classical art in Rome, study mural painting in Florence, and admire the dazzling lush oil painting in Venice. The idea took hold that artists could express as much through painted, sculptural, and architectural forms as poets could with words or musicians with melody. The notion of divinely inspired creativity supplanted manual artistry.

Intense religiosity vied with materialistic enterprise early in the century. The crafts also emerged as splendid fine arts, as seen in pictorial tapestries, gold and silver show-piece tableware, and glazed ceramics, among other mediums. All the arts of personal display—cut velvet and brocade gowns and robes, chains and jewels of state—can be studied in portraits.

The Protestants carried on the tradition of using the visual arts to promote a cause, to educate, and to glorify with grand palaces and portraits—just as the Catholic Church had over the centuries used great church buildings and religious art for its didactic as well as aesthetic values. The effects of the Reformation and the Counter-Reformation would continue to reverberate in the arts of the following century throughout Europe and, across the Atlantic, in America.

VEIT STOSS
**ANNUNCIATION AND
VIRGIN OF THE ROSARY**
1517–18

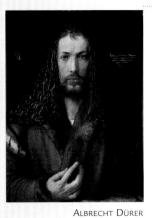

ALBRECHT DÜRER
SELF-PORTRAIT
1500

PIERRE LESCOT
WEST WING. COUR CARRÉ,
PALAIS DU LOUVRE, PARIS
BEGUN 1546

PIETER BRUEGEL THE ELDER
RETURN OF THE HUNTERS
1565

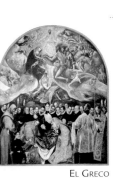

EL GRECO
BURIAL OF COUNT ORGAZ
1586

ROBERT SMYTHSON
**HIGH GREAT CHAMBER, HARDWICK
HALL, SHREWSBURY, ENGLAND**
1591–97

1500

1520

1540

1560

1580

1600

SIXTEENTH-CENTURY ART IN NORTHERN EUROPE AND THE IBERIAN PENINSULA

◀ Luther Protests Church's Sale of Indulgences 1517

◀ Charles V Holy Roman Emperor 1519–56

◀ First Circumnavigation of Earth 1522

◀ Peasants' War 1524–26

◀ Charles V Orders Sack of Rome 1527

◀ Church of England Separates from Roman Church 1534

◀ Council of Trent 1545–63

◀ Elizabeth I Queen of England 1558–1603

◀ Dutch Unite against Spanish Rule 1579

◀ English Defeat Spanish Navy in Spanish Armada 1588

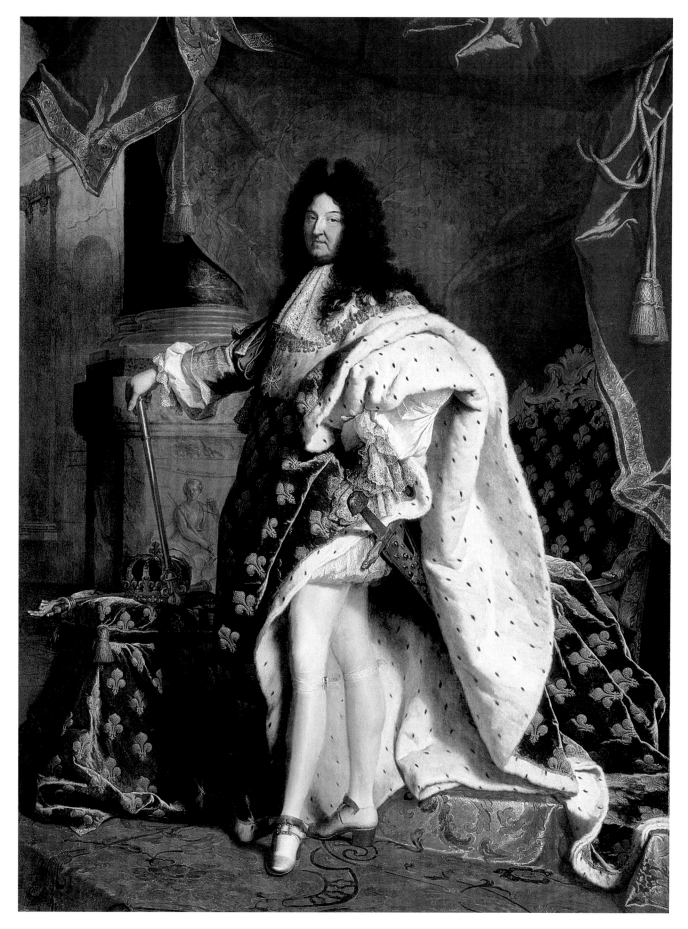

| Hyacinthe Rigaud **LOUIS XIV** 1701. Oil on canvas, 9′2″ × 7′10¾″ (2.19 × 2.4 m). Musée du Louvre, Paris.

CHAPTER TWENTY-TWO

BAROQUE ART

In Hyacinthe Rigaud's 1701 portrait of **LOUIS XIV** (FIG. 22–1), the richly costumed monarch known as *le Roi Soleil* ("the Sun King"; ruled 1643–1715) is presented to us by an unseen hand that pulls aside a huge billowing curtain. Showing off his elegant legs, of which he was very proud, the 63-year-old French monarch poses in an elaborate robe of state, decorated with gold *fleurs-de-lis* and white ermine, and he wears the red-heeled built-up shoes he had invented to compensate for his short stature. At first glance, the face under the huge wig seems almost incidental to the overall grandeur of the presentation. Yet the directness of Louis XIV's gaze makes him movingly human despite the pompous pose and the overwhelming magnificence that surrounds him. Rigaud's genius in portraiture was always to capture a good likeness while idealizing his subjects' less attractive features and giving minute attention to the virtuoso rendering of textures and materials of the costume and setting.

Louis XIV had ordered this portrait as a gift for his grandson Philip, but when Rigaud finished the painting, Louis liked it so much that he kept it. Three years later, Louis ordered a copy from Rigaud to give his grandson, now King Philip V of Spain (ruled 1700–46). The request for copies of

22

portraits was not unusual, for the royal and aristocratic families of Europe were linked through marriage, and paintings made appropriate gifts for relatives. Rigaud's workshop produced between thirty and forty portraits a year. His portraits varied in price according to whether the entire figure was painted from life or whether Rigaud merely added a portrait head to a stock figure in a composition he had designed for his workshop to execute.

Rigaud's long career spanned a time of great change in Western art. Not only did new manners of representation emerge, but, whereas art had once been under the patronage of the Church and the aristocracy, a kind of broad-based commercialism arose that was reflected both by portrait workshops such as Rigaud's and by the thousands of still-life and landscape painters producing works for the middle-class households that could now afford to decorate their homes. These changes of the seventeenth and eighteenth centuries—the Baroque period in Europe—took place in a cultural context in which individuals and organizations were grappling with the effects of religious upheaval, economic growth, colonial expansion, political turbulence, and a dramatic explosion of scientific knowledge.

THE BAROQUE PERIOD

The word *baroque* was initially used in the late 1700s as a derogatory term to characterize the exuberant and extravagant aspects of some of the art of the preceding century and a half. Today, *Baroque* can designate certain formal characteristics of style, as well as refer to a period in the history of art lasting from the end of the sixteenth into the eighteenth century. Baroque style is characterized by an emotional rather than intellectual response to a work of art and by an interest in exploiting the dramatic moment through choice of subject and style. Artists created open compositions in which elements are placed or seem to move diagonally, expand upward, or overlap their supposed frames. Many artists developed a loose, free technique using rich colors and dramatic contrasts of light and dark, producing what one critic called an "absolute unity" of form. This unified concept extends to the more expansive unity between architecture, sculpture, and painting and the theatrical effects that could be created by what we would term a multimedia approach. Although many of the formal characteristics of the Baroque have been applied to other periods, like Hellenistic Greek styles, the term *Baroque* will be used here to refer to the complex of styles—including a more restrained, classical stream—that developed against the historical backdrop of the Counter-Reformation, the advancement of science, the expanding world of exploration and trade, and the rise of private patronage in the arts.

By the seventeenth century, the permanent division within Europe between Roman Catholicism and Protestantism had a critical effect on European art. As part of the Counter-Reformation program that came to fruition in the seventeenth century, the Church used art to encourage piety among the faithful and to persuade those it regarded as heretics to return to the fold. Patronage of art in Catholic as well as Protestant countries was spurred by economic growth that helped to support not only the aristocracy, but a large, affluent middle class eager to build and furnish fine houses and even palaces. Buildings ranged from magnificent churches and palaces to stage sets for plays and ballets, while painting and sculpture varied from large religious works and history paint-ings to portraits, still lifes, and **genre** paintings (scenes of everyday life). At the same time, scientific advances compelled people to question their worldview. Of great importance was the growing understanding that Earth was not the center of the universe but was a planet revolving around the sun (see "Science and the Changing Worldview," page 746).

Within these historical parameters, artists achieved spectacular technical virtuosity and an impressive ability to produce for their patrons and the market. Painters manipulated their mediums from the thinnest glazes to heavy **impasto** (thickly applied pigments), taking pleasure in the very quality of the material. A desire for realism led some artists to reach for a verisimilitude that went against the idealization of classical and Renaissance styles. The English leader Oliver Cromwell supposedly demanded that his portrait be painted "warts and all." Leading artists such as Rubens and Rembrandt organized their studios into veritable picture factories. Artists were admired for the originality of a concept or design, and their shops produced paintings on demand—including copy after copy of popular themes or portraits. The respect for the "original," or first edition, is a modern concept.

The role of viewers also changed. Earlier, Renaissance painters and patrons had been fascinated with the visual possibilities of perspective, but even such displays as Mantegna's ceiling fresco at Mantua (SEE FIG. 19–34) remained an intellectual conceit. Seventeenth-century masters, on the other hand, treated viewers as participants in the artwork, and the space of the work included the world beyond the frame. In Catholic countries, representations of horrifying scenes of martyrdom or the passionate spiritual life of a mystic in religious ecstasy inspired a renewed faith (SEE FIG. 22–6). In Protestant countries, images of civic parades and city views inspired pride in accomplishment (SEE FIGS. 22–45, 22–49). Viewers participated in art like audiences in a theater—vicariously but completely—as the work of art reached out visually and emotionally to draw them into its orbit. The seventeenth-century French critic Roger de Piles described this exchange when he wrote: "True painting . . . calls to us; and has so powerful an effect, that we cannot help coming near it, as if it had something to tell us" (quoted in Puttfarken, page 55).

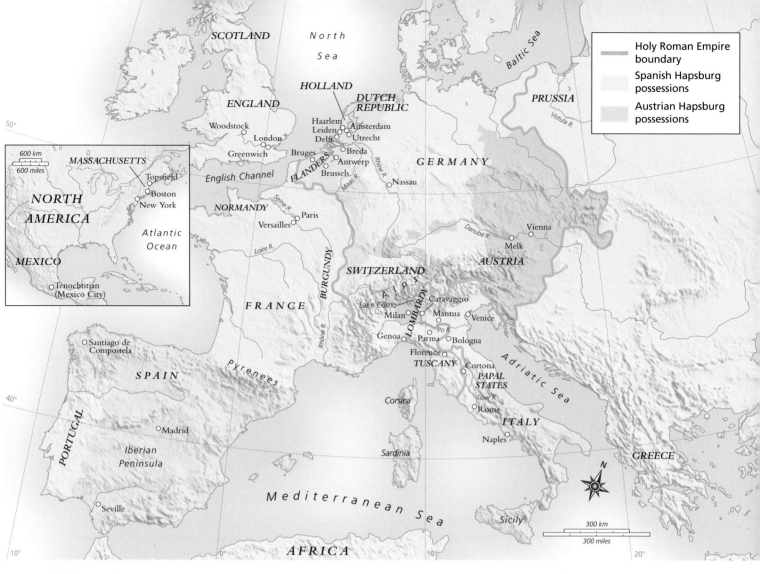

MAP 22—1 | THE SEVENTEENTH CENTURY IN EUROPE AND NORTH AMERICA

Protestantism dominated in northern Europe, while Roman Catholicism remained strong after the Counter-Reformation in southern Europe.

ITALY

Italy in the seventeenth century remained a divided land in spite of a common history, language, and geography with borders defined by the seas. The Kingdom of Naples and Sicily was Spanish; the Papal States crossed the center; Venice maintained its independence as a republic; and the north remained divided among small principalities. In spite of religious wars raging in Germany and France, churchmen remained powerful patrons of the arts, especially as they recognized the visual arts' role in propaganda campaigns. The popes, cardinals, and their families turned to artists to enhance their status. Additionally, the Church had set down rules for art at the Council of Trent (1563) that went against the arcane, worldly, and often lascivious trends exploited by Mannerism. The clergy's call for clarity, simplicity, chaste subject matter, and the ability to rouse a very Catholic piety in the face of Protestant revolt found a response in the fresh approaches to subject matter and style offered by a new generation of artists.

Architecture and Sculpture in Rome

A major goal of the Counter-Reformation was to properly embellish the Church and its mother city. Pope Sixtus V (papacy 1585–90) had begun the renewal by cutting long straight avenues through the city to link the major pilgrimage churches with one another and with the main gates of Rome. Sixtus also ordered open spaces—piazzas—cleared in front of major churches, marking each site with an Egyptian obelisk. (His chief architect, Domenico Fontana, performed remarkable feats of engineering to move the huge monoliths.) In a practical vein, Sixtus also reopened one of the ancient aqueducts to stabilize the city's water supply. Unchallengeable power and vast financial resources were required to carry out such an extensive plan of urban renewal and to materially fashion Rome—which had been the victim of rapacity and neglect since the Middle Ages—once more into the center of spiritual and worldly power.

The Counter-Reformation popes had great wealth, although eventually they nearly bankrupted the Church with

SCIENCE AND THE CHANGING WORLDVIEW

Investigations of the natural world that had begun during the Renaissance changed the way people of the seventeenth and eighteenth centuries—including artists—saw the world. Some of the new discoveries brought a sense of the grand scale of the universe, while others focused on the minute complexity of the microscopic world of nature. As frames of reference expanded and contracted, artists found new ways to mirror these changing perspectives in their own works.

The philosophers Francis Bacon (1561–1626) of England and René Descartes (1596–1650) of France established a new scientific method of studying the world by insisting on scrupulous objectivity and logical reasoning. Bacon proposed that facts be established by observation and tested by controlled experiments. Descartes argued for the deductive method of reasoning, in which a conclusion was arrived at logically from basic premises—the most fundamental example being "I think, therefore I am."

In 1543, the Polish scholar Nicolaus Copernicus (1473–1543) published *On the Revolutions of the Heavenly Spheres,* which contradicted the long-held view that Earth is the center of the universe (the Ptolemaic theory) by arguing that Earth and other planets revolve around the sun. The Church put the book on its Index of Prohibited Books in 1616, but Johannes Kepler (1571–1630) continued demonstrating that the planets revolve around the sun in elliptical orbits. Galileo Galilei (1564–1642), an astronomer, mathematician, and physicist, developed the telescope as a tool for observing the heavens. His findings provided further confirmation of the Copernican theory, but since the Church prohibited teaching that theory, Galileo was tried for heresy by the Inquisition and forced to recant his views. As the first person to see the craters of the moon through a telescope, Galileo began the exploration of space that eventually led humans to take their first steps on the moon in 1969.

Seventeenth-century science explored not only the vastness of outer space but also the smallest elements of inner space, thanks to the invention of the microscope by the Dutch lens maker and amateur scientist Antoni van Leeuwenhoek (1632–1723). Although embroiderers, textile inspectors, manuscript illuminators, and painters had long used magnifying glasses in their work, Leeuwenhoek perfected grinding techniques and increased the power of his lenses far beyond what those uses required. Ultimately, he was able to study the inner workings of plants and animals and even see microorganisms. Soon, scientists learned to draw, or depended on artists to draw, the images revealed by the microscope for further study

and publication. Not until the discovery of photography in the nineteenth century could scientists communicate their discoveries without an artist's help.

Maria Sibylla Merian **PLATE 9 FROM DISSERTATION IN INSECT GENERATIONS AND METAMORPHOSIS IN SURINAM** 1719. Hand-colored engraving, 18⅞ × 13″ (47.9 × 33 cm). National Museum of Women in the Arts, Washington, D.C.
Gift of Wallace and Wilhelmina Holladay Collection, funds contributed by Mr. and Mrs. George G. Anderman and an anonymous donor (1976.56)

Maria Sibylla Merian (1647–1717) was unusual in making noteworthy contributions as both researcher and artist. German by birth and Dutch by training, Merian was once described by a Dutch contemporary as a painter of flowers, fruit, birds, worms, flies, mosquitoes, spiders, "and other filth." At the time, it was believed that insects emerged spontaneously from the soil, but Merian's research on the life cycles of insects proved otherwise, findings she published in 1679 and 1683 as *The Wonderful Transformation of Caterpillars and (Their) Singular Plant Nourishment.* In 1699, Amsterdam subsidized Merian's research on plants and insects in the Dutch colony of Surinam in South America; her results were published as *Dissertation in Insect Generations and Metamorphosis in Surinam,* illustrated with sixty large plates engraved after her watercolors. Each plate is scientifically precise, accurate, and informative, presenting insects in various stages of development, along with the plants they live on.

their building programs. Sixtus began to renovate the Vatican and its library. He completed the dome of Saint Peter's and built splendid palaces. The Renaissance ideal of the central-plan church continued to be used for the shrines of saints, but Counter-Reformation thinking called for churches with long, wide naves to accommodate large congregations assem-

bled to hear firm sermons as well as to participate in the Mass. In the sixteenth century, the decoration of new churches had been generally austere, but seventeenth- and eighteenth-century Catholic taste favored opulent and spectacular visual effects to heighten the emotional involvement of worshipers.

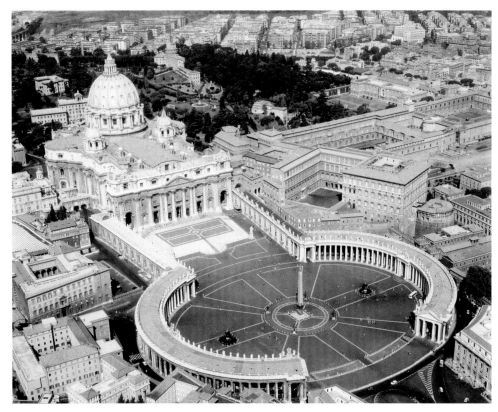

22–2 | **SAINT PETER'S BASILICA AND PIAZZA, VATICAN, ROME**
Carlo Maderno, façade, 1607–26; Gianlorenzo Bernini, piazza design, c. 1656–57.

Perhaps only a Baroque artist of Bernini's talents could have unified the many artistic periods and styles that come together in Saint Peter's Basilica (starting with Bramante's original design for the building in the sixteenth century). The basilica in no way suggests a piecing together of parts made by different builders at different times but rather presents itself as a triumphal unity of all the parts in one coherent whole.

SAINT PETER'S BASILICA IN THE VATICAN. Half a century after Michelangelo had returned Saint Peter's Basilica to Bramante's original vision of a central-plan building, Pope Paul V (papacy 1605–21) commissioned Carlo Maderno (1556–1629) to provide the church with a longer nave and a new façade (FIG. 22–2). Construction began in 1607, and everything but the façade bell towers was completed by 1615 (see "Saint Peter's Basilica," Chapter 20, page 679). In essence, Maderno took the concept of Il Gesù's façade (SEE FIG. 20–31) and enlarged it to befit the most important church of the Catholic world. Maderno's façade for Saint Peter's "steps out" in three progressively projecting planes: from the corners to the doorways flanking the central entrance area, then the entrance area, then the central doorway itself. Similarly, the colossal orders connecting the first and second stories are flat pilasters at the corners but fully round columns where they flank the doorways. These columns support a continuous entablature that also steps out—following the columns—as it moves toward the central door. A triangular pediment provides vertical movement, as does the superimposition of pilasters on the relatively narrow attic story above the entablature.

When Maderno died in 1629, he was succeeded as Vatican architect by his collaborator of five years, Gianlorenzo Bernini (1598–1680). Gianlorenzo was taught by his father,

and part of his training involved sketching the Vatican collection of ancient sculpture, such as *Laocoön and His Sons* and the Farnese Hercules (see Introduction, Fig. 23), as well as the many examples of Renaissance painting in the papal palace. Throughout his life, Bernini admired antique art and, like other artists of this period, considered himself a classicist. Today, we not only appreciate his strong debt to the Renaissance tradition but also consider his art a breakthrough that takes us into a new, Baroque style.

When Urban VIII was elected pope in 1623, he unhesitatingly gave the young Bernini the demanding task of designing an enormous bronze **baldachin,** or canopy, for the high altar of Saint Peter's. The church was so large that a dramatic focus on the altar was essential. The resulting **BALDACCHINO** (FIG. 22–3), completed in 1633, stands almost 100 feet high and exemplifies the Baroque artists' desire to combine architecture and sculpture—and sometimes painting as well—so that works no longer fit into a single category or a single medium. The twisted columns symbolize the union of Old and New Testaments—the vine of the Eucharist climbing the columns of the Temple of Solomon. The fanciful Composite capitals, combining elements of both the Ionic and the Corinthian orders, support an entablature with a crowning element topped with an orb (a sphere representing the

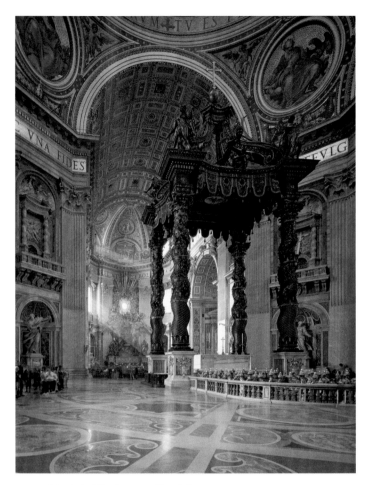

belonged to Saint Peter as the first bishop of Rome. The Chair of Peter symbolized the direct descent of Christian authority from Peter to the current pope, a belief rejected by Protestants and therefore deliberately emphasized in Counter-Reformation Catholicism. In Bernini's work, the chair is carried by four theologians and is lifted even farther by a surge of gilded clouds moving upward to the Holy Spirit, who materializes in the stained-glass window in the form of a dove surrounded by an oval of golden rays. Adoring, gilded angels and gilt-bronze rays fan out around the window and seem to extend the penetration of the natural light—and the Holy Spirit—into the apse of the church. The gilding also reflects the light back to the window, creating a dazzling, ethereal effect that the seventeenth century, with its interest in mystics and visions, would equate with the activation of divinity—and the sort of effect that present-day artists achieve by resorting to electric spotlights.

At approximately the same time that he was at work on the Chair of Peter, Bernini designed and supervised the building of a colonnade to form a huge double piazza in front of the entrance to Saint Peter's (SEE FIG. 22–2). The open space that he had to work with was irregular, and an Egyptian obelisk and a fountain already in place (part of

22–3 | Gianlorenzo Bernini **BALDACCHINO**
1624-33. Gilt bronze, height approx. 100′ (30.48 m). Chair of Peter shrine, 1657-66. Gilt bronze, marble, stucco, and glass. Pier decorations, 1627-41. Gilt bronze and marble. Crossing, Saint Peter's Basilica, Vatican, Rome.

universe) and a cross (symbolizing the reign of Christ). Figures of angels and *putti* decorate the entablature, which is hung with tasseled panels in imitation of a cloth canopy. These symbolic elements, both architectural and sculptural, not only mark the site of the tomb of Saint Peter but also serve as a monument to Urban VIII and his family, the Barberini, whose emblems—including honeybees and suns on the tasseled panels, and laurel leaves on the climbing vines—are prominently displayed.

Between 1627 and 1641, Bernini and several other sculptors, again combining architecture and sculpture, rebuilt Bramante's crossing piers as giant reliquaries. Statues of saints Helena, Veronica, Andrew, and Longinus stand in niches below alcoves containing their relics, to the left and right of the *baldacchino*. Visible through the *baldacchino*'s columns in the apse of the church is another reliquary: the gilded stone, bronze, and stucco shrine made by Bernini between 1657 and 1666 for the ancient wooden throne thought to have

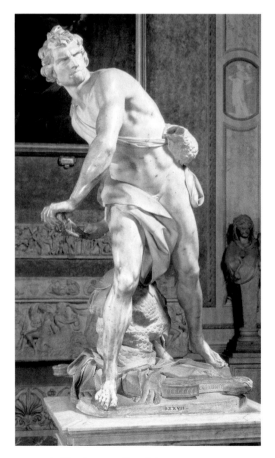

22–4 | Gianlorenzo Bernini **DAVID**
1623. Marble, height 5′7″ (1.7 m). Galleria Borghese, Rome.

Sixtus V's plan for Rome) had to be incorporated into the overall plan. Bernini's remarkable design frames the oval piazza with two enormous curved porticoes, or covered walkways, supported by Doric columns. These curved porticoes are connected to two straight porticoes, which lead up a slight incline to the two ends of the church façade. Bernini spoke of his conception as representing the "motherly arms of the Church" reaching out to the world. He had intended to build a third section of the colonnade closing the side of the piazza facing the church so that pilgrims, after crossing the Tiber River bridge and passing through narrow streets, would suddenly emerge into the enormous open space before the church. Even without the final colonnade section, the great church, colonnade, and piazza with its towering obelisk and monumental fountains—Bernini added the second one to balance the first—are an awe-inspiring vision.

BERNINI AS SCULPTOR. Even after Bernini's appointment as Vatican architect in 1629, he was able to accept outside commissions by virtue of his large workshop. In fact, Bernini first became famous as a sculptor, and he continued to work as a sculptor throughout his career, for both the papacy and private clients. A man of many talents, he was also a painter and even a playwright—an interest that dovetailed with his genius for theatrical and dramatic aspects in his sculpture and architecture.

Bernini's **DAVID** (FIG. 22–4), made for a nephew of Pope Paul V in 1623, introduced a new type of three-dimensional composition that intrudes forcefully on the viewer's space. Inspired by the athletic figures Annibale Carracci had painted in the Farnese gallery some twenty years earlier (SEE, for example, the Giant preparing to heave a boulder at the far end of the gallery, FIG. 22–13), Bernini's *David* bends at the waist and twists far to one side, ready to launch the lethal rock. Unlike Michelangelo's cool and self-confident youth (SEE FIG. 20–10), this more mature *David,* with his lean, sinewy body, is all tension and determination, a frame of mind emphasized by his ferocious expression, tightly clenched mouth, and straining muscles. Bernini's energetic, twisting figure includes the surrounding space as part of the composition by implying the presence of an unseen adversary somewhere behind the viewer. Thus, the viewer becomes part of the action that is taking place at that very moment. This immediacy, the emphasis on the climactic moment, and the inclusion of the viewer in the work of art represent an important new direction for art.

From 1642 until 1652, Bernini worked on the decoration of the funerary chapel of Venetian cardinal Federigo Cornaro (FIG. 22–5) in the Church of Santa Maria della Vittoria, designed by Carlo Maderno earlier in the century. Like Il Gesù (SEE FIG. 20–32), the church had a single nave with shallow side chapels. Santa Maria della Vittoria was built by the order of the Discalced (unshod) Carmelite Friars, and the chapel of the Cornaro family was dedicated to one of the

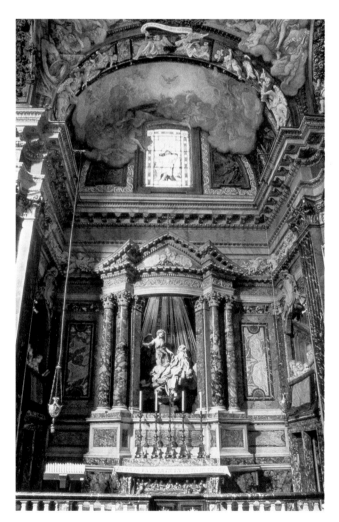

22–5 │ Gianlorenzo Bernini **CORNARO CHAPEL, CHURCH OF SANTA MARIA DELLA VITTORIA, ROME** 1642–52.

order's great figures, the Spanish saint Teresa of Ávila, canonized only twenty years earlier. Bernini designed the chapel to be a rich and theatrical setting in which to portray an event in Teresa's life that contributed to her sainthood. To accomplish this, he covered the walls with colored marble panels

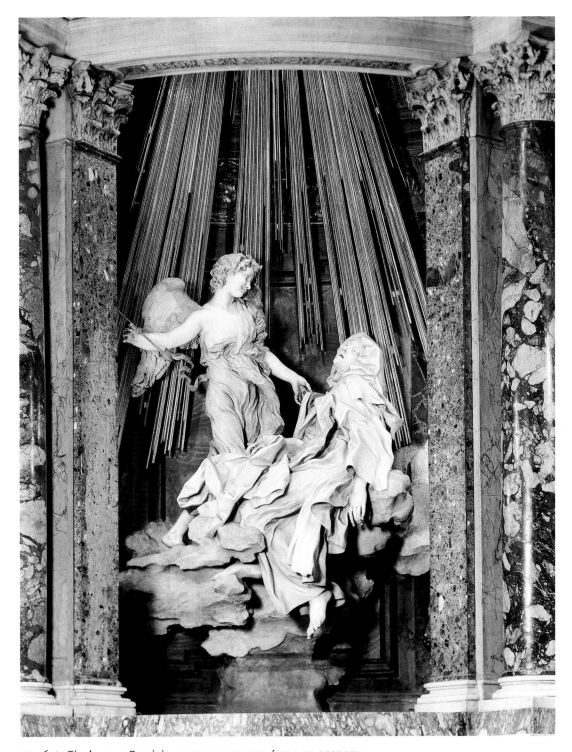

22-6 | Gianlorenzo Bernini **SAINT TERESA OF ÁVILA IN ECSTASY**

1645-52. Marble, height of the group 11'6" (3.5 m). Cornaro Chapel, Church of Santa Maria della Vittoria, Rome.

and crowned them with a projecting cornice supported by marble pilasters.

In the center of the chapel and framed by columns in the huge oval niche above the altar, Bernini's marble group **SAINT TERESA OF ÁVILA IN ECSTASY** (FIG. 22-6) represents a vision described by the Spanish mystic in which an angel pierced her body repeatedly with an arrow, transporting her to a state of indescribable pain, religious ecstasy, and a sense of oneness with God. Saint Teresa and the angel, who seem to float upward on moisture-laden stucco clouds, are cut from a heavy mass of solid marble supported on a hidden pedestal and by hidden metal bars sunk deep into the chapel wall. Bernini's skill at capturing the movements and emotions of these figures is matched by his virtuosity in simulating different textures

and colors in the pure white medium of marble; the angel's gauzy, clinging draperies seem silken in contrast with Teresa's heavy woolen robe, the habit of her order. Yet Bernini effectively used the configuration of the garment's folds to convey the swooning, sensuous body beneath, even though only Teresa's face, hands, and bare feet are actually visible.

As he would later do for the Chair of Peter (SEE FIG. 22–3), Bernini used a directed light source to announce the divine presence that enfolds the saint's ecstasy and spiritual martyrdom. Above the cornice on the back wall, the curved ceiling surrounds a concealed window that mysteriously illuminates the niche that houses Saint Teresa and dissolves the descending rays of gilt bronze, the solid marble figures, and the clouds on which they are suspended into a painterly vision. Kneeling at what appear to be *prie-dieux* on both sides of the chapel are marble portraits of Federigo, his deceased father (a Venetian doge), and six cardinals of the Cornaro family. The figures are informally posed and naturalistically portrayed. Two read from their prayer books, others exclaim at the miracle taking place in the light-infused realm above the altar, and one leans out from his seat, apparently to look at someone entering the chapel—perhaps the viewer, whose space these figures share. The frescoed vault, above, executed by another artist, depicts the dove of the Holy Spirit hovering over angels and stuccoed scenes of the saint's life.

Gianlorenzo Bernini was deeply religious and held fast to the tenets espoused by the Counter-Reformation. Although he created a "stage" for his subject, his purpose was not to produce a mere spectacle but to capture a critical, dramatic moment at its emotional and sensual height and by doing so guide the viewer to identify totally with the event—and perhaps be transformed in the process.

Bernini's complex, theatrical interplay of media—sculpture, architecture, and painting—and of the various levels of illusion in the chapel—divine, mystical, and actual—invite the beholder to identify with Teresa's experience. His brilliant solution to the problem of transfixing the momentary in physical materials was imitated by sculptors throughout Europe.

BORROMINI'S CHURCH OF SAN CARLO. The intersection of two of the wide straight avenues created by Pope Sixtus V inspired city planners to add a special emphasis, with fountains marking each of the four corners of the crossing. In 1634, the Trinitarian monks decided to build a new church at the site and awarded the commission for **SAN CARLO ALLE QUATTRO FONTANE** (Saint Charles at the Four Fountains) to Francesco Borromini (1599–1667). Borromini, a nephew of architect Carlo Maderno, had arrived in Rome in 1619 from northern Italy to enter his uncle's workshop. Later, he worked under Bernini's supervision on the decoration of Saint Peter's, and some details of the *Baldacchino,* as well as the structural engineering, are now attributed to him, but San Carlo was his first independent commission. Unfinished at

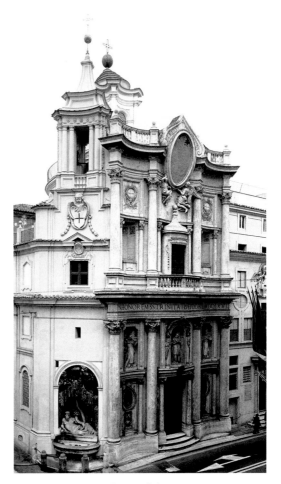

22–7 Francesco Borromini **FAÇADE, CHURCH OF SAN CARLO ALLE QUATTRO FONTANE, ROME** 1665-67.

Borromini's death, the church was nevertheless completed according to his design.

San Carlo stands on a narrow piece of land, with one corner cut off to accommodate one of the four fountains that give the church its name (FIG. 22–7). To fit the irregular site, Borromini created an elongated central-plan interior space with undulating walls (FIG. 22–8), whose powerful, sweeping curves create an unexpected feeling of movement, as if the walls were heaving in and out. Robust pairs of columns support a massive entablature, over which an oval dome, supported on pendentives, seems to float. The coffers (inset panels in geometric shapes) filling the interior of the oval-shaped dome form an eccentric honeycomb of crosses, elongated hexagons, and octagons (FIG. 22–9). These coffers decrease sharply in size as they approach the apex, or highest point, where the dove of the Holy Spirit hovers in a climax that brings together geometry used in the chapel: oval, octagon, circle, and—very important—a triangle, symbol of the Trinity as well as of the church's patrons. The dome appears be shimmering and inflating, thanks to light sources placed in the lower coffers and the lantern.

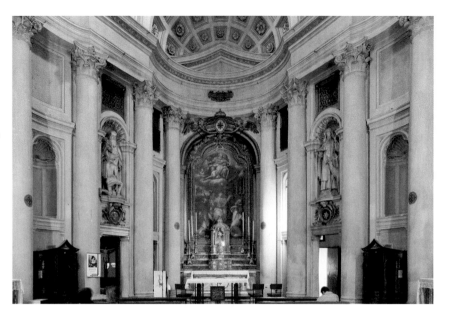

22–8 | Francesco Borromini
INTERIOR, CHURCH OF SAN CARLO ALLE QUATTRO FONTANE, ROME
1638–41

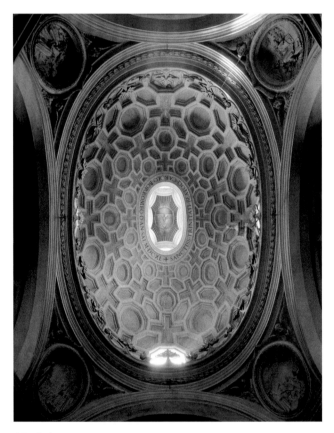

22–9 | **DOME INTERIOR, CHURCH OF SAN CARLO ALLE QUATTRO FONTANE**
1638–41.

It is difficult today to appreciate how audacious Borromini's design for this small church was. In it he abandoned the modular, additive system of planning taken for granted by every architect since Brunelleschi. He worked instead from an overriding geometrical scheme for the ideal, domed, central-plan church. Borromini looked at his buildings in terms of geometrical units as a Gothic architect might, subdividing the units to obtain more complex, rational shapes. For example, the elongated, octagonal plan of San Carlo is composed of two triangles set base to base along the short axis of the plan (**FIG. 22–10**). This diamond shape is then subdivided into secondary triangular units made by calculating the distances between what will become the concave centers of the four major and five minor niches. Yet Borromini's conception of the whole is not medieval. The chapel is dominated horizontally by a classical entablature that breaks any surge upward toward the dome, allowing the eye to play with the rhythm of paired Corinthian columns. Borromini's treatment of the architectural elements as if they were malleable was also unprecedented. His contemporaries understood immediately what an extraordinary innovation the church represented; the Trinitarian monks who had commissioned it received requests for plans from visitors from all over Europe. Although Borromini's invention had little influence on the architecture of classically minded Rome, it was widely imitated in northern Italy and beyond the Alps.

Borromini's design for San Carlo's façade (SEE FIG. 22–7), done more than two decades later, was as innovative as his plan for its interior had been. He turned the building's front into an undulating, sculpture-filled screen punctuated with large columns and deep concave and convex niches that create dramatic effects of light and shadow. Borromini also gave his façade a strong vertical thrust in the center by placing over the tall doorway a statue-filled niche, then a windowed niche covered with a canopy, then a giant, forward-leaning cartouche held up by angels carved in such high relief that they appear to hover in front of the wall. The entire façade is crowned with a balustrade broken by the sharply pointed frame of the cartouche. Borromini's façade was enthusiastically imitated in northern Italy and especially in northern and eastern Europe.

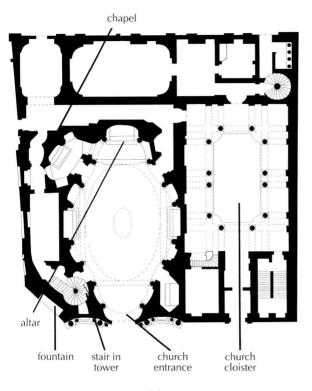

chapel

altar

fountain stair in church church
 tower entrance cloister

22–10 | Francesco Borromini **PLAN OF THE CHURCH OF
SAN CARLO ALLE QUATTRO FONTANE, ROME**
1638–41.

PIAZZA NAVONA. Rome's **PIAZZA NAVONA,** a popular site for festivals and celebrations, became another center of urban renewal with the election of Innocent X as pope (papacy 1644–55). Both the palace and parish church of his family, the Pamphilis, fronted on the piazza, which had been the site of a stadium built by Emperor Domitian in 86 CE, and it still retains the shape of the ancient racetrack. The stadium, in ruins, had been used for festivals during the Middle Ages and as a marketplace since 1477. A modest shrine to Saint Agnes stood on the site of her martyrdom.

The Pamphilis enlarged their palace in 1644–50 and in 1652 decided to rebuild their parish church, the Church of Sant'Agnese (Saint Agnes). In 1653–57 Francesco Borromini took the commission, altered the interior, and designed the façade, conceiving a plan that unites church and piazza (**FIG. 22–11**). The façade sweeps inward from two flanking towers to a monumental portal approached by broad stairs. The inward curve of the façade brings the dome nearer the entrance than usual, making it clearly visible from the piazza. The templelike design of columns and pediment around the door also leads the eye to the steeply rising dome on its tall drum. As the pope had wished, the church truly dominates the urban space.

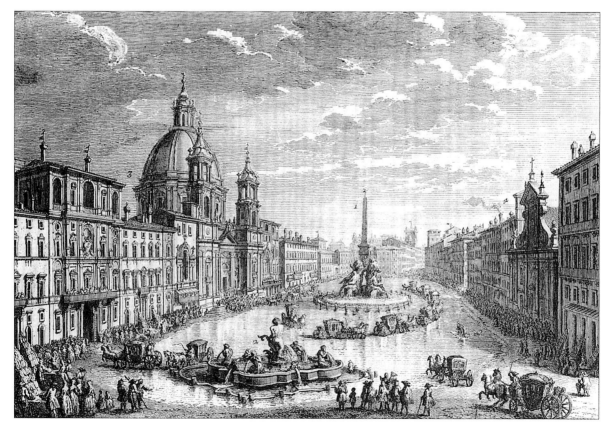

22–11 | **PIAZZA NAVONA, ROME**
In the middle ground, Gianlorenzo Bernini's Four Rivers Fountain, 1648–51. To the left of the fountain, Franceso Borromini's Church of Sant'Agnese, 1653–57. In the foreground, Giacomo della Porta's fountain of 1576.
Giuseppe Vasi, *The Flooding of the Piazza Navona,* 18th century, engraving.

The south end of the piazza was already graced by a 1576 fountain by Giacomo della Porta. The contest for a second monumental fountain in the center of the piazza was meant to celebrate the pope's redirection of one of Rome's main water supplies to the piazza. It was won by Borromini, who originated the fountain's theme of the Four Rivers and who brought in the water supply for it in 1647. Gianlorenzo Bernini, who had been publicly disgraced in 1646 when a bell tower he had begun for Saint Peter's threatened to collapse, had not been invited to compete for the fountain's design. However, after some skillful maneuvering, Pope Innocent X saw Bernini's model for the fountain and transferred the project to him the next year.

Bernini was at his most ingenious in fountain designs (FIG. 22–12). Executed in marble and **travertine**, a porous stone that is less costly and more easily worked than marble, the now famed **FOUNTAIN OF THE FOUR RIVERS** was completed in 1651. In the center a rocky hill seems to be suspended over an open grotto, within which a hidden collecting pool feeds streams of water signifying the four great rivers of the world. Above the streams recline colossal personifications of the four continents then recognized by contemporary geographers—the Nile (Africa), the Ganges (Asia), the Danube (Europe), and the Rio de la Plata (Americas). In the center soars a towering ancient Roman imitation of an Egyptian obelisk that Bernini has crowned with a dove: a sign of peace and the Trinity but also the emblem of the pope's family. The towering complex is therefore a dual memorial to the might and reach of the papacy throughout the world as well as the power and status of the Pamphili.

Painting

Painting in seventeenth-century Italy followed one of two principal paths: the classicism of the Carracci or the naturalism of Caravaggio. Although the leading exponents of these paths were northern Italians—the Carracci family was from Bologna, and Caravaggio was apprenticed briefly in Milan—they were all eventually drawn to Rome, the center of power and patronage. The Carracci family as well as Caravaggio were schooled in northern Italian Renaissance realism, with its emphasis on chiaroscuro, as well as in Venetian color and *sfumato*. They painted with increased realism by using live models. The Carracci quite consciously rejected the difficulties of the Mannerist style and fused their northern roots with the central Italian Renaissance insistence on line *(disegno)*, compositional structure, and figural solidity. They looked to Raphael, Michelangelo, and the models provided by classical sculpture for their ideal figural types. To their

22–12 │ Gianlorenzo Bernini and His Shop
FOUNTAIN OF THE FOUR RIVERS, THE GANGES (ASIA)
1648-51. Travertine and marble. Piazza Navona, Rome.

22–13 | Annibale Carracci
**CEILING OF GALLERY,
PALAZZO FARNESE, ROME**
1597–1601. Fresco, approx. 68 × 21'
(20.7 m × 6.4 m)

contemporaries, the Carraccis' dramatic but decorous style seemed, as one critic wrote, "to intuit the intentions of nature and thereby to close the gap between imagination and reality" (Minor, *Baroque and Rococo Art and Culture,* page 160). Caravaggio, on the other hand, satisfied the Baroque demand for drama and clarity by developing realism in a powerful new direction. He painted less than elevated subjects—the lowlife of Rome—and worked directly from his model without elaborate drawings and compositional notes. Unlike the Carracci, he claimed to ignore the masters. He intended to give the impression of immediacy, although he must have considered and adjusted his compositions carefully.

THE CARRACCI. The brothers Agostino (1557–1602) and Annibale Carracci (1560–1609) and their cousin Ludovico (1555–1619) shared a studio in Bologna. As their reevaluation of the High Renaissance masters attracted interest among their peers, they opened their doors to friends and students and then, in 1582, founded an art academy, where students

drew from live models and studied art theory, Renaissance painting, and antique classical sculpture. The Carracci placed a high value on accurate drawing, complex figure compositions, complicated narratives, and technical expertise in both oil and fresco painting. During its short life the academy had an impact on the development of the arts—and art education—through its insistence on both life drawing (to achieve naturalism) and aesthetic theory.

In 1595, Annibale was hired by the Cardinal Odoardo Farnese to decorate the principal rooms of his family's immense Roman palace. In the long *galleria* (gallery), to celebrate the wedding of Duke Ranuccio Farnese of Parma to the niece of the pope, the artist was requested to paint scenes of love based on Ovid's *Metamorphosis* (**FIG. 22–13**). Throughout their palace, the Farnese had an important collection of sculpture (see Introduction, Fig. 23). Undoubtedly, Annibale and Agostino, who assisted him, felt both inspiration and competition from the sculpture and architecture in the rooms below.

22–14 | Annibale Carracci **LANDSCAPE WITH THE FLIGHT INTO EGYPT**
1603–04. Oil on canvas, 48 × 90½". Galleria Doria Pamphili, Rome.

The primary image, set in the center of the vault, is *The Triumph of Bacchus and Ariadne,* a joyous procession celebrating the wine god Bacchus's love for Ariadne, a woman whom he rescued after her lover, Theseus, abandoned her on the island of Naxos. Annibale combines the great tradition of ceiling painting of northern Italy—seen in the work of Mantegna and Correggio (FIGS. 19–34, 20–21)—with influences gained by his study of central Italian Renaissance painters and the classical heritage of Rome. Annibale organized his complex theme by using illusionistic devices to create multiple levels of reality. Gold-framed easel paintings called *quadri riportati* ("transported paintings") "rest" against the actual cornice of the vault and overlap "bronze" medallions that are flanked, in turn, by realistically colored *ignudi,* dramatically lit from below. The viewer is invited to compare the warm flesh tones of these youths, and their realistic poses, with the more idealized "painted" bodies in the framed scenes next to them. Above, paintings of stucco-colored sculptures of herms (plain shafts topped by human torsos) appear to support the painted framework of the vault, yet many of them also wear human expressions and seem to communicate with one another. Many of Annibale's motifs are inspired by Michelangelo's Sistine Chapel ceiling (FIG. 20–12). The figure types, true to their source, are heroic, muscular, and drawn with precise anatomical accuracy. But instead of Michelangelo's cool illumination and intellectual detachment, the Carracci ceiling glows with a warm light

that recalls the work of the Venetian painters Titian and Veronese and seems buoyant with optimism.

The ceiling was highly admired and became famous almost immediately. The Farnese family, proud of the gallery, generously allowed young artists to sketch the figures there, so that Carracci's masterpiece influenced Italian art well into the following century.

Among those present for the initial viewing of the galleria was the nephew of Pope Clement VIII, Pietro Aldobrandini, who subsequently commissioned the artist to decorate the six lunettes of his private chapel with scenes from the life of the Virgin, sometime between 1603 and 1604. **LANDSCAPE WITH THE FLIGHT INTO EGYPT** (FIG. 22–14), the largest of the six— and one of only two that show Annibale's hand—probably occupied the position above the altar. In contrast to the dramatic figural compositions Annibale created for the Farnese gallery, the escape of the holy family is conceived within a contemplative pastoral landscape filled with golden light in the tradition of Venetian Renaissance painting (SEE FIG. 20–23). The design of the work and its affective spirit of melancholy result, however, in one of the fundamental exercises in Baroque classicism that would influence artists for generations to come. Here is nature ordered by man. Trees in the left foreground and right middle ground gracefully frame the scene; and the collection of ancient buildings in the center of the composition form a stable and protective canopy for the flight of the holy family. Space progresses gradually from foreground to background in diago-

22–15 | Caravaggio **BACCHUS**
1595–96. Oil on canvas, 37 × 33½″ (94 × 85.1 cm). Galleria degli Uffizi, Florence.

nal movements that are indicated by people, animals, and architecture. Nothing is accidental, yet the whole appears unforced and entirely natural. The French painter Nicolas Poussin would soon learn lessons from Annibale's work (SEE FIG. 22–62).

CARAVAGGIO. A new powerful naturalism was introduced into painting by the Carracci's younger contemporary Michelangelo Merisi (1571–1610), known as "Caravaggio" after his family's home town in Lombardy. Lombard painters not only favored realistic art with careful drawing, they also had an interest in still life, which had been revived in the sixteenth century but was still unusual at the time. The young painter demonstrated those interests in his first known paintings when, late in 1592, he arrived in Rome from Milan and found work in the studio of the Cavaliere d'Arpino as a specialist painter of fruit and vegetables. When he began to paint on his own, he continued to paint still lifes but also included half-length figures, as in the **BACCHUS** (FIG. 22–15). By this time, his reputation had grown to the extent that an agent offered to market his pictures.

Caravaggio painted for a small circle of sophisticated Roman patrons. His subjects from this early period include still lifes and low-life scenes featuring fortune-tellers, cardsharps, and street urchins dressed as musicians or mythological figures like Bacchus. The figures in these pictures tend to be large, brightly lit, and set close to the picture plane. His important innovation was the decision to paint directly on the canvas. He

sketched out the figure with a sharp point—perhaps the end of his brush—and the marks can be seen through the paint. in *Bacchus,* Caravaggio painted what he saw: a slightly flabby, undressed youth. The parts of the skin that have been exposed to sun (hands and face) are darker in color than the rest of the body. His half-closed, slightly unfocused eyes look past the viewer even as he offers a glass filled with wine. Caravaggio's skill as a still-life painter is apparent in the bowl of half-rotten fruit and the decanter of wine on the table. Caravaggio's youth may appear to be simply a street tough masquerading as Bacchus, the classical god of wine; however, the painting may also have been meant as an allegory of the sins of lust and gluttony.

Most of Caravaggio's commissions after 1600 were religious, and reactions to them were mixed. On occasion, patrons rejected his powerful, sometimes brutal, naturalism as unsuitable to the subject's dignity. Critics differed as well. An early critic, the Spaniard Vincente Carducho, wrote in his *Dialogue on Painting* (Madrid, 1633) that Caravaggio was an "omen of the ruin and demise of painting" because he painted "with nothing but nature before him, which he simply copied in his amazing way" (Enggass and Brown, pages 173–74). Others recognized him as a great innovator who reintroduced realism into art and developed new, dramatic lighting effects. The art historian Giovanni Bellori, in his *Lives of the Painters* (1672), described Caravaggio's painting as

> . . . reinforced throughout with bold shadows and a great deal of black to give relief to the forms. He went so far in this manner of working that he never brought his figures out into the daylight, but placed them in the dark brown atmosphere of a closed room, using a high light that descended vertically over the principal parts of the bodies while leaving the remainder in shadow in order to give force through a strong contrast of light and dark. . . .
>
> (Bellori, *Lives of the Painters,* Rome, 1672, in Enggass and Brown, page 79.)

Caravaggio's approach has been likened to the preaching of Filippo Neri (1515–95), the Counter-Reformation priest and mystic who founded a Roman religious group called the Congregation of the Oratory. Neri, called the Apostle of Rome and later canonized, focused his missionary efforts on ordinary people for whom he strove to make Christian history and doctrine understandable and meaningful. Caravaggio, too, interpreted his religious subjects directly and dramatically, combining intensely observed figures, poses, and expressions with strongly contrasting effects of light and color. His knowledge of Lombard painting, where the influence of Leonardo was strong, must have aided him in his development of the technique now known as **tenebrism,** in which forms emerge from a dark background into a strong light that often falls from a single source outside the painting. The effect is that of a modern spotlight.

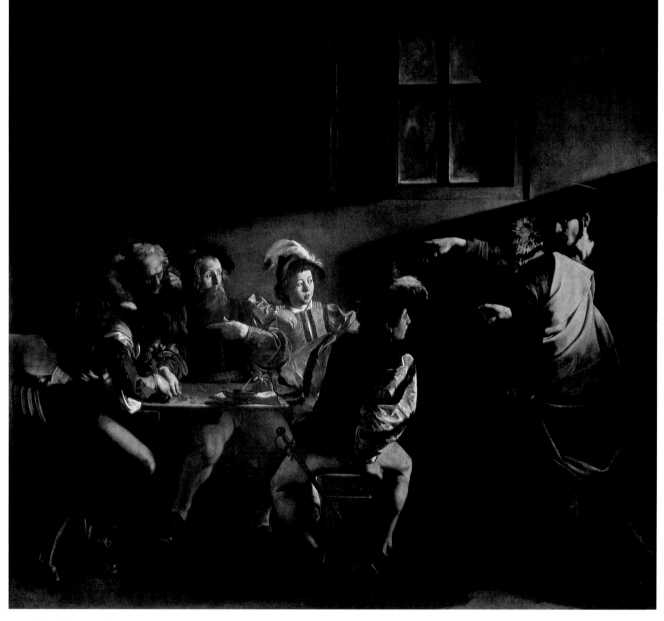

22–16 | Caravaggio **THE CALLING OF SAINT MATTHEW**
1599–1600. Oil on canvas, 10′7½″ × 11′2″ (3.24 × 3.4 m). Contarelli Chapel, Church of San Luigi dei Francesi,
Rome.

Caravaggio's first public commission, paintings for the Contarelli Chapel in the French community's Church of Saint Louis (Church of San Luigi dei Francesi), included **THE CALLING OF SAINT MATTHEW** (FIG. 22–16), painted about 1599–1600 and meant to suggest conversion, one of the tasks of the Church. The work is painted in oils. (Caravaggio had a very short apprenticeship and never seemed to have mastered the technique of fresco—nor, perhaps, skill in painting figures in depth.) The painting depicts Jesus calling Levi, the tax collector, to join his apostles (Mark 2:14). Levi sits at a table, counting out gold coins for a boy at the left, surrounded by overdressed young men in plumed hats, velvet doublets, and satin shirts. Nearly hidden behind the cloaked apostle Peter, at the right, the gaunt-

faced Jesus points dramatically at Levi, a gesture that is repeated by the tax collector's surprised response of pointing to himself. An intense raking light enters the painting from a high, unseen source at the right, above the altar, and spotlights the faces of the men. The viewpoint of the chapel visitor is the empty space across from Saint Matthew, so that she or he directly participates in the dramatic moment of conversion. For all of his realism and claims of independence, Caravaggio also used antique and Renaissance sources. Jesus's outstretched arm, for example, recalls God's gesture giving life to Adam in Michelangelo's *Creation of Adam* on the Sistine Chapel ceiling (SEE FIG. 20–14). It is now restated as Jesus's command to Levi to begin a new life by becoming his disciple Matthew.

The emotional power of Baroque realism combines with a solemn monumentality in Caravaggio's **ENTOMBMENT** (**FIG. 22–17**), painted in 1603–4 for a chapel in Santa Maria in Vallicella, the church of Neri's Congregation of the Oratory. With almost physical force, the size and immediacy of this painting strike the viewer, whose perspective is from within the burial pit into which Jesus's lifeless body is being lowered. The figures form a large off-center triangle, within which angular elements are repeated: the projecting edge of the stone slab; Jesus's bent legs; the akimbo arm, bunched coat, and knock-kneed stance of the man on the right; and even the spaces between the spread fingers of the raised hands. The Virgin and Mary Magdalen barely intrude on the scene, which, through the careful placing of the light, focuses on the dead Jesus, the sturdy-legged laborer supporting his body at the right, and the young John the Evangelist at the triangle's apex.

Despite the great esteem in which Caravaggio was held by some, especially the younger generation of artists, his violent temper repeatedly got him into trouble. During the last decade of his life, he was frequently arrested, generally for minor offenses such as street brawling. In 1606, however, he killed a man in a fight over a tennis match and had to flee Rome. He went first to Naples, then to Malta, finding work in both places. The Knights of Malta awarded him the cross of their religious and military order in July 1608, but in October he was imprisoned for insulting one of their number, and again he escaped and fled. The aggrieved knight's agents tracked him to Naples in the spring of 1610 and severely wounded him. The artist recovered and moved north to Port'Ercole, where he died of a fever on July 18, 1610, just short of his thirty-ninth birthday. Caravaggio's intense realism and tenebrist lighting influenced nearly every important European artist of the seventeenth century.

GENTILESCHI. One of Caravaggio's most successful Italian followers was Artemisia Gentileschi (1593–c. 1652/53), whose international reputation helped spread the Caravaggesque style beyond Rome. Born in Rome, Artemisia first studied and worked under her father, one of the early followers of Caravaggio. In 1616, she moved to Florence, where she worked for the grand duke of Tuscany and was elected, at the age of twenty-three, to the Florentine Academy of Design. As a resident of Florence, Artemisia was well aware of the city's identification with the Jewish hero David and heroine Judith (both subjects of sculpture by Donatello and Michelangelo), and she painted several versions of Judith triumphant over the Assyrian general Holofernes (**FIG. 22–18**). Artemisia brilliantly uses Baroque naturalism and tenebrist effects, dramatically showing Judith still holding the bloody sword and hiding the candle's light as her maid stuffs the general's head into a sack. Tension mounts—enhanced by the dramatic use of light—as the women listen for the sounds of guards.

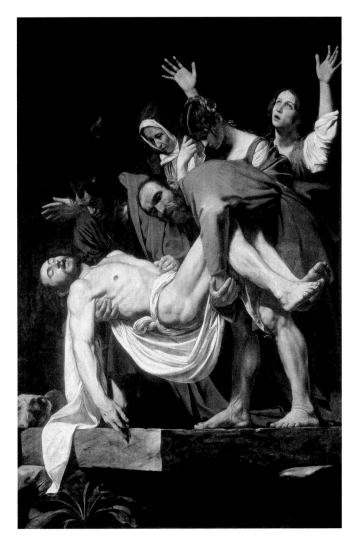

22–17 Caravaggio **ENTOMBMENT**
Vittrici Chapel, Church of Santa Maria in Vallicella, Rome. 1603-4. Oil on canvas, 9′10⅛″ × 6′7¹⁵⁄₁₆″ (3 × 2.03 m). Musei Vaticani, Pinacoteca, Rome.

The *Entombment* was one of many paintings confiscated from Rome's churches and taken to Paris during the French occupation by Napoleon's troops in 1798 and 1808-14. It was one of the few to be returned after 1815 through the negotiations of Pius VII and his agents, who were assisted greatly by the Neoclassical sculptor Antonio Canova, a favorite of Napoleon. The decision was made not to return the works to their original churches and chapels but instead to assemble them in a gallery where the general public could enjoy them. Today, Caravaggio's painting is one of the most important in the collections of the Vatican Museums.

Religious subjects have dominated Western art since the medieval period. Beginning in the Renaissance, however, themes drawn from mythology, literature, daily life, and folklore began to play a significant role. Starting with Mannerism, and continuing into the Baroque period, artists and patrons delighted in iconography that was often complex and extremely subtle. A sourcebook, the *Iconologia,* by Cesare Ripa (1593), became an essential tool for creating and deciphering

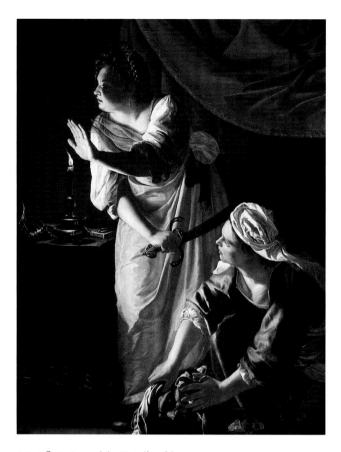

22–18 | Artemisia Gentileschi **JUDITH AND MAIDSERVANT WITH THE HEAD OF HOLOFERNES**
1625. Oil on canvas, 6′½″ × 4′7″ (1.84 × 1.41 m).
The Detroit Institute of Arts.
Gift of Leslie H. Green, (52.253)

22–19 | Artemisia Gentileschi **SELF-PORTRAIT AS THE ALLEGORY OF PAINTING**
1630. Oil on canvas, 38 × 29″ (96.5 × 73.7 cm).
The Royal Collection, Windsor Castle, England.
(RCIN 405551, ML 49 BP 2652)

seventeenth- and eighteenth-century art. Painters and patrons turned to it when they needed detailed instruction or new ways to present a subject or person. Artemisia Gentileschi was no exception. In 1630, she painted **SELF-PORTRAIT AS THE THE ALLEGORY OF PAINTING** (FIG. 22–19), personified by a richly dressed woman with palette and brushes. The *Iconologia*'s influence is revealed in the woman's gold necklace with its mask pendant. Ripa writes that the mask imitates the human face, as painting imitates nature, and the gold chain symbolizes "the continuity and interlocking nature of painting, each man learning from his master and continuing his master's achievements in the next generation" (cited in E. Maser, trans. no. 197). Artemisia may have painted her own features as the personification of painting, in which case she not only commemorates her profession but also pays tribute to those who came before.

FOLLOWERS OF THE CARRACCI. The Carracci had many Italian followers and students. Baroque classicism was preferred by patrons and artists for the altarpieces and murals required by the many new churches being built in Rome.

Giovanni Francesco Barbieri (1591–1666), called "Il Guercino" ("The Little Squinter"), responded to developments in classicism, and perhaps also to the work of Ludovico Carracci, during a brief sojourn in Rome in 1621–23. In Guercino's painting of *Saint Luke Displaying a Painting of the Virgin* (Introduction, Fig. 15) for the high altar of the Franciscan church in Reggio nell'Emilia, near Bologna, his palette has evolved from the pronounced chiaroscuro of his early work to the lighter colors of artists like Guido Reni (SEE FIG. 22–20). In keeping with the desire for greater naturalism and contemporary relevance in religious art, Luke turns to the viewer as if in the middle of a discussion about his painting of the Virgin and Child, a copy of a Byzantine icon believed by the Bolognese to have been painted by Luke himself. Although Protestants ridiculed the idea that paintings by Luke existed, Catholics staunchly defended their authenticity. Guercino's painting, then, is both an homage to the patron saint of painters and a defense of the miracle-working Madonna di San Luca in his hometown. The classical architecture and idealized figures typify Bolognese academic art.

The most important Italian Baroque classicist after Annibale Carracci was the Bolognese artist Guido Reni (1575–1642), who briefly studied at the Carracci academy in 1595. By 1620, Guido Reni had become the most popular painter in Italy.

In 1613–14, during a sojourn in Rome, Reni decorated the ceiling of a palace garden house (*casino* in Italian) in Rome with his most famous work, **AURORA (FIG. 22–20)**. The fresco emulates the illusionistic mythological scenes in *quadro riportato* on the Farnese ceiling, although Reni made no effort to relate his painting's space to that of the room. Indeed, *Aurora* appears to be a framed oil painting incongruously attached to the ceiling. The composition itself, however, is Baroque classicism at its most lyrical. Framed by self-emanating golden light, Apollo, escorted by Cupid and the Seasons, drives the sun chariot. Ahead, the flying figure of Aurora, goddess of the dawn, leads Apollo's horses at a sharp diagonal over a dramatic Venetian sky. The measured, processional staging and idealized forms seem to have been derived from an antique relief, and the precise drawing owes much to Annibale Carracci and academic training. But the graceful figures, the harmonious rhythms of gesture and drapery, and the intense color are Reni's own, demonstrating his close study of models and his skillful combination of the real and ideal.

BAROQUE CEILINGS: CORTONA AND GAULLI. Theatricality, intricacy, and the opening of space reached an apogee in Baroque ceiling decoration. Baroque ceiling projects were complex constructions combining architecture, painting, and stucco sculpture. These grand illusionistic projects were carried out on the domes and vaults of churches, civic buildings, palaces, and villas, and went far beyond even Michelangelo's Sistine Chapel ceiling (SEE FIG. 20–12) or Correggio's dome (SEE FIG. 20–21). In addition to using the device of the *quadro riportato,* Baroque ceiling painters were also concerned with achieving the drama of an immeasurable heaven that extended into vertiginous zones far beyond the limits of High Renaissance taste. To achieve this, they employed the system of *quadratura* (literally, "squaring" or "gridwork"): an architectural setting painted in meticulous perspective and usually requiring that it be viewed from a specific spot to achieve the effect of soaring space. The resulting viewpoint is called *di sotto in su* ("from below to above"), which we first saw, in a limited fashion, in Mantegna's ceiling (FIG. 19–34). Because it required such careful calculation, figure painters usually had specialists in *quadratura* paint the architectural frame for them.

Pietro Berrettini (1596–1669), called "Pietro da Cortona" after his hometown, carried the development of the Baroque ceiling away from classicism into a more strongly unified and illusionistic direction. Trained in Florence and inspired by Veronese's ceiling in the doge's palace, which he saw on a trip to Venice in 1637, the artist was commissioned in the early 1630s by the Barberini family of Pope Urban VIII to decorate the ceiling of the audience hall of their Roman palace. A drawing by a Flemish artist visiting Rome, Lieven Cruyl (1640–c. 1720), gives us a view of the Barberini's huge palace, piazza, and the surrounding city. Bernini's Trident Fountain stands in the center of the piazza, and his scallop shell fountain can be seen at the right (FIG. 22–21).

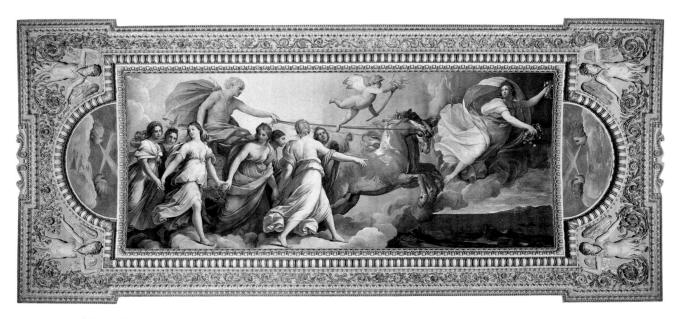

22–20 | Guido Reni **AURORA**
Ceiling of the Garden House, Palazzo Rospigliosi-Palavacini, Rome. 1613-14. Fresco.

22–21 | **BARBERINI PALACE AND SQUARE**
1628-36. Drawing by Lieven Cruyl, 1665. Ink and chalk on paper, 15 × 19¾" (38.2 × 49.4 cm). The Cleveland Museum of Art, Cleveland, Ohio. Dudley P. Allen Fund 1943.265.

Maderno, Bernini, and Borromini collaborated on the Barberini Palace between 1628 and 1636, and in the 1670s the structure underwent considerable remodeling. The original plan is unique, having no precedents or imitators in the history of Roman palaces. The structure appears as a single massive pile, but in fact it consists of a central reception block flanked by two residential wings and two magnificent staircases. Designed to house two sides of the family, the rooms are arranged in suites allowing visitors to move through them achieving increasing intimacy and privacy. Since Cruyl visited the city during Carnival, a Carnival float with musicians and actors takes center stage among the strollers. The Carnival floats are among the ephemera of art. (Today we might call them "performance art.") Cruyl, who includes his own image at the left, published his drawings as engravings, a set of fifteen plates called *Views of Rome,* in 1665.

Pietro's great fresco, **THE GLORIFICATION OF THE PAPACY OF URBAN VIII,** became a model for a succession of Baroque illusionistic palace ceilings throughout Europe (FIG. 22–22). Cortona structured his mythological scenes around a vault-like skeleton of architecture, painted in *quadratura* that appears to be attached to the actual cornice of the room. But in contrast to Annibale Carracci's neat separations and careful *quadro riportato* framing, Pietro's figures weave in and out of their setting in active and complex profusion; some rest on the actual cornice, while others float weightlessly against the sky. Instead of Annibale's warm, nearly even light, Pietro's dramatic illumination, with its bursts of brilliance alternating with deep shadows, fuses the ceiling into a dense but unified whole.

The subject is an elaborate allegory of the virtues of the pope. Just below the center of the vault, seated at the top of a pyramid of clouds and figures personifying Time and the Fates, Divine Providence (in gold against an open sky) gestures toward three giant bees surrounded by a huge laurel wreath (both Barberini emblems) carried by Faith, Hope, and Charity. Immortality offers a crown of stars, while other figures present the crossed keys and the triple-tiered crown of the papacy. Around these figures are scenes of Roman gods and goddesses, who demonstrate the pope's wisdom and virtue by triumphing over the vices. So complex was the imagery that a guide gave visitors an explanation, and one member of the household published a pamphlet, still in use today, explaining the painting.

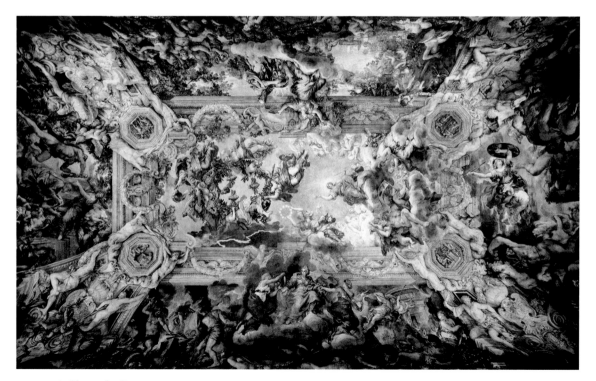

22–22 | Pietro da Cortona **THE GLORIFICATION OF THE PAPACY OF URBAN VIII**
Ceiling in the Gran Salone, Palazzo Barberini, Rome. 1632-39. Fresco.

22–23 | Giovanni Battista Gaulli **THE TRIUMPH OF THE NAME OF JESUS AND THE FALL OF THE DAMNED**
Vault of the Church of Il Gesù, Rome. 1672–85. Fresco with stucco figures.

The most spectacular of all, and the ultimate illusionistic Baroque ceiling, is Gaulli's **THE TRIUMPH OF THE NAME OF JESUS AND THE FALL OF THE DAMNED (FIG. 22–23),** which fills the vault of the Jesuit church Il Gesù. In the 1560s, Giacomo da Vignola had designed an austere interior for Il Gesù, but when the Jesuits renovated their church a century later, they commissioned a religious allegory to cover the nave's plain ceiling. Giovanni Battista Gaulli (1639–1709) designed and executed the spectacular illusion between 1672 and 1685, fusing sculpture and painting to eliminate any appearance of

architectural division. It is impossible to understand which figures are three-dimensional and which are painted, and some paintings are on real panels that extend over the actual architectural frame. Gaulli, who arrived in Rome from Genoa in 1657, had worked in his youth for Bernini, from whom he absorbed a taste for drama and for multimedia effects. The elderly Bernini, who worshiped daily at Il Gesù, may well have offered his personal advice to his former assistant, and Gaulli was certainly familiar with other illusionistic paintings in Rome as well, including Pietro da Cortona's Barberini ceiling.

Gaulli's astonishing creation went beyond anything that had preceded it in unifying architecture, sculpture, and painting. Every element is dedicated to creating the illusion that clouds and angels have floated down through an opening in the church's vault into the upper reaches of the nave. The extremely foreshortened figures are projected as if seen from below, and the whole composition is focused off-center on the golden aura around the letters *IHS,* the monogram of Jesus and the insignia of the Jesuits. The subject is, in fact, a Last Judgment, with the elect rising joyfully toward the name of God and the damned plummeting through the ceiling toward the nave floor. The sweeping inclusion in the work of the space of the nave, the powerful and exciting appeal to the viewer's emotions, and the nearly total unity of visual effect have never been surpassed.

THE HABSBURG LANDS

When the Holy Roman Emperor Charles V abdicated in 1556 (see Chapter 21), he left Spain and its American colonies, the Netherlands, Burgundy, Milan, and the Kingdom of Naples and Sicily to his son Philip II and the Holy Roman Empire (Germany and Austria) to his brother Ferdinand. Ferdinand and the Habsburg emperors who succeeded him ruled their territories from Vienna in Austria, but much of German-speaking Europe remained divided into small units in which local rulers decided on the religion of their territory. Catholicism prevailed in southern and western Germany and in Austria, while the north was Lutheran.

The Spanish Habsburg kings Philip III (ruled 1598–1621), Philip IV (ruled 1621–65), and Charles II (ruled 1665–1700) reigned over a weakening empire. After repeated local rebellions, Portugal reestablished its independence in 1640. The Kingdom of Naples remained in a constant state of unrest. After eighty years of war, the Protestant northern Netherlands—which had formed the United Dutch Republic—gained independence in 1648. Amsterdam grew into one of the wealthiest cities of Europe, and the Dutch Republic became an increasingly serious threat to Spanish trade and colonial possessions. The Catholic southern Netherlands (Flanders), discussed separately below, remained under Spanish and then Austrian Habsburg rule.

What had seemed an endless flow of gold and silver from the Americas to Spain diminished, as precious-metal production in Bolivia and Mexico lessened. Agriculture, industry, and trade at home also suffered. As they tried to defend the Roman Catholic Church and their empire on all fronts, the Spanish kings squandered their resources and finally went bankrupt in 1692. Nevertheless, despite the decline of the Habsburgs' Spanish empire, seventeenth-century writers and artists produced much of what is considered the greatest Spanish literature and art, and the century is often called the Spanish Golden Age.

Painting in Spain's Golden Age

The primary influence on Spanish painting in the fifteenth century had been the art of Flanders; in the sixteenth, it had been the art of Florence and Rome. Seventeenth-century Spanish painting, profoundly influenced by Caravaggio's powerful art, was characterized by an ecstatic religiosity combined with intense realism whose surface details emerge from the deep shadows of tenebrism. This influence is not surprising, since the Kingdom of Naples was ruled by Spanish monarchs, and contact between Naples and the Iberian peninsula was strong and productive.

JUAN SÁNCHEZ COTÁN. Late in the sixteenth century, Spanish artists developed a significant interest in paintings of artfully arranged objects rendered with intense attention to detail. Juan Sánchez Cotán (1561–1627) was one of the earliest painters of these pure still lifes in Spain. In **STILL LIFE WITH**

22–24 | Juan Sánchez Cotán **STILL LIFE WITH QUINCE, CABBAGE, MELON, AND CUCUMBER**
c. 1602. Oil on canvas, 27⅛ × 33¼" (68.8 × 84.4 cm). San Diego Museum of Art.
Gift of Anne R. and Amy Putnam

22–25 | Jusepe de Ribera **MARTYRDOM OF SAINT BARTHOLOMEW**
1634. Oil on canvas, 41¼ × 44⅞" (1.05 × 1.14 m). National Gallery of Art, Washington, D.C.

Gift of the 50th Anniversary Gift Committee (1990.137.1)

QUINCE, CABBAGE, MELON, AND CUCUMBER (FIG. 22–24), of about 1602, he plays off the irregular, curved shapes of the fruits and vegetables against the angular geometry of the ledge. His precisely ordered subjects—two of which are suspended from strings—form a long arc from the upper left to the lower right. It is not clear whether the seemingly airless space is a wall niche or a window ledge or why these objects have been arranged in this way. Set in a strong light against impenetrable darkness, this highly artificial arrangement portrayed in an intensely realistic manner suggests not only a fascination with spatial ambiguity but a contemplative sensibility and interest in the qualities of objects that look forward to the work of Zurbarán and Velázquez.

JUSEPE DE RIBERA. José or Jusepe de Ribera (c. 1591–1652), born in Seville but living in Naples, has been claimed by both Spain and Italy; however, Naples was ruled by Spain, and in Italy he was known as "Lo Spagnoletto" ("the Little

Spaniard"). He combined the classical and Caravaggesque styles he had learned in Rome, and after settling in Naples in 1620, he created a new Neapolitan—and eventually Spanish—style. Ribera became the link extending from Caravaggio in Italy to the Spanish masters Zurbarán and Velázquez. Ribera was once thought to epitomize Spanish religiosity.

Scenes of martyrdom became popular as the church—aiming to draw people back to Catholicism—ordered art depicting heroic martyrs who had endured shocking torments as witness to their faith. Others, like Saint Teresa (SEE FIG. 22–6), reinforced the importance of personal religious experience and intuitive knowledge. A striking response to this call for relevance and passion is Ribera's painting of Saint Bartholomew, an apostle who was martyred by being skinned alive (FIG. 22–25). The bound Bartholomew looks heavenward as his executioner tests the knife that he will soon use on his still-living victim. Ribera has learned the lessons of Caravaggio well, as he highlights the intensely realistic aged

22–26 | Francisco de Zurbarán **SAINT SERAPION**
1628. Oil on canvas, 47½ × 40¾″ (120.7 × 103.5 cm).
Wadsworth Atheneum, Hartford, Connecticut.
Ella Gallup Sumner and Mary Catlin Sumner Collection Fund

faces with the dramatic light of tenebrism and depicts the aging wrinkled flesh with almost painful naturalism. The compression of the figures into the foreground space heightens their immediacy and horror.

FRANCISCO DE ZURBARÁN. Equally horrifying in its depiction of martyrdom, but represented with understated control, is the 1628 painting of **SAINT SERAPION** (FIG. 22–26) by Francisco de Zurbarán (1598–1664). Little is known of his early years before 1625, but Zurbarán too came under the influence of the Caravaggesque taste prevalent in Seville, the major city in southwestern Spain. His own distinctive style incorporated a taste for abstract design, which some critics see as part of the heritage of centuries of Islamic Moorish occupation.

Zurbarán executed his major commissions for the monastic orders. In the painting shown here, he portrays the martyrdom of Serapion, who was a member of the thirteenth-century Mercedarians, a Spanish order founded to rescue the Christian prisoners of the Moors. Following the vows of his order, Serapion sacrificed himself in exchange for Christian captives. The dead man's pallor, his rough hands,

and the coarse ropes contrast with the off-white of his creased Mercedarian habit, its folds carefully arranged in a pattern of highlights and varying depths of shadow. The only colors are the red and gold of the insignia. This composition, almost timeless in its immobility, is like a tragic still life, a study of fabric and flesh.

DIEGO VELÁZQUEZ. Diego Rodríguez de Silva y Velázquez (1599–1660), the greatest painter to emerge from the Caravaggesque school of Seville, shared this fascination with objects. Velázquez entered Seville's painters' guild in 1617. Like Ribera, he began his career as a tenebrist and naturalist. During his early years, he painted figural works set in taverns, markets, and kitchens and emphasized still lifes of various foods and kitchen utensils. His early **WATER CARRIER OF SEVILLE** (FIG. 22–27) is a study of surfaces and textures of the splendid ceramic pots that characterized folk art through the centuries. Velázquez was devoted to studying and sketching from life, and the man in the painting was a well-known Sevillian water seller. Like Sánchez Cotán, Velázquez arranged the elements of his paintings with almost mathematical rigor. The objects and figures allow the artist to exhibit his virtuosity in rendering sculptural volumes and contrasting textures illuminated by dramatic natural light. Light reacts to the surfaces: reflecting off the glazed waterpot at the left and the coarser clay jug in the foreground; being absorbed by the rough wool and dense velvet of the costumes; and reflecting, being refracted, and passing through the clear glass held by the man and through the waterdrops on the jug's surface.

In 1623, Velázquez moved to Madrid, where he became court painter to young King Philip IV, a prestigious position that he held until his death in 1660. The opportunity to study paintings in the royal collection, as well as to travel, enabled the development of his distinctive personal style. The Flemish painter Peter Paul Rubens (see pages 774–777), during a 1628–29 diplomatic visit to the Spanish court, convinced the king that Velázquez should visit Italy. Velázquez made two trips, the first in 1629–31 and a second in 1649–51. He was profoundly influenced by contemporary Italian painting, and on the first trip seems to have taken a special interest in narrative paintings with complex figure compositions.

Velázquez's Italian studies and his growing skill in composition are apparent in both figure and landscape painting. In **THE SURRENDER AT BREDA** (FIG. 22–28), painted in 1634–35, Velázquez treats the theme of triumph and conquest in an entirely new way—far removed from traditional gloating military propaganda. Years earlier, in 1625, the duke of Alba, the Spanish governor, had defeated the Dutch at Breda. In Velázquez's imagination, the opposing armies stand on a hilltop overlooking a vast valley where the city of Breda burns and soldiers are still deployed. The Dutch commander, Justin of Nassau, hands over the keys of Breda to the

22–27 | Diego Velázquez **WATER CARRIER OF SEVILLE**
c. 1619. Oil on canvas, 41½ × 31½" (105.3 × 80 cm). Victoria & Albert Museum,
London.

In the hot climate of Seville, Spain, where this painting was made, water vendors walked
the streets selling cool drinks from large clay jars like the one in the foreground. In this
scene, the clarity and purity of the water are proudly attested to by its seller, who offers the
customer a sample poured into a glass goblet. The jug contents were usually flavored with
the addition of a piece of fresh fruit or a sprinkle of aromatic herbs.

victorious Spanish commander, Ambrosio Spinola, the duke
of Alba. The entire exchange seems extraordinarily gracious;
the painting represents a courtly ideal of gentlemanly con-
duct. The victors stand at attention, holding their densely
packed lances upright in a vertical pattern—giving the paint-
ing its popular name, "The Lances"—while the defeated
Dutch, a motley group, stand out of order, with pikes and
banners drooping. The painting is memorable as a work of

art, not as history. According to reports, no keys were
involved and the Dutch were more presentable in appearance
than the Spaniards. The victory was short-lived: The Dutch
retook Breda in 1637.

In *The Surrender at Breda,* Velázquez displays his ability to
arrange a large number of figures to tell a story effectively. A
strong diagonal starting in the sword of the Dutch soldier in
the lower left foreground and ending in the checked banner

on the upper right unites the composition and moves the viewer thematically from the defeated to the victorious soldiers. Portraitlike faces, meaningful gestures, and brilliant control of color and texture convince us of the reality of the scene. The landscape painting is almost startling. Across the huge canvas, Velázquez painted an entirely imaginary Netherlands in greens and blues worked with flowing, liquid brushstrokes. Luminosity is achieved by laying down a thick layer of lead white and then flowing the layers of color over it. The silvery light forms a background for dramatically silhouetted figures and weapons. Velázquez revealed a breadth and intensity unsurpassed in his century; his painting has inspired modern artists such as Manet and Picasso.

Although complex compositions became characteristic of many of Velázquez's paintings, perhaps his most striking and enigmatic work is the enormous multiple portrait, nearly 10½ feet tall and over 9 feet wide, known as **LAS MENINAS (THE MAIDS OF HONOR)** (FIG. 22–29). Painted in 1656, near the end of the artist's life, this painting continues to challenge the viewer and stimulate debate. Like Caravaggio's *Entombment* (SEE FIG. 22–17), it draws the viewer directly into its action, for in one interpretation, the viewer is apparently standing in the space occupied by King Philip and the queen, whose reflections can be seen in the large mirror on the back wall. (Others say the mirror reflects the canvas on which Velázquez is working.) The central focus, however, is not on the royal couple or on the artist but on the 5-year-old *infanta* (princess) Margarita, who is surrounded by her attendants, most of whom are identifiable portraits.

The cleaning of *Las Meninas* in 1984 revealed much about Velázquez's methods. He used a minimum of underdrawing, building up his forms with layers of loosely applied paint and finishing off the surfaces with dashing highlights in white, lemon yellow, and pale orange. Velázquez tried to depict the optical properties of light rather than using it to model volumes in the classical time-honored manner. While his technique captures the appearance of light on surfaces, at close inspection his forms dissolve into a maze of individual strokes of paint.

No consensus exists today on the meaning of this monumental painting. Yes, it is a royal portrait; it is also a self-portrait of Velázquez standing at his easel. But more than that, *Las Meninas* seems to have been a personal statement. Throughout his life, Velázquez had sought respect and acclaim for himself and for the art of painting. Here, dressed as a courtier, the Order of Santiago on his chest (added later) and the keys of the palace in his sash, Velázquez proclaimed the dignity and importance of painting as one of the liberal arts.

22–28 | Diego Velázquez **THE SURRENDER AT BREDA (THE LANCES)**
1634–35. Oil on canvas, 10′⅞″ × 12′½″ (3.07 × 3.67 m). Museo del Prado, Madrid.

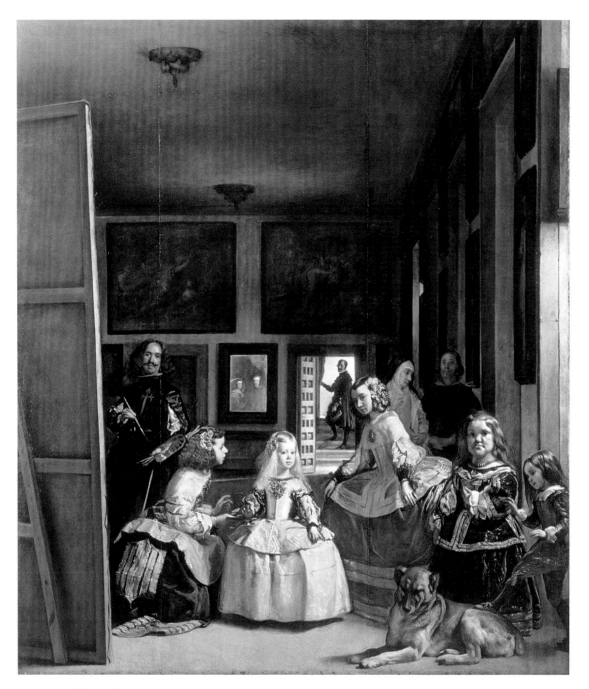

22–29 | Diego Velázquez **LAS MENINAS (THE MAIDS OF HONOR)**
1656. Oil on canvas, 10′5″ × 9′½″ (3.18 × 2.76 m). Museo del Prado, Madrid.

Bartolomé Esteban Murillo. The Madrid of Velázquez was the center of Spanish art; Seville declined after an outbreak of plague in 1649. Still living and working in Seville, however, was Bartolomé Esteban Murillo (1617–82). Seville was a center for trade with the Spanish colonies, where Murillo's work had a profound influence on art and religious iconography. Many patrons wanted images of the Virgin Mary and especially of the Immaculate Conception, the controversial idea that Mary was born free from original sin. Although the Immaculate Conception became Catholic dogma only in

1854, the concept, as well as devotion to Mary, was widespread during the seventeenth and eighteenth centuries.

Counter-Reformation authorities provided specific instructions for artists painting the Virgin: Mary was to be dressed in blue and white, her hands folded in prayer, as she is carried upward by angels, sometimes in large flocks. She may be surrounded by an unearthly light ("clothed in the sun") and may stand on a crescent moon in reference to the woman of the apocalypse. Angels often carry palms and symbols of the Virgin, such as a mirror, a fountain, roses, and lilies, and

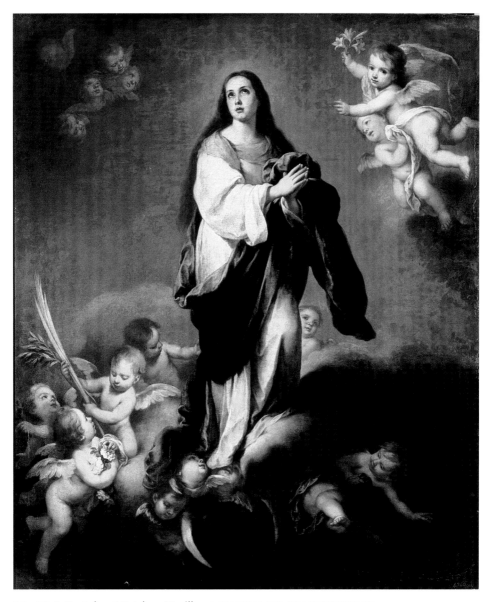

22–30 | Bartolomé Esteban Murillo **THE IMMACULATE CONCEPTION**
c. 1645–50. Oil on canvas, 7′8″ × 6′5″ (2.35 × 1.96 m). State Hermitage Museum,
St. Petersburg, Russia.

they may vanquish the serpent, Satan. Today, Murillo's paintings are admired for his skill as a draftsman and colorist. His version of ideal beauty—in Mary, Jesus, or the cherubs that surround Mary—is never cloying. The Church exported many paintings by Murillo, Zurbarán, and others to the New World. When the native population began to visualize the Christian story, paintings such as Murillo's **THE IMMACULATE CONCEPTION** provided the imagery (FIG. 22–30).

Architecture in Spain and Austria

THE CATHEDRAL OF SANTIAGO DE COMPOSTELA. Turning away from the severity displayed in the sixteenth-century El Escorial monastery-palace (SEE FIG. 21–19), Spanish architects again embraced the lavish decoration that had characterized

their art since the fourteenth century. The profusion of ornament typical of Moorish and Gothic architecture in Spain swept back into fashion, first in huge retablos (altarpieces), then in portals (main doors often embellished with sculpture), and finally in entire buildings.

In the seventeenth century, the role of Saint James as patron saint of Spain was challenged by the supporters of Saint Teresa of Ávila and then by supporters of Saint Michael, Saint Joseph, and other popular saints. It became important to the archbishop and other leaders in Santiago de Compostela, where the Cathedral of Saint James was located, to establish their primacy. They reinforced their efforts to revitalize the yearly pilgrimage to the city, undertaken by Spaniards since the ninth century, and used architecture as part of their campaign.

Renewed interest in pilgrimages to the shrines of saints in the seventeenth century brought an influx of pilgrims, and consequently financial security, to the city and the church. The cathedral chapter ordered a façade of almost unparalleled splendor to be added to the twelfth-century pilgrimage church (FIG. 22–31). The twelfth-century portal had already been closed with doors in the sixteenth century and a staircase built that incorporated the western crypt. A south tower was built in 1667–80 and then later copied as the north tower.

The last man to serve as architect and director of works, Fernando Casas y Nóvoas (active 1711–49), tied the disparate elements together at the west—towers, portal, stairs—in a grand design focused on a veritable wall of glass, popularly called "The Mirror." His design culminates in a freestanding gable soaring above the roof, visually linking the towers, and framing a statue of Saint James. The extreme simplicity of the cloister walls and the archbishop's palace at each side of the portal heighten the dazzling effect of this enormous expanse of glass windows, glittering jewel-like in their intricately carved granite frame.

THE BENEDICTINE ABBEY, MELK. The arts suffered in seventeenth-century Germanic lands, including Austria, during and after the Protestant Reformation. Wars over religion ravaged the land. When peace finally returned in the eighteenth cen-

Sequencing Events
KEY SCIENTIFIC AND MATHEMATICAL DISCOVERIES IN THE SEVENTEENTH CENTURY

1609, 1619	Johannes Kepler (Germany) publishes his three laws of planetary motion
1619	William Harvey (England) announces discovery of the circulation of the blood
1643	Evangelista Torricelli (Italy) invents barometer
1654	Blaise Pascal and Pierre de Fermat (France) develop the theory of probability
1675	Ole Romer (Denmark) establishes that light travels at a determined speed
1687	Isaac Newton (England) publishes his laws of gravity and motion

tury, Catholic Austria and Bavaria (southern Germany) saw a remarkable burst of building activity, including the creation and refurbishing of churches and palaces with exuberant interior decoration. Emperor Charles VI (ruled 1711–40) inspired building in his capital, Vienna, and throughout Austria.

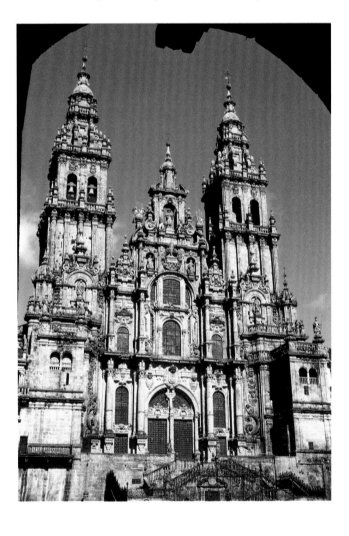

22–31 | **WEST FAÇADE, CATHEDRAL OF SAINT JAMES, SANTIAGO DE COMPOSTELA, SPAIN.**
South tower 1667–1680; north tower and central block finished mid-18th century by Fernando de Casas y Nóvoas.

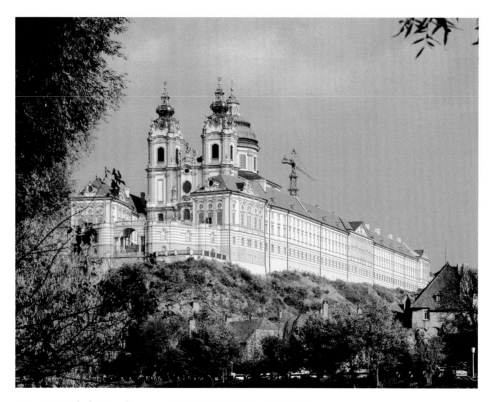

22–32 | Jakob Prandtauer **BENEDICTINE MONASTERY CHURCH, MELK**
Austria. 1702–36 and later.

Church architecture looked to Italian Baroque developments, which were then added to German medieval forms such as tall bell towers. With these elements, German Baroque architects gave their churches an especially strong vertical emphasis. One of the most imposing buildings of this period is the Benedictine Abbey of Melk, built high on a promontory overlooking the Danube River on a site where there had been a Benedictine monastery since the eleventh century. The complex combines church, monastery, library, and—true to the Benedictine tradition of hospitality—guest quarters that evolved into a splendid palace to house the traveling court (**FIG. 22–32**). The architect, Jakob Prandtauer (1660–1726), oversaw its construction from 1702 until his death in 1726. The buildings were finished in 1749.

Seen from the river, the monastery appears to be a huge twin-towered church, but it is in fact a complex of buildings. Two long (1,050 feet) parallel wings flank the church; one contains a great hall and the other, the monastery's library. The wings are joined by a curving building and terrace overlooking the river in front of the church. Large windows and open galleries take advantage of the river view. Colossal pilasters and high, bulbous-domed towers emphasize the building's verticality. Its grand and palacelike appearance is a reminder that the monastery was an ancient foundation enjoying imperial patronage.

Spectacular as it is, even the Danube River view does not prepare one for the interior of the church (**FIG. 22–33**). People descending the spiral staircase from the hall and library emerge into an amazing yellow and pink confection. Every surface moves. Huge deep red pilasters support a massive undulating entablature. They establish the semblance of a wall behind which the chapels, galleries, and screens curve and disappear in a maze of gilded sculpture. Light from huge clerestory windows, reminiscent of ancient Roman architecture, enhance the effect of detachment. One cannot distinguish actual from fictive architecture. Figures seem to spill out over the architecture which—as in Gaulli's ceiling for Il Gesù (SEE FIG. 22–23)—sometimes is actually built and sometimes is fiction. Overhead white, gold, and pastel colors cause the frescoed vault to seem to float upward, detached from architecture below. The painting is the work of the first great Austrian Baroque muralist, Johann Michael Rottmayr (c. 1654–1750).

FLANDERS AND THE NETHERLANDS

After a period of relative autonomy from 1598 to 1621 under a Habsburg regent, Flanders, the southern—and predominantly Catholic—part of the Netherlands, returned to direct Spanish rule. Led by the nobleman Prince William of Orange, the Netherlands' Protestant northern provinces (present-day Holland) rebelled against Spain in 1568. The seven provinces joined together as the United Provinces in 1579 and began the long struggle for independence, achieved in the seventeenth century. The king of Spain considered the Dutch heretical rebels, but finally the Dutch prevailed. In

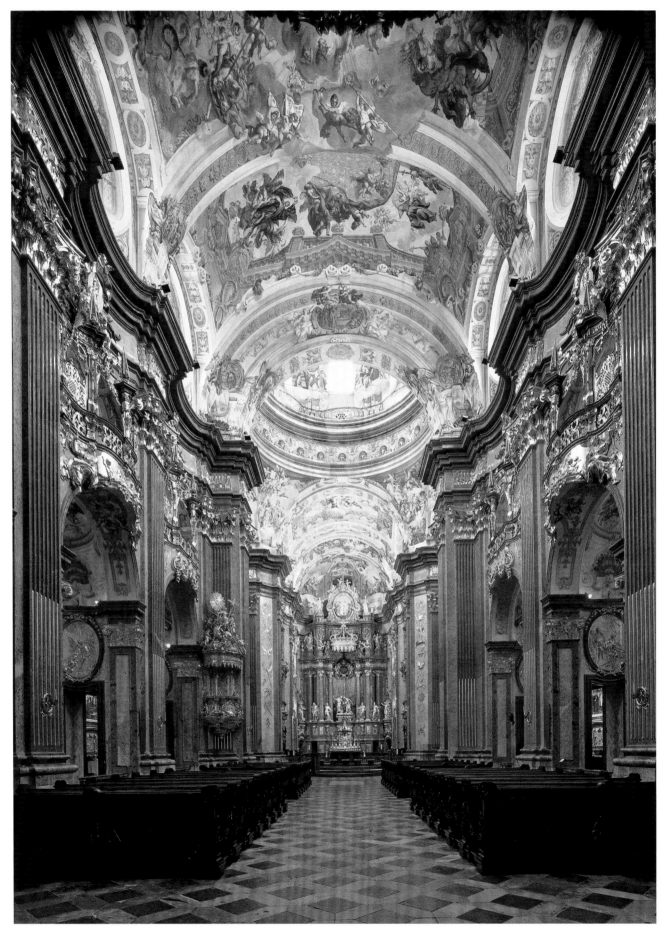

22–33 | **INTERIOR, BENEDICTINE MONASTERY CHURCH, MELK**
Austria. Completed after 1738, after designs by Prandtauer, Antonio Beduzzi, and Joseph Munggenast.

1648, the United Provinces joined emissaries from Spain, the Vatican, the Holy Roman Empire, and France on equal footing in peace negotiations. The resulting Peace of Westphalia recognized the independence of the northern Netherlands.

Flanders

With the southern Netherlands remaining under Catholic Habsburg rule, churches were restored and important commissions went to religious subject matter. As Antwerp, the capital city and major arts center of the southern Netherlands, gradually recovered from the turmoil of the religious wars, artists of great talent flourished there. Painters like Peter Paul Rubens and Anthony Van Dyck established international reputations that brought them important commissions from foreign as well as local patrons.

RUBENS. Peter Paul Rubens (1577–1640), whose painting has become synonymous with Flemish Baroque art, was born in Germany, where his father, a Protestant, had fled from his native Antwerp to escape religious persecution. In 1587, after her husband's death, Rubens's mother and her children returned to Antwerp and to Catholicism. Rubens decided in his late teens to become an artist and at age twenty-one was accepted into the Antwerp painters' guild, a testament to his energy, intelligence, and skill. Shortly thereafter, in 1600,

Rubens left for Italy. In Venice, Rubens's work came to the attention of the duke of Mantua, who offered him a court post. His activities on behalf of the duke over the next eight years did much to prepare him for the rest of his long and successful career. Surprisingly, other than designs for court entertainments and occasional portraits, the duke never acquired an original painting by Rubens. Instead, he had him copy famous paintings in collections all over Italy to add to the ducal collection.

Rubens visited every major Italian city, went to Madrid as the duke's emissary, and spent two extended periods in Rome, where he studied the great works of Roman antiquity and the Italian Renaissance. While in Italy, Rubens studied the paintings of two contemporaries, Caravaggio and Annibale Carracci. Hearing of Caravaggio's death in 1610, Rubens encouraged the duke of Mantua to buy the artist's *Death of the Virgin,* which the patron had rejected because of the shocking realism. The duke eventually bought the painting.

In 1608, Rubens returned to Antwerp, where he accepted employment by the Habsburg governors of Flanders, Archduke Albert and Princess Isabella Clara Eugenia, the daughter of Philip II. Shortly after his return he married and in 1611 built a house, studio, and garden in Antwerp (FIG. 22–34). Rubens lived in a large typical Flemish house. He added a studio in the

22–34 | Peter Paul Rubens **RUBENS HOUSE**
Built 1610-15. Looking toward the garden: house at left, studio at right. From an engraving of 1684. British Museum, London. The house was restored and opened as a museum in 1946.

22–35 | Peter Paul Rubens **THE RAISING OF THE CROSS**
Church of Saint Walpurga, Antwerp, Belgium. 1610–11. Oil on canvas, center panel 15′1⅞″ × 11′1½″
(4.62 × 3.39 m); each wing 15′1⅞″ × 4′11″ (4.62 × 1.52 m). Cathedral of Our Lady, Antwerp.
©IRPA-KIK, Brussels

Italian manner across a courtyard, joining the two buildings by a second-floor gallery over the entrance portal. Beyond the courtyard lay the large formal garden, laid out in symmetrical beds. The living room permitted access to a gallery overlooking Rubens's huge studio, a room designed to accommodate large paintings and to house what became virtually a painting factory. The large arched windows provided ample light for the single, two-story room, and a large door permitted the assistants to move finished paintings out to their designated owners. Across the courtyard, one can see the architectural features of the garden, which inspired the architecture of the painting *Garden of Love* (SEE FIG. 22–37).

Rubens's first major commission in Antwerp was a large canvas triptych for the main altar of the Church of Saint Walpurga, **THE RAISING OF THE CROSS** (FIG. 22–35), painted in 1610–11. Rubens continued the Flemish tradition of uniting the triptych by extending the central action and the landscape through all three panels (see Rogier van der Weyden's Last Judgment Altarpiece, FIG. 18–16). At the center, Herculean figures strain to haul upright the wooden cross with Jesus already stretched upon it. At the left, the followers of Jesus join in mourning, and at the right, indifferent soldiers

supervise the execution. All the drama and intense emotion of Caravaggio and the virtuoso technique of Annibale Carracci are transformed and reinterpreted according to Rubens's own unique ideal of thematic and formal unity. The heroic nude figures, dramatic lighting effects, dynamic diagonal composition, and intense emotions show his debt to Italian art, but the rich colors and surface realism, with minute attention given to varied textures and forms, belong to his native Flemish tradition.

Rubens had created a powerful, expressive visual language that was as appropriate for the secular rulers who engaged him as it was for the Catholic Church. Moreover, his intelligence, courtly manners, and personal charm made him a valuable and trusted courtier to his royal patrons, who included Philip IV of Spain, Queen-Regent Marie de' Medici of France, and Charles I of England. In 1621, Marie de' Medici, who had been regent for her son Louis XIII, asked Rubens to paint the story of her life, to glorify her role in ruling France, and also to commemorate the founding of the new Bourbon royal dynasty. In twenty-four paintings, Rubens portrayed Marie's life and political career as one continuous triumph overseen by the ancient gods of Greece and Rome.

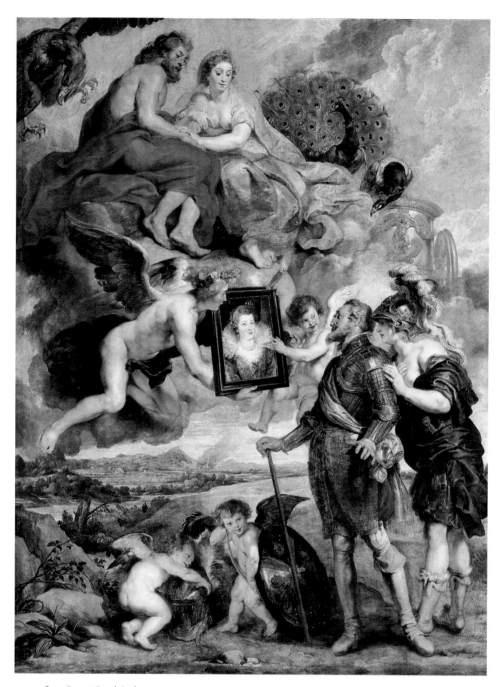

22–36 | Peter Paul Rubens **HENRI IV RECEIVING THE PORTRAIT OF MARIE DE' MEDICI**
1621–25. Oil on canvas, 12'11⅛" × 9'8⅛" (3.94 × 2.95 m). Musée du Louvre, Paris.

In the painting depicting the royal engagement (FIG. 22–36), Henri IV falls in love at once with Marie's portrait, shown to him—at the exact center of the composition—by Cupid and Hymen, the god of marriage, while the supreme Roman god, Jupiter, and his wife, Juno, look down from the clouds. Henri, wearing his steel breastplate and silhouetted against a landscape in which the smoke of a battle lingers in the distance, is encouraged by a personification of France to abandon war for love, as *putti* play with the rest of his armor. The ripe colors, multiple tex-

tures, and dramatic diagonals give a sustained visual excitement to these enormous canvases, making them not only important works of art but also political propaganda of the highest order.

In 1630, while Rubens was in England on a peace mission, Charles I knighted him and commissioned him to decorate the ceiling of the new Banqueting House at Whitehall Palace, London (SEE FIG. 22–65). There, he painted the apotheosis of James I (Charles's father) and the glorification of the Stuart dynasty.

For all the grandeur of his commissioned paintings, Rubens was a sensitive, innovative painter, as the works he created for his own pleasure clearly demonstrate. His greatest joys seem to have been his home in Antwerp and his home in the country, Castle Steen, a working farm with gardens, fields, woods, and streams.

In **GARDEN OF LOVE**—a garden reminiscent of his own—Rubens may have portrayed his second wife, Helene Fourment, as the leading lady among a crowd of beauties (FIG. 22–37). *Putti* encourage the lovers, and one pushes a hesitant young woman into the garden. The couple joins the ladies and gentlemen who are already enjoying the pleasures of nature. The sculpture and architectural setting recall Italian Mannerist conceits. For example, the nymph presses water from her breasts to create the fountain. Herms flank the entrance and columns banded with rough-hewn rings support the pavilion that forms the entrance to the grotto of Venus. All is lush color, shimmering satin, falling water, and sunset sky—the visual and tactile effects so appreciated by seventeenth-century viewers achieved through masterful brushwork.

To satisfy his clients all over Europe, Rubens employed dozens of assistants, many of whom were, or became, important painters in their own right. Using workshop assistants was standard practice for a major artist, but Rubens was particularly methodical, training or hiring specialists in costumes, still lifes, landscapes, portraiture, and animal painting who together could complete a work from his detailed sketches. Among his friends and collaborators were Anthony Van Dyck and his friend and neighbor Jan Brueghel.

PORTRAITS AND STILL LIFES. One of Rubens's collaborators, Anthony Van Dyck (1599–1641), had an illustrious independent career as a portraitist. Son of an Antwerp silk merchant, he was listed as a pupil of the dean of Antwerp's Guild of Saint Luke at age 10. He had his own studio and roster of pupils at age 16 but was not made a member of the guild until 1618, the year after he began his association with Rubens as a painter of heads. The need to blend his work seamlessly with that of Rubens enhanced Van Dyck's technical skill; his independent work shows an elegance and aristocratic refinement that seems to express his own character. After a trip to the English court of James I (ruled 1603–25) in 1620, Van Dyck traveled to Italy and worked as a portrait painter for seven years before returning to Antwerp. In 1632, he returned to England as the court painter to Charles I (ruled 1625–49), by whom he was knighted and given a studio, a summer home, and a large salary.

22–37 │ Peter Paul Rubens **GARDEN OF LOVE**
1630-32. Oil on canvas, 6′6″ × 9′3½″ (1.98 × 2.83 m). Museo del Prado, Madrid.

22–38 | Anthony Van Dyck
CHARLES I AT THE HUNT
1635. Oil on canvas,
8'11" × 6'11"
(2.75 × 2.14 m).
Musée du Louvre, Paris.

Van Dyck's many portraits of the royal family provide a sympathetic record of their features. In **CHARLES I AT THE HUNT** (**FIG. 22–38**), of 1635, Van Dyck was able, by clever manipulation of the setting, to portray the king truthfully and yet as a quietly imposing figure. Dressed casually for the hunt and standing on a bluff overlooking a distant view (a device used by Rubens to enhance the stature of Henry IV; SEE FIG. 22–36), Charles is shown as being taller than his pages and even than his horse, since its head is down and its heavy body is partly off the canvas. The viewer's gaze is diverted from the king's delicate and rather short frame to his pleasant features, framed by his jauntily cocked cavalier's hat. As if in decorous homage, the tree branches bow gracefully toward him, echoing the circular lines of the hat.

Yet another painter working with Rubens, Jan Brueghel (1568–1625), specialized in settings rather than portraits. Jan was the son of Pieter Bruegel the Elder; recall that Jan added the "h" to the family name (see Chapter 21). Brueghel and Rubens's allegories of the five senses—five paintings illustrating sight, hearing, touch, taste, and smell—in effect invited the viewer to wander in an imaginary space and to enjoy an amazing collection of works of art and scientific equipment

(see Brueghel and Rubens's *Allegory of Sight*, page 780). This remarkable painting is a display, a virtual inventory, and a summary of the wealth, scholarship, and connoisseurship created through the patronage of the Habsburg rulers of the Spanish Netherlands.

Our term *still life* for paintings of artfully arranged objects on a table comes from the Dutch *stilleven*, a word coined about 1650. The Antwerp artist Clara Peeters (1594–c. 1657) specialized in still-life tabletop arrangements. She was a precocious young woman whose career seems to have begun before she was fourteen. Of some fifty paintings now attributed to her (of which more than thirty are signed), many are of the type called "breakfast pieces," showing a table set for a meal of bread and fruit. Peeters was one of the first artists to combine flowers and food in a single painting, as in her **STILL LIFE WITH FLOWERS, GOBLET, DRIED FRUIT, AND PRETZELS** (**FIG. 22–39**), of 1611. Peeters arranged rich tableware and food against neutral, almost black backgrounds, the better to emphasize the fall of light over the contrasting surface textures. In a display of decorative arts that must have appealed to her clients, the luxurious goblet and bowl contrast with simple stoneware and pewter, as do the delicate

22–39 | Clara Peeters **STILL LIFE WITH FLOWERS,
GOBLET, DRIED FRUIT, AND PRETZELS**
1611. Oil on panel, 20½ × 28¾" (52 × 73 cm).
Museo del Prado, Madrid.

Like many breakfast pieces, this painting features a pile of pretzels
among the elegant tablewares. The salty, twisted bread was called
pretzel (from the Latin *pretiola*, meaning "small reward") because it
was invented by southern German monks to reward children who
had learned their prayers: The twisted shape represented the
crossed arms of a child praying.

flowers with the homey pretzels. The pretzels, piled high on
the pewter tray, are a particularly interesting Baroque ele-
ment, with their complex multiple curves.

The Dutch Republic

The House of Orange was not notable for its patronage of
the arts, but patronage improved significantly under Prince
Frederick Henry (ruled 1625–47), and Dutch artists found
many other eager patrons among the prosperous middle class
in Amsterdam, Leiden, Haarlem, Delft, and Utrecht. The
Hague was the capital city and the preferred residence of the
House of Orange, but Amsterdam was the true center of
power, because of its sea trade and the enterprise of its mer-
chants, who made the city an international commercial cen-
ter. The Dutch delighted in depictions of themselves and
their country—the landscape, cities, and domestic life—not
to mention beautiful and interesting objects to be seen in
still-life paintings and interior scenes or exotic things (like
the Farnese Hercules admired by Dutch travelers in Rome;
see Introduction, Fig. 24). A well-educated people, the Dutch
were also fascinated by history, mythology, the Bible, new sci-
entific discoveries, commercial expansion abroad, and colo-
nial exploration.

Visitors to the Netherlands in the seventeenth century
noted the popularity of art among merchants and working

people. Peter Mundy, an English traveler, wrote in 1640 that
even butchers, bakers, shoemakers, and blacksmiths had pic-
tures in their houses and shops. This taste for art stimulated a
free market for paintings that functioned like other commod-
ity markets. Artists had to compete to capture the interest of
the public by painting on speculation. Naturally, specialists in
particularly popular types of images were likely to be finan-
cially successful, and what most Dutch patrons wanted were
paintings of themselves, their country, their homes, and the
life around them. The demand for art gave rise to an active
market for the graphic arts, both for original compositions
and for copies of paintings, since one copperplate could pro-
duce hundreds of impressions, and worn-out plates could be
reworked and used again.

THE INFLUENCE OF ITALY. Hendrik Goltzius (1558–1617)
from Haarlem, the finest engraver in the Netherlands, perhaps
in Europe, had visited Florence and Rome in 1590–91. His
engravings of antiquities and of Mannerist paintings, which
he made on his return, were widely circulated and intro-
duced many people to Italian art (See Introduction, Fig. 24).
The fascination continued. Flemish travelers like Leiven
Cruyl (1640–1720) published engravings of the views of
Rome he made in 1665 (SEE FIG. 22–21).

Hendrick ter Brugghen (1588–1629) had spent time in
Rome, perhaps between 1608 and 1614, where he must have
seen Caravaggio's works and became an enthusiastic fol-
lower. On his return home, in 1616, he entered the Utrecht
painters' guild, bringing Caravaggio's style into the Nether-
lands. Ter Brugghen's **SAINT SEBASTIAN TENDED BY SAINT IRENE**
introduced the Netherlandish painters to the new art of
Baroque Italy **(FIG. 22–40)**. The suffering and recovery of
Saint Sebastian was equated to the Crucifixion and Resur-
rection of Christ. The sickly gray-green flesh of the nearly
dead saint, set in an almost monochromatic palette, contrasts
with the brilliant red and gold brocade of his garment—
actually the cope of the bishop of Utrecht, which survived
the destruction by Protestants and became a symbol of
Catholicism in Utrecht. The saint is a heroic figure: His
strong, youthful body is still bound to the stake. But Saint
Irene (the patron saint of nurses) carefully removes one of
the arrows that pierce him, and her maid is about to untie his
wrists. In a typically Baroque manner, the powerful diagonal
created by Saint Sebastian's left arm dislodges him from the
triangular stability of the group: His corpse is in transition
and will soon fall forward. The immediacy and emotional
effectiveness of the work are further strenghtened by setting
all the figures in the foreground plane, an effect strangthened
by the low horizon line. The use of tenebrism and dramatic
light effects, and realism recalling Caravaggio, made an
impact on the Dutch artists who had not had the opportu-
nity to travel to Italy. Rembrandt, Vermeer, and Rubens all
admired ter Brugghen's painting.

THE ●BJECT SPEAKS

BRUEGHEL AND RUBENS'S *ALLEGORY OF SIGHT*

In 1599, the Spanish Habsburg princess Isabel Clara Eugenia married the Austrian Habsburg archduke Albert, uniting two branches of the family. Together they ruled the Habsburg Netherlands for the king of Spain. They were patrons of the arts and sciences and friends of artists—especially Peter Paul Rubens. Their interests and generous patronage were abundantly displayed in five allegorical paintings of the senses by Rubens and Jan Brueghel. The two artists were neighbors and frequently collaborated; Rubens painted the figures, and Brueghel created the settings. Such collaboration between major artists was not unusual in Antwerp.

Of the five paintings, the ALLEGORY OF SIGHT is the most splendid: It is like an illustrated catalog of the ducal collection.

Gathered in a huge vaulted room are paintings, sculpture, furniture, objects in gold and silver, and scientific equipment—all under the magnificent double-headed eagle emblems of the Habsburgs. We explore the painting inch by inch, as if reading a book or scanning a palace inventory. There on the table are Brueghel's copies of Rubens's portraits of Archduke Albert and Princess Isabel Clara Eugenia; another portrait of the duke rests on the floor. Besides the portraits, we can find Rubens's *Daniel in the Lions' Den* (upper left corner), *The Lion and Tiger Hunt* (top center), and *The Drunken Silenus* (lower right), as well as the *Madonna and Child in a Wreath of Flowers* (far right), a popular seventeenth-century subject, for which Rubens painted the Madonna and Brueghel created the wreath. Brueghel

also included Raphael's *Saint Cecilia* (behind the globe) and Titian's *Venus and Psyche* (over the door).

In the foreground, the classical goddess Venus, attended by Cupid (both painted by Rubens), has put aside her mirror to contemplate a painting of *Christ Healing the Blind*. She is surrounded by the equipment needed to see and to study: The huge globe at the right and the armillary sphere with its gleaming rings at the upper left—the Earth and the solar system—symbolize the extent of humanistic learning, an image that speaks to viewers of our day as clearly as it did to those of its own. The books and prints, ruler, compasses, magnifying glass, and the more complex astrolabe, telescope, and eyeglasses may also refer to spiritual blindness—to those who look but do not see.

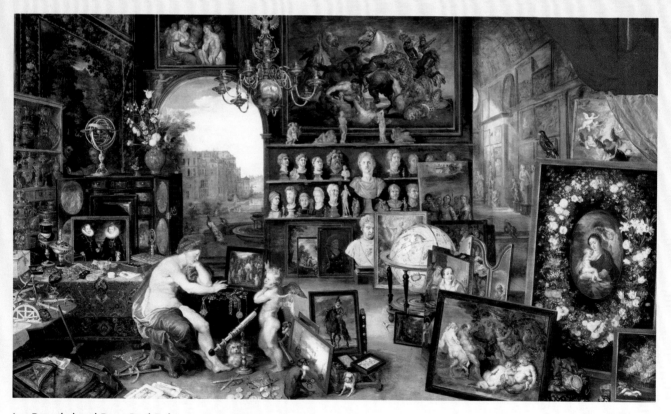

Jan Brueghel and Peter Paul Rubens **ALLEGORY OF SIGHT**
From *Allegories of the Five Senses.* c. 1617–18. Oil on wood panel, 25⅝ × 43″ (65 × 109 cm). Museo del Prado, Madrid.

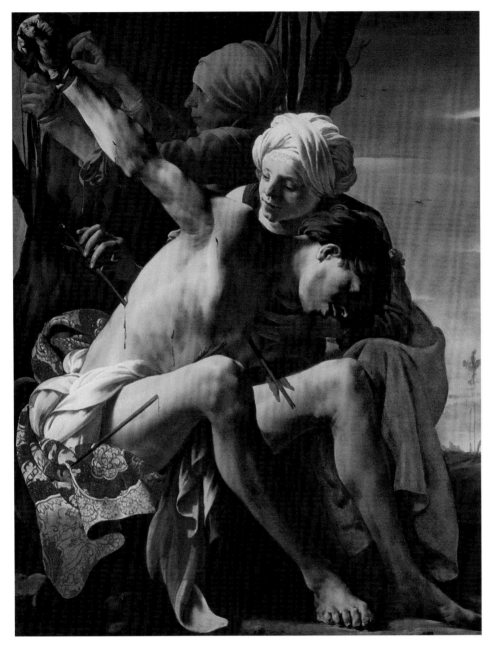

22–40 | Hendrick ter Brugghen
**SAINT SEBASTIAN TENDED BY
SAINT IRENE**
1625. Oil on canvas,
58¹⁵⁄₁₆ × 47½″ (149.6 × 120 cm).
Allen Memorial Art Museum,
Oberlin College, Ohio.

PORTRAITS. Dutch Baroque portraiture took many forms, ranging from single portraits in sparsely furnished settings to allegorical depictions of people in elaborate costumes surrounded by appropriate symbols. Although the accurate portrayal of facial features and costumes was the most important gauge of a portrait's success, the best painters went beyond pure description to convey a sense of mood or emotion in the sitter. (We cannot know if it was an accurate representation of their personality in the modern sense, however.) Group portraiture documenting the membership of corporate organizations was a Dutch specialty. These large canvases, filled with many individuals who shared the cost of the commission, challenged painters to present a coherent, interesting composition that nevertheless gave equal attention to each individual portrait.

Frans Hals (c. 1581/85–1666), the leading painter of Haarlem, developed a style grounded in the Netherlandish love of realism and inspired by the Caravaggesque style introduced by artists such as ter Brugghen. Like Velázquez, he tried to re-create the optical effects of light on the shapes and textures of objects. He painted boldly, with slashing strokes and angular patches of paint. When his work is seen at a distance, however, all the colors merge into solid forms over which a flickering light seems to move. In Hals's hands, this seemingly effortless technique suggests a boundless joy in life.

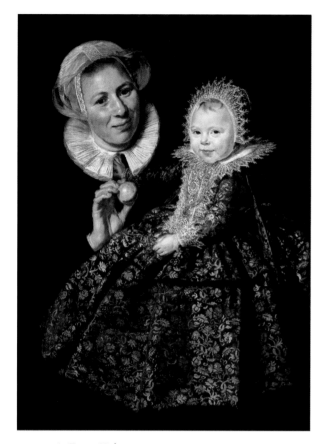

22–41 | Frans Hals **CATHARINA HOOFT AND HER NURSE**
c. 1620. Oil on canvas, 33¾ × 25½" (85.7 × 64.8 cm).
Staatliche Museen zu Berlin, Preussischer Kulturbesitz,
Gemäldegalerie.

In his painting **CATHARINA HOOFT AND HER NURSE** (FIG. 22–41), of about 1620, Hals captured the vitality of a gesture and a fleeting moment in time. While the portrait records for posterity the great pride of the parents in their child, the painting also records their wealth in its study of rich fabrics, laces, and expensive toys (a golden rattle). Hals depicted the heartwarming delight of a child, who seems to be acknowledging the viewer as a loving family member while her doting nurse tries to distract her with an apple.

In contrast to this intimate individual portrait are Hals's official group portraits, such as his **OFFICERS OF THE HAARLEM MILITIA COMPANY OF SAINT ADRIAN** (FIG. 22–42), of about 1627. Less imaginative artists had arranged their sitters in neat rows to depict every face clearly. Instead, Hals's dynamic composition turned the group portrait into a lively social event. The composition is based on a strong underlying geometry of diagonal lines—gestures, banners, and sashes—balanced by the stabilizing perpendiculars of table, window, tall glass, and striped banner. The black suits and hats make the white ruffs and sashes of rose, white, and blue even more brilliant.

The company, made up of several guard units, was charged with the military protection of Haarlem. Officers came from the upper middle class and held their commissions for three years, whereas the ordinary guards were tradespeople and craftworkers. Each company was organized like a guild, under the patronage of a saint. When the men were not on war alert, the company functioned as a fraternal order, holding archery competitions, taking part in city processions, and maintaining an altar in the local church (SEE ALSO FIG. 22–45.)

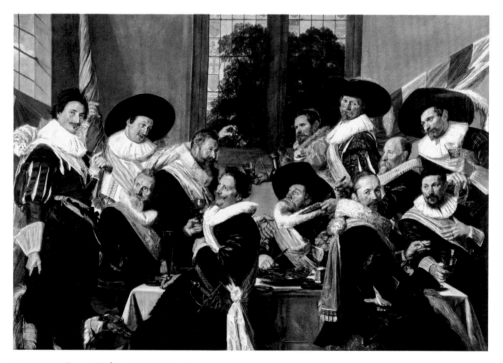

22–42 | Frans Hals **OFFICERS OF THE HAARLEM MILITIA COMPANY OF SAINT ADRIAN**
c. 1627. Oil on canvas, 6' × 8'8" (1.83 × 2.67 m). Frans Halsmuseum, Haarlem.

A painting long praised as one of Hals's finest works was recently discovered to be by Judith Leyster (c. 1609–60), Hals's contemporary. A cleaning uncovered her distinctive signature, the monogram *JL* with a star, which refers to her surname, meaning "pole star." Leyster's work shows clear echoes of her exposure to the Utrecht painters who had enthusiastically adopted Caravaggio's realism, dramatic tenebrist lighting effects, large figures pressed into the foreground plane, and, especially, theatrically presented themes. Since in 1631 Leyster signed as a witness at the baptism in Haarlem of one of Hals's children, it is assumed they were close; she may also have worked in Hals's shop. She entered Haarlem's Guild of Saint Luke in 1633, which allowed her to take pupils into her studio, and her competitive relationship with Frans Hals around that time is made clear by the complaint she lodged against him in 1635 for luring away one of her apprentices.

Leyster is known primarily for her informal scenes of daily life, which often carry an underlying moralistic theme. In her lively **SELF-PORTRAIT** of 1635 (**FIG. 22-43**), the artist has paused momentarily in her work to look back, as if the viewer had just entered the room. Her elegant dress and the fine chair in which she sits are symbols of her success as an artist whose popularity was based on the very type of painting underway on her easel. (One critic has suggested that her subject—a man playing a violin—may be a visual pun on the painter with palette and brush.) Leyster's understanding of light and texture is truly remarkable. The brushwork she used to depict her own flesh and delicate ruff is finer than Hals's technique and forms an interesting contrast to the broad strokes of thick paint used to create her full, stiff skirt. She further emphasized the difference between her portrait and her painting by executing the image on her easel in lighter tones and soft, loose brushwork. The narrow range of colors sensitively dispersed in the composition and the warm spotlighting are typical of Leyster's mature style.

REMBRANDT VAN RIJN. The most important painter working in Amsterdam in the seventeenth century was Rembrandt van Rijn (1606–69). Rembrandt, one of nine children born in Leiden to a miller and his wife, enrolled at the University of Leiden in 1620 at age 14 but chose instead to study painting with a local artist. Later he studied briefly under

22–44 Rembrandt van Rijn **THE ANATOMY LESSON OF DR. NICOLAES TULP**
1632. Oil on canvas, 5′3¾″ × 7′1¼″ (1.6 × 2.1 m). Mauritshuis, The Hague, Netherlands.

Pieter Lastman (1583–1633), the principal painter in Amsterdam at the time. From Lastman, a history painter who had worked in Rome, Rembrandt learned the new styles developed in Rome by Annibale Carracci and Caravaggio: naturalism, drama, and extreme tenebrism. He was back in Leiden by 1626, painting religious and historical scenes as well as fantasy portraits from models likely drawn from his family and acquaintances. Late in 1631 he returned to Amsterdam to work primarily as a portrait painter, although he continued to paint a wide range of narrative themes and landscapes.

In his first group portrait, **THE ANATOMY LESSON OF DR. NICOLAES TULP** (FIG. 22-44) of 1632, Rembrandt combined his scientific and humanistic interests. Frans Hals had activated the group portrait rather than conceiving it as a simple reproduction of figures and faces; Rembrandt transformed it into a dramatic narrative scene. Doctor Tulp, who was head of the surgeons' guild from 1628 to 1653, sits right of center, and the other doctors gather around to observe the cadaver and listen to the famed anatomist. Rembrandt built his composition on a sharp diagonal that pierces space from right to left, uniting the cadaver on the table, the calculated

arrangement of speaker and listeners, and the open book into a climactic event. Rembrandt makes effective use of Caravaggio's tenebrist technique. The figures emerge from a dark and undefined ambience with their faces framed by brilliant white ruffs. Radiant light from an unknown source streams down on the juxtaposed arms and hands, as Dr. Tulp flexes his own left hand to demonstrate the action of the cadaver's arm muscles. Unseen by the viewers are the illustrations of the huge book. It must be an edition of Andreas Vesalius's study of human anatomy, published in Basel in 1543, which was the first attempt at accurate anatomical illustrations in print. Rembrandt's painting has been seen as an homage to Vesalius and to science, as well as a portrait of the members of the Amsterdam surgeons' guild.

Prolific and popular with Amsterdam clientele, Rembrandt ran a busy studio producing works that sold for high prices. The prodigious output of his large workshop and of many followers who imitated his manner has made it difficult for scholars to define his body of work, and many paintings by students and assistants formerly attributed to Rembrandt have recently been assigned to other artists. Rembrandt's

22–45 | Rembrandt van Rijn **CAPTAIN FRANS BANNING COCQ MUSTERING HIS COMPANY (THE NIGHT WATCH)**
1642. Oil on canvas, 11'11″ × 14'4″ (3.63 × 4.37 m). (Cut down from the original size.)
Rijksmuseum, Amsterdam.

mature work reflected his cosmopolitan city environment, his study of science and nature, and the broadening of his artistic vocabulary by the study of Italian Renaissance art, chiefly from engravings and paintings. Thanks to prints imported by the busy Amsterdam art market, he could study such works as Leonardo's *Last Supper* (see Introduction, Fig. 18).

In 1642, Rembrandt was one of several artists commissioned by a wealthy civic-guard company to create large group portraits of its members for its new meeting hall. The result, **CAPTAIN FRANS BANNING COCQ MUSTERING HIS COMPANY (FIG. 22–45)**, carries the idea of the group portrait as drama even further. Because of the dense layer of grime and darkened varnish on it and its dark background architecture, this painting was once thought to be a night scene and was therefore called "The Night Watch." After cleaning and restoration in 1975–76 it now exhibits a natural golden light that sets afire the palette of rich colors—browns, blues, olive green, orange, and red—around a central core of lemon yellow in the costume of a lieutenant. To the dramatic group composition, showing a company forming for a parade in an Amsterdam street, Rembrandt added several colorful but

seemingly unnecessary figures. While the officers stride purposefully forward, the rest of the men and several mischievous children mill about. The radiant young girl in the left middle ground, carrying a chicken and wearing a money pouch, may be a pun on the kind of guns *(klower)* that gave the name (the Kloveniers) to the company. Chicken legs with claws *(klauw* in Dutch) also are part of their coat of arms. She may stand as a kind of symbolic mascot of the militia company.

In his enthusiasm for printmaking as an important art form with its own aesthetic qualities, Rembrandt was remarkably like Albrecht Dürer (SEE FIGS. 21–9, 21–10). He focused on etching, which uses acid to inscribe a design on metal plates. His earliest etchings date from 1627. About a decade later, he began to experiment with making additions to his compositions in the **drypoint** technique, in which the artist uses a sharp needle to scratch shallow lines in a plate. Because etching and drypoint allow the artist to work directly on the plate, the style of the finished print can have the relatively free and spontaneous character of a drawing. Rembrandt's commitment to the full exploitation of the medium is indicated by the fact that in these works he alone

22–46 | Rembrandt van Rijn **THREE CROSSES**
(FIRST STATE)
1653. Drypoint and etching, 15⅛ × 17¾″ (38.5 × 45 cm).
Rijksmuseum, Amsterdam.

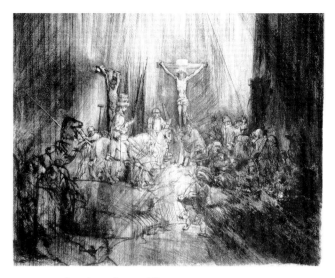

22–47 | Rembrandt van Rijn **THREE CROSSES**
(FOURTH STATE)
1653. Drypoint and etching, 15⅛ × 17¾″ (38.5 × 45 cm).
The Metropolitan Museum of Art, New York.
Gift of Felix M. Warburg and his family, 1941 (41.1.33)

carried the creative process through, from the preparation of the plate to its inking and printing, and he constantly experimented with the technique, with methods of inking, and with papers for printing.

Rembrandt experienced a deep religious faith that was based on his personal study of the Bible. His deep consideration of the meaning of the life of Christ can be studied in a series of prints, **THREE CROSSES,** that comes down to us in five states, or stages, of the creative and printing process. (Only the first and fourth are reproduced here.) Rembrandt tried to capture the moment described in the Gospels when, during the Crucifixion, darkness covered the Earth and Jesus cried out, "Father, into thy hands I commend my spirit." In the first state **(FIG. 22–46),** the centurion kneels in front of the cross while other terrified people run from the scene. The Virgin Mary and John share the light flooding down from heaven. By the fourth state **(FIG. 22–47),** Rembrandt has completely reworked and reinterpreted the theme. In each version, the shattered hill of Golgotha dominates the foreground, but now a mass of vertical lines, echoing the rigid body of Jesus, fills the space, obliterates the shower of light, and virtually eliminates the former image, including even Mary and Jesus's friends. The horseman holding a lance now faces Jesus. Compared with the first state, the composition is more compact, the individual elements are simplified, and the emotions are intensified. The first state is a detailed rendering of the scene in realistic terms; the fourth state, a reduction of the event to its essence. The composition revolves in an oval of half-light around the base of the cross, and the viewer's attention is drawn to the figures of Jesus and the people, in mute confrontation. In *Three Crosses,* Rembrandt defined the mystery of Christianity in Jesus's sacrifice, presented in realistic terms but as something beyond rational

explanation. In Rembrandt's late works, realism relates to the spirit of inner meaning, not of surface details. The eternal battles of dark and light, doom and salvation, evil and good—all seem to be waged anew.

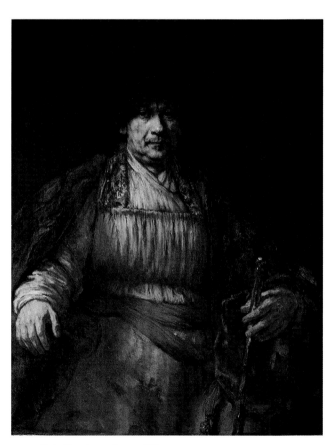

22–48 | Rembrandt van Rijn **SELF-PORTRAIT**
1658. Oil on canvas, 52⅝ × 40⅞″ (133.6 × 103.8 cm).
The Frick Collection, New York.

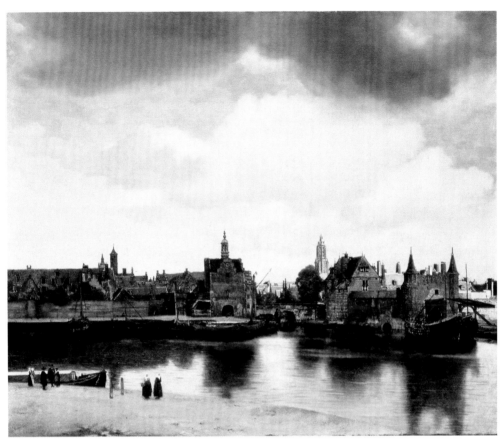

22–49 | Jan Vermeer **VIEW OF DELFT**
c. 1662. Oil on canvas, 38½ × 46¼" (97.8 × 117.5 cm). Mauritshuis, The Hague.
The Johan Maurits van Nassau Foundation.

As he aged Rembrandt painted ever more brilliantly, varying textures and paint from the thinnest glazes to thick impasto, creating a rich luminous chiaroscuro, ranging from deepest shadow to brilliant highlights in a dazzling display of gold, red, and chestnut brown. His sensitivity to the human condition is perhaps nowhere more powerfully expressed than in his late self-portraits which became more searching as the artist aged. Distilling a lifetime of study and contemplation, he expressed an internalized spirituality new in the history of art. In this **SELF-PORTRAIT** of 1658 (FIG 22-48), the artist assumes a regal pose, at ease with arms and legs spread and holding a staff as if it were a baton of command. Yet his face and eyes seem weary, and we know that fortune no longer smiled on him (he had to declare bankruptcy that same year). A few well-placed brush strokes suggest the physical tension in the fingers and the weariness of the deep-set eyes. Mercilessly analytical, the portrait depicts the furrowed brow, sagging flesh, and prematurely aged face of one who has suffered deeply but still retains his dignity.

JAN (JOHANNES) VERMEER. One of the most intriguing Dutch artists of this period is Jan (Johannes) Vermeer (1632–75), who was also an innkeeper and art dealer. He entered the Delft artists' guild in 1653 and painted only for local patrons. Meticulous in his technique, with a unique compositional approach and painting style, Vermeer produced fewer than forty canvases that can be securely attributed to him; and the more these paintings are studied, the more questions arise about the artist's life and his methods. Vermeer's **VIEW OF DELFT** (FIG. 22–49), for example, is no simple cityscape. Although the artist convinces the viewer of its authenticity, he does not paint a photographic reproduction of the scene; Vermeer moves buildings around to create an ideal composition. He endows the city with a timeless stability by a stress on horizontal lines, the careful placement of buildings, the quiet atmosphere, and the clear, even light that seems to emerge from beneath low-lying clouds. Vermeer may have experimented with the mechanical device known as the camera obscura (see Chapter 30), not as a method of reproducing the image but as another tool in the visual analysis of the landscape. The camera obscura would have enhanced optical distortions that led to the "beading" of highlights (seen here on the harbored ships and dark gray architecture), which creates the illusion of brilliant light but does not dissolve the underlying form.

Vermeer seemed to favor enigmatic scenes of women in their homes, alone or with a servant, who are occupied with

some cultivated activity, such as writing, reading letters, or playing a musical instrument. Most of his accepted works are of a similar type—quiet interior scenes, low-key in color, and asymmetrical but strongly geometric in organization. Vermeer achieved his effects through a consistent architectonic construction of space in which every object adds to the clarity and balance of the composition. An even light from a window often gives solidity to the figures and objects in a room.

All emotion is subdued, as Vermeer evokes the stillness of meditation. Even the brushwork is so controlled that it becomes invisible, except when he paints reflected light as tiny droplets of color.

In **WOMAN HOLDING A BALANCE** (FIG. 22–50), perfect equilibrium creates a monumental composition and a moment of supreme stillness. The woman contemplates the balance and so calls our attention to the act of weighing and

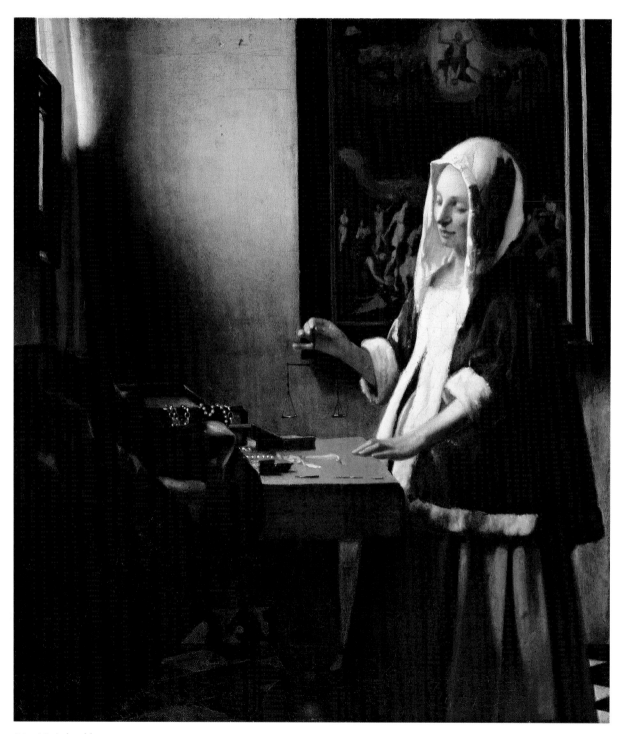

22–50 | Jan Vermeer **WOMAN HOLDING A BALANCE**
c. 1664. Oil on canvas, 15⅞ × 14″ (39 × 35 cm). National Gallery of Art, Washington, D.C.
Widener Collection (1942.9.97)

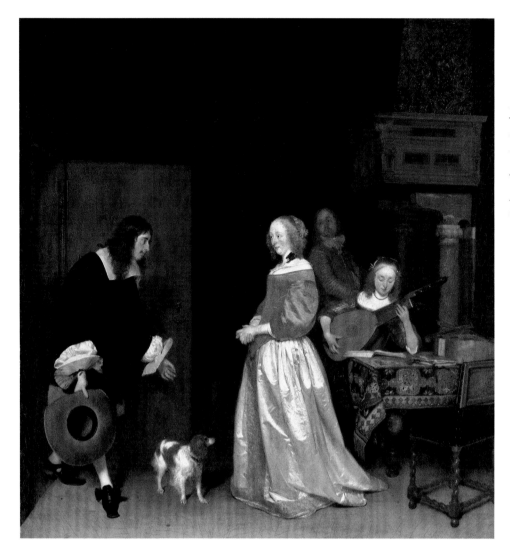

22–51 | Gerard ter Borch
THE SUITOR'S VISIT
c. 1658. Oil on canvas,
32½ × 29⅝" (82.6 × 75.3 cm).
National Gallery of Art,
Washington, D.C.

Andrew W. Mellon Collection
(1937.1.58).

judging. Her hand and the scale are central, but directly over her head, on the wall of the room, an image of Christ in a gold aureole appears in a large painting of the Last Judgment. Thus, Vermeer's painting becomes a metaphor for eternal judgment. The woman's moment of quiet introspection before she touches the gold or pearls, shimmering with the reflected light from the window, also recalls the *vanitas* theme of the transience of life, allowing the painter to comment on the ephemeral quality of material things.

LIFE IN THE CITY, GENRE SCENES. Continuing a long Netherlandish tradition, genre paintings of the Baroque period—generally painted for private patrons and depicting scenes of contemporary daily life—were often laden with symbolic references, although their meaning is not always clear. A clean house might indicate a virtuous housewife and mother while a messy household suggested laziness and the sin of sloth. Ladies dressing in front of mirrors certainly could be succumbing to vanity, and drinking parties led to overindulgence and lust.

One of the most refined of the genre painters was Gerard ter Borch (1617–81). In his painting traditionally known as **THE SUITOR'S VISIT** (FIG. 22–51), from about 1658, a well-dressed man bows gracefully to an elegant woman arrayed in white satin, who stands in a sumptuously furnished room in which another woman plays a lute. Another man, in front of a fireplace, turns to observe the newcomer. The painting appears to represent a prosperous gentleman paying a call on a lady of equal social status, possibly a courtship scene. The dog in the painting and the musician seem to be simply part of the scene, but we are already familiar with the dog as a symbol of fidelity, and stringed instruments were said to symbolize, through their tuning, the harmony of souls and thus, possibly, a loving relationship. On the other hand, it has been suggested that the theme is not so innocent: that the gestures here suggest a liaison. The dog could be interpreted sexually, as sniffing around, and the music making could be associated with sensory pleasure. Ter Borch was renowned for his exquisite rendition of lace, velvet, and especially satin, and such wealth could be seen as a symbol of excess. One critic has

even suggested that the white satin is a metaphor for the women's skin. If there is a moral lesson, it is presented discreetly and ambiguously.

Another important genre painter is Jan Steen (1626–79), whose larger brushstrokes contrast with the meticulous treatment of ter Borch. Steen painted over 800 (mostly undated) works but never achieved financial success. Most of his scenes used everyday life to portray moral tales, illustrate proverbs and folk sayings, or make puns to amuse the spectator. Steen moved about the country for most of his life, and from 1670 until his death he kept a tavern in Leiden. He probably found inspiration and models all about him. Early in his career Steen was influenced by Frans Hals, and his work, in turn, influenced a **school,** or circle of artists working in a related style, of Dutch artists who emulated his ever-changing style and subjects. Steen could be very summary or extremely detailed in his treatment of forms. His paintings of often riotous and disorderly interiors gave rise to the saying "a Jan Steen household."

Jan Steen's paintings of children are especially remarkable, for he captured not only their childish physiques but also their fleeting moods and expressions with rapid and fluid brushstrokes. His ability to capture such transitory dispositions was well expressed in his painting **THE DRAWING LESSON** (Introduction, Fig. 17). Here, youthful apprentices—a boy and a well-dressed young woman—observe the master artist correct an example of drawing, a skill widely believed to be the foundation of art. The studio is cluttered with all the supplies the artists need. On the floor at the lower right, objects such as a lute, wine jug, book, and skull also remind the viewer of the transitory nature of life in spite of the permanence art may seem to offer.

Emanuel de Witte (1617–92) of Rotterdam specialized in architectural interiors, first in Delft in 1640 and then in Amsterdam after settling there permanently in 1652. Although many of his interiors were composites of features from several locations combined in one idealized architectural view, de Witte also painted faithful "portraits" of actual buildings. One of these is his **PORTUGUESE SYNAGOGUE, AMSTERDAM** (FIG. 22–52), of 1680. The synagogue, which still stands and is one of the most impressive buildings in Amsterdam, is shown here as a rectangular hall divided into one wide central aisle with narrow side aisles, each covered with a wooden barrel vault resting on lintels supported by columns. De Witte's shift of the viewpoint slightly to one side has created an interesting spatial composition, and strong contrasts of light and shade add dramatic movement to the simple interior. The caped figure in the foreground and the dogs provide a sense of scale for the architecture and add human interest.

Today, the painting is interesting both as a record of seventeenth-century synagogue architecture and as evidence of Dutch religious tolerance in an age when Jews were often persecuted. Ousted from Spain and Portugal in the late fifteenth and early sixteenth centuries, many Jews had settled first in

22–52 | Emanuel de Witte **PORTUGUESE SYNAGOGUE, AMSTERDAM**
1680. Oil on canvas, 43½ × 39″ (110.5 × 99.1 cm). Rijksmuseum, Amsterdam. Architect Daniel Stalpaert built the synagogue in 1670-75.

Flanders and then in the Netherlands. The Jews in Amsterdam enjoyed religious and personal freedom, and their synagogue was considered one of the outstanding sights of the city.

LANDSCAPE. The Dutch loved the landscapes and vast skies of their own country, but those who painted them were not slaves to nature as they found it: The concept was foreign to this time period. The artists constructed and refined their work in the confines of their studio and were never afraid to remake a scene by rearranging, adding, or subtracting to give their compositions formal organization or a desired mood. Starting in the 1620s, view painters generally adhered to a convention in which little color was used beyond browns, grays, and beiges. After 1650, they tended to be more individualistic in their styles, but nearly all brought a broader range of colors into play. One continuing motif was the emphasis on cloud-filled expanses of sky dominating a relatively narrow horizontal band of earth below. Painters specialized in the sea, the countryside, the city, and its buildings. Paintings of architectural interiors also became popular and seem to have been painted for their own beauty, just as exterior views of the land, cities, and harbors were.

The Haarlem landscape specialist Jacob van Ruisdael (1628/29–82), whose popularity drew many pupils to his workshop, was especially adept at both the invention of

22–53 Jacob van Ruisdael
THE JEWISH CEMETERY
1655–60. Oil on canvas,
4′ 6″ × 6′2½″ (1.42 × 1.89 m).
The Detroit Institute of Arts.
Gift of Julius H. Haass in memory of
his brother Dr. Ernest W. Haass (24.3)

dramatic compositions and the projection of moods in his canvases. His **JEWISH CEMETERY** (FIG. 22–53), of 1655–60, is a thought-provoking view of silent tombs, crumbling ruins, and stormy landscape, with a rainbow set against dark, scudding clouds. Ruisdael was greatly concerned with spiritual meanings of the landscape, which he expressed in his choice of such environmental factors as the time of day, the weather, the appearance of the sky, or the abstract patterning of sun and shade. The barren tree points its branches at the tombs. Here the tombs, ruins, and fallen and blasted trees suggest an allegory of transience. The melancholy mood is mitigated by the rainbow, a traditional symbol of renewal and hope.

STILL LIFES AND FLOWER PIECES. The Dutch were so proud of their artists' still-life paintings that they presented one (a flower piece by Rachel Ruysch) to the French queen Marie de' Medici when she made a state visit to Amsterdam. A still-life painting might carry moralizing connotations and commonly had a *vanitas* theme, reminding viewers of the transience of life, material possessions, and even art.

One of the first Dutch still-life painters was Pieter Claesz (1596/97–1660) of Haarlem, who, like the Antwerp artist Clara Peeters, painted "breakfast pieces," that is, a meal of bread, fruits, and nuts. In subtle, nearly monochromatic paintings, such as **STILL LIFE WITH A WATCH** (FIG. 22–54), Claesz seems to give life to inanimate objects. He organizes dishes in diagonal positions to give a strong sense of space, and he gives the maximum contrast of textures within a color scheme of white, grays, and browns. The brilliant yellow lemon provides visual excitement with its rough curling peel, juicy flesh, and soft pulpy inner skin. The tilted silver tazza contrasts with the half-filled glass that becomes a towering monumental presence and permits Claesz to display his skill at transparencies

22–54 Pieter Claesz **STILL LIFE WITH A WATCH**
1636. Oil on panel, Royal Picture Gallery, Maurithuis, The Hague.

The heavy round glass is a Roemer, an inexpensive, everyday item, as are the pewter plates. The gilt cup (tazza) was a typical ornamental piece. Painters owned and shared such valuable props, and this and other show pieces appear in many paintings.

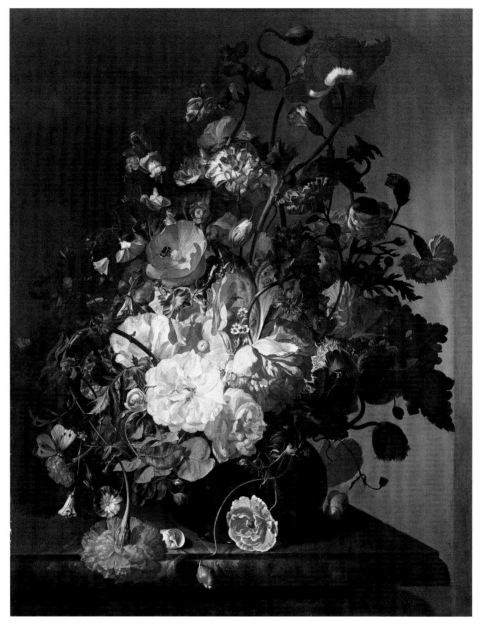

22–55 | Rachel Ruysch **FLOWER STILL LIFE**
After 1700. Oil on canvas, 30 × 24″ (76.2 × 61 cm). The Toledo Museum of Art, Ohio.
Purchased with funds from the Libbey Endowment. Gift of Edward Drummond Libbey (1956.57)

and reflections. No longer are inanimate objects represented for their symbolic value as in fifteenth-century Flemish painting, yet meaning is not entirely lost, for such paintings suggest the prosperity of Claesz's patrons. The food might be simple, but the lemon is a luxury imported from Mediterranean lands, and the silver ornamental cup graced the tables of only the wealthy. Finally, the meticulously painted timepiece suggests a deeper meaning—perhaps human achievement in science and technology, or perhaps it also becomes a *vanitas* symbol of the inexorable passage of time and the fleet-

ing life of human beings, thoughts also suggested by the interrupted breakfast.

Still-life paintings in which cut-flower arrangements predominate are referred to simply as "flower pieces." Significant advances were made in botany during the seventeenth century through the application of orderly scientific methods and objective observation (see "Science and the Changing Worldview," page 746). The Dutch were major growers and exporters of flowers, especially tulips, which appear in nearly every flower piece in dozens of exquisite

variations. The Dutch tradition of flower painting peaked in the long career of Rachel Ruysch (1664–1750) of Amsterdam. Her flower pieces were highly prized for their sensitive, free-form arrangements and their unusual and beautiful color harmonies. During her seventy-year career, she became one of the most sought-after and highest-paid still-life painters in Europe—her paintings brought twice what Rembrandt's did.

In her **FLOWER STILL LIFE** (FIG. 22–55), painted after 1700, Ruysch placed the container at the center of the canvas's width, then created an asymmetrical floral arrangement of pale oranges, pinks, and yellows rising from lower left to top right of the picture, offset by the strong diagonal of the tabletop. To further balance the painting, she placed highlighted blossoms and leaves against the dark left half of the canvas and silhouetted them against the light wall area on the right. Ruysch often emphasized the beauty of curving flower stems and enlivened her compositions with interesting additions, such as casually placed pieces of fruit or insects, in this case a large gray moth (lower left) and two snail shells.

Flower painting, a much-admired specialty in the seventeenth- and eighteenth-century Netherlands, was almost never a straightforward depiction of actual fresh flowers. Instead, artists made color sketches of fresh examples of each type of flower and studied scientifically accurate color illustrations in botanical publications. Using their sketches and notebooks, in the studio they would compose bouquets of perfect specimens of a variety of flowers that could never be found blooming at the same time. The short life of blooming flowers was a poignant reminder of the fleeting nature of beauty and of human life.

FRANCE

The early seventeenth century in France was marked by almost continuous foreign and civil wars. The assassination of King Henri IV in 1610 left France in the hands of the queen, Marie de' Medici (regency 1610–17; SEE FIG. 22–36), as regent for her 9-year-old son, Louis XIII (ruled 1610–43). When Louis came of age, the brilliant and unscrupulous Cardinal Richelieu became chief minister and set about increasing the power of the Crown at the expense of the French nobility. The death of Louis XIII again left France with a child king, the five-year-old Louis XIV (ruled 1643–1715). His mother, Anne of Austria, became regent, with the assistance of another powerful minister, Cardinal Mazarin. At Mazarin's death in 1661, Louis XIV (SEE FIG. 22–1) began his long personal reign, assisted by yet another able minister, Jean-Baptiste Colbert.

An absolute monarch whose reign was the longest in European history, Louis XIV expanded royal art patronage, making the French court the envy of every ruler in Europe. The arts, like everything else, came under royal control. In 1635, Cardinal Richelieu had founded the French Royal Academy, directing the members to compile a definitive dictionary and grammar of the French language. In 1648, the Royal Academy of Painting and Sculpture was founded, which, as reorganized by Colbert in 1663, maintained strict control over the arts (see "Grading the Old Masters," page 799). Although it was not the first European arts academy, none before it had exerted such dictatorial authority—an authority that lasted in France until the late nineteenth century. Membership in the academy assured an artist of royal and civic commissions and financial success, but many talented artists did well outside it.

Architecture and Its Decoration at Versailles

French architecture developed along classical lines in the second half of the seventeenth century under the influence of François Mansart (1598–1666) and Louis Le Vau (1612–70). When the Royal Academy of Architecture was founded in 1671, its members developed guidelines for architectural design based on the belief that mathematics was the true basis of beauty. Their chief sources for ideal models were the books of Vitruvius and Palladio (see Chapter 20).

In 1668, Louis XIV began to enlarge the small château built by Louis XIII at Versailles, not far from Paris. Louis moved to the palace in 1682 and eventually required his court to live in Versailles; 5,000 aristocrats lived in the palace itself, together with 14,000 servants and military staff members. The town had another 30,000 residents, most of whom were employed by the palace. The designers of the palace and park complex at Versailles (FIG. 22–56) were Le Vau, Charles Le Brun (1619–90), who oversaw the interior decoration, and André Le Nôtre (1613–1700), who planned the gardens (see "French Baroque Garden Design," page 796). For both political and sentimental reasons, the old Versailles château was left standing, and the new building went up around it. This project consisted of two phases: the first additions by Le Vau, begun in 1668; and an enlargement completed after Le Vau's death by his successor, Jules Hardouin-Mansart (1646–1708), from 1670 to 1685.

Hardouin-Mansart was responsible for the addition of the long lateral wings and the renovation of Le Vau's central block on the garden side to match these wings (FIG. 22–57). The three-story elevation has a lightly rusticated ground floor, a main floor lined with enormous arched windows separated by Ionic pilasters, an attic level whose rectangular windows are also flanked by pilasters, and a flat, terraced roof. The overall design is a sensitive balance of horizontals and verticals relieved by a restrained overlay of regularly spaced projecting blocks with open, colonnaded porches.

In his renovation of Le Vau's center-block façade, Hardouin-Mansart enclosed the previously open gallery on the main level, creating the famed **HALL OF MIRRORS** (FIG. 22–58), which is about 240 feet (73 meters) long and

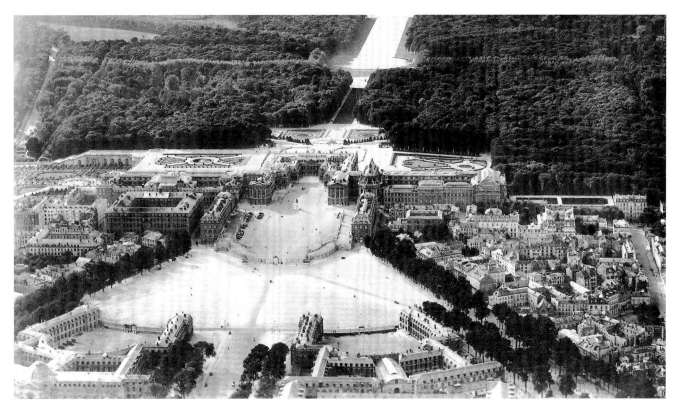

22–56 | Louis Le Vau and Jules Hardouin-Mansart **PALAIS DE VERSAILLES, VERSAILLES**
France. 1668–85. Gardens by André Le Nôtre.

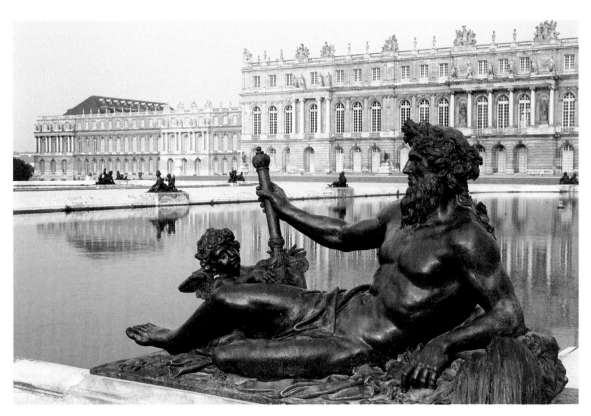

22–57 | **CENTRAL BLOCK OF THE GARDEN FAÇADE, PALAIS DE VERSAILLES**

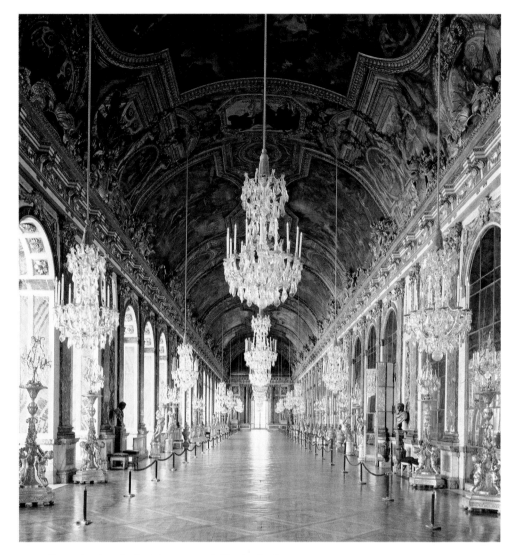

22–58 Jules Hardouin-Mansart and Charles Le Brun **HALL OF MIRRORS, PALAIS DE VER-SAILLES**
Begun 1678. Length approx. 240′ (73 cm).

In the seventeenth century, mirrors and clear window glass were enormously expensive. To furnish the Hall of Mirrors, hundreds of glass panels of manageable size had to be assembled into the proper shape and attached to one another with glazing bars, which became part of the decorative pattern of the vast room.

47 feet (13 meters) high. He achieved architectural symmetry and extraordinary effects by lining the interior wall opposite the windows with Venetian glass mirrors the same size and shape as the arched windows. (Mirrors were tiny and extremely expensive in the seventeenth century, and these huge walls of glass were created by fitting eighteen-inch panels together.) The mirrors reflect the natural light from the windows and give the impression of an even larger space; at night, the reflections of flickering candles must have turned the mirrored gallery into a veritable painting in which the king and courtiers saw themselves as they promenaded. Inspired by Carracci's Farnese ceiling (SEE FIG. 22–13), Le Brun decorated the vaulted ceiling with paintings (on canvas, which is more stable in the damp northern climate) glorify-

ing the reign of Louis XIV and Louis's military triumphs, assisted by the classical gods. In 1642, he had studied in Italy, where he came under the influence of the classical style of his compatriot Nicolas Poussin (discussed later in this chapter). As "First Painter to the King" and director of the Royal Academy, Le Brun controlled art education and patronage from 1661/63 until his death in 1690. He tempered the more exuberant Baroque ceilings he had seen in Rome with Poussin's classicism to produce spectacular decorations for the king. The underlying theme for the design and decoration of the palace was the glorification of the king as Apollo the Sun God, with whom Louis identified. Louis XIV thought of the duties of kingship, including its pageantry, as a solemn performance, so it is most appropriate that Rigaud's portrait

Elements of Architecture
FRENCH BAROQUE GARDEN DESIGN

Wealthy landowners commissioned garden designers to transform their large properties into gardens extending over many acres. The challenge for garden designers was to unify diverse elements—buildings, pools, monuments, plantings, natural land formations—into a coherent whole. At Versailles, André Le Nôtre imposed order upon the vast expanses of palace gardens and park by using broad, straight avenues radiating from a series of round focal points. He succeeded so thoroughly that his plan inspired generations of urban designers as well as landscape architects.

In Le Nôtre's hands, the palace terrain became an extraordinary work of art and a visual delight for its inhabitants. Neatly contained stretches of lawn and broad, straight vistas seemed to stretch to the horizon, while the formal gardens became an exercise in precise geometry. The Versailles gardens are classically harmonious in their symmetrical, geometric design but Baroque in their vast size and extension into the surrounding countryside, where the gardens thickened into woods cut by straight avenues.

The most formal gardens lay nearest the palace, and plantings became progressively less elaborate and larger in scale as the distance from the palace increased. Broad, intersecting paths separated reflecting pools and planting beds, which are called embroidered **parterres** for their colorful patterns of flowers outlined with trimmed hedges. After the formal zone of parterres came lawns, large fountains on terraces, and trees planted in thickets to conceal features such as an open-air ballroom and a colonnade. Statues carved by at least seventy sculptors also adorned the park. A mile-long canal, crossed by a sec-

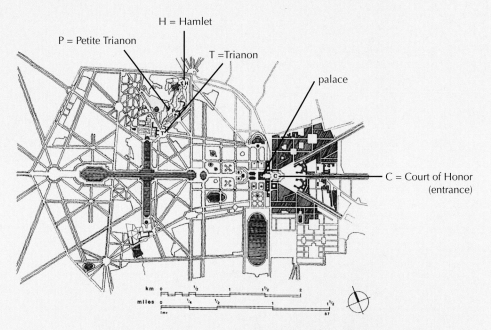

Louis Le Vau and André Le Nôtre **PLAN OF THE PALAIS DE VERSAILLES**
Versailles, France. c. 1661–1785. Drawing by Leland M. Roth after Delagrive's engraving of 1746.

ond canal nearly as large, marked the main axis of the garden. Fourteen waterwheels brought the water from the river to supply the canals and the park's 1,400 fountains. Only the fountains near the palace played all day; the others were turned on only when the king approached.

At the north of the secondary canal, a smaller pavilion-palace, the Trianon, was built in 1669. To satisfy the king's love of flowers year-round, the gardens of the Trianon were bedded out with blooming plants from the south, shipped in by the French navy. Even in midwinter, the king and his guests could stroll through a summer garden. The head gardener is said to have had nearly 2 million flowerpots at his disposal. In the eighteenth century, Louis XV added greenhouses and a botanical garden. The facilities of the fruit and vegetable garden that supplied the palace in 1677–83 today house the National School of Horticulture.

presents him on a raised, stagelike platform, with a theatrical curtain (SEE FIG. 22–1). Versailles was the splendid stage on which the king played this grandiose drama.

In the seventeenth century, French taste in sculpture tended to favor classicizing works inspired by antiquity and the Italian Renaissance. A highly favored sculptor in this classical style, François Girardon (1628–1715) had studied the monuments of classical antiquity in Rome in the 1640s.

He had worked with Le Vau and Le Brun before he began working to decorate Versailles. In keeping with the repeated identification of Louis XIV with Apollo, Girardon created the sculpture group **APOLLO ATTENDED BY THE NYMPHS OF THETIS** (FIG. 22–59), executed about 1666–75, for the central niche of the so-called Grotto of Thetis—a formal, triple-arched pavilion named after a sea nymph beloved by the Sun God. In Girardon's circular grouping, Apollo, after

his long journey across the heavens, is attended by the graceful nymphs of Thetis. As in classical or Renaissance sculpture, the composition is best understood from a fixed viewpoint. The original setting was destroyed in 1684, and in 1776, Louis XVI had the painter Hubert Robert design a "natural" rocky cavern for Girardon's sculpture.

Painting

The lingering Mannerism of the sixteenth century in France gave way as early as the 1620s to Baroque classicism and Caravaggism—the use of strong chiaroscuro (tenebrism) and raking light—and the placement of large-scale figures in the foreground. Later in the century, under the control of the academy and inspired by studies of the classics and the surviving antiquities in Rome, French painting was dominated by the classical influences propounded by Le Brun.

THE INFLUENCE OF CARAVAGGIO. One of Caravaggio's most important followers in France, Georges de La Tour (1593–1652) received major royal and ducal commissions and became court painter to Louis XIII in 1639. La Tour may have traveled to Italy in 1614–16, and in the 1620s he almost certainly visited the Netherlands, where Caravaggio's style was being enthusiastically emulated. Like Caravaggio, La Tour filled the foreground of his canvases with monumental figures, but in place of Caravaggio's detailed naturalism he used a simplified setting and a light source within the picture so intense that it often seems to be his real subject. La Tour painted Mary Magdalen many times. In **MARY MAGDALEN WITH THE SMOKING FLAME** (FIG. 22–60), as in many of his paintings, the light emanates from a candle. The hand and skull, symbols of mortality, act as devices to establish a foreground plane, and the compression of the figure within the pictorial space lends a sense of intimacy. The light is the unifying element of the painting and conveys the somber mood. Mary Magdalen has put aside her rich clothing and jewels and meditates on the frailty and vanity of human life. She sighs, and the candle flickers.

Something of this same feeling of timelessness pervades the paintings of the Le Nain brothers, Antoine (c. 1588–1648), Louis (c. 1593–1648), and Mathieu (1607–1677). Although the brothers were working in Paris by about 1630, little else is known about their lives and careers. Because they collaborated closely with each other, art historians have only recently begun to distinguish their individual styles. They painted genre scenes imbued with a strange sense of foreboding and enigmatic meaning. **THE VILLAGE PIPER** (FIG. 22–61) of 1642, by Antoine Le Nain, is typical of the brothers' work. Peasant children gather around the figure of a flute player. The simple homespun garments and undefined setting turn the painting into a study in neutral colors and rough textures, with soft young

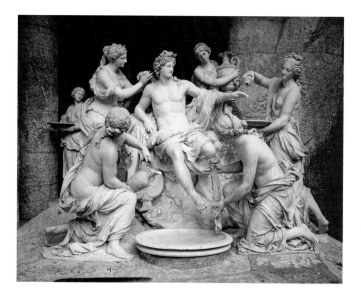

22–59 François Girardon **APOLLO ATTENDED BY THE NYMPHS OF THETIS**
From the Grotto of Thetis, Palais de Versailles, Versailles, France. c. 1666-75. Marble, life-size. Grotto by Hubert Robert in 1776; sculpture reinstalled in a different configuration in 1778.

faces that contrast with the old man, who seems lost in his simple music. Why the brothers chose to paint these peasants and who bought the paintings are questions still not resolved.

THE CLASSICAL LANDSCAPE: POUSSIN AND CLAUDE LORRAIN. The painters Nicolas Poussin (1594–1665) and Claude Gellée (called "Claude Lorrain" or simply "Claude," 1600–82) pursued their careers in Italy although they usually worked for French patrons. They perfected the ideal "classical" landscape and profoundly influenced painters for the next two centuries. Poussin and Claude were classicists in that they organized natural elements and figures into idealized compositions. Both were influenced by Annibale Carracci and to some extent by Venetian painting, yet each evolved an unmistakable personal style that conveyed an entirely different mood from that of their sources and from each other.

Nicolas Poussin, born in Normandy, settled in Paris, where his career as a painter was unremarkable. Determined to go to Rome, he finally arrived there in 1624. The Barberini became his foremost patrons, and Bernini considered Poussin to be one of the greatest painters in Rome. Poussin's landscapes with figures are the epitome of the orderly, arranged, classical landscape. In his **LANDSCAPE WITH SAINT JOHN ON PATMOS** (FIG. 22–62), from 1640, Poussin created a consistent perspective progression from the picture plane back into the distance through a clearly defined foreground, middle ground, and background. These zones are

22–60 | Georges de La Tour **MARY MAGDALEN WITH THE SMOKING FLAME**
c. 1640. Oil on canvas, 46¼ × 36⅛″ (117 × 91.8 cm). Los Angeles County Museum of Art.
Gift of the Ahmanson Foundation (M. 77.73)

marked by alternating sunlight and shade, as well as by architectural elements. Surrounded by the huge, tumbled ruins of ancient Rome—and by extension all earthly empires—Saint John writes the Book of Revelation, describing the end of the world, the Last Judgment, and the Second Coming of Christ: a renewal of life suggested by the flourishing vegetation. This grand theme is represented in the highly intellectualized format of Poussin's classical composition. In the middle distance are a ruined temple and an obelisk, and the round building in the distant city is Hadrian's Tomb, which Poussin knew from Rome. Precisely placed trees, hills, mountains, water, and even clouds take on a solidity of form that seems almost as structural as architecture. The reclining evangelist and the eagle, his symbol, seem immobile—locked into this perfect landscape. The triumph of the rational mind takes on moral overtones. The subject of Poussin's painting is not the story of John the Evangelist but rather the balance and order of nature.

In the second half of the seventeenth century, the French Academy took Poussin's paintings and notes on

Defining Art
GRADING THE OLD MASTERS

The members of the French Royal Academy of Painting and Sculpture considered ancient classical art to be the standard by which contemporary art should be judged. By the 1680s, however, younger artists of the academy began to argue that modern art might equal and even surpass the art of the ancients—a radical thought that sparked controversy.

A debate arose over the relative merits of drawing and color in painting. The conservatives argued that drawing was superior to color because drawing appealed to the mind while color appealed to the senses. They saw Nicolas Poussin as embodying perfectly the classical principles of subject and design. But the young artists who admired the vivid colors of Titian, Veronese, and Rubens claimed that painting should deceive the eye, and since color achieves this deception more convincingly than drawing, application of color should be valued over drawing. Adherents to the two positions were called *poussinistes* (in honor of Poussin) and *rubénistes* (for Rubens).

The portrait painter and critic Roger de Piles (1635-1709) took up the cause of the *rubénistes* in a series of pamphlets. In *The Principles of Painting*, Piles evaluated the most important painters on a scale of 0 to 20 in four categories. He gave no score higher than 72 (18 in each category), since no mortal artist could achieve perfection. Caravaggio received the lowest grade, a 0 in expression and 6 in drawing for a low of 28, while Michelangelo and Leonardo both got a 4 in color and Rembrandt a 6 in drawing.

Most of the painters we have studied don't do very well. Raphael and Rubens get 65 points, Van Dyck comes close with 55. Poussin and Titian earn 53 and 51, while Rembrandt slips by with 50. Leonardo da Vinci gets 49, and Michelangelo and Dürer with 37 and Caravaggio with 28 all are resounding failures in Piles's view.

22–61 | Antoine Le Nain **THE VILLAGE PIPER**
1642. Oil on copper, 8¾ × 11½" (21.3 × 29.2 cm). Detroit Institute of Arts.

painting as a final authority. From then on, whether as a model to be followed or one to be reacted against, Poussin influenced French art.

When Claude Lorrain went to Rome in 1613, he first studied with Agostino Tassi, an assistant of Guercino and a specialist in architectural painting. Claude, however, preferred landscape. He sketched outdoors for days at a time, then returned to his studio to compose his paintings. Claude was fascinated with light, and his works are often studies of the effect of the rising or setting sun on colors and the atmosphere. A favorite and much imitated device was to place one or two large objects in the foreground—a tree, building, or hill—past which the viewer's eye enters the scene and proceeds, often by zigzag paths, into the distance.

Claude used this compositional device to great effect in paintings such as **EMBARKATION OF THE QUEEN OF SHEBA** (FIG. 22–63). Instead of balanced, symmetrically placed elements, Claude leads the viewer into the painting in a zigzag fashion. A ruined building with Corinthian cornice and columns frames the composition at the left; light catching the seashore leads the eye to the right, where a handsome palace with a grand double staircase and garden with trees establishes a middle ground. Across the water the sails and rigging of ships provide extra visual interest. More distant still are the harbor fortification with town and lighthouse and finally the breakwater (at the left). On the horizon the sun illuminates the clouds in a clearing sky and catches the waves to make a glowing sea path to shore. The small figures—workers and onlookers in the foreground, the queen and her courtiers waiting on the quay and about to board—seem incidental, added to give the painting a subject. Claude's meticulous one-point perspective focuses on the sun with the same driving force with which earlier painters focused on Christ and the saints.

HYACINTHE RIGAUD. Hyacinthe Rigaud (1659–1743), trained by his painter father, won the Royal Academy's prestigious Prix de Rome in 1682, which would have paid his expenses for study at the Academy's villa in Rome. Rigaud rejected the prize, however, and opened his own Paris studio. After painting a portrait of Louis XIV's brother in 1688, he became a favorite of the king himself. His representation of the monarch (SEE FIG. 22–1) reveals a more extravagant style than the restrained classicism of Le Brun. In fact, Louis favored a more theatrical presentation for himself and his court, and Rigaud's representation of the Sun King embodies official portraiture as the height of royal propaganda.

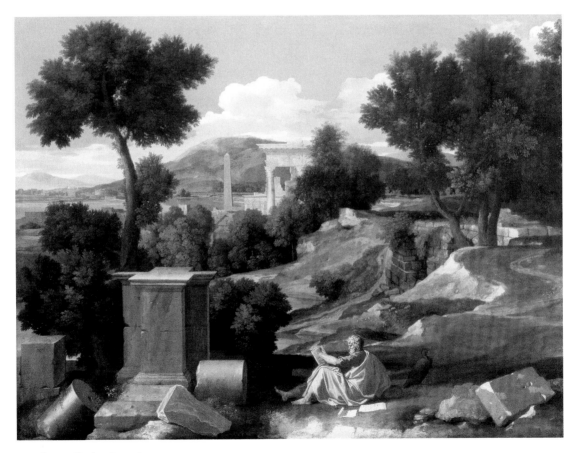

22–62 | Nicolas Poussin **LANDSCAPE WITH SAINT JOHN ON PATMOS**
1640. Oil on canvas, 40 × 53½″ (101.8 × 136.3 cm). The Art Institute of Chicago.
A. A. Munger Collection, 1930.500

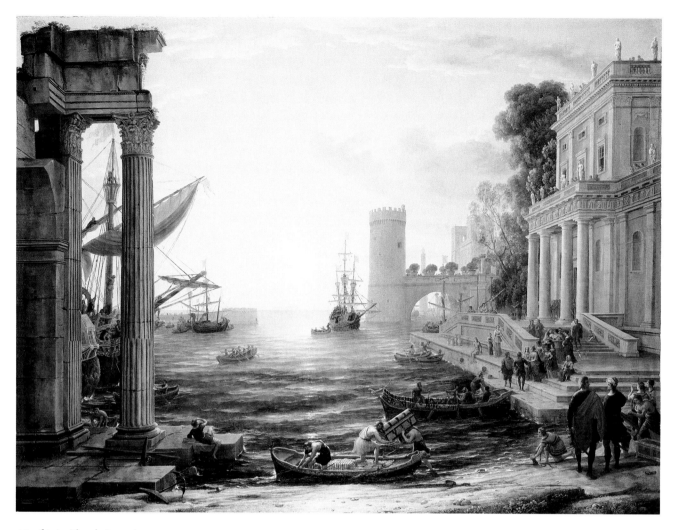

22–63 | Claude Lorrain **EMBARKATION OF THE QUEEN OF SHEBA**
1648. Oil on canvas, 4' 10" × 6' 4" (1.48 × 1.93 m). National Gallery, London.

ENGLAND

England and Scotland were joined in 1603 with the ascent to the English throne of James VI of Scotland, who reigned over Great Britain as James I (ruled 1603–25). James increased royal patronage of British artists, especially in literature and architecture. William Shakespeare wrote *Macbeth,* featuring the king's legendary ancestor Banquo, in tribute to the new royal family, and the play was performed at court in December 1606.

Although James's son Charles I was an important collector and patron of painting, religious and political tensions that erupted into civil wars cost Charles his throne and his life in 1649. A succession of republican and monarchical rulers who alternately supported Protestantism or Catholicism followed, until the Catholic king James II was deposed in the Glorious Revolution of 1689 by his Protestant son-in-law and daughter, William and Mary. After Mary's death in 1694, William (the Dutch great-grandson of William of Orange, who had led the Netherlands' independence movement) ruled on his own until his death in 1702. He was succeeded by Mary's sister Anne (ruled 1702–14).

Architecture and Landscape Design

In sculpture and painting, the English court patronized foreign artists. The field of architecture, however, was dominated in the seventeenth century by the Englishmen Inigo Jones, Christopher Wren, and Nicholas Hawkmoor. They replaced the country's long-lived Gothic style with a classical one and were followed in a more Baroque mode by another English architect, John Vanbrugh. Major changes in landscape architecture took place during the eighteenth century, led by the innovative designer Lancelot "Capability" Brown.

INIGO JONES. In the early seventeenth century, the architect Inigo Jones (1573–1652) introduced his version of Renaissance classicism—an architectural design based on the style of the architect Andrea Palladio—into England. Jones had studied Palladio's work in Venice, and he filled his copy of Palladio's *Four Books of Architecture* (which has been preserved) with notes. Appointed surveyor-general in 1615, Jones was commissioned to design the Queen's House in Greenwich and the Banqueting House for the royal palace of Whitehall.

The **BANQUETING HOUSE, WHITEHALL PALACE** (FIG. 22–64), built in 1619–22 to replace an earlier hall destroyed by fire, was used for court ceremonies and entertainments such as the popular masques—dance-dramas combining theater, music, and dance in a spectacle in which professional actors, courtiers, and even members of the royal family participated. The west front shown here, consisting of what appears to be two upper stories with superimposed Ionic and Composite orders raised over a plain basement level, exemplifies the understated elegance of Jones's interpretation of Palladian design. Pilasters flank the end bays, and engaged columns subtly emphasize the three bays at the center. These vertical elements are repeated in the balustrade along the roofline. A rhythmic effect was created in varying window treatments from triangular and segmental (semicircular) pediments on the first level to cornices with volute (scroll-form) brackets on the second. The sculpted garlands just below the roofline add an unexpected decorative touch, as does the use of a different-color stone—pale golden, light brown, and white—for each story (no longer visible after the building was refaced in uniformly white Portland stone).

Although the exterior suggests two stories, the interior of the Banqueting House (FIG. 22–65) is actually one large hall divided by a balcony, with antechambers at each end. Ionic pilasters suggest a colonnade but do not impinge on the ideal, double-cube space, which measures 55 feet in width by 110 feet in length by 55 feet in height. In 1630, Charles I commissioned Peter Paul Rubens to decorate the ceiling. Jones had divided the flat ceiling into nine compartments, for which Rubens painted canvases glorifying the reign of James I. Installed in 1635, the paintings show the triumph of the Stuart dynasty with the king carried to heaven in clouds of glory. The large rectangular panel beyond it depicts the birth of the new nation, flanked by allegorical paintings of heroic strength and virtue overcoming vice. In the long paintings on each side, *putti* holding the fruits of the Earth symbolize the peace and prosperity of England and Scotland under Stuart rule. So proud was Charles of the result that, rather than allow the smoke of candles and torches to harm the ceiling decoration, he moved evening entertainments to an adjacent pavilion.

CHRISTOPHER WREN. After Jones's death, English architecture was dominated by Christopher Wren (1632–1723). Wren began his professional career in 1659 as a professor of astronomy; architecture was a sideline until 1665, when he traveled to France to further his education. While there, he met with French architects and with Bernini, who was in Paris to consult on his designs for the Louvre. Wren returned to England with architectural books, engravings, and a greatly increased admiration for French classical Baroque design. In 1669, he was made surveyor-general, the position once held by Inigo Jones; in 1673, he was knighted.

After the Great Fire of 1666 demolished central London, Wren was continuously involved in rebuilding the city. He built more than fifty Baroque churches. His major project from 1675 to 1710, however, was the rebuilding of **SAINT PAUL'S CATHEDRAL** (FIG. 22–66). Attempts to salvage the burned-out medieval church on the site failed, and a new cathedral was needed. Wren's famous second design for Saint Paul's (which survives in the so-called Great Model of 1672–73) was for a centrally planned building with a great dome in the manner of Bramante's plan for Saint Peter's. This was rejected, but Wren ultimately succeeded both in satisfying Reformation tastes for a basilica and in retaining the unity inherent in the dome. Saint Paul's has a long nave and equally long sanctuary articulated by small, domed bays. Semicircular, colonnaded porticoes open into short transepts that compress themselves against the crossing, where the dome rises 633 feet from ground level. Wren's dome for Saint Paul's has an interior masonry vault with an oculus and an exterior sheathing of lead-covered wood but also has a brick cone rising from the inner oculus to support a tall lantern. (The ingenuity of the design and engineering remind one that Wren was mathematician and professor of astronomy at Oxford.) The columns surrounding the drum on the exterior recall Bramante's Tempietto in Rome (SEE FIG. 20–17), although Wren never went to Italy and knew Italian architecture only from books.

On the façade of Saint Paul's, two stages of paired Corinthian columns support a carved pediment. The deep-set porticoes and columned pavilions atop the towers create dramatic areas of light and shadow. Not only the huge size of the cathedral but also its triumphant verticality, complexity of form, and chiaroscuro effects make it a major monument of the English Baroque. Wren recognized the importance of the

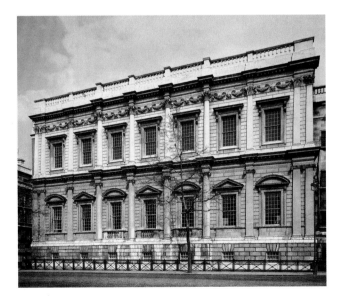

22–64 Inigo Jones **BANQUETING HOUSE, WHITEHALL PALACE**
London. 1619-22.

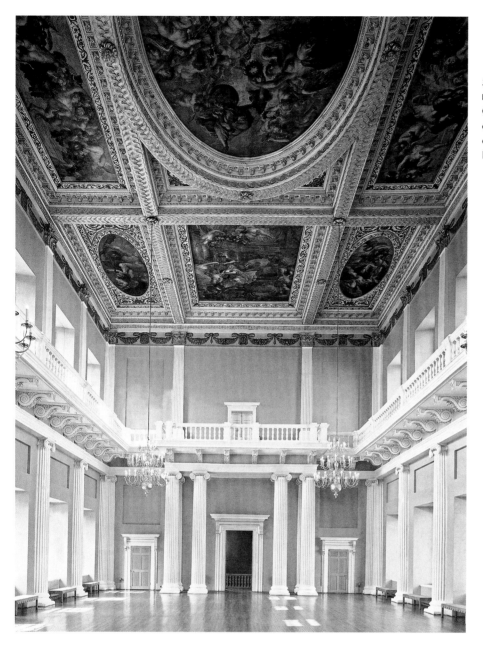

22–65 | **INTERIOR, BANQUETING HOUSE, WHITEHALL PALACE**
Ceiling paintings of the apotheosis of King James and the glorification of the Stuart monarchy by Peter Paul Rubens. 1630–35.

building. On the simple marble slab that forms his tomb in the crypt of the cathedral, he had engraved: "If you want to see his memorial, look around you."

BLENHEIM PALACE. Like Wren, Sir John Vanbrugh (1664–1726) came late to architecture. His heavy, angular style, utterly unlike Wren's, was well suited to buildings intended to express power and domination. Wren's assistant Nicholas Hawksmoor (1661–1736) also worked in a bolder style. Perhaps the most important achievement of the two was **BLENHEIM PALACE (FIG. 22–67),** built in two phases (1705–12 and 1715–25) in Woodstock, just northwest of London. Van-

brugh was an amateur, a soldier and playwright whose architectural designs are indeed theatrical. Hawksmoor was an established professional who understood building and engineering. The two combined to create the imposing and impractical monument to the glory of England—an architectural challenge to Louis XIV and Versailles. Built by Queen Anne, with funds from Parliament, for John Churchill, duke of Marlborough, after his 1704 victory over the armies of Louis XIV at Blenheim, the palace was made a national monument as well as the residence of the dukes of Marlborough. Except for the formal gardens at each side of the center block, the informal and natural landscaping is the work of

22–66 | Christopher Wren **SAINT PAUL'S CATHEDRAL, LONDON**
Designed 1673, built 1675–1710.

Lancelot "Capability" Brown. Blenheim's enormous size and symmetrical plan, with service and stable wings flanking an entrance court, recall Versailles as they reach out to encompass the surrounding terrain.

Blenheim's grounds originally comprised a practical kitchen garden, an avenue of elm trees, and another garden. In the 1760s, the grounds were redesigned by Lancelot "Capability" Brown (1716–83) according to his radical new style now called, appropriately, "landscape architecture." In contrast to the geometric rigor of the French and Italian gardens, Brown's designs appeared to be both informal and natural. The "natural" appearance was created by feats of engineering, as the land was reformed to create views inspired by the paintings of Claude Lorrain. In order to accomplish this at Blenheim, Brown dammed the small river flowing by the palace to form two lakes and a rockwork cascade, then created sweeping lawns and vistas with artfully arranged trees. (Gardeners and their patrons thought of the future, as they planted trees that they would never see grow to maturity.) The formal gardens in the French style now seen at each side of Blenheim's center block were added in the twentieth century.

22–67 | John Vanbrugh **BLENHEIM PALACE, WOODSTOCK**
Oxfordshire, England. 1705–12 and 1715–25.

English Colonies in North America

In the seventeenth century, the art of North America reflected the tastes of the European rulers—England on the East Coast, France in Canada and Louisiana, Spain in the Southwest. Not surprisingly, much of the colonial art was the work of immigrant artists, and styles often lagged behind the European mainstream. The rigors of colonial life meant that few people could afford to think of fine houses and art collections. Furthermore, the Puritans, religious dissenters who had left England and settled in the Northeast beginning in 1620, wanted simple, functional buildings for homes and churches. Architecture and crafts responded more quickly than sculpture and painting in the development of native styles. Although by the last decades of the seventeenth century a market for fine furniture and portraits had developed, native artists of outstanding talent often found it advantageous to resettle in Europe.

ARCHITECTURE. Early architecture in the British North American colonies was derived from European timber construction. Wood, so easily obtained in the Northeast, was used to create the same kinds of houses and churches then being built in rural England (as well as in Holland and France, which also had colonies in North America). In seventeenth-century New England, many buildings reflected the adapta-

tion of contemporary English country buildings, which were appropriate to the severe North American winters—framed-timber construction with steep roofs, massive central fireplaces and chimneys, overhanging upper stories, and small windows with tiny panes of glass or parchment screens. Following a time-honored tradition, walls consisted of wooden frames filled with **wattle and daub** (woven branches packed with clay) or brick in more expensive homes. Instead of leaving this construction exposed, as was common in Europe, colonists usually weatherproofed it with horizontal plank siding, called **clapboard**. The **PARSON CAPEN HOUSE** in Topsfield, Massachusetts (FIG. 22–68), built in 1683, is a well-preserved example. The earliest homes generally consisted of a single

22–68 | **PARSON CAPEN HOUSE**
Topsfield, Massachusetts. 1683.

22–69 | Anonymous ("Freake Painter") **MRS. FREAKE
AND BABY MARY**
c. 1674. Oil on canvas, 42¼ × 36¼″ (108 × 92.1 cm).
Worcester Museum of Art, Worcester, Massachusetts.
Gift of Mr. and Mrs. Albert W. Rice

"great room" and fireplace, but the Capen House has two
stories, each with two rooms flanking the central fireplace
and chimney. The main fireplace was the center of domestic
life; all the cooking was done there, and the firelight provided
illumination for reading and sewing.

PAINTING. Painting and sculpture had to wait for more set-
tled and affluent times in the eastern seacoast colonies. For a
long time, the only works of sculpture were carved or
engraved tombstones. Painting, too, was sponsored as a neces-
sary part of family record keeping, and portraits done by itin-
erant "face painters," called **limners**, have a charm and sincerity
that appeal to the modern eye. The anonymous painter of
MRS. FREAKE AND BABY MARY (FIG. 22–69), dated about
1674, seems to have known Dutch portraiture, probably

through engraved copies that were imported and sold in the
colonies. Even though the "Freake Painter" was clearly self-
taught and lacked skills in illusionistic, three-dimensional
composition, emotionally this portrait has much in common
with Frans Hals's *Catharina Hooft and Her Nurse* (SEE FIG.
22–41). Maternal pride in an infant and hope for her future
are universal ideals that apply to little Mary as well as to
Catharina, even though their worlds were far apart.

IN PERSPECTIVE

Cataclysmic forces unleashed in the sixteenth century came
to fruition in the arts only in the seventeenth century, as
political and religious factions attacked each other with lethal
fanaticism and enlisted art—as well as God—on their side.
Spectacular visions, brilliant state portraits, and grandiose
palaces and churches proclaimed the power of church and
state. In papal Rome, Bernini, Borromini, and Gaulli worked
their visual magic while Caravaggio revolutionized painting
with his new naturalism. In Spain, France, and England, artists
such as Rigaud and Van Dyck created portraits that were mir-
acles of royal propaganda while Velázquez and Rubens glori-
fied political and military victories.

Florence, Venice, and even Antwerp lost their economic
and hence cultural advantage while papal Rome, Louis XIV's
Paris and Versailles, and the commercial center of Amsterdam
became the economic engines of the arts. In the Protestant
countries, religious art was replaced by secular subject matter
and a strong realistic style as the arts found a new economic
basis—the open art market. Artists like Vermeer or Ruisdael
painted themes considered "lesser" by the critics but with
sales in mind: still lifes, landscapes, and scenes of daily life. As
the universities became the centers of intellectual life, cur-
riculum changed from religion and philosophy to science
and mathematics. Artists like Maria Sibylla Merian joined sci-
entists in the exploration and recording of nature, and Rem-
brandt probed the human mind and spirit.

Trade became global, and fortunes were to be made as
ships replaced the overland routes between Europe and Asia
and new trade routes crossed the Atlantic. The fascinating
phenomenon today referred to as "core and periphery"—
cultural transference between colonial power and colony—is
epitomized by the comparison of two portraits, Hals's *Catha-
rina Hooft* and the "Freake Painter's" *Baby Mary*—as a new art
center arose in the New World.

PEETERS
**STILL LIFE WITH FLOWERS, GOBLET,
DRIED FRUIT AND PRETZLES**
1611

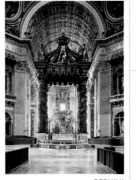

BERNINI
BALDACCHINO
SAINT PETER'S BASILICA, VATICAN
1624–1633

LA TOUR
**MARY MAGDALEN WITH
THE SMOKING FLAME**
c. 1640

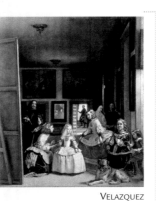

VELAZQUEZ
LAS MENINAS
1656

WREN
ST. PAUL'S CATHEDRAL
DESIGNED 1673

DE WITTE
PORTUGUESE SYNAGOGUE, AMSTERDAM
1680

1600

1620

1640

1660

1680

1700

◄ **Thirty Year's War** 1618–48
◄ **Mayflower Lands in North America**
1620

◄ **Galileo Forced to Recant** 1633

◄ **Louis XIV of France Ruled** 1643–1715
◄ **French Royal Academy of Painting
and Sculpture** 1648
◄ **Spanish Habsburgs Recognize
Independence of United Provinces**
1648
◄ **Charles I of England Beheaded;
England a Commonwealth** 1649

◄ **Restoration of Charles II and
Monarchy in England** 1660

◄ **Great Fire of London** 1666
◄ **French Royal Academy of
Architecture** 1671

◄ **Newton Publishes Laws of Gravity
and Motion** 1687
◄ **Glorious Revolution in England** 1689

◄ **Steam Engine Invented** 1698

GLOSSARY

abacus The flat slab at the top of a **capital**, directly under the **entablature**.

absolute dating A method of assigning a precise historical date to periods and objects based on known and recorded events in the region as well as technically extracted physical evidence (such as carbon-14 disintegration). See also **radiometric dating, relative dating**.

abstract, abstraction Any art that does not represent observable aspects of nature or transforms visible forms into a stylized image. Also: the formal qualities of this process.

acropolis The **citadel** of an ancient Greek city, located at its highest point and housing temples, a treasury, and sometimes a royal palace. The most famous is the Acropolis in Athens.

acroterion (acroteria) An ornament at the corner or peak of a roof.

adobe Sun-baked blocks made of clay mixed with straw. Also: the buildings made with this material.

adyton The back room of a Greek temple. At Delphi, the place where the **oracles** were delivered. More generally, a very private space or room.

aedicula (aediculae) A decorative architectural frame, usually found around a niche, door, or window. An aedicula is made up of a **pediment** and **entablature** supported by **columns** or **pilasters**.

agora An open space in a Greek town used as a central gathering place or market. See also **forum**.

aisle Passage or open corridor of a church, hall, or other building that parallels the main space, usually on both sides, and is delineated by a row, or **arcade**, of **columns** or piers. Called side aisles when they flank the **nave** of a church.

album A book consisting of a series of painting or prints (album leaves) mounted into book form.

all'antica Meaning, "in the ancient manner."

allegory In a work of art, an image (or images) that symbolically illustrates an idea, concept, or principle, often moral or religious.

alloy A mixture of metals; different metals melted together.

amalaka In Hindu architecture, the circular or square-shaped element on top of a spire (*shikhara*), often crowned with a **finial**, symbolizing the cosmos.

ambulatory The passage (walkway) around the **apse** in a basilican church or around the **central space in a central-plan building**.

amphiprostyle Term describing a building, usually a temple, with **porticoes** at each end but without **columns** along the other two sides.

amphora An ancient Greek jar for storing oil or wine, with an egg-shaped body and two curved handles.

aniconic A symbolic representation without images of human figures, very often found in Islamic art.

animal interlace Decoration made of interwoven animals or serpents, often found in Celtic and early medieval Northern European art.

ankh A looped cross signifying life, used by ancient Egyptians.

appropriation Term used to describe an artist's practice of borrowing from another source for a new work of art. While in previous centuries artists often copied one another's figures, motifs, or compositions, in modern times the sources for appropriation extend from material culture to works of art.

apse, apsidal A large semicircular or polygonal (and usually vaulted) niche protruding from the end wall of a building. In the Christian church, it contains the altar. Apsidal is an adjective describing the condition of having such a space.

arabesque A type of linear surface decoration based on foliage and **calligraphic** forms, usually characterized by flowing lines and swirling shapes.

arcade A series of **arches**, carried by **columns** or **piers** and supporting a common wall or lintel. In a blind arcade, the arches and supports are engaged (attached to the wall) and have a decorative function.

arch In architecture, a curved structural element that spans an open space. Built from wedge-shaped stone blocks called **voussoirs**, which, when placed together and held at the top by a trapezoidal **keystone**, form an effective space-spanning and weight-bearing unit. Requires buttresses at each side to contain the outward thrust caused by the weight of the structure. **Corbel** arch: arch or **vault** formed by **courses** of stones, each of which projects beyond the lower course until the space is enclosed; usually finished with a **capstone**. Horseshoe arch: an arch of more than a half-circle; typical of western Islamic architecture. Ogival arch: a pointed arch created by S curves. Relieving arch: an arch built into a heavy wall just above a post-and-lintel structure (such as a gate, door, or window) to help support the wall above by transferring the load to the side walls.

archaic smile The curved lips of an ancient Greek statue, usually interpreted as an attempt to animate the features.

architrave The bottom element in an **entablature**, beneath the **frieze** and the **cornice**.

art brut French for "raw art." Term introduced by Jean Dubuffet to denote the often vividly **expressionistic** art of children and the insane, which he considered uncontaminated by culture.

articulated Joined; divided into units; in architecture, divided into parts to make spatial organization intelligible.

ashlar A highly finished, precisely cut block of stone. When laid in even **courses**, ashlar masonry creates a uniform face with fine joints. Often used as a facing on the visible exterior of a building, especially as a veneer for the **façade**. Also called **dressed stone**.

assemblage Artwork created by gathering and manipulating two and/or three-dimensional found objects.

astragal A thin convex decorative **molding**, often found on classical **entablatures**, and usually decorated with a continuous row of beadlike circles.

atelier The studio or workshop of a master artist or craftsperson, often including junior associates and apprentices.

atmospheric perspective See **perspective**.

atrial cross The cross placed in the atrium of a church. In Colonial America, used to mark a gathering and teaching place.

atrium An unroofed interior courtyard or room in a Roman house, sometimes having a pool or garden, sometimes surrounded by columns. Also: the open courtyard in front of a Christian church; or an entrance area in modern architecture.

automatism A technique whereby the usual intellectual control of the artist over his or her brush or pencil is foregone. The artist's aim is to allow the subconscious to create the artwork without rational interference.

avant-garde Term derived from the French military word meaning "before the group," or "vanguard." Avant-garde denotes those artists or concepts of a strikingly new, experimental, or radical nature for the time.

axis mundi A concept of an "axis of the world," which marks sacred sites and denotes a link between the human and celestial realms. For example, in Buddhist art, the axis mundi can be marked by monumental freestanding decorative pillars.

baldachin A canopy (whether suspended from the ceiling, projecting from a wall, or supported by columns) placed over an honorific or sacred space such as a throne or church altar.

bargeboards Boards covering the rafters at the gable end of a building; bargeboards are often carved or painted.

barrel vault See **vault**.

bar tracery See **tracery**.

bas-de-page French: bottom of the page; a term used in manuscript studies to indicate pictures below the text, literally at the bottom of the page.

base Any support. Also: masonry supporting a statue or the **shaft** of a **column**.

basilica A large rectangular building. Often built with a **clerestory**, side **aisles** separated from the center **nave** by **colonnades**, and an **apse** at one or both ends. Roman centers for administration, later adapted to Christian church use. Constantine's architects added a transverse aisle at the end of the nave called a **transept**.

bay A unit of space defined by architectural elements such as **columns**, **piers**, and walls.

beehive tomb A **corbel-vaulted** tomb, conical in shape like a beehive, and covered by an earthen mound.

Benday dots In modern printing and typesetting, the individual dots that, together with many others, make up lettering and images. Often machine- or computer-generated, the dots are very small and closely spaced to give the effect of density and richness of tone.

bestiary A book describing characteristics, uses, and meaning illustrated by moralizing tales about real and imaginary animals, especially popular during the Middle Ages in western Europe.

bi A jade disk with a hole in the center.

biomorphic Adjective used to describe forms that resemble or suggest shapes found in nature.

black-figure A style or technique of ancient Greek pottery in which black figures are painted on a red clay ground. See also **red-figure**.

bodhisattva In Buddhism, a being who has attained enlightenment but chooses to remain in this world in order to help others advance spiritually. Also defined as a potential Buddha.

boss A decorative knoblike element. Bosses can be found in many places, such as at the intersection of a Gothic vault rib. Also buttonlike projections in decorations and metalwork.

bracket, bracketing An architectural element that projects from a wall to support a horizontal part of a building, such as beams or the eaves of a roof.

brandea An object, such as a linen strip, having contact with a relic and taking on the power of the relic.

buon fresco *See* **fresco**.

cairn A pile of stones or earth and stones that served both as a prehistoric burial site and as a marker of underground tombs.

calligraphy Handwriting as an art form.

calyx krater *See* **krater**.

came (cames) A lead strip used in the making of leaded or **stained-glass** windows. Cames have an indented vertical groove on the sides into which the separate pieces of glass are fitted to hold the design together.

cameo Gemstone, clay, glass, or shell having layers of color, carved in **low relief** to create an image and ground of different colors.

camera obscura An early cameralike device used in the Renaissance and later for recording images of nature. Made from a dark box (or room) with a hole in one side (sometimes fitted with a lens), the camera obscura operates when bright light shines through the hole, casting an upside-down image of an object outside onto the inside wall of the box.

canon of proportions A set of ideal mathematical ratios in art based on measurements of the human body.

capital The sculpted block that tops a **column**. According to the conventions of the orders, capitals include different decorative elements. See **order**. Also: a historiated capital is one displaying a narrative.

capriccio A painting or print of a fantastic, imaginary landscape, usually with architecture.

capstone The final, topmost stone in a **corbel arch** or vault, which joins the sides and completes the structure.

cartoon A full-scale drawing used to transfer the outline of a design onto a surface (such as a wall, canvas, panel, or tapestry) to be painted, carved, or woven.

cartouche A frame for a **hieroglyphic** inscription formed by a rope design surrounding an oval space. Used to signify a sacred or honored name. Also: in architecture, a decorative device or plaque, usually with a plain center used for inscriptions or epitaphs.

caryatid A sculpture of a draped female figure acting as a column supporting an **entablature**.

catacomb A subterranean burial ground consisting of tunnels on different levels, having niches for urns and **sarcophagi** and often incorporating rooms (cubiculae).

celadon A high-fired, transparent **glaze** of pale bluish-green hue whose principal coloring agent is an oxide of iron. In China and Korea, such glazes typically were applied over a pale gray **stoneware** body, though Chinese potters sometimes applied them over **porcelain** bodies during the Ming (1368-1644) and Qing (1644-1911) dynasties. Chinese potters invented celadon glazes and initiated the continuous production of celadon-glazed wares as early as the third century CE.

cella The principal interior room at the center of a Greek or Roman temple within which the cult statue was usually housed. Also called the **naos**.

cenotaph A funerary monument commemorating an individual or group buried elsewhere.

centering A temporary structure that supports a masonry **arch** and **vault** or **dome** during construction until the mortar is fully dried and the masonry is self-sustaining.

centrally planned building Any structure designed with a primary central space surrounded by symmetrical areas on each side. For example, **Greek-cross plan** (equal-armed cross).

ceramics A general term covering all types of wares made from fired clay, including **porcelain** and **terra cotta**.

chaitya A type of Buddhist temple found in India. Built in the form of a hall or **basilica**, a chaitya hall is highly decorated with sculpture and usually is carved from a cave or natural rock location. It houses a sacred shrine or stupa for worship.

chamfer The slanted surface produced when an angle is trimmed or beveled, common in building and metalwork.

chasing Ornamentation made on metal by incising or hammering the surface.

chattri (*chattris*) A decorative pavilion with an umbrella-shaped **dome** in Indian architecture.

chevron A decorative or heraldic motif of repeated Vs; a zigzag pattern.

chiaroscuro An Italian word designating the contrast of dark and light in a painting, drawing, or print. Chiaroscuro creates spatial depth and volumetric forms through gradations in the intensity of light and shadow.

chiton A thin sleeveless garment, fastened at waist and shoulders, worn by men and women in ancient Greece.

citadel A fortress or defended city, if possible placed in a high, commanding location.

clapboard Horizontal overlapping planks used as protective siding for buildings, particularly houses in North America.

clerestory The topmost zone of a wall with windows in a **basilica** extending above the **aisle** roofs. Provides direct light into the central interior space (the **nave**).

cloisonné An enamel technique in which metal wire or strips are affixed to the surface to form the design. The resulting areas (cloisons) are filled with enamel (colored glass).

cloister An open space, part of a monastery, surrounded by an **arcaded** or **colonnaded** walkway, often having a fountain and garden, and dedicated to nonliturgical activities and the secular life of the religious. Members of a cloistered order do not leave the monastery or interact with outsiders.

codex (codices) A book, or a group of **manuscript** pages (folios), held together by stitching or other binding on one side.

coffer A recessed decorative panel that is used to reduce the weight of and to decorate ceilings or **vaults**. The use of coffers is called coffering.

colonnade A row of **columns**, supporting a straight lintel (as in a **porch** or **portico**) or a series of arches (an **arcade**).

colophon The data placed at the end of a book listing the book's author, publisher, illuminator, and other information related to its production. Also, in East Asian handscrolls, the inscriptions which follow the painting are called colophons.

column An architectural element used for support and/or decoration. Consists of a rounded or polygonal vertical **shaft** placed on a **base** and topped by a decorative **capital**. In classical architecture, built in accordance with the rules of one of the architectural **orders**. Columns can be freestanding or attached to a background wall (**engaged**).

complementary color The primary and secondary colors across from each other on the color wheel (red and green, blue and orange, yellow and purple). When juxtaposed, the intensity of both colors increases. When mixed together, they negate each other to make a neutral gray-brown.

Composite order *See* **order**.

cong A square or octagonal jade tube with a cylindrical hole in the center. A symbol of the earth, it was used for ritual worship and astronomical observations in ancient China.

connoisseurship A term derived from the French word connoisseur, meaning "an expert," and signifying the study and evaluation of art based primarily on formal, visual, and stylistic analysis. A connoisseur studies the style and technique of an object to deduce its relative quality and possible maker. This is done through visual association with other, similar objects and styles. See also **contextualism**; **formalism**.

contextualism An interpretive approach in art history that focuses on the culture surrounding an art object. Unlike **connoisseurship**, contextualism utilizes the literature, history, economics, and social developments (among other things) of a period, as well as the object itself, to explain the meaning of an artwork. See *also* **connoisseurship**.

contrapposto An Italian term meaning "set against," used to describe the twisted pose resulting from parts of the body set in opposition to each other around a central axis.

corbel, corbeling An early roofing and **arching** technique in which each course of stone projects slightly beyond the previous layer (a corbel) until the uppermost corbels meet. Results in a high, almost pointed **arch** or **vault**. A corbel table is a ledge supported by corbels.

corbeled vault *See* **vault**.

Corinthian order *See* **order**.

cornice The uppermost section of a Classical **entablature**. More generally, a horizontally projecting element found at the top of a building wall or **pedestal**. A raking cornice is formed by the junction of two slanted cornices, most often found in **pediments**.

course A horizontal layer of stone used in building.

crenellation Alternating high and low sections of a wall, giving a notched appearance and creating permanent defensive shields in the walls of fortified buildings.

crockets A stylized leaf used as decoration along the outer angle of spins, pinnacles, gables, and around **capitals** in Gothic architecture.

cuneiform An early form of writing with wedge-shaped marks impressed into wet clay with a stylus, primarily used by ancient Mesopotamians.

curtain wall A wall in a building that does not support any of the weight of the structure. Also: the freestanding outer wall of a castle, usually encircling the inner bailey (yard) and keep (primary defensive tower).

cyclopean construction or **masonry** A method of building using huge blocks of rough-hewn stone. Any large-scale, monumental building project that impresses by sheer size. Named after the Cyclopes (sing. Cyclops) one-eyed giants of legendary strength in Greek myths.

cylinder seal A small cylindrical stone decorated with incised patterns. When rolled across soft clay or wax, the resulting raised pattern or design (**relief**) served in Mesopotamian and Indus Valley cultures as an identifying signature.

dado (dadoes) The lower part of a wall, differentiated in some way (by a **molding** or different coloring or paneling) from the upper section.

daguerreotype An early photographic process that makes a positive print on a light-sensitized copperplate; invented and marketed in 1839 by Louis-Jacques-Mandé Daguerre.

demotic writing The simplified form of ancient Egyptian hieratic writing, used primarily for administrative and private texts.

dharmachakra Sanskrit for "wheel" (*chakra*) and "law" or "doctrine" (*dharma*); often used in Buddhist iconography to signify the "wheel of the law."

diptych Two panels of equal size (usually decorated with paintings or reliefs) hinged together.

dogu Small human figurines made in Japan during the Jomon period. Shaped from clay, the figures have exaggerated expressions and are in contorted poses. They were probably used in religious rituals.

dolmen A prehistoric structure made up of two or more large upright stones supporting a large, flat, horizontal slab or slabs.

dome A round **vault**, usually over a circular space. Consists of a curved masonry vault of shapes and cross sections that can vary from hemispherical to bulbous to ovoidal. May use a supporting vertical wall (**drum**), from which the vault springs, and may be crowned by an open space (**oculus**) and/or an exterior **lantern**. When a dome is built over a square space, an intermediate element is required to make the transition to a circular drum. There are two types: A dome on **pendentives** (spherical triangles) incorporates **arched**, sloping intermediate sections of wall that carry the weight and thrust of the dome to heavily buttressed supporting **piers**. A dome on **squinches** uses an arch built into the wall (squinch) in the upper corners of the space to carry the weight of the dome across the corners of the square space below. A half-dome or conch may cover a semicircular space.

domino construction System of building construction introduced by the architect Le Corbusier in which reinforced concrete floor slabs are floated on six freestanding posts placed as if at the positions of the six dots on a domino playing piece.

Doric order See **order**.

dressed stone See **ashlar**.

drum The wall that supports a **dome**. Also: a segment of the circular **shaft** of a **column**.

drypoint An **intaglio** printmaking process by which a metal (usually copper) plate is directly inscribed with a pointed instrument (**stylus**). The resulting design of scratched lines is inked, wiped, and printed. Also: the print made by this process.

earthenware A low-fired, opaque **ceramic** ware that is fired in the range of 800 to 900 degrees Celsius. Earthenware employs humble clays that are naturally heat resistant; the finished wares remain porous after firing unless **glazed**. Earthenware occurs in a range of earth-toned colors, from white and tan to gray and black, with tan predominating.

echinus A cushionlike circular element found below the **abacus** of a Doric **capital**. Also: a similarly shaped **molding** (usually with egg-and-dart motifs) underneath the **volutes** of an Ionic **capital**.

electron spin resonance techniques Method that uses magnetic field and microwave irradiation to date material such as tooth enamel and its surrounding soil.

emblema (emblemata) In a mosaic, the elaborate central motif on a floor, usually a self-contained unit done in a more refined manner, with smaller **tesserae** of both marble and semiprecious stones.

encaustic A painting technique using pigments mixed with hot wax as a medium.

engaged column A **column** attached to a wall. See also column.

engraving An intaglio printmaking process of inscribing an image, design, or letters onto a metal or wood surface from which a print is made. An engraving is usually drawn with a sharp implement (burin) directly onto the surface of the plate. Also: the print made from this process.

entablature In the **Classical orders**, the horizontal elements above the **columns** and **capitals**. The entablature consists of, from bottom to top, an **architrave**, a **frieze**, and a **cornice**.

entasis A slight swelling of the **shaft** of a Greek column. The optical illusion of entasis makes the column appear from afar to be straight.

exedra (exedrae) In architecture, a semicircular niche. On a small scale, often used as decoration, whereas larger exedrae can form interior spaces (such as an **apse**).

expressionism, expressionistic Terms describing a work of art in which forms are created primarily to evoke subjective emotions rather than to portray objective reality.

façade The face or front wall of a building.

faience Type of **ceramic** covered with colorful, opaque glazes that form a smooth, impermeable surface. First developed in ancient Egypt.

fang ding A square or rectangular bronze vessel with four legs. The fang ding was used for ritual offerings in ancient China during the Shang dynasty.

fête galante A subject in painting depicting well-dressed people at leisure in a park or country setting. It is most often associated with eighteenth-century French Rococo painting.

filigree Delicate, lacelike ornamental work.

fillet The flat ridge between the carved out flutes of a **column shaft**. See also **fluting**.

finial A knoblike architectural decoration usually found at the top point of a spire, pinnacle, canopy, or gable. Also found on furniture; also the ornamental top of a staff.

fluting In architecture, evenly spaced, rounded parallel vertical grooves **incised** on **shafts** of **columns** or columnar elements (such as **pilasters**).

foreshortening The illusion created on a flat surface in which figures and objects appear to recede or project sharply into space. Accomplished according to the rules of **perspective**.

formal analysis See **formalism**.

formalism, formalist An approach to the understanding, appreciation, and valuation of art based almost solely on considerations of form. This approach tends to regard an artwork as independent of its time and place of making. See also **connoisseurship**.

four-iwan mosque See **iwan** and **mosque**.

fresco A painting technique in which waterbased pigments are applied to a surface of wet plaster (called **buon fresco**). The color is absorbed by the plaster, becoming a permanent part of the wall. **Fresco secco** is created by painting on dried plaster, and the color may flake off. Murals made by both these techniques are called frescoes.

fresco secco See **fresco**.

frieze The middle element of an **entablature**, between the **architrave** and the **cornice**. Usually decorated with sculpture, painting, or **moldings**. Also: any continuous flat band with **relief sculpture** or painted decorations.

frottage A design produced by laying a piece of paper over a textured surface and rubbing with charcoal or other soft medium.

fusuma Sliding doors covered with paper, used in traditional Japanese construction. Fusuma are often highly decorated with paintings and colored backgrounds.

galleria See **gallery**.

gallery In church architecture, the story found above the side **aisles** of a church, usually open to and overlooking the nave. Also: in secular architecture, a long room, usually above the ground floor in a private house or a public building used for entertaining, exhibiting pictures, or promenading. *Also:* a building or hall in which art is displayed or sold. Also: *galleria*.

garbhagriha From the Sanskrit word meaning "womb chamber," a small room or shrine in a Hindu temple containing a holy image.

genre A type or category of artistic form, subject, technique, style, or medium. See also genre painting.

gesso A ground made from glue, gypsum, and/or chalk forming the ground of a wood panel or the priming layer of a canvas. Provides a smooth surface for painting.

gilding The application of paper-thin **gold leaf** or gold pigment to an object made from another medium (for example, a sculpture or painting). Usually used as a decorative finishing detail.

giornata (giornate) Adopted from the Italian term meaning "a day's work," a giornata is the section of a **fresco** plastered and painted in a single day.

glaze See **glazing**.

glazing An outermost layer of vitreous liquid (**glaze**) that, upon firing, renders **ceramics** waterproof and forms a decorative surface. In painting, a technique particularly used with oil mediums in which a transparent layer of paint (**glaze**) is laid over another, usually lighter, painted or glazed area.

gloss A type of clay **slip** used in **ceramics** by ancient Greeks and Romans that, when fired, imparts a colorful sheen to the surface.

golf foil A thin sheet of gold.

gold leaf Paper-thin sheets of hammered gold that are used in **gilding**. In some cases (such as Byzantine **icons**), also used as a ground for paintings.

gopura The towering gateway to an Indian Hindu temple complex. A temple complex can have several different gopuras.

Grand Manner An elevated style of painting popular in the eighteenth century in which the artist looked to the ancients and to the Renaissance for inspiration; for portraits as well as history painting, the artist would adopt the poses, compositions, and attitudes of Renaissance and antique models.

Grand Tour Popular during the eighteenth and nineteenth centuries, an extended tour of cultural sites in southern Europe intended to finish the education of a young upper-class person from Britain or North America.

grattage A pattern created by scraping off layers of paint from a canvas laid over a textured surface. See also *frottage*.

Greek-cross plan See **centrally planned building**.

Greek-key pattern A continuous rectangular scroll often used as a decorative border. Also called a **meander pattern**.

grid A system of regularly spaced horizontally and vertically crossed lines that gives regularity to an architectural plan. Also: in painting, a grid enables designs to be enlarged or transferred easily.

grisaille A style of monochromatic painting in shades of gray. Also: a painting made in this style.

groin vault See **vault**.

guild An association of craftspeople. The medieval guild had great economic power, as it set standards and controlled the selling and marketing of its members' products, and as it provided economic protection, group solidarity, and training in the craft to its members.

hall church A church with a **nave** and **aisles** of the same height, giving the impression of a large, open hall.

handscroll A long, narrow, horizontal painting or text (or combination thereof) common in Chinese and Japanese art and of a size intended for individual use. A handscroll is stored wrapped tightly around a wooden pin and is unrolled for viewing or reading.

hanging scroll In Chinese and Japanese art, a vertical painting or text mounted within sections of silk. At the top is a semicircular rod; at the bottom is a round dowel. Hanging scrolls are kept rolled and tied except for special occasions, when they are hung for display, contemplation, or commemoration.

haniwa Pottery forms, including cylinders, buildings, and human figures, that were placed on top of Japanese tombs or burial mounds.

hemicycle A semicircular interior space or structure.

henge A circular area enclosed by stones or wood posts set up by Neolithic peoples. It is usually bounded by a ditch and raised embankment.

hieratic In painting and sculpture, a formalized style for representing rulers or sacred or priestly figures.

hieratic scale The use of different sizes for significant or holy figures and those of the everyday world to indicate importance. The larger the figure, the greater the importance.

high relief Relief sculpture in which the image projects strongly from the background. See also **relief sculpture**.

himation In ancient Greece, a long loose outer garment.

historicism The strong consciousness of and attention to the institutions, themes, styles, and forms of the past, made accessible by historical research, textual study, and archaeology.

history painting Paintings based on historical, mythological, or biblical narratives. Once considered the noblest form of art, history paintings generally convey a high moral or intellectual idea and are often painted in a grand pictorial style.

hollow-casting See **lost-wax casting**.

hypostyle hall A large interior room characterized by many closely spaced **columns** that support its roof.

icon An image in any material representing a sacred figure or event in the Byzantine, and later in the Orthodox, Church. Icons were venerated by the faithful, who believed them to have miraculous powers to transmit messages to God.

iconoclasm The banning or destruction of images, especially icons and religious art. Iconoclasm in eighth- and ninth-century Byzantium and sixteenth- and seventeenth-century Protestant territories arose from differing beliefs about the power, meaning, function, and purpose of imagery in religion.

iconographic See **iconography**.

iconography The study of the significance and interpretation of the subject matter of art.

iconostasis The partition screen in a Byzantine or Orthodox church between the **sanctuary** (where the Mass is performed) and the body of the church (where the congregation assembles). The iconostasis displays **icons**.

idealism *See* idealization.

idealization A process in art through which artists strive to make their forms and figures attain perfection, based on pervading cultural values and/or their own mental image of beauty.

ideograph A written character or symbol representing an idea or object. Many Chinese characters are ideographs.

ignudi Heroic figures of nude young men.

illumination A painting on paper or **parchment** used as illustration and/or decoration for **manuscripts** or **albums**. Usually done in rich colors, often supplemented by gold and other precious materials. The illustrators are referred to as illuminators. Also: the technique of decorating manuscripts with such paintings.

impasto Thick applications of pigment that give a painting a palpable surface texture.

impost, impost block A block, serving to concentrate the weight above, imposed between the **capital** of a **column** and the springing of an arch above.

in antis Term used to describe the position of columns set between two walls, as in a **portico** or a **cella**.

incising A technique in which a design or inscription is cut into a hard surface with a sharp instrument. Such a surface is said to be incised.

ink painting A monochromatic style of painting developed in China using black ink with gray **washes**.

inlay To set pieces of a material or materials into a surface to form a design. *Also:* material used in or decoration formed by this technique.

installation art Artworks created for a specific site, especially a gallery or outdoor area, that create a total environment.

intaglio Term used for a technique in which the design is carved out of the surface of an object, such as an engraved seal stone. In the graphic arts, intaglio includes **engraving**, etching, and **drypoint**—all processes in which ink transfersto paper from incised, ink-filled lines cut into a metal plate.

intarsia Decoration formed through wood **inlay**.

intuitive perspective See **perspective**.

Ionic order See **order**.

iwan A large, **vaulted** chamber in a **mosque** with a monumental arched opening on one side.

jamb In architecture, the vertical element found on both sides of an opening in a wall, and supporting an **arch** or lintel.

japonisme A style in French and American nineteenth-century art that was highly influenced by Japanese art, especially prints.

jasperware A fine-grained, unglazed, white **ceramic** developed by Josiah Wedgwood, often colored by metallic oxides with the raised designs remaining white.

jataka **tales** In Buddhism, stories associated with the previous lives of Shakyamuni, the historical Buddha.

joined-wood sculpture A method of constructing large-scale wooden sculpture developed in Japan. The entire work is constructed from smaller hollow blocks, each individually carved, and assembled when complete. The joined-wood technique allowed the production of larger sculpture, as the multiple joints alleviate the problems of drying and cracking found with sculpture carved from a single block.

joggled voussoirs Interlocking voussoirs in an arch or lintel, often of contrasting materials for colorful effect.

kantharos A type of Greek vase or goblet with two large handles and a wide mouth.

key block A key block is the master block in the production of a colored **woodblock print**, which requires different blocks for each color. The key block is a flat piece of wood with the entire design carved or drawn on its surface. From this, other blocks with partial drawings are made for printing the areas of different colors.

keystone The topmost **voussoir** at the center of an **arch**, and the last block to be placed. The pressure of this block holds the arch together. Often of a larger size and/or decorated.

kiln An oven designed to produce enough heat for the baking, or firing, of clay.

kinetic art Artwork that contains parts that can be moved either by hand, air, or motor.

kondo The main hall inside a Japanese Buddhist temple where the images of Buddha are housed.

kore (korai) **An Archaic** Greek statue of a young woman.

kouros (kouroi) An Archaic Greek statue of a young man or boy.

krater An ancient Greek vessel for mixing wine and water, with many subtypes that each have a distinctive shape. **Calyx krater:** a bell-shaped vessel with handles near the base that resemble a flower calyx. Volute krater: a type of krater with handles shaped like scrolls.

kufic An ornamental, angular Arabic script.

kylix A shallow Greek vessel or cup, used for drinking, with a wide mouth and small handles near the rim.

lacquer A type of hard, glossy surface varnish used on objects in East Asian cultures, made from the sap of the Asian sumac or from shellac, a resinous secretion from the lac insect. Lacquer can be layered and manipulated or combined with pigments and other materials for various decorative effects.

lakshana Term used to designate the thirty-two marks of the historical Buddha. The lakshana include, among others, the Buddha's golden body, his long arms, the wheel impressed on his palms and the soles of his feet, and his elongated ear-lobes.

lamassu Supernatural guardian-protector of ancient Near Eastern palaces and throne rooms, often represented sculpturally as a combination of the bearded head of a man, powerful body of a lion or bull, wings of an eagle, and the horned headdress of a god, and usually possessing five legs.

lancet A tall narrow window crowned by a sharply pointed **arch**, typically found in Gothic architecture.

lantern A turretlike structure situated on a roof, **vault**, or **dome**, with windows that allow light into the space below.

lekythos (lekythoi) A slim Greek oil vase with one handle and a narrow mouth.

limner An artist, particularly a portrait painter, in England during the sixteenth and seventeenth centuries and in New England during the seventeenth and eighteenth centuries.

lingam shrine A place of worship centered on an object or representation in the form of a phallus (the lingam), which symbolizes the power of the Hindu god Shiva.

literati The English word used for the Chinese wenren or the Japanese bunjin, referring to well-educated artists who enjoyed literature, **calligraphy**, and painting as a pastime. Their painting are termed **literati painting**.

literati painting A style of painting that reflects the taste of the educated class of East Asian intellectuals and scholars. Aspects include an appreciation for the antique, small scale, and an intimate connection between maker and audience.

lithograph See **lithography**.

lithography Process of making a print (**lithograph**) from a design drawn on a flat stone block with greasy crayon. Ink is applied to the wet stone and adheres only to the greasy areas of the design.

loggia Italian term for a covered open-air. **gallery**. Often used as a corridor between buildings or around a courtyard, loggias usually have **arcades** or **colonnades**.

lost-wax casting A method of casting metal, such as bronze, by a process in which a wax mold is covered with clay and plaster, then fired, melting the wax and leaving a hollow form. Molten metal is then poured into the hollow space and slowly cooled. When the hardened clay and plaster exterior shell is removed, a solid metal form remains to be smoothed and polished.

low relief Relief sculpture whose figures project slightly from the background. See also **relief sculpture**.

lunette A semicircular wall area, framed by an arch over a door or window. Can be either plain or decorated.

lusterware Ceramic pottery decorated with metallic **glazes**.

madrasa An Islamic institution of higher learning, where teaching is focused on theology and law.

maenad In ancient Greece, a female devotee of the wine god Dionysos who participated in orgiastic rituals. She is often depicted with swirling drapery to indicate wild movement or dance. (Also called a Bacchante, after Bacchus, the Roman name of Dionysos.)

majolica Pottery painted with a tin glaze that, when fired, gives a lustrous and colorful surface.

mandala An image of the cosmos represented by an arrangement of circles or concentric geometric shapes containing diagrams or images. Used for meditation and contemplation by Buddhists.

mandapa In a Hindu temple, an open hall dedicated to ritual worship.

mandorla Light encircling, or emanating from, the entire figure of a sacred person.

manuscript A handwritten book or document.

maqsura An enclosure in a Muslim mosque, near the mihrab, designated for dignitaries.

martyrium (martyria) In Christian architecture, a church, chapel, or shrine built over the grave of a martyr or the site of a great miracle.

mastaba A flat-topped, one-story structure with slanted walls over an ancient Egyptian underground tomb.

matte Term describing a smooth surface that is without shine or luster.

mausoleum A monumental building used as a tomb. Named after the tomb of Mausolos erected at Halikarnassos around 350 BCE.

meander See **Greek-key pattern**.

medallion Any round ornament or decoration. Also: a large medal.

megalith A large stone used in prehistoric building. Megalithic architecture employs such stones.

megaron The main hall of a Mycenaean palace or grand house, having a columnar **porch** and a room with a central fireplace surrounded by four **columns**.

memento mori From Latin for "remember that you must die." An object, such as a skull or extinguished candle, typically found in a *vanitas* image, symbolizing the transience of life.

memory image An image that relies on the generic shapes and relationships that readily spring to mind at the mention of an object.

menorah A Jewish lamp-stand with seven or nine branches; the nine-branched menorah is used during the celebration of Hanukkah. Representations of the seven-branched menorah, once used in the Temple of Jerusalem, became a symbol of Judaism.

metope The carved or painted rectangular panel between the **triglyphs** of a **Doric frieze**.

mihrab A recess or niche that distinguishes the wall oriented toward Mecca (*qibla*) in a **mosque**.

minaret A tall slender tower on the exterior of a mosque from which believers are called to prayer.

minbar A high platform or pulpit in a **mosque**.

miniature Anything small. In painting, miniatures may be illustrations within **albums** or **manuscripts** or intimate portraits.

mirador In Spanish and Islamic palace architecture, a very large window or room with windows, and sometimes balconies, providing views to interior courtyards or the exterior landscape.

mithuna The amorous male and female couples in Buddhist sculpture, usually found at the entrance to a sacred building. The mithuna symbolize the harmony and fertility of life.

moat A large ditch or canal dug around a castle or fortress for military defense. When filled with water, the moat protects the walls of the building from direct attack.

mobile A sculpture made with parts suspended in such a way that they move in a current of air.

modeling In painting, the process of creating the illusion of three-dimensionality on a two-dimensional surface by use of light and shade. In sculpture, the process of molding a three-dimensional form out of a malleable substance.

module A segment or portion of a repeated design. Also: a basic building block.

molding A shaped or sculpted strip with varying contours and patterns. Used as decoration on architecture, furniture, frames, and other objects.

monolith A single stone, often very large.

mortise-and-tenon joint A method of joining two elements. A projecting pin (tenon) on one element fits snugly into a hole designed for it (mortise) on the other. Such joints are very strong and flexible.

mosaic Images formed by small colored stone or glass pieces (tesserae), affixed to a hard, stable surface.

mosque An edifice used for communal Muslim worship.

mudra A symbolic hand gesture in Buddhist art that denotes certain behaviors, actions, or feelings.

mullion A slender vertical element or **colonnette** that divides a window into subsidiary sections.

muqarnas Small nichelike components stacked in tiers to fill the transition between differing vertical and horizontal planes.

naos The principal room in a temple or church. In ancient architecture, the **cella**. In a Byzantine church, the **nave** and **sanctuary**.

narthex The vestibule or entrance porch of a church.

naturalism, naturalistic A style of depiction that seeks to imitate the appearance of nature. A naturalistic work appears to record the visible world.

nave The central space of a **basilica**, two or three stories high and usually flanked by **aisles**.

necking The molding at the top of the **shaft** of the **column**.

necropolis A large cemetery or burial area; literally a "city of the dead."

nemes headdress The royal headdress of Egypt.

niello A metal technique in which a black sulfur alloy is rubbed into fine lines engraved into a metal (usually gold or silver). When heated, the alloy becomes fused with the surrounding metal and provides contrasting detail.

nishiki-e A multicolored and ornate Japanese print.

nocturne A night scene in painting, usually lit by artificial illumination.

nonrepresentational art An **abstract** art that does not attempt to reproduce the appearance of objects, figures, or scenes in the natural world. Also called nonobjective art.

oculus (oculi) In architecture, a circular opening. Oculi are usually found either as windows or at the apex of a **dome**. When at the top of a dome, an oculus is either open to the sky or covered by a decorative exterior lantern.

ogee An S-shaped curve. See **arch**.

olpe Any Greek vase or jug without a spout.

one-point perspective See **perspective**.

opithodomos In greek temples, the entrance porch or room at the back.

oracle A person, usually a priest or priestess, who acts as a conduit for divine information. Also: the information itself or the place at which this information is communicated.

orant The representation of a standing figure praying with outstretched and upraised arms.

orchestra The circular performance area of an ancient Greek theater. In later architecture, the section of seats nearest the stage or the entire main floor of the theater.

order A system of proportions in Classical architecture that includes every aspect of the building's plan, elevation, and decorative system. Composite: a combination of the Ionic and the Corinthian orders. The **capital** combines acanthus leaves with **volute** scrolls. **Corinthian:** the most ornate of the orders, the Corinthian includes a **base**, a fluted **column shaft** with a capital elaborately decorated with acanthus leaf carvings. Its **entablature** consists of an **architrave** decorated with **moldings**, a **frieze** often containing **sculptured reliefs**, and a **cornice** with dentils. Doric: the column shaft of the Doric order can be fluted or smooth-surfaced and has no base. The Doric capital consists of an undecorated **echinus** and **abacus**. The Doric entablature has a plain architrave, a frieze with **metopes** and **triglyphs**, and a simple cornice. Ionic: the column of the Ionic order has a base, a fluted shaft, and a capital decorated with volutes. The Ionic entablature consists of an architrave of three panels and moldings, a frieze usually containing sculpted relief ornament, and a cornice with dentils. **Tuscan:** a variation of Doric characterized by a smooth-surfaced column shaft with a base, a plain architrave, and an undecorated frieze. A colossal order is any of the above built on a large scale, rising through several stories in height and often raised from the ground by a **pedestal**.

orthogonal Any line running back into the represented space of a picture perpendicular to the imagined picture plane. In linear perspective, all orthogonals converge at a single **vanishing point** in the picture and are the basis for a **grid** that maps out the internal space of the image. An orthogonal plan is any plan for a building or city that is based exclusively on right angles, such as the grid plan of many modern cities.

pagoda An East Asian **reliquary** tower built with successively smaller, repeated stories. Each story is usually marked by an elaborate projecting roof.

palace complex A group of buildings used for living and governing by a ruler and his or her supporters, usually fortified.

palmette A fan-shaped ornament with radiating leaves.

parapet A low wall at the edge of a balcony, bridge, roof, or other place from which there is a steep drop, built for safety. A parapet walk is the passageway, usually open, immediately behind the uppermost exterior wall or battlement of a fortified building.

parchment A writing surface made from treated skins of animals. Very fine parchment is known as **vellum**.

parterre An ornamental, highly regimented flowerbed. An element of the ornate gardens of seventeenth-century palaces and châteaux.

pastel Dry pigment, chalk, and gum in stick or crayon form. Also: a work of art made with pastels.

pedestal A platform or **base** supporting a sculpture or other monument. Also: the block found below the base of a Classical **column** (or **colonnade**), serving to raise the entire element off the ground.

pediment A triangular gable found over major architectural elements such as Classical Greek **porticoes**, windows, or doors. Formed by an **entablature** and the ends of a sloping roof or a raking **cornice**. A similar architectural element is often used decoratively above a door or window, sometimes with a curved upper **molding**. A broken pediment is a variation on the traditional pediment, with an open space at the center of the topmost angle and/or the horizontal cornice.

pendentive The concave triangular section of a **vault** that forms the transition between a square or polygonal space and the circular base of a **dome**.

peplos A loose outer garment worn by women of ancient Greece. A cloth rectangle fastened on the shoulders and belted below the bust or at the waist.

peripteral A term used to describe any building (or room) that is surrounded by a single row of columns. When such **columns** are engaged instead of freestanding, called pseudo-peripteral.

peristyle A surrounding **colonnade** in Greek architecture. A peristyle building is surrounded on the exterior by a colonnade. Also: a peristyle court is an open colonnaded courtyard, often having a pool and garden.

perspective A system for representing three-dimensional space on a two-dimensional surface. **Atmospheric** perspective: A method of rendering the effect of spatial distance by subtle variations in color and clarity of representation. **Intuitive perspective:** A method of giving the impression of recession by visual instinct, not by the use of an overall system or program. Oblique perspective: An intuitive spatial system in which a building or room is placed with one corner in the picture plane, and the other parts of the structure recede to an imaginary vanishing point on its other side. Oblique perspective is not a comprehensive, mathematical system. **One-point** and multiple-point **perspective** (also called linear, scientific or mathematical perspective): A method of creating the illusion of three-dimensional space on a two-dimensional surface by delineating a horizon line and multiple orthogonal lines. These recede to meet at one or more points on the horizon (called **vanishing** points), giving the appearance of spatial depth. Called scientific or mathematical because its use requires some

knowledge of geometry and mathematics, as well as optics. **Reverse perspective:** A Byzantine perspective theory in which the orthogonals or rays of sight do not converge on a vanishing point in the picture, but are thought to originate in the viewer's eye in front of the picture. Thus, in reverse perspective the image is constructed with orthogonals that diverge, giving a slightly tipped aspect to objects.

photomontage A photographic work created from many smaller photographs arranged (and often overlapping) in a composition.

picture plane The theoretical spatial plane corresponding with the actual surface of a painting.

picture stone A medieval northern European memorial stone covered with figural decoration. See also **rune stone**.

picturesque A term describing the taste for the familiar, the pleasant, and the pretty, popular in the eighteenth and nineteenth centuries in Europe. When contrasted with the sublime, the picturesque stood for all that was ordinary but pleasant.

piece-mold casting A casting technique in which the mold consists of several sections that are connected during the pouring of molten metal, usually bronze. After the cast form has hardened, the pieces of the mold are disassembled, leaving the completed object.

pier A masonry support made up of many stones, or rubble and concrete (in contrast to a **column shaft** which is formed from a single stone or a series of **drums**), often square or rectangular in plan, and capable of carrying very heavy architectural loads.

pietra dura Italian for "hard stone." Semi-precious stones selected for color variation and cut in shapes to form ornamental designs such as flowers or fruit.

pietra serena A gray Tuscan limestone used in Florence.

pilaster An **engaged** columnar element that is rectangular in format and used for decoration in architecture.

pillar In architecture, any large, freestanding vertical element. Usually functions as an important weight-bearing unit in buildings.

plate tracery See **tracery**.

plinth The slablike **base** or **pedestal** of a **column**, statue, wall, building, or piece of furniture.

pluralism A social structure or goal that allows members of diverse ethnic, racial, or other groups to exist peacefully within the society while continuing to practice the customs of their own divergent cultures. Also: an adjective describing the state of having many valid contemporary styles available at the same time to artists.

podium A raised platform that acts as the foundation for a building, or as a platform for a speaker.

polychrome See **polychromy**.

polychromy The multicolored painted decoration applied to any part of a building, sculpture, or piece of furniture.

polyptych An altarpiece constructed from multiple panels, sometimes with hinges to allow for movable wings.

porcelain A high-fired, vitrified, translucent, white **ceramic** ware that employs two specific clays—kaolin and petuntse—and that is fired in the range of 1,300 to 1,400 degrees Celsius. The

relatively high proportion of silica in the body clays renders the finished porcelains translucent. Like **stonewares**, porcelains are glazed to enhance their aesthetic appeal and to aid in keeping them clean. By definition, porcelain is white, though it may be covered with a **glaze** of bright color or subtle hue. Chinese potters were the first in the world to produce porcelain, which they were able to make as early as the eighth century.

porch The covered entrance on the exterior of a building. With a row of **columns** or **colonnade**, also called a **portico**.

portal A grand entrance, door, or gate, usually to an important public building, and often decorated with sculpture.

portico In architecture, a projecting roof or porch supported by columns, often marking an entrance. See also porch.

post-and-lintel construction An architectural system of construction with two or more vertical elements (posts) supporting a horizontal element (lintel).

potassium-argon dating Technique used to measure the decay of a radioactive potassium isotope into a stable isotope of argon, an inert gas.

potsherd A broken piece of ceramic ware.

Prairie Style A style of architecture initiated by the American Frank Lloyd Wright (1867-1959), in which he sought to integrate his structures in an "organic" way into the surrounding natural landscape, often having the lines of the building follow the horizontal contours of the land. Since Wright's early buildings were built in the Prairie States of the Midwest, this type of architecture became known as the Prairie Style.

primitivism The borrowing of subjects or forms usually from non-Western or prehistoric sources by Western artists. Originally practiced by Western artists as an attempt to infuse their work with the naturalistic and expressive qualities attributed to other cultures, especially colonized cultures, primitivism also borrowed from the art of children and the insane.

pronaos The enclosed vestibule of a Greek or Roman temple, found in front of the **cella** and marked by a row of **columns** at the entrance.

proscenium The stage of an ancient Greek or Roman theater. In modern theater, the area of the stage in front of the curtain. Also: the framing **arch** that separates a stage from the audience.

psalter In Jewish and Christian scripture, a book containing the psalms, or songs, attributed to King David.

punchwork Decorative designs that are stamped onto a surface, such as metal or leather, using a punch (a handheld metal implement).

putto (putti) A plump, naked little boy, often winged. In classical art, called a cupid; in Christian art, a cherub.

pylon A massive gateway formed by a pair of tapering walls of oblong shape. Erected by ancient Egyptians to mark the entrance to a temple complex.

qibla The mosque wall oriented toward Mecca indicated by the mihrab.

quatrefoil A four-lobed decorative pattern common in Gothic art and architecture.

quincunx A building in which five **domed** bays are arranged within a square, with a central unit and four corner units. (When the central unit has similar units extending from each side, the form becomes a **Greek cross**.)

quoin A stone, often extra large or decorated for emphasis, forming the corner of two walls. A vertical row of such stones is called quoining.

radiometric dating A method of dating prehistoric works of art made from organic materials, based on the rate of degeneration of radiocarbons in these materials. *See also* **relative dating, absolute dating.**

raigo A painted image that depicts the Amida Buddha and other Buddhist deities welcoming the soul of a dying worshiper to paradise.

raku A type of **ceramic** pottery made by hand, coated with a thick, dark **glaze**, and fired at a low heat. The resulting vessels are irregularly shaped and glazed, and are highly prized for use in the Japanese tea ceremony.

readymade An object from popular or material culture presented without further manipulation as an artwork by the artist.

realism In art, a term first used in Europe around 1850 to designate a kind of **naturalism** with a social or political message, which soon lost its didactic import and became synonymous with naturalism.

red-figure A style and technique of ancient Greek vase painting characterized by red clay-colored figures on a black background. (The figures are reversed against a painted ground and details are drawn, not engraved, as in black-figure style.) See also **black-figure.**

register A device used in systems of spatial definition. In painting, a register indicates the use of differing **groundlines** to differentiate layers of space within an image. In sculpture, the placement of self-contained bands of **reliefs** in a vertical arrangement. In printmaking, the marks at the edges used to align the print correctly on the page, especially in multiple-block color printing.

registration marks In Japanese **woodblock** printing, these were two marks carved on the blocks to indicate proper alignment of the paper during the printing process. In multicolor printing, which used a separate block for each color, these marks were essential for achieving the proper position or registration of the colors.

relative dating See also **radiometric dating**.

relief sculpture A three-dimensional image or design whose flat background surface is carved away to a certain depth, setting off the figure. Called high or **low (bas) relief** depending upon the extent of projection of the image from the background. Called **sunken relief** when the image is carved below the original surface of the background, which is not cut away.

reliquary A container, often made of precious materials, used as a repository to protect and display sacred relics.

repoussé A technique of hammering metal from the back to create a protruding image. Elaborate reliefs are created with wooden armatures against which the metal sheets are pressed and hammered.

reverse perspective See **perspective**.

rhyton A vessel in the shape of a figure or an animal, used for drinking or pouring liquids on special occasions.

rib vault See **vault**.

ridgepole A longitudinal timber at the apex of a roof that supports the upper ends of the rafters.

rosette A round or oval ornament resembling a rose.

rotunda Any building (or part thereof) constructed in a circular (or sometimes polygonal) shape, usually producing a large open space crowned by a **dome**.

round arch See **arch.**

roundel Any element with a circular format, often placed as a decoration on the exterior of architecture.

rune stone A stone used in early medieval northern Europe as a commemorative monument, which is carved or inscribed with runes, a writing system used by early Germanic peoples.

running spirals A decorative motif based on the shape formed by a line making a continuous spiral.

rustication In building, the rough, irregular, and unfinished effect deliberately given to the exterior facing of a stone edifice. Rusticated stones are often large and used for decorative emphasis around doors or windows, or across the entire lower floors of a building. Also, masonry construction with conspicuous, often beveled joints.

salon A large room for entertaining guests; a periodic social or intellectual gathering, often of prominent people; a hall or **gallery** for exhibiting works of art.

sanctuary A sacred or holy enclosure used for worship. In ancient Greece and Rome, consisted of one or more temples and an altar. In Christian architecture, the space around the altar in a church called the chancel or presbytery.

sarcophagus (sarcophagi) A stone coffin. Often rectangular and decorated with **relief sculpture**.

scarab In Egypt, a stylized dung beetle associated with the sun and the god Amun.

scarification Ornamental decoration applied to the surface of the body by cutting the skin for cultural and/or aesthetic reasons.

school of artists An art historical term describing a group of artists, usually working at the same time and sharing similar styles, influences, and ideals. The artists in a particular school may not necessarily be directly associated with one another, unlike those in a workshop or **atelier**.

scribe A writer; a person who copies texts.

scriptorium (scriptoria) A room in a monastery for writing or copying manuscripts.

scroll painting A painting executed on a rolled support. Rollers at each end permit the horizontal scroll to be unrolled as it is studied or the vertical scroll to be hung for contemplation or decoration.

seals Personal emblems usually carved of stone in **intaglio** or **relief** and used to stamp a name or legend onto paper or silk. They traditionally employ the archaic characters appropriately known as "seal script," of the Zhou or Qin. Cut in stone, a seal may state a formal given name, or it may state any of the numerous personal names that China's painters and writers adopted throughout their lives. A treasured work of art often bears not only the seal of its maker but also those of collectors and admirers through the centuries. In the Chinese view, these do not disfigure the work but add another layer of interest.

seraph (seraphim) An angel of the highest rank in the Christian hierarchy.

serdab In Egyptian tombs, the small room in which the ka statue was placed.

sfumato Italian term meaning "smoky," soft, and mellow. In painting, the effect of haze in an image. Resembling the color of the atmosphere at dusk, sfumato gives a smoky effect.

sgraffito Decoration made by incising or cutting away a surface layer of material to reveal a different color beneath.

shaft The main vertical section of a column between the capital and the base, usually circular in cross section.

shaftgrave A deep pit used for burial.

shikhara In the architecture of northern India, a conical (or pyramidal) spire found atop a Hindu temple and often crowned with an **amalaka**.

shoji A standing Japanese screen covered in translucent rice paper and used in interiors.

sinopia The preparatory design or underdrawing of a **fresco**. Also: a reddish chalklike earth pigment.

site-specific sculpture A sculpture commissioned and/or designed for a particular spot.

slip A mixture of clay and water applied to a **ceramic** object as a final decorative coat. Also: a solution that binds different parts of a vessel together, such as the handle and the main body.

spandrel The area of wall adjoining the exterior curve of an arch between its **springing** and the **keystone**, or the area between two arches, as in an **arcade**.

springing The point at which the curve of an arch or vault meets with and rises from its support.

squinch An **arch** or lintel built across the upper corners of a square space, allowing a circular or polygonal **dome** to be more securely set above the walls.

stained glass Molten glass is given a color that becomes intrinsic to the material. Additional colors may be fused to the surface (flashing). Stained glass is most often used in windows, for which small pieces of differently colored glass are precisely cut and assembled into a design, held together by **cames**. Additional painted details may be added to create images.

stele (stelae) A stone slab placed vertically and decorated with inscriptions or reliefs. Used as a grave marker or memorial.

stereobate A foundation upon which a Classical temple stands.

still life A type of painting that has as its subject inanimate objects (such as food, dishes, fruit, or flowers).

stoa In Greek architecture, a long roofed walkway, usually having columns on one long side and a wall on the other.

stoneware A high-fired, vitrified, but opaque **ceramic** ware that is fired in the range of 1,100 to 1,200 degrees Celsius. At that temperature, particles of silica in the clay bodies fuse together so that the finished vessels are impervious to liquids, even without **glaze**. Stoneware pieces are glazed to enhance their aesthetic appeal and to aid in keeping them clean (since unglazed ceramics are easily soiled). Stoneware occurs in a range of earth-toned colors, from white and tan to gray and black, with light gray predominating. Chinese potters were the first in the world to produce stoneware, which they were able to make as early as the Shang dynasty.

stucco A mixture of lime, sand, and other ingredients into a material that can be easily molded or modeled. When dry, produces a very durable surface used for covering walls or for architectural sculpture and decoration.

stupa In Buddhist architecture, a bell-shaped or pyramidal religious monument, made of piled earth or stone, and containing sacred relics.

stylobate In Classical architecture, the stone foundation on which a temple **colonnade** stands.

stylus An instrument with a pointed end (used for writing and printmaking), which makes a delicate line or scratch. Also: a special writing tool for **cuneiform** writing with one pointed end and one triangular wedge end.

sublime Adjective describing a concept, thing, or state of high spiritual, moral, or intellectual value; or something awe-inspiring. The sublime was a goal to which many nineteenth-century artists aspired in their artworks.

sunken relief See **relief sculpture**.

syncretism In religion or philosophy, the union of different ideas or principles.

taotie A mask with a dragon or animal-like face common as a decorative motif in Chinese art.

tapestry Multicolored pictorial or decorative weaving meant to be hung on a wall or placed on furniture.

tatami Mats of woven straw used in Japanese houses as a floor covering.

tempera A painting medium made by blending egg yolks with water, pigments, and occasionally other materials, such as glue.

tenebrism The use of strong **chiaroscuro** and artificially illuminated areas to create a dramatic contrast of light and dark in a painting.

terra cotta A medium made from clay fired over a low heat and sometimes left unglazed. Also: the orange-brown color typical of this medium.

tessera (tesserae) The small piece of stone, glass, or other object that is pieced together with many others to create a mosaic.

tetrarchy Four-man rule, as in the late Roman Empire, when four emperors shared power.

thatch A roof made of plant materials.

thermo-luminescence dating A technique that measures the irradiation of the crystal structure of material such as flint or pottery and the soil in which it is found, determined by luminescence produced when a sample is heated.

tholos A small, round building. Sometimes built underground, as in a Mycenaean tomb.

thrust The outward pressure caused by the weight of a vault and supported by buttressing. See **arch**.

tierceron In **vault** construction, a secondary rib that arcs from a **springing** point to the rib that runs lengthwise through the vault, called the ridge rib.

tokonoma A niche for the display of an art object (such as a screen, scroll, or flower arrangement) in a Japanese hall or tearoom.

tondo A painting or **relief sculpture** of circular shape.

torana In Indian architecture, an ornamented gateway arch in a temple, usually leading to the stupa.

toron In West African **mosque** architecture, the wooden beams that project from the walls. Torons are used as support for the scaffolding erected annually for the replastering of the building.

tracery Stonework or woodwork applied to wall surfaces or filling the open space of windows. In **plate tracery**, opening are cut through the wall. In **bar tracery**, **mullions** divide the space into vertical segments and form decorative patterns at the top of the opening or panel.

transept The arm of a cruciform church, perpendicular to the **nave**. The point where the nave and transept cross is called the crossing. Beyond the crossing lies the **sanctuary**, whether **apse**, choir, or chevet.

travertine A mineral building material similar to limestone, typically found in central Italy.

trefoil An ornamental design made up of three rounded lobes placed adjacent to one another.

triglyph Rectangular block between the **metopes** of a **Doric frieze**. Identified by the three carved vertical grooves, which approximate the appearance of the end of a wooden beam.

triptych An artwork made up of three panels. The panels may be hinged together so the side segments (**wings**) fold over the central area.

trompe l'oeil A manner of representation in which the appearance of natural space and objects is re-created with the express intention of fooling the eye of the viewer, who may be convinced that the subject actually exists as three-dimensional reality.

trumeau A column, pier, or post found at the center of a large portal or doorway, supporting the lintel.

tugra A calligraphic imperial monogram used in Ottoman courts.

Tuscan order See **order**.

twisted perspective A convention in art in which every aspect of a body or object is represented from its most characteristic viewpoint.

ukiyo-e A Japanese term for a type of popular art that was favored from the sixteenth century, particularly in the form of color **woodblock prints**. Ukiyo-e prints often depicted the world of the common people in Japan, such as courtesans and actors, as well as landscapes and myths.

urna In Buddhist art, the curl of hair on the forehead that is a characteristic mark of a buddha. The urna is a symbol of divine wisdom.

ushnisha In Asian art, a round turban or tiara symbolizing royalty and, when worn by a buddha, enlightenment.

vanishing point In a **perspective** system, the point on the horizon line at which **orthogonals** meet. A complex system can have multiple vanishing points.

vanitas An image, especially popular in Europe during the seventeenth century, in which all the objects symbolize the transience of life. Vanitas paintings are usually of **still lifes** or **genre** subjects.

vault An **arched** masonry structure that spans an interior space. Barrel or tunnel vault: an elongated or continuous semicircular vault, shaped like a half-cylinder. **Corbeled** vault: a vault made by projecting courses of stone. **Groin** or cross vault: a vault created by the intersection of two barrel vaults of equal size which creates four side compartments of identical size and shape. Quadrant or half-barrel vault: as the name suggests, a half-barrel vault. Rib vault: ribs (extra masonry) demarcate the junctions of a groin vault. Ribs may function to reinforce the groins or may be purely decorative. See also **corbeling**.

veduta (vedute) Italian for "vista" or "view."

Paintings, drawings, or prints often of expansive city scenes or of harbors.

vellum A fine animal skin prepared for writing and painting. See also parchment.

veneer In architecture, the exterior facing of a building, often in decorative patterns of fine stone or brick. In decorative arts, a thin exterior layer of finer material (such as rare wood, ivory, metal, and semiprecious stones) laid over the form.

verism A style in which artists concern themselves with capturing the exterior likeness of an object or person, usually by rendering its visible details in a finely executed, meticulous manner.

vihara From the Sanskrit term meaning "for wanderers." A vihara is, in general, a Buddhist monastery in India. It also signifies monks' cells and gathering places in such a monastery.

vimana The main element of a Southern Indian Hindu temple, usually in the shape of a pyramidal or tapering tower raised on a **plinth**.

volute A spiral scroll, as seen on an Ionic **capital**.

votive figure An image created as a devotional offering to a god or other deity.

voussoirs The oblong, wedge-shaped stone blocks used to build an **arch**. The topmost voussoir is called a **keystone**.

warp The vertical threads in a weaver's loom. Warp threads make up a fixed framework that provides the structure for the entire piece of cloth, and are thus often thicker than **weft** threads. See also **weft**.

wash A diluted watercolor or ink. Often washes are applied to drawings or prints to add tone or touches of color.

wattle and daub A wall construction method combining upright branches, woven with twigs (wattles) and plastered or filled with clay or mud (daub).

weft The horizontal threads in a woven piece of cloth. Weft threads are woven at right angles to and through the **warp** threads to make up the bulk of the decorative pattern. In carpets, the weft is often completely covered or formed by the rows of trimmed knots that form the carpet's soft surface. See also **warp**.

white-ground A type of ancient Greek pottery in which the background color of the object is painted with a slip that turns white in the firing process. Figures and details were added by painting on or **incising** into this **slip**. White-ground wares were popular in the Classical period as funerary objects.

wing A side panel of a **triptych** or **polyptych** (usually found in pairs), which was hinged to fold over the central panel. Wings often held the depiction of the donors and/or subsidiary scenes relating to the central image.

woodblock print A print made from one or more carved wooden blocks. In Japan, woodblock prints were made using multiple blocks carved in relief, usually with a block for each color in the finished print. See also **woodcut**.

woodcut A type of print made by carving a design into a wooden block. The ink is applied to the block with a roller. As the ink remains only on the raised areas between the carved-away lines, these carved-away areas and lines provide the white areas of the print. Also: the process by which the woodcut is made.

x-ray style In Aboriginal art, a manner of representation in which the artist depicts a figure or animal by illustrating its outline as well as essential internal organs and bones.

yaksha, yakshi The male (yaksha) and female (yakshi) nature spirits that act as agents of the Hindu gods. Their sculpted images are often found on Hindu temples and other sacred places, particularly at the entrances.

ziggurat In Mesopotamia, a tall stepped tower of earthen materials, often supporting a shrine.

BIBLIOGRAPHY

Susan V. Craig

This bibliography is composed of books in English that are appropriate "further reading" titles. Most items on this list are available in good libraries, whether college, university, or public institutions. I have emphasized recently published works so that the research information would be current. There are three classifications of listings: general surveys and art history reference tools, including journals and Internet directories; surveys of large periods that encompass multiple chapters (ancient art in the Western tradition, European medieval art, European Renaissance through eighteenth-century art, modern art in the West, Asian art, and African and Oceanic art and art of the Americas); and books for individual chapters 1 through 32.

General Art History Surveys and Reference Tools

Adams, Laurie Schneider. *Art across Time*. 2nd ed. New York: McGraw-Hill, 2002.

Barnet, Sylvan. *A Short Guide to Writing about Art*. 8th ed. New York: Pearson/Longman, 2005.

Boström, Antonia. *Encyclopedia of Sculpture*. 3 vols. New York: FitzroyDearborn, 2004.

Broude, Norma, and Garrard, Mary D., eds. *Feminism and Art History: Questioning the Litany*. Icon Editions. New York: Harper & Row, 1982.

Chadwick, Whitney. *Women, Art, and Society*. 3rd ed. New York: Thames and Hudson, 2002.

Chilvers, Ian, ed. The Oxford Dictionary of Art. 3rd ed. New York: Oxford Univ. Press, 2004.

Curl, James Stevens. *A Dictionary of Architecture and Landscape Architecture*. 2nd ed. Oxford: Oxford Univ. Press, 2006.

Davies, Penelope J.E., et al. *Janson's History of Art: The Western Tradition*. 7th ed. Upper Saddle River, NJ: Prentice Hall, 2006.

Dictionary of Art, The. 34 vols. New York: Grove's Dictionaries, 1996.

Encyclopedia of World Art. 16 vols. New York: McGraw-Hill, 1972–83.

Frank, Patrick, Duane Preble, and Sarah Preble. *Preble's Artforms*. 8th ed. Upper Saddle River, NJ: Prentice Hall, 2006.

Gardner, Helen. *Gardner's Art through the Ages*. 12th ed. Ed. Fred S. Kleiner & Christin J. Mamiya. Belmont, CA: Thomson/Wadsworth, 2005.

Gaze, Delia, ed. *Dictionary of Women Artists*. 2 vols. London: Fitzroy Dearborn Publishers, 1997.

Griffiths, Antony. *Prints and Printmaking: An Introduction to the History and Techniques*. 2nd ed. London: British Museum Press, 1996.

Hadden, Peggy. *The Quotable Artist*. New York: Allworth Press, 2002.

Hall, James. *Illustrated Dictionary of Symbols in Eastern and Western Art*. New York: Icon Editions, 1994.

Holt, Elizabeth Gilmore, ed. *A Documentary History of Art*. 3 vols. New Haven: Yale Univ. Press, 1986.

Honour, Hugh, and John Fleming. *The Visual Arts: A History*. 7th ed. Upper Saddle River, NJ: Prentice Hall, 2005.

Hults, Linda C. *The Print in the Western World: An Introductory History*. Madison: Univ. of Wisconsin Press, 1996.

Johnson, Paul. Art: *A New History*. New York: HarperCollins, 2003.

Kaltenbach. G. E. *Pronunciation Dictionary of Artists' Names*. 3rd ed. Rev. Debra Edelstein. Boston: Little, Brown, and Co., 1993.

Kemp, Martin. *The Oxford History of Western Art*. Oxford: Oxford Univ. Press, 2000.

Kostof, Spiro. *A History of Architecture: Settings and Rituals*. 2nd ed. Rev. Greg Castillo. New York: Oxford Univ. Press, 1995.

Mackenzie, Lynn. *Non-Western Art: A Brief Guide*. 2nd ed. Upper Saddle River, NJ: Prentice Hall, 2001.

Marmor, Max, and Alex Ross, eds. *Guide to the Literature of Art History 2*. Chicago: American Library Association, 2005.

Onians, John, ed. *Atlas of World Art*. New York: Oxford Univ. Press, 2004.

Roberts, Helene, ed. *Encyclopedia of Comparative Iconography: Themes Depicted in Works of Art*. 2 vols. Chicago: Fitzroy Dearborn, 1998.

Rogers, Elizabeth Barlow. *Landscape Design: A Cultural and Architectural History*. New York: Harry N. Abrams, 2001.

Sayre, Henry M. *Writing about Art*. 5th ed. Upper Saddle River, NJ: Pearson/Prentice Hall, 2006.

Sed-Rajna, Gabrielle. *Jewish Art*. Trans. Sara Friedman and Mira Reich. New York: Abrams, 1997.

Slatkin, Wendy. *Women Artists in History: From Antiquity to the Present*. 4th ed. Upper Saddle River, NJ: Prentice Hall, 2000.

Sutton, Ian. *Western Architecture: From Ancient Greece to the Present*. World of Art. New York: Thames and Hudson, 1999.

Trachtenberg, Marvin, and Isabelle Hyman. *Architecture: From Prehistory to Postmodernity*. 2nd ed. Upper Saddle River, NJ: Prentice Hall, 2001.

Tufts, Eleanor. Our Hidden Heritage: *Five Centuries of Women Artists*. New York: Paddington Press, 1974.

West, Shearer. *Portraiture*. Oxford History of Art. Oxford: Oxford Univ. Press, 2004.

Wilkins, David G., Bernard Schultz, and Katheryn M. Linduff. *Art Past, Art Present*. 5th ed. Upper Saddle River, NJ: Prentice Hall, 2005.

Watkin, David. *A History of Western Architecture*. 4th ed. New York: Watson-Guptill Publications, 2005.

Art History Journals: A Select List of Current Titles

African Arts. Quarterly. Los Angeles: Univ. of California at Los Angeles, James S. Coleman African Studies Center, 1967–

American Art: The Journal of the Smithsonian American Art Museum. 3/year. Chicago: Univ. of Chicago Press, 1987–

American Indian Art Magazine, Quarterly. Scottsdale, AZ: American Indian Art Inc, 1975–

American Journal of Archaeology. Quarterly. Boston: Archaeological Institute of America, 1885–

Antiquity: A Periodical of Archaeology. Quarterly. Cambridge, UK: Antiquity Publications Ltd, 1927–

Apollo: The International Magazine of the Arts. Monthly. London: Apollo Magazine Ltd, 1925–

Architectural History. Annually. Farnham, UK: Society of Architectural Historians of Great Britain, 1958–

Archives of American Art Journal. Quarterly. Washington, D.C.: Archives of American Art, Smithsonian Institution, 1960–

Archives of Asian Art. Annually. New York: Asia Society, 1945–

Ars Orientalis: The Arts of Asia, Southeast Asia, and Islam. Annually. Ann Arbor: Univ. of Michigan Dept. of Art History, 1954–

Art Bulletin. Quarterly. New York: College Art Association, 1913–

Art History: Journal of the Association of Art Historians. 5/year. Oxford: Blackwell Publishing Ltd, 1978–

Art in America. Monthly. New York: Brant Publications Inc, 1913–

Art Journal. Quarterly. New York: College Art Association, 1960–

Art Nexus. Quarterly. Bogata, Colombia: Arte en Colombia Ltda, 1976–

Art Papers Magazine. Bi-monthly. Atlanta: Atlanta Art Papers Inc, 1976–

Artforum International. 10/year. New York: Artforum International Magazine Inc, 1962–

Artnews. 11/year. New York: Artnews LLC, 1902–

Bulletin of the Metropolitan Museum of Art. Quarterly. New York: Metropolitan Museum of Art, 1905–.

Burlington Magazine. Monthly. London: Burlington Magazine Publications Ltd, 1903–

Dumbarton Oaks Papers. Annually. Locust Valley, NY: J. J. Augustin Inc, 1940–

Flash Art International. Bimonthly. Trevi, Italy: Giancarlo Politi Editore, 1980–

Gesta. Semiannually. New York: International Center of Medieval Art, 1963–

History of Photography. Quarterly. Abingdon, UK: Taylor & Francis Ltd, 1976–

International Review of African American Art. Quarterly. Hampton, VA: International Review of African American Art, 1976–

Journal of Design History. Quarterly. Oxford: Oxford Univ. Press, 1988–

Journal of Egyptian Archaeology. Annually. London: Egypt Exploration Society, 1914–

Journal of Hellenic Studies. Annually. London: Society for the Promotion of Hellenic Studies, 1880–

Journal of Roman Archaeology. Annually. Portsmouth, RI: Journal of Roman Archaeology LLC, 1988–

Journal of the Society of Architectural Historians. Quarterly. Chicago: Society of Architectural Historians, 1940–

Journal of the Warburg and Courtauld Institutes. Annually. London: Warburg Institute, 1937–

Leonardo: Art, Science and Technology. 6/year. Cambridge, MA: MIT Press, 1968–

Marg. Quarterly. Mumbai, India: Scientific Publishers, 1946–

Master Drawings. Quarterly. New York: Master Drawings Association, 1963–

October. Cambridge, MA: MIT Press, 1976–

Oxford Art Journal. 3/year. Oxford: Oxford Univ. Press, 1978–

Parkett. 3/year. Züürich, Switzerland: Parkett Verlag AG, 1984–

Print Quarterly. Quarterly. London: Print Quarterly Publications, 1984–

Simiolus: Netherlands Quarterly for the History of Art. Quarterly. Apeldoorn, Netherlands: Stichting voor Nederlandse Kunsthistorische Publicaties, 1966–

Woman's Art Journal. Semiannually. Philadelphia: Old City Publishing Inc, 1980–

Internet Directories for Art History Information

ARCHITECTURE AND BUILDING

http://library.nevada.edu/arch/rsrce/webrsrce/contents.html

A directory of architecture websites collected by Jeanne Brown at the Univ. of Nevada at Las Vegas. Topical lists include architecture, building and construction, design, history, housing, planning, preservation, and landscape architecture. Most entries include a brief annotation and the last date the link was accessed by the compiler.

ART HISTORY RESOURCES ON THE WEB

http://witcombe.sbc.edu/ARTHLinks.html

Authored by Christopher L. C. E. Witcombe of Sweet Briar College in Virginia since 1995, the site includes an impressive number of links for various art historical eras as well as links to research resources, museums, and galleries. The content is frequently updated.

ART IN FLUX: A DIRECTORY OF RESOURCES FOR RESEARCH IN CONTEMPORARY ART

http://www.boisestate.edu/art/artinflux/intro.html

Cheryl K. Shutleff of Boise State Univ. in Idaho has authored this directory, which includes sites selected according to their relevance to the study of national or international contemporary art and artists. The subsections include artists, museums, theory, reference, and links.

ARTCYCLOPEDIA: THE FINE ARTS SEARCH ENGINE

With over 2,100 art sites and 75,000 links, this is one of the most comprehensive web directories for artists and art topics.

The primary searching is by artist's name but access is also available by artistic movement, nation, timeline and medium.

MOTHER OF ALL ART HISTORY LINKS PAGES

http://www.art-design.umich.edu/mother/

Maintained by the Dept. of the History of Art at the Univ. of Michigan, this directory covers art history departments, art museums, fine arts schools and departments as well as links to research resources. Each entry includes annotations.

VOICE OF THE SHUTTLE

http://vos.ucsb.edu

Sponsored by Univ. of California, Santa Barbara, this directory includes over 70 pages of links to humanities

and humanities-related resources on the Internet. The structured guide includes specific sub-sections on architecture, on art (modern & contemporary), and on art history. Links usually include a one sentence explanation and the resource is frequently updated with new information.

YAHOO! ARTS>ART HISTORY
http://dir.yahoo.com/Arts/Art_History/
Another extensive directory of art links organized into subdivisions with one of the most extensive being "Periods and Movements." Links include the name of the site as well as a few words of explanation.

European Renaissance through Eighteenth-Century Art, General

Black, C. F., et al. *Cultural Atlas of the Renaissance.* New York: Prentice Hall General Reference, 1993.

Blunt, Anthony. *Art and Architecture in France, 1500–1700.* 5th ed. Rev. Richard Beresford. Pelican History of Art. New Haven: Yale Univ. Press, 1999.

Brown, Jonathan. *Painting in Spain: 1500–1700.* Pelican History of Art. New Haven: Yale Univ. Press, 1998.

Cole, Bruce. *Italian Art, 1250–1550: The Relation of Renaissance Art to Life and Society.* New York: Harper & Row, 1987.

Graham-Dixon, Andrew. *Renaissance.* Berkeley: Univ. of California Press, 1999.

Harbison, Craig. *The Mirror of the Artist: Northern Renaissance Art in Its Historical Context.* Perspectives. New York: Abrams, 1995.

Harris, Ann Sutherland. *Seventeenth-Century Art & Architecture.* Upper Saddle River, NJ: Pearson Prentice Hall, 2005

Harrison, Charles, Paul Wood, and Jason Gaiger. *Art in Theory 1648–1815: An Anthology of Changing Ideas.* Oxford: Blackwell, 2000.

Hartt, Frederick, and David G. Wilkins. *History of Italian Renaissance Art: Painting, Sculpture, Architecture.* 6th ed. Upper Saddle River, NJ: Prentice Hall, 2007.

Jestaz, Bertrand. *The Art of the Renaissance.* Trans. I. Mark Paris. New York: Abrams, 1995.

Levenson, Jay A., ed. *Circa 1492: Art in the Age of Exploration.* Washington: National Gallery of Art, 1991.

McCorquodale, Charles. *The Renaissance: European Painting, 1400–1600.* London: Studio Editions, 1994.

Minor, Vernon Hyde. *Baroque & Rococo: Art & Culture.* New York: Abrams, 1999.

Murray, Peter. *Renaissance Architecture.* History of World Architecture. Milan: Electa, 1985.

Paoletti, John T., and Gary M. Radke. *Art in Renaissance Italy.* 3rd ed. Upper Saddle River, NJ: Prentice Hall, 2006.

Ripa, Cesare. *Baroque and Rococo Pictorial Imagery: The 1758-60 Hertel Edition of Ripa's 'Iconologia.'* Introd., transl., & commentaries Edward A. Maser. The Dover Pictorial Archives Series. New York: Dover Publications, 1991

Smith, Jeffrey Chipps. *The Northern Renaissance.* Art & Ideas. New York: Phaidon Press, 2004.

Stechow, Wolfgang. *Northern Renaissance, 1400–1600: Sources and Documents.* Upper Saddle River, NJ: Prentice Hall, 1966.

Summerson, John. *Architecture in Britain, 1530–1830.* 9th ed. Yale Univ. Press Pelican History of Art. New Haven: Yale Univ. Press, 1993.

Waterhouse, Ellis K. *Painting in Britain, 1530 to 1790.* 5th ed. Yale Univ. Press Pelican History of Art. New Haven: Yale Univ. Press, 1994.

Whinney, Margaret Dickens. *Sculpture in Britain: 1530–1830.* 2nd ed. Rev. John Physick. Pelican History of Art. London: Penguin, 1988.

CHAPTER 17
Fourteenth Century Art in Europe

Alexander, Jonathan, and Paul Binski, eds. *Age of Chivalry: Art in Plantagenet England, 1200–1400.* London: Royal Academy of Arts, 1987.

Art from the Court of Burgundy: The Patronage of Philip the Bold and John the Fearless 1364-1419. Cleveland: The Cleveland Museum of Art, 2004.

Backhouse, Janet. *Illumination from Books of Hours.* London: British Library, 2004.

Boehm, Barbara Drake, and Jifíí Fajt, eds. *Prague: The Crown of Bohemia, 1347-1437.* New York: Metropolitan Museum, 2005.

Bony, Jean. *The English Decorated Style: Gothic Architecture Transformed, 1250-1350.* The Wrightsman Lecture, 10th. Oxford: Phaidon Press Limited, 1979.

Borsook, Eve. *The Mural Painters of Tuscany: From Cimabue to Andrea del Sarto.* 2nd ed. rev. & enlg. Oxford Studies in the History of Art and Architecture. Oxford: Clarendon Press 1980.

Branner, Robert. *St. Louis and the Court Style in Gothic Architecture.* Studies in Architecture, v. 7. London, A. Zwemmer, 1965.

Bruzelius, Caroline Astrid. *The 13th-Century Church at St-Denis. Yale Publications in the History of Art, 33.* New Haven: Yale University Press, 1985.

Fajt, Jifíí, ed. *Magister Theodoricus, Court Painter to Emperor Charles IV: The Pictorial Decoration of the Shrines at Karlstejn Castle.* Prague : National Gallery, 1998.

Ladis, Andrew. ed, *The Arena Chapel and the Genius of Giotto: Padua.* Giotto and the World of Early Italian Art, 2. New York: Garland Pub., 1998.

Moskowitz, Anita Fiderer. *Italian Gothic Sculpture: c. 1250-c. 1400.* New York: Cambridge Univ. Press, 2001.

Norman, Diana, ed. Siena, *Florence, and Padua: Art, Society, and Religion 1280-1400.* 2 vols. New Haven: Yale Univ. Press in assoc. with the Open Univ., 1995.

Paolucci, Antonio. *The Origins of Renaissance Art: The Baptistry Doors, Florence.* Trans. Franççoise Pouncey Chiarini. New York: George Braziller, 1996.

Poeschke, Joachim. *Italian Frescoes, the Age of Giotto, 1280-1400.* New York: Abbeville Press, 2005.

Welch, Evelyn S. *Art in Renaissance Italy, 1350-1500.* New Ed. Oxford: Oxford Univ. Press, 2000.

White, John. *Art and Architecture in Italy, 1250 to 1400.* 3rd ed. Pelican History of Art. Harmondsworth, UK: Penguin, 1993.

Wieck, Roger S. *Painted Prayers: The Book of Hours in Medieval and Renaissance Art.* New York: George Braziller in assoc. with the Pierpont Morgan Library, 1997.

Chapter 18
Fifteenth-Century Art in Northern Europe and the Iberian Peninsula

Baxandall, Michael. *The Limewood Sculptors of Renaissance Germany.* New Haven Yale Univ. Press, 1980.

Blum, Shirley. *Early Netherlandish Triptychs: A Study in Patronage.* California Studies in the History of Art. Berkeley: Univ. of California Press, 1969.

Borchert, Till-Holger. *Age of Van Eyck: The Mediterranean World and Early Netherlandish Painting, 1430-1530.* New York: Thames & Hudson, 2002.

Cavallo, Adolph S. *The Unicorn Tapestries at the Metropolitan Museum of Art.* New York: The Museum, 1998.

Chastel, Andrèè. *French Art: The Renaissance, 1430–1620.* Paris: Flammarion, 1995.

Dhanens, Elisabeth. Van Eyck: The Ghent Altarpiece. New York: Viking Press, 1973.

Flanders in the Fifteenth Century: Art and Civilization. Detroit: Detroit Institute of Arts, 1960.

Füüssel, Stephan. *Gutenberg and the Impact of Printing.* Trans. Douglas Martin. Burlington, VT: Ashgate Pub., 2005.

Kuskin, William, ed. *Caxton's Trace: Studies in the History of English Printing.* Notre Dame, IN: Univ. of Notre Dame Press, 2006.

Lane, Barbara G. *The Altar and the Altarpiece: Sacramental Themes in Early Netherlandish Painting.* New York: Harper & Row, 1984.

Marks, Richard, and Paul Williamson, eds. *Gothic: Art for England 1400-1547.* London: V & A, 2003.

Meiss, Millard. *French Painting in the Time of Jean de Berry: The Limbourgs and their Contemporaries.* 2 vols. New York: G. Braziller, 1974

Müüller, Theodor. *Sculpture in the Netherlands, Germany, France, and Spain: 1400–1500.* Trans. Elaine & William Robson Scott. Pelican History of Art. Harmondsworth, Eng.: Penguin, 1966.

Päächt, Otto. *Early Netherlandish Painting: From Rogier van der Weyden to Gerard David.* Ed. Monika Rosenauer. Trans. David Britt. London: Harvey Miller, 1997.

Panofsky, Erwin. *Early Netherlandish Painting.* Its Origins and Character. 2 vols. Cambridge, MA: Harvard Univ. Press, 1966.

Parshall, Peter W. and Rainer Schoch. *Origins of European Printmaking: Fifteenth-Century Woodcuts and their Public.* Washington, D.C.: National Gallery of Art, 2005.

Plummer, John. *The Last Flowering: French Painting in Manuscripts, 1420–1530, from American Collections.* New York: Pierpont Morgan Library, 1982.

Scott, Kathleen L. *Later Gothic Manuscripts, 1390–1490.* A Survey of Manuscripts Illuminated in the British Isles, 6. 2 vols. London: H. Miller, 1996.

Snyder, James. *Northern Renaissance Art: Painting, Sculpture, the Graphic Arts from 1350 to 1575.* 2nd.ed Rev. Larry

Silver and Henry Luttikhuizen. Upper Saddle River, NJ: Prentice Hall, 2005.

Vos, Dirk de. *The Flemish Primitives: The Masterpieces.* Princeton: Princeton Univ. Press, 2002.

Zuffi, Stefano. *European Art of the Fifteenth Century.* Trans. Brian D. Phillips. Art through the Centuries. Los Angeles: J. Paul Getty Museum, 2005.

Chapter 19
Renaissance Art in Fifteenth-Century Italy

Adams, Laurie Schneider. *Italian Renaissance Art.* Boulder, CO: Westview Press, 2001.

Ahl, Diane Cole, ed. *The Cambridge Companion to Masaccio.* New York: Cambridge Univ. Press, 2002.

Alexander, J.J.G. *The Painted Page: Italian Renaissance Book Illumination, 1450–1550.* Munich: Prestel, 1994.

Ames-Lewis, Francis. *Drawing in Early Renaissance Italy.* 2nd ed. New Haven: Yale Univ. Press, 2000.

——. *The Intellectual Life of the Early Renaissance Artist.* New Haven: Yale Univ. Press, 2000.

Baxandall, Michael. *Painting and Experience in Fifteenth-Century Italy: A Primer in the Social History of Pictorial style.* Oxford: Clarendon, 1972.

Boskovits, Miklóós. *Italian Paintings of the Fifteenth Century. The Collections of the National Gallery of Art.* Washington, D.C.: National Gallery of Art, 2003.

Botticelli and Filippino: Passion and Grace in Fifteenth-Century Florentine Painting. Milano: Skira, 2004.

Brown, Patricia Fortini. *Art and Life in Renaissance Venice.* Perspectives. New York: Harry N. Abrams, 1997. Reissued. Upper Saddle River, NJ: Prentice Hall, 2006.

Christianity and the Renaissance: Image and Religious Imagination in the Quattrocento. Syracuse, NY: Syracuse Univ. Press, 1990.

Christiansen, Keith, Laurence B. Kanter, and Carl Brandon Strehlke. P*ainting in Renaissance Siena, 1420–1500.* New York: Metropolitan Museum of Art, 1988.

Christine, de Pisan. *The Book of the City of Ladies.* Trans. Rosalind Brown-Grant. London: Penguin Books, 1999.

Gilbert, Creighton, ed. *Italian Art, 1400–1500: Sources and Documents.* Evanston: Northwestern Univ. Press, 1992.

Heydenreich, Ludwig Heinrich. *Architecture in Italy, 1400–1500.* Rev. Paul Davies. Pelican History of Art. New Haven: Yale Univ. Press, 1996.

Hind, Arthur M. *An Introduction to a History of Woodcut.* New York: Dover, 1963.

Huizinga, Johan. *The Autumn of the Middle Ages.* Trans. Rodney J. Payton & Ulrich Mammitzsch. Chicago: Univ. of Chicago Press, 1996.

Hyman, Timothy. *Sienese Painting: The Art of a City-Republic (1278-1477).* World of Art. New York: Thames & Hudson, 2003.

King, Ross. *Brunelleschi's Dome: How a Renaissance Genius Reinvented Architecture.* New York: Walker & Co., 2000.

Lavin, Marilyn Aronberg, ed. *Piero della Francesca and his Legacy.* Studies in the History of Art, 48: Symposium Papers, 28. Washington, D.C.: National Gallery of Art, 1995.

Levey, Michael. *Early Renaissance.* Harmondsworth, UK: Penguin, 1967.

Päächt, Otto. *Venetian Painting in the 15th Century: Jacopo, Gentile and Giovanni Bellini and Andrea Mantegna.* Ed. Margareta Vyoral-Tschapka & Michael Päächt. Trans. Fiona Elliott. London: Harvey Miller Pub., 2003.

Partridge, Loren W. *The Art of Renaissance Rome, 1400-1600.* Perspectives. New York: Harry N. Abrams, 1996. Reissue Ed. Upper Saddle River, NJ: Prentice Hall, 2006.

Poeschke, Joachim. *Donatello and his World: Sculpture of the Italian Renaissance.* Trans. Russell Stockman. New York: H. N. Abrams, 1993.

Randolph, Adrian W. B., *Engaging Symbols: Gender, Politics, and Public Art in Fifteenth-Century Florence.* New Haven: Yale Univ. Press, 2002.

Seymour, Charles. *Sculpture in Italy 1400–1500.* Pelican History of Art. Harmondsworth, UK: Penguin, 1966.

Troncelliti, Latifah. The Two Parallel Realities of Alberti and Cennini: The Power of Writing and the Visual Arts in the Italian Quattrocento. Studies in Italian Literature, v. 14. Lewiston, N.Y: Edwin Mellen Press, 2004.

Turner, Richard. *Renaissance Florence: The Invention of a New Art.* Perspectives. New York: Abrams, 1997. Reissue ed. Upper Saddle River, NJ: Prentice Hall, 2006.

Walker, Paul Robert. *The Feud that Sparked the Renaissance: How Brunelleschi and Ghiberti Changed the Art World.* New York: William Morrow, 2002.

Welch, Evelyn S. *Art and Society in Italy, 1350–1500.* Oxford History of Art. Oxford: Oxford Univ. Press, 1997.

Chapter 20
Sixteenth-Century Art in Italy

Acidini Luchinat, Cristina, et al. *The Medici, Michelangelo, & the Art of Late Renaissance Florence.* New Haven: Yale Univ. Press, 2002.

Andrews, Lew. *Story and Space in Renaissance Art: The Rebirth of Continuous Narrative.* New York: Cambridge Univ. Press, 1995.

Bambach, Carmen. *Drawing and Painting in The Italian Renaissance Workshop: Theory and Practice, 1330–1600.* Cambridge, U.K.: Cambridge Univ. Press, 1999.

Barriault, Anne B., ed. *Reading Vasari.* London: Philip Wilson in assoc. with the Georgia Museum of Art, 2005.

Brown, Patricia Fortini. *Art and Life in Renaissance Venice.* Perspectives. New York: Abrams, 1997.

Burroughs, Charles. *The Italian Renaissance Palace Facade: Structures of Authority, Surfaces of Sense.* Cambridge, U.K.: Cambridge Univ. Press, 2002.

Cellini, Benvenuto. *My Life.* Trans. & notes Julia Conaway Bondanella & Peter Bondanella. Oxford World's Classics. New York: Oxford Univ. Press, 2002.

Chastel, Andrée. *The Age of Humanism: Europe, 1480–1530.* Trans. Katherine M. Delavenay & E. M. Gwyer. London: Thames and Hudson, 1963.

Chelazzi Dini, Giulietta, Alessandro Angelini, and Bernardina Sani. *Sienese Painting: From Duccio to the Birth of the Baroque.* New York: Abrams, 1998.

Cole, Alison. *Virtue and Magnificence: Art of the Italian Renaissance Courts.* Perspectives. New York: Abrams, 1995. Reissue ed. Art of the Italian Courts. Prespectives. Upper Saddle River, NJ: Prentice Hall, 2006.

Dixon, Annette, ed. *Women Who Ruled: Queens, Goddesses, Amazons in Renaissance and Baroque Art.* Ann Arbor: Univ. of Michigan Museum of Art, 2002.

Franklin, David, ed. *Leonardo da Vinci, Michelangelo, and the Renaissance in Florence.* Ottawa: National Gallery of Canada in assoc. with Yale Univ. Press, 2005.

Freedberg, S. J. *Painting in Italy, 1500 to 1600.* 3rd ed. Pelican History of Art. New Haven: Yale Univ. Press, 1993.

Goffen, Rona. *Renaissance Rivals: Michelangelo, Leonardo, Raphael, Titian.* New Haven: Yale Univ. Press, 2002.

Gröössinger, Christa. *Picturing Women in Late Medieval and Renaissance Art.* New York: St. Martin's Press, 1997.

Hall, Marcia B. *After Raphael: Painting in Central Italy in the Sixteenth Century.* New York: Cambridge Univ. Press, 1999.

———., ed. *The Cambridge Companion to Raphael.* New York: Cambridge Univ. Press, 2005.

Hollingsworth, Mary. *Patronage in Sixteenth Century Italy.* London: Murray, 1996.

Hopkins, Andrew. *Italian Architecture: From Michelangelo to Borromini.* World of Art. New York: Thames & Hudson, 2002.

Hughes, Anthony. *Michelangelo.* London: Phaidon, 1997.

Huse, Norbert, and Wolfgang Wolters. *Art of Renaissance Venice: Architecture, Sculpture and Painting, 1460–1590.* Trans. Edmund Jephcott. Chicago: Univ. of Chicago Press, 1990.

Jacobs, Fredrika Herman. *Defining the Renaissance Virtuosa: Women Artists and the Language of Art History and Criticism.* Cambridge, U.K.: Cambridge Univ. Press, 1997.

Joannides, Paul. *Titian to 1518: The Assumption of Genius.* New Haven: Yale Univ. Press, 2001.

King, Ross. *Michelangelo & the Pope's Ceiling.* New York: Walker & Company, 2003.

Klein, Robert, and Henri Zerner. *Italian Art, 1500–1600: Sources and Documents.* Upper Saddle River, NJ: Prentice Hall, 1966.

Kliemann, Julian-Matthias, and Michael Rohlmann, *Italian Frescoes: High Renaissance and Mannerism, 1510-1600.* Trans. Steven Lindberg. New York: Abbeville Press, 2004.

Landau, David, and Peter Parshall. *The Renaissance Print: 1470–1550.* New Haven: Yale Univ. Press, 1994.

Lieberman, Ralph. *Renaissance Architecture in Venice, 1450–1540.* New York: Abbeville, 1982.

Lotz, Wolfgang. *Architecture in Italy, 1500–1600.* Rev. Deborah Howard. Pelican History of Art. New Haven: Yale Univ. Press, 1995.

Manca, Joseph. *Moral Essays on the High Renaissance: Art in Italy in the Age of Michelangelo.* Lanham, MD: Univ. Press of America, 2001.

Mann, Nicholas, and Luke Syson, eds. *The Image of the Individual: Portraits in the Renaissance.* London: British Museum Press, 1998.

Meilman, Patricia, ed. *The Cambridge Companion to Titian.* New York: Cambridge Univ. Press, 2004

Mitrovic, Branko. *Learning from Palladio.* New York: W. W. Norton, 2004.

Murray Linda. *The High Renaissance and Mannerism: Italy, the North and Spain, 1500–1600.* World of Art. London: Thames and Hudson, 1995.

Olson, Roberta J. M. *Italian Renaissance Sculpture.* World of Art. New York: Thames and Hudson, 1992.

Partridge, Loren W. *The Art of Renaissance Rome, 1400–1600.* New York: Abrams, 1996.

Pietrangeli, Carlo, et al. *The Sistine Chapel: The Art, the History, and the Restoration.* New York: Harmony, 1986.

Pilliod, Elizabeth. *Pontormo, Bronzino, Allori: A Genealogy of Florentine Art.* New Haven: Yale Univ. Press, 2001.

Poeschke, Joachim. *Michelangelo and his World: Sculpture of the Italian Renaissance.* Trans. Russell Stockman. New York: Harry N. Abrams, 1996.

Pope-Hennessy, Sir John. *Italian High Renaissance and Baroque Sculpture.* 3rd ed. Oxford: Phaidon, 1986.

——. *Italian Renaissance Sculpture.* 3rd ed. Oxford: Phaidon, 1986.

Rosand, David. *Painting in Cinquecento Venice: Titian, Veronese, Tintoretto.* Rev. ed. Cambridge, U.K.: Cambridge Univ. Press, 1997.

Rowe, Colin, and Leon Satkowski. *Italian Architecture of the 16th Century.* New York: Princeton Architectural Press, 2002.

Rowland, Ingrid D. *The Culture of the High Renaissance: Ancients and Moderns in Sixteenth Century Rome.* Cambridge, U.K.: Cambridge Univ. Press, 1998.

Shearman, John. *Mannerism.* Harmondsworth, UK: Penguin, 1967. Reissue ed. New York: Penguin Books, 1990.

Vasari, Giorgio. *The Lives of the Artists.* Trans. Julia Conaway Bondanella & Peter Bondanella. New York: Oxford Univ. Press, 1991.

Verheyen, Egon. *The Paintings in the Studiolo of Isabella d'Este at Mantua.* Monographs on Archaeology and Fine Arts. New York: New York Univ. Press, 1971.

Williams, Robert. *Art, Theory, and Culture in Sixteenth-Century Italy: From Techne to Metateche.* Cambridge, U.K.: Cambridge Univ. Press, 1997.

Chapter 21
Sixteenth-Century Art in Northern Europe and the Iberian Peninsula

Bartrum, Giulia. *Albrecht Düürer and his Legacy: The Graphic Work of a Renaissance Artist.* London: British Museum Press, 2002.

Bartrum, Giulia. *German Renaissance Prints 1490-1550.* London: British Museum Press, 1995.

Buck, Stephanie, and Jochen Sander. *Hans Holbein the Younger: Painter at the Court of Henry VIII.* Trans. Rachel Esner & Beverley Jackson. New York: Thames & Hudson, 2004.

Chapuis, Julien. *Tilman Riemenschneider: Master Sculptor of the Late Middle Ages.* Washington, D.C.: National Gallery of Art, 1999.

Cloulas, Ivan, and Michèèle Bimbenet-Privat. *Treasures of the French Renaissance.* Trans. John Goodman. New York: Harry N. Abrams, 1998.

Davies, David, and John H. Elliott. *El Greco.* London: National Gallery, 2003.

Dixon, Laurinda. *Bosch.* Art & Ideas. New York: Phaidon, 2003.

Foister, Susan. *Holbein and England.* New Haven: Published for Paul Mellon Centre for Studies in British Art by Yale Univ. Press, 2004.

Hayum, Andréé. *The Isenheim Altarpiece: God's Medicine and the Painter's Vision.* Princeton Essays on the Arts. Princeton: Princeton Univ. Press, 1989.

Hearn, Karen, ed. *Dynasties: Painting in Tudor and Jacobean England, 1530-1630.* New York: Rizzoli, 1996.

Koerner, Joseph Leo. *The Reformation of the Image.* Chicago: Univ. of Chicago Press, 2004.

Kubler, George. *Building the Escorial.* Princeton: Princeton Univ. Press, 1982.

Osten, Gert von der, and Horst Vey. *Painting and Sculpture in Germany and the Netherlands, 1500–1600.* Pelican History of Art. Harmondsworth, UK: Penguin, 1969.

Price, David Hotchkiss. *Albrecht Düürer's Renaissance: Humanism, Reformation, and the Art of Faith.* Studies in Medieval and Early Modern Civilization. Ann Arbor: Univ. of Michigan Press, 2003.

Roberts-Jones, Philippe, and Francoise Roberts-Jones. *Pieter Bruegel.* New York: Harry N. Abrams, 2002.

Smith, Jeffrey Chipps. *Nuremberg, a Renaissance City, 1500–1618.* Austin: Huntington Art Gallery, Univ. of Texas, 1983.

Strong, Roy C. *Artists of the Tudor Court: The Portrait Miniature Rediscovered, 1520–1620.* London: Victoria and Albert Museum, 1983.

The Word Made Image: Religion, Art, and Architecture in Spain and Spanish America, 1500-1600. Fenway Court, 28. Boston: Published by the Trustees of the Isabella Stewart Gardner Museum, 1998.

Wheeler, Daniel. *The Chateaux of France.* New York: Vendome Press, 1979.

Zerner, Henri. *Renaissance Art in France: The Invention of Classicism.* Paris: Flammarion, 2003.

Zorach, Rebecca. *Blood, Milk, Ink, Gold: Abundance and Excess in the French Renaissance.* Chicago: Univ. of Chicago Press, 2005.

CHAPTER 22
Baroque Art

Adams, Laurie Schneider. *Key Monuments of the Baroque.* Boulder, CO: Westview Press, 2000.

The Age of Caravaggio. New York: Metropolitan Museum of Art, 1985.

Allen, Christopher. *French Painting in the Golden Age.* World of Art. New York: Thames & Hudson, 2003.

Alpers, Svetlana. *The Making of Rubens.* New Haven: Yale Univ. Press, 1995.

Barberini, Maria Giulia, et al. *Life and the Arts in the Baroque Palaces of Rome: Ambiente Barocco.* Eds. Stefanie Walker and Frederick Hammond. New Haven: Published for the Bard Graduate Center for Studies in the Decorative Arts, New York by Yale Univ. Press, 1999.

Blankert, Albert. *Rembrandt: A Genius and his Impact.* Melbourne: National Gallery of Victoria, 1997.

Boucher, Bruce. *Italian Baroque Sculpture.* World of Art. New York: Thames and Hudson, 1998.

Brown, Beverly Louise, ed. *The Genius of Rome, 1592-1623.* London: Royal Academy of Arts, 2001.

Careri, Giovanni. *Baroques.* Tran. Alexandra Bonfante-Warren. Princeton: Princeton Univ. Press, 2003.

Chong, Alan, and Wouter Kloek. *Still-Life Paintings from the Netherlands, 1550-1720.* Zwolle: Waanders Publishers, 1999.

Franits, Wayne E. *Dutch Seventeenth-Century Genre Painting: Its Stylistic and Thematic Evolution.* New Haven: Yale Univ. Press, 2004.

Harbison, Robert. *Reflections on Baroque.* Chicago: Univ. of Chicago Press, 2000.

Kiers, Judikje, and Fieke Tissink. *Golden Age of Dutch Art: Painting, Sculpture, Decorative Art.* London: Thames and Hudson, 2000.

Lagerlof, Margaretha Rossholm. *Ideal Landscape: Annibale Caracci, Nicolas Poussin, and Claude Lorrain.* New Haven: Yale Univ. Press, 1990.

McPhee, Sarah. *Bernini and the Bell Towers: Architecture and Politics at the Vatican.* New Haven: Yale Univ. Press, 2002.

Millon, Henry A., ed. *The Triumph of the Baroque: Architecture in Europe, 1600-1750.* New York: Rizzoli, 1999.

Morrissey, Jake. *The Genius in the Design: Bernini, Borromini, and the Rivalry that Transformed Rome.* New York: William Morrow, 2005.

Slive, Seymour. *Dutch Painting 1600–1800.* Pelican History of Art. New Haven: Yale Univ. Press, 1995.

Stratton, Suzanne L., ed. *The Cambridge Companion to Veláázquez.* New York: Cambridge Univ. Press, 2002.

Summerson, John. *Inigo Jones.* New Haven: Published for the Paul Mellon Centre for Studies in British Art by Yale Univ. Press, 2000.

Vlieghe, Hans. *Flemish Art and Architecture, 1585–1700.* Pelican History of Art. New Haven: Yale Univ. Press, 1998. Reissue ed. 2004.

Wheelock Jr., Arthur K. *Flemish Paintings of the Seventeenth Century.* Washington, D.C.: National Gallery of Art, 2005.

Wittkower, Rudolf. *Art and Architecture in Italy, 1600 to 1750.* 3 vols. 4th ed. Rev. Joseph Connors & Jennifer Montague. Pelican History of Art. New Haven: Yale Univ. Press, 1999.

Zega, Andrew, and Bernd H. Dams. *Palaces of the Sun King: Versailles, Trianon, Marly: The Chââteaux of Louis XIV.* New York: Rizzoli, 2002.

CREDITS

Chapter 17

17-1, 17-2, 17-3, 17-5 Achim Bednorz; 17-4 © Guide Gallimard Florence, Illustration by Pilippe Biard; 17-6 Tosi Index Ricerca Iconografica; 17-7 Cimabue (Cenni di Pepi) Index Ricerca Iconografica, 17-8 Galleria degli Uffizi; 17-9, 17-10 Alinari / Art Resource, NY; 17-11Piero Codato / Canali Photobank; 17-12 Canali Photobank; 17-13 Thames & Hudson International, Ltd; 17-14 Photograph © Board of Trustees, National Gallery of Art, Washington, D.C.; 17-14, 17-16, 17-17 Scala Art Resource, NY;17-15 Canali Photobank; 17-16 Mario Quattrone / IKONA; 17-18 M. Beck-Coppola / Art Resource / Musee du Louvre; 17-19 Photography © 1991 The Metropolitan Museum of Art; 17-20 The Walters Art Museum, Baltimore; 17-21 Photograph © 1981 The Metropolitan Museum of Art; 17-23 Jan Gloc; 17-24, 17-25 © Radovnn Bocek; BOX: Canali Photobank; BOX: Alinari / Art Resource, NY.

Chapter 18

18-1, 18-4, 18-12, 18-16 Erich Lessing / Art Resource, NY; 18-2 SCALA Art Resource, NY; 18-3 Reunion des Musees Nationaux / Art Resource, NY; 18-5L Giradon / Art Resource, NY; 18-5R SCALA Art Resource, NY; 18-6 R.G. Ojeda / Art Resource, NY; 18-7 Bildarchiv der Osterreichische Nationalbibliothek; 18-8 Photograph © 1998 The Metropolitan Museum of Art, NY; 18-9 Kunsthistorisches Museum, Vienna; 18-10 Photograph © 1996 The Metropolitan Museum of Art, NY; 18-11 © National Gallery, London; 18-12 Photograph © Board of Trustees, National Gallery of Art, Washington, D.C.; 18-13 © National Gallery, London; 18-14 © Museo Nacional Del Prado; 18-19 Photograph © 1993 The Metropolitan Museum of Art, NY; 18-19 Speltdoorn / Musees Royaux des Beaux-Arts de Belgique; 18-20 Galleria degli Uffizi; 18-22 Joerg P. Anders / Art Resource /Bildarchiv Preussischer Kulturbesitz; 18-23, 18-24, 18-25 Achim Bednorz; 18-26 SCALA Art Resource, NY; 18-27 Musee d'art et d'histoire, Geneve; 18-28 John Rylands University Library of Manchester; 18-30 Photograph © 1997 The Metropolitan Museum of Art, NY; 18-31 The Pierpont Morgan Library / Art Resource, NY; BOX: H. Martaans, Bruges / Brugge; BOX: Bibliotheque Nationale de France.

Chapter 19

19-1, 19-39 © National Gallery, London; 19-2Photo Nimitallah / Art Resource, NY; 19-6, 19-7, 19-9, 19-12, 19-13, 19-15, 19-30, 19-32, 19-40 Achim Bednorz; 19-8 Cantarelli / Index Ricerca Iconografica; 19-10 Canali Photobank; 19-11 Museo Nazionale del Bargello, Florence / Canali Photobank; 19-12 Nimatallah / Art Resource, NY; 19-14 © Piazza del Santo, Padua, Italy / The Bridgeman Art Library; 19-16, 19-21 Erich Lessing / Art Resource, NY; 19-16 Art Resource, NY; 19-17 SCALA Art Resource, NY; 19-18 Cincinnati Art Museum, Ohio; 19-19 Sta. Maria Novella, Florence / Canali Photobank; 19-20, 19-22 Studio Mario Quattrone; 19-23, 19-26, 19-27, 19-33, 19-37, BOX: Scala / Art Resource, NY; 19-24 Canali Photobank; 19-25 Alinari /Art Resource, NY; 19-28, 19-29, BOX: Nicolo Orsi Battaglini / Art Resource, NY; 19-34 © Canali Photobank; 19-36 Orsi Battaglini / Index Ricerca Iconografica; 19-39 Galleria degli Uffizi, Florence / Canali Photobank; 19-41 Galleria Dell'Accademia, Venice / Cameraphoto Arte di Codato G.P. & C.snc; 19-44 Campolini / Art Resource, NY; 19-43 © The Frick Collection, NY; BOX: Art Resource / The Pierpont Morgan Library; BOX: The J. Paul Getty Museum; BOX: SCALA Art Resource, NY: BOX: Canali Photobank.

Chapter 20

20-1, 20-6, 20-8 Musei Vaticani; 20-2 Studio Mario Quattrone; 20-3 © National Gallery, London; 20-4 Lewandowski / LeMage / Art Resource, NY; 20-5 Photograph © Board of Trustees, National Gallery of Art, Washington, D.C.; 20-7 Alinari / Art Resource, NY; 20-9, 20-14, 20-29, 20-34, 20-42 Canali Photobank; 20-10, 20-20, 20-21, 20-27, 20-31, BOX: SCALA Art Resource, NY; 20-11 Zigrossi Bracchetti / Vatican Musei / IKONA; 20-12 AKG-Images; 20-15Hirmer Fotoarchiv; 20-16 © Raffaello Bencini / Ikona; 20-17, 20-47, BOX: Achim Bednorz; 20-18, BOX: © Alinari / Ikona; 20-19 SuperStock, Inc.; 20-22 Ikona; 20-23 Cameraphoto / Art Resource, NY; 20-24 Musee du Louvre / RMN Reunion des Musees Nationaux / Erich Lessing / Art Resource, NY; 20-25 Embassy of Italy; 20-26 Summerfield / Galleria degli Uffizi, Florence / Index Ricerca Iconografica; 20-28 A. Braccetti - P. Zigrossi / Musei Vaticani; 20-30 Alinari / Art Resource, NY; 20-33 Index Ricerca Iconografica; 20-35 Galleria degli Uffizi; 20-36 Photograph © 1990 The Metropoligan Museum of Art; 20-37 © National Gallery, London; 20-38 Photo Joseph Zehavi / Art Resource, NY; 20-39 © 2005 Museum of Fine Arts, Boston. All Rights Reserved; 20-39 Photograph © 2007 Museum of Fine Arts, Boston; 20-40, 20-41, BOX: Kunsthistorisches Museum, Vienna; 20-43 Cameraphoto / Art Resource, NY; 20-44 Erich Lessing / Art Resource, NY; 20-45 © Bildarchiv Monheim GmbH / Alamy.

Chapter 21

21-1 V & A Picture Library; 21-2, 21-3, 21-16, 21-22, 21-26 Erich Lessing / Art Resource, NY; 21-04 Photo O. Zimmermann; 21-5 Musee d'Unterlinden; 21-6 Germanisches Nationalmuseum Nurnberg; 21-7 SCALA / Alte Pinakothek, Munich / Art Resource, NY; 21-8 Laurie Platt Winfrey, Inc. / The Metrpolitan Museum of Art, NY; 21-9 Los Angeles County Museum of Art / Culver Pictures, Inc.; 21-10, 21-12 Alte Pinakothek, Munich. Bayerische Staatsgemaldesammlungen, Neue Pinakothek, Munich; 21-11 Photograph © Board of Trustees, National Gallery of Art, Washington, D.C.; 21-13 Reunion des Musees Natinaux/Art Resource, NY; 21-14 © GlobalQuest Photography / L. B. Foy; 21-15 Giraudon / The Bridgeman Art Library International; 21-17 Musee du Louvre / RMN Reunion des Musees Nationaux / SCALA Art Resource, NY; 21-20 Photograph © 2007 The Metropolitan Museum of Art, NY; 21-21 Photo Oronoz. Derechos reservados © Museo Nacional Del Prado; 21-22, BOX: SCALA Art Resource, NY; 21-24 Martin Buhler / Kunstmuseum Basel; 21-25 Musees Royaux des Beaux-Arts de Belgique; 21-27 Index Ricerca Iconografica; 21-28 The Royal Collection © 2008, Her Majesty Queen Elizabeth II; 21-29 The Nelson-Atkins Museum of Art; 21-30 © Hardwick Hall, Derbyshire, UK / The Bridgeman Art Library; 21-31 A.F. Kersting; BOX: Photograph © 2007 The Metropolitan Museum of Art.

Chapter 22

22-1 Herve Lewandowski / Louvre, Paris / Reunion des Musees Nationaux / Art Resource, NY; 22-02 © Alinari Archives / Corbis; 22-3, 22-8, 22-9, 22-14 Achim Bednorz; 22-4 SCALA Art Resource, NY; 22-5 Adros Studio Fotografia; 22-6, 22-16, 22-17 Canali Photobank; 22-7 IKONA; 22-10 Allen Memorial Art Museum; 22-11 Joseph Martin / akg-images; 22-12 Vincenzo Pirozzi / IKONA; 22-13 Canali Photobank; 22-15 Dagli Orti / The Art Archive; 22-18 Detroit Institute of Arts; 22-19 The Royal Collection © 2007, Her Majesty Queen Elizabeth II. Photo by A. C. Cooper Ltd.; 22-20 Casino Rospigliosi / Canali Photobank; 22-21 © The Cleveland Museum of Art, Dudley P. Allen Fund. 1943.265a; 22-22 Palazzo Barberini, Italy / Canali Photobank; 22-23 SCALA / Il Gesu, Rome, Italy / Art Resource, NY; 22-24 San Diego Museum of Art; 22-24 Markus Bassler / Bildarchiv Monheim GmbH / Alamy Images; 22-25 Bob Grove / Photograph © Board of Trustees, National Gallery of Art, Washington, D.C.; 22-26 Wadsworth Atheneum; 22-27 V & A Picture Library; 22-28, 22-29 Derechos reservados © Museo Nacional Del Prado; 22-30 The State Hermitage Museum; 22-31 Courtesy of Marilyn Stokstad, Private Collection; 22-32, 22-37, 22-54 Erich Lessing / Art Resource, NY; 22-33 Jakob Prandtauer / Achim Bednorz; 22-33 Institut Royal du Patrimoine Artistique (IRPA-KIK) © IRPA-KIK, Brussels; 22-36, 22-38 © Reunion des Musees Nationaux / Art Resource, NY; 22-39 Ashmolean Museum, Oxford, England; 22-41 Art Resource / Bildarchiv Preussischer Kulturbesitz; 22-42 Frans Hals Museum De Hallen; 22-43, 22-77 Photograph © Board of Trustees, National Gallery of Art, Washington, D.C.; 22-44, BOX: SCALA Art Resource, NY; 22-45, 22-46, 22-52 Rijksmuseum, Amsterdam; 22-47 Photograph © 2007 The Metropolitan Museum of Art; 22-48 Frick Art Reference Library / The Frick Collection, NY; 22-49 Stichting Vrienden van Het Mauritshuis; 22-50, 22-51 Richard Carafelli / Photograph © Board of Trustees, National Gallery of Art, Washington, D.C.; 22-53 Detroit Institute of Arts; 22-55 The Toledo Museum of Art; 22-56, 22-67 Altitude / Yann Arthus Bertrand; 22-57 Hugh Rooney / Eye Ubiquitos / Corbis-NY; 22-58 © Marc Deville / Corbis; 22-59 © Peter Willi / Superstock; 22-60 Photograph © 2000 Museum Associates/LACMA. All Rights Reserved; 22-61 Photo © 2004, Detroit Institute of Arts; 22-62 Photograph © 2007, The Art Institute of Chicago. All Rights Reserved; 22-63 © National Gallery, London; 22-64, 22-66 A.F. Kersting; 22-65 Inigo Jones / Historic Royal Palaces Enterprises Ltd; 22-68 Janet Urso @ bimmy.com; 22-69 Worcester Museum of Art. Gift of Mr. and Mrs. Albert W. Rice; BOX: National Museum of Women In the Arts.

INDEX